GOVERNORS STATE UNIVERSITY LIBRARY

P9-BYH-073
3 1611 00147 9929

DATE DUE

7/6			
NOV 1 4 2017			

UNIVERSITY LIBRARY
GOVERNORS STATE UNIVERSITY
UNIVERSITY PARK, IL 60466

Art After Modernism:

RETHINKING REPRESENTATION

DATE DUE

APR 0 6 1987		
NOV 2 10-30-88 /PASE 3		
NOV 2 8 1988		

DEMCO NO. 38-298

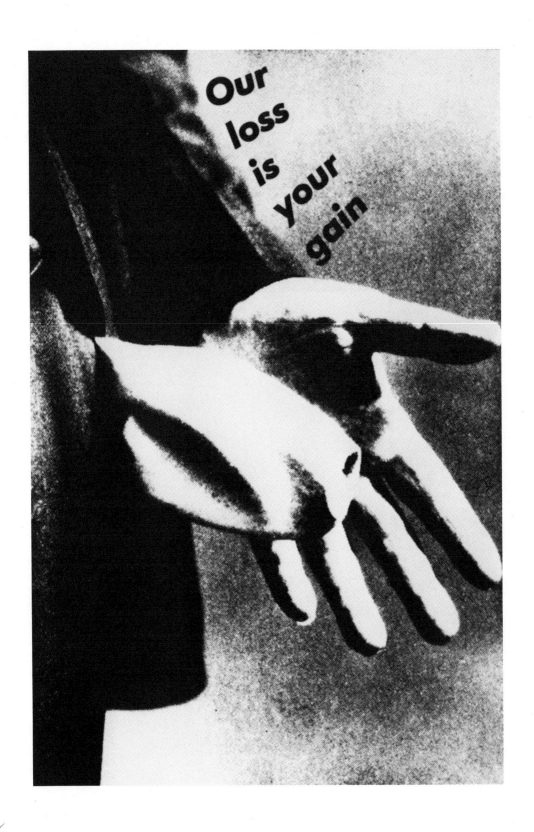

Art After Modernism:
RETHINKING REPRESENTATION

Edited and with an Introduction by
BRIAN WALLIS
Foreword by
MARCIA TUCKER

GOVERNORS STATE UNIVERSITY
UNIVERSITY PARK
IL. 60466

The New Museum of Contemporary Art, New York
in association with David R. Godine, Publisher, Inc., Boston

The New Museum of Contemporary Art, New York

Documentary Sources in Contemporary Art

Series Editor: Marcia Tucker
Staff Editors: Christopher Phillips
 Brian Wallis
 Tim Yohn

This volume is made possible through a generous grant
from the Henry Luce Fund for Scholarship in American Art.

The New Museum of Contemporary Art, 583 Broadway, New York, N.Y. 10012
David R. Godine, Publisher, Inc., 300 Massachusetts Ave., Boston, Mass. 02115

© 1984 by The New Museum of Contemporary Art
All rights reserved, Published 1984
Printed in the United States of America
Second printing, October 1986

Library of Congress Cataloging in Publication Data
Main entry under title:

Art after modernism.

(Documentary sources in contemporary art)
Bibliography: p.
Includes index.
1. Postmodernism—Addresses, essays, lectures.
2. Arts, Modern—20th century—Addresses, essays,
lectures. I. Wallis, Brian, 1953– . II. Series.
NX456.5.P66A74 1984 700'.9'04 84-22708

ISBN 0-87923-563-2
ISBN 0-87923-564-0 (pbk.)

Type set by Dix Type Inc., Syracuse, New York

Printed by Halliday Lithograph Corp., West Hanover, Mass.

Designed by Katy Homans, Homans/Salsgiver

Photographs selected and arranged by Louise Lawler, in collaboration with Brian Wallis

Endpapers: Andy Warhol, *Rorschach Test*, 1984, acrylic on canvas, 10 x 16' (3.04 x 4.88 m).
(Photos: courtesy Leo Castelli Gallery)

Frontispiece: Barbara Kruger, *Our Loss is Your Gain*, 1984, photomontage, 72 x 48" (183 x 122
cm). (Photo: courtesy the artist)

Permissions to reprint essays in this volume were generously granted by the original publishers
unless otherwise indicated.

Contents

NX 456.5 .P66 A74 1984

Art after modernism

Foreword
Marcia Tucker vii

Introduction
Brian Wallis xi

I. Image / Author / Critique 1

Pierre Menard, Author of the Quixote
Jorge Luis Borges 3

The Originality of the Avant-Garde: A Postmodern Repetition
Rosalind Krauss 13

Realism for the Cause of Future Revolution
Kathy Acker 31

II. Dismantling Modernism 43

The Rise of Andy Warhol
Robert Hughes 45

After Avant-Garde Film
J. Hoberman 59

Photography After Art Photography
Abigail Solomon-Godeau 75

Re-Viewing Modernist Criticism
Mary Kelly 87

III. Paroxysms of Painting 105

Figures of Authority, Ciphers of Regression
Benjamin H. D. Buchloh 107

Flak from the "Radicals": The American Case against German Painting
Donald B. Kuspit 137

Last Exit: Painting
Thomas Lawson 153

IV. Theorizing Postmodernism 167

From Work to Text
Roland Barthes 169

Pictures
Douglas Crimp 175

Re: Post
Hal Foster 189

The Allegorical Impulse: Toward a Theory of Postmodernism
Craig Owens 203

V. The Fictions of Mass Media 237

Progress Versus Utopia; or, Can We Imagine the Future?
Fredric Jameson 239

The Precession of Simulacra
Jean Baudrillard 253

Eclipse of the Spectacle
Jonathan Crary 283

VI. Cultural Politics 295

The Author as Producer
Walter Benjamin 297

Lookers, Buyers, Dealers, and Makers: Thoughts on Audience
Martha Rosler 311

Trojan Horses: Activist Art and Power
Lucy R. Lippard 341

VII. Gender / Difference / Power 359

Visual Pleasure and Narrative Cinema
Laura Mulvey 361

"A Certain Refusal of Difference": Feminist Film Theory
Constance Penley 375

Representation and Sexuality
Kate Linker 391

The Subject and Power
Michel Foucault 417

Bibliography 435

Index 447

Contributors 460

Foreword

MARCIA TUCKER

In much thinking and writing about contemporary art today, the
focus is on those aspects of art that have more to do with questions of taste,
style, fashion, or judgment than with more fundamental ideas and issues. This
is partly because contemporary art has become increasingly visible and popular
since the mid-1970s. Art is no longer seen as an elitist pursuit, remote from
the interests and concerns of the public at large. Today, contemporary art has
lost much of its radical hermeticism; even the term "avant-garde" has little
impact when every new artistic manifestation seems equally subject to co-
option by commercial interests.

Ironically, at the moment of contemporary art's greatest popularity, its
criticism has become the subject of considerable abuse. Over and over again
we hear that there is no single dominant issue on which to cut one's aesthetic
teeth, or that "pluralism" indicates not only a lack of artistic quality, but also
a lack of critical leadership. Or, worse yet, that art criticism has now receded
into a deeper hermeticism, behind a veil of pompous jargon. This anthology
attempts to redress some of this confusion and to provide a serious critical
frame of reference for the art of our time.

The New Museum of Contemporary Art was founded on the premise that
works of art are not only objects for visual delectation and assessment, but are
repositories for ideas that reverberate in the larger context of our culture. Since
the Museum is devoted to showing the work of the previous ten years, schol-
arship and documentation are essential to its basic function. Indeed, the more
recent the work, the more important it is to provide it with a historical and
critical framework. Therefore, as no comprehensive anthology of important
writing on contemporary art of the 1980s has yet been published and especially
in the light of the increasing popularity of the visual arts in recent years, we
hope that this anthology will provide valuable documentary resource material.

This book is directed to several audiences at once. First, it is intended for
a general audience, regularly exposed to images of the contemporary art world
through the media, but often without the benefit of analysis or understanding.
At the same time, it is directed to art professionals, for whom the issues
addressed are an essential part of our work. These include critics and writers,
museum professionals, dealers, and teachers of art history and aesthetics, all of
whom support and contribute to the critical dialogue. And, of course, this

volume is also intended for artists who today, more than ever, are knowledgeable, informed, and articulate, and increasingly participate in this critical exchange.* Finally, our book is intended for students of all kinds and ages who are interested in the pleasure and provocation of thinking not only about what the art of our time is, but also about what it means.

The critical climate of the 1980s, as represented in this anthology, is substantially different from that of the previous two decades. It is considerably more diversified, both in terms of the kind of writing it has produced and the backgrounds and interests of its writers. There is an increasing implementation of interdisciplinary thought and study; work in other fields—philosophy, linguistics, anthropology, applied and behavioral sciences, to name just a few—serves as a point of reference, a model, or becomes itself incorporated into the fabric of critical dialogue. Art criticism is thus linked to a larger world of intellectual endeavor and today is likely to include political, cultural, and sociological, as well as purely formal analysis. Diversification has occurred also because in recent years artists themselves have provided some of the most challenging writing, undertaken in response to what seemed to be a dearth of analysis following the critical polemic of conceptualism. We have seen as well a marked change in writing style, which includes the gradual diminution of the disembodied, authoritative third-person voice and the recuperation of a more personal, subjective tone, both leading to more inventive critical writing.

In its subject matter, this anthology takes into account areas other than painting and sculpture, since film, video, television, photography, and performance are interrelated in terms of the essential issues they address. We have limited ourselves for the most part to articles originally written in English, in particular those addressing aesthetic issues of importance in the United States. We have also chosen to include essays that seemed to us to be provocative, and even opinionated, rather than simply analytical or descriptive, and have decided not to publish essays which, while important, have been reprinted often in recent years. We have also commissioned a number of essays in order to address questions that had not been raised elsewhere in the past ten years.

The volume is unconventional in that it also contains essays of a more purely philosophical, theoretical, or literary nature which are not, strictly speaking, art criticism, but which have played a formative role in shaping today's critical dialogue. Similarly, although several essays fall well outside the time frame of the anthology (which concentrates primarily on writings done within the past five years), they were included not only because they are contemporary in spirit, but because they represent seminal sources of issues relevant to art writing and thought. The essays cover a wide range of writing styles, some of considerable complexity and others which are more casual in tone. It is our hope that this range, while accurately representing the state of contemporary art criticism, will prompt the general reader to test the waters of

* *Art After Modernism* is the first volume of the Museum's series, "Documentary Sources in Contemporary Art," and will be followed by an anthology of artists' critical, fictional, and journalistic writings of the past decade.

rigorous thought and analysis, while those for whom this is common practice may be tempted to relax for a moment on the shores of more informal discussion.

In publishing this anthology The New Museum is honored to acknowledge the generous support of the Henry Luce Foundation's Luce Fund for Scholarship in American Art. This volume is evidence of our joint commitment to excellence, scholarship, and intellectual achievement in the field of contemporary art.

Among the many others without whom this book would not have been possible, we would like to thank the essayists whose contributions here enliven the practice and the understanding of contemporary art. We make this acknowledgement with the realization that this selection of essays is only one among the many possible; therefore, we extend our sincere gratitude to critics in all fields, who make this such an important component of contemporary intellectual activity. In this vein also we would like to thank all those individuals in the art field—critics, museum personnel, artists, dealers—who responded to our initial letters of inquiry and who followed up with generous assistance.

Above all, my own thanks to Brian Wallis, who edited this volume, wrote the introductory essay, and saw the book through every detail of production. It is primarily through his initiative, skill, and enthusiasm that such a complex project has come to fruition.

On our own staff there is not a single member who has not had some participation in the development of this book. Deserving special mention, however, are Ed Jones, Robin Dodds, and Maria Reidelbach, who handled the initial stages of formulation and research of the project; Charles Schwefel, who prepared the grant proposal; Marcia Landsman, who assisted in many ways and shared her editorial expertise; and our staff of editors, Tim Yohn, Christopher Phillips, and Brian Wallis, who handled the myriad technical details of language, often under deadlines.

Others who contributed to this long project should be mentioned: Phil Mariani and May Castleberry, who prepared the book's bibliography and index; Tracy Hatton and Melissa Harris, whose proofreading and research skills provide the basis for this book's accuracy and thoroughness; Anne Glusker and Andy Berler, who assisted with editing and proofreading; and interns Seth Grodofsky and Jim Ferraro from Rutgers University, who helped considerably in the early stages of research.

Special thanks is due to Katy Homans and the staff of Homans/Salsgiver for the book's design and for cheerful and patient assistance at every stage of the production. Louise Lawler should also be singled out for her tremendous contribution in editing and arranging the photographs for this volume. We would also like to thank Barbara Kruger for her special cover design.

Finally, for his assistance in realizing this project and for crucial advice in our first major publishing venture, we acknowledge the foresight and commitment of our copublisher, David R. Godine.

We hope this volume merits the long and faithful commitment of these and other contributors.

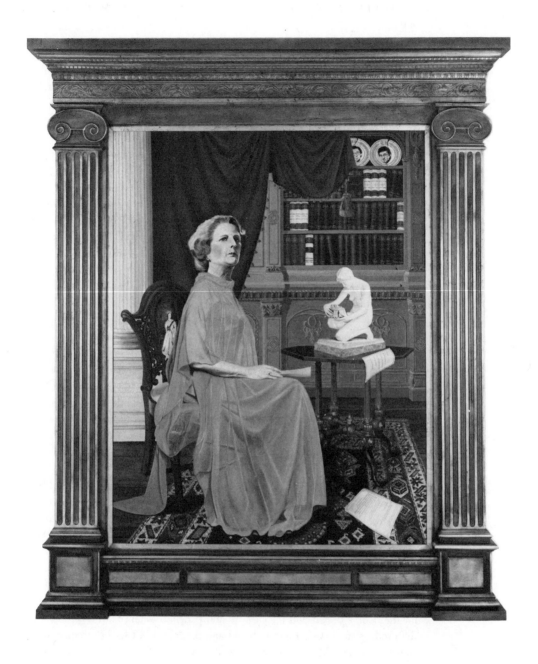

Hans Haacke. *Taking Stock (unfinished),* 1983–1984. Oil on canvas, in a wooden gold-leaf frame, 95 x 81 x 7″ (241.3 x 205.7 x 17.8 cm). (Photo: Zindman/Fremont; courtesy John Weber Gallery)

What's Wrong With This Picture?
An Introduction

B R I A N W A L L I S

Beyond the more obviously symbolic overtones of 1984, the year

Art After Modernism

may be remembered in the art world as that in which a debate, resulting from the loss of public funding for American art critics, revealed deep fissures and contradictions in contemporary art criticism as a whole. Many traditional critics –writers for *The New York Times*, *Newsweek*, and *New York* magazine, for example–publicly confessed to doubts about the intellectual worth of criticism owing to its supplemental position, subservient to the primary creative activity of the artist. At the same time, neoconservative critics seized the opportunity to insist, once again, that contemporary criticism is too political and that most art critics are "opposed to just about every policy of the United States except the one that put money in their own pockets."[1] In this paradoxical climate–where some see art criticism as having too much power while others find it impotent– it is hardly surprising that many observers, especially in the growing audience for art, should find this a period of particular crisis in art criticism.

The picture we get–of a conflicted, two-sided debate–is not altogether ac- curate, however. For if we examine closely the apparent contradiction, we find that both arguments stem from the same, fundamentally modernist, premise: that criticism could and should be value-free. In other words, the single argu- ment is that art criticism fulfills its purpose best when it keeps its place, when it confines itself to the elucidation and evaluation of high art. In this way, art and art criticism form a mutually supportive closed circuit, cloistered from the exigencies of social reality. By denying criticism an interest or leverage in social, economic, or political structures (particularly those in which art circulates), these arguments act as a kind of moral smokescreen, self-righteously rejecting alternate forms of criticism, but also masking the real political service their own criticism provides both through noninterference and through the promotion of prevailing values. Any purported failure of criticism then is only its failure to conform to these standards and expectations of modernist art criticism.

This supposedly apolitical stance of traditional or modernist art criticism, then, is in fact political in what it represses. On the other hand, in much recent writing, the political and social function of all kinds of criticism is acknowl-

1. Hilton Kramer, "Criticism endowed: reflections on a debacle," *The New Criterion* 2, no. 3 (November 1983): 4.

edged, and critics have actively explored the use of criticism as a positive means for social critique and change. It is this avowed social responsibility for art and criticism that lies at the heart of the essays in this volume. This interventionist criticism, as it is often called, represents a sharp break with the primarily formalist and idealist pretentions of modernist criticism.

Any understanding of contemporary art and criticism is necessarily bound up with a consideration of modernism, for modernism is the cultural standard which even today governs our conception of what art is. Modernism was the great dream of industrial capitalism, an idealistic ideology which placed its faith in progress and sought to create a new order. A self-consciously experimental movement covering well over a century, modernism encompasses a plenitude of positions. In the present context, however, modernism is taken to refer not to the terms of this historical program in its diversity, nor is it seen in terms of its original historical context, but rather as the aestheticized modernism which has been left at our doorstep: modernism as an institution. Today modernism is exhausted; its once provocative or outrageous products lie entombed in the cultural institutions they once threatened and offended. Picasso, Joyce, Lawrence, Brecht, Pollock, and Sartre are our contemporary classics. The rapid assimilation of these once-transgressive modernists, the reduction of their works to academic studies, has at the same time made newer art forms and activities, which do not conform to mainstream modernist canons, seem marginal or unimportant. Now, not only is the avant-garde no longer radical, though its forms continue to be reproduced and simulated for an overextended art market, but in a final irony, modernism has become the official culture, the aesthetic haven of neoconservatives.

Today our understanding of modernist art is shaped by the systematic critical theory which was applied to its history by Clement Greenberg and his followers. In a series of eloquent and highly persuasive essays published from the 1930s to the 1960s, Greenberg argued that the terms of modernist art practice were objectively verifiable, that they conformed to certain immutable laws. In this sense he saw modernism as the fulfillment of the promise of the Enlightenment in which rational determinations governed the parceling of all disciplines, all fields of knowledge, into discrete areas of competence—this applied to science, philosophy, history, as well as art. In all fields the mark of achievement, the attainment of high quality, was determined by self-criticism, self-definition, and elimination of elements from other disciplines. As Greenberg wrote, "The essence of modernism lies, as I see it, in the use of the characteristic methods of a discipline to criticize the discipline itself—not in order to subvert it, but to entrench it more firmly in its area of competence."[2]

In painting, for example, the inherent qualities of the medium—identified by Greenberg as color, flatness, edge, scale—formed the basis for determinations of quality. Characteristics considered extrinsic, particularly literary or theatrical qualities such as narrative, realism, description, subject matter, or drama, were regarded as detrimental and constituted impurities. Logically, Greenberg favored an art of expression and form, one exemplified by abstract painting,

2. Clement Greenberg, "Modernist Painting," *Arts Yearbook*, no. 4 (1961): 48.

such as that of the abstract expressionists, or later that of Morris Louis and Kenneth Noland.

In this way, modernism was constantly bound to its own formally reductive system. Transgression or critique could take place only within the terms of artistic creation already established. Stylistic change in this medium-specific system was based primarily on technical innovation, and progress was identified with advancements in technique which increased the degree of pure, aesthetic pleasure. Factors determining the nature and causes of cultural production were limited, in criticism, to specifically artistic ones. Modernism marginalized the issue of artistic motivations or interests outside the art system, denying that artworks were themselves bound by a web of connections to specific historical and social contexts. Indeed, in the aesthetic economy of modernism, the amount of pure pleasure provided by a work of art was often gauged by how effectively that work separated itself from the "real" world to provide an imaginary space of ideal reflection. One principal attitude, which the essays in this book contest, is this tendency of modernism to posit artworks as the products of an autonomous, disengaged form of labor and consumption, freed from normal social commerce by virtue of their status as objects designed exclusively for visual pleasure.

The central purpose of art and art criticism since the early 1960s has been the dismantling of the monolythic myth of modernism and the dissolution of its oppressive progression of great ideas and great masters. As the leading cultural products of late modernism—abstract expressionism, the *nouveau roman*, existentialism, avant-garde film, New Criticism—were gradually set aside, they were replaced by art forms and critical models which specifically countered the ideals of modernism. Pop art, for instance, deliberately accepted as its subject matter the low-culture, tabloid images rejected disdainfully by modernism; similarly, minimalism exaggerated hyperbolically the formalist codes of late modernism, creating spare but "theatrical" works. Subsequent artistic production, throughout the late 1960s and 1970s, defiantly deviated from the clearly defined aesthetic categories of modernism. There were significant crossovers between art and music, film and performance, sculpture and architecture, painting and popular culture. This gradual shift or mutation in the rigidly structured forms of modernist art has led not to another style, but to a fully transformed conception of art founded on alternate critical premises.

Indigenous transformations in American art and criticism in the 1970s were fueled by the introduction of new translations of European critical theory, particularly the works of the Frankfurt School, Roland Barthes, Michel Foucault, Jean Baudrillard, Jacques Derrida, Jacques Lacan, Continental feminist theory, and British film theory. This extensive body of critical and theoretical work, responding to the breakdown of modernist discourse in literary theory, psychoanalysis, and the social sciences, shifted attention away from the masterworks toward the operations of modernism itself, and from the established divisions of traditional culture toward an interdisciplinary examination of the dynamics of representation. Specifically, this work studied the function of cultural myths in representation, the construction of representation in social systems, and the perpetuation and function of these systems through representation. In film studies, for example, the critique of the Hollywood film system

by the British film journal *Screen* (exemplified by Laura Mulvey's essay "Visual Pleasure and Narrative Cinema"), followed precisely these lines.

By focusing on the wider issue of representation (of which art forms a part), artists and critics sought to, first, undercut the authority of certain dominant representations (especially as they emanated from the media through photography), and, second, to begin to construct representations which would be less confining and oppressive (in part by providing a space for the viewer, in part through signifying its own position and affiliations). This critique of representation forms the centerpiece of an alliance of theoretical and critical positions which have examined and influenced the art of the late 1970s and early 1980s. In addition to underlying the restructuring of much recent art, issues of representation in society provide the focus for the critical approaches in this book. Therefore, a somewhat greater analysis of the function of representation is warranted at this point.

Rethinking Representation

This book first arose out of a passage in Borges, out of the laughter that shattered, as I read the passage, all the familiar landmarks of my thought—our thought, the thought that bears the stamp of our age and our geography—breaking up all the ordered surfaces and all the planes with which we are accustomed to tame the wild profusion of existing things, and continuing long afterwards to disturb and threaten with collapse our age-old distinction between the Same and the Other. This passage quotes a 'certain Chinese encyclopedia' in which it is written that 'animals are divided into: (a) belonging to the Emperor, (b) embalmed, (c) tame, (d) sucking pigs, (e) sirens, (f) fabulous, (g) stray dogs, (h) included in the present classification, (i) frenzied, (j) innumerable, (k) drawn with a very fine camelhair brush, (l) et cetera, (m) having just broken the water pitcher, (n) that from a long way off look like flies.' In the wonderment of this taxonomy, the thing we apprehend in one great leap, the thing that, by means of the fable, is demonstrated as the exotic charm of another system of thought, is the limitation of our own, the stark impossibility of thinking that.

—Michel Foucault, *The Order of Things*

In his introduction to *The Order of Things* in 1966, Michel Foucault identified Borges' story of the Chinese encyclopedia as an allegory which pointedly suggests the limits of representation. The irony of Borges' allegory centers on his demonstration that such classifications, such representations—the "landmarks of our thought"—are themselves fictional and contradictory constructions. The name, the genre, the category, the image, are all ways of circumscribing branches of knowledge by initially isolating certain elements of similitude and making these the criteria for differentiation. Foucault's laughter underscores his recognition that the cultural codes we live by, the orders of discourse we follow, all manners of representation—are not natural and secure, but are arbitrary and historically determined; they are, therefore, subject to critique and revision. Moreover, being critically formulated, such systems and dis-

courses are governed by the biases of any critical process and, in assuming the authority to enact distinctions, initiate their own limitations and exclusions based on particular interests.

There are of course many forms of representation; art forms a single, highly visible example. In the wildest sense, representations are those artificial (though seemingly immutable) constructions through which we apprehend the world: conceptual representations such as images, languages, definitions; which include and construct more social representations such as race and gender. Although such constructions often depend on a material form in the real world, representations constantly are posed as natural "facts" and their misleading plenitude obscures our apprehension of reality. Our access to reality is mediated by a gauze of representation. What is fragile about this oppressive contract is that the representational model we employ (and which cannot be avoided) is based on a critical selectivity—defining, naming, ordering, classifying, cataloguing, categorizing—that is just as arbitrary as that in Borges' encyclopedia. Two implications immediately arise: first, that the founding act of representation involves an assumption of authority in the process of segregation, accumulation, selection, and confinement; and second, that critical theory might provide a key to understanding and countering certain negative effects of representation. For criticism addresses the fact that while the rational *surface* of representation—the name or image—is always calm and whole, it covers the *act* of representing which necessarily involves a violent decontextualization.[3] In Roland Barthes' words, "Representations are formations, but they are also deformations."

Considered in social terms, representation stands for the interests of power. Consciously or unconsciously, all institutionalized forms of representation certify corresponding institutions of power. As Louis Althusser demonstrated, this power may be encoded subliminally in the iconography of communication, as well as in the anonymous evaluations which construct the "ideological state apparatuses" of the family, religion, law, culture, and nationality. Typical cultural representations, such as newspaper photographs, films, advertisements, popular fiction, and art, carry such ideologically charged messages. Advertisements, for example, depict particular mythologies or stereotypical ideals of "the good life." And while no one would deny that advertisements purposefully embody the ideological projections of the particular class whose interests they perpetuate, the point is that all cultural representations function this way, including representations of gender, class, and race. Such designations are inevitably hierarchical in the manner by which they privilege one element over another, in the ways they direct and dominate. Therefore, it is not that representations possess an inherent ideological content, but that they carry out an ideological function in determining the production of meaning.

If we acknowledge this system of inclusion and exclusion, and reject the implication (which Borges' story lampoons) that any system of representation can be successfully unifying and totalizing, then it follows that there may exist

3. Edward Said, "In the Shadow of the West," *wedge*, nos. 7–8 (Winter-Spring 1985): 4.

within any system not only margins which may serve as sites for resistance, but also whole fields or communities of interest which might be inhabited and invigorated. The recognition that the critique of representation necessarily takes as its object those types of cultural constructions (images, ideologies, symbols) with which art traditionally deals, suggests that art and artmaking might be one effective site for such critical intervention. From this point of view, the issue is less how art criticism can best serve art than how art can serve as a fruitful realm for critical and theoretical activity. This gives to art criticism a responsibility and a political potential it is often denied (what the artist Victor Burgin refers to as "the politics of representation," as opposed to the "representation of politics"). Further, it shows the way to a more general critical practice which, surrounding and playing off art, might place in broader circulation an important body of issues and ideas.

Rather than simply ridiculing the ideal of determinate meaning, then, Foucault's laughter underscores the potential of cultural criticism to challenge the fixed notions of representation. This new criticism would reexamine representation as a discourse, analyzing the way it produces and enforces knowledge (the institutions and operations which ensure its circulation), making clear how such knowledge is legitimated, and initiating a less exclusive and more generative means for interpreting the products of our culture. There is no possibility of operating outside the confinements of representation; rather—as is suggested in much of the criticism in this volume—the strategy is to work against such systems from within, to create new possibilities.

This book, then, comprises a kind of argument. In contrast to the narrowly stylistic and ostensibly apolitical theories of modernist criticism, the essays in this book insist on a variety of rigorous, interdisciplinary approaches, using economic, psychoanalytic, literary, and sociological theories to establish specific connections between art and social operations. This argument accepts as a historical determinant the waning validity of modernism as a radical endeavor and proposes in its wake a more heterogeneous set of options and strategies to operate as a "working definition" of what art can be and how it can function critically. (How art criticism functions in this expanded field of art activity forms the subtext of this argument.) The main lines of this polemic emerge through clusters of essays which specifically address one another or each contribute to the dialogue on a particular issue.

Three very different essays in the first section of the book raise three fundamental formal issues which signal the break with modernist aesthetics: the so-called "death of the author" (Borges); the importance of originality and innovation in the construction of the "aura," desirability, and value of the modernist art work (Krauss); and the displacement of the production of meaning from the artist to the reception or "completion" of the work by the viewer (Acker). Discounting these former linchpins of aesthetic production has in a certain sense liberated contemporary artists from modernist constraints. Yet, at the same time, there persist vestiges of modernist practice and ideology, in many respects anachronistic, which complicate the critical issues. The terms of this struggle between the still-dominant modernism and its critical opposition

are charted in the various short histories of painting (Hughes), film (Hoberman), photography (Solomon-Godeau), and criticism (Kelly), contained in the chapter entitled "Dismantling Modernism."[4]

Current, somewhat frantic, attempts by the art market to salvage the commercial products of the collapsed modernist project are epitomized by the present, peculiarly vaunted status of painting as a preferred medium. Benjamin Buchloh sees in this revival of figurative expressionistic painting an echo of the reactionary revival of traditional craftsmanship and subject matter in European painting of the 1920s. Donald Kuspit and Thomas Lawson, on the other hand, both argue for the continued validity of painting as a radical endeavor, though their arguments proceed along different paths. Kuspit contends that New German Painting retains a radical capacity to serve as a public exorcism of personal or national trauma. Lawson, accepting the central, privileged position of painting in the art system, argues for it as the most visible and expedient site for critical intervention.

As a cultural term, postmodernism has been used to describe everything from a broad cultural shift (coinciding with postindustrialism) to new directions in rock music. Since in a broad sense postmodernist critical practices underlie all the essays in this book, the section "Theorizing Postmodernism" focuses rather narrowly on the original definitions of that term in relation to recent art. To a great extent these definitions depend on a literary source, particularly Roland Barthes' theory of the text and, more broadly, poststructuralism. Hal Foster's essay provides an excellent introduction to the ways in which several art critics used these theories to interpret the shifting attitudes of artists in the late 1970s. Douglas Crimp and Craig Owens, in particular, argue that works of art function like texts in that they facilitate the active response of the viewer. As with allegorical fragments, the viewer must fill in, add to, build upon suggestive elements in the text supplying extraneous historical, personal, and social references, rather than, as in modernism, transporting himself to the special world and time of the artist's original production.

This tendency to read all cultural products as "texts" has led to considerations of the structure and function of representation outside of high art. Elements of popular culture—anathema to modernist critics such as Greenberg—are regarded as equally fruitful objects of critical investigation as painting and sculpture. Thus Fredric Jameson's investigations of the subgenres of science fiction and detective stories as bearers of contemporary ideologies, or Jonathan Crary's recognition in *General Hospital* of a digitized interchangeability of characters, do more than describe the mechanisms of the media, they attempt to deconstruct and expose their contradictory codes.

Jean Baudrillard has suggested that these media-derived representations are more real to us today than reality. Or, at least, that certain forms of imagery and narrative strategies in the media, having no basis in fact, have warped our definition of and access to material reality. Today no action, no feeling, no

4. "Dismantling modernism" echoes the title of Allan Sekula's seminal essay, "Dismantling Modernism, Reinventing Documentary (Notes on the Politics of Representation)," *Massachusetts Review* 19, no. 4 (Winter 1978): 859–883.

thought we own has not been preformed by a thousand movies, commercials, television sitcoms, or magazine articles. Our society, supersaturated with information and images, not only has no need for individuality, it no longer owns such a concept.

As the technical means for producing or distributing mass-media representations becomes increasingly remote from the individual, the need for a critical understanding of the network and institutions which produce such images becomes even more important. In this respect Walter Benjamin's essay provides a still-timely model for how the artist might function politically through changing the forms of artistic production, particularly by effective use of preexisting mass media forms of photojournalism, promotion, and distribution. As Benjamin establishes a direct, functional relationship between the context and distribution of photographic images and the interests of capital, Martha Rosler extends this project in her own essay examining the contemporary art world institutions which govern the production, critical assessment, and circulation of photographs as art. Lucy Lippard adopts a more overtly militant activist response to specific social and political situations, especially in relation to overtly unequal distributions of social and political power.

A rigorous questioning of such hierarchical conditions is central to current feminist theory and to its contribution to the analysis of the social function of representations. Today feminist critiques of representation and power address a number of issues which have not been examined elsewhere with equal force or clarity: the repositioning of the subject in relation to power (Acker, Foucault, Mulvey); the ability to reread and question inherited knowledge (Mulvey, Penley); the understanding that power is knowledge and knowledge power (Linker, Foucault); and ultimately the rejection of logic and representation themselves as demonstrably patriarchal concepts (Acker, Linker).

Inasmuch as any anthology is retrospective in character, this book is in a productive way backward-looking, providing a summing-up of several, by now established directions in recent criticism. This approach, however, inevitably harbors its own exclusions and foreshortens consideration of issues which only now appear on the horizon. The exclusions are of great concern not only for what has been left out, but also for what has not been written (a serious study of black culture in relation to the institutionalized art world, for instance) —or what will never be written given present institutional practices. With these limitations in mind, we can make further demands on future criticism: to explore the specific economic motivations and impingements on the institutions of the art world—museums, galleries, publications, critics themselves; to examine the methods by which specific racial, social, and ethnic groups are marginalized, their interests and images stereotyped or suppressed; to address particular audiences for art and criticism and establish new means of distributions to meet such audiences; to consider how certain issues elude representation or are assimilated into conventional modes of representation (images of work, poverty, history, nature, for example); and, finally, given the invisible imperialism of global information networks, to retain access to the apparatus of image production, but also to insist on access to criticism of the system itself.

I.

Image / Author / Critique

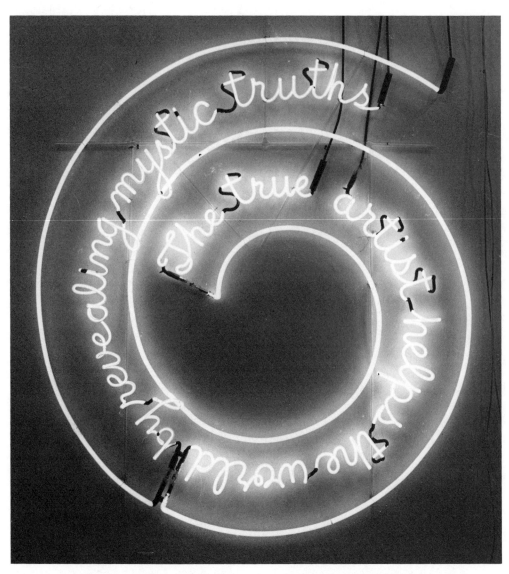

Bruce Nauman. *Window or Wall Sign,* 1967. Blue and peach neon tubing, 59 x 55" (149.8 x 139.7 cm).
(Photo: courtesy Leo Castelli Gallery)

Pierre Menard, Author of the Quixote

JORGE LUIS BORGES

The *visible* work left by this novelist is easily and briefly enumer-
ated. Impardonable, therefore, are the omissions and additions perpetrated by

For Silvina
Ocampo

Madame Henri Bachelier in a fallacious catalogue which a certain daily, whose *Protestant* tendency is no secret, has had the inconsideration to inflict upon its deplorable readers—though these be few and Calvinist, if not Masonic and circumcised. The true friends of Menard have viewed this catalogue with alarm and even with a certain melancholy. One might say that only yesterday we gathered before his final monument, amidst the lugubrious cypresses, and already Error tries to tarnish his Memory . . . Decidedly, a brief rectification is unavoidable.

I am aware that it is quite easy to challenge my slight authority. I hope, however, that I shall not be prohibited from mentioning two eminent testimonies. The Baroness de Bacourt (at whose unforgettable *vendredis* I had the honor of meeting the lamented poet) has seen fit to approve the pages which follow. The Countess de Bagnoregio, one of the most delicate spirits of the Principality of Monaco (and now of Pittsburgh, Pennsylvania, following her recent marriage to the international philanthropist Simon Kautzsch, who has been so inconsiderately slandered, alas! by the victims of his disinterested maneuvers) has sacrificed "to veracity and to death" (such were her words) the stately reserve which is her distinction, and, in an open letter published in the magazine *Luxe*, concedes me her approval as well. These authorizations, I think, are not entirely insufficient.

I have said that Menard's visible work can be easily enumerated. Having examined with care his personal files, I find that they contain the following items:

a) A symbolist sonnet which appeared twice (with variants) in the review *La conque* (issues of March and October 1899).

b) A monograph on the possibility of constructing a poetic vocabulary

Reprinted from Jorge Luis Borges, *Labyrinths: Selected Stories and Other Writings*, trans. Donald A. Yates and James E. Irby (New York: New Directions Publishing Corp., 1964), pp. 36-44.

of concepts which would not be synonyms or paraphrases of those which make up our everyday language, "but rather ideal objects created according to convention and essentially designed to satisfy poetic needs" (Nîmes, 1901).

c) A monograph on "certain connections or affinities" between the thought of Descartes, Leibniz, and John Wilkins (Nîmes, 1903).

d) A monograph on Leibniz's *Characteristica universalis* (Nîmes, 1904).

e) A technical article on the possibility of improving the game of chess, eliminating one of the rook's pawns. Menard proposes, recommends, discusses, and finally rejects this innovation.

f) A monograph on Ramón Lull's *Ars magna generalis* (Nîmes, 1906).

g) A translation, with prologue and notes, of Ruy López de Sigura's *Libro de la invención liberal y arte del juego del axedrez* (Paris, 1907).

h) The work sheets of a monograph on George Boole's symbolic logic.

i) An examination of the essential metric laws of French prose, illustrated with examples taken from Saint-Simon (*Revue des langues romanes*, Montpellier, October 1909).

j) A reply to Luc Durtain (who had denied the existence of such laws), illustrated with examples from Luc Durtain (*Revue des langues romanes*, Montpellier, December 1909).

k) A manuscript translation of the *Aguja de navegar cultos* of Quevedo, entitled *La boussole des précieux*.

l) A preface to the Catalogue of an exposition of lithographs by Carolus Hourcade (Nîmes, 1914).

m) The work *Les problèmes d'un problème* (Paris, 1917), which discusses, in chronological order, the different solutions given to the illustrious problem of Achilles and the tortoise. Two editions of this book have appeared so far; the second bears as an epigraph Leibniz's recommendation *"Ne craignez point, monsieur, la tortue"* and revises the chapters dedicated to Russell and Descartes.

n) A determined analysis of the "syntactical customs" of Toulet (*N.R.F.*, March 1921). Menard—I recall—declared that censure and praise are sentimental operations which have nothing to do with literary criticism.

o) A transposition into alexandrines of Paul Valéry's *Le Cimetière marin* (*N.R.F.*, January 1928).

p) An invective against Paul Valéry, in the *Papers for the Suppression of Reality* of Jacques Reboul. (This invective, we might say parenthetically, is the exact opposite of his true opinion of Valéry. The latter understood it as such and their old friendship was not endangered.)

q) A "definition" of the Countess de Bagnoregio, in the "victorious volume"—the locution is Gabriele d'Annunzio's, another of its collaborators—published annually by this lady to rectify the inevitable falsifications of journalists and to present "to the world and to Italy" an authentic image of her person, so often exposed (by very reason of her beauty and her activities) to erroneous or hasty interpretations.

r) A cycle of admirable sonnets for the Baroness de Bacourt (1934).

s) A manuscript list of verses which owe their efficacy to their punctuation.[1]

This, then, is the *visible* work of Menard, in chronological order (with no omission other than a few vague sonnets of circumstance written for the hospitable, or avid, album of Madame Henri Bachelier). I turn now to his other work: the subterranean, the interminably heroic, the peerless. And—such are the capacities of man!—the unfinished. This work, perhaps the most significant of our time, consists of the ninth and thirty-eighth chapters of the first part of *Don Quixote* and a fragment of Chapter XXII. I know such an affirmation seems an absurdity; to justify this "absurdity" is the primordial object of this note.[2]

Two texts of unequal value inspired this undertaking. One is that philological fragment by Novalis—the one numbered 2005 in the Dresden edition—which outlines the theme of a *total* identification with a given author. The other is one of those parasitic books which situate Christ on a boulevard, Hamlet on La Cannebière, or Don Quixote on Wall Street. Like all men of good taste, Menard abhorred these useless carnivals, fit only—as he would say—to produce the plebeian pleasure of anachronism or (what is worse) to enthrall us with the elementary idea that all epochs are the same or are different. More interesting, though contradictory and superficial of execution, seemed to him the famous plan of Daudet: to conjoin the Ingenious Gentleman and his squire in *one* figure, which was Tartarin. . . . Those who have insinuated that Menard dedicated his life to writing a contemporary *Quixote* calumniate his illustrious memory.

He did not want to compose another *Quixote*—which is easy—but *the Quixote itself*. Needless to say, he never contemplated a mechanical transcription of the original; he did not propose to copy it. His admirable intention was to produce a few pages which would coincide—word for word and line for line—with those of Miguel de Cervantes.

"My intent is no more than astonishing," he wrote me the 30th of September, 1934, from Bayonne. "The final term in a theological or metaphysical demonstration—the objective world, God, causality, the forms of the universe—is no less previous and common than my famed novel. The only difference is that the philosophers publish the intermediary stages of their labor in pleasant volumes and I have resolved to do away with those stages." In truth, not one worksheet remains to bear witness to his years of effort.

The first method he conceived was relatively simple. Know Spanish well, recover the Catholic faith, fight against the Moors or the Turks, forget the

1. Madame Henri Bachelier also lists a literal translation of Quevedo's literal translation of the *Introduction à la vie dévote* of St. Francis of Sales. There are no traces of such a work in Menard's library. It must have been a jest of our friend, misunderstood by the lady.

2. I also had the secondary intention of sketching a personal portrait of Pierre Menard. But how could I dare to compete with the golden pages which, I am told, the Baroness de Bacourt is preparing or with the delicate and punctual pencil of Carolus Hourcade?

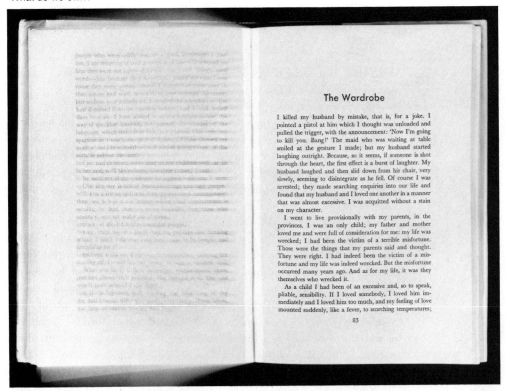

Alberto Moravia, Barbara Kruger, Louise Lawler, and Sherrie Levine, 1980. Centerfold from the Franklin Furnace *Flue*, no. 1 (December 1980)

and the more I loved, the more I effaced myself, driving myself from my mind and forcing the beloved person into it. At that time this person was my mother. To say that I loved her is putting it mildly: to such an extent had I identified myself with her that, at certain moments when we were together, it almost seemed to me that there was only one single person present: my mother. During those years she appeared to me to be very unhappy; in reality she was happy, but in her own way, that is, thanks to a married life scrupulously spaced out with quarrels and equally passionate reconciliations. I understood nothing of it; and when, at table, I was present at a brawl between my parents I was vehement in taking my mother's side. One day my father's hand crossed my visual field and landed, with violence, on the face of my mother. A moment later she and I were together in my bedroom. My mother sobbed and hugged me convulsively to her breast; all of a sudden she cried: 'Get ready, take your belongings, put on your coat. I'm going to pack my suitcase. We're leaving this house, for good.' She went out. Full of excitement and zeal I put my favourite toys and some underclothes into a bag, slipped on my coat and then ran to my mother's room. The door was only half closed; I had a jumbled view of my mother and father on the bed; they were one on top of the other; and her voice, languid, faint, annoyed, called me by name and told me to go back to my own room.

I was mortified, hurt, horror-struck. I had the hateful sensation of having placed myself blindly and completely in unworthy hands. I do not know what happened. Instinctively and without effort I divided myself, so to speak, into two persons, of whom one, the real, the genuine one, continued on her own account; while the other, a successful imitation of the first, was delegated to have relations with the world. Thus I no longer ran the risk of being implicated

84

and absorbed by others through the fault of my excessive sensibility. It was my other self which loved; it was also my other self which suffered disappointment. My first self remained at a distance, impassive, ironical, and watching.

I no longer suffered. But, on the other hand, I felt myself more and more alone, through the years; I no longer communicated with anybody, it was the other self, invented by me and delegated for that purpose, which communicated. I must admit that the other self managed extremely well: she was quick-witted, active, uninhibited, aggressive. But action is one thing, to watch action is another. For fear of mortifications of the kind that my mother had inflicted upon me, I had condemned myself to a sort of paralysis. I watched the life of my other self, but I myself did not live. I felt more and more isolated, more and more restricted and impotent. For my defence I had built a fortress; and now this fortress was being transformed, more and more, into a prison.

I was invited to a big villa in the country. Among the guests was a young man of very serious aspect who had recently taken a degree in engineering and who paid court to me in a timid way. For years I had moved amongst people without having relations with anyone. This time I told my other self that I had no need of her; I wanted to be myself, without intermediaries and without delegates, to love and be loved. To give an assessment of the violence of my need for love, all I need do is to describe the manner in which I forced the hand of my over-cautious wooer. One evening after supper he stayed downstairs playing billiards; and I went upstairs. I went to my bedroom, put on my prettiest nightdress and hurried to his room, where I shut myself up in his wardrobe, among his coats and ties. Possibly this wardrobe, in which, in the dark, with anxiously beating heart, I waited for him to come up to

85

for the trip. When you return, you must give him back to me.'

My husband and I spent a week in Paris; and it was a second honeymoon. Someone, perhaps, will wish to know how I managed to recreate our former love relationship. It was simple: I repeated the scene of our first encounter. As soon as we arrived in Paris, I sent my husband out of the hotel on some pretext or other; then I undressed, put on my prettiest nightdress and shut myself up in the wardrobe. Once again the dark, stifling wardrobe, stuffy-smelling and encumbered with clothes, seemed to symbolize the psychological prison in which I had immured myself. I waited a long time, then heard my husband come in and call me; and then, with a shrill cry of joy, I opened the wardrobe door and threw myself into his arms. I was saved.

But as soon as we got back to Italy, there was the other one, pushing herself forward actually at the airport, placing herself at my side as we walked across the runway and enjoining me to give my husband back to her. I refused firmly. That murderess (the moment has come to call her so) next morning left the house uttering vaguely threatening remarks. I followed her, saw her enter a gunsmith's shop and acquire a pistol. I understood her plan and decided to thwart it. At a time when she had gone out, I went into her room, searched and found the pistol, removed the magazine and took it away with me. Then I felt calmer and went to join my husband at table.

The rest you know. We were sitting at table; I was contemplating my husband with melting tenderness and the other one was watching us with gnawing jealousy. Then she took out the pistol and pointed it at him, saying: 'Now I'm going to kill you. Bang!' I did not move. I knew it was not a joke, as it was intended to appear; but I was sure of

88

my facts: the pistol was without its magazine. I had not reckoned with the perversity of the other one, who had taken the precaution of slipping a bullet into the breech. The pistol went off and my husband fell to the floor, dead.

As I have said, I asserted that the pistol went off by mistake, and thus I saved the other one from certain conviction. Why did I save her? Because I do not trust myself; it might happen to me once again to love too much, and then I should have need of her. But, in saving her, I have tied myself to a murderess. I am her accomplice and I know for certain that the killing of my husband is only the first of a long series of crimes. Impunity will encourage her. In the meantime my parents are looking for a new husband for me. I tremble for him even before knowing him. Once I am married, I shall have to give him over to the other one and isolate myself; or else run the risk of seeing him killed before my eyes.

89

Reprinted by permission of Farrar, Strauss and Giroux, Inc. "The Wardrobe," from *Bought and Sold* by Alberto Moravia, translated by Angus Davidson. English translation copyright 1971 by Martin Secker and Warburg, Ltd.

history of Europe between the years 1602 and 1918, *be* Miguel de Cervantes. Pierre Menard studied this procedure (I know he attained a fairly accurate command of seventeenth-century Spanish) but discarded it as too easy. Rather as impossible! my reader will say. Granted, but the undertaking was impossible from the very beginning and of all the impossible ways of carrying it out, this was the least interesting. To be, in the twentieth century, a popular novelist of the seventeenth seemed to him a diminution. To be, in some way, Cervantes and reach the *Quixote* seemed less arduous to him—and, consequently, less interesting—than to go on being Pierre Menard and reach the *Quixote* through the experiences of Pierre Menard. (This conviction, we might say in passing, made him omit the autobiographical prologue to the second part of *Don Quixote.* To include that prologue would have been to create another character —Cervantes—but it would also have meant presenting the *Quixote* in terms of that character and not of Menard. The latter, naturally, declined that facility.) "My undertaking is not difficult, essentially," I read in another part of his letter. "I should only have to be immortal to carry it out." Shall I confess that I often imagine he did finish it and that I read the *Quixote*—all of it—as if Menard had conceived it? Some nights past, while leafing through Chapter XXVI—never essayed by him—I recognized our friend's style and something of his voice in this exceptional phrase: "the river nymphs and the dolorous and humid Echo." This happy conjunction of a spiritual and a physical adjective brought to my mind a verse by Shakespeare which we discussed one afternoon:

Where a malignant and a turbaned Turk . . .

But why precisely the *Quixote?* our reader will ask. Such a preference, in a Spaniard, would not have been inexplicable; but it is, no doubt, in a symbolist from Nîmes, essentially a devotee of Poe, who engendered Baudelaire, who engendered Mallarmé, who engendered Valéry, who engendered Edmond Teste. The aforementioned letter illuminates this point. "The *Quixote*," clarifies Menard, "interests me deeply, but it does not seem—how shall I say it?—inevitable. I cannot imagine the universe without Edgar Allan Poe's exclamation:

Ah, bear in mind this garden was enchanted!

or without the *Bateau ivre* or the *Ancient Mariner,* but I am quite capable of imagining it without the *Quixote.* (I speak, naturally, of my personal capacity and not of those works' historical resonance.) The *Quixote* is a contingent book; the *Quixote* is unnecessary. I can premeditate writing it, I can write it, without falling into a tautology. When I was ten or twelve years old, I read it, perhaps in its entirety. Later, I have reread closely certain chapters, those which I shall not attempt for the time being. I have also gone through the interludes, the plays, the *Galatea,* the exemplary novels, the undoubtedly laborious tribulations of Persiles and Sigismunda, and the *Viage del Parnaso.* . . . My general recollection of the *Quixote*, simplified by forgetfulness and indifference, can well equal the imprecise and prior image of a book not yet written. Once that image (which no one can legitimately deny me) is postu-

lated, it is certain that my problem is a good bit more difficult than Cervantes' was. My obliging predecessor did not refuse the collaboration of chance: he composed his immortal work somewhat *à la diable*, carried along by the inertias of language and invention. I have taken on the mysterious duty of reconstructing literally his spontaneous work. My solitary game is governed by two polar laws. The first permits me to essay variations of a formal or psychological type; the second obliges me to sacrifice these variations to the 'original' text and reason out this annihilation in an irrefutable manner. . . . To these artificial hindrances, another—of a congenital kind—must be added. To compose the *Quixote* at the beginning of the seventeenth century was a reasonable undertaking, necessary and perhaps even unavoidable; at the beginning of the twentieth, it is almost impossible. It is not in vain that three hundred years have gone by, filled with exceedingly complex events. Amongst them, to mention only one, is the *Quixote* itself."

In spite of these three obstacles, Menard's fragmentary *Quixote* is more subtle than Cervantes'. The latter, in a clumsy fashion, opposes to the fictions of chivalry the tawdry provincial reality of his country; Menard selects as his "reality" the land of Carmen during the century of Lepanto and Lope de Vega. What a series of *espagnolades* that selection would have suggested to Maurice Barrès or Dr. Rodríguez Larreta! Menard eludes them with complete naturalness. In his work there are no gypsy flourishes or conquistadors or mystics or Philip the Seconds or *autos da fé*. He neglects or eliminates local color. This disdain points to a new conception of the historical novel. This disdain condemns *Salammbô*, with no possibility of appeal.

It is no less astounding to consider isolated chapters. For example, let us examine Chapter XXXVIII of the first part, "which treats of the curious discourse of Don Quixote on arms and letters." It is well known that Don Quixote (like Quevedo in an analogous and later passage in *La hora de todos*) decided the debate against letters and in favor of arms. Cervantes was a former soldier: his verdict is understandable. But that Pierre Menard's Don Quixote—a contemporary of *La trahison des clercs* and Bertrand Russell—should fall prey to such nebulous sophistries! Madame Bachelier has seen here an admirable and typical subordination on the part of the author to the hero's psychology; others (not at all perspicaciously), a *transcription* of the *Quixote*; the Baroness de Bacourt, the influence of Nietzsche. To this third interpretation (which I judge to be irrefutable) I am not sure I dare to add a fourth, which concords very well with the almost divine modesty of Pierre Menard: his resigned or ironical habit of propagating ideas which were the strict reverse of those he preferred. (Let us recall once more his diatribe against Paul Valéry in Jacques Reboul's ephemeral surrealist sheet.) Cervantes' text and Menard's are verbally identical, but the second is almost infinitely richer. (More ambiguous, his detractors will say, but ambiguity is richness.)

It is a revelation to compare Menard's *Don Quixote* with Cervantes'. The latter, for example, wrote (Part I, Chapter IX):

> . . . *truth, whose mother is history, rival of time, depository of deeds, witness of the past, exemplar and adviser to the present, and the future's counselor.*

Written in the seventeenth century, written by the "lay genius" Cervantes, this enumeration is a mere rhetorical praise of history. Menard, on the other hand, writes:

> . . . truth, whose mother is history, rival of time, depository of deeds, witness of the past, exemplar and adviser to the present, and the future's counselor.

History, the *mother* of truth: the idea is astounding. Menard, a contemporary of William James, does not define history as an inquiry into reality but as its origin. Historical truth, for him, is not what has happened; it is what we judge to have happened. The final phrases—*exemplar and adviser to the present, and the future's counselor*—are brazenly pragmatic.

The contrast in style is also vivid. The archaic style of Menard—quite foreign, after all—suffers from a certain affectation. Not so that of his forerunner, who handles with ease the current Spanish of his time.

There is no exercise of the intellect which is not, in the final analysis, useless. A philosophical doctrine begins as a plausible description of the universe; with the passage of the years it becomes a mere chapter—if not a paragraph or a name—in the history of philosophy. In literature, this eventual caducity is even more notorious. The *Quixote*—Menard told me—was, above all, an entertaining book; now it is the occasion for patriotic toasts, grammatical insolence, and obscene deluxe editions. Fame is a form of incomprehension, perhaps the worst.

There is nothing new in these nihilistic verifications; what is singular is the determination Menard derived from them. He decided to anticipate the vanity awaiting all man's efforts; he set himself to an undertaking which was exceedingly complex and, from the very beginning, futile. He dedicated his scruples and his sleepless nights to repeating an already extant book in an alien tongue. He multiplied draft upon draft, revised tenaciously, and tore up thousands of manuscript pages.[3] He did not let anyone examine these drafts and took care they should not survive him. In vain have I tried to reconstruct them.

I have reflected that it is permissible to see in this "final" *Quixote* a kind of palimpsest, through which the traces—tenuous but not indecipherable—of our friend's "previous" writing should be translucently visible. Unfortunately, only a second Pierre Menard, inverting the other's work, would be able to exhume and revive those lost Troys. . . .

"Thinking, analyzing, inventing [he also wrote me] are not anomalous acts; they are the normal respiration of the intelligence. To glorify the occasional performance of that function, to hoard ancient and alien thoughts, to recall with incredulous stupor what the *doctor universalis* thought, is to confess

3. I remember his quadricular notebooks, his black crossed-out passages, his peculiar typographical symbols, and his insect-like handwriting. In the afternoons he liked to go out for a walk around the outskirts of Nîmes; he would take a notebook with him and make a merry bonfire.

our laziness or our barbarity. Every man should be capable of all ideas and I understand that in the future this will be the case."

Menard (perhaps without wanting to) has enriched, by means of a new technique, the halting and rudimentary art of reading: this new technique is that of the deliberate anachronism and the erroneous attribution. This technique, whose applications are infinite, prompts us to go through the *Odyssey* as if it were posterior to the *Aeneid* and the book *Le jardin du Centaure* of Madame Henri Bachelier as if it were by Madame Henri Bachelier. This technique fills the most placid works with adventure. To attribute the *Imitatio Christi* to Louis Ferdinand Céline or to James Joyce, is this not a sufficient renovation of its tenuous spiritual indications?

Translated by
James E. Irby

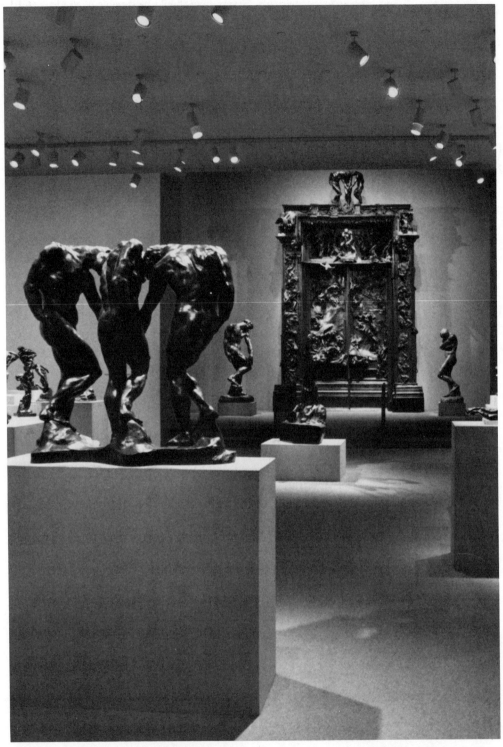

Installation view of the exhibition *Rodin Rediscovered* at the National Gallery of Art, Washington, D.C., June 28, 1981–April 11, 1982. Section 7, "*The Gates of Hell* and Their Offspring." (Photo: James Pipkin)

The Originality of the Avant-Garde:
A Postmodernist Repetition

ROSALIND KRAUSS

In the summer of 1981 the National Gallery in Washington installed
what it proudly described as "the largest Rodin exhibition, ever." Not only
was this the greatest public gathering of Rodin's sculpture, but it included, as
well, much of his work never before seen. In certain cases the work had not
been seen because it consisted of pieces in plaster that had lain on the shelves
in storage at Meudon since the artist's death, closed off to the prying eyes of
scholars and public alike. In other instances the work had not been seen
because it had only just been made. The National Gallery's exhibition included,
for example, a brand-new cast of *The Gates of Hell*, so absolutely recent that
visitors to the exhibition were able to sit down in a little theater provided for
the occasion to view a just-completed movie of the casting and finishing of this
new version.

To some–though hardly all–of the people sitting in that theater watching
the casting of *The Gates of Hell*, it must have occurred that they were witness-
ing the making of a fake. After all, Rodin has been dead since 1918, and
surely a work of his produced more than sixty years after his death cannot be
the genuine article, cannot, that is, be an original. The answer to this is more
interesting than one would think; for the answer is neither yes nor no.

When Rodin died he left the French nation his entire estate, which
consisted not only of all the work in his possession, but also all of the rights of
its reproduction, that is, the right to make bronze editions from the estate's
plasters. The Chambre des Députés, in accepting this gift, decided to limit the
posthumous editions to twelve casts of any given plaster. Thus *The Gates of
Hell*, cast in 1978 by perfect right of the State, is a legitimate work: a real
original we might say.

But once we leave the lawyer's office and the terms of Rodin's will, we
fall immediately into a quagmire. In what sense is the new cast an original? At
the time of Rodin's death *The Gates of Hell* stood in his studio like a mammoth
plaster chessboard with all the pieces removed and scattered on the floor. The
arrangement of the figures on *The Gates* as we know it reflects the most current
notion the sculptor had about its composition, an arrangement documented by

Reprinted from *October*, no. 18 (Fall 1981): 47-66.

numbers penciled on the plasters corresponding to numbers located at various stations on *The Gates*. But these numbers were regularly changed as Rodin played with and recomposed the surface of the doors; and so, at the time of his death, *The Gates* were very much unfinished. They were also uncast. Since they had originally been commissioned and paid for by the State, they were, of course, not Rodin's to issue in bronze, even had he chosen to do so. But the building for which they had been commissioned had been canceled; *The Gates* were never called for, hence never finished, and thus never cast. The first bronze was made in 1921, three years after the artist's death.

So, in finishing and patinating the new cast there is no example completed during Rodin's lifetime to use for a guide to the artist's intentions about how the finished piece was to look. Due to the double circumstance of there being no lifetime cast *and*, at time of death, of there existing a plaster model still in flux, we could say that *all* the casts of *The Gates of Hell* are examples of multiple copies that exist in the absence of an original. The issue of authenticity is equally problematic for each of the existing casts; it is only more conspicuously so for the most recent.

But, as we have constantly been reminding ourselves ever since Walter Benjamin's "The Work of Art in the Age of Mechanical Reproduction," authenticity empties out as a notion as one approaches those mediums which are inherently multiple. "From a photographic negative, for example," Benjamin argued, "one can make any number of prints; to ask for the 'authentic' print makes no sense." For Rodin, the concept of the "authentic bronze cast" seems to have made as little sense as it has for many photographers. Like Atget's thousands of glass negatives for which, in some cases, no lifetime prints exist, Rodin left many of his plaster figures unrealized in any permanent material, either bronze or marble. Like Cartier-Bresson, who never printed his own photographs, Rodin's relation to the casting of his sculpture could only be called remote. Much of it was done in foundries to which Rodin never went while the production was in progress; he never worked on or retouched the waxes from which the final bronzes were cast, never supervised or regulated either the finishing or the patination, and in the end never checked the pieces before they were crated to be shipped to the client or dealer who had bought them. From his position deep in the ethos of mechanical reproduction, it was not as odd for Rodin as we might have thought to have willed his country posthumous authorial rights over his own work.

The ethos of reproduction in which Rodin was immersed was not limited, of course, to the relatively technical question of what went on at the foundry. It was installed within the very walls, heavy with plaster dust—the blinding snow of Rilke's description—of Rodin's studio. For the plasters that form the core of Rodin's work are, themselves, casts. They are thus potential multiples. And at the core of Rodin's massive output is the structural proliferation born of this multiplicity.

In the tremulousness of their balance, *The Three Nymphs* compose a figure of spontaneity—a figure somewhat discomposed by the realization that these three are identical casts of the same model; just as the magnificent sense of improvisatory gesture is strangely bracketed by the recognition that *The Two Dancers* are not simply spiritual, but mechanical twins. *The Three Shades*, the

composition that crowns *The Gates of Hell*, is likewise a production of multiples, three identical figures, triple-cast, in the face of which it would make no sense—as little as with the nymphs or dancers—to ask which of the three is the original. *The Gates* themselves are another example of the modular working of Rodin's imagination, with the same figure compulsively repeated, repositioned, recoupled, recombined.[1] If bronze casting is that end of the sculptural spectrum which is inherently multiple, the forming of the figurative originals is, we would have thought, at the *other* end—the pole consecrated to uniqueness. But Rodin's working procedures force the fact of reproduction to traverse the *full length* of this spectrum.

Now, nothing in the myth of Rodin as the prodigious form-giver prepares us for the reality of these arrangements of multiple clones. For the form-giver is the maker of originals, exultant in his own originality. Rilke had long ago composed that incantatory hymn to Rodin's originality in describing the profusion of bodies invented for *The Gates:*

> . . . *bodies that listen like faces and lift themselves like arms; chains of bodies, garlands and single organism; bodies that listen like faces and lift tendrils and heavy clusters of bodies into which sin's sweetness rises out of the roots of pain. . . . The army of these figures became much too numerous to fit into the frame and wings of "Gates of Hell." Rodin made choice after choice and eliminated everything that was too solitary to subject itself to the great totality; everything that was not quite necessary was rejected.*[2]

This swarm of figures that Rilke evokes is, we are led to believe, composed of *different* figures. And we are encouraged in this belief by the cult of originality that grew up around Rodin, one that he himself invited. From the kind of reflexively intended hand-of-God imagery of Rodin's own work, to his carefully staged publicity—as in his famous portrait as genius progenitor by Edward Steichen—Rodin courted the notion of himself as form-giver, creator, crucible of originality. Rilke chants,

> *One walks among these thousand forms, overwhelmed with the imagination and the craftsmanship which they represent, and involuntarily one looks for the two hands out of which this world has risen. . . . One asks for the man who directs these hands.*[3]

1. For a discussion of Rodin's figural repetitions, see my *Passages in Modern Sculpture* (New York: The Viking Press, 1977), chapter 1; and Leo Steinberg, *Other Criteria: Confrontations with Twentieth-Century Art* (New York: Oxford University Press, 1972), pp. 322-403.

2. Rainer Maria Rilke, *Rodin*, trans. Jessie Lemont and Hans Trausil (London: The Grey Walls Press, 1946), p. 32.

3. Ibid., pp. 1-2. [The following quotation—from Henry James, *The Ambassadors* (New York and London: Harper & Brothers Publishers, 1903), p. 135—is an epigraph to Rilke's *Rodin*—ed. note.]

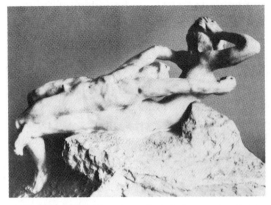

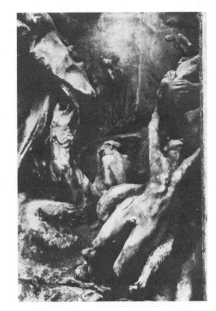

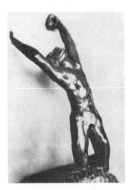

(Above) Auguste Rodin. *Fugit Amor,* ca. 1883(?), before 1887. Marble, 14½ x 17½ x 7⅝" (36.8 x 44.4 x 19.4 cm). Musée Rodin, Paris

(Right) Auguste Rodin. *The Gates of Hell* (detail), 1880– ca. 1887. Bronze, entire: 18' x 12' x 33" (5.49 m x 3.66 m x 83.8 cm). Musée Rodin, Paris

Auguste Rodin. *The Prodigal Son (L'Enfant Prodigue),* before 1899. Bronze, 54 x 28 x 34½" (137.2 x 71.2 x 87.6 cm). Musée Rodin, Paris

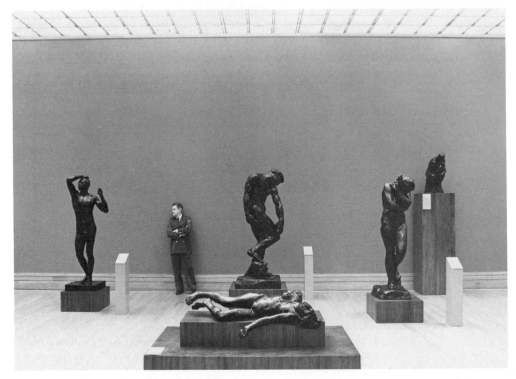

Installation of Rodin sculptures in the André Meyer Galleries of The Metropolitan Museum of Art, New York. (Photo: Louise Lawler, *Figures and Guard,* 1983)

Henry James, in *The Ambassadors*, had added,

> *With his genius in his eyes, his manners on his lips, his long career*
> *behind him and his honors and rewards all round, the great artist . . .*
> *affected our friend as a dazzling prodigy of type . . . with a personal*
> *lustre almost violent, he shone in a constellation.*

What are we to make of this little chapter of the *comédie humaine*, in which the artist of the last century most driven to the celebration of his own originality and of the autographic character of his own kneading of matter into formal life, *that* artist, should have given his own work over to an afterlife of mechanical reproduction? Are we to think that in this peculiar last testimony Rodin acknowledged the extent to which his was an art of reproduction, of multiples without originals?

But at a second remove, what are we to make of our own squeamishness at the thought of the future of posthumous casting that awaits Rodin's work? Are we not involved here in clinging to a culture of originals which has no place among the reproductive mediums? Within the current photography market this culture of the original—the vintage print—is hard at work. The vintage print is specified as one made "close to the aesthetic moment"—and thus an object made not only by the photographer himself, but produced, as well, contemporaneously with the taking of the image. This is of course a mechanical view of authorship—one that does not acknowledge that some photographers are less good printers than the printers they hire; or that years after the fact photographers reedit and recrop older images, sometimes vastly improving them; or that it is possible to re-create old papers and old chemical compounds and thus to resurrect the look of the nineteenth-century vintage print, so that authenticity need not be a function of the history of technology.

But the formula that specifies a photographic original as a print made "close to the aesthetic moment" is obviously a formula dictated by the art historical notion of period style and applied to the practice of connoisseurship. A period style is a special form of coherence that cannot be fraudulently breached. The authenticity folded into the concept of *style* is a product of the way style is conceived as having been generated: that is, collectively and unconsciously. Thus an individual could not, by definition, consciously will a style. Later copies will be exposed precisely because they are not of the period; it is exactly that shift in sensibility that will get the chiaroscuro wrong, make the outlines too harsh or too muddy, disrupt the older patterns of coherence. It is this concept of period style that we feel the 1978 cast of *The Gates of Hell* will violate. We do not care if the copyright papers are all in order; for what is at stake are the aesthetic rights of style based on a culture of originals. Sitting in the little theater, watching the newest *Gates* being cast, watching this violation, we want to call out, "Fraud!"

Now why would one begin a discussion of avant-garde art with this story about Rodin and casts and copyrights? Particularly since Rodin strikes one as the very last artist to introduce to the subject, so popular was he during his lifetime,

so celebrated, and so quickly induced to participate in the transformation of his own work into kitsch.

The avant-garde artist has worn many guises over the first hundred years of his existence: revolutionary, dandy, anarchist, aesthete, technologist, mystic. He has also preached a variety of creeds. One thing only seems to hold fairly constant in the vanguardist discourse and that is the theme of originality. By originality, here, I mean more than just the kind of revolt against tradition that echoes in Ezra Pound's "Make it new!" or sounds in the futurists' promise to destroy the museums that cover Italy as though "with countless cemeteries." More than a rejection or dissolution of the past, avant-garde originality is conceived as a literal origin, a beginning from ground zero, a birth. Marinetti, thrown from his automobile one evening in 1909 into a factory ditch filled with water, emerges as if from amniotic fluid to be born—without ancestors—a futurist. This parable of absolute self-creation that begins the first *Futurist Manifesto* functions as a model for what is meant by originality among the early twentieth-century avant-garde. For originality becomes an organicist metaphor referring not so much to formal invention as to sources of life. The self as origin is safe from contamination by tradition because it possesses a kind of originary naiveté. Hence Brancusi's dictum, "When we are no longer children, we are already dead." Or again, the self as origin has the potential for continual acts of regeneration, a perpetuation of self-birth. Hence Malevich's pronouncement, "Only he is alive who rejects his convictions of yesterday." The self as origin is the way an absolute distinction can be made between a present experienced *de novo* and a tradition-laden past. The claims of the avant-garde are precisely these claims to originality.

Now, if the very notion of the avant-garde can be seen as a function of the discourse of originality, the actual practice of vanguard art tends to reveal that "originality" is a working assumption that itself emerges from a ground of repetition and recurrence. One figure, drawn from avant-garde practice in the visual arts, provides an example. This figure is the grid.

Aside from its near ubiquity in the work of those artists who thought of themselves as avant-garde—their numbers include Malevich as well as Mondrian; Léger as well as Picasso; Schwitters, Cornell, Reinhardt, and Johns as well as Andre, LeWitt, Hesse, and Ryman—the grid possesses several structural properties which make it inherently susceptible to vanguard appropriation. One of these is the grid's imperviousness to language. "Silence, exile, and cunning," were Stephen Dedalus' passwords: commands that in Paul Goodman's view express the self-imposed code of the avant-garde artist. The grid promotes this silence, expressing it moreover as a refusal of speech. The absolute stasis of the grid, its lack of hierarchy, of center, of inflection, emphasizes not only its antireferential character, but—more importantly—its hostility to narrative. This structure, impervious both to time and to incident, will not permit the projection of language into the domain of the visual, and the result is silence.

This silence is not due simply to the extreme effectiveness of the grid as a barricade against speech, but to the protectiveness of its mesh against all intrusions from outside. No echoes of footsteps in empty rooms, no scream of birds across open skies, no rush of distant water—for the grid has collapsed the

spatiality of nature onto the bounded surface of a purely cultural object. With its proscription of nature as well as of speech, the result is still more silence. And in this new-found quiet, what many artists thought they could hear was the beginning, the origins of Art.

For those for whom art begins in a kind of originary purity, the grid was emblematic of the sheer disinterestedness of the work of art, its absolute purposelessness, from which it derived the promise of its autonomy. We hear this sense of the originary essence of art when Schwitters insists, "Art is a primordial concept, exalted as the godhead, inexplicable as life, indefinable and without purpose." And the grid facilitated this sense of being born into the newly evacuated space of an aesthetic purity and freedom.

While for those for whom the origins of art are not to be found in the idea of pure disinterest so much as in an empirically grounded unity, the grid's power lies in its capacity to figure forth the material ground of the pictorial object, simultaneously inscribing and depicting it, so that the image of the pictorial surface can be seen to be born out of the organization of pictorial matter. For these artists, the grid-scored surface is the image of an absolute beginning.

Perhaps it is because of this sense of a beginning, a fresh start, a ground zero, that artist after artist has taken up the grid as the medium within which to work, always taking it up as though he were just discovering it, as though the origin he had found by peeling back layer after layer of representation to come at last to this schematized reduction, this graph-paper ground, were *his* origin, and his finding it an act of originality. Waves of abstract artists "discover" the grid; part of its structure one could say is that in its revelatory character it is always a new, a unique discovery.

And just as the grid is a stereotype that is constantly being paradoxically rediscovered, it is, as a further paradox, a prison in which the caged artist feels at liberty. For what is striking about the grid is that while it is most effective as a badge of freedom, it is extremely restrictive in the actual exercise of freedom. Without doubt the most formulaic construction that could possibly be mapped on a plane surface, the grid is also highly inflexible. Thus just as no one could claim to have invented it, so once one is involved in deploying it, the grid is extremely difficult to use in the service of invention. And thus when we examine the careers of those artists who have been most committed to the grid, we could say that from the time they submit themselves to this structure their work virtually ceases to develop and becomes involved, instead, in repetition. Exemplary artists in this respect are Mondrian, Albers, Reinhardt, and Agnes Martin.

But in saying that the grid condemns these artists not to originality but to repetition, I am not suggesting a negative description of their work. I am trying instead to focus on a pair of terms—originality and repetition—and to look at their coupling unprejudicially; for within the instance we are examining, these two terms seem bound together in a kind of aesthetic economy, interdependent and mutually sustaining, although the one—originality—is the valorized term and the other—repetition or copy or reduplication—is discredited.

We have already seen that the avant-garde artist above all claims originality as his right—his birthright, so to speak. With his own self as the origin of

Sol LeWitt. *Modular Cube Series,* 1969–1976. Various sizes and locations. As designed by Sol LeWitt for the catalogue *Sol LeWitt,* edited by Alicia Legg (New York: Museum of Modern Art, 1978)

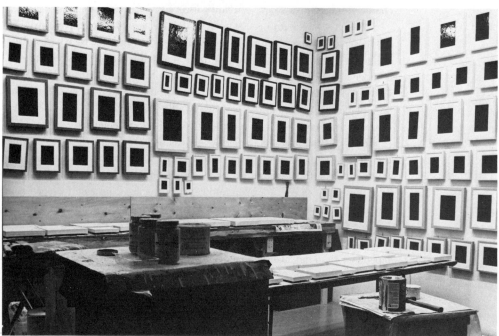

Installation of paintings in the studio of Allan McCollum, New York City. (Photo: Louise Lawler, *Artist's Studio [Allan McCollum],* 1983)

his work, that production will have the same uniqueness as he; the condition of his own singularity will guarantee the originality of what he makes. Having given himself this warrant, he goes on, in the example we are looking at, to enact his originality in the creation of grids. Yet as we have seen, not only is he —artist *x*, *y*, or *z*—*not* the inventor of the grid, but *no one* can claim this patent: the copyright expired sometime in antiquity and for many centuries this figure has been in the public domain.

Structurally, logically, axiomatically, the grid *can only be repeated.* And, with an act of repetition or replication as the "original" occasion of its usage within the experience of a given artist, the extended life of the grid in the unfolding progression of his work will be one of still more repetition, as the artist engages in repeated acts of self-imitation. That so many generations of twentieth-century artists should have maneuvered themselves into this partic- ular position of paradox—where they are condemned to repeating, as if by compulsion, the logically fraudulent original—is truly compelling.

But it is no more compelling than that other, complementary fiction: the illusion not of the originality of the artist, but of the originary status of the pictorial surface. This origin is what the genius of the grid is supposed to manifest to us as viewers: an indisputable zero-ground beyond which there is no further model, or referent, or text. Except that this experience of originari- ness, felt by generations of artists, critics, and viewers is itself false, a fiction. The canvas surface and the grid that scores it do not fuse into that absolute unity necessary to the notion of an origin. For the grid *follows* the canvas surface, doubles it. It is a representation of the surface, mapped, it is true, onto the same surface it represents, but even so, the grid remains a figure, picturing various aspects of the "originary" object: through its mesh it creates an image of the woven infrastructure of the canvas; through its network of coordinates it organizes a metaphor for the plane geometry of the field; through its repetition it configures the spread of lateral continuity. The grid thus does not reveal the surface, laying it bare at last; rather it veils it through a repetition.

As I have said, this repetition performed by the grid must follow, or come after, the actual, empirical surface of a given painting. The representational text of the grid however also precedes the surface, comes *before* it, preventing even that literal surface from being anything like an origin. For behind it, logically prior to it, are all those visual texts through which the bounded plane was collectively organized as a pictorial field. The grid summarizes all these texts: the gridded overlays on cartoons, for example, used for the mechanical transfer from drawing to fresco; or the perspective lattice meant to contain the perceptual transfer from three dimensions to two; or the matrix on which to chart harmonic relationships, like proportion; or the millions of acts of enfram- ing by which the picture was reaffirmed as a regular quadrilateral. All these are the texts which the "original" ground plane of a Mondrian, for example, repeats—and, by repeating, represents. Thus the very ground that the grid is thought to reveal is already riven from within by a process of repetition and representation; it is always already divided and multiple.

What I have been calling the fiction of the originary status of the picture surface is what art criticism proudly names the opacity of the modernist picture

plane, only in so terming it, the critic does not think of this opacity as fictitious. Within the discursive space of modernist art, the putative opacity of the pictorial field must be maintained as a fundamental concept. For it is the bedrock on which a whole structure of related terms can be built. All those terms—singularity, authenticity, uniqueness, originality, original—depend on the originary moment of which this surface is both the empirical and the semiological instance. If modernism's domain of pleasure is the space of autoreferentiality, this pleasure dome is erected on the semiological possibility of the pictorial sign as nonrepresentational and nontransparent, so that the signified becomes the redundant condition of a reified signifier. But from *our* perspective, the one from which we see that the signifier cannot be reified; that its objecthood, its quiddity, is only a fiction; that every signifier is itself the transparent signified of an already-given decision to carve it out as the vehicle of a sign—from *this* perspective there is no opacity, but only a transparency that opens onto a dizzying fall into a bottomless system of reduplication.

This is the perspective from which the grid that signifies the pictorial surface, by representing it, only succeeds in locating the signifier of another, prior system of grids, which have beyond them, yet another, even earlier system. This is the perspective in which the modernist grid is, like the Rodin casts, logically multiple: a system of reproductions without an original. This is the perspective from which the real condition of one of the major vehicles of modernist aesthetic practice is seen to derive not from the valorized term of that couple which I invoked earlier—the doublet, *originality/repetition*—but from the discredited half of the pair, the one that opposes the multiple to the singular, the reproducible to the unique, the fraudulent to the authentic, the copy to the original. But this is the negative half of the set of terms that the critical practice of modernism seeks to repress, *has* repressed.

From this perspective we can see that modernism and the avant-garde are functions of what we could call the discourse of originality, and that that discourse serves much wider interests—and is thus fueled by more diverse institutions—than the restricted circle of professional art-making. The theme of originality, encompassing as it does the notions of authenticity, originals, and origins, is the shared discursive practice of the museum, the historian, and the maker of art. And throughout the nineteenth century all of these institutions were concerted, together, to find the mark, the warrant, the certification of the original.[4]

That this would be done despite the ever-present reality of the copy as the *underlying condition of the original* was much closer to the surface of consciousness in the early years of the nineteenth century than it would later be

4. On the discourse of origins and originals, see Michel Foucault, *The Order of Things: An Archaeology of the Human Sciences* (New York: Pantheon Books, 1970), pp. 328-335: "But this thin surface of the original, which accompanies our entire existence . . . is not the immediacy of a birth; it is populated entirely by those complex mediations formed and laid down as a sediment in their own history by labor, life, and language; so that . . . what man is reviving, without knowing it, is all the intermediaries of a time that governs him almost to infinity" (pp. 330-331).

permitted to be. Thus, in *Northanger Abbey* Jane Austen sends Catherine, her sweetly provincial young heroine, out for a walk with two new, rather more sophisticated friends; these friends soon embark on viewing the countryside, as Austen says, "with the eyes of persons accustomed to drawing, and decided on its capability of being formed into pictures, with all the eagerness of real taste." What begins to dawn on Catherine is that her countrified notions of the natural—"that a clear blue sky" is for instance "proof of a fine day"—are entirely false and that the natural, which is to say, the landscape, is about to be constructed for her by her more highly educated companions:

> . . . a lecture on the picturesque immediately followed, in which his instructions were so clear that she soon began to see beauty in every thing admired by him. . . . He talked of fore-grounds, distances, and second distances—side-screens and perspectives—lights and shades;—and Catherine was so hopeful a scholar that when they gained the top of Beechen Cliff, she voluntarily rejected the whole city of Bath, as unworthy to make part of a landscape.[5]

To read any text on the picturesque is instantly to fall prey to that amused irony with which Austen watches her young charge discover that nature itself is constituted in relation to its "capability of being formed into pictures." For it is perfectly obvious that through the action of the picturesque the very notion of landscape is constructed as a second term of which the first is a representation. Landscape becomes a reduplication of a picture which preceded it. Thus when we eavesdrop on a conversation between one of the leading practitioners of the picturesque, the Reverend William Gilpin, and his son, who is visiting the Lake District, we hear very clearly the order of priorities.

In a letter to his father, the young man describes his disappointment in the first day's ascent into the mountains, for the perfectly clear weather insured a total absence of what the elder Gilpin constantly refers to in his writings as "effect." But the second day, his son assures him, there was a rainstorm followed by a break in the clouds.

> Then what effects of gloom and effulgence. I can't describe [them]—nor need I—for you have only to look into your own store house [of sketches] to take a view of them—It gave me however a very singular pleasure to see your system of effects so compleatly confirmed as it was by the observations of that day—wherever I turned my eyes, I beheld a drawing of yours.[6]

In this discussion, it is the drawing—with its own prior set of decisions about *effect*—that stands behind the landscape authenticating its claim to represent nature.

5. Jane Austen, *Northanger Abbey: and Persuasion* (1818), ed. John Davie (London: Oxford University Press, 1971), Vol. 1, Chapter 14, p. 100.

6. In Carl Paul Barbier, *William Gilpin* (Oxford: The Clarendon Press, 1963), p. 111.

The 1801 Supplement to Johnson's Dictionary gives six definitions for the term *picturesque*, the six of them moving in a kind of figure eight around the question of the landscape as originary to the experience of itself. According to the Dictionary the picturesque is: (1) what pleases the eye; (2) remarkable for singularity; (3) striking the imagination with the force of paintings; (4) to be expressed in painting; (5) affording a good subject for a landscape; (6) proper to take a landscape from.[7] It should not be necessary to say that the concept of singularity, as in the part of the definition that reads, "remarkable for singularity," is at odds semantically with other parts of the definition, such as "affording a good subject for a landscape," in which *a landscape* is understood to mean a type of painting. Because that pictorial type—in all the formulaic condition of Gilpin's "effects"—is not single (or singular) but multiple, conventional, a series of recipes about roughness, chiaroscuro, ruins, and abbeys, and therefore, when the effect is found in the world at large, that natural array is simply felt to be repeating another work—a "landscape"—that already exists elsewhere.

But the *singularity* of the Dictionary's definition deserves even further examination. Gilpin's *Observations on Cumberland and Westmorland* addresses this question of singularity by making it a function of the beholder and the array of singular moments of his perception. The landscape's singularity is thus not something which a bit of topography does or does not possess; it is rather a function of the images it figures forth at any moment in time and the way these pictures register in the imagination. That the landscape is not static but constantly recomposing itself into different, separate, or singular pictures, Gilpin advances as follows:

> *He, who should see any one scene, as it is differently affected by the lowering sky, or a bright one, might probably see two very different landscapes. He might not only see distances blotted out; or splendidly exhibited; but he might even see variations produced in the very objects themselves; and that merely from the different times of the day, in which they were examined.*[8]

With this description of the notion of singularity as the perceptual-empirical unity of a moment of time coalesced in the experience of a subject, we feel ourselves entering the nineteenth-century discussion of landscape and the belief in the fundamental, originary power of nature dilated through subjectivity. That is, in Gilpin's two-different-landscapes-because-two-different-times-of-day, we feel that the prior condition of landscape as being already a picture is being let go of. But Gilpin then continues, "In a warm sunshine the purple hills may skirt the horizon, and appear broken into numberless pleasing forms; but under a sullen sky a total change may be produced," in which case, he insists, "the distant mountains, and all their beautiful projection may disap-

7. Cited in ibid., p. 98.

8. William Gilpin, *Observations on Cumberland and Westmorland* (Richmond, Eng.: The Richmond Publishing Co., 1973), p. vii. The book was written in 1772 and first published in 1786.

pear, and their place be occupied by a dead flat." Gilpin thus reassures us that the patent to the "pleasing forms" as opposed to the "dead flat" has already been taken out by painting.

Thus what Austen's, Gilpin's, and the Dictionary's picturesque reveals to us is that although the *singular* and the *formulaic* or repetitive may be semantically opposed, they are nonetheless conditions of each other: the two logical halves of the concept *landscape*. The priorness and repetition of pictures is necessary to the singularity of the picturesque, because for the beholder singularity depends on being recognized as such, a re-cognition made possible only by a prior example. If the definition of the picturesque is beautifully circular, that is because what allows a given moment of the perceptual array to be seen as singular is precisely its conformation to a multiple.

Now this economy of the paired opposition—singular and multiple—can easily be examined within the aesthetic episode that is termed *the Picturesque*, an episode that was crucial to the rise of a new class of audience for art, one that was focused on the practice of taste as an exercise in the recognition of singularity, or—in its application within the language of romanticism—originality. Several decades later into the nineteenth century, however, it is harder to see these terms still performing in mutual interdependence, since aesthetic discourse—both official and nonofficial—gives priority to the term originality and tends to suppress the notion of repetition or copy. But harder to see or not, the notion of the copy is still fundamental to the conception of the original. And nineteenth-century practice was concerted towards the exercise of copies and copying in the creation of that same possibility of recognition that Jane Austen and William Gilpin call taste. Adolphe Thiers, the ardent Republican who honored Delacroix's originality to the point of having worked on his behalf in the awarding of important government commissions, had nevertheless set up a museum of copies in 1834. And forty years later in the very year of the first impressionist exhibition, a huge Musée des Copies was opened under the direction of Charles Blanc, then the Director of Fine Arts. In nine rooms the museum housed 156 newly commissioned full-scale oil copies of the most important masterpieces from foreign museums as well as replicas of the Vatican Stanze frescoes of Raphael. So urgent was the need for this museum, in Blanc's opinion, that in the first three years of the Third Republic, *all* monies for official commissions made by the Ministry of Fine Arts went to pay for copyists.[9] Yet, this insistence on the priority of copies in the formation of taste hardly prevented Charles Blanc, no less than Thiers, from deeply admiring Delacroix, or from providing the most accessible explanation of advanced color theory then available in print. I am referring to the *Grammar of the Arts of Design*, published in 1867, and certainly the obvious text in which the budding impressionists could read about simultaneous contrast, complementarity, or achromatism, and be introduced to the theories and diagrams of Chevreul and Goethe.

This is not the place to develop the truly fascinating theme of the role of

9. For details, see Albert Boime, "Le Musée des Copies," *Gazette des Beaux-Arts* 64 (1964): 237-247.

the copy within nineteenth-century pictorial practice and what is emerging as its necessity to the concept of the original, the spontaneous, the new.[10] I will simply say that the copy served as the ground for the development of an increasingly organized and codified sign or seme of spontaneity—one that Gilpin had called roughness, Constable had termed "the chiaroscuro of nature"—by which he was referring to a completely conventionalized overlay of broken touches and flicks of pure white laid in with a palette knife—and Monet later called instantaneity, linking its appearance to the conventionalized pictorial language of the sketch or *pochade*. *Pochade* is the technical term for a rapidly made sketch, a shorthand notation. As such, it is codifiable, recognizable. So it was both the rapidity of the *pochade* and its abbreviated language that a critic like Edouard Chesneau saw in Monet's work and referred to by the way it was produced: "the chaos of palette scrapings," he called it.[11] But as recent studies of Monet's impressionism have made explicit, the sketchlike mark, which functioned as the *sign* of spontaneity, had to be prepared for through the utmost calculation, and in this sense spontaneity was the most fakable of signifieds. Through layers of underpainting by which Monet developed the thick corrugations of what Robert Herbert calls his texture-strokes, Monet patiently laid the mesh of rough encrustation and directional swaths that would signify speed of execution, and from this speed, mark both the singularity of the perceptual moment and uniqueness of the empirical array.[12] On top of this constructed "instant," thin, careful washes of pigment establish the actual relations of color. Needless to say, these operations took—with the necessary drying time—many days to perform. But the illusion of spontaneity—the burst of an instantaneous and originary act—is the unshakable result. Rémy de Gourmont falls prey to this illusion when he speaks in 1901 of canvases by Monet as "the work of an instant," the specific instant being "that flash" in which "genius collaborated with the eye and the hand" to forge "a personal work of absolute originality."[13] The illusion of unrepeatable, separate instants is the product of a fully calculated procedure that was necessarily divided up into stages and sections and worked on piecemeal on a variety of canvases at the same time, assembly-line style. Visitors to Monet's studio in the last decades of his life were startled to find the master of instantaneity at work on a lineup of a dozen or more canvases. The production of spontaneity through the constant overpainting of canvases (Monet kept back the Rouen Cathedral series from his dealer, for example, for three years of reworking) employs the same aesthetic economy of the pairing of singularity and multiplicity, of uniqueness and reproduction, that we saw at the outset in Rodin's method. In addition, it

10. For a discussion of the institutionalization of copying within nineteenth-century artistic training, see Albert Boime, *The Academy and French Painting in the 19th Century* (London: Phaidon Press, 1971).

11. Cited by Steven Z. Levine, "The 'Instant' of Criticism and Monet's Critical Instant," *Arts Magazine* 55, no. 7 (March 1981): 118.

12. See Robert Herbert, "Method and Meaning in Monet," *Art in America* 67, no. 5 (September 1979): 90-108.

13. Cited by Levine, " 'Instant' of Criticism," p. 118.

involves that fracturing of the empirical origin that operates through the example of the modernist grid. But as was true in those other cases as well, the discourse of originality in which impressionism participates represses and discredits the complementary discourse of the copy. Both the avant-garde and modernism depend on this repression.

What would it look like not to repress the concept of the copy? What would it look like to produce a work that acted out the discourse of reproductions without originals, that discourse which could only operate in Mondrian's work as the inevitable subversion of his purpose, the residue of representationality that he could not sufficiently purge from the domain of his painting? The answer to this, or at least one answer, is that it would look like a certain kind of play with the notions of photographic reproduction that begins in the silkscreen canvases of Robert Rauschenberg and has recently flowered in the work of a group of younger artists whose production has been identified by the critical term *pictures*.[14] I will focus on the example of Sherrie Levine, because it seems most radically to question the concept of origin and with it the notion of originality.

Levine's medium is the pirated print, as in the series of photographs she made by taking images by Edward Weston of his young son Neil, and simply rephotographing them, in violation of Weston's copyright. But as has been pointed out about Weston's "originals," these are already taken from models provided by others; they are given in that long series of Greek kouroi by which the nude male torso has long ago been processed and multiplied within our culture.[15] Levine's act of theft, which takes place, so to speak, in front of the surface of Weston's print, opens the print from behind to the series of models from which it, in turn, has stolen, of which it is itself the reproduction. The discourse of the copy, within which Levine's act must be located has, of course, been developed by a variety of writers, among them Roland Barthes. I am thinking of his characterization, in *S/Z*, of the realist as certainly not a copyist from nature, but rather a "pasticher," or someone who makes copies of copies. As Barthes says:

> To depict is to . . . refer not from a language to a referent, but from one
> code to another. Thus realism consists not in copying the real but in
> copying a (depicted) copy. . . . Through secondary mimesis [realism]
> copies what is already a copy.[16]

14. The relevant texts are by Douglas Crimp; see his exhibition catalogue *Pictures* (New York: Artists Space, 1977); and "Pictures," *October*, no. 8 (Spring 1979): 75-88. [Reprinted in this volume, pp. 175–187.]

15. See Douglas Crimp, "The Photographic Activity of Postmodernism," *October*, no. 15 (Winter 1980): 98-99.

16. Roland Barthes, *S/Z*, trans. Richard Miller (New York: Hill and Wang, 1974), p. 55.

Sherrie Levine. *After Eliot Porter,* 1981. Color photograph, 10 x 8" (25.5 x 20.3 cm)

In another series by Levine in which the lush, colored landscapes of Eliot Porter are reproduced, we again move through the "original" print, back to the origin in nature and—as in the model of the picturesque—through another trap door at the back wall of "nature" into the purely textual construction of the sublime and its history of degeneration into ever more lurid copies.

Now, insofar as Levine's work explicitly deconstructs the modernist notion of origin, her effort cannot be seen as an *extension* of modernism. It is, like the discourse of the copy, postmodernist. Which means that it cannot be seen as avant-garde either.

Because of the critical attack it launches on the tradition that precedes it, we might want to see the move made in Levine's work as yet another step in the forward march of the avant-garde. But this would be mistaken. In deconstructing the sister notions of origin and originality, postmodernism establishes a schism between itself and the conceptual domain of the avant-garde, looking back at it from across a gulf that in turn establishes a historical divide. The historical period that the avant-garde shared with modernism is over. That seems an obvious fact. What makes it more than a journalistic one is a conception of the discourse that has brought it to a close. This is a complex of cultural practices, among them a demythologizing criticism and a truly postmodernist art, both of them acting now to void the basic propositions of modernism, to liquidate them by exposing their fictitious condition. It is thus from a strange new perspective that we look back on the modernist origin and watch it splintering into endless replication.

Francisco Goya. *The Dog (Perro),* 1820–1823. Oil on canvas, 52¾ x 31½″ (134 x 80 cm). Museo del Prado, Madrid

Realism for the Cause of Future Revolution

K A T H Y A C K E R

Three men are talking. These're the men who cause war. One man

I. Realism in Art Language: Simple Descriptions of Some Paintings by Francisco Goya

has on a Renaissance hat or else has genetically-flawed hair. His right eye is larger than his left so he's smirking, as his shoulders curve inwards. Except for the hat, he's naked. The person facing him is short and has deformed that is loopy fingers. All these people are deformed and recognizable.

A man who has light hair, since he's looking into a mirror, is a female. She wears an armless white tee-shirt. The man almost directly in front of her but slightly to her right is ugly. He has ugly monkey lips. Black, greasy hair is dripping down the neck. A classical white toga, the sign of the highest human culture, knowledge, and being-in-the-world, hangs off of his hairy shoulders. His body is unbalanced. These hideous monsters-being-men are controlling the world Our Father Who Art All Men're Created. They are our fates. They are floating on a white cloud because the world is theirs, those who control this world are above it.

The fourth man: the ape-man is either eating a half-peeled banana or holding a cross. Reality isn't clear.

1. Atropos o El Destino (Atropos Or The Fates): We Who Are Neither Men Nor Women

Francisco Goya. *The Fates (Atropos),* 1820–1823. Oil on canvas, 48½ x 104¾" (123 x 266 cm). Museo del Prado, Madrid

The ape-man looks down on his territorial holdings: acres after acres of clear fields, streams, running nature. A few trees, you can't tell the difference between tree and tree-shadow or image. All the world could be a reflection.

2. La Cocina de las Brujas (The Witches' Kitchen):

Humans're both dogs and skulls. Both humans and dogs like to eat and feel heat. Skulls just lie there. Human-dogs eat and feel heat in a kitchen. Women control the kitchen or kitsch (men control the den where criminals lurk), but there are no women among the human-dogs or maybe the human-dog whose face is old-approaching-skull is male or female or it no longer matters. Since a broom's sweeping his/her bald pate, the broom-rider must be a witch which. The dog-who-stands-like-a-man stares at this broom, and behind him a male skull laughs. What's he laughing at? Another human-dog pisses on the floor because he's a bum pissing in a concrete doorway. These aren't scenes of war; this **is** war.

Francisco Goya. *The Witches' Kitchen (La Cocina de las Brujas)*, 1797–1798. Oil on canvas, 16½ x 12⅝″ (45 x 32 cm). Pani Collection, Mexico City

Francisco Goya. *The Witches' Sabbath (El Aquelarre)*, 1797–1798. Oil on canvas, 17 x 12¼″ (43 x 31 cm). Fundazión Lázaro Galdiano, Madrid. (Photo: José Latora Fernandez-Luna, Madrid)

3. El Aquellare (The Witches' Sabbath):

A big goat is making love to a woman 'cause his paw's on her tit. He wants to fuck this woman. His horns are beautiful. He's horny as hell. Being a beast, he's bigger than all the humans. The woman he wants to fuck, who's holding a baby (all children should die whenever they open their mouths), looks longingly at the beast. In front of her, a crone who has almost dehydrated into a skeleton holds a skeleton up to the monster. He must be their guru or leader. The moon pukes. Another old bitch behind the monster is halfway to being a skeleton. The only foliage in the world occurs not on the ground, but around the monster's horns.

This world is sick. Why? There's no reason.

It's sick because there're monsters in it.

Behind the monster, The Virgin Mary and Her cohorts Who're palely or politely fading away don't have any expressions 'cause They have no faces

'cause They're pure and religious. The human beings who worship The Beast wear female togas 'cause they or worship is classical, and dead children lie between them.

I see what I see immediately; I don't rethink it. My seeing is as rough or unformed as what I'm seeing. This is *realism:* the unification of my perceiving and what I perceive or a making of a mirror relation between my world and the world of the painting.

One of the humans who's fat and female over her left shoulder holds a stick from which tiny, obviously dead babies hang down. This is her banner. The ground is barren. The hills behind are barren. The sky is barren. The sky is nighttime. Humans are witches.

(4. Imitated by Goya: Pier Leone Ghezzi's The Evening Meal):

A middle-aged mommy has a nose like a pig's and doesn't have a mouth. She doesn't have a mouth because flesh is shutting up her mouth because women don't have language. Instead of having language, women have babies. This baby is uglier than this mommy. It has President Ronald Reagan's eyes, nose, a caricature of a fat slob's mouth, and no body. People bring up kids by training them to stop being. A nose almost as lengthy as a small cock and hair over a head reveals the husband's sensitivity. His mouth is smarmy. He's looking at his child with love. The child is wrapped up like a mummy.)

Pier Leone Ghezzi. *The Evening Meal,* (?). Oil on canvas, dimensions unknown. Formerly collection of Baron and Baroness von Riddlestein

Francisco Goya. *Two Old People Eating Soup (Witch and Wizard) (Dos Brujos),* 1820–1823. Oil on canvas, 20¾ x 33½" (53 x 85 cm). Museo del Prado, Madrid

*4. Dos Viejos
Comiendo Sopa
(Two Old People
Eating Soup) (this
is Goya's copy of
the above paint-
ing):*

A woman who looks like a skull is eating soup. The spoon she's holding faces downward to a wooden bowl as if she's so gaga she can't quite manage to hold it. The hands holding the spoon are big, ugly, and knotty. The face is so thin, you can almost see its bones. Since she almost looks like a man, due to her huge nose, the cloth (shawl?) covering her head is both a female dress and funereal swathing. The difference between life and death in this male/female female is as minimal as the artistry of the brushstrokes: the rough brushstrokes barely indicate what they intend to. Old people're as stupid as newborn children.

The old woman must be fond of her soup, it's probably her only pleasure in life, because she's grinning hard. She's grinning so hard, her grin is the grin of a skull. Big black pupils in her big man's eyes pop out of her head so far, they almost detach themselves from the skull. To her left's a lifeless skull.

This skull is as big as the woman's head, but it's fallen lower than her shoulders. Even though the painting's title says this skull is alive, this skull isn't alive. The expression of the bows of flesh sticking out over its mouthbones is animal. The fingers on its left hand, bones, point toward the old woman's soup bowl. Maybe he wants food. Maybe this is why the female skull's eyes're popping out of her skull: she's happy because she has the bowl of soup. She's not eating it: she doesn't need to eat it. Her spoon is pointing toward the bowl because she owns the food. Ownership is enough. The male skull is lower and deader than her. Ownership, for old people, is everything.

There are no children in this world.

A dog is sticking its head over a barricade you can't see what the barricade is. The only event that is seen and seeable is the dog's head.

Woof. The only language which is heard and sayable is "Woof."

II.
Insert on
Language

Language, any language including verbal and visual ones, supposes a community. In the Western world, prior to the end of the eighteenth century, art had a place in the overall society. "Religion and dynasty were the dominant forces that gave art substance over the centuries."[1]

The onset of the French, American, and industrial revolutions allowed or forced artists to question the relations between art and religion and political power. "The Church and the dynasty . . . were no longer there to sponsor art, and the artist was cut off from financial support and from . . . response . . . Now, with the coming of revolution, the artist produced his work in the void . . . He was no longer a man (or woman) whose handiwork was needed by society."[2] Meaning had become a political issue.

The artist has to consider how to make society want his work or accept his nonsense as language, communication. The Black Paintings, some of which I have simply described in the paragraphs above, Goya in the years 1820

1. Licht, Fred, *Goya and the Origins of the Modern Temper in Art* (New York: Universe Books, 1979), p.15.

2. Ibid.

through 1823 painted directly on the walls of his farmhouse outside Madrid. These paintings were not on canvases. Goya, who had before always been interested in making money out of his work and was successful at it, didn't want to show these paintings to anyone. He refused to have a language. Why?

What or who is a human who doesn't have language? The Black Paintings are descriptions. They are realistic. I have simply described some of them. They aren't or don't include judgments. I haven't judged them. Are such descriptions, communication? What is being communicated? What is being communicated by this "realism"?

Language is that which depends on other language. It's necessarily reactive. An isolated word has no meaning. Art, whether or not it uplifts the spirit, is necessarily dependent on contexts such as socio-economic ones. What can this language be which refuses?

The only reaction against an unbearable society is equally unbearable nonsense.

The Spanish Bourbon government's oppression increased. In 1824, Goya requested a passport to France under the pretext of taking the Plombières' bath waters. In this permanent exile, becoming more and more deaf, in such total isolation, Goya moved in his painting from nihilism (one kind of realism), to painting or visually describing workers. "It was in his work as a painter that Goya discovered his own salvation, and it was in work," the work of negation, "that he found the strongest intimation of the survival of man's dignity."[3] What's this language which describes yet refuses to be reactive, to be only a language which is socially given? It is making.

III. Caravaggio's Realism: Being Itself

1. The Early Sexual World: Self-Portrait As Bacchus (1593-1594?)

A boy is looking at me. What's his look? I see: his flesh's thickness; that, though the muscles are showing in his upper right arm, which is facing me, and in the part of the back below the shoulder blade, the musculature is round and soft; his lips are thick; the nose is blunt and wide. He's sexy. This is his look: he's looking at me sexually. My looking is his identity is his look. This triangular relation (the painting) is sex; desire is the triadic look. This boy is sex.

What's his expression? Sex. What's my look? Sex. This sexual, soft and round, world is (one of) connection.

Since this is a self-portrait, Caravaggio has set up a sexual relation between himself and me.

Since my seeing's (I'm) sexually connected to him, I'm curious who he is. If his identity's sexuality, what's sexuality? Who is the boy?

The leaf-wreath perching on his head indicates he's natural. I'm not positively sure he's looking at/desiring me: his sexuality or naturalness is sly. Sexuality isn't trustworthy.

His hands, near his chin, hold a bunch of grapes. Since he's not looking at these grapes (nature), he wants more than food. Sexual desire must be more than need. He's both weak and strong.

3. Ibid., p. 269

Caravaggio. *Self-Portrait as Bacchus (Bacchino Malato),* ca. 1591–1594. Oil on canvas, 25⅜ x 21⅞″ (67 x 53 cm). Galleria Borghese, Rome. (Photo: Anderson)

This picture (this looking, this sex) is/is now about setting up a language. Defining words and their intersimilarities. The world of connectedness.

If this picture's now a setting-up of language, what's art criticism? Looking at him (the boy, the artist) looking at me, mirror on mirror on mirror, is how language works. My verbally describing this visual description is my mirror of/is my being part of this sex, this connected world. This is a living world.

The sheet of a child or a Roman toga falls from his left shoulder under his right arm, downward: His look, sexual desire, which fades as soon as it starts to happen, is ageless. No wonder looking or sexual desire is more complex than slyness: in terms of time, looking or sexual desire is simultaneously eternal and momentary. The boy's physical fragility underlines this momentariness: his muscles, young, about to sink into soppiness; thick flesh is about to become ugly unwantable fat flesh.

The way he's looking at me is mysterious: sexual desire's un-logical or mysterious.

The Gypsy Fortuneteller (1594-1595)

A physically similar young boy who's slightly older in years occupies the whole right half of my visual space. I know he's older because the clothes he's wearing are more sophisticated: a black hat flying a white-and-black feather; an orange velvet jacket (black velvet bands framing its seams) over a frilled white shirt; wide black cloth (as opposed to the first boy's white cotton) flung, seemingly carelessly, over his left shoulder. His right orange-leather-gloved hand, holding the other orange leather glove, rests on his waist, again seemingly carelessly, above the scabbard. He's older than the first boy because he's developed an image; or because he's developed a presentation in the social world he's older.

His face's image is similarly clear. The fullness of the first boy's face, his expression was ambiguous or unknowable. This boy's similarly young full-tending-toward-fat cheek muscles now are knowing: thick lips, whose left ends lift slightly upwards, almost smirk. The nose smells the same smirk. Just as his expression's no longer ambiguous unknowable, so his look's object's no longer questionable. His look therefore his sexual desire is clear. He has an identity;

sexuality unites with identity. The image is defined, so I'm excluded from this world; I'm excluded from this world so the image is defined. He no longer wants me.

He looks at a young woman. She looks back at him. Her lips, physically like his, rise in the same way his do. Their looks mirror each other; their desires mirror each other, mirror on mirror on mirror on mirror; their looks occur only within the painted space. Their looks form a sphere or enclosure; they have made a world; look reflects look as the spread legs wind around the cock's head and enclose it. The snake bites its own head. When two people look at/ fuck each other, they don't see anyone or anything else.

The young woman occupies the full left half of my visual space. The white cloth wrapping around the back of her neatly-parted dark-brown hair then tying under her chin repeats the white of his hat feather. The color of a blouse which hints at being transparent but is actually white, made out of gathers which again almost reveal/hint at revealing a breast, echoes the white of his shirt which peeks out from under his orange velvet jacket. These are the only (almost) pure whites in the painting. Colors, that form, announce relations.

Just as their looks forming a sphere touch each other, so her hands hold his hand. What happens in the upper intellectual world takes place in the lower animal sphere.

realism

Gypsies're the scum of the earth. No one in her right mind would have anything to do with them. They're (were?) just lower sexual animals of course they're all women and all women being sexual animals're witches. How can

Caravaggio. *The Gypsy Fortuneteller (La Buona Ventura)*, ca. 1594. Oil on canvas, 39 x 51½" (99 x 131 cm). The Louvre, Paris

these beautiful young aristocratic boy's eyes, his very intellect, his soul, and her scum-being be one total world? Because the intellectual sphere mirrors and connects to the animal sphere: sexuality is this totality: the looks of these two people, which is my look as I look at them, is a certain definition of sexual desire.

Bacchus (1595-1596?): Realism

A young boy's looking at me. I'm looking at him. This time, though I'm sure it's at me he's looking, his eyes are veiled. His sexuality's questionable. Why questionable?

Again a wreath is sitting on his dark, now abundantly curling locks. Now the leaves are gigantic and huge batches of huge grapes are growing out of his hair; fertility's flowing. Can I handle this boy who obviously wants me, this much fertility and pleasure?

I thought men can have only one orgasm at a time.

His face is more defined than the other two boys' faces: His lips though fat seem thin because they're pressed together. His chest where one tit's actually sticking out is both fuller, rounder, fatter, and has more muscles than the other two boys'. In him male and female physical characteristics have blossomed to their extremes, like the grapes jutting out of his hairs. To a fuller extent than the intellectual and animal spheres within the humans in *The Gypsy Fortune-teller*, here human mirrors plant life. Such abundance, such sexuality is questionable because it's almost unbearable. So the boy's look at me is, beyond sly, complex: his sexuality is this complex. If I accept him, I am this: this non-stagnant always burgeoning almost hideous and comic overgrowth.

This boy isn't beautiful.

Will I be able to accept my sexuality?

Caravaggio. *Bacchus (Bacco adolescente),* 1593–1594. Oil on canvas, 37½ x 33½" (95 x 85 cm). Galleria degli Uffizi, Florence. (Photo: Edizione Alinari)

A toga like the one the first boy was wearing drapes across his left (as I'm looking at him) shoulder. This toga has now become—for even inanimate things burgeon in this overly fertile world—a sheet which falls over the pillows against which he's leaning. His left hand's holding a huge glass of red wine out to me; he's not even bothering to look at me. I can't understand what happens in this world. It's all change. Sexuality or constant change scares me. This sexuality (wine) is that which confuses human understanding.

These changes include all possibilities: Below the glass of red wine, more fruit is bouncing out of a low china bowl. Some of this fruit's decaying. Mold covers some of the spatially lower peaches. Apples are perfectly hard. His left hand's pinky is crooking to the fruit. From this lowest decay and rot up, through his hand, the red wine—this confusion or this totality of all possible possibilities—which he's offering me, up to the head-grapes, from lower to higher: all this is sexuality. This sexuality is unbearable and noncomprehendible not only because it confuses, but also because it incorporates the world. Totality or orgasm is unbearable. This is the world of *The Gypsy Fortuneteller* in all its possible extremes.

His fat right hand's fat second finger crooks around a black velvet bow. The sort of bow a beautiful courtly woman would sport. Does an aristocratic velvet bow, a Roman toga, decaying fruit, and a tiny tit fit in the same look? What identity can this be? How can this be my sexuality, identity? My identity sexuality, if I look here, has to be constantly fluctuating possibilities: things aren't things: fertility. Fertility isn't only bearable: it is (sexuality).

2. Adulthood's Sexuality: Conversion Of St. Paul (1600-1601)

Two figures occupy the space's foreground. One figure is an animal and the other figure is a human. The animal is on top of the human. The animal is slightly bigger than the human.

The animal, a horse, looks almost pensive or melancholy because its eye, the one I can see, is dark and lidded and its head droops downward. As it's (he's? I can't decipher its gender) looking at the human, this animal intends— its right foreleg is raised and poised—to strike downward.

The leg is raised over the human's head. The figure is a male who's lying on his back. Since his head's the part of him closest to me, I can't tell whether his eyes're closed or whether he's looking at the horse's torso's underside. Since his head's turned halfway to my right, he's looking, if his eyes aren't closed, at the horse's eyes. The animal's and the human's looks, as the gypsy's and the aristocratic young man's, form an enclosed sphere: Are they making love?

(The man's eyes probably aren't closed because, as he's lying on his back, his arms, straight out and stiff, rise halfway upwards and to the side. And his legs ((hidden in shadows (the shadow cast by the animal's ass which is closer to him and to me than the animal's face))) ((secretive)) are raised as a woman's are often held when she fucks lying on her back. The man knows what's happening/about to happen to him: the man's eyes're seeing the horse's eyes. The horse's about to strike the man. This sexuality is dangerous, complex.)

The man's sword lies apart from his body, to his left. Since his face's turned to the right and he's looking that way, he's abandoned his sword. The animal's leg's raised probably over the man's cock. As the animal's and the

man's eyes connect, so do their lower parts (again as in the case of the gypsy and the young aristocratic man). Does the man want the horse to kill him? I know the horse's intention. What's the man's? What's sexuality?

The man's eyes're closed therefore he's serene. He more than wants, he's ecstatic or acceptive. Because the horse must be above him.

In the space's background, a man who's old because there're many lines in his face, standing behind the horse's face, holds the face downward. This man is smaller than the other two figures and almost hidden. His clothes, almost unseeable, hint of the peasantry; (the larger man clearly wears warrior drag). The old man looks totally concentratedly down at the horse's head who's looking down at the soldier who's looking ecstatically and unseeingly up at the horse. Human and animal and human—for here acceptance is active—work together; the human social classes—even through violence—work together: as they are in/are the world. Really seeing or accepting this, the soldier, as I see, is ecstatic. The triadic look is sexual desire. This sexuality incorporates more of the world or is more complex than that of *The Gypsy Fortuneteller*.

3. Old Age's Sexuality Or The Sexuality From Full Human Experience

The visual space is so dark it's almost black. I have to strain to see. Perhaps my eyes aren't good anymore. Here "realism" is the painter's using his painting as a tool to make a certain perceptual mode, which mirrors and connects to a certain content, occur in me. This is the visual space of uncertainty or old age.

In this blackness there's a beautiful boy. The expression of this beautiful boy's face is clear and strong: eyebrows curve upwards at the beginning of the nose, while eyes look downward to what the left hand's holding; a large Roman nose emphasizes the slightly rigid and melancholy cast of lips, which would otherwise be desirable. Shadows are almost hiding his face's left half. An

Caravaggio. *The Conversion of Saint Paul (Conversione di San Paolo)*, 1600–1601. Oil on canvas, 102½ x 68⅞" (230 x 175 cm). Capella Cerasi, Santa Maria del Popolo, Rome

Caravaggio. *David with the Head of Goliath (David con la Testa di Golia)*, ca. 1605–1606. Oil on canvas, 49¼ x 39⅜" (125 x 100 cm). Galleria Borghese, Rome. (Photo: Alinari-Scala)

unsheathed sword in his right hand rests on the uppermost part of his right leg. The precariousness of this sword's position indicates that it's just been used.

The boy's left hand is holding the second figure: a cut-off head. Since it's cut off, the young boy has just cut it off even though he's looking at it sadly. Since the part of the boy's body which is closest to me is his left hand and the cut-off head is even nearer to me, the boy, though he's not looking at me, is displaying the head to me. A description can't be that which it is describing. This is one of language's presumptions. Formally, here, Caravaggio's describing or showing. Such description's the opposite of fucking or connecting. As the head's cut off, relations in the world are cut off: the young boy looks at he who doesn't and can't look back at him; I can look at only what I'm shown. Sexuality, disconnected.

Cut-off: The head is a middle-aged-to-old man. Though his features—dark rather than gray and lots rather than scanty hair; a large similarly-colored mustache; a nose physically like the boy's—indicate he's middle-age; the hair's wildness, the eyes' combinative look of melancholy and contemplation, the open wet mouth's scream agony, the cheek muscles' tenseness indicate a fuller experiential range. The cut-off man has seen everything truly; the dead man whose very being is a scream is the human world. Realism: Caravaggio simultaneously shows me this and makes me/my perceptual mode be this; (since the cut-off head isn't looking at me but downward and into himself, I'm not being desired: I'm cut off from the sexuality I see). I'm being totally denied. I scream. I live in this world.

The beautiful boy, looking at his own sexuality, has to turn his sexuality or himself into frigidity or an image. The sexual is the political realm. There's no engagement.

Cindy Sherman. Untitled, 1981. Color photograph, 24 x 48″ (61 x 122 cm). (Photo: courtesy Metro Pictures)

II.

Dismantling Modernism

Richard Avedon. *Andy Warhol, Artist, New York City, August 20, 1969,* 1969. Black-and-white photograph, dimensions variable. (Photo: courtesy the artist)

The Rise of Andy Warhol

ROBERT HUGHES

To say that Andy Warhol is a famous artist is to utter the merest commonplace. But what kind of fame does he enjoy? If the most famous artist in America is Andrew Wyeth, and the second most famous is LeRoy Neiman (Hugh Hefner's court painter, inventor of the Playboy femlin, and drawer of football stars for CBS), then Warhol is the third. Wyeth, because his work suggests a frugal, bare-bones rectitude, glazed by nostalgia but incarnated in real objects, which millions of people look back upon as the lost marrow of American history. Neiman, because millions of people watch sports programs, read *Playboy*, and will take any amount of glib abstract-expressionist slather as long as it adorns a recognizable and pert pair of jugs. But Warhol? What size of public likes his work, or even knows it at first hand? Not as big as Wyeth's or Neiman's.

To most of the people who have heard of him, he is a name handed down from a distant museum-culture, stuck to a memorable face: a cashiered Latin teacher in a pale fiber wig, the guy who paints soup cans and knows all the movie stars. To a smaller but international public, he is the last of the truly successful social portraitists, climbing from face to face in a silent delirium of snobbery, a man so interested in elites that he has his own society magazine. But Warhol has never been a *popular* artist in the sense that Andrew Wyeth is or Sir Edwin Landseer was. That kind of popularity entails being seen as a normal (and hence, exemplary) person from whom extraordinary things emerge.

Warhol's public character for the last twenty years has been the opposite: an abnormal figure (silent, withdrawn, eminently visible but opaque, and a bit malevolent) who praises banality. He fulfills Stuart Davis' definition of the new American artist. "a cool Spectator-Reporter at an Arena of Hot Events." But no mass public has ever felt at ease with Warhol's work. Surely, people feel, there must be something empty about a man who expresses no strong leanings, who greets everything with the same "uh, gee, great." Art's other Andy, the Wyeth, would not do that. Nor would the midcult heroes of *The Agony and the Ecstasy* and *Lust for Life*. They would discriminate between experiences, which is what artists are meant to do for us.

Warhol has long seemed to hanker after the immediate visibility and

Reprinted from *The New York Review of Books*, February 18, 1982, pp.6-10.

popularity that "real" stars like Liz Taylor have, and sometimes he is induced to behave as though he really had it. When he did ads endorsing Puerto Rican rum or Pioneer radios, the art world groaned with secret envy: what artist would not like to be in a position to be offered big money for endorsements, if only for the higher pleasure of refusing it? But his image sold little rum and few radios. After two decades as voyeur-in-chief to the marginal and then the rich, Warhol was still unloved by the world at large; all people saw was that weird, remote guy in the wig. Meanwhile, the gesture of actually being in an ad contradicted the base of Warhol's fame within the art world. To the extent that his work was subversive at all (and in the sixties it was, slightly), it became so through its harsh, cold parody of ad-mass appeal—the repetition of brand images like Campbell's soup or Brillo or Marilyn Monroe (a star being a human brand image) to the point where a void is seen to yawn beneath the discourse of promotion.

The tension this set up depended on the assumption, still in force in the sixties, that there was a qualitative difference between the perceptions of high art and the million daily instructions issued by popular culture. Since then, Warhol has probably done more than any other living artist to wear that distinction down; but while doing so, he has worn away the edge of his work. At the same time, he has difficulty moving it toward that empyrean of absolute popularity, where LeRoy Neiman sits, robed in sky-blue polyester. To do that, he must make himself accessible. But to be accessible is to lose magic.

The depth of this quandary, or perhaps its lack of relative shallowness, may be gauged from a peculiar exhibition mounted in November 1981 by the Los Angeles Institute of Contemporary Art: a show of portraits of sports stars, half by Neiman and half by Warhol, underwritten by Playboy Enterprises. It was a promotional stunt (LAICA needed money, and exhibitions of West Coast conceptualists do not make the turnstiles rattle), but to give it a veneer of respectability the Institute felt obliged to present it as a critique of art world pecking orders. Look, it said in effect: Neiman is an arbitrarily rejected artist, whose work has much to recommend it to the serious eye (though *what*, exactly, was left vague); we will show he is up there with Warhol.

This effort backfired, raising the unintended possibility that Warhol was down there with Neiman. The Warhol of yore would not have let himself in for a fiasco like the LAICA show. But then he was not so ostentatiously interested in being liked by a mass public. This may be why his output for the last decade or so has floundered—he had no real subjects left; why *Interview*, his magazine, is less a periodical than a public relations sheet; and why books like *Exposures* and *POPism* get written.[1]

Between them *POPism: The Warhol '60s* and *Exposures* give a fairly good picture of Warhol's concerns before and after 1968, the year he was shot. Neither book has any literary merit, and the writing is chatty with occasional flecks of *diminuendo* irony—just what the package promises. *POPism* is mostly

1. Andy Warhol, *Andy Warhol's Exposures* (New York: Grosset and Dunlap, 1979), and Andy Warhol and Pat Hackett, *POPism: The Warhol '60s* (New York: Harcourt Brace Jovanovich, 1980).

surface chat, *Exposures* entirely so. For a man whose life is subtended by gossip, Warhol comes across as peculiarly impervious to character. "I never know what to think of Eric," he says of one of his circle in the sixties, a scatterbrained lad with blond ringlets whose body, a postscript tells us, was found in the middle of Hudson Street, unceremoniously dumped there, according to "rumors," after he overdosed on heroin. "He could come out with comments that were so insightful and creative, and then the next thing out of his mouth would be something *so* dumb. A lot of the kids were that way, but Eric was the most fascinating to me because he was the most extreme case— you absolutely couldn't tell if he was a genius or a retard." [2]

Of course, poor Eric Emerson—like nearly everyone else around the Factory, as Warhol's studio came to be known—was neither. They were all cultural space-debris, drifting fragments from a variety of sixties subcultures (transvestite, drug, S&M, rock, Poor Little Rich, criminal, street, and all the permutations) orbiting in smeary ellipses around their unmoved mover. Real talent was thin and scattered in this tiny universe. It surfaced in music, with figures like Lou Reed and John Cale; various punk groups in the seventies were, wittingly or not, the offspring of Warhol's Velvet Underground. But people who wanted to get on with their own work avoided the Factory, while the freaks and groupies and curiosity-seekers who filled it left nothing behind them.

Its silver-papered walls were a toy theater in which one aspect of the sixties in America, the infantile hope of imposing oneself on the world by terminal self-revelation, was played out. It had a nasty edge, which forced the paranoia of marginal souls into some semblance of style; a reminiscence of art. If Warhol's "Superstars," as he called them, had possessed talent, discipline, or stamina, they would not have needed him. But then, he would not have needed them. They gave him his ghostly aura of power. If he withdrew his gaze, his carefully allotted permissions and recognitions, they would cease to exist; the poor ones would melt back into the sludgy undifferentiated chaos of the street, the rich ones end up in McLean's. Valerie Solanas, who shot him, said Warhol had too much control over her life.

Those whose parents accused them of being out of their tree, who had unfulfilled desires and undesirable ambitions, and who felt guilty about it all, therefore gravitated to Warhol. He offered them absolution, the gaze of the blank mirror that refuses all judgment. In this, the camera (when he made his films) deputized for him, collecting hour upon hour of tantrum, misery, sexual spasm, campery, and nose-picking trivia. It too was an instrument of power— not over the audience, for which Warhol's films were usually boring and alienating, but over the actors. In this way the Factory resembled a sect, a parody of Catholicism enacted (not accidentally) by people who were or had been Catholic, from Warhol and Gerard Malanga on down. In it, the rituals of dandyism could speed up to gibberish and show what they had become—a hunger for approval and forgiveness. These came in a familiar form, perhaps the only form American capitalism knows how to offer: publicity.

2. Warhol and Hackett, *POPism*, p. 212.—Ed.

Warhol was the first American artist to whose career publicity was truly intrinsic. Publicity had not been an issue with artists in the forties and fifties. It might come as a bolt from the philistine blue, as when *Life* made Jackson Pollock famous; but such events were rare enough to be freakish, not merely unusual. By today's standards, the art world was virginally naive about the mass media and what they could do. Television and the press, in return, were indifferent to what could still be called the avant-garde. "Publicity" meant a notice in *The New York Times*, a paragraph or two long, followed eventually by an article in *Art News* which perhaps five thousand people would read. Anything else was regarded as extrinsic to the work—something to view with suspicion, at best an accident, at worst a gratuitous distraction. One might woo a critic, but not a fashion correspondent, a TV producer, or the editor of *Vogue*. To be one's own PR outfit was, in the eyes of the New York artists of the forties or fifties, nearly unthinkable—hence the contempt they felt for Salvador Dali. But in the 1960s all that began to change, as the art world gradually shed its idealist premises and its sense of outsidership and began to turn into the Art Business.

Warhol became the emblem and thus, to no small extent, the instrument of this change. Inspired by the example of Truman Capote, he went after publicity with the voracious single-mindedness of a feeding bluefish. And he got it in abundance, because the sixties in New York reshuffled and stacked the social deck: the press and television, in their pervasiveness, constructed a kind of parallel universe in which the hierarchical orders of American society—vestiges, it was thought, but strong ones, and based on inherited wealth—were replaced by the new tyranny of the "interesting." Its rule had to do with the rapid shift of style and image, the assumption that all civilized life was discontinuous and worth only a short attention span: better to be Baby Jane Holzer than the Duchesse de Guermantes.

To enter this turbulence, one might only need to be born—a fact noted by Warhol in his one lasting quip, "In the future, *everyone* will be famous for fifteen minutes." But to remain in it, to stay drenched in the glittering spray of promotional culture, one needed other qualities. One was an air of detachment; the dandy must not look into the lens. Another was an acute sense of nuance, an eye for the eddies and trends of fashion, which would regulate the other senses and appetites and so give detachment its point.

Diligent and frigid, Warhol had both to a striking degree. He was not a "hot" artist, a man mastered by a particular vision and anxious to impose it on the world. Jackson Pollock had declared that he wanted to be Nature. Warhol, by contrast, wished to be Culture and Culture only: "I want to be a machine." Many of the American artists who rose to fame after abstract expressionism, beginning with Jasper Johns and Robert Rauschenberg, had worked in commercial art to stay alive, and other pop artists besides Warhol, of course, drew freely on the vast reservoir of American ad-mass imagery. But Warhol was the only one who embodied a culture of promotion as such. He had enjoyed a striking success as a commercial artist, doing everything from shoe ads to recipe illustrations in a blotted, perky line derived from Saul Steinberg. He understood the tough little world, not yet an "aristocracy" but trying to become one, where the machinery of fashion, gossip, image-bending,

and narcissistic chic tapped out its agile pizzicato. He knew packaging, and could teach it to others.

Warhol's social visibility thus bloomed in an art world which, during the sixties, became more and more concerned with the desire for and pursuit of publicity. Not surprisingly, many of its figures in those days—crass social climbers like the Sculls, popinjays like Henry Geldzahler, and the legion of insubstantial careerists who leave nothing but press cuttings to mark their passage—tended to get their strategies from Warhol's example.

Above all, the working-class kid who had spent so many thousands of hours gazing into the blue, anesthetizing glare of the TV screen, like Narcissus into his pool, realized that the cultural moment of the mid-sixties favored a walking void. Television was producing an affectless culture. Warhol set out to become one of its affectless heroes. It was no longer necessary for an artist to act crazy, like Salvador Dali. Other people could act crazy for you: that was what Warhol's Factory was all about. By the end of the sixties craziness was becoming normal, and half of America seemed to be immersed in some tedious and noisy form of self-expression. Craziness no longer suggested uniqueness. Warhol's bland translucency, as of frosted glass, was much more intriguing.

Like Chauncey Gardiner, the hero of Jerzy Kosinski's *Being There*, he came to be credited with sibylline wisdom because he was an absence, conspicuous by its presence—intangible, like a TV set whose switch nobody could find. Disjointed public images—the Campbell's soup cans, the Elvises and Lizzes and Marilyns, the electric chairs and car crashes, and the jerky, shapeless pornography of his movies—would stutter across this screen; would pour from it in a gratuitous flood.

But the circuitry behind it, the works, remained mysterious. (Had he made a point of going to the shrink, like other New York artists, he would have seemed rather less interesting to his public.) "If you want to know all about Andy Warhol," he told an interviewer in those days, "just look at the surface of my paintings and films and me, and there I am. There's nothing behind it."[3] This kind of coyness looked, at the time, faintly threatening. For without doubt, there was something strange about so firm an adherence to the surface. It went against the grain of high art as such. What had become of the belief, dear to modernism, that the power and cathartic necessity of art flowed from the unconscious, through the knotwork of dream, memory, and desire, into the realized image? No trace of it; the paintings were all superficies, no symbol. Their blankness seemed eerie.

They did not share the reforming hopes of modernism. Neither dada's caustic anxiety, nor the utopian dreams of the constructivists; no politics, no transcendentalism. Occasionally there would be a slender, learned spoof, as when Warhol did black-and-white paintings of dance-step diagrams in parody of Mondrian's black-and-white *Fox Trot* (1930). But in general, his only subject was detachment: the condition of being a spectator, dealing hands-off with the world through the filter of photography.

3. Andy Warhol, quoted in Kasper König, Pontus Hultén, Olle Granath, eds., *Andy Warhol*; exhibition catalogue, Moderna Museet, Stockholm (New York: Worldwide Books, 1969), n.p.—Ed. note.

(Left) Andy Warhol. Installation of *Thirteen Most Wanted Men,* New York State Pavilion, New York World's Fair, 1964. The work was subsequently painted over, following protests that it demeaned Italian-Americans

(Below) Andy Warhol. *Before and After, 3,* 1962. Acrylic on canvas, 72⅛ x 99⅞" (183 x 253.7 cm). Collection the artist. (Photo: Geoffrey Clements)

(Above) Andy Warhol. *Race Riot,* 1963. Acrylic on canvas, 30 x 33" (76.2 x 83.8 cm). Collection Sam Wagstaff, New York. (Photo: courtesy Leo Castelli Gallery)

(Above right) Andy Warhol. *Brillo,* 1964. Painted wood, 17 x 17 x 14" (43.2 x 43.2 x 35.5 cm). Various collections. (Photo: Rudolph Burckhardt)

(Right) Andy Warhol. Still from *Empire,* 1964. Black-and-white film, sound, 16mm, 480 minutes

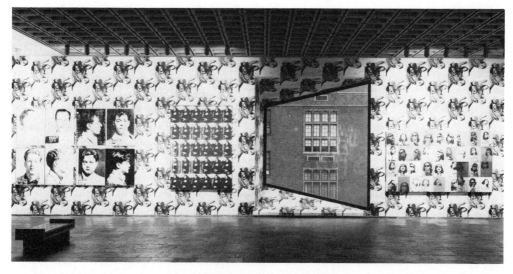

Andy Warhol. Installation of the exhibition, *Andy Warhol,* at the Whitney Museum of American Art, May 1–June 20, 1971 (left to right: *Most Wanted Men,* 1963; *30 Are Better than 1,* 1963; *Ethel Scull 36 Times,* 1963; on *Cow Wallpaper,* 1964). (Photo: Geoffrey Clements)

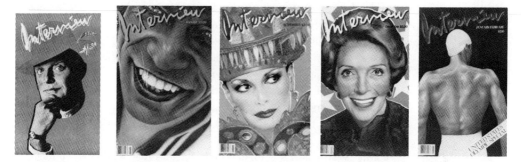

Interview, Andy Warhol, publisher. Featuring on the cover: Truman Capote (January 1978); Mick Jagger (August 1981); Diane von Furstenburg (November 1981); Nancy Reagan (December 1981); and U.S. Olympians (January-February 1983)

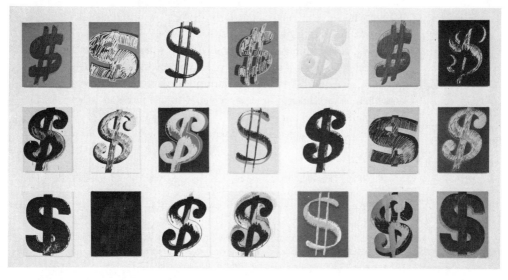

Andy Warhol. *Dollar Signs,* 1981. Acrylic on canvas, each: 20 x 16″ (51 x 40.6 cm). Various Collections. (Photo: courtesy Leo Castelli Gallery)

Thus his paintings, roughly silkscreened, full of slips, mimicked the dissociation of gaze and empathy induced by the mass media: the banal punch of tabloid newsprint, the visual jabber and bright sleazy color of TV, the sense of glut and anesthesia caused by both. Three dozen Elvises are better than one; and one Marilyn, patched like a gaudy stamp on a ground of gold leaf (the favorite color of Byzantium, but of drag queens too) could become a sly and grotesque parody of the Madonna-fixations of Warhol's own Catholic childhood, of the pretentious enlargement of media stars by a secular culture, and of the similarities between both. The rapid negligence of Warhol's images parodied the way mass media replace the act of reading with that of scanning, a state of affairs anticipated by Ronald Firbank's line in *The Flower Beneath the Foot:* "She reads at such a pace . . . and when I asked her *where* she had learnt to read so quickly, she replied, 'On the screens at Cinemas.' "[4]

Certainly, Warhol had one piercing insight about mass media. He would not have had it without his background in commercial art and his obsession with the stylish. But it was not an *aperçu* that could be developed: lacking the prehensile relationship to experience of Claes Oldenburg (let alone Picasso), Warhol was left without much material. It is as though, after his near death in 1968, Warhol's lines of feeling were finally cut; he could not appropriate the world in such a way that the results meant much as art, although they became a focus of ever-increasing gossip, speculation, and promotional hoo-ha. However, his shooting reflected back on his earlier paintings—the prole death in the car crashes, the electric chair with the sign enjoining SILENCE on the nearby door, the taxidermic portraits of the dead Marilyn—lending them a fictive glamour as emblems of fate. Much breathless prose was therefore expended on Andy, the Silver Angel of Death, and similar conceits. (That all these images were suggested by friends, rather than chosen by Warhol himself, was not stressed.)

Partly because of this gratuitous aura, the idea that Warhol was a major interpreter of the American scene dies hard—at least in some quarters of the art world. "Has there ever been an artist," asked Peter Schjeldahl at the end of a panegyric on Warhol's fatuous show of society portraits at the Whitney in 1979, "who so coolly and faithfully, with such awful intimacy and candor, registered important changes in a society?"[5] (Well, maybe a couple, starting with Goya.) Critics bring forth such borborygms when they are hypnotized by old radical credentials. Barbara Rose once compared his portraits, quite favorably, to Goya's. John Coplans, the former editor of *Artforum*, wrote that his work "almost by choice of imagery alone, it seems, forces us to squarely face the existential edge of our existence."[6]

In 1971 an American Marxist named Peter Gidal, later to make films as

4. Ronald Firbank, *The Flower Beneath the Foot* (New York: Brentano's, 1924), pp. 5-6.–Ed. note.

5. Peter Schjeldahl, "Warhol and Class Content," *Art in America* 68, No. 5 (May 1980): 112.–Ed. note.

6. John Coplans, "Andy Warhol: The Art," in *Andy Warhol*, ed. Coplans, with Jonas Mekas and Calvin Tomkins; exhibition catalogue, Pasadena Art Museum (Greenwich, Conn.: New York Graphic Society, 1970), p. 49.–Ed. note.

numbing as Warhol's own, declared that "unlike Chagall, Picasso, Rauschenberg, Hamilton, Stella, most of the Cubists, Impressionists, Expressionists, Warhol never gets negatively boring"[7]—only, it was implied, *positively* so, and in a morally bracing way. If the idea that Warhol could be the most interesting artist in modern history, as Gidal seemed to be saying, now looks a trifle *voulu*, it has regularly been echoed on the left—especially in Germany, where, by one of those exquisite contortions of social logic in which the *Bundesrepublik* seems to specialize, Warhol's status as a blue chip was largely underwritten by Marxists praising his "radical" and "subversive" credentials.

Thus the critic Rainer Crone, in 1970, claimed that Warhol was "the first to create something more than traditional 'fine art' for the edification of a few."[8] By mass producing his images of mass production, to the point where the question of who actually made most of his output in the sixties has had to be diplomatically skirted by dealers ever since (probably half of it was run off by assistants and merely signed by Warhol), the pallid maestro had entered a permanent state of "anaesthetic revolutionary practice"—delicious phrase! In this way the "elitist" forms of middle-class idealism, so obstructive to art experience yet so necessary to the art market, had been short-circuited. Here, apparently, was something akin to the "art of five kopeks" Lunacharsky had called on the Russian avant-garde to produce after 1917. Not only that: the People could immediately see and grasp what Warhol was painting. They were used to soup cans, movie stars, and Coke bottles. To make such bottles in a factory in the South and sell them in Abu Dhabi was a capitalist evil; to paint them in a factory in New York and sell them in Düsseldorf, an act of cultural criticism.

These efforts to assimilate Warhol to a "revolutionary" aesthetic now have a musty air. The question is no longer whether such utterances were true or false—Warhol's later career made them absurd anyway. The real question is: how could otherwise informed people in the sixties and seventies imagine that the man who would end up running a gossip magazine and cranking out portraits of Sao Schlumberger for a living was really a cultural subversive? The answer probably lies in the change that was coming over their own milieu, the art world itself.

Warhol did his best work at a time (1962-1968) when the avant-garde, as an idea and a cultural reality, still seemed to be alive, if not well. In fact it was collapsing from within, undermined by the encroaching art market and by the total conversion of the middle-class audience; but few people could see this at the time. The ideal of the radical, "outsider" art of wide social effect had not yet been acknowledged as fantasy. The death of the avant-garde has since become such a commonplace that the very word has an embarrassing aura. In the late seventies, only dealers used it; today, not even they do, except in Soho. But in the late sixties and early seventies, avant-garde status was still

7. Peter Gidal, *Andy Warhol: Films and Paintings* (New York: E. P. Dutton; London: Studio Vista, 1971), p. 76.—Ed. note.

8. Rainer Crone, *Andy Warhol*, trans. John William Gabriel (New York: Praeger Publishers, 1970), p. 23. See also Crone and Wilfried Wiegand, *Die revolutionäre Ästhetik Andy Warhol's* (Darmstadt: Melzer Verlag, 1972).—Ed. note.

The Rise of Andy Warhol 53

thought to be a necessary part of a new work's credentials. And given the political atmosphere of the time, it was mandatory to claim some degree of "radical" political power for any nominally avant-garde work.

Thus Warhol's silence became a Rorschach blot, onto which critics who admired the idea of political art—but would not have been seen dead within a hundred paces of a realist painting—could project their expectations. As the work of someone like Agam is abstract art for those who hate abstraction, so Warhol became realist art for those who loathed representation as "retro-grade." If the artist, blinking and candid, denies that he was in any way a "revolutionary" artist, his admirers knew better; the white mole of Union Square was just dissimulating. If he declared that he was only interested in getting rich and famous, like everyone else, he could not be telling the truth; instead, he was parodying America's obsession with celebrity, the better to deflate it. From the recesses of this exegetical knot, anything Warhol did could be taken seriously. In a review of *Exposures,* the critic Carter Ratcliff solemnly asserted that "he is secretly the vehicle of artistic intentions so complex that he would probably cease to function if he didn't dilute them with nightly doses of the inane."[9] But for the safety valve of Studio 54, he would presumably blow off like the plant at Three Mile Island, scattering the culture with unimagined radiations.

One wonders what these "artistic intentions" may be, since Warhol's output for the last decade has been concerned more with the smooth develop-ment of product than with any discernible insights. As Harold Rosenberg remarked, "In demonstrating that art today is a commodity of the art market, comparable to the commodities of other specialized markets, Warhol has liq-uidated the century-old tension between the serious artist and the majority culture."[10] It scarcely matters what Warhol paints; for his clientele, only the signature is fully visible. The factory runs, its stream of products is not inter-rupted, the market dictates its logic. What the clients want is *a* Warhol, a recognizable product bearing his stamp. Hence any marked deviation from the norm, such as an imaginative connection with the world might produce, would in fact seem freakish and unpleasant: a renunciation of earlier products. War-hol's sales pitch is to soothe the client by repetition while preserving the fiction of uniqueness. Style, considered as the authentic residue of experience, becomes its commercial-art cousin, styling.

Warhol has never deceived himself about this: "It's so boring painting the same picture over and over," he complained in the late sixties. So he must introduce small variations into the package, to render the last product a little obsolete (and to limit its proliferation, thus assuring its rarity), for if all Warhols were exactly the same there would be no market for new ones. Such is his parody of invention, which now looks normal in a market-dominated art world. Its industrial nature requires an equally industrial kind of *facture:* this consists of making silkscreens from photos, usually Polaroids, bleeding out a

9. Carter Ratcliff, "Starlust: Andy's Photos," *Art in America* 68, no. 5 (May 1980): 120.–Ed. note.

10. Harold Rosenberg, "Warhol: Art's Other Self," in *Art on the Edge: Creators and Situations* (Chicago: The University of Chicago Press, 1975), pp. 105-106.–Ed. note.

good deal of the information from the image by reducing it to monochrome, and then printing it over a fudgy background of decorative color, applied with a wide, loaded brush to give the impression of verve. Only rarely is there even the least formal relationship between the image and its background.

This formula gave Warhol several advantages, particularly as a portraitist. He could always flatter the client by selecting the nicest photo. The lady in Texas or Paris would not be subjected to the fatigue of long scrutiny; in fact she would feel rather like a *Vogue* model, whether she looked like one or not, while Andy did his stuff with the Polaroid. As social amenity, it was an adroit solution; and it still left room for people who should know better, like the art historian Robert Rosenblum in his catalogue essay to Warhol's portrait show at the Whitney in 1979, to embrace it: "If it is instantly clear that Warhol has revived the visual crackle, glitter, and chic of older traditions of society portraiture, it may be less obvious that despite his legendary indifference to human facts, he has also captured an incredible range of psychological insights among his sitters."[11] Legendary, incredible, glitter, insight: stuffing to match the turkey.

The perfunctory and industrial nature of Warhol's peculiar talent and the robotic character of the praise awarded it, appears most baldly of all around his prints, which were given a retrospective at Castelli Graphics in New York and a *catalogue raisonné* by Hermann Wünsche. "More than any other artist of our age," one of its texts declares, "Andy Warhol is intensively preoccupied with concepts of time"; quite the little Proust, in fact. "His prints above all reveal Andy Warhol as a universal artist whose works show him to be thoroughly aware of the great European traditions and who is a particular admirer of the glorious French *Dixneuvième*, which inspired him to experience and to apply the immanent qualities of 'pure' *peinture*."[12] No doubt something was lost in translation, but it is difficult to believe that Hans Gerd Tuchel, the author, has looked at the prints he speaks of. Nothing could be flatter or more perfunctory, or have less to do with those "immanent qualities of pure *peinture*," than Warhol's recent prints. Their most discernible quality is their transparent cynicism and their Franklin Mint approach to subject matter. What other "serious" artist, for instance, would contemplate doing a series called "Ten Portraits of Jews of the Twentieth Century,"[13] featuring Kafka, Buber, Einstein, Gertrude Stein, and Sarah Bernhardt? But then, in the moral climate of today's art world, why not treat Jews as a special-interest subject like any other? There is a big market for bird prints, dog prints, racing prints, hunting prints, yachting prints; why not Jew prints?

Yet whatever merits these mementos may lack, nobody could rebuke their author for inconsistency. The Jew as Celebrity: it is of a piece with the

11. Robert Rosenblum, "Andy Warhol: Court Painter to the 70s," in *Andy Warhol: Portraits of the 70s,* ed. David Whitney; exhibition catalogue, Whitney Museum of American Art (New York: Random House, 1979), p. 18.–Ed. note.

12. Hans Gerd Tuchel, "Andy Warhol als Graphiker/Andy Warhol as Graphic Artist," trans. Dennis S. Clarke, in Herman Wünsche, *Andy Warhol: Das Graphische Werk 1962-1980* (Bonn: Bonner Universitat Buchdruckerai, 1980), n.p.–Ed. note.

13. "Ten Portraits of Jews of the Twentieth Century," The Jewish Museum, September 17, 1980-January 4, 1981.

ruling passion of Warhol's career, the object of his fixated attention—the state of being well known for well-knownness. This is all *Exposures* was about—a photograph album of film stars, rock idols, politicians' wives, cocottes, catamites, and assorted bits of International White Trash baring their teeth to the socially emulgent glare of the flashbulb: I am flashed, therefore I am. It is also the sole subject of Warhol's house organ, *Interview*.

Interview began as a poor relative of *Photoplay*, subtitled "Andy Warhol's Movie Magazine." But by the mid-seventies it had purged itself of the residue of the "old" Factory and become a punkish *feuilleton* aimed largely at the fashion trade—a natural step, considering Warhol's background. With the opening of Studio 54 in 1977, the magazine found its "new" Factory, its spiritual home. It then became a kind of marionette theater in print: the same figures, month after month, would cavort in its tiny proscenium, do a few twirls, suck or snort something, and tittup off again—Marisa, Bianca, Margaret Trudeau, and the rest of the fictive stars who replaced the discarded Superstars of the Factory days.

Because the magazine is primarily a social-climbing device for its owner and staff, its actual gossip content is quite bland. Many stones lie unturned, but no breech is left unkissed. As a rule the interviews, taped and transcribed, sound as though a valet were asking the questions, especially when the subject is a regular advertiser in the magazine. Sometimes the level of gush exceeds the wildest inventions of S. J. Perelman. "I have felt since I first met you," one interviewer exclaims to Diane von Furstenberg, "that there was something extraordinary about you, that you have the mystic sense and quality of a pagan soul. And here you are about to introduce a new perfume, calling it by an instinctive, but perfect name." And later:

> Q. *I have always known of your wonderful relationship with your children. By this, I think you symbolize a kind of fidelity. Why did you bring back these geese from Bali?*
> A. *I don't know.*
> Q. *You did it instinctively.*
> A. *Yes, it just seemed right. One thing after the other. . . . It's wild.*
> Q. *There's something about you that reminds me of Aphrodite.*
> A. *Well, she had a good time.*

Later, Aphrodite declares that "I don't want to be pretentious," but that "I was just in Java and it has about 350 active volcanoes. I'll end up throwing myself into one. I think that would be very glamorous." [14]

In politics, *Interview* has one main object of veneration: the Reagans, around whose elderly flame the magazine flutters like a moth, waggling its little thorax at Jerry Zipkin, hoping for invitations to White House dinners or, even better, an official portrait commission for Warhol. Moving toward that day, it is careful to run flattering exchanges with White House functionaries like Muffie

14. Iris Love, "Diane von Furstenberg," *Interview* 11, no. 11 (November 1981): 26, 29.—Ed. note.

Brandon. It even went so far as to appoint Doria Reagan, the daughter-in-law, as a "contributing editor." To its editor, Reagan is *Caesar Augustus Americanus* and Nancy a blend of Evita and the Virgin Mary, though in red. Warhol seems to share this view, though he did not always do so. For most of the seventies he was in some nominal way a liberal Democrat, like the rest of the art world—doing campaign posters for McGovern, trying to get near Teddy Kennedy. Nixon, who thought culture was for Jews, would never have let him near the White House. When Warhol declared that Gerald Ford's son Jack was the only Republican he knew, he was telling some kind of truth. However, two things changed this in the seventies: the Shah, and the Carter administration.

One of the odder aspects of the late Shah's regime was its wish to buy modern Western art, so as to seem "liberal" and "advanced." Seurat in the parlor, SAVAK in the basement. The former Shahbanou, Farah Diba, spent millions of dollars exercising this fantasy. Nothing pulls the art world into line faster than the sight of an imperial checkbook, and the conversion of the remnants of the American avant-garde into ardent fans of the Pahlavis was one of the richer social absurdities of the period. Dealers started learning Farsi, Iranian fine-arts exchange students acquired a sudden cachet as research assistants, and invitations to the Iranian embassy—not the hottest tickets in town before 1972—were now much coveted.

The main beneficiary of this was Warhol, who became the semi-official portraitist to the Peacock Throne. When the *Interview* crowd were not at the tub of caviar in the consulate like pigeons around a birdbath, they were on an Air Iran jet somewhere between Kennedy Airport and Tehran. All power is delightful, as Kenneth Tynan once observed, and absolute power is absolutely delightful. The fall of the Shah left a hole in *Interview*'s world: to whom could it toady now? Certainly the Carter administration was no substitute. Those southern Baptists in polycotton suits lacked the finesse to know when they were being flattered. They had the social grace of car salesmen, drinking Amaretto and making coarse jests about pyramids. They gave dull parties and talked about human rights. The landslide election of Reagan was therefore providential. The familiar combination of private opulence and public squalor was back in the saddle; there would be no end of parties and patrons and portraits. The Wounded Horseman might allot $90 million for brass bands while slashing the cultural endowments of the nation to ribbons and threads; who cared? Not Warhol, certainly, whose work never ceases to prove its merits in the only place where merit really shows, the market.

Great leaders, it is said, bring forth the praise of great artists. How can one doubt that Warhol was delivered by Fate to be the Rubens of this administration, to play Bernini to Reagan's Urban VIII? On the one hand, the shrewd old movie actor, void of ideas but expert at manipulation, projected into high office by the insuperable power of mass imagery and secondhand perception. On the other, the shallow painter who understood more about the mechanisms of celebrity than any of his colleagues, whose entire sense of reality was shaped, like Reagan's sense of power, by the television tube. Each, in his way, coming on like Huck Finn; both obsessed with serving the interests of privilege. Together, they signify a new moment: the age of supply-side aesthetics.

The Rise of Andy Warhol 57

Stills from avant-garde films (reading from top to bottom):

Joseph Cornell. *Rose Hobart,* ca. 1936. Black-and-white film, silent (accompanied by record), 16mm, 19 min

Ernie Gehr. *Eureka,* 1974–1979. Black-and-white film, silent, 16mm, 30 min

Stan Brakhage. *Dog Star Man,* 1959–1964. Color and black-and-white film, silent, 16mm, 78 min

Morgan Fisher. *The Actor and His Director,* 1968. Black-and-white film, sound, 16mm, 15 min

Hollis Frampton. *Hapax Legomena (Nostalgia),* 1971. Black-and-white film, sound, 16mm, 26 min

Anthony McCall, Claire Pajaczkowska, Andrew Tyndall, and Jane Weinstock. *Sigmund Freud's Dora: A Case of Mistaken Identity,* 1979. Color film, sound, 16mm, 40 min

Yvonne Rainer. *Film About a Woman Who . . . ,* 1974. Black-and-white film, sound, 16mm, 105 min

Ericka Beckman. *Out of Hand,* 1980. Color film, sound, super-8, 30 min

Vivienne Dick. *Visibility: Moderate,* 1981. Black-and-white film, sound, super-8, 30 min

Jean-Luc Godard. *France/Tour/Detour/Two/Children,* 1980. Color video, sound, 150 min

After Avant-Garde Film

J . H O B E R M A N

"Avant-garde" is a problematic term, and nowhere is it more so than when applied to cinema. In 1932, filmmaker Germaine Dulac used "avant-garde" to designate those films "whose techniques, employed with a view to a renewed expressiveness of image and sound, break with established traditions to search out, in the strictly visual and auditory realm, new emotional chords," those filmmakers who, "detached from motives of profit, march boldly on towards the conquest of the new modes of expression . . . to expand cinematic thought."[1] Allowing for Dulac's romantic categories, hers could stand as a contemporary definition—keeping in mind Janet Bergstrom's observation that "avant-garde does not mean 'in advance of' a developing film tradition; it is taken to mean, rather, *apart from* the commercial cinema,"[2] with the further caveat that avant-garde film is not simply other than, but often opposed to commercial cinema, in terms of distribution, production, and articulation.

Avant-garde films derange what Noël Burch has usefully termed the "institutional mode of representation"—defined as "that set of (written or unwritten) directives which has been historically interiorized by directors and technicians as the irreducible base of 'film language' within the Institution and which has remained a constant over the past fifty years, independently of the vast stylistic changes which have taken place."[3] (Formal aspects of the institutional mode of representation include synchronous sound, the use of music to reinforce onscreen action, established conventions of screen direction and point-of-view, as well as arbitrary signs such as a dissolve to indicate the

1. Germaine Dulac, "The Avant-Garde Cinema," reprinted in *The Avant-Garde Film: A Reader of Theory and Criticism*, ed. P. Adams Sitney (New York: New York University Press, 1978), pp. 43.
2. Janet Bergstrom, "The Avant-Garde—Histories and Theories," *Screen* 19, no. 3 (Autumn 1978): 120.
3. Noël Burch, "How We Got Into Pictures," *Afterimage*, nos. 8-9 (Winter 1980-81): 24. Burch's notion of the "Institution" comes from Christian Metz's *The Imaginary Signifier: Psychoanalysis and Cinema* (1977), trans. Celia Britton et al. (Bloomington: Indiana University Press, 1982), where it is defined as "not just the cinema industry (which works to fill cinemas, not to empty them), it is also the mental machinery—another industry—which spectators 'accustomed to the cinema' have internalized historically and which has adapted them to the consumption of film" (p. 7).

passage of time or a commercial length of 90 to 120 minutes.) On one hand, avant-garde films are those which undermine, negate, or reinvent the conventions of narrative, documentary, or animated movies. On the other hand, avant-garde has a historical meaning.

The cinema was invented in 1895, scarcely a decade before the period of the historic (art) avant-garde and was included in the program of virtually every major vanguard movement from futurism to Bolshevism. (Where it was not, as in cubism, it has been read back into the movement by subsequent historians and critics.) At the same time, as Walter Benjamin realized, movies were inherently avant-garde—their very form and processes undermining the cultural assumptions and institutions of the nineteenth century. Commercial movies, frequently made in America, stimulated the European avant-gardes as did, to varying degrees, such other American mass-cultural modes as jazz, comic strips, and the tabloid press. If the weakness of America's high culture during the early part of the century inhibited the development of an indigenous avant-garde art, then it was the protean strength of American mass culture—specifically the Hollywood movie—which inhibited the development of a film avant-garde.

For American film culture, the two most important stimuli were European vanguard movements—namely early Soviet cinema and French surrealism, both of which suggested strategies for opposing the hegemony of Hollywood. Although it is customary to begin accounts of the American avant-garde film with Maya Deren and Alexander Hammid's surrealistic *Meshes of the Afternoon* (1943), it can be argued that the Workers Film and Photo League—established in 1930 with support from the Workers' International Relief—was the first indigenous avant-garde.

Inspired as much by Dziga Vertov's "kino-eye" as by Sergei Eisenstein's theories of montage, Film and Photo League activists documented those aspects of American social reality—including strikes, breadlines, and demonstrations—that were studiously ignored by Hollywood films and commercial newsreels. In addition, the Film and Photo League provided a model for subsequent avant-garde filmmakers by establishing equipment cooperatives, film-study courses, film journals, and distribution networks. Although most films by the Film and Photo League and successor groups like the unaffiliated but leftwing Nykino and Frontier Films were informational, Nykino's *Pie in the Sky* (1934-35) is a remarkable proto-underground movie. It anticipates by twenty-five years or more Robert Frank and Alfred Leslie's *Pull My Daisy* (1958), Ron Rice's *The Flower Thief* (1960), Jack Smith's *Flaming Creatures* (1963), Ken Jacobs and Bob Fleischner's *Blonde Cobra* (1959-62), et al., in its aggressive cheapness, casual blasphemy, and emphasis on the detritus of industrial civilization. Set in a Long Island City garbage dump, *Pie in the Sky*'s antireligious antics were improvised around such found props as a decaying Christmas tree, a wrecked car, and a battered department-store dummy, any of which could have figured in a film by Smith or Rice. "While [*Pie in the Sky*] is essentially experimental," the program notes for a 1935 screening explained, "Nykino feels that the film is nevertheless a contribution and an advance step toward the creation of a highly developed American revolutionary film, that has nothing in common with Hollywood or the Hollywood product."

The influence of surrealism on American avant-garde cinema was less straightforward than that of the Soviet model, but perhaps even more pervasive. P. Adams Sitney's *Visionary Film*, the most authoritative account of the development of American avant-garde cinema through 1968, begins with a description of Luis Buñuel and Salvador Dali's *Un Chien Andalou* (1929). Yet, according to Sitney, it was the quasi-surrealism of Jean Cocteau's *Le Sang d'un Poète* (1930) that more closely influenced (or paralleled) the aspirations of the psychodramas or "trance films" of Maya Deren, Gregory Markopoulos, Kenneth Anger, and Stan Brakhage, that characterized the post-World War II American avant-garde. Sitney further cites surrealism as an influence on the work of Sidney Peterson, James Broughton, and the San Francisco school, as well as on the animator Harry Smith: "The surrealist cinema suddenly disappeared after Buñuel's *L'Age d'Or* (1930) to reemerge thirteen years later in America, essentially transformed."[4] This transformation amounted to virtual depoliticization. *Un Chien Andalou* and *L'Age d'Or* were films which subverted, deconstructed, and disrupted the institutional mode of representation while simultaneously attacking the "purity" of the French commercial avant-garde. By contrast, the first films of Deren, Markopoulos, and Anger are essentially recuperative—part of the wave of diluted surrealism and pop Freudianism that swept Hollywood during the 1940s, manifested in such diverse phenomena as *Citizen Kane*, the films of Alfred Hitchcock (whose debt to surrealism has never been fully explored), and film noir. All of these tendencies, along with their influences on experimental film, found a particularly sensitive reception in the writings of Parker Tyler.

Only one American film can be located directly within the surrealist attempt at cultural revolution. The first masterpiece of American avant-garde cinema, Joseph Cornell's *Rose Hobart* (completed during the late 1930s) is also the most radical example of surrealist filmmaking to follow *Un Chien Andalou* and *L'Age d'Or*. Extending his collage methodology into film, Cornell performed a work of surrealist synthetic criticism on a 1931 Hollywood potboiler, *East of Borneo*. By deconstructing, recycling, and revealing the latent content of a commercial movie (turning it into an oneiric documentary of its leading lady), Cornell intimates what Andreas Huyssen would later assert—that "it was the culture industry, not the avant-garde which succeeded in transforming everyday life in the twentieth century."[5] Virtually unknown for thirty-five years, *Rose Hobart* (like *Pie in the Sky*) looks forward to the American postmodernist avant-garde or underground of the 1960s.

In the decades following World War II, the work of isolated "experimental" filmmakers—Maya Deren and Marie Menken in New York, Kenneth Anger and Gregory Markopoulos in Los Angeles, Sidney Peterson and Harry Smith

4. P. Adams Sitney, *Visionary Film: The American Avant-Garde* (New York: Oxford University Press, 1974), p. 267.

5. Andreas Huyssen, "The Search for Tradition: Avant-Garde and Postmodernism in the 1970s," *New German Critique*, no. 22 (Winter 1981): 23–40.

in San Francisco, Stan Brakhage and Larry Jordan in Denver—evolved into an autonomous film avant-garde. The paradigmatic figure of this avant-garde was Stan Brakhage, a filmmaker whose eschewal of the institutional mode of representation in the service of an essentially narrative cinema is surely the most absolute in film history. Younger than Deren, Peterson, and the other pioneers of the experimental film, Brakhage appeared on the scene during the mid-1950s, a few years after the first burst of avant-garde film activity and precisely at the moment that the triumph of "Action Painting" marked the ascension of a genuine American modernism.

Beginning in the tradition of the Cocteau-influenced psychodrama, Brakhage increasingly emphasized film as material, integrating emulsion scratches and end-flares into his work. For him, however, this materiality was not an end in itself but rather a new form of film expressiveness—akin, in its way, to Griffith's codification of irises, fades, close-ups, and flashbacks during the period between 1908 and 1912. With *Anticipation of the Night* (1958), Brakhage broke through to a particular form of psychodrama in which the protagonist of the film was not the figure before but the consciousness *behind* the camera. Increasingly concerned with the quotidian doings of his immediate family and their lives in the Colorado Rockies, Brakhage's intensely subjective, first-person cinema continued to develop throughout the sixties and seventies.

In 1960, however, *Anticipation of the Night* represented only the most radical tendency in the so-called "New American Cinema"—an amalgam of independent social realists (Shirley Clarke, Jonas Mekas), experimental animators (Robert Breer, Larry Jordan), assemblagists (Bruce Conner, Stan VanDerBeek), beatniks (Alfred Leslie, Robert Frank), and unclassifiable enthusiasts (Marie Menken), united principally by their antipathy to Hollywood, their reliance on alternate modes of distribution, and their common insistence on an artisanal means of production.

The journalistic term "underground movies" which replaced "experimental cinema" as a blanket categorization during the early sixties, can be more exactly applied to one particular movement within the New American Cinema which, in common with Pop Art (as well as the contemporary criticism of Susan Sontag and Leslie Fiedler) purposefully blurred the distinction between high art and mass culture. Films like Kenneth Anger's *Scorpio Rising* (1962-64) and Jack Smith's *Flaming Creatures* (1962-63), as well as the contemporary work of Bruce Conner, Ron Rice, Ken Jacobs, and the Kuchar brothers, took the received *langue* of the American culture industry (particularly Hollywood) and, using their own impoverished means, transformed it into a personal *parole*.

All tendencies in this autonomous film avant-garde were celebrated by Jonas Mekas in the *Village Voice* and found additional defenders in the pages of his own journal, *Film Culture*, which was also (for a time) the leading American auteurist journal. In addition to producing publicity, propaganda, and manifestos—urging filmmakers to abandon "all the existing professional, commercial values, rules, subjects, techniques, pretensions"[6]—Mekas was in-

6. Jonas Mekas, "Where Are We—The Underground?" in *The New American Cinema*, ed. Gregory Battcock (New York: E. P. Dutton, 1967), p. 19.

strumental in organizing New York showcases for avant-garde films and creating a cooperative to distribute the work. By the early 1960s, then, the American avant-garde had become an oppositional cinema—founded on diversity and supported by a popular base—with its own alternative institutions and quasi-utopian ideology. Identifying exploitation, alienation, sexual repression, and homogeneity as the prevailing characteristics of dominant cinema, the New American Cinema criticized Hollywood movies as an institution, both directly (as in underground film) and by example of its alternative forms of production and distribution. Here Brakhage, who went furthest in developing an arcane, personalized film language and individualistic means of production (while paradoxically limiting his subject matter to the ordinary and the everyday), was the exemplar. In every sense other than the first, Brakhage had more in common with the amateur home-movie enthusiast than with any director of commercial films.

Yet, even as Brakhage was at work on the epic *Dog Star Man* (1961-64), his most complex and ambitious work to date (the "cycle of all history, all mankind," as Sitney enthusiastically described it), a countervailing force had begun to produce films of virtually unparalleled and outrageous simplicity. Static, unedited recordings, Andy Warhol's *Sleep* (1963), *Empire* (1964), and *Eat* (1964), were instantly notorious examples of a cinema stripped bare. "Andy Warhol is taking cinema back to its origins, to the days of Lumière, for a rejuvenation and a cleansing," wrote Jonas Mekas as *Film Culture* presented Warhol with its Sixth Independent Film Award. "In his work, he has abandoned all the 'cinematic' form and subject adornments that cinema had gathered around itself until now. He has focused his lens on the plainest images possible in the plainest manner possible." Warhol's work, Mekas prophesied, would transform cinema into "a new adventure; the world seen through a consciousness that is not running after big dramatic events but is focused on more subtle changes . . ."[7]

Mekas was right. Although Warholian cinema was to evolve ever closer to the institutional mode of representation—recapitulating the technological evolution of the Hollywood film with the successive "discovery" of stars, sound, scenarios, editing, color, widescreen, camera movement, and even 3-D—other filmmakers followed the lead of Warhol's first films in the radical suppression of the human subject and the abolition of the guided gaze. Michael Snow's *Wavelength* (1967)—a single 45-minute zoom across a Lower Manhattan loft—became the model for a new "cinema of structure," identified by Sitney in an influential essay.[8]

The new emphasis on perception (a shift away from both the personalized psychodrama and the language of mass culture) was paralleled by an unprecedented calling of attention to the materials of filmmaking. Cinema became reflexive. As the flicker films of Tony Conrad and Paul Sharits foregrounded the cinematic apparatus (projector, persistence of vision, the individual frame),

7. [Jonas Mekas], "Sixth Independent Film Award," *Film Culture*, no. 33 (Summer 1964): 1.

8. P. Adams Sitney, "Structural Film," *Film Culture*, no. 47 (Summer 1969): 1-10.

George Landow's *Film in Which There Appear Sprocket Holes, Edge Lettering, Dirt Particles, Etc.* (1966) and Ernie Gehr's refilmed *Reverberation* (1969) were films which examined film virtually as an object. Where many underground movies had steeped themselves in Hollywood mythology (the better to exorcize it), Morgan Fisher's self-explanatory *The Director and His Actor Look at Footage Showing Preparations for an Unmade Film* (1968) or his *Documentary Footage* (1968) and *Production Stills* (1970) were films whose subjects were precisely the specific conditions of their own making—narratives which demystified the procedures of filmmaking by emptying them of any external reference.

Warhol heralded a move away from the psychologically charged, intensely subjective (ultimately surrealist-derived) cinema of Stan Brakhage towards a more detached and antiexpressive avant-garde—one which shared many preoccupations with art world minimalism while retaining the irony of underground movies. At the same time, Warhol redeemed a cherished avant-garde project in particularly American terms. Warhol, as Mekas pointed out, returned cinema to its origins. Not only was the institutional mode of representation abolished but the movies were born again as Art, without the taint of fairground attraction. And, as the cinema had been reinvented, so could its history be rewritten—outside the historical institution of cinema.

Thus, Hollis Frampton announced his baldly titled *Information* (1966)—a four-minute documentary of a lightbulb—as "a hypothetical 'first film' for a synthetic tradition constructed from scratch on reasonable principles," and Michael Snow saluted Gehr's *History* (1970)—forty minutes of seething grain patterns, produced by dispensing with the camera lens and exposing the film through a piece of black cheesecloth—with the enthusiastic endorsement, "at last, the first film!" An alternate metahistory of cinema began to take shape. *Wavelength*, as well as Snow's subsequent epics of pure camera movement, ⟷ (1969) and *La Région Centrale* (1971), reasonably follow the naive panoramas of the pre-Griffith period. Taking its methodology from Gehr's *Reverberation*, Jacobs' *Tom, Tom, the Piper's Son* (1969) renarrativized a pre-Griffith story film with a welter of close-ups, pans, freeze frames, variations in speed, superimpositions, masks, and wipes, as though to suggest the development of cinema in an alternate universe.[9]

In short, only at the twilight of modernism, did an authentically modernist film avant-garde come into existence. With his Romantic subjectivity and emphasis on a personal language, Brakhage came to seem the Last of the Mohicans—an anachronistic throwback to the heroic modernism of Joyce and Picasso. The "new" modernism was anti-illusionist and reflexive, essentialist and didactic, an investigation of cinema's own unique and irreducible proper-

9. Other examples include Frampton's *Zorns Lemma* (1970), which sets out to reinvent film syntax; Klaus Wyborny's *Birth of a Nation* (1973), which returns to the founding moment of narrative grammar; and J. J. Murphy's *Print Generation* (1973)—a synthesis of *Zorns Lemma* and *History*—which establishes the ground zero of cinematic representation by printing and reprinting and re-reprinting a one-minute, 60-shot piece of film until its images are high-contrasted into oblivion.

ties and operations. It was the modernism of Clement Greenberg, transplanted from the art world (courtesy of Andy Warhol). But, in the process of legitimating cinematic modernism, the once unruly underground submitted to the formalist concerns of the art world and took its place within the institutional web of administered culture. *Tom, Tom, the Piper's Son*, for example, can be seen as the depoliticized offspring of *Rose Hobart* and *The Man with the Movie Camera*, challenging neither traditional means of aesthetic production nor reception.

As the chaotic underground was superseded by the "cinema of structure" —a confusing term that forecast the theorizing that would soon dominate avant-garde thinking—few recognized the key structural event of the early 1970s, namely the institutionalization of the avant-garde. Even as an entire issue of *Artforum* was devoted to the accomplishments of the New American Cinema, the underground surrendered its popular base to the new phenomenon of midnight movies. Meanwhile, the free-wheeling programming policies of the Film-makers' Cinematheque were succeeded by the restrictive selections of the Anthology Film Archives. Opening in December 1970, the Anthology reified the avant-garde tradition, creating a fixed pantheon of filmmakers and a certified canon of masterpieces, drawing heavily upon the late efflorescence of structural film. Avant-garde cinema left the theaters and entered the classrooms. By the early 1970s, almost all of the major filmmakers (and a host of minor ones) had come in from the cold—\ protected species, like academic poets—to spawn a new generation of university-trained, tenure-seeking filmmakers, film theorists, and film critics.

The brief and belated flowering of film's modernist avant-garde can be hypostatized in Gehr's *Eureka*, completed in 1974 but not released for another five years. Among other things, the film synthesizes Snow's *Wavelength* and Jacobs' *Tom, Tom, the Piper's Son*—as *Tom, Tom* re-presented a pre-1905 narrative, *Eureka* re-presents a 1905 panorama, filmed by a camera mounted in the front car of a San Francisco trolley. But whereas *Tom, Tom* drastically transformed its raw material, *Eureka* eschews both expressionism and performance, merely step-printing the original film at a ratio of eight-to-one.

If Warhol can be seen as taking cinema back to its origins and Snow's *Wavelength* as charting the trajectory of an authentic film modernism, *Eureka* is the film in which both aspirations are collapsed in the pre-Griffith world of 1905 (a haunting precursor, in Gehr's hands, to the media-saturated environment of 1984). Devoid of literature, psychology, and all but the most rudimentary narrative motion, it posits a world wholly mediated by cinema: Nature can only be approached through its filmic representation. *Eureka* suggests that film is not simply the proper subject for film but, in fact, the only subject.

Poststructural film has been less a perceptual field than a text to be read. Language is used both with and against the image; and it is precisely this emphasis on language which is the poststructuralist film's most obvious characteristic. In this sense, poststructural film is a reaction against the formalism of Michael Snow as well as Stan Brakhage. "From the beginning of cinema,

again and again, we can find an impulse on the part of filmmakers to banish language and reduce film to the status of a 'pure' visual art," Peter Wollen observed in 1981. Following Walter Benjamin's polemical demand for captioned photographs, Wollen argues that language is intrinsic to film, as crucial as image: "Language is the component of film which both threatens to regulate the spectator, assigned a place within the symbolic order, and also offers the hope of liberation from the closed world of identification and the lure of the image." [10]

This insistence on language (rather than simply "sound") lends a polemical edge to Wollen's project for using the avant-garde to reform the institutional mode of representation (or vice versa), suggesting the possibility of producing films with fixed meanings. Both as a filmmaker and a film theorist, Wollen is among the key figures of poststructural film, not least because the film avant-garde of the 1970s was as concerned with the production of theory as the production of films. Indeed, theorists like Christian Metz, Stephen Heath, Raymond Bellour, have been as important to the poststructural avant-garde as filmmakers. More global than previous avant-garde theorists, Metz and his followers have steered clear of those films (e.g., the films of Stan Brakhage) which problematize the institutional mode of representation, preferring to reread their own theories back into the films of the institution. In this way, Alfred Hitchcock has been recuperated as an avant-garde filmmaker.

Still, the centrality of this "theoretical discourse"—the post-1968 blend of Marx (via Althusser), Freud (as read by Lacan), and semiotics (mainly Barthes)—has been paralleled by the development of what has been dubbed the "new talkie." [11] The avatar of the new talkie—as mediated by late modernism—can be found in Hollis Frampton's *Poetic Justice* (1971). Although silent, *Poetic Justice* resembles most narrative films in that it is a filmed scenario. It is, however, literally that; the scenario has not been staged but merely filmed. Some 240 successive pages, each describing the action and camera placement for a single shot, appear consecutively on a kitchen table. The narrative which *Poetic Justice* demands the spectator imagine (while incidentally meditating for 30-odd minutes on a nearly static still life) is a complicated tale of sexual infidelity whose intricate permutations—including the elaborate use of images within the image—would be difficult, if not impossible, to represent on film and whose protagonists—"you," "your lover," and "I"—are comically suggestive of the Oedipal triangle. Terminally reflexive, the film ends with a shot that describes the photography of the very sheets of paper which provide the arena for its action. *Poetic Justice* insists on voyeurism as intrinsic to cinematic pleasure even as it methodically frustrates the viewer's own voyeurism in the film's consumption.

Poetic Justice proved to be only a diversion in Frampton's career, as he turned to making a Brakhagian epic entitled *Straits of Magellan* (1974-). But

10. Peter Wollen, "The Field of Language in Film," *October*, no. 17 (Summer 1981): 54.

11. The term was apparently coined by Noël Carroll, "Interview with a Woman Who . . . ," *Millennium Film Journal*, nos. 7-8-9 (Fall-Winter 1980-81): 37.

a nexus of films appeared during the early 1970s which were equally steeped in issues of narrativity, spectatorship, identification, sexual difference, and visual pleasure. These include Jackie Raynal's *Deux Fois* (1970), Yvonne Rainer's *Lives of Performers* (1972) and *Film About a Woman Who . . .* (1974), Chantal Akerman's *Je, tu, il, elle* (1974), Laura Mulvey and Peter Wollen's *Penthesilea* (1974), and Babette Mangolte's *What Maisie Knew* (1975). Raynal, Rainer, and Akerman were the protagonists as well as the producers of their films (while Mangolte, a professional cinematographer, used a subjective camera to identify her protagonist with the camera's gaze). Thus, in several respects, this new tendency was a new psychodrama—cool, ironic, and behaviorist, as opposed to the romantic, symbolist, Jungian psychodrama of the 1940s and 1950s; a mode influenced by Jean-Luc Godard rather than Jean Cocteau.

Claire Johnston's manifesto "Women's Cinema as Counter-Cinema" (1973) provided an important position paper which identified this poststructural avant-garde as essentially feminist, as did Mulvey's influential essay, "Visual Pleasure and Narrative Cinema" (1975).[12] The rise of a theoretical feminist film practice dovetailed with another post-1968 aspiration, namely the desire to reunite the aesthetic and political avant-gardes, divorced for the last time during the period between the wars. Wollen's polemic, "The Two Avant-Gardes" (1975) schematized avant-garde film history so as to clear a space for his own enterprise. According to Wollen, the first avant-garde, which developed out of the "Cubist cinema" of the 1920s, led to the cul-de-sac of the "co-op movement" (a term by which Wollen totalized the structuralists, the underground, and Brakhage, as well as their English and German equivalents). The second avant-garde, whose origins Wollen located in the Soviet cinema of the 1920s and in Brecht's *Kuhle Wampe* (1933), is represented by the post-1968 films of Jean-Luc Godard, Jean-Marie Straub and Danièle

12. Claire Johnston, "Women's Cinema as Counter-Cinema," in Claire Johnston, ed., *Notes on Women's Cinema* (London: Society for Education in Film and Television, 1973), and Laura Mulvey, "Visual Pleasure and Narrative Cinema," *Screen* 16, no. 3 (Autumn 1975): 6-18 [Reprinted in this volume, pp. 360-373]. It has often seemed as though a second wave of new talkies—the collectively-made *Sigmund Freud's Dora: A Case of Mistaken Identity* (1979), Sally Potter's *Thriller* (1979) and *Gold Diggers* (1983), the later films of Wollen and Mulvey—have followed the lead of film theorists in creating films to illustrate their doctrines. By addressing themselves to a specific audience, such films resemble such late works of the New American Cinema as James Benning's *Grand Opera* (1981) and George Landow's *Wide Angle Saxon* (1975), both highly self-conscious films that rely upon the viewer's familiarity with various avant-garde personalities and issues. The whole tendency has been parodied by Manuel DeLanda's *Raw Nerves: A Lacanian Thriller* (1979). According to the filmmaker, his film is nothing less than "an allegorical mise-en-scène of certain key concepts in contemporary psychoanalysis. Whereas critical discourses often attempt to elucidate the structure of films by describing them in the terms of some theoretical system, here the film operates as a dramatization of a part of one of those systems. The result is not didactic. It does not add to the understanding of those concepts. It displaces them from the context where they are operative and inserts them in a narrative space where they can be properly *misused.*"

Huillet, and Miklós Jancsó. The films of this second avant-garde, Wollen argues, provide a context for those of Yvonne Rainer and other new talkies (including his own).[13]

Although immeasurably more sophisticated than previous leftist attacks on the New American Cinema,[14] Wollen's critique was considerably simplified. Repressing all mention of surrealism—an avant-garde neither "Cubist" nor Soviet—he further minimized the importance of alternative modes of production and distribution. The New German Cinema (Kluge, Schroeter, Fassbinder, Syberberg, Wenders, Herzog), which might be considered the seventies equivalent of a commercial avant-garde, was totally ignored, as was the militant Third World cinema of the late sixties (Santiago Alvarez, Glauber Rocha, Mrinal Sen, Dusan Makavejev) which, no less than Anglo-American poststructuralism, could legitimately be called the heir to the Soviet cinema of the twenties.

Although the acolytes of film theory succeeded in displacing the defenders of structuralist film as an academic avant-garde, their sacred texts proved only marginally less rarefied. Indeed, rather than a conflict between the two avant-gardes, the key (yet unacknowledged) opposition in Wollen's essay was that between the two "postmodernisms"—the genuinely populist, sixties postmodernism of Pop Art and underground movies and the mandarin, seventies postmodernism of continental theory.

As many have observed, the past dozen years has been a period of pervasive cultural nostalgia. The end of the counterculture can be virtually dated to the release of George Lucas' *American Graffiti* (1973)—the first Hollywood film to show the sixties as a historical era (and, characteristically, a remake of Federico Fellini's *I vitelloni*). Hollywood product since then has been characterized by uncritical genre pastiches *(Star Wars, Raiders of the Lost Ark, Body Heat)*, inflated remakes *(King Kong, Breathless, Scarface)*, and the continual recycling of mass-cultural artifacts *(Superman, Flash Gordon, Conan the Barbarian)*. The films of university-educated directors—Martin Scorsese, Steven Spielberg, George Lucas, Paul Schrader, John Milius, John Carpenter, Joe Dante, and Brian De Palma—are filled with allusions to earlier films (as are those of their West German contemporaries Wim Wenders and R. W. Fassbinder)—employing those strategies of appropriation, quotation, and pastiche that some critics have associated with postmodernism.[15]

Another sort of postmodernist repetition occurred during the winter of 1978-79 with the unexpected appearance of a group of young New York super-8 filmmakers popularly known as "punks." The label was primarily

13. Peter Wollen, "The Two Avant-Gardes," *Studio International* 190, no. 978 (November-December 1975): 171-175.

14. Cf., Graeme Farnell, "Which Avant-Garde?," *Afterimage*, no. 2 (Autumn 1970): 64-72.

15. Cf., Fredric Jameson, "Postmodernism and Consumer Society," in *The Anti-Aesthetic: Essays On Postmodern Culture*, ed. Hal Foster (Port Townsend, Wash.: Bay Press, 1983), pp. 111-125; see also the criticism of Douglas Crimp and Craig Owens.

inspired by the filmmakers' close association with the avant-garde fringe of the New York rock scene and, secondarily, by their unequivocal rejection of all institutionalized avant-gardes (the Anthology Film Archives, academic structuralism, theoretical discourse). These filmmakers included Charlie Ahearn, Beth B and Scott B, Vivienne Dick, Becky Johnston, John Lurie, Eric Mitchell, and James Nares. Their films were first screened either at local rock clubs or at the New Cinema, a short-lived storefront theater run by Mitchell, Johnston, and Nares (located on St. Marks Place, coincidentally just a few doors east of what had once been the venue where Jack Smith's *Flaming Creatures* was seized by the New York Police Department in 1964).

Both the non-specialized, populist nature of the punk film audiences, and the content of the films themselves, harked back to the New York underground of the mid-1960s, particularly the work of Jack Smith, Ron Rice, Andy Warhol, and the Kuchar brothers. The early, Jack-Smith-influenced work of Ken Jacobs and Kenneth Anger's *Scorpio Rising* were other key precursors. Indeed, Mitchell's *Kidnapped* was advertised as "a 1960s underground movie happening today" when it opened at the New Cinema in early 1979.

Modeled on Warhol's *Vinyl* (one of the few early Warhols available in New York), *Kidnapped* makes blatant use of real time—splicing together fifteen unedited super-8 rolls—and overdetermined camera work. While Warhol's camera is static, Mitchell's pans continually around a barren Lower East Side apartment, remorselessly chopping off torsos at the neck. A few jittery extroverts—Mitchell's "superstars"—stimulated by drugs, the filmmaker's on-screen direction, and the rock music blaring from a plastic phonograph on the floor—jostle each other for dominance. Everything in *Kidnapped* is proudly second-hand, even "Satisfaction" is sung by Devo. Other films—Nares' *Rome '78* (1978) and John Lurie's *Men in Orbit* (1978)—also suggested Warhol pastiches, while Mitchell's *Red Italy* (1978) was a clever parody of Fellini and Antonioni. Mitchell was also active as an actor and in Harold Vogel's *Dear Jimmy* (1978)—a self-conscious chronicle of the new underground—he appears as a super-8 director who appropriately asserts the impossibility of doing "anything new in films."

In rebelling against the avant-garde ghetto, however, the punks were forced to develop new venues and audiences. Thus, in certain respects, the super-8 underground became a corrective to its sixties model, demystifying the latter through the use of unprepossessing super-8 hardware, the thematic displacement of Hollywood by TV and rock'n'roll, and most importantly, the preponderance of women filmmakers. *Guérillère Talks* (1978), Vivienne Dick's first film, consists of eight unedited rolls of super-8 sound footage each of which is a sort of screen test for Dick's female subjects (most associated with the punk music scene). As with *Kidnapped*, *Guérillère Talks* can be seen as the extension of Warholian pragmatism to super-8 talkies. However, by juxtaposing various examples of female self-definition against the backdrop of a decaying social order, the film is also the rehearsal and paradigm for Dick's subsequent work.

She Had Her Gun All Ready (1978) explores the enigmatic relationship between two antithetical types, passive Pat Place and active Lydia Lunch, both

of whom appeared in *Guérillère Talks*. On the one hand, their battle of wills has a playful, conspiratorial quality; it is characterized, on the other hand, by an increasingly violent animosity. Dick's own description of the film implies that it deals with the anxiety of influence, and depicts a kind of exorcism. Like Jacobs' *Little Stabs at Happiness* (1963), *She Had Her Gun All Ready* makes brilliant use of an improvisational home-movie mode. Denser and more free-associational, *Beauty Becomes the Beast* (1979) is a virtual catalogue of female media images, ranging from Patty Hearst to "I Love Lucy." Switching scenes and modes like a bored TV-watcher idly spinning the dial, Dick depicts a world where mother and daughter are reciprocal roles in an ongoing chain of victimization. A more militant and focused restatement of earlier themes, *Liberty's Booty* (1980) uses a matter-of-fact view of middle-class, white prostitution as both a work of sexual demystification and an ironic exposition of American "permissiveness." Dick's most disturbing film, *Liberty's Booty* purposefully blurs the distinction between spectacle and document, license and exploitation, prostitution and daily life. Here, as in her previous films, Dick's mainly female cast and feminist interests accentuate the oppositional and anti-authoritarian aspects of the earlier underground's tropes.

The repetitions of the commercial cinema are seldom as productive, although Brian De Palma—the flashiest and least reverent of the directors Noël Carroll calls "allusionists"—lifts blatantly from Alfred Hitchcock or Michelangelo Antonioni, desecrating this received tradition with a mixture of low comedy, near-porn, TV-commercial pyrotechnics, and shameless sentimentality. *Blow-Out* (1981), De Palma's richest and most reflexive film, begins as a parody of his earlier *Dressed to Kill* (1980)—itself a pastiche of *Psycho*—and dealing as it does with the problematic nature of mechanical reproduction (in Hollywood as well as in general) goes on to appropriate the premise of an earlier movie, Antonioni's *Blow Up* (1966). One may complain, as Carroll does, that "without *Blow Up* as a hermeneutic key, *Blow-Out* has very little to say about the purported problem of the relation of representation and reality."[16] But this is to miss De Palma's postmodernist point: *Blow-Out* is a 1960s art film happening today. It doesn't represent reality, it represents *Blow Up*.

16. Noël Carroll, "The Future of Allusion: Hollywood in the Seventies (and Beyond)," *October*, no. 20 (Spring 1982): 74. Carroll makes a compelling analogy between "the film school allusionism of the new Hollywood" and the "Althusserian-Lacanian 'new talkie.'" Both, he writes, "testify to the victory of certain critical-theoretical positions—American auteurism, on the one hand, and Anglo-French psychoanalytic semiotics on the other. Both artistic practices try to incorporate the prejudices of their critical lights in their works and deeds . . . In many instances, artists of the new Hollywood and the new-talkie wing of the avant-garde appear to be taking their marching orders from established criticism. This, at the very least, is a reversal of the conventional order of things . . . [and] perhaps this reversal is what accounts for the feeling that much of the production of the new Hollywood and the semiological wing of the avant-garde is dull, predictable, and authority-bound. It is as if the unprecedented, extended process of film education that many contemporary filmmakers have undergone has resulted in an unexpected catastrophe—through overexposure to the medium, the cinéaste has succumbed to the essentially authoritarian features of the film-viewing

De Palma's circular narrative—a sort of cinematic Moebius strip—hinges upon a series of repetitions, including transformation or rereading of the original. Antonioni's detached fashion photographer is here a marginal sound-technician; swinging London has become seedy Philadelphia; the mod world of 1966 is corroded with the events of the recent past. Evoking the political disasters of Chappaquidick, Watergate, and the Kennedy Assassination in the context of the Bicentennial celebration, *Blow-Out* is an overwhelmingly bleak and tawdry film. More rigorous than Antonioni, De Palma flaunts the specifics of the recording device, at once celebrating the amoral pleasures of filmmaking, decrying the state of American cinema, and insisting on his film as a spectacle.

Similarly, Harold Vogel's super-8 *Dear Jimmy*, which was not publicly shown in New York until 1981 (at which point the "New Cinema" group had already dispersed), ironically details what often seems nothing more than a tropistic desire to make movies. The film juxtaposes barely coherent aesthetic manifestos with quotidian dream sequences, grotesque Lower East Side pastorals, and scenes from assorted films within the film. Invited to star in one of these projects, a neighborhood superstar agrees under one condition: "no more fucking Godard remakes." Like Warhol, Godard is a quintessential sixties figure who continues to dominate the aspirations of young filmmakers. And, just as Warhol was paradoxically the catalyst for structural film as well as the inspiration for its punk antithesis, Godard—the first filmmaker to perceive film history as a text—is the patron saint of both the new talkie and the New Hollywood.

De Palma once aspired to be "the American Godard" and Godard provides another model in that he managed to span both the worlds of avant-garde and commercial filmmaking. But if De Palma is a commercial filmmaker who, at times, approaches the poststructuralist avant-garde, the last few years have seen a number of younger independent filmmakers who have fused the interests of the new talkies with the more commercial sheen of punk cinema—a synthesis represented by Bette Gordon's *Empty Suitcases* (1981) and *Variety* (1983), Lizzie Borden's *Born in Flames* (1983), Wollen and Mulvey's *Crystal Gazing* (1982), and Michael Oblowitz's *King Blank* (1982). Simultaneously, several super-8 filmmakers have gone on to produce more elaborate (and conventional) films—Eric Mitchell's *Underground U.S.A.* (1980) was followed by Charlie Ahearn's *Wild Style* (1982) and Beth B and Scott B's *Vortex* (1982). Eagerly embraced by the international film festival circuit, edging closer to commercial distribution circuits at home, these films are more of a regional, New York (or London) style than a new underground. Ultimately, they are less an intervention into, than acceptance of, the institutional mode of representation.

situation. Or perhaps it was the authoritarianism of the medium that attracted these particular cinéastes to film in the first place" (p. 81). (DeLanda's *Raw Nerves*, a mock *noir* as well as a Lacanian thriller, conjoins both tendencies and can be regarded as a quintessential film of the late seventies or early eighties.)

Although a film avant-garde will exist (if only in theory) until the final withering away—or, at the very least, the relativization—of the institutional mode, the current crisis is due (in part) to the avant-garde's past twenty-five years of success. The New American Cinema has left a crucial legacy of venues and distribution networks, as well as a sometimes backward institutional mentality. Similarly, even as the poststructural avant-garde of the seventies has raised the level of critical discourse, it now threatens to become, as one filmmaker puts it, a "guarantor of the established order"—particularly in the recent call of various theorists for a "return to narrative."[17]

The punk underground of the late seventies seems to have resulted in the commercialization of the avant-garde sphere, rather than vice versa. (Insofar as the latter possibility goes, the most promising development has been the popularity of rock music "videos"—an authentically a-narrative, non-linear mass cultural mode.) At present, the most unreconciled avant-garde filmmakers are those who choose to turn popular forms against themselves. The recent work of Chantal Akerman has been exemplary in this sense. Abandoning the commercial art cinema gloss of *Les Rendez-vous d'Anna* (1978), Akerman's *Toute une Nuit* (1981-82) and *The Golden Eighties* (1983) are decentered, deconstructed films, drawing their figures from the commercial cinema and yet subverting the totalizing impulses at work in both the commercial cinema and the New York school.

Toute une Nuit is a feature-length series of disconnected amorous vignettes—a melodramatic loop that suggests *Rose Hobart* remade with a cast of thousands. *The Golden Eighties* is similarly fragmented. The first hour consists of bits of videotaped rehearsals, shards of readings, and blocked out movements for an unmade 35mm feature musical. The film's final twenty minutes synthesize the preceding fragments into an elaborate but obviously incomplete production number set in the various emporia of a vast shopping mall, subsuming the rehearsal work in a stylized representation of "work."

Like Dara Birnbaum's TV collage films, *Wonder Woman* and *Kiss the Girls: Make Them Cry* (both 1979), *The Golden Eighties* dissolves genre specifics into a meditation on the mass-cultural image of woman. Similarly, Ericka Beckman uses children's games and competitive sports, stripped of their familiar signifieds, as metaphors for cognition and behavior. Her *You the Better* (1983), an abstract version of "Wide World of Sports" (including the commercials), addresses the audience directly, positioning them against the house, with the expectation that "things can only change for the better." (Paired with Godard's *Passion* at the 1983 New York Film Festival, Beckman's film all but provoked a riot in an audience that was prepared to accept a disruption of the institutional mode of representation only under an established rubric.)

If the super-8 underground has all but dissolved—the confessional films of Joe Gibbons, no-frills exposures of home-movie vanity and artistic pretense, are an exception—video has grown increasingly important to the production of

17. Al Razutis, "Ménage à Trois: Contemporary Film Theory, New Narrative and the Avant-Garde," *Opsis* 1, no. 1 (Spring 1984): 52-65.

an avant-garde cinema. (The ease with which Akerman and Birnbaum pass between film and video is a harbinger of future developments.) While certain video artists like Bill Viola and Barbara Buckner represent a post-film manifestation of the New American Cinema, video (as well as MTV and television itself) offers other models for the scrambling and derangement of mass culture—and thus the perpetuation of a postmodern avant-garde.

Dara Birnbaum. Stills from *Kiss the Girls: Make Them Cry*, 1979. Color video, sound, 7 minutes. (Photos: Dara Birnbaum)

Mirrors
and Windows
American
Photography
since 1960

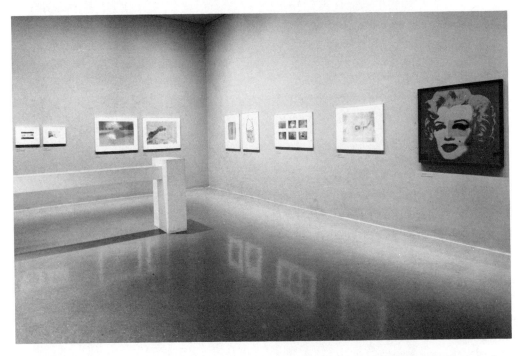

Installation views of the exhibition, *Mirrors and Windows: American Photography since 1960,* at The Museum of Modern Art, New York, July 26–October 2, 1978. (Photos: courtesy The Museum of Modern Art, New York)

Photography After Art Photography

ABIGAIL SOLOMON-GODEAU

In 1977, John Szarkowski organized a large photography exhibi- tion at the Museum of Modern Art under the title "Mirrors and Windows," premised on the critical conceit that the 200-odd prints included could be apprehended either as records of some exterior reality (windows), or as interiorized visions revelatory of the photographer's own inner being (mirrors). Critical response to the exhibition was mixed. One persistent refrain, however, was that many of the pictures could easily be shifted from one category to the other and make just as much, or as little, sense.

In retrospect, what seems most curious about the organization of the exhibition—a significantly more ecumenical emporium than its recent predecessors at MoMA—was the inclusion of *artists*, such as Robert Rauschenberg, Ed Ruscha, and Andy Warhol. For like the proverbial foxes in the henhouse, the inclusion of these artists—and more specifically, the issues raised by their respective uses of photography—posed an explicit challenge to the brand of modernism enshrined in MoMA's Department of Photography.

Common to the photographic usages of these three artists was an insistence on what Roland Barthes termed the *déjà-lu* (already-read, already-seen) aspect of cultural production, a notion alternatively theorized, with respect to postmodernist art practice, as a shift from production to reproduction.[1] In contrast to modernist art photography's claims in regard to the self-containment of the image and the palpable presence of the author, works such as those by Rauschenberg et alia emphasized in every way possible their dependency on already-existing and highly conventionalized imagery drawn from the mass media. Thus at the same time that modernist boundaries between "high" and "low" cultural forms were breached or obscured (an important

1. See for example the essays in *The Anti-Aesthetic: Essays on Postmodern Culture*, ed. Hal Foster (Port Townsend, Wash.: Bay Press, 1983). Walter Benjamin, particularly in his essays "The Work of Art in the Age of Mechanical Reproduction," and "The Author as Producer," discussed the implications of this shift. The former essay is included in *Illuminations*, ed. Hannah Arendt, trans. Harry Zohn (New York: Schocken Books, 1969) and the latter in *Reflections: Essays, Aphorisms, Autobiographical Writings*, ed. Peter Demetz, trans. Edmund Jephcott (New York: Harcourt Brace Jovanovich, 1978), pp. 220-238. [The latter also reprinted in this volume, see pp. 297-309.]

component of pop art a decade earlier), the modernist stress on the purity of the aesthetic signifier was effectively jettisoned.

The culture of postmodernism has been theorized in various ways and approached from various perspectives. Whether premised on the shift from industrial capitalism and the national state to managed capital and the multinational corporation, or identified with the new informational economies and the profound effects of mass communications and global consumerism, the occurrence of basic structural changes in society argues for a subsequent alteration in the terms of cultural production. Thus, while it is possible to currently identify an anti-modernist impulse which signals the declining authority of modernist culture, postmodernism has been thought to possess a critical agenda and distinct features of its own.

But however one wishes to theorize postmodernist art (and one cannot speak of a critical consensus), the importance of photography within it is undeniable. More interestingly, the properties of photographic imagery which have made it a privileged medium in postmodern art are precisely those which for generations art photographers have been concerned to disavow.

Without in any way wishing to gloss over the very real differences between Rauschenberg, Ruscha, and Warhol, their respective uses of the medium had less to do with its formal qualities per se than with the ways that photography, in its normative and ubiquitous uses, actually functions. As photography has historically come to mediate, if not wholly represent, the empirical world for most of the inhabitants of industrialized societies (indeed, the production and consumption of images serves as one of the distinguishing characteristics of advanced societies), it has become a principal agent and conduit of culture and ideology.

Accordingly, when photography began to be incorporated in the art of the 1960s, its identity as a multiply reproducible mass medium was insistently emphasized, nowhere more so than in the work of Andy Warhol. Warhol's exclusive use of already-existent popular imagery, his production of series and multiples, his replication of assembly-line procedures for the production of images, his dubbing his studio "The Factory," and his cultivation of a public persona that undercut romantic conceptions of the artist (Warhol presented himself as an impresario) constituted a significant break with modernist values.

The kind of art production exemplified by Andy Warhol displayed an important affinity to certain aspects of the work of Marcel Duchamp. Most prominently with his readymades, Duchamp was concerned to demonstrate that the category of art was itself entirely contingent and arbitrary, a function of discourse and not of revelation. In contrast to any notion of the art object as inherently and autonomously endowed with significance, meaning, or beauty, Duchamp was proposing that the identity, meaning, and value of the work of art were actively and dynamically constructed—a radical refusal of modernist, idealist aesthetics. Following the logic of the readymade, artists such as Warhol, Rauschenberg, Ruscha, or Johns, in re-presenting photographic images from mass culture, moved on to the postmodernist concept of what might be called the "already-made."

Douglas Crimp has directed attention to another aspect of photographic use in postmodernism which he terms "hybridization"—another divergence

from the formal categories of modernist aesthetics.[2] While the mixing of heterogeneous media, genres, objects, and materials violates the purity of the modernist art object, the incorporation of photography violates it in a particular way. As an indexical as well as an iconic image, the photograph draws the (represented) world into the field of the art work—thereby undermining its claims to a separate sphere of existence and an intrinsic aesthetic yield.

For art photographers following in the footsteps of Alfred Stieglitz or Edward Weston, of Walker Evans or Harry Callahan, an intrinsic aesthetic yield—an auratic image—is not easily renounced. Indeed, photography's ascent to fine art status was virtually predicated on its claims to aura. Walter Benjamin, who theorized the concept, described it as comprised of those qualities of singularity and uniqueness which produced the authoritative "presence" of the original work of art. Aura was the very quality, he argued, that must wither in the age of mechanical reproduction. Notwithstanding Benjamin's conviction of its demise, the continuous valorization of aura in the modern age masks an ideological construction (as does modernist theory), one of whose elements is the inevitable commodification of the art object itself.

While few contemporary photographers linger over aesthetic notions of Form and Beauty in the same way as the landscape photographer Robert Adams (in his recent *Beauty in Photography: Essays in Defense of Traditional Values*), neither are they prepared to go on record as recognizing such terms as historical constructions that today can serve only the purposes of a fetishistic, retrograde, and thoroughly commodified concept of art making. In so far as contemporary art photography has become as much a creation of the marketplace as an engine of it, it comes as no surprise to encounter the ultimate denial of photography as a mechanically reproducible technology in such phenomena as Emmet Gowin's recent production of "monoprints"—editions of a single print from a negative. Indeed, a recent press release from the Laurence Miller Gallery announces on the occasion of an exhibition entitled "The One and Only": "Contrary to popular belief that a photograph is but one of a potentially infinite number of prints capable of being printed from a single negative, this exhibition demonstrates that a long and exciting history of one-of-a-kind photographs exists. Two possible themes suggest themselves: unique by process and unique by conscious choice." Needless to say, it is the latter alternative that has, since at least the days of the Photo-Secession, served as an important strategy in realigning photographic discourse to conform to the demands of print connoisseurship.

The generic distinction I am attempting to draw between photographic use in postmodernism and art photography lies in the former's potential for institutional and/or representational critique, analysis, or address, and the latter's deep-seated inability to acknowledge any need even to think about such matters. The contradictory position in which contemporary art photography now finds itself with respect to both self-definition and the institutional trap-

2. Douglas Crimp, "The Photographic Activity of Postmodernism," *October*, no. 15 (Winter 1980): 91-101, and Rosalind Krauss, "Sculpture in the Expanded Field," *October*, no. 8 (Spring 1979): 31-44.

(Above left) Edward Weston. *Excusado,* 1925. Black-and-white photograph, 9½ x 7½ (24.2 x 19.0 cm). Center for Creative Photography, Tucson, Arizona. (Photo: © 1981, Arizona Board of Regents); (Above right) Bernd and Hill Becher. *Watertowers,* 1980. Black-and-white photographs, each: 20¼ x 16¼″ (51.6 x 41 cm); overall: 61¼ x 49″ (155.1 x 124.7 cm). (Photo: courtesy Sonnabend Gallery, New York); (Bottom) James Welling. *4.1.84.B,* 1984. Black-and-white photograph, 8 x 10″ (20.3 x 25.5 cm). (Photo: courtesy the artist)

pings of its newly acquired status is nowhere better illustrated than in the head-scratchings and ramblings of museum curators confronted with the task of constructing some kind of logical framework for the inclusions (and exclusions) of photography in the museum. Although denizens of the art photography establishment are well aware that something disjunct from traditional art photography is represented by postmodernist uses of the medium, the terms in which they are accustomed to thinking prevent them from discerning precisely the issues that are most at stake. And while occasionally, in a moment of media slippage, a photography writer is assigned to review a particularly well-publicized artist such as Cindy Sherman or Barbara Kruger, for the most part there is little discursive overlap between these two distinct domains.

That the traditional art photography construct today functions as a theoretical no less than a creative cul-de-sac is revealed in a recent round-table discussion in the pages of *The Print Collector's Newsletter*. Since 1973, every five years, six designated photography experts (the one practicing photographer being Aaron Siskind) have compared notes on the current state of the art. The interchange here takes place between gallery owner Ronald Feldman and Peter Bunnell, McAlpin Professor of Photography and Modern Art at Princeton University:

> RF: *Well, Peter, do you find a Cindy Sherman interesting?*
>
> PB: *I find her interesting as an artist but uninteresting as a photographer.*
>
> RF: *Interesting as an artist but not as a photographer?*
>
> PB: *I don't see her raising significant questions with regard to this medium. I find her imagery fascinating, but as I interpret her work, I have no notion that I could engage her in a discourse about the nature of the medium through which she derives her expression. . . . I've had discussions with artists who have utilized our medium in very interesting ways as independent expression, but I have never perceived them as participants with the structure or the tradition I have referred to here. Of course, that changes or evolves. I think the tension between the structure that originates in an awareness of our own history and that of a number of artists who derive their vitality from the absence of that knowledge is right at the cutting edge. That's where the excitement is and that's where the pressure is coming from contemporary artists.* [3]

Professor Bunnell is perhaps right to find Sherman interesting as an artist but not as a photographer. "Our medium" as he describes it, restricted to photography as defined, practiced, and understood within the framework of art photography, has very little importance in Sherman's work. *Her* medium of photography—her use of it—is predicated rather on the uses and functions of photography in the mass media, be they in advertising, fashion, movies, pin-ups, or magazines. When Professor Bunnell employs the term "tradition" to

3. "Photographs and Professionals III," *The Print Collector's Newsletter* 14, no. 3 (July-August 1983): 88-89.

indicate what Sherman and others of her ilk are not participating in, he is indicating his belief that the tradition that matters is the one carved out by art photographers (or those who have been assimilated into that tradition), and not the global production of imagery so profoundly instrumental in the production of meaning, ideology, and desire.

The photographic usages I am here designating as postmodernist are in no way to be understood as cohering into some kind of school, style, or overarching aesthetic. Quite the contrary: the kinds of production represented by artists as disparate as John Baldessari, Victor Burgin, Hilla and Bernd Becher, and Dan Graham, or more recently by younger artists such as Sarah Charlesworth, Barbara Kruger, Louise Lawler, Sherrie Levine, Richard Prince, Cindy Sherman, Laurie Simmons, or Jim Welling evidence a considerable range of concerns. What they share is an obdurate resistance to formal analysis or placement within the modernist paradigm. A formulation of common critical ground would encompass a shared propensity to contest notions of subjectivity, originality, and (most programmatically in the work of Levine and Prince) authorship. It is here, perhaps, that it is possible to locate the most obvious departure from the ethos of art photography and here, too, where the Duchampian legacy is most clearly demonstrated. Such work specifically addresses the conditions of commodification and fetishization that enfold and inform art production. The purview of such practices are the realm of discursivity, ideology and representation, cultural and historical specificity, meaning and context, language and signification.

That photography should thus figure as a crucial term in postmodernism seems both logical and (at least retrospectively) inevitable. Virtually every critical and theoretical issue with which postmodernist art may be said to engage in one sense or another can be located within photography. Issues having to do with authorship, subjectivity, and uniqueness are built into the very nature of the photographic process itself; issues devolving on the simulacrum, the stereotype, and the social and sexual positioning of the viewing subject are central to the production and functioning of advertising and other mass-media forms of photography. Postmodernist photographic activity may deal with any or all of these elements and it is worth noting too that even work constructed by the hand (e.g., Troy Brauntuch, Jack Goldstein, Robert Longo) is frequently predicated on the photographic image.

Seriality and repetition, appropriation, intertextuality, simulation or pastiche: these are the primary devices employed by postmodernist artists. Utilized singly or in combination, what is of importance in the context of this essay is the way each device can be employed as a refusal or subversion of the putative autonomy of the work of art as conceived within modernist aesthetics. The appearance of such practices in the 1970s seemed to portend the possibility of a socially grounded, critical, and potentially radical art practice that focused on issues of representation as such. Collectively, use of such devices to prompt dialectical and critical modes of perception and analysis may be termed deconstructive. (This deconstructive impulse is of special importance for feminist theory and art practice in particular, in that the space of representation is increasingly theorized as the very site of feminist struggle.) Thus, if postmodernist practice has displaced notions of the self-sufficiency of the aesthetic

signifier with a new concern for the referent, it must also be said that it is with the referent as a problem, not as a given.[4]

Within the range of postmodernist art, it is those works that dismantle traditional notions of authorship or which most specifically address the institutional and discursive space of art that best demonstrate a deconstructive orientation. Roland Barthes' 1968 essay "The Death of the Author" remains the *ur*-text to delineate the implications of the shift away from the author as both source and locus of meaning, asserting instead that meaning is never invented, much less locked in: "We know now that a text is not a line of words releasing a single 'theological' meaning (the 'message' of the Author-God) but a multidimensional space in which a variety of writings, none of them original, blend and clash. The text is a tissue of quotations drawn from the innumerable centers of culture. . . . Succeeding the Author, the scriptor no longer bears within him passions, humors, feelings, impressions, but rather this immense dictionary from which he draws a writing that can know no halt: life never does more than imitate the book, and the book itself is only a tissue of signs, an imitation that is lost, infinitely deferred."[5]

For Barthes, the refusal of authorship and originality was an innately revolutionary stance "since to refuse to fix meaning is, in the end, to refuse God and his hypostases—reason, science, law."[6] Similarly, the dismantling of the notion of unique subjectivity Barthes understood as a salutary blow struck against an ossified and essentially retrograde bourgeois humanism. But whether postmodernist appropriation and other related strategies have indeed functioned in the liberating and revolutionary fashion that Barthes' text would indicate is open to question. While unmediated appropriation (exemplified by Levine and Prince) still retains its transgressive edge, pastiche operations are as much to be found in television commercials and rock videos as Tribeca lofts. Moreover, if the workings of the art marketplace demonstrate anything at all, it is its capacity to assimilate, absorb, neutralize and commodify virtually any practice at all. Finally, many artists find it difficult to avoid making those adjustments and accommodations that will permit their work to be more readily accepted by the market; a condition, after all, of simple survival.

In attempting to map out a topography of photographic practice as it presents itself now, I have constructed an opposition between an institutionalized art photography and postmodernist art practices which use photography. Such an opposition suggests itself because the working assumptions, and the goals and intentions, of the respective approaches thereby reflect back on one another. A critical reading of modernist values does not devolve on the "failure" of modernism, any more than a discussion of postmodernist photographic practice implies a criterion of success. Rather, what is at stake in art photography or postmodernism concerns their respective agendas and how as art practices they are positioned—or how they position themselves—in relation to

4. Jacqueline Rose, "Sexuality in the Field of Vision," in *Difference: On Representation and Sexuality*, ed. Kate Linker (New York: The New Museum of Contemporary Art, 1984).

5. Roland Barthes, "The Death of the Author," in *Image-Music-Text*, trans. Stephen Heath (New York: Hill and Wang, 1977), pp. 146-147.

6. Ibid., p. 147.

their institutional spaces. By institutional spaces, I refer not only to the space of exhibition, but to all the discursive formations—canons, art and photography histories, criticism, the marketplace—that together constitute the social and material space of art.

These formations have been crucial agents in the recent repositioning of photography as a modernist art form. Such a massive reconsideration mandates that the apparatuses of canon formation, connoisseurship, *kunstwissenschaft*, and criticism be marshaled to impose the triple unities of artist, style, and oeuvre on the protean field of photography.[7] The principal problem of intentionality (which might appear to sabotage such an enterprise) has been neatly sidestepped by recourse to a modernist formulation of a photographic ontology: Once photography is theorized in terms of inherent properties (time, the frame, the detail, the thing itself, and the vantage point, in John Szarkowski's efficient distillation) instead of its actual uses, any picture and any photographer can in principle enter the canon. This enables the portal of the canon to take on the attributes of a revolving door, and messy questions of intention and context can be effectively banished.

Art photography and postmodernist photography do not, in any case, encompass all the field. The traditional uses and forms continue: documentary practices, reportage, and all the utilitarian and commercial functions photography has regularly fulfilled. Perhaps the most durable legacy of art photography has been its success in establishing that photography is a medium like any other with which an artist might work. But a too-circumscribed conception of how the medium should be used, as well as a blind and unquestioning adherence to the modernist values which historically elevated it, has produced the current impasse of art photography. Refuge from the generally lackluster, albeit plentiful contemporary production of art photography is now routinely taken by recourse to an assiduous mining of the past, the hagiographic re-presentation of the already canonized (the recent spate of texts and exhibitions on Alfred Stieglitz is one such example), and the relentless overproduction of third- and fourth-generation variants of a vitiated academic formalism.

In contradistinction, the most interesting of recent developments is the burgeoning, if not flourishing, of photographic practices that in a certain sense invent themselves for the project at hand. Here the issue is not photography *qua* photography, but its use toward a specific end. This instrumental approach to the medium often entails that photographs are combined with texts, adapted to book or multimedia format, or geared to pointedly critical ends.

We might consider, by way of example, some recent work by Vincent Leo, who, in contrast to most other postmodernist artists now using photogra-

7. This art-historical strategy is effectively dismantled in Rosalind Krauss' indispensable essay "Landscape/View: Photography's Discursive Spaces," *Art Journal* 42, no. 4 (Winter 1982): 311-319. See also in this regard, Christopher Phillips, "A Mnemonic Art? Calotype Aesthetics at Princeton," *October*, no. 26 (Fall 1983): 35-62, Douglas Crimp, "The Museum's Old, The Library's New Subject," *Parachute*, no. 22 (Spring 1981): 32-37, and my own "Calotypomania: The Gourmet Guide to Nineteenth-Century Photography," *Afterimage* 11, nos. 1-2 (Summer 1983): 7-12.

phy, has a background as a practicing photographer. Upon first examination, these black-and-white photographs appear to belong to the ever-increasing stockpile of derivative variations on the work of the officially-designated masters of American photography. More precisely, they look like pastiches of the photographs of Robert Frank. In fact—and here Leo's work separates itself resolutely from the realm of academic pasticheur—they *are* the photographs of Robert Frank. What Leo has done is to cut up the reproductions in Frank's seminal book *The Americans*, reposition and collage different photographs, and then rephotograph the results to yield (in Marcel Duchamp's words) "a new thought for that object."

On the most immediate level, the joke in Leo's photographs is that he is deliberately enacting what legions of contemporary art photographers unreflectively recapitulate. A photographer such as Tod Papageorge working in the manner or tradition of Garry Winogrand, Robert Frank, or Walker Evans is by no means unusual in art photography. On the contrary, the pervasiveness of such "influence" in art photography is attended by remarkably little anxiety. As Harold Bloom has observed, however, a voluntary parody is more impressive than an involuntary one. Leo's direct conscription of his sources serves to undercut pointedly both the myth and mystique of photographic originality.

Although Leo uses the images from *The Americans* as the (literal) building blocks of his own work, his pictures are finally less about the style of Robert Frank or the iconography of *The Americans* than about the discursive positioning of both within art photography. It is this emphasis that most decisively distinguishes the formalist belief that photography is ultimately about photography from Leo's critical demonstration of the way meaning as well as value are produced by photography's very textuality. Photography, here, is conceived not as defined by its own making, but by what is made of it.

In a wholly different mode, Connie Hatch has produced, among other work, an ongoing photographic project entitled "The De-Sublimation of Romance." If, as Laura Mulvey argues, woman is constructed as spectacle, as fetish, as object rather than subject of the gaze, Hatch's enterprise is to foreground precisely these operations—to take exactly those conventions of photographic representation (and even more specifically, that mode of photographic practice most assaultive and appropriative) and turn it back upon itself.

The conventions that Hatch re-appropriates and re-presents are first of all the kind of street photography exemplified by photographers such as Garry Winogrand, Lee Friedlander, and Tod Papageorge—a form of photographic production that is both dominated by men and predicated on the assumption that meaning is fortuitously found in the world and framed in the image. Hatch's rigorous understanding of the way photography works, with particular regard for subject/object relationships and the mastery conferred on the viewer, enables her to perform a critical intervention that goes beyond the revelation of the network of complicity between photographer, spectator, and spectacle. By taking as the very subject of her work the act of looking (or not looking), Hatch draws attention to the warp and woof of power relations as they are inscribed in the operations of the gaze itself; the photographer's, the spectator's, and the gazes represented in the pictures.

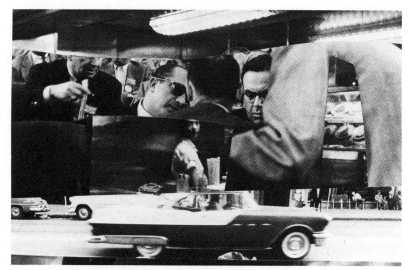

Vincent Leo. Untitled, 1982. Black-and-white photograph, 16 x 20″ (40.6 x 51 cm). (Photo: courtesy the artist)

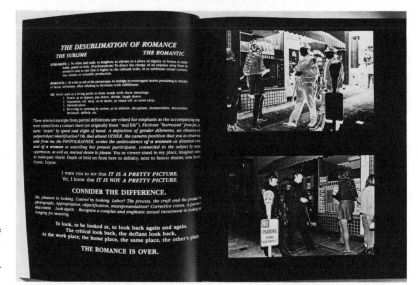

Connie Hatch. *The De-Sublimation of Romance,* a series of photographs with text, as presented in *wedge,* no. 6 (Winter 1984), pp. 20–21

Martha Rosler. *The Bowery in Two Inadequate Descriptive Systems,* 1974–1975. From *martha rosler, 3 works* (Halifax: The Press of the Nova Scotia College of Art and Design, 1981), pp. 24–25

Martha Rosler's "The Bowery in Two Inadequate Descriptive Systems," a work employing text and photographs is yet another example of photographic work that conforms to no specific rubric, but demonstrates nevertheless photography's potential for rigorous, critical, and conceptually sophisticated works. Pairing images of Bowery storefronts and doorways emptied of their bums with a lexicon of drunkenness, Rosler effects a critique of traditional social documentary, an examination of the lacunae of representation, and an experiment in "refusal" as a politically informed art practice. Rosler's work "takes off" on two familiar currents in photography (the liberal humanist tradition of "concerned" documentary, and the formalist celebration of American vernacular culture), but is in no way a critical parody (as is Leo's) or a supplemental critique in any simple fashion. Rosler's laconic, frontal photographs evoke the shade of Walker Evans and certain of his progeny, but pointedly subvert the aesthetic premises that inform their photography. The aristocratic perception of exemplary form to be found in, say, sharecropper's shanties, does not cross over to the streets of the Bowery.

The pieties of photographic concern are likewise dismantled by Rosler, who remarks in the essay that accompanies the work; "Imperialism breeds an imperialist sensibility in all phases of cultural life." The conspicuous absence of the subjects—the victims—in her photographs mentally conjures up their presence in all the representational sites where we have seen them before. And, as Rosler's project implicitly questions, to what end and to what purposes? It is more than moral rectitude that determines the refusal to image the victim as spectacle; it is rather an understanding of the structural complicities such representations propagate.

Leo, Hatch, and Rosler represent only three possible examples of photographic use that exists outside of photography as conventionally theorized and practiced. Such artists tend to be marginalized both within photography and within the mainstream art world. The promise of such work lies in its relative freedom from the institutional orthodoxies of both camps, although it is in its lack of conformity to these orthodoxies that its marginalization inevitably follows. The current political environment, moreover, does not favor critical practices in any media, and it seems reasonable to predict that the photographic practices that will remain most favored will be those that call the fewest things into question.

Photography after art photography appears as an expanded rather than a diminished field; this is in part a consequence of the success of art photography in legitimizing the camera. If at this point, however, art photography seems capable of yielding little of interest, the problems lie entirely within itself. Today art photography reaps the dubious reward of having accomplished all that was first set out in its mid-nineteenth century agenda: general recognition as an art form, a place in the museum, a market (however erratic), a patrimonial lineage, an acknowledged canon. Yet hostage still to a modernist allegiance to the autonomy, self-referentiality, and transcendence of the work of art, art photography has systematically engineered its own irrelevance and triviality. It is, in a sense, all dressed up with nowhere to go.

. . . the painterly signifier.
Jackson Pollock, *No. 5,* 1950

pāint'ing, *n.* 1. the act or occupation of covering surfaces with paint.
2. the act, art, or occupation of picturing scenes, objects, persons, etc. in paint.
3. a picture in paint, as an oil, water color, etc.
4. colors laid on. [Obs.]
5. delineation that raises a vivid image in the mind; as, word-*painting.* [Obs.]

. . . the linquistic analogy.
Joseph Kosuth, *Art as Ideas as Art,* 1967

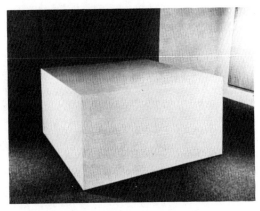

. . . the irreducible object.
Robert Morris, Untitled, 1964

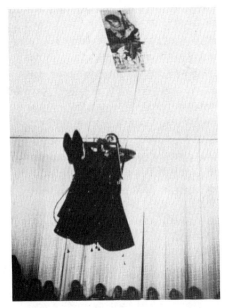

. . . the hermeneutic image.
Ulrike Rosenbach, *Salto Mortale,* 1978

. . . the irrefutable experience of pain.
Rudolf Schwarzkogler, *Action,* 1965

Re-viewing Modernist Criticism

MARY KELLY

Although the phenomenon of the temporary exhibition first made
its appearance in the nineteenth century, it was only in the postwar period that
it became the most prominent form of entertainment and tuition in the visual
arts. The ascendency of the temporary exhibition, notably the Annuals, Bien-
nials, theme shows, and historical surveys, indicated a significant shift in the
system of patronage from the private sector to institutions funded by the state.
This change coincided with an expansion in the art publishing industry, re-
newed emphasis on the practice of reviewing and the sanctioning of art criticism
as an academic discipline. These occurences, their points of intersection and
divergence, establish the framework for an analysis of the effects and limitations
of modernist criticism in particular. In this article, modernism is defined as a
determinant discursive field with reference to critical writing since 1945. It is
maintained that modernist discourse is produced at the level of the statement,
by the specific practices of art criticism, by the art activities implicated in the
critic/author's formulations, and by the institutions which disseminate and
disperse the formulations as events. An analysis of the formation and transfor-
mation of statements in this field is very much needed, but it is beyond the
scope of the introductory issues being raised here. However, it is hoped that by
identifying the persistent themes of that discourse, pointing out its diversions,
describing the process of its modification at a particular moment and making
proposals for the construction of a different object in the domain of criticism at
the present time, a space will be opened for future work.

The Pictorial Paradigm

In a note to the article "Photography and Aesthetics," Peter Wollen remarks,
"The category of 'modernism' has increasingly been captured by those who see
twentieth-century art primarily in terms of reflexivity and ontological explora-
tion." [1] If it is possible to define this capture in other terms as the predominance

Reprinted from *Screen* 22, no. 3 (Autumn 1981): 41-62

1. Peter Wollen, "Photography and Aesthetics," *Screen* 19, no. 4 (Winter 1978-
1979): 27, note 22. However, in the context of this article, it would be more problematic to
follow Wollen's suggestion that "the category 'avant-garde' is best reserved for works which
prolong and deepen the historic rupture of Cubism," since, regardless of oppositional inten-

of a particular discourse within the hierarchy of discourses which constitute modernism as a discursive field, then the effectivity of that discourse can be described more exactly as the production of a norm for pictorial representation which does not necessarily correspond to definite pictures, but rather to a set of genereal assumptions concerning "Modern Art." Further, if these assumptions are not seen to be based on the consensus of a homogeneous mass audience of art viewers, but formed within calculated practices of reviewing, publishing, and exhibiting art for a specific public, then the reading of artistic texts is always in some sense subjected to the determining conditions of these practices, crucially those of criticism. Here, at least two preliminary points can be made about the way in which modernist criticism functions as a practice, that is, the rules it deploys in forming these general assumptions as a network of themes which construct definite objects and a system of strategic choices which also permit their modification.

Firstly, the normalization of a mode of representation always entails the marginalization of an alternative set of practices and discourses; for instance, Sam Hunter, hailing the rise of abstract expressionism in *Art Since 1945*, claimed that almost every other art practice at that time—geometric abstraction as well as romantic realism and surrealism, was an "exception rather than the rule."[2] But marginalization is not simply a matter of chronological displacement or exclusion. It can also be effected by incorporation. In a passage written later, in 1968, for an exhibition entitled "New Directions in American Painting," Hunter referred an even wider area of emergent artistic practices back to the ontological norm:

> *When the contemporary artist moves towards the object, the world of packaged mass culture or even towards formal purification, critical problems of artistic choice remain and compromise his most apparently anonymous productions. The idea of the work of art as an uncertain and problematic act of continual creation, filtered through a temperature and retaining evidence in its final form of that passage, was one of the central contributions of Abstract Expressionism.*[3]

The modernist discourse constructs the category of the artistic text. It must demonstrate pictoriality without radical purification, retain the evidence of a passage without imposing the problem of interpretation, filter a temperament without reference to social constraints. *It is preeminently "expressive" and primarily given at the level of the "picture."* Those practices, particularly

tions, works are continually being recaptured by a reflexive criticism. It would be maintained here that the "rupture of Cubism" does not constitute a continuous discourse, i.e., a set of persistent themes and objects in transformation, it is relative to a particular instance, consequently, contemporary art practices cannot prolong it, they must reinvent it.

2. Sam Hunter, chapter on the United States in *Art Since 1945* (New York: Harry N. Abrams, Inc., 1958).

3. Sam Hunter, from the catalogue of the exhibition *New Directions in American Painting* (Waltham, Mass.: The Poses Institute of Fine Arts, Brandeis University, 1963).

those anonymous productions which do not in some sense conform to the unity, the homogeneity of the pictorial paradigm and express the essential creativity of the artistic subject are not merely marginal; they are not art!

Secondly, despite incompatible practices or divisions in the discourse, modernism's central themes persist. The current revival of painting (neo-expressionism, New Imagism, Energism) and the coincident dispersal of narrative, conceptual, and social purpose art gives some indication of the political consequences of artistic choices founded on a reappropriation of modernist themes. It also implies that the designations "avant-garde" and more recently "post-movement," "post-modernist," and "trans-avant-garde" express nothing more than a desire to break through the circuitous logic of a discourse which demands experiment but nevertheless compels repetition. They reiterate the attempt to find a possible position, although it may be represented as a forbidden place, at the limit of the discourse.

Within the specific institutions and discourses of Fine Art, the category of "Modern Art" occupies a place comparable in its centrality to that of the classic narrative film in the domain of cinema. This suggests it is not possible to pose the problem of realism unilaterally across the entire range of representational practices, from film, video, and photography to diverse forms of painting, sculpture, and performance art. The discursive operations which inform them are determined by different historical circumstances.

As Wollen also points out, one of the responses to the advances in photographic techniques was for painting to embrace a Kantian perspective and emphasize the subjective and the intuitive.[4] This response linked photographic history with the apparatus and associated technological progress with the evolutionary perfection of seeing. In contrast it claimed that art was invented with the first graphic expression of the human hand and that artistic production concerned a timeless refinement of feeling in the field of the look. This representation of essential differences, between sight and insight, between the filmed event and the painted mark, has also produced at the level of concrete practices, a radical asymmetry in their respective modes of address. What is unfeasible for the narrative film is practicable, indeed, imperative for modernist painting—that is, the subjective image. While in the former, the cinematic apparatus is employed to remove the traces of its own steps, in the latter, the painterly signifier is manipulated precisely to trace a passage, to give evidence of an essentially human action, to mark the subjectivity of the artist in the image itself. It is above all the artistic gesture which constitutes, at least metaphorically, the imaginary signifier of "Modern Art."

Why gesture? Of all the painterly signifiers, why is gesture the privileged term of the pictorial paradigm? If signifying function is a property of figure, then color for instance is too elusive, it never really accedes to the signifier but remains, as Schefer describes it "the difference in the field where 'it' is found."[5]

4. Wollen, "Photography and Aesthetics," p. 10.

5. See Jean-Louis Schefer, "Split colour/blur," trans. Paul Smith, *20th Century Studies*, nos.15-16 (December 1976): 82-100, special issue on Visual Poetics.

Gesture, on the other hand, even the most minimal action, retains a certain residue of figuration. The play of presence and absence within the pictorial space turns on gesture; its materialization sustaining texture, matter; its dematerialization transporting color, light, to the field of the signifier. Modernist painting, expressive abstraction in particular, foregrounds precisely this production of the signifier, but it would be unfounded, consequently, to suppose that this practice implies a deconstruction, a violation or transgression of the pictorial space. Clement Greenberg referred to Jackson Pollock's overall paintings as the "domestication of wild things," what he called the "look of accident" and the "look of the void." Thus gesture, however agitated, excessive, or evasive, is immobilized and mastered by the frame, brought to heel by the authority of that inevitable edge. Moreover, abstraction's apparent liberation of gesture from the figurative constraints of perspectival representation renders even more exactly the imaginary effect of a transcendental *chiaroscuro* whereby the spectator recognizes, in the mark of the enouncing subject, an essential humanness, smoothly eliding the look of the artist, that unique vision, with his own, assuming in that image an essential creativity which authenticates his experience as aesthetic and validates the object as art.

Gesture is the term which the proponents of modernism cannot afford (literally in the financial sense) to efface. In the 1960s, when the "avant-garde" expelled gesture, denied expression, contested the notion of an essential creativity, the spectator was called upon to sustain a certain loss: the presence (or rather, presentified absence) of the artistic subject. The dealer, too, was threatened with a deficit: the authenticating mark which figures so prominently in the art market's peculiar structure of desire and exchange. It is not only a particular work of art which is purchased (the title), but also "something" by a unique individual which is possessed (the name). That "something," the object's investment with artistic subjectivity, is secured by gesture, or more explicitly, a signature.

The legal subject according to Edelman (in Hirst and Kingdom's exposition), is presupposed as possessor of itself.[6] In terms of the law, man's freedom follows from his self-possession, thus he has the right to acquire property, moreover he is his own property. For the artist to sell his painterly property (products) or his labor (as in performance) is merely a confirmation of his freedom. The legal interpellation of the creative subject coincides dramatically with its "imaginary" construction in the critical discourses of modernism. One is reminded again of Hunter writing on the abstract expressionists, "they argue that only the artistic self which is certain of its identity, since it knows that its existence can be proved through an act of creation is able to be free."[7] At one level it could be said that what is bought in the form of the art object is a commodity; but because, as Hirst and Kingdom put it, the law posits the subject in the form of a commodity, i.e., man's freedom consists of putting himself in circulation. At another level it could be suggested that what

6. Paul Hirst and Elizabeth Kingdom, "On Edelman's 'Ownership of the Image,'" *Screen* 20, nos. 3-4 (Winter 1979-80): 135-140.

7. Hunter, *Art Since 1945*, p. 326.

is desired and exchanged is an originary creativity and above all an exemplary act of human freedom. It is necessary to include in the modernist determinants of the efficacious artistic text, not only self-definition, but also crucially, the self-possession of the artistic subject. Thus the work of art, filtered through the institutions and discourses that determine its specific conditions of existence, produces artistic authorship in the fundamental form of the bourgeois subject: creative, autonomous, and proprietorial. In a sense there is no "alternative" to that passage: for the very moment that the work of art enters into circulation it is sanctioned by law as the property of a creative subject (but not to enter into such contract would be to forfeit even the possibility that the artistic text, in the process of its construction of meaning, could indeed interrogate that form).

It is relevant here to point to Edelman's "paradox of photography" for the law of property in the nineteenth century, which ascertained that the image could only be property to the extent that it was mixed with subject, that is, re-presented and transformed through his creative labor.[8] Although it can now be legally maintained that "a creative subject and his purpose is installed behind the camera," this does not mean that it is generally sanctioned within the traditional institutions and discourses of Fine Art. Artistic practices employing film or photography as well as those using found objects, processes, or systems where creative labor is apparently absent, continue to problematize the tran-scendental imperatives which predominate in critical and historical literature on art.

Criticism's function is to initiate that work which art history eventually accomplishes in the form of the "biographic narrative" that is, as Griselda Pollock describes it "the production of an artistic subject for works of art."[9] The critic's dilemma is the production of artistic subjects for works of art at a time when their authenticity (and market value) are still tentative. Modernist criticism became particularly precarious when it concerned the installation of creative purposes behind objects which were recalcitrant to such efforts or even, in the case of some conceptual work, absent altogether.

The Crisis of Artistic Authorship

Greenberg's writing is often cited as the apodictic core of modernist criticism; but it is far from coherent. Rather, it marks a point of diffraction, of incoher-ence in that discourse. His particular attention to the materiality of the object allowed a divergence from the ontological norm which was furthered by devel-

8. See Bernard Edelman, *Ownership of the Image: Elements for a Marxist Theory of Law*, trans. Elizabeth Kingdom, introduction Paul Q. Hirst (London: Routledge & Kegan Paul, 1979). It is also relevant to note here that the position of artists in Great Britain under the present 1956 Copyright Act (amended in 1971) is not much improved. For example, a sculptor or equivalent can only get protection under the law if he or she can prove that the production of the work involves "craftsmanship" and constituted more than "machining of parts." See Richard Mann, "British Copyright Council," *Artists Union Journal* (August 1980).

9. Griselda Pollock, "Artists, Mythologies and Media—Genius, Madness and Art History," *Screen* 21, no.3 (Fall 1980): 57-96.

opments of art practice and which, consequently, required a restatement of modernism's central themes at a moment when the vacuity of that project was keenly perceived in contrast to the aims and intentions of some of the artists to whom he referred.

In "Photography, Phantasy, Function," Victor Burgin summarizes Greenberg's definition of modernism as "the tendency of an art practice toward self-reference by means of a foregrounding of: the tradition of the practice; the difference of the practice from other (visual arts) practices; the 'cardinal norms' of the practice; the material substrate, or 'medium' of the practice." [10] At first, Greenberg appears to be ignoring the ontological imperative to self-expression by insisting on a self-referential art, and at the same time avoiding the pictorial constraints of that discourse by emphasizing the specificity and diversity of art forms. But, in fact, his proposal for a scientific, neo-Kantian aesthetics of the art object is founded exclusively on the practice of painting. Sculpture's requisite three-dimensionality, for instance, is forever haunted by the specter of resemblance to ordinary things. With respect to photography, Burgin points out Greenberg's dilemma: to insist on the materiality of the print would be to undermine its founding attribute, that of illusion. Even painting, if it is illusionistic, according to Greenberg only uses art to conceal art. Hence it is not simply painting, but abstraction in particular, which is purely pictorial, essentially optical, uniquely flat, and capable of complete self-reference.

In "Modernist Painting," Greenberg claimed that "visual art should confine itself to what is given in visual experience and make no reference to any other orders of experience." [11] But when the canons of self-criticism, self-definition, and self-reference were rigorously applied in so-called "minimal art," Greenberg rejected their implications. The aesthetics of "utter flatness" had gone too far; it was verging on a kind of existential recumbency, tending towards a condition of "non-art." For instance, where the catalogue *The Art of the Real* stated, "The art of the today's real makes no direct appeal to the emotions, nor is it involved with uplift, but instead offers itself in the form of the irreducible, irrefutable object," [12] it meant that the pictorial space was threatened with extinction by the encroachment of shapefulness and impending "objecthood." Consequently, Greenberg made a significant qualification. In "After Abstract Expressionism" he said "The question now asked . . . is no longer what constitutes art or the art of painting, but what irreducibly constitutes *good* art as such." [13]

10. Victor Burgin, "Photography, Phantasy, Function," *Screen* 21, no.1 (Spring 1980): 73. See also Burgin's critique of Greenberg in "Modernism in the *Work* of Art," *20th Century Studies*, nos.15-16 (December 1976): 34-55.

11. Clement Greenberg, "Modernist Painting," *Arts Yearbook*, no.4 (1961), reprinted in *The New Art*, ed. Gregory Battcock (New York: E. P. Dutton, 1973), p. 74.

12. See the cover of the catalogue for the exhibition *The Art of the Real: American Painting and Sculpture 1948-1968* (New York: The Museum of Modern Art, 1968; London: The Tate Gallery, 1969).

13. Clement Greenberg, "After Abstract Expressionism," *Art International* 6, no. 8 (October 1962): 30.

Thus Greenberg's attempt to establish the objective purposiveness of the art object, to define its particular forms of adaption to definite ends in terms of material substrate, is continually undermined by the exigencies of a subjective judgment of *taste*. And here an altogether different order of purpose emerges. The only necessary condition for *judging* good art is common sense; but for *producing* good art, genius is required. With reference to Kant's *Critique*, genius is the mental disposition *(ingenium)* through which nature gives the rule to art. No definite rule can be given for the products of genius, hence originality is its first property.[14] At this point the modernist discourse emerges as the site of an insistent contradiction which is indicated in Greenberg's criticism and repeated in the opposing strategies of the institutions of education on the one hand and those of entertainment and art patronage on the other. The former exacts a formal field of knowledge about art, an empirical domain of teachable crafts, while the latter requires a transcendental field of aesthetic experience and reflection founded on the unteachable tenets of genius and originality. During the 1960s artistic practices attempted to repudiate the notions of genius, originality, and taste, by introducing material processes, series, systems, and ideas in place of an art based on self-expression. Some artists maintained that it was necessary to purge the modernist program of such obsolete philosophical presumptions in order to refine its fundamental argument for an exclusively self-referential art. Joseph Kosuth for instance, following Greenberg's initiative and taking up Kant's distinction between analytic and synthetic propositions, insisted that works of art were analytic propositions: "The propositions of art are not factual, but linguistic in character, that is, they do not describe the behavior of physical or even mental objects; they express definitions of art, or the formal consequences of definitions of art."[15]

The limitations of proposing the linguistic analogy are numerous but primarily concern the fact that images, unlike words, are not doubly articulated. Verbal language is the only signifying system which has the ability to analyze itself. Hence the work of art, with reference to its internal structure, does not possess the means of defining itself as art. This is not to say that unless the artistic text includes a written message, it inhabits a realm of extra-discursive, "purely visual" determinations; rather, that the text is informed by discursive operations at the level of its conception, production, and reception in a way which is neither prior to, nor derived from, but coincident with, language. However this suggests an area of investigation which Kosuth's positivism does not allow. The significance of his refinement of formalism lies in

14. Immanuel Kant, *Critique of Judgment*, trans. J. H. Bernard, First Part, Second Book, *Analytic of the Sublime* (New York: Hafner Pub. Co., 1951), pp. 150-153.

15. Joseph Kosuth, "Art After Philosophy I & II" *Studio International* (October and November 1969), reprinted in *Idea Art*, ed. Gregory Battcock (New York: E. P. Dutton, 1973), p. 84. Cf., Thierry Kuntzel and Bernar Venet, *Lecture de Representation graphique de la fonction* y $= -x^2/_4$ (Paris: Arthur Hubschmid, 1975). They also emphasize the linguistic character of art, not as an analogy but as an alternative practice. Using Jacques Bertin's semiology, they propose a denotative art based on the graphic image (monosemy) in place of the pervading ambiguity (polysemy) of pictorial representation.

the problem it poses in the domain of aesthetic judgment. In place of the ever-widening spiral of connotations imposed by taste, the linguistic analogy proposes the denotative reading of artistic texts. Artistic practices which are based on such assumptions, however Edenic (as Barthes describes the desire for a radically objective or innocent image), nevertheless contested the unique identity, the authorial status, of the art object. Critical discourse, on the contrary, continually shifts to recuperate its lost investment in the transcendental field namely, artistic subjectivity.

When, in "Art and Objecthood" [16] Michael Fried maintained that a successful painting was capable of "compelling conviction," he took Greenberg's commonsense notion of "good art" and elevated it from the realm of opinion to that of faith (art which is compatible with the morality of the viewer?). Conviction, however, demands more than a self-defining art object, more than the mechanical product of genius; it requires a level of artistic decision, of choice. Fried insisted that the task of the modernist painter was to discover those conventions which at a given moment alone were capable of establishing his work's identity as painting (he writes, "what constitutes the art of painting and what constitutes good painting, are no longer separable.") The rule of art (material substrate) and the rule of nature (genius) are reconciled within the modernist discourse, as in the Kantian dialectic, by positing a supersensible substrate of artistic freedom.

With minimalism's eradication of the painterly signifier, exactly how did the modernist critic establish an authentic presence for specific works of art? Firstly, there was the phenomenological insistence on the pure act of perception, an attempt to rescue authenticity as a kind of mechanical aftereffect of the *gestalt*. Fried suggested that presence could be conferred by size or by "the look of non-art." The look of non-art was precisely the pictorial frame, extended to include the entire situation: variables of the object, light, space, and crucially the spectator's body. Awareness of size or scale, as Robert Morris maintained, was a function of the comparison made between one's body size and the object—and again according to Fried this process of comparison extorted a special complicity from the viewer. "Something is said to have presence when it demands that the beholder take it into account, that he takes it seriously—and when the fulfillment of that demand consists simply in being aware of it." [17]

Secondly, establishing the identity, the authorial status of the art object became increasingly dependent on an extended documentation of the installation or of the artist-at-work, and on critical commentary including statements by the artist. What cannot be reduced to pictures on the gallery wall can nevertheless be reproduced as pictures in the pages of a book.

Although Fried referred to the minimal object as having "stage presence," in effect it remained no more than a prop without the intervention of

16. Michael Fried, "Art and Objecthood," *Artforum* 5, no.10 (June 1967); reprinted in *Minimal Art: A Critical Anthology*, ed. Gregory Battcock (New York: E. P. Dutton, 1968), pp. 143-146.

17. Ibid., p. 124.

the actor/artist and his script. Ultimately, it became both necessary and expedient for the artist to stage himself; necessary because it was logically bound up with the interrogation of the object, and expedient because at the same time it rescued a semblance of propriety for ephemeral art forms.

The unity, the homogeneity of the pictorial space was disrupted by an insistence on temporality and by the intrusion of non-self-referential contents (the return of the repressed synthetic proposition); but what was evacuated at the level of the signifying substance of creative labor (gesture, matter, color)—signifiers of a unique artistic presence, reappeared in the figure of the artist: *his* person, *his* image, *his* gestures. As early as 1965, Rudolf Schwarzkogler stated that his performance "Aktionen" made its appearance "in place of pictures executed by hand." The insertion of the artist's body within this new pictorial space had nothing to do with the traditional constraints of the artistic nude re-presented as information or spectacle but, as Schwarzkozler insisted, it concerned the "total nude . . . [a transcendental nudity?] which places itself above the senses through the various possibilities of its repetitive gestures and its repetitive presence."[18] In performance work it is no longer a question of investing the object with an artistic presence: the artist is present and creative subjectivity is given as the effect of an essential self-possession, that is, of the artist's body and his inherent right of disposition over it.

Furthermore, there is what could be described as the peculiar paradox of photography for the precarious art practices of the late 1960s and early 1970s. That is to say, what remains of performance, with its temporality, its specific relation of audience and event impossible to trace, is the film or the photograph. What is lost in *that* image, in so far as it can no longer be emphatically marked as the property of the creative subject, is gained to the extent that it is, precisely, a photograph of the artist and as the possessive subject (in law) he has "the right of the photographer" over the disposal of his own image. More importantly, what is taken away from the pictorial text—the painterly signifier of bodily gesture, is given back in photographic form as the visible body, its peculiar gestures acceding to the status of the signifier in another space, that of pictorial quotation.

Benjamin's "aura" may wither away in the age of mechanical reproduction but authenticity remains. What is made more explicit, more transparent, by the so-called "dematerialization" of the object, is that *the production of authenticity requires more than an author for the object; it exacts the "truth" of the authorial discourse.*

By putting himself in circulation, the performance artist parodied the commercial exchange and distribution of an artistic personality in the form of a commodity. Nevertheless, for criticism, performance art initiated an appropriate synthesis of the disparate elements that had fractured the modernist discourse. On the one hand it provided the empirical domain with a universal object—the body, and on the other, to the transcendental field, it brought the incontestable authenticity of the artist's experience of his own body.

18. Rudolf Schwarzkogler, "Panorama Manifesto I/II: The Total Nude, 1965," in Lea Vergine, *Il Corpo Come Linguaggio* (Milan: Giampaolo Prearo Editore, 1974), n.p.

With Lea Vergine's account of "body art," *Il Corpo Come Linguaggio*, criticism seems to subside once again in the direction of ontology. She speaks of "the individual obsessed by the obligation to exhibit himself in order to be." [19] But she is anxious to point out that this move is more than a revival of expressionism. The use of the body in art is not simply a return to origins, "the individual is led back to a specific mode of existence." Moreover these activities, "phenomena" as she puts it, also document a style of living that remains "outside of art." The critic finds in the analysis of the artist's *actual experience*, the third term which metaphorically grounds the experience of nature (the body) and art (the culture). In *Art Povera*, Germano Celant's artist-alchemist mixes himself with environment, "he has chosen to live within direct experience, no longer the representative, he aspires to live, not see." [20] According to Michel Foucault, modern thought is a radical contestation of both positivism and eschatology: it searches for a discourse neither in the order of a reduction nor in the order of a promise. It is precisely a discourse which constitutes the subject as the locus of a knowledge empirically acquired but always referred back to what makes it possible, and finds in the analysis of actual experience a third term in which both the experience of the body and of the culture can be seen to be grounded. [21]

Throughout the 1970s, the critics who identified their project with the "avant-garde" effectively modernized Greenberg's archaic classicism. Significantly, Vergine quotes not Kant but Husserl:

> *Among the bodies of this nature that is reduced to what belongs to me, I discover my own body. It can be distinguished from all other bodies because of but a single particular: it is the only body that is not simply a body, but also my body. It is the only body that exists inside the strata of abstraction that I have chiselled into the world in which, in accordance with experience, I coordinate fields of sensation in various ways.* [22]

Similarly, the authenticity of body art cannot be inscribed at the level of a particular morphology, it must be chiselled into the world in accordance with direct experience. The discourse of the body in art is more than a repetition of the eschatological voices of abstract expressionism; the actual experience of the body fulfills the prophecy of the painted mark. It is also more than a confirmation of the positivist aspirations of the *Art of the Real*. The art of the "real body" does not pertain to the truth of a visible form, but refers back to its essential content: the irreducible, irrefutable experience of *pain*. The body, as

19. Lea Vergine, in *Il Corpo Come Linguaggio*, p. 3.

20. Germano Celant, ed., *Art Povera: Conceptual, Actual or Impossible Art?* (London: Studio Vista, 1969), p. 225.

21. Michael Foucault, *The Order of Things* (New York: Random House, 1970), pp. 320-321.

22. Husserl, quoted by Vergine, in *Il Corpo*, p. 21 (cf., Edmund Husserl, *Cartesian Meditations* (The Hague: Martinus Nijhoff, 1977), p. 97).

artistic text, bears the authenticating imprint of pain like a signature; Vergine insists, "the experiences we are dealing with are authentic, and they are consequently cruel and painful. Those who are in pain will tell you that they have the right to be taken seriously."[23] (It is no longer a question of good art, but of serious artists.)

Here, it is relevant to note Judith Barry and Sandy Flitterman's observations with regard to the performances of Gina Pane. They maintain that by counterposing an "aesthetics of pain" to one of pleasure, the artist merely reinforces the dualistic bias of Western metaphysics and that particularly, by practicing self-mutilation in her art, a woman invokes the traditional representation of female masochism.[24] Quite rightly, they point out that this type of art practice is not necessarily in opposition to the dominant discourse of art. However, it seems to be more a matter of phenomenology than metaphysics: an aesthetics of lived experience, rather than pain specifically, is being counterposed to that of the object, and not to pleasure as such. In this case, pain is not opposed to pleasure but becomes a privileged signifier in the field of sensations which the artist coordinates in the name of self-expression. Pane's art addresses not the sexual body but the Husserlian body, discovered as what belongs to me, my body, the body of the self-possessing artistic subject whose guarantee of truth is grounded in the painful state.

Alternatively, the specific contribution of feminists in the field of performance has been to pose the question of sexual difference across the discourse of the body in a way which focuses on the construction not of the individual, but of the sexed subject. The body is not perceived as the repository of an artistic essence: it is *seen* as a kind of hermeneutic image. The so-called "enigma of femininity" is formulated as the problem of representation (images of women, how to change them) and then resolved by the discovery of a true identity behind the patriarchal facade. This true identity is "the essence in women" according to Ulrike Rosenbach, who defines feminist art as "the elucidation of the woman-artist's identity; of her body, of her psyche, her feelings, her position in society."[25]

23. Ibid., p. 5.

24. Judith Barry and Sandy Flitterman, "Textual Strategies—The Politics of Art Making." *Screen* 21, no. 2 (Summer 1980): 37-38.

25. Ulrike Rosenbach, *Körpersprache* (Frankfurt: Haus am Waldsee, 1975). As regards the hermeneutic image, for instance in *Salto Mortale*, Rosenbach poses on a swing (posing the theme of the enigma) and aims the video camera at the ceiling where two different representations of woman have been posted: a photograph of the Palestinian commando, Leila Khaled, and a reproduction of a painting by Lochner of a Madonna and child. Then she swings below them, showing first one image, then the other, on the video monitor (formulating the enigma as a question) "which is the true one?" The answer is delayed, she continues to swing. Then she stops suspended between the two possibilities (leaving the spectator in suspense). Finally, she turns upside down revealing her own image on the monitor—filmed in a mirror below with the light and camera concealed under her skirt. Thus she proposes an answer: reject existing models, trust yourself, "discover the true feminine structure behind the facade erected by patriarchal thinking" (the enigma resolved). See also catalogue for the exhibition *feministische kunst internationaal* (The Hague: Haags Gemeentemuseum, 1979), pp. 98-99, 103-104.

Clearly the question of the body and the question of sexuality do not necessarily intersect.[26] When they do, for instance in this particular discourse, the body is decentered and it is radically split; positioned; not simply *my* body, but *his* body, *her* body. Here, no third term emerges to salvage a transcendental sameness for aesthetic reflection. Within this system of representation, actual experience merely confirms an irrevocable difference in the field of the other.

Partially because of this intransigence, feminist art has been problematic for criticism; how does the critic authenticate the work of art when the author is sexed and "his" truth no longer universal? Consequently, most of this work has been marginalized by or excluded from the so-called "mainstream" even when the critic's concerns have included areas such as psychoanalysis (Vergine's book is an obvious case in point). Moreover the predominant forms of feminist writing on art continue to counterpose a visible form to a hidden content; excavating a different, but similarly fundamental order of truth–the truth of the woman, her original feminine identity. But in practice what persistently emerges as a result of foregrounding the question of representation–particularly the image, is more in the order of an underlying contradiction than an essential content. The woman artist "sees" her experience as a woman particularly in terms of the "feminine position," as object of the look, but she must also account for the "feeling" she experiences as the artist, occupying the "masculine position" as subject of the look. The former she defines as the socially prescribed position of the woman, one to be questioned, exorcised, or overthrown (note Rosenbach), while the implications of the latter (that there can be only one position with regard to active looking and that is masculine) cannot be acknowledged and is construed instead as a kind of psychic truth–a natural, instinctual, preexistent, and essential femininity. Frequently, in the process of its production, the feminist text repudiates its own essentialism and testifies instead to the insistent bisexuality of the drives. It would seem to be a relevant project for feminist criticism to take this further–to examine how that contradiction (the crisis of positionality) is articulated in particular practices and to what extent it demonstrates that masculine and feminine positions are never finally fixed–for the artist, her work, or her public.

In contrast, Vergine's phenomenology constructs the body as empirically given yet impossible to know, a body which is radically divided among the discourses and practices of individual artists (literally the pages of her book), but nevertheless unified by a certain psychological insight, she proposes: "at the basis of 'body art' and all other operations presented in this book, one can discover the unsatisfied need for a love."[27] The question of desire in relation to the representation of pain and to the spectator's pleasure would indeed be pertinent here, but she does not finally address these issues. Instead, the iconography of the art object is merely displaced by a symptomatology of the artist (she gives a canonical list of neuroses). The subject suffers, is "alienated," even sexed, but still remains the unified and coherent center of the signifying system of the artistic text.

26. See Beverly Brown and Parveen Adams, "The Feminine Body and Feminist Politics," *m/f*, no. 3 (1979): 35-50.

27. Vergine, *Il Corpo*, p. 1.

Following the paradoxical logic of modernism's demand for objective purposes as well as transcendental truths, avant-garde practices between 1965 and the mid-1970s initiated areas of work that divided the very field of which they were an effect. The potential of that divergence has not been completely realized. First, the materiality of the practice: initially defined in terms of the constraints of a particular medium, it must now be redefined as a specific production of meaning. Secondly, sociality, raised as the question of context, is the gallery system (inside vs. outside), and the commodification of art (object vs. process, action, idea, etc.). This must be reconsidered as the question of institutions, of the conditions which determine the reading of artistic texts and the strategies which would be appropriate for interventions (rather than "alternatives") in that context. Thirdly, sexuality, posed as the problem of images of women and how to change them, must be reformulated as a concern with positionality, with the production of readers as well as authors for artistic texts and crucially, with the sexual overdetermination of meaning which takes place in that process.

The dominant critical practices of that same period have, however, so consistently converged on the traditional vanishing point of the artistic subject, self-possessed and essentially creative, that it is not surprising now to find a certain consolidation of that position in artistic practices themselves, in the return of painterly signifiers and their privileged site–the classical pictorial text.[28] Finally, a further question is raised–why theoretical criticism, with a very different history from that discussed so far, was also unable to sustain the discontinuities in the modernist discourse and develop an accessible critique.

Exhibition and System

Critical writing on art which places emphasis on the analysis of signifying practice rather than on the exhortation or description of artistic auteurs, generally acknowledges that art forms are inscribed within the social context that gives rise to them. Nevertheless, there is a problematic tendency to constitute the pictorial text as the paradigmatic insistence of that inscription in a way which forecloses the question of its institutional placing. The pictorial paradigm constructs the artistic text as both essentially singular and as centrally concerned with the practice of painting; but, as Hubert Damisch has pointed out, when painting is considered at the semiotic level, that is with reference to its internal system, it functions as an epistemological obstacle–an obstacle never surmounted, only prodded by an endless redefinition of the sign or averted altogether by taking the semantic route.[29] Perhaps to some extent this accounts for what appears to be a certain impasse in the area of art criticism when compared, for instance, with developments in film theory.

28. Cf., Benjamin Buchloh, "Figures of Authority, Ciphers of Regression: Notes on the Return of Representation in European Painting," *October*, no. 16 (Spring 1981): 39-68. [Reprinted in this volume, see pp. 107-135.] He takes the view that representational art forms are historically coincident with periods of economic recession and political conservatism.

29. See Hubert Damisch, "Eight Theses For (or Against?) a Semiology of Painting," *enclitic* 3, no. 1 (Spring 1979): 1-15.

Critical texts have focused either on analysis of the individual *tableau* (sometimes an individual artist's *oeuvre*) or on the construction of general cultural categories and typologies of art. This work has been both necessary and important. The arguments outlined here are not so much against such contributions as for a reconsideration of what might constitute appropriate terms for the analysis of current practices in art. This reconsideration is prompted firstly by developments within particular practices. Feminist art, for instance, cannot be posed in terms of cultural categories, typologies, or even certain insular forms of textual analysis, precisely because it entails the assessment of political interventions, campaigns, and commitments as well as artistic strategies. In this instance, interpretation is not simply a matter of what can be discovered at the interior of a composition. Secondly, a reconsideration of critical methods is required if one takes account of the specific conditions which determine the organization of artistic texts and their readings at the present time; that is, *the temporary exhibition and its associated field of publications— the catalogue, the art book, and the magazine.* From this point of view, "art" is never given in the form of individual works but is constructed as a category in relation to a complex configuration of texts.

In terms of analysis, the exhibition system marks a crucial intersection of discourses, practices, and sites which define the institutions of art within a definite social formation. Moreover, it is exactly here, within this inter-textual, inter-discursive network, that the work of art is produced as text.

Rather schematically, it can be said that at one level an exhibition is a discursive practice involving the selection, organization, and evaluation of artistic texts according to a particular genre (the one-person show, the group show, the theme exhibition, the historical survey, and the Annual, Biennial, etc.), displayed in certain types of institutions (museums, galleries), within specific legal structures (contractual agreements, fees, insurance), and preserved by definite material techniques in a number of ways (catalogues, art books, magazines). At another level, an exhibition is a system of meanings—a discourse—which, taken as a complex unit or enunciative field, can be said to constitute a group of statements; the individual works comprising fragments of imaged discourse or utterances which are anchored by the exhibition's titles, subheadings, and commentary, but at the same time unsettled, exceeded, or dispersed in the process of their articulation as events.

An exhibition takes place; its spatio-temporal disposition, conventions of display, codes of architecture, construct a certain passage; not the continuous progression of images unfolding on the cinema screen, but the flickering, fragmented frames of the editing machine; a passage very much at the disposal of the spectator to stop frame, rewind, push forward; it displays discernible openness, a radical potential for self-reflexivity. There is nevertheless a logic of that passage, of partition and naming, and in a sense there is a narrative organization of what is seen in the exhibition catalogue; its written (editorial/ critical) commentary fixes the floating meaning, erodes the apparent polysemy of the exhibition's imaged discourse. Within a specific order of the book, the catalogue confers an authorship, an authority, on the exhibition events. In it, positions and statuses are assigned for "agents" defined as artists, organizers,

critics, and "the public." The authors/organizers impose a declarative order on the exhibition's evasive discursivity (artists, it should be noted are often the subjects of exhibition statements, but rarely the authors of its formulation). The catalogue constructs a specific reading, opens the space of a possible reworking or perhaps effects a closure; but it always has definite political consequences. This suggests that the catalogue is also an important site for interventions. Catalogue and exhibition constitute what could be called a *diatext*, that is, two separate signifying systems which function together; more precisely, it is at the point of their intersection and crucially in their difference, that the production of a certain knowledge takes place.

The exhibition has a definite substantive duration. In its phenomenal form the installation is subject to the constraints of a definite site, it is only reproducible in a limited sense, but the catalogue remains. It is infinitely reproducible and, moreover, it constitutes the determinant means of institutional control over the continued distribution of works of art. In this context, the absence of a catalogue also becomes significant. Artists generally maintain that the catalogue is more important than the exhibition itself. It gives a particular permanence to temporary events, an authenticity in the form of historical testimony. Together with art books and magazines, exhibition catalogues constitute the predominant forms of receiving and, in a certain sense, possessing images of art. The exhibition remains the privileged mode of reception in terms of the viewer's access to the "original" work, but far more often the reader's knowledge of art is based on reproductions in books and magazines. Critical theories of art founded on the notion of artisanal production fail to recognize that these historically specific means of organization, circulation, distribution, not only determine the reception—reading, viewing, reviewing, reworking—of artistic texts, but also have an effect on the signifying practices themselves. The phenomenon of artists' books, together with the emergence of specialist publishers, is now well known; this is often commented on, but rarely analyzed in terms of the particular relations of representation it prescribes.

How is the work of art, now reproduced as photographic image, produced as the artistic text within the system of the book? What kind of readers and authors are positioned there? Obviously, there is the loss of material specificity—problems of black-and-white reproduction, aspect ratios, etc.—the characteristic homogenizing tendency of the book; but the difference between the reproduction in the catalogue and the original in the exhibition is not merely a question of photographic techniques. It is a question of particular practices of writing, of the gaps, omissions, and points of emphasis through which certain images are outlined and others erased. The authorial discourse (organizer, critic, or artist) constructs a pictorial textuality which pertains more to the readable than to the visible.

In this sense it would be appropriate to speak of quoting rather than illustrating artistic texts (although this is not to say they are essentially quotable). At one level the signifying structure of the pictorial quotation has something in common with the press photograph insofar as it presumes to "record" the exhibition events or to identify the object to which the reproduction supposedly refers. This process of identification appears to be immediately fixed

by the denominative function of the linguistic text which accompanies it: name, title, dimensions, medium. More crucially, however, it depends on a certain cultural knowledge, as Barthes suggested, a body of techniques and practices already-read as art.[30] This reading is grounded in the academic discourse of Fine Art and circumscribed by the limits of its traditional regimes: Architecture, Painting, and Sculpture.

The quotation subscribes to a form of pictorial rhetoric which defines those regimes (and the varied practices they subsume) in terms of medium: thus painting's pictorial quality, its one-dimensionality, is signified by the correspondence of frame to edge of photograph; video by the framing edge of the monitor and the "grain" of an electronically transmitted image; sculpture's three-dimensionality by lighting or architectural setting; performance, similarly, by an establishing shot (i.e., performer in context of audience, camera, etc.); photography also relies on an installation shot or the repetition of units to signify its fine art context. But the pictorial quotation seems to be subject to a double imperative which repeats the dilemma of modernist criticism; while identifying the art object in terms of medium, at the same time it must establish the unique and individuating style of a particular artist's work. Hence there is also the "artistic photograph": the detail, the interesting composition which displaces the record. It gives the appearance of transgression, but effectively it is a fragment, a metonymy, enveloped by the all-pervasive pictorial metaphor, addressing the reader with continued reference to the grand regime of Painting.

However, if the work of art is extracted from the discursive system in which it is established as statement, as event, then it is possible not only to construct a rather utopian view of the pictorial text as essentially concerned with a single picture, but also to assume, as Raymond Bellour does in "The Unattainable Text," that unlike the filmic text "the pictorial text is in fact a quotable text."[31] The concept of pictorial quotability suppresses the diversity of artistic practices insofar as it foregrounds a particular system of representation, the painting. Moreover, when he adds, "From the critical point of view it has one advantage that only painting possesses: one can see and take in the work at one glance," another problem is posed: Precisely what forms of painting possess this advantage of being taken in at a glance? Here Bellour's perceptual emphasis implicates his arguments with those of modernist criticism by constructing a similar object, namely, the purely visual, uniquely flat, abstractionist painting which illustrates Greenberg's pictorial paradigm.

Consequently, even if, at the center of that paradigm, it is not the truth of an author but that of the signifier itself which is sought, as long as the site of that search is designated as the object or even the system "Painting," a problem remains. On the one hand the pictorial text, with reference to the object, is too easily attained—taken in at a glance; on the other hand, as Damisch describes it, pictorial textuality is constituted in a divergence between

30. See Roland Barthes, "Rhetoric of the Image," in *Image-Music-Text*, trans. Stephen Heath (New York: Hill and Wang, 1977).

31. Raymond Bellour, "The Unattainable Text," *Screen* 16, no. 3 (Autumn 1975): 21-22.

the register of the visible and that of the readable. "A divergence by way of which it is appropriate, in relation to the system Painting to pose the question of the signifier." But since the signifier cannot be produced or even recognized by way of a position of exteriority, the effect of painting, like that of the dream-work, is created "outside any relation of interpretation."[32] The truth of painting, like that of the signifier, is the impossibility of knowing it. And the pictorial text remains in a certain sense unknowable, impossible, unattainable. That is why it now seems more appropriate, in relation to the signifying system of the artistic text, to pose, not the question of the signifier but that of the *statement:* as Foucault suggests, "to situate these meaningful units in a space in which they breed and multiply."[33]

32. Damisch. "Eight Theses," pp. 14-15.

33. Michel Foucault, *The Archaeology of Knowledge*, trans. A. M. Sheridan Smith. (New York: Pantheon Books, 1972), p. 100.

III.

Paroxysms of Painting

Gino Severini.
*Spherical Expansion
of Light (Espansione
sferica delle luce
[Centrifuga]),* 1914.
Oil on canvas, 24⅜ x
19¾" (62 x 50 cm).
Collection Riccardo
Jucker, Milan

Gino Severini.
*Maternity
(Maternità),* 1916. Oil
on canvas, 36¼ x
25½" (92 x 65 cm).
Museo dell'Academia
Etrusca, Cortone

Carlo Carrà. *Patriotic
Celebration
(Manifestazione
Interventista, festa
patriottica),* 1914.
Pasted paper and
newsprint on cloth,
mounted on board.
15¼ x 12" (38.5 x 30
cm). Collection Dr.
Gianni Mattioli, Milan

Carlo Carrà. *The
Daughters of Lot (Le
figlie di Loth),* 1919.
Oil on canvas, 43¼ x
31½" (110 x 80 cm).
Private collection,
Bolzano

Francis Picabia.
Tabac-Rat, ca. 1919–
1921 and ca. 1948–
1949. Ink, cord, and
cardboard in an open
frame, 35⅞ x 27½"
(91 x 70 cm).
Succession Picabia,
Paris

Francis Picabia.
*Self-Portrait
(Autoportrait),* ca.
1940–1943. Oil on
canvas, 32¾ x 28¼"
(83 x 72 cm).
Collection Paride
Accetti, Milan

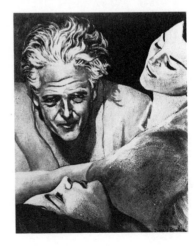

Figures of Authority, Ciphers of Regression

Notes on the Return of Representation in European Painting

BENJAMIN H. D. BUCHLOH

> *The crisis consists precisely in the fact that the old is dying and the new cannot be born; in this interregnum a great variety of morbid symptoms appears.*
>
> —Antonio Gramsci, *Prison Notebooks*

How is it that we are nearly forced to believe that the return to traditional modes of representation in painting around 1915, two years after the Readymade and the Black Square, was a shift of great historical or aesthetic import? And how did this shift come to be understood as an autonomous achievement of the masters, who were in fact the servants of an audience craving for the restoration of the visual codes of recognizability, for the reinstatement of figuration? If the perceptual conventions of mimetic representation —the visual and spatial ordering systems that had defined pictorial production since the Renaissance and had in turn been systematically broken down since the middle of the nineteenth century—were reestablished, if the credibility of iconic referentiality was reaffirmed, and if the hierarchy of figure-ground relationships on the picture plane was again presented as an "ontological" condition, what other ordering systems outside of aesthetic discourse had to have already been put in place in order to imbue the new visual configurations with historical authenticity? In what order do these chains of restorative phenomena really occur and how are they linked? Is there a simple causal connection, a mechanical reaction, by which growing political oppression necessarily and irreversibly generates traditional representation? Does the brutal increase of restrictions in socioeconomic and political life unavoidably result in the bleak anonymity and passivity of the compulsively mimetic modes that we witness, for example, in European painting of the mid-1920s and early 1930s?

Reprinted from *October*, no. 16 (Spring 1981): 39-68.

I have limited my investigations here to European phenomena, even though I am aware that a comparable movement is presently emerging in North America. The reasons for such a limitation are best described by Georg Lukács: "We will restrict our observations to Germany, even though we know that expressionism was an international phenomenon. As much as we understand that its roots are to be found everywhere in imperialism, we know as well that the uneven development in the various countries had to generate various manifestations. Only after a concrete study of the development of expressionism has been made can we come to an overview without remaining in the abstract," " 'Grösse und Verfall' des Expressionismus" (1934), in *Gesammelte Werke*, vol. 4: *Essays über Realismus* (Berlin: Hermann Luchterhand Verlag, 1971), p. 111n. [For an English translation of Lukács' essay, see "Expressionism: Its Significance and Decline," trans. David Fernbach, in *Essays on Realism*, ed. Rodney Livingstone (Cambridge, Mass.: The MIT Press, 1981), pp. 76-113.]

It would certainly appear that the attitudes of the Neue Sachlichkeit and Pittura Metafisica cleared the way for a final takeover by such outright authoritarian styles of representation as Fascist painting in Germany and Italy and socialist realism in Stalinist Russia. When Georg Lukács discussed the rise and fall of expressionism in his "Problems of Realism," he seemed to be aware of the relationship of these phenomena, without, however, clarifying the actual system of interaction between protofascism and reactionary art practices: "The realism of the Neue Sachlichkeit is so obviously apologetic and leads so clearly away from any poetic reproduction of reality that it can easily merge with the Fascist legacy."[1] Paradoxically, however, both traditional Marxism and standard liberalism exempt artists from their responsibilities as sociopolitical individuals: Marxism through its reflection model, with its historical determinism; liberalism through its notion of the artist's unlimited and uninhibited freedom to produce and express. Thus both political views extend to artists the privilege of assuming their determinate necessity to produce unconscious representations of the ideological world.

But would it not be more appropriate to conceive of these radical shifts of the period between the wars, with such decisive selections of production procedures, iconographic references, and perceptual conventions, as calculated? Should we not assume that every artist making these decisions would be aware of their ramifications and consequences, of the sides they would be taking in the process of aesthetic identification and ideological representation?

The question for us now is to what extent the rediscovery and recapitulation of these modes of figurative representation in present-day European painting reflect and dismantle the ideological impact of growing authoritarianism; or to what extent they simply indulge and reap the benefits of this increasingly apparent political practice; or, worse yet, to what extent they cynically generate a cultural climate of authoritarianism to familiarize us with the political realities to come.

In order to analyze the contemporary phenomenon, it may be useful to realize that the collapse of the modernist idiom is not without precedent. The bankruptcy of capitalist economics and politics in the twentieth century has been consistently anticipated and accompanied by a certain rhythm of aesthetic manifestations. First there is the construction of artistic movements with great potential for the critical dismantling of the dominant ideology. This is then negated by those movements' own artists, who act to internalize oppression, at first in haunting visions of incapacitating and infantilizing melancholy and then, at a later stage, in the outright adulation of manifestations of reactionary power. In the present excitement over "postmodernism" and the "end of the avant-garde," it should not be forgotten that the collapse of the modernist paradigm is as much a cyclical phenomenon in the history of twentieth-century art as is the crisis of capitalist economics in twentieth-century political history: overproduction, managed unemployment, the need for expanding markets and profits and the resultant war-mongering as the secret promise of a final solution for capitalism's problems. It seems necessary to insist upon seeing present

1. Lukács, " *'Grosse und Verfall' des Expressionismus,"* p. 147.

developments in the larger context of these historical repetitions, in their nature as response and reaction to particular conditions that exist outside the confines of aesthetic discourse.

If the current debate does not place these phenomena in historical context, if it does not see through the eagerness with which we are assured from all sides that the avant-garde has completed its mission and has been accorded a position of comfort within a pluralism of meanings and aesthetic masquerades, then it will become complicit in the creation of a climate of desperation and passivity. The ideology of postmodernism seems to forget the subtle and manifest political oppression which is necessary to save the existing power structure. Only in such a climate are the symbolic modes of concrete anticipation transformed into allegorical modes of internalized retrospection. If one realizes that melancholy is at the origin of the allegorical mode, one should also realize that this melancholy is enforced by prohibition and repression. What is taken as one of the key works for postmodernist aesthetics and the central reference for any contemporary theory of the return to allegory in aesthetic production and reception, Walter Benjamin's *The Origin of German Tragic Drama*, was written during the dawn of rising fascism in Germany. Its author was well aware of the work's allusion to contemporary artistic and political events, as is confirmed by Benjamin's friend Asja Lacis:

> *He said that he did not consider this thesis simply as an academic investigation but that it had very direct interrelationships with acute problems of contemporary literature. He insisted explicitly on the fact that in his thesis he defined the dramaturgy of the baroque as an analogy to expressionism in its quest for a formal language. Therefore I have, so he said, dealt so extensively with the artistic problems of allegory, emblems, and rituals.*[2]

Or, as George Steiner describes it in his introduction to the English edition of Benjamin's study:

> *As during the crises of the Thirty Years' War and its aftermath, so in Weimar Germany the extremities of political tension and economic misery are reflected in art and critical discussion. Having drawn the analogy, Benjamin closes with hints towards a recursive theory of culture: eras of decline resemble each other not only in their vices but also in their strange climate of rhetorical and aesthetic vehemence. . . . Thus a study of the baroque is no mere antiquarian archival hobby: it mirrors, it anticipates and helps grasp the dark present.*[3]

2. Asja Lacis, *Revolutionär im Beruf, Berichte über proletarisches Theater, Über Meyerhold, Brecht, Benjamin und Piscator*, ed. Hildegard Brenner (Munich: Rogner & Bernhard, 1971), p. 44, author's trans.

3. George Steiner, "Introduction," in Walter Benjamin, *The Origin of German Tragic Drama* (London: New Left Books, 1977), p. 24.

Repression and Repre-sentation

It is generally agreed that the first major breakdown of the modernist idiom in twentieth-century painting occurs at the beginning of the First World War, signaled by the end of cubism and futurism and the abandonment of critical ideals by the very artists who had initiated those movements. Facing the deadlock of their own academicization and the actual exhaustion of the historical significance of their work, Picasso, Derain, Carrà, and Severini—to name but a few of the most prominent figures—were among the first to call for a return to the traditional values of high art. Creating the myth of a new classicism to disguise their condition, they insisted upon the continuation of easel painting, a mode of production that they had shortly before pushed to its very limits, but which now proved to be a valuable commodity which was therefore to be revalidated. From this situation originated their incapacity or stubborn refusal to face the epistemological consequences of their own work. Already by 1913 their ideas had been developed further by younger artists working in cultural contexts which offered broader historical, social, and political options to dismantle the cultural tenets of the European bourgeoisie. This is particularly the case with Duchamp in America and Malevich and the constructivists in Russia. But, even in Paris, such artists as Francis Picabia recognized the imminent demise of cubism. Upon his return from his first journey to New York in 1913, he wrote, "But, as you know, I have surpassed this stage of development and I do not define myself at all as a cubist anymore. I have come to realize that one cannot always make cubes express the thoughts of the brain and the feelings of the psyche."[4] And in his "Manifeste de l'École Amorphiste," published in a special issue of *Camera Work* in 1913, he was even more explicit: "One has said of Picasso that he studies objects in the way a surgeon dissects a cadaver. We do not want these bothersome cadavers anymore which are called objects."[5]

Even in 1923 these polemics continued among various factions of the Parisian avant-garde. On the occasion of the first performance of Tristan Tzara's *Coeur à Gaz* at the "Soirée du 'Coeur à Barbe,'" a fistfight broke out in the audience when one of the artists present jumped onto the stage and shouted, "Picasso is dead on the field of battle."[6] But even artists who had been allied with the cubist movement realized by the end of the second decade that it was exhausted, without, however, necessarily advocating a return to the past. Blaise Cendrars, for example, in his text "Pourquoi le cube s'effrite?" published in 1919, announced the end of the relevance of the cubist language of form. On the other hand, in the very same year a number of ideological

4. Francis Picabia, "Comment je vois New York. Pourquoi New York est la seule ville cubiste au monde,"in *Francis Picabia* (Paris: Musée National d'Art Moderne, 1976), p. 67, author's trans.

5. Ibid., p. 68, author's trans.

6. See William Rubin, *Picasso* (New York: Museum of Modern Art, 1980), p. 224. The awareness of Picasso's decline eventually developed even among art historians who had been previously committed to his work: "Picasso belongs to the past. . . . His downfall is one of the most upsetting problems of our era" (Germain Bazin [1932], quoted in Rubin, *Picasso*, p. 277).

justifications appeared for the regression that had begun around 1914-15. Among the many documents of the new attitude of authoritarian classicism are a pamphlet by the cubist dealer Léonce Rosenberg, *Cubisme et Tradition*, published in 1920, and Maurice Raynal's "Quelques intentions du cubisme," written in 1919 and published in 1924, which stated, "I continue to believe that knowledge of the Masters, right understanding of their works, and respect for tradition might provide strong support."[7] If properly read, this statement, in its attempt to legitimize the academicization of an aging and ailing cubist culture, already reveals the inherent authoritarian tendency of the myth of a new classicism. Then as now, the key terms of this ideological backlash are the idealization of the perennial monuments of art history and its masters, the attempt to establish a new aesthetic orthodoxy, and the demand for respect for the cultural tradition. It is endemic to the syndrome of authoritarianism that it appeal to and affirm the "eternal" or ancient systems of order (the law of the tribe, the authority of history, the paternal principle of the master, etc.). This unfathomable past history then serves as a screen upon which the configurations of a failed historical presence can be projected. In 1915, when Picasso signals his return to a representational language by portraying the cubist poet Max Jacob, recently converted to Catholicism, in the guise of a Breton peasant, drawn in the manner of Ingres, we get a first impression of the degree of eclecticism that is necessary to create the stylistic and historical pose of classical simplicity and equilibrium, with its claim to provide access to the origins and essentials of universal human experience. Subsequently this historicist eclecticism becomes an artistic principle, and then, as in Jean Cocteau's "Rappel à l'Ordre" of 1926, it is declared the new avant-garde program.

In Picasso's work the number and heterogeneity of stylistic modes quoted and appropriated from the fund of art history increases in 1917: not only Ingres's classical portraits but, as a result of Picasso's journey to Italy in the company of Cocteau, the iconography of the Italian commedia dell'arte and the frescoes of Herculaneum (not to mention the sculpture of the Parthenon frieze and the white figure vases at the Louvre, the peasant drawings of Millet, the late nudes of Renoir, the pointillism of Seurat, as Blunt, Green, and other Picasso scholars have pointed out). And, of course, there is the self-quotation of synthetic cubist elements, which lend themselves so easily to the high sensuousness of Picasso's decorative style of the early twenties.

Again it is Maurice Raynal who naively provides the clue to an analysis of these works when he describes Picasso's 1921 *Three Musicians* as "rather like magnificent shop windows of cubist inventions and discoveries."[8] The free-floating availability of these cubist elements and their interchangeability indicate how the new language of painting—now wrenched from its original symbolic function—has become reified as "style" and thus no longer fulfills any purpose but to refer to itself as an aesthetic commodity within a dysfunctional discourse. It therefore enters those categories of artistic production that by their

7. Maurice Raynal, "Quelques intentions du cubisme," *Bulletin de l'effort moderne*, no. 4 (1924): 4.

8. Ibid.

very nature either work against the impulse to dissolve reification or are oblivious to that impulse: the categories of decoration, fashion, and objets d'art.

This transformation of art from the practice of the material and dialectical transgression of ideology to the static affirmation of the conditions of reification and their psychosexual origins in repression have been described as the source of a shift towards the allegorical mode by Leo Bersani:

> *It is the extension of the concrete into memory and fantasy. But with the negation of desire, we have an immobile and immobilizing type of abstraction. Instead of imitating a process of endless substitutions (desire's ceaseless "travelling" among different images), abstraction is now a transcendence of the desiring process itself. And we move toward an art of allegory.*[9]

This becomes even more evident in the iconography of Pittura Metafisica, which de Chirico and the former futurist Carrà initiated around 1913. The conversion of the futurists, parallel to that of the cubists, involved not only a renewed veneration of the cultural tradition of the past—as opposed to their original fervent antipathy to the past—but also a new iconography of haunting, pointlessly assembled quotidian objects painted with meticulous devotion to representational conventions. De Chirico describes his paintings as stages decorated for imminent but unknown and threatening acts, and insists on the demons that are inherent in the objects of representation: "The metaphysical work of art seems to be joyous. Yet one has the impression that something is going to happen in this joyous world."[10] De Chirico speaks of the tragedy of joy, which is nothing other than the calm before the storm, and the canvas now becomes the stage upon which the future disaster can be enacted. As the Italian historian Umberto Silva pointed out, "De Chirico is the personification of Croce's Italian disease: not quite fascism yet, but the fear of its dawn."[11]

As was the case in Picasso's conversion, the futurists now fully repudiated their earlier nonrepresentational modes and procedures of fragmentation and pictorial molecularization. They further rejected the collage techniques by which they had forced the simultaneous presence of heterogeneous materials and procedures within the painted surface, and through which they had underlined the interaction of aesthetic phenomena with their social and political context. It is surely no accident that one of Severini's first paintings to manifest his return to history is a work called *Maternity*, which represents a mother suckling an infant in the traditional pose of the Madonna. Even more conspicuous perhaps is the case of Carrà, who had been one of the most important futurists due to his development of nonmimetic pictorial signs, his systematic transgression of verbal and visual codes through the insertion of verbal frag-

9. Leo Bersani, *Baudelaire and Freud* (Berkeley: University of California Press, 1977), p. 98.

10. Giorgio de Chirico, "Über die metaphysische Kunst," in *Wir Metaphysiker*, ed. Wieland Schmied (Berlin: Propyläen Verlag, 1973), p. 45 author's trans.

11. Umberto Silva, *Ideologia e arte del Fascismo* (Milan: Gabriele Mazzotta Editore, 1973), p. 109.

ments within painting, and his mechanization of pictorial production processes and their juxtaposition with pictorialized remnants of mechanical production processes. Carrà turned at that time to representational depictions of biblical scenes in the manner of Tuscan painting.

Art, Past and Master

To the very same extent that the rediscovery of history serves the authoritarian purpose of justifying the failure of modernism, the atavistic notion of the master artist is reintroduced to continue a culture oriented to an esoteric elite, thus guaranteeing that elite's right to continued cultural and political leadership. The language of the artists themselves (or rather these particular artists, for there is an opposite definition of artistic production and culture simultaneously developing in the Soviet Union) blatantly reveals the intricate connection between aesthetic mastery and authoritarian domination. Three examples from three different decades may serve to illustrate this aesthetic stance:

Hysteria and dilettantism are damned to the burial urns. I believe that everybody is fed up now with dilettantism: whether it be in politics, literature, or painting. –Giorgio de Chirico, 1919.[12]

12. Giorgio de Chirico, "Il ritorno al mastiere" [The Return to Craft], *Valori Plastici* 1, nos. 11-12 (1919): 19. This phenomenon finds its explicit manifestation in de Chirico's declaration "Pictor sum classicus," with which he concludes emphatically his call for a return to the law of history and classic order. Like Carlo Carrà in his "Pittura Metafisica," also published in 1919, de Chirico not only requests the return to the "classic" tradition and the "masters" of that tradition (Uccello, Giotto, Piero della Francesca), but to the specific *nationality* of that tradition. This is the most obvious of the three historical fictions in that authoritarian construct of a return to the past, since the nation-state as a socio-economic and political ordering system did not exist at the time of these masters' production.

It is only logical to find Carrà's name subsequently among the artists who signed the "Manifesto of Fascist Painting" in 1933 which reads as follows: "Fascist Art rejects research and experiments. . . . The style of Fascist art has to orient itself towards antiquity."

It seems that with increasing authoritarianism in the present the projection into the past has to be removed further and further away—from Renaissance to antiquity in this case. More explicitly we find this substitution of present history by mnemosynic fictions of past history in an essay by Alberto Savinio, published in *Valori Plastici* in 1921: "Memory generates our thoughts and our hopes . . . we are forever the devoted and faithful sons of Memory. Memory is our past; it is also the past of all other men, of all men who have preceded us. And since memory is the ordered recollection of our thoughts and those of the others, memory is our religion: *religio.*"

When the French art historian Jean Clair tries to understand these phenomena outside of their historical and political context, his terminology, which is supposed to explain these contradictions and save them for a new reactionary anti-modernist art history writing, has to employ the same clichés of authoritarianism, the fatherland, and the paternal heritage: "[These painters] come to collect their paternal heritage, they do not even dream of rejecting it. . . . Neoclassicism is lived as a meditation on the exile, far from the lost fatherland which is also that of painting, the lost fatherland of paintings" (Jean Clair, " 'Metafisica' et 'Unheimlichkeit'," in *Les Réalismes 1919-1939* [Paris, Musée National d'Art Moderne, 1981], p. 32).

Socialism has only been invented for the mediocre and the weak. Can you imagine socialism or communism in Love or in Art? One would burst into laughter–if one were not threatened by the consequences.
–Francis Picabia, 1927.[13]

And finally, Picasso's notorious statement from 1935:

There ought to be an absolute dictatorship . . . a dictatorship of painters . . . a dictatorship of one painter . . . to suppress all those who have betrayed us, to suppress the cheaters, to suppress the tricks, to suppress mannerisms, to suppress charms, to suppress history, to suppress a heap of other things.[14]

Like senile old rulers who refuse to step down, the stubbornness and spite of the old painters increase in direct proportion to the innate sense of the invalidity of their claims to save a cultural practice that had lost its viability. When, in the early twenties, the former German dadaist Christian Schad attempts a definition of the Neue Sachlichkeit by portraying members of the Weimar hautemonde and demimonde in the manner of Renaissance portraits; when, in 1933, Kasimir Malevich portrays himself and his wife in Renaissance costumes; then obviously the same mechanism of authoritarian alienation is at work. In a text from 1926, Schad delivers a complete account of the syndrome's most conspicuous features:

Oh, it is so easy to turn one's back on Raphael. Because it is so difficult to be a good painter. And only a good painter is able to paint well. Nobody will ever be a good painter if he is only capable of painting well. One has to be born a good painter. . . . Italy opened my eyes about my artistic volition and capacity. . . . In Italy the art is ancient and ancient art is often newer than the new art.[15]

13. "Francis Picabia contre Dada ou le retour à la Raison," *Comoedia*, March 14, 1927, p. 1. "The Return to Reason" and "The Return to Order" not only espoused almost identical programs of authoritarian neoclassicism, but also shared the same supposed enemies and targets of attack. Dada was, of course, one of them, so it seems useful in this context to recall the attitudes of the literary neoclassicist T. S. Eliot towards dada: "Mr. Aldington treated Mr. Joyce as a prophet of chaos and wailed at the flood of Dadaism which his prescient eye saw bursting forth at the tap of the magician's rod. . . . A very great book may have a very bad influence indeed. . . . A man of genius is responsible to his peers, not to a studio full of uneducated and undisciplined coxcombs" (T. S. Eliot, "Ulysses, Order and Myth," *The Dial*, 75 [1923]: 480-481).

14. Pablo Picasso, in conversation with Christian Zervos, in *Cahiers d'Art* 10, nos. 7-10 (1935): 173.

15. Christian Schad, statement in exhibition catalogue, "Christian Schad," Galerie Würthle, Vienna, 1927. See also a nearly identical statement by the former expressionist Otto Dix: "The new element of painting for me resides in the intensification of forms of expression which *in nuce* exist already as givens in the work of *old masters*" (in *Das Objekt ist das Primäre*, Berlin, 1927). Compare this with the statement by George Grosz, a peer of Schad

The idealization of the painter's craft, the hypostasis of a past culture that serves as a fictitious realm of successful solutions and achievements that have become unattainable in the present, the glorification of the Other culture—in this case Italy—all of these features—currently discussed and put into practice once again—recur through the first three decades of twentieth-century modernism. They seek to halt that modernism and to deny its historical necessity as well as to deny the dynamic flux of social life and history through an extreme form of authoritarian alienation from these processes. It is important to see how these symptoms are rationalized by the artists at the time of their appearance, how they are later legitimized by art historians, and how they are finally integrated into an ideology of culture.

The concepts of "aesthetic paradox" and "novelty," essential features of avant-garde practice, serve as explanations for these contradictions. Here, for example, is Christopher Green's justification for Cocteau's and Picasso's neoclassicism:

> *For Cocteau a return to narrative clarity and to form in the novel did not mean a denial of paradox, and in the same way neither did a return to representation in painting. Indeed it seems possible that it was at least partially out of a sense of paradox that Picasso turned against the antirepresentational dogma associated with Cubism to revive Ingres in 1915. . . . Cocteau suggests that where audacity had become convention—as in the Parisian avant-garde—the resurrection of the old modes could create a special kind of novelty: that looking backwards the artist could even more dramatically look forward. There is no direct evidence that Picasso consciously aimed to create such a paradox, but the fact remains . . . that by turning back he did achieve novelty and that his perverse development of Synthetic Cubism and representational styles alongside one another between 1917 and 1921 was calculated to throw the paradox implicit in his progressive move backwards into the highest possible relief.*[16]

The Carnival of Style

The degree of congruity between Cocteau's antimodernist stance (or should we say cliché of ahistorical thought?) and the arguments against avant-garde practice in the art press's current discussion of postmodernism is striking. The stereotype of the avant-garde's audacity having become convention is, of course, used primarily by those who want to disguise their new conservatism as its own kind of audacity (Cocteau at the time of "Rappel à l'Ordre" had just turned to Catholicism). They deny the fact that conventionalization itself

and Dix: "The return to French classicist painting, to Poussin, Ingres, and Corot, is an insidious fashion of *Biedermeier*. It seems that the political reaction is therefore followed by an intellectual reaction" (in *Das Kunstblatt*, 1922, as a reply to Paul Westheim's inquiry "Towards a New Naturalism?").

16. Christopher Green, *Léger and the Avant-Garde* (New Haven: Yale University Press, 1976), pp. 217-218.

Christian Schad.
*Portrait of a Woman
(Relief) (L'image
d'une femme),* 1920.
Painted wood relief
with collage, 23⅝ x
11¾ x 4″ (60 x 30 x 10
cm). Collection
Christian Schad,
Keilberg

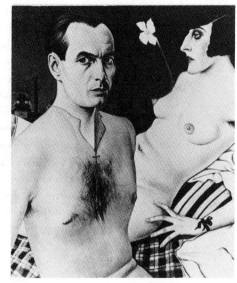

Christian Schad. *Self-
Portrait with Model
(Selbstbildnis mit
Modell),* 1927. Oil on
canvas, 29⅞ x 24½″
(76 x 62 cm).
Collection Wolf
Uecker, Hamburg

Kasimir Malevich.
*Suprematist Compo-
sition (Black Cross)
(Suprematichezkay
Kompozitsya),* after
1920. Oil on canvas,
43¼ x 43¼″ (110 x
110 cm). Russian
Museum, Leningrad

Kasimir Malevich.
*Self-Portrait
(Avtoportret),* 1933.
Oil on canvas, 28¾ x
26″ (73 x 66 cm).
Russian Museum,
Leningrad

Alexander
Rodchenko.
*Oval Hanging
Construction No. 12
(Mobil),* ca. 1920.
Painted plywood and
wire, 33 x 23 x 21″
(83.5 x 58.5 x 43.3
cm). The George
Costakis Collection,
Athens

Alexander
Rodchenko.
*Romance (Circus
Scene) (Tsirk),* 1935.
Oil on canvas, 35½ x
27¼″ (90.5 x 69 cm).
Tretayakov Museum,
Moscow

is a maneuver to silence any form of critical negation, and they wish to share in the benefits that bourgeois culture bestows on those who support false consciousness as it is embodied in cultural conventions. With regard to historical eclecticism, the congruity between the neoclassicists of the 1920s and the contemporary figuration is even more astounding. Intellectual acrobatics are needed to make the ideological stance look like an organic historical necessity, as opposed to a construct determined by extreme social and political factors. Whatever we are to understand by a "progressive move backwards" or a "paradox as novelty," and however Green's observation of Picasso's "perverse development" indicates his limited awareness of the contradictions resulting from the art historian's need to accommodate a cultural notion of the master who necessarily moves from achievement to achievement, it becomes even more evident that the art historian's maneuvers cannot explain the contradictions when we read:

> His [Picasso's] work between 1917 and 1921, ranging as it did from a
> gay Synthetic Cubism to a sober Classicism repeatedly confirmed the
> irrelevance for him of having a style and the relevance for him of
> Cocteau's idea of "style." The bright color planes of Cubism are right
> for the carnival brilliance of the 1918 Arlequin, the sheer figurative
> weight of Roman fresco painting and of Ingres' Madame Moitessier were
> right for the monumental stability of La Femme assise lisant; the
> implication was that any style, old or new, could be adapted to
> Picasso's needs, could be made subject to his will. [17]

Style, the very gem of reified art-historical thinking, the fiction that there could be a pictorial mode or a discursive practice that might function autonomously—traditionally rejected by artists—is now applied by the artists to imbue these exhausted modes with historical meaning. "All the wasms have become isms," is a vulgar contemporary variation on the theme of historicism put forward by the self-styled spokesman of postmodernist architecture, Charles Jencks.

Style then becomes the ideological equivalent of the commodity: its universal exchangeability, its free-floating availability indicating a historical moment of closure and stasis. When the only option left to aesthetic discourse is the maintenance of its own distribution system and the circulation of its commodity forms, it is not surprising that all "audacities have become convention" and that paintings start looking like shop windows decorated with fragments and quotations of history.

None of the manifold features of this eclecticism should be seen as random; they confirm one another in an intricate network of historical meaning, which may, however, be read differently from the intentions of the authors or the interests of their audience and the art historians who constitute their cultural reception. This transformation of the subversive function of aesthetic produc-

17. Ibid.

tion to plain affirmation necessarily manifests itself in every detail of production. The discovery of "history" as a treasure trove into which one might dip for the appropriation of abandoned elements of style is but one obvious step. The secret attraction of the iconography of Italian theater for Picasso and others at that time becomes more comprehensible in such a perspective. The Harlequins, Pierrots, Bajazzos, and Pulcinelles invading the work of Picasso, Beckmann, Severini, Derain, and others in the early twenties (and, in the midthirties, even the work of the former constructivist/productivist Rodchenko in Russia) can be identified as ciphers of an enforced regression. They serve as emblems for the melancholic infantilism of the avant-garde artist who has come to realize his historical failure. The clown functions as a social archetype of the artist as an essentially powerless, docile, and entertaining figure performing his acts of subversion and mockery from an undialectical fixation on utopian thought.[18]

This carnival of eclecticism, this theatrical spectacle, this window dressing of self-quotation becomes transparent as a masquerade of alienation from history, a return of the repressed in cultural costume. It is essential to the functioning of historicism and its static view of history that it assemble the various fragments of historical recollection and incantation according to the degree of projection and identification that these images of the past will provide for the needs of the present. Quite unlike the modernist collage, in

18. When Max Beckmann in the twenties referred to himself as the "alienated clown and the mysterious king" he expressed precisely the unconscious dilemma of the artist's fluctuation between authoritarian rule and melancholy, as George Steiner puts it in his introduction to *The Origin of German Tragic Drama:* "Prince and puppet are impelled by the same frozen violence" (p. 18). Renato Poggioli described this dilemma without coming to an adequate understanding: "Aware that bourgeois society looks at him only as a charlatan the artist deliberately and ostentatiously assumes the role of the comic actor. From this stems the myth of the artist as Pagliaccio and mountebank. Between the alternating extremes of self-criticism and self-pity, the artist comes to see himself as a comic victim and sometimes as a tragic victim, although the latter seems to be predominant" (Renato Poggioli, "The Artist in the Modern World," in *The Spirit of the Letter* [Cambridge, Mass.: Harvard University Press, 1965], p. 327).

This new icon of the clown is only matched in frequency in the paintings of that period by the representation of the *manichino*, the wooden puppet, the reified body, originating from both shop-window decoration and from the props of the classical artist's studio. If the first icon appears in the context of the carnival and the circus as the masquerades of alienation from present history, the second appears on the stage set of reification. With due historical transformation we can observe parallel phenomena in the iconography of the "New Painting." As described in the following example: "The comic and the self-effacing aspects . . . loom very large (and very small) in the work of many recent artists. Miniaturization, stick figures, dimpled dollies, micro-Greeks and the humanoid progeny of Krazy Kat are all parts of an ever increasing Lilliputian population; the doll house syndrome is very much with us" (Klaus Kertess, "Figuring It Out," *Artforum* 19, no. 3 [November 1980]: 33-34). Or, a more adequate critical understanding of these phenomena: "In another of a long string of ironic (?) refusals of virtuosity and 'sensitivity,' painters have recently adopted a reduced, brutish figuration (seemingly chosen from a lexicon of the drastically damaged mentally) whose nihilism strikes not at any society in particular, but at 'civilization'—a familiar desperate move" (Martha Rosler, unpublished notes on quotation).

which various fragments and materials of experience are laid bare, revealed as fissures, voids, unresolvable contradictions, irreconcilable particularizations, pure heterogeneity, the historicist image pursues the opposite aim: that of synthesis, of the illusory creation of a unity and totality which *conceals* its historical determination and conditioned particularity.[19] This appearance of a unified pictorial representation, homogeneous in mode, material, and style, is treacherous, supplying as it does aesthetic pleasure as false consciousness, or vice versa. If the modernist work provides the viewer with perceptual clues to all its material, procedural, formal, and ideological qualities as part of its modernist program, which therefore gives the viewer an experience of increased *presence* and autonomy of the self, then the historicist work pretends to a successful resolution of the modernist dilemma of aesthetic self-negation, particularization, and restriction to detail.

The Returns of the New

The meaning structure of art seems to have been undergoing reorganization while the market merely faltered briefly and then regained its stride. The seventies may turn out to have been a revanchist period in which controlling influences within audience and market elites regrouped to reestablish the stratification of the audience and its objects, thereby reasserting, for example, the preeminence of painting as artifactual meaning bearer and as tangible investment.

—Martha Rosler, "Lookers, Buyers, Dealers, Makers: Thoughts on Audience"

Perceptual and cognitive models and their modes of artistic production function in a manner similar to the libidinal apparatus that generates, employs. and receives them. Historically, they lead a life independent of their original contexts and develop specific dynamics: they can be easily reinvested with different meanings and adapted to ideological purposes. Once exhausted and made obsolete by subsequent models, these production modes can generate the same

19. These "concealed collages" in painting represent a false unification. Fredric Jameson describes this analogous attempt at unification in literature: ". . . the mirage of the continuity of personal identity, the organizing unity of the psyche or the personality, the concept of society itself, and not least, the notion of the organic unity of the work of art" (*Fables of Aggression* [Berkeley: University of California Press, 1980], p. 8). The term "painted collages" was used by Max Ernst in his "Au-delà de la Peinture" in 1936 to describe the painting of Magritte and Dali. Ernst was not able to provide a historical differentiation between the original collage techniques and their implications and the attempt of renewed painterly unification of fragmentation, fissures, and discontinuity of the plastic language. Since then several authors have described the phenomenon of the "painted collage" in the neoclassicist paintings and their peculiar unreal spatiality, a surface and pictorial space that seem to be made of glass or ice. See, for example, Wieland Schmied, "L'Histoire d'une influence: 'Pittura Metafisica' et 'Nouvelle Objectivité,' " in *Les Réalismes 1919-1939*, p. 22. This is of course the spatial configuration of the static melancholic experience which is fixated on the authoritarian images of the alien and the ancient and that recognizes itself in the shimmering surface of classicist painting that seems to contain life in a shrine.

nostalgia as does iconic representation for an obsolete code. Emptied of their historical function and meaning, they do not disappear but rather drift in history as empty vessels waiting to be filled with reactionary interests in need of cultural legitimation. Like other objects of cultural history, aesthetic production modes can be wrenched from their contexts and functions, to be used to display the wealth and power of the social group that has appropriated them.

To invest these obsolete modes with meaning and historical impact requires, however, that they be presented as *radical* and *new*. The secret awareness of their obsolescence is belied by the obsession with which these regressive phenomena are announced as innovation. "The New Spirit of Painting," "The New Fauves," "Naive Nouveau," "Il Nuove Nuove," "The Italian New Wave" are some of the labels attached to recent exhibitions of retrograde contemporary art (as though the prefix *neo* did not indicate the restoration of preexisting forms). It is significant in this regard that the German neoexpressionists who have recently received such wide recognition in Europe (presumably to be followed by a similar acclaim in North America) have been operating on the fringes of the German art world for almost twenty years. Their "newness" consists precisely in their current historical availability, not in any actual innovation of artistic practice.

The historical specificity of iconographic codes is generally more apparent than that of production procedures and materials. It had seemed until recently, for example, that the representation of saints and clowns, of female nudes and landscapes, was entirely proscribed as an authentic expression of individual or collective experience. This proscription did not extend, though, to less conspicuous aspects of pictorial and sculptural production. Excited brushwork and heavy impasto paint application, high contrast colors and dark contours are still perceived as "painterly" and "expressive" twenty years after Stella's, Ryman's, and Richter's works demonstrated that the painted sign is not transparent, but is a coded structure which cannot be an unmediated "expression." Through its repetition the physiognomy of this painterly gesture so "full of spontaneity" becomes, in any case, an empty mechanics. There is only pure desperation in the recently reiterated claim of "energism," which betrays a secret foreboding of the instant reification that awaits such a naive notion of the liberating potential of apolitical and undialectical aesthetic practices.

But the intentions of the artists and their apologists remain to be understood, because contrary to their claim to psychic universality they in fact "express" only the needs of a very circumscribed social group. If "expressivity" and "sensuousness" have again become criteria of aesthetic evaluation, if we are once again confronted with depictions of the sublime and the grotesque then that notion of sublimation which defines the individual's work as determined by alienation, deprivation, and loss is reaffirmed. This process is simply described by Lillian Robinson and Lise Vogel:

> *Suffering is portrayed as a personal struggle, experienced by the individual in isolation. Alienation becomes a heroic disease, for which there is no social remedy. Irony masks resignation to a situation one cannot alter or control. The human situation is seen as static, with*

certain external forms varying but the eternal anguish remaining. Every political system is perceived to set some small group into power, so that changing the group will not affect our "real" (that is, private) lives. . . . Thus simply expressed, the elements of bourgeois ideology have a clear role in maintaining the status quo. Arising out of a system that functions through corporate competition for profits, the ideas of the bourgeoisie imply the ultimate powerlessness of the individual, the futility of public action, and the necessity of despair.[20]

Modernist high culture canonized aesthetic constructs with the appellation "sublime" when the artists in question had proven their capacity to maintain utopian thought in spite of the conditions of reification, and when, instead of actively attempting to change those conditions, they simply shifted subversive intentions into the aesthetic domain. The attitude of individual powerlessness and despair is already reaffirmed in the resignation implicit in a return to the traditional tools of the craft of painting and in the cynical acceptance of its historical limitations and its materially, perceptually, and cognitively primitivist forms of signification.

Such paintings, experienced by a certain audience as sensuous, expressive, and energetic, perform and glorify the ritual of instant excitation and perpetually postponed gratification that is the bourgeois mode of experience. This bourgeois model of sublimation—which has, of course, been countered by an avant-garde tradition of negation, a radical denial of that model's perpetrations of the extreme division of labor and specialization of sexual role behavior— finds its appropriate manifestation in the repeated revitalization of obsolete representational and expressive pictorial practices. It is not accidental that Balthus—champion of the bourgeois taste for high titillation with his scopophilic pictures of sleeping or otherwise unaware adolescent female nudes—has recently received renewed acclaim and is regarded as one of the patriarchal figures of the "new" figuration. Nor is it accidental that not *one* of the German neoexpressionists or the Italian Arte Cifra painters is female. At a time when cultural production in every field is becoming increasingly aware of, if not actively countering, the inherent oppression of traditional role distinctions based on the construction of sexual difference, contemporary art (or at least that segment of it that is currently receiving prominent museum and market exposure) returns to concepts of psychosexual organization that date from the origins of bourgeois character formation. The bourgeois concept of the avant-garde as the domain of heroic male sublimation functions as the ideological complement and cultural legitimation of social repression. Laura Mulvey has analyzed this phenomenon in the context of the "visual pleasure" of cinematic experience:

Woman then stands in patriarchal culture as signifier for the male other, bound by a symbolic order in which man can live out his

20. Lillian Robinson and Lise Vogel, "Modernism and History," *New Literary History* 3, no. 1 (Autumn 1971): 196.

phantasies and obsessions through linguistic command by imposing them on the silent image of woman still tied to her place as bearer of meaning, not maker of meaning.[21]

And Max Kozloff puts it explicitly in the context of the visual arts:

Further scouting might produce more evidence that virility is often equated with the probing of space or the masterful brushing of a surface. The metaphor of sculptural extension or battling with the canvas is easily sexualized because it conflates two desirable goals associated with the energy of creation. With Expressionist theory, German and American, we are never far removed from its special aura. . . . The imagery of modern art, of course, is rich with overtones of masculine aggression and depersonalization of woman.[22]

The abandonment of painting as sexual metaphor that occurred around 1915 implied not only formal and aesthetic changes but also a critique of traditional models of sublimation. This is most evident in Duchamp's interest in androgyny and in the constructivists' wish to abolish the production mode of the individual master in favor of one oriented to collective and utilitarian practice. In contradistinction, those painting practices which operate under the naive assumption that gestural delineation, high contrast color, and heavy impasto are immediate (unmediated, noncoded) representations of the artist's desire propagate the traditional role model; and they do so far more effectively than the painting practices which systematically investigate their own procedures. The former's attraction and success, its role and impact with regard to notions of high culture and the hierarchy of the visual arts, are governed by its complicity with these models of psychosexual organization. Carol Duncan has described how psychosexual and ideological concepts interrelate, how they are concealed and mediated in early twentieth-century expressionist painting:

According to their paintings, the liberation of the artist means the domination of others; his freedom requires their unfreedom. Far from contesting the established social order, the male-female relationship that these paintings imply–the drastic reduction of women to objects of specialized male interests–embodies on a sexual level the basic class relationship of capitalist society. In fact such images are splendid metaphors for what the wealthy collectors who eventually acquired them did to those beneath them in the social as well as the sexual hierarchy. However, if the artist is willing to regard women as merely a means to his own ends, if he exploits them to achieve his boast of virility, he, in his turn, must merchandise and sell himself–an illusion of himself and

21. Laura Mulvey, "Visual Pleasure and Narrative Cinema," *Screen* 16, no. 3 (Autumn 1975): 7. [Reprinted in this volume, see p. 360.]

22. Max Kozloff, "The Authoritarian Personality in Modern Art," *Artforum* 12, no. 9 (May 1974): 46.

his intimate life—on the open, competitive avant-garde market. He must promote (or get dealers and critic friends to promote) the value of his special credo, the authenticity of his special vision, and—most importantly—the genuineness of his antibourgeois antagonism. Ultimately, he must be dependent on and serve the pleasure of this very bourgeois world or enlightened segments of it that his art and life seem to contest.[23]

Inasmuch as this sexual and artistic role is itself reified, *peinture*—the fetishized mode of artistic production—can assume the function of an aesthetic equivalent and provide a corresponding cultural identification for the viewer. Not surprisingly, then, both German neoexpressionists and Italian Arte Cifra painters draw heavily upon the stock of painterly styles that predate the two major shifts in twentieth-century art history: fauvism, expressionism, and Pittura Metafisica before Duchamp and constructivism; surrealist automatism and abstract expressionism before Rauschenberg and Manzoni—the two essential instances in modern art when the production process of painting was radically questioned for its claim to organic unity, aura, and presence, and replaced by heterogeneity, mechanical procedures, and seriality.

The contemporary regressions of "postmodernist" painting and architecture are similar in their iconic eclecticism to the neoclassicism of Picasso, Carrà, and others. A variety of production procedures and aesthetic categories, as well as the perceptual conventions that generated them, are now wrested from their original historical contexts and reassembled into a spectacle of availability. They postulate an experience of history as private property; their function is that of *decorum*. The gaudy frivolity with which these works underscore their awareness of the ephemeral function they perform cannot conceal the material and ideological interests they serve; nor can their aggressivity and bravura disguise the exhaustion of the cultural practices they try to maintain.

The works of the contemporary Italians explicitly revive, through quotation, historical production processes, iconographic references, and aesthetic categories. Their techniques range from fresco painting (Clemente) to casting sculpture in bronze (Chia), from highly stylized primitivist drawing to gestural abstraction. Iconographic references range from representations of saints (Salvo) to modish quotations from Russian constructivism (Chia). With equal versatility they orchestrate a program of dysfunctional plastic categories, often integrated into a scenario of aesthetic surplus: freestanding figurative sculpture combined with an installation of aquatint etchings, architectural murals with small-scale easel paintings, relief constructions with iconic objects.

The German neoexpressionists are equally protean in their unearthing of atavistic production modes, including even primitivist hewn wood polychrome sculpture, paraphrasing the expressionist paraphrase of "primitive" art (Immendorff). The rediscovery of ancient Teutonic graphic techniques such as

23. Carol Duncan, "Virility and Domination in Early Twentieth Century Painting," *Artforum* 12, no. 10 (June 1974): 38.

woodcuts and linocuts flourishes (Baselitz, Kiefer), as does their iconography: the nude, the still life, the landscape, and what these artists conceive of as allegory.

Concomitant with the fetishization of painting in the cult of *peinture* is a fetishization of the perceptual experience of the work as *auratic*. The contrivance of aura is crucial for these works in order that they fulfill their function as the luxury products of a fictitious high culture. In the tangibility of the auratic, figured through crafted surface textures, aura, and commodity coalesce. Only such synthetic uniqueness can satisfy the contempt that the bourgeois character holds for the "vulgarities" of social existence; and only this "aura" can generate "aesthetic pleasure" in the narcissistic character disorder that results from this contempt. Meyer Schapiro saw this symbiotic relationship between certain artists and their patrons in 1935: "[The artist's] frequently asserted antagonism to organized society does not bring him into conflict with his patrons, since they share his contempt for the 'public' and are indifferent to practical social life." [24]

The aesthetic attraction of these eclectic painting practices originates in a nostalgia for that moment in the past when the painting modes to which they refer had historical authenticity. But the specter of derivativeness hovers over every contemporary attempt to resurrect figuration, representation, and traditional modes of production. This is not so much because they actually derive from particular precedents, but because their attempt to reestablish forlorn aesthetic positions immediately situates them in historical secondariness. That is the price of instant acclaim achieved by affirming the status quo under the guise of innovation. The primary function of such cultural re-presentations is the confirmation of the hieratics of ideological domination.

National Identity and Product Protection

. . . but the European has been unhoused for a long time, he is a déraciné, *and as he could in no way face up to it and did not have the courage to admit it, he became a* parvenu. *To be a* parvenu *means to maintain the pretense of being at home in the world . . .*

—Otto Freundlich, *Bulletin D,* 1919

If the object status of historicist work is that of private property, and fashion the discourse in which it manifests and maintains itself, then it is only natural that the work itself has the characteristics of the cliché: compulsively repeated gestures emptied of meaning and congealed into grotesques. Beyond the obsolete and stereotyped conception of the artist's role and character; beyond the fetishized conventions, procedures, and materials which we have analyzed, these clichés are most easily recognized in the artists' call for a return to national culture with its "roots and laws."

Carrà's demand for *italianità* in the 1920s now recurs in both Italian and German painting as the claim of national cultural identity. But such a

24. Meyer Schapiro, quoted in Kozloff, "Authoritarian Personality," p. 47.

claim cannot hide its economic function as product protection in the increasingly competitive international art market. Its ideological function has been defined by Fredric Jameson in another context:

> *National allegory should be understood as a formal attempt to bridge the increasing gap between the existential data of everyday life within a given nation-state and the structural tendency of monopoly capital to develop on a worldwide, essentially transnational scale. . . .*[25]

Just as history has been rediscovered as an inexhaustible source for fictions of identity and subjectivity in commercial culture (fashion, advertising, etc.), so the regressive practices of "high" cultural production provide luxury goods directed at the identity and subjectivity of the managerial class. When Lenin said that "Nationality and Fatherland are essential forms of the bourgeois system," he could hardly have anticipated that "history" would subsequently assume the same function. The nostalgia of artistic production for its own past conventions corresponds to this class's nostalgia for its past processes of individuation at the time of its historical ascendancy.

The very same call for a return to the fictions of national and cultural identity as we observed in the regressive art of the twenties is now taking place in Arte Cifra and neoexpressionism. Frequent references to the late de Chirico and the painterly manner of Sironi's work of the twenties occur in contemporary Italian painting, while the current German painters refer to the pictorial characteristics and production techniques of German expressionism.

The reference to expressionism in contemporary West German art is the natural move to make at a time when the myth of cultural identity is to be established specifically against the dominance of American art during the entire period of reconstruction. Since the Second World War, expressionism, the "German intuition" of early twentieth-century modern painting, has received increasing esteem. It had of course lacked just this esteem in the post-World War I period, prior to its eventual suppression under fascism. But during the early sixties skyrocketing prices indicated that expressionism had achieved the status of a national treasure, the best of the pre-Fascist heritage of German culture. As opposed to the political radicalism of Berlin dada, expressionism presented an avant-garde position acceptable to the newly reconstituted upper middle class, and it thus became the key object for historical study, collection, and speculation. The apolitical humanitarian stance of the expressionist artists, their devotion to spiritual regeneration, their critique of technology, and their romanticization of exotic and primal experience perfectly accorded with the desire for an art that would provide spiritual salvation from the daily experience of alienation resulting from the dynamic reconstruction of postwar capitalism.

The generation of contemporary neoexpressionists—now in their forties—received their education during this period from artists who had themselves only recently learned the lessons of post-surrealist automatism as represented

25. Jameson, *Fables of Aggression*, p. 94.

(Above) Max Beckmann. *Carnival (Fastnacht),* 1920. Oil on canvas, 73⅜ x 36″ (186.6 x 91.5 cm). Private collection, Hamburg

(Above right) Gino Severini. *The Two Polinchinelle (Les deux Polichinelles),* 1922. Oil on canvas, 36¼ x 24″ (92 x 61 cm). Gemeentemuseum, The Hague

(Right) Giorgio de Chirico. *Portrait of Guillaume Apollinaire (Bildnis des Guillaume Apollinaire),* 1914. Oil on canvas, 32⅛ x 25½″ (81.5 x 65 cm). Musée National d'Art Moderne, Centre National d'Art et Culture Georges Pompidou, Paris

by *art informel* and abstract expressionism. The first "scandals" of individual achievement of the present generation occurred in the early sixties, when they "dared" to reintroduce figurative subject matter and highly expressive gestural and chromatic qualities into their art. Their "courage" consisted, then, precisely in committing themselves to the emerging myth of Germany's cultural heritage and national identity through the adoption of the artist's traditional role and the willful ignorance or rejection of all the aesthetic, epistemological, and philosophical developments of the first two decades of the century.

Originally—that is, in the early to mid-sixties—some of these artists had produced work of considerable interest. (The early activities of Immendorff at the Düsseldorf Academy and his subsequent LIDL happenings, and the early work of the East German "primitivist" painter Penck are cases in point.) But subsequent to their discovery by the market and museums, these painters underwent a stylistic streamlining that resulted in the "movement" of neoexpressionism. The first step was the return to large-scale easel painting. For that purpose individual eccentricities of aesthetic activity had to be sacrificed, as did all references to twentieth-century developments contesting the practice of painting. The second step was the conversion of the various idiosyncratic activities of the artists into a homogeneous neoexpressionist style.

The neoexpressionists and their apologists understandably reject an exclusive alignment with the German expressionist patrimony, since their painterly erudition and ambition extends to an assimilation of the pictorial standards of the New York School and the economic value set by it. Any art that wants to supplant the dominance of American art through the programmatic return to a national idiom can only be successful on the market if it acknowledges the dominant "foreign" style. After all it had been the major problem of postwar European painting that it never achieved the "qualitative" level of the New York School (just as, according to Greenberg, the major problem facing American painting before the war was attaining the level of "quality" of the School of Paris). This is particularly evident in the work of the neoexpressionist Georg Baselitz, whose canvases' size and scale, drawing, and painterly gesture owe as much to abstract expressionism as to German expressionism.

The successful institutionalization of neoexpressionism has required a complex and subtle set of maneuvers by the market and museums. For example, historical continuity had to be established in order to legitimize the neoexpressionists as heirs to the German cultural heritage. A recent example of how this authentication may be achieved is a spectacular case of *Geschichtsklitterung* (eclectic historicist construct), the *First Study for a Sculpture* by Baselitz. The large-scale, seated figure, hewn out of a wood block, raising its right arm in such a way that hostile critics have called it a Fascist gesture, was recently shown at the Whitechapel Gallery in London. For this exhibition, it was surrounded by the late triptychs of Max Beckmann, thus establishing the historical pedigree, the continuity of specifically German art. Thus accredited with authenticity, local products can succeed on the international market.

A second strategy, complementing this contrived national continuity, is that of carefully placing the work in the context of the contemporary international avant-garde. For example, a reproduction of a painting by the neoprim-

itivist Penck appears on the frontispiece of a catalogue for a recent exhibition of the Italian artists Fabro, Kounellis, Merz, and Paolini at the Kunsthalle, Bern—one of the strongholds of German neoexpressionism. And more overtly, the catalogue introduction states the museum director's proposal to combine work by this group of truly significant Italian artists with that of the neoexpressionists who are described as their "Nordic" counterparts. Thus the intellectual subtlety and analytic clarity of these Italian artists is conferred upon the reactionary German artists, when the proper German peers of these Italians are, of course, Darboven, Palermo, and Richter.

Critical Clichés, Manufactured Visions

Social reasons for this impotence [of historicism]: the fantasy of the bourgeois class ceases to focus on the future of the forces of productivity which it released. The specific Gemütlichkeit *of the middle of the century results from this conditioned fading away of social fantasy. The desire to have children is only a weaker stimulation of potency in comparison to the images of the future that this social fantasy once engendered.*

—Walter Benjamin, *"Zentralpark"*

When art emphasizing national identity attempts to enter the international distribution system, the most worn-out historical and geopolitical clichés have to be employed. And thus we now see the resurrection of such notions as the Nordic versus the Mediterranean, the Teutonic versus the Latin. A typical formulation of the clichéd idea of German character appears in an art historian's comment on a neoexpressionist painter's work: "The tendency of German art to literature, to profound allegories, and ideological symbolism, but also to the mysticism and ecstasy of an exuberant imagination has found expression here."[26]

Just as the art itself resorts to cliché as the reliable strategy for operating within an obsolete context, so the critics and curators who have become the spokesmen of the "new art" resurrect a critical language of false naiveté and bloated trivialities which forms the terminology of the new subjectivity. The lack of historical specificity and reflection upon methodology, the willful ignorance of radical changes in other fields of research bearing upon aesthetic practice (semiology, psychoanalysis, criticism of ideology) are particularly revealing. Take for example the British art historian and curator Nicholas Serota discussing the manner in which one of the neoexpressionist painters

has adopted the seemingly more traditional ground of the painter of still life. He has created for himself a kind of theatre in which the absurd object, emblems, allegory and metaphor are used to reinterpret universals such as the creation and awakening of life, the interaction of

26. Siegfried Gohr, "Remarks on the Paintings of Markus Lüpertz," in *Markus Lüpertz-Stil Paintings* (London: Whitechapel Gallery, 1979), n.p.

*natural forces, human emotions and ideologies and the experience of
death. For a comparison one has to look back to the triptychs of
Beckmann, though Beckmann's use of narrative structure is quite
different.*[27]

Or, more hyperbolically, Rudi Fuchs, Dutch art historian and director of one
of Europe's most active museums in exhibiting contemporary art, claims that:

*Painting is salvation. It presents freedom of thought of which it is the
triumphant expression. . . . The painter is a guardian-angel carrying
the palette in blessing over the world. Maybe the painter is the darling
of the Gods.*[28]

And the German art historian Siegfried Gohr, in a text published by London's
Whitechapel Gallery, writes:

*The relationships between beauty and terror, eros and death, those time-
honored themes of art, are presented again by the painting. Negativity,
death is introduced as a theme.*[29]

The lack of formal and historical complexity in the painters' works and
the attendant avoidance of genuine critical analysis of their contrived "visions"
results inevitably in a stereotypical critical language. Here, for example, are
two virtually identical statements by two critics writing about different painters:

*The motifs which Georg Baselitz time and again employs in his
paintings are insignificant as content. They are only meaningful within
his pictorial method: as formal points of departure.*[30]

*The value of the motif in these paintings of Lüpertz's lay only in the
way in which he used it as a starting point for the development of a
meaningful activity.*[31]

As was the case in the call to order by regressive artists of the twenties, a
growing aggressivity is now becoming apparent in the manner that these clichés
of vision and language are propagated. With the demise of liberalism, its
underside—authoritarianism—no longer feels inhibited. And it thus comes to the
fore in the guise of irrationality and the ideology of individual expression. In
reaction against social consciousness and political awareness, proto-fascist lib-

27. Nicholas Serota, *Markus Lüpertz-Stil Paintings*, n.p.
28. R. H. Fuchs, *Anselm Kiefer* (Venice: Edizioni "La Biennale di Venezia," 1980),
p. 62.
29. Gohr, "Remarks," n.p.
30. R. H. Fuchs, *Georg Baselitz—Bilder 1977-1978* (Eindhoven: Van Abbemuseum,
1979), n.p.
31. Gohr, "Remarks," n.p.

ertarianism prepares the way for the seizure of state power by a reactionary autocratic elite. Without questioning the reasons for the failure of enlightenment, the end of modernism and the enforced silencing of its critical potential are taken as excuses for indulging in defeat.

The following programmatic statements, couched in a pastiche of Deleuze and Guattari, Stirner, and Spengler, fervently advocate the received ideas of petit bourgeois anarchism in relation to Arte Cifra:

> *Arte Cifra exposes itself as an art of the most extreme subjectivism. . . . The disillusionment is the strongest with those who even at the beginning of the seventies still believed in an immediately imminent collapse of capitalism—generated by criticism and revelation. . . . Now it is much more important to develop new forms which relate to pure intensity, to the indivisibility of desire and to the unconscious investments of desire. Desire therefore assumes a revolutionary position. But as desire itself is always a part of infinitely complicated and ambivalent interdependences, its particular investments must come to bear in their totality, even if they are partially "regressive," "bourgeois," or "nonrevolutionary". . . . The failure of bourgeois enlightenment—well understood long ago in political and ideological thought—was not acknowledged by this (art of the seventies). . . . Arte Cifra attempts a formation of the "here and now". . . . Its aim is the opposite of utopia—it's atopia, the discovery of the other in the immediacy of the present.* [32]

And here, in the explicitly proto-fascist language of an Italian critic:

> *The new force of art is born from this very tension, turning a relationship of quantity into a relationship of intensity. The work is taken from a socially underprivileged position back to an individual centrality, reestablishing the creative need by means of an image in opposition to the shapeless fogginess of social needs.* [33]

Rather than face up to its own bankruptcy and the necessity of political change, this frankly elitist notion of subjectivity ultimately opts for the destruction of the very historical and cultural reality that it claims to possess. The secret longing for destruction as a solution to contradictions that can only be met in political, not cultural, terms, manifests itself in fantasies of catastrophe. This climate of finality—when the end of a class is mistaken for the end of the world—generates apocalyptic and necrophilic visions, first in high art, then spread throughout the culture. Eventually self-destruction can be seen as an

32. Wolfgang Max Faust, *Arte Cifra*, exhibition catalogue, Cologne, 1979, pp. 6-10, author's trans.

33. Achille Bonito Oliva, "The Bewildered Image," *Flash Art*, nos. 96-97 (April 1980): 35.

act of heroism. These tendencies are again to be found in the painting of neoexpressionism and its accompanying criticism:

> It represents one of the great tyrannical gestures in aesthetics: an emperor burning down a city to make way for a new and grander one. As a theme it belongs of course to a larger topological framework which dates back to the beginning of time: renewal and purification through fire. . . . Fire destroys but it also cleanses.[34]

And:

> Last year . . . I accompanied Lüpertz to the Ruhleben crematorium on the outskirts of the city. As we walked slowly down a wide path to the modern crematorium . . . a pall of black smoke began to rise slowly from the chimneys. Suddenly the silence was broken by the sharp report of rifles firing on the British artillery range hidden behind the crematorium. The conjunction was typical of Berlin. Inside the building was a pair of paintings by Lüpertz. . . . They have a quality of universal truth.[35]

The historical "authenticity" of these works is contained, then, in the very retardation and regression which they enact: the continuing domination of the obsolete. In the pathetic farce of their repetition-compulsion, we can still recognize the tragic failure of the original forms of the protest of expressionism. In the mockery and mimicry of contemporary neoexpressionism we see the afterimage of that anarchic and subversive, but ultimately apolitical, radicalism that was doomed to failure, to be appropriated by the very forces that it had set out to oppose. It is Lukács, once again, who has described this mechanism:

> Mythologizing the problems allows one to avoid looking at the phenomena which are criticized as being part of capitalism, or to render capitalism in such a spurious, distorted, and mystified form that the critique does not generate a confrontation of the problems but a parasitic complacency with the system; by inversion, even an affirmation coming from the "soul" can be derived from this critique. . . . Without doubt, expressionism is only one of the many bourgeois ideological currents eventually leading to fascism, and its role as ideological preparation is not any more or less important than currents of the imperialist epoch, inasmuch as they express decadent parasitic features, including all the fake revolutionary and oppositional forces. . . . This schism is deeply inherent in the character of anti-bourgeois expressionism and this abstracting impoverishment of content not only indicates the tendency of expressionism; it is from the very beginning its

34. Fuchs, *Anselm Kiefer*, p. 57.
35. Serota, *Markus Lüpertz*, n.p.

central, insurmountable stylistic problem, because its extraordinary
poverty of content marks a blatant contradiction of the pretense of its
performance, of the hybrid subjective pathos of its representation.[36]

The mock avant-garde of contemporary European painters now benefits from the ignorance and arrogance of a racket of cultural parvenus who perceive it as their mission to reaffirm the politics of a rigid conservatism through cultural legitimation.

Postscript This essay was written in the fall of 1980. Since then the fictions and realities of the art world—in terms of the amount of attention devoted in museums and in the art marketplace to the work discussed here—have fulfilled my own worst fears. What in 1980 still seemed the eccentricities of a particular group of afficionados, collectors, and dealers, have in the meantime been heralded as the new art-historical norms: late Picabia, late de Chirico, Raoul Dufy, and of course Balthus. With these guideposts in mind, historians of twentieth-century art are now encouraged to rewrite history from the perspective of the Reagan Era.

Not since the 1920s has cultural production (or at least that segment of it controlled by the market) made such aggressive claims in asserting its reactionary political affiliations and in its defense of a notion of culture that is right-wing, sexist, and elitist, but also willfully ignorant of the implications of cultural production in different circumstances and contexts. In this respect, I hope that in spite of its sketchiness this essay's depiction of a broader historical panorama may still be of some help in understanding particular cultural formations in the present. (For a recent, thorough discussion of the political and cultural milieu of Europe between the wars—unfortunately unavailable at the time I wrote this essay—see Kenneth Silver, *"Esprit de Corps:* The Great War and French Art, 1914-1925," Ph.D. diss., Yale University, 1981.)

In another respect, however, reality has proven the severe limitations of an art-historical attempt to clarify present-day conditions in terms of a repetition-compulsion of unresolved problems of the past, or in terms of a recycling of artistic strategies which may serve the stereotypical interests of a class that resists, with equal fervor, change in both political and cultural practice. The present situation then may perhaps be less profitably compared with the twenties than I originally suspected, presenting instead conditions which are altogether unique and specific.

While certain American critics now celebrate the "Germanness" of German *angst* in painting, the authenticity of its reflection upon the fascist past, and its reconstitution of national self-consciousness, seldom do they (or, of course, the paintings in question) reflect upon the *real* fears (and practices of protest) brought on by the aggressive policies of the Reagan administration and by the deployment of missiles on the territory likely to be the first "war theater." In a recent interview—in true Picabia manner, at the wheel of his

36. Lukács, " 'Grösse und Verfall' des Expressionismus," p. 116, author's trans.

luxurious sports car—the most bombastic of the German painters claimed, "My generation doesn't worry about survival." Here one recognizes, once again, what motivates this generation of artists: a profound cynicism and a contempt for the social and political reality that surrounds them. They share this contempt with their clients, who are grateful that these artists have put art back where *they* always thought it belonged: on their walls and in their vaults and in the museum (to receive its institutional blessings).

These paintings then function as the perfect mirage (and herein lies the secret of their attraction and success): they assure us that, in a period of conservatism and defunding, the arts are flourishing, and that those who rule are generous in their support of the arts (if it abides by their standards). They tell us that even in the realm of culture the old means of production are still the most viable since they (after all) produce affluence and excellence. But, as Irving Howe has recently maintained, this notion of a culture of excellence is no longer acceptable on historical grounds; indeed, by virtue of its exclusivity and its contempt for the social reality within which it exists, the proposition itself advocates cultural barbarism.

These paintings function as a perfect mirage in another sense as well: they project a mirage-image of individuality and personal freedom. In their mode of production and their iconography, as well as their object-status as auratic works of art, they pretend to be the last bastion against the destruction of individuality and the totalitarian conditions of mass-culture.

When it comes to the production of handcrafted luxury objects, American myth (and the commercial reality to which it contributes) holds that Europeans can do it better. This is due in part to the typical American cliché-image of the European individual as bound to an identity afforded by their ancient nation-states, that is, possessing an identity more ingrained with history, more solid, more profound. The new European painting brings just these clichés to bear, providing the warranty for a satisfaction of precisely those desires for the deeply rooted, the deeply felt, and the solidly produced: in other words, for the true individuality that only the few can have. At the same time, current European painting (German painting in particular) offers an additional attraction which European art of the sixties and seventies—which passed by largely unnoticed in the United States—refused to offer. This new European painting is the first international avant-garde in which reverberates the profound influence of American abstract expressionism. What makes Kiefer, Penck, and Baselitz so attractive to Americans (in particular) is that they teach a new art history lesson, one that begins with Picasso and Matisse, passes through German expressionists and the surrealists (especially Fautrier and the later postwar painting), and then decisively registers the extraordinary impact of Still, de Kooning, Kline, and Pollock. Who would not be seduced by the reflection of one's own national culture in the art of a succeeding generation, especially in a different geopolitical context? So, when we look at a painting by Anselm Kiefer, for example, we see first of all a German national asserting through his art the national authenticity and identity, but also tackling or toying with the distant monstrosity of German Fascism, simultaneously exorcising as it were its power in today's society and performing for us the labor of mourning occasioned by

a barbarism that has quickly receded into the past. But, at the same time, we see an obedient disciple, who now for the first time has encapsulated the lessons of the "School of New York," in exactly the way that generation after generation of American avant-garde artists learned their lessons from the European schools.

Thus the aesthetic mirage fulfills (almost miraculously) all our needs at the same time. It keeps at bay our worst fears about the present—the here-and-now of the Age of Reagan—by projecting them onto the distant historical reality of authoritarian politics in other countries. It vigorously asserts the perpetuation of a hierarchical organization of society and the rule of the individual, emphasizing the cultural legitimation of nationalism as an essential feature of that individualism. And, as with all colonialized representations, it provides an image of obedience and assent: the various foreign cultures validate the hegemony of the dominant culture. (The recent Museum of Modern Art "survey," for instance, showed examples of German, French, Italian, and English, as well as Canadian and Australian neoexpressionism.)

While one might imagine that the flooding of the market with manufactured originality would have to be carefully avoided, it seems that, for the time being at least, that familiar ideologeme—the private, individual, nationalistic, male artist—remains powerful and (paradoxically) can easily withstand an inflationary accumulation and sheer endless repetition of the same originality.

One other shortcoming of this essay—a major one in retrospect—is that it does not make any attempt to analyze the current situation in terms of its economy. Now, more clearly than ever before, drastic structural shifts have taken place in the art world. The number of corporate and private collectors has increased tremendously and, if nothing else, it has become apparent that investment in art, if well managed, can generate interest and revenue exceeding most other small-time investment gambles of the affluent. (We are after all *not* talking about real business, but only about the destruction of surplus capital which traditionally has been invested in luxury goods.) As in the case of all luxury goods (e.g., designer clothes), the desire to possess artworks and the need to use them for the constitution of individuality and social identity not only grows constantly, but can be massively propagated as well. With the rising number of speculators in this gamble, the number of certified artists and products participating in the race has to be dramatically increased. Not only can the original artists not produce quickly enough, but also the products they do produce move very quickly out of the price range of the many newcomers to this (new) stock exchange. We then see the emergence (as in the East Village) of substitute designer ware (often more interesting than the stepped-up manufacturing of the original masters). Now even the most liberal critics would have to recognize as historical reality the view that High Culture *has* after all merged its enterprise with the conditions of the culture industry.

These then are the issues that this essay failed to address in 1980. Their thorough discussion and analysis in terms of the present, and not in the guise of an art-historical exemplum, remains to be carried out.

Hans Haacke. *Painting in Oils– Hommage to Marcel Broodthaers (Oelgemaelde– Hommage a Marcel Broodthaers),* Parts I and II, 1982. Painting in gold frame, 35½ x 29" (90.2 x 73.7 cm), plus brass picture lamp, brass plaque with title, brass stanchions with velvet rope, red carpet runner, 54 feet (16.47 m). Photo- mural represents anti-Reagan/anti- nuclear weapons demonstration, Bonn, June 10, 1982, during Reagan's state visit in Bonn. As exhibited at *Documenta 7,* 1982

Paintings by Francesco Clemente and Keith Haring in the home of Dr. Donald and Mira Rubell, New York City.
(Photo: Louise Lawler, 1983)

Flak from the "Radicals": The American Case against Current German Painting

DONALD B. KUSPIT

In the late 1970s a new German painting arrived on the American

I. scene. Perhaps the climax of that first appearance occurred at the end of 1981, when five German painters—Georg Baselitz, Markus Lüpertz, A. R. Penck, Rainer Fetting, and Salomé—were shown in seven New York art galleries. The new painting was fiercely opposed from the start. Violent anger met its own violence, as if to defy its authority. Its forceful paint and use of the figure were like red flags to the bull of Abstraction. The defenders of abstraction, both conceptual and perceptual, accused the new painting of reactionary authoritarianism. It regressed, they argued, not merely to expressionism (a decadent style) but to painting (an obsolete convention). Above all, the new German painting was said to lack the critical character of modern art—as if abstraction, with its tired strategies of negation, was still critical with respect to society and other art. In sum, the German neoexpressionists, as they were called, were regarded as the creators of a neobourgeois art.

Not only were the German painters "postmodern," as Benjamin H. D. Buchloh wrote, in perhaps the most powerful attack—a Marxist blitzkrieg—on them, they were not even novel. Their "newness" consisted in their "current historical availability, not in any actual innovation of artistic practice." They were a reminder that "the collapse of the modernist paradigm is as much a cyclical phenomenon in the history of twentieth-century art as is the crisis of capitalist economics in twentieth-century political history."[1] The collapse is tied to the renewal of political oppression. The new painting symbolizes this oppression for Buchloh, which is why he regards it as more a social symptom than artistic innovation. It never occurs to him that the modernist paradigm might have collapsed of its own weight—that it might have been a hollow ruin needing only a push to fall in on itself. Buchloh never considers the possibility that modernism might have become an empty stereotype of itself, and that its strategies of "parody and appropriation" might have been overused and

Reprinted from Jack Cowart, ed., *Expressions: New Art from Germany* (St. Louis: The St. Louis Art Museum/Munich: Prestel-Verlag, 1983), pp. 43-55.

1. Benjamin H. D. Buchloh, "Figures of Authority, Ciphers of Regression: Notes on the Return of Representation in European Painting," *October*, no. 16 (Spring 1981): 41. [Reprinted in this volume, see p. 108.]

abused to the point of becoming mechanical reflexes. Nor is it recognized that new critical strategies, rather than old involuntary responses, might be required in a situation in which neither the artistic nor social alternatives are particularly clear. None of these considerations occurs in the criticism of new German painting. It is presented as a handicapped art, crippled by multiple sins of regression—sins of commission adding up to one major sin of omission, namely, the absence of the epistemological understanding of art called "modernism."[2]

Buchloh is the foremost critic attempting to dismiss the new German painters. Thomas Lawson, Douglas Crimp, Peter Schjeldahl, Kim Levin, and the conceptual artist Joseph Kosuth also consistently deny their importance. In one way or another they are regarded as foolishly traditional. But perhaps these critics are not sufficiently self-critical to see their own approaches as conventional and traditional to the point of being obsolete, which is why they may be unable to see the critical point of the new German painting. These critics above all intend to deny its vanguard character, because to acknowledge its radicality would mean for them to deny their own. They have an unwittingly ahistorical and thus subtly irrelevant conception of avant-garde radicality. They refuse to see themselves as traditionalists loyal to an old cause of modernism, for then they would have to see themselves, rather than the Germans, as decadent. Unwilling to reexamine the concept of avant-garde intention, they regard the new German painting as a simulated vanguardism, succeeding in its deception because it looks "different" at the moment.

For these critics, the new German painting is willfully decadent, not only incapable of rising to the heights of modernist criticality. To the extent they can demonstrate the outright decadence of the new German painting—blurring perception of it with their label "neoexpressionist" is an easy way of doing so— they protect their own reputations as progressive and radical. They want the panache of being left-leaning without any conception of what an authentic leftist art and society might be these days. The new German painting is a convenient whipping boy for ineffectual, directionless criticism—a criticality that no longer really knows its goals. Indeed, it is too impotent to imagine any future for art other than the same modernist missionary position of "classical" negation.

For its critics, the major sign of decadence in the new German painting is its return to "the perceptual conventions of mimetic representation"—surely the most misunderstood feature of the new painting. It is not merely a matter of reaffirming referentiality and the hierarchy of figure-ground relationships. Rather, it is a matter of creating a fictional reference, of which the figure is the instrument, to create an illusion of being-natural.[3] The creation of this illusion —to bring into question the artificiality of art and technological society—is a major critical aspect of the new German painting. A kind of artificial natural expression is used to lay bare the artificiality and abstractness of all expression,

2. Douglas Crimp, "The End of Painting," *October*, no. 16 (Spring 1981): 80.

3. See Donald B. Kuspit, "New German Painting: The Recovery of Expression," in *New Figuration: Contemporary Art from Germany* (Los Angeles: Frederick S. Wight Art Gallery, University of California at Los Angeles, 1983), for a fuller discussion of this idea.

particularly our own modern abstractness, subtly devaluing and distancing us from the world of experience.

The point seems self-evident: whatever access abstraction affords is relinquished by its eventual possession of us. It is as though our power of abstraction—and our apparent power over the world—grows only at the expense of our naturalness. To survive, it must take a scandalous form, such as that shown in the new German painting, where it at once becomes an ideal of sensibility and an invasion from an unexpected, hidden reality. The "natural" shows itself as a case of the return of the repressed in the service of the ego of art. Since we no longer know what it is to be natural, nature is no longer a norm, and there is no norm of what it is to be natural, only the deceptive possibility of being "natural" through the release of repressed attitudes and gestures.

Marxist critics assume that the "natural attitude" to things is the enemy, for it implies a refusal to suspend our relations with them for the sake of an analysis of our attitude toward them. Such a disengagement presumably leads to an abstract understanding of their meaning. But in a world overdetermined by analytic abstractions—artificial understandings of all kinds—which seem to have an "expressivity" of their own, the natural attitude toward things becomes a desirable if elusive goal, a critical factor for survival, and the only method for the recovery of concreteness and engagement. The natural attitude implies the creation of a new kind of concreteness, resistant to abstraction, even questioning the abstractness of its own expression. In the new German painting, concreteness through the skeptical gesture—the disintegrative and self-destructive mark—is the proposed mode of operation of the new natural attitude.

The new German painters question the tendency to take abstraction literally without denying its value as figurative language. This is a not unfamiliar enterprise; all thought and art eventually recur to it, as to a touchstone. But the new German painting's means of accomplishing this critique of abstraction are especially appropriate for our times. The Germans create an illusion of intense but bizarre naturalness, involving the invention of "disfigured" forms that are recognizable as still existing within the horizon of the natural. These forms, transformed by the experience of abstraction, so they become allegorical, are energetically—aggressively—asserted. They have at once the conceptual power of authoritative abstractions and the "natural" power of things to which we are concretely—passionately—committed. They are doubly focused, and thus become fixed points of reference as limits to our becoming and signs of its elemental forcefulness. The historical German symbols within the new painting show this double character, making them especially trenchant. They are at once abstract specters and natural realities; on the one hand they are fatalistically accepted as irrevocable absolutes and on the other they are overcome by being artistically appropriated and experienced, digested by a powerful creative process. The forms are partly demonic, nightmarishly possessing us in a bad dream of history from which we cannot awaken, and partly "second nature," to which we must become critically reconciled, over which we must imaginatively triumph.

In the new German paintings we watch these signs which no longer

(Top left) Georg Baselitz. *Strandbild, 4,* 1980, in the home of Mr. and Mrs. Robert Kaye, Rumson, New Jersey. (Photo: Louise Lawler, *Baselitz and Hanging Lamp, New Jersey,* 1983); (Top right) Georg Baselitz. *Die Aehrenleserin,* 1978. Oil on canvas, 129 x 97" (327.6 x 246.4 cm). (Photo: Zindman/Fremont; courtesy Mary Boone-Michael Werner Gallery); (Above) From *The New York Times Magazine,* April 24, 1983, pp. 28–29: ''Georg Baselitz. The artist, far right, with an assistant in his home, a magnificent former abbey south of Hamburg. Baselitz recognized that the German genius is not for abstract painting but for narrative and symbol, evocation and incantation.'' (Photo: Ken Probst/Outline)

clearly signify, yet are still charged with significance. They are being absorbed by a new generation of Germans who have not experienced the reality of which the signs are the vestige, yet upon whom they impinge. Yielding their paralyzing, hypnotic abstractness in their passage from the collective unconscious through the artist's personal consciousness, these symbols can finally be laid to rest. In Anselm Kiefer, for example, we watch these signs—still hauntingly contemporary—of German historical and cultural power, being laid to rest in the collective consciousness by being treated idealistically as unconditional sources of artistic power. They become freshly originative, and are thus revealed as archetypal. They suggest that art still has a redemptive power of transformation over history—that art can be an effective intervention in history, using its materials to reveal something more fundamental, yet inseparable from it. Such artistically transformed historical signs—transformed to reveal the artistic process in history—are no longer restless, aimless ghosts but latent forces that give, and take, "natural" form. Kiefer's use of paint is like the use of fire to cremate the bodies of dead, however dubious, heroes, in the expectation of their phoenixlike resurrection in another form. The new German painters perform an extraordinary service for the German people. They lay to rest the ghosts—profound as only the monstrous can be—of German style, culture, and history, so that the people can be authentically new. They are collectively given the mythical opportunity to create a fresh identity. They can now identify themselves without first being identified as the "strange Others." They can be freed of a past identity by artistically reliving it.

The new German painting naturalizes a denatured, abstract notion of "being German," without first forcing a new German nature upon us. Instead, the figures it offers remain highly ambiguous "disfigures," who inhabit an allegorical realm. They are forever disfigured because there are no norms of natural appearance to determine them. There is no norm of—or guidelines for—"being German" today. Not being normative, they can signal a new German freedom. Not being actual, they can "naturally" symbolize new German possibility. Thus, to see these pictures is to be confronted with the special necessity and special freedom of the Germanic today. Indeed, it is the same necessity and freedom that constitutes us all, for we are all increasingly possessed by an abstract past that we must transcend. Above all, we are increasingly possessed by the demonic power of abstraction. It makes us forget our potential for naturalness, which, for all its uncertainty, is more of a clue to our future than the certainty our abstract knowledge gives us. The new German painters want to recover this apparently specious naturalness because they regard it as the only alternative to an abstractness that has made us hollow. The disclosure of the hollowness within the superficially solid Germanic insignias is the beginning of the recovery of an uncertain naturalness—a demonstration of an uncertainty which itself can become a source of "naturalness."

II.

The new German painters do not seek unmediated expression, as their critics have thought. Rather, using an already existing code of natural expression which depends on the spontaneous union of opposites in a single gesture, the

German painters attempt to provoke in us resistance to abstraction. But the point is that an abstract gesture that is only superficially spontaneous is used, as in the best of Baselitz, to disintegrate a dominating abstraction, a representation that has acquired the status of an abstraction because of its typicality. What it "represents" is undone, leaving us with the "abstract" naturalness and riskiness of it as an "expression." There is no real appeal to instinct in this use of gesture. From the beginning it is socially determined, just as the figures are culturally conditioned. Neither gesture nor figure tries to escape its overdetermined situation, nor do they attempt to articulate a freedom that does not exist. Rather they together stage a freedom—the freedom to resist mythologized abstractions. This staged freedom, in turn, gives the myth of natural expression substance.

The new German expressionism, then, has nothing to do with the biological utopianism of the old German expressionism. Rather, the new German painting involves a sense of social dis-appearance, a certain "symbolic truth." [4] This accounts for its use of mythological German iconography—one of landscape as well as allegorical emblems. That is, it makes use of old abstractions of culture and history which have disappeared, but still exists as "dis-appearance." To exist as a dis-appearance—as a barren sign—is to be read as an appearance signaling a contradictory and ambiguous state of affairs. In the new German painting there is a vivifying, unresolved contrast between the allegorical figural abstractions embodying old German expectations and the new German energy embedded in hyperactive paint. But the situation may be reversible; an old energy may be renewed by the paint, and a new expectation may be announced by the allegorical figural abstractions. The contrast between old abstractions and a new concreteness and naturalness of energy is crucial to the new German painting. The figural abstractions become more symbolic than allegorical in that they participate in and present the problem rather than represent an unequivocal meaning. And the painterly is probably there less in and for itself than defiantly, as if to create an artificial rawness. For all this sense of manipulation and equivocation, the paintings bespeak a wounded, disturbed state. The tension between the abstract and the energetic creates a sense of untamed expression. They come to us as deviant, incompletely socialized expressions, under the sway of blind "abstract" necessity.

Whether or not this theory is correct, Buchloh's assessment of the new German painters as artists who "internalize oppression" falsifies them in a particularly vicious way. For the two steps of this internalization are classic stages of the development towards fascism: "first in haunting visions of incapacitating and infantilizing melancholy and then, at a later stage, in the out-

4. Alfred North Whitehead, *Adventures of Ideas* (New York: The New American Library, 1955), p. 247. To paraphrase Whitehead, symbolic truth involves the establishing of a community of subjective form between aesthetic appearance and the reality of such dimly perceived things as National Life, or . . . the Essence of God. By putting such dim objective reality in an emotional clothing which changes it into a clear appearance, its subjective form or basis is disclosed—the subjective form of a community (p. 248).

right adulation of manifestations of reactionary power."[5] From helplessness embodied in desperate paint action to fantasy figuration that fulfills the unconscious wish for a strongman leader, Buchloh suggests that the art, perhaps coyly, perhaps unawares, flirts with authoritarianism. It is an art, he and the other critics suggest, without irony and with absolutist demands—an art that provokes with its own naiveté. They do not imagine that the new painterly figuration may involve, in Craig Owens' words, "a *critique* of representation, an attempt to use representation against itself to challenge its authority."[6] In the case of the new German painting representation is used to create a fiction of the natural, a presentational effect that is the implicit ideal of every representation.

Where art once tried to imitate nature, "nature" is now an artistic effect, a fiction achieved through manipulation of representative style. The natural is no longer unconditionally given as a starting point that informs one's abstractions from it, but rather an end to which one must regress, with no certainty that one has ever reached it. Nature is no longer the self-evident touchstone of art, but a desirable and unexpectedly necessary ideal effect and perhaps the only hope for self-innovation in a world where the self is at once abstract and dispensable. The new German painting reminds us that nature has "disappeared" but can be recovered abstractly, which, paradoxically, makes it a more haunting "dis-appearance." As in the past, it is nature which seems to propose "salvation." But ironically it is now absent: nature itself has become as absorbed into abstraction as everything else, and exists only as an uncertain effect of artificial "nature." The "naturalness" offered by the new German painters is a fiction of concreteness, created from representative abstractions. The semblance of nature that exists in these paintings has the power to haunt us rather than to define us. It is not clear whether this makes it more or less alive than when it was taken for granted; the ideal of naturalness remains, however, powerfully possessive of our souls. In the new German painting we see a new return to nature, involving the re-naturalization of denatured gesture and symbol.

The underused style of painterly figuration becomes representative of the natural mode because, being déclassé, its fictionality is already self-evident. In contrast, the overused styles of abstraction have an apparent substantiality that makes it hard to see them as fictions. Since abstraction today is a fiction which no longer signifies, its effect of "presence" is no longer guaranteed; in fact, it increasingly calls itself an effect of absence. The apparent naturalness of abstraction today has to do with belief in itself as the ontological basis of art. But this insistence on its own fundamentality means that it is no longer regarded critically and that it no longer has a critical effect on us. Abstraction today does not, as it once did, force us back on ourselves in a searching critical process. Instead, today it is painterly figuration that comes to us as critically

5. Buchloh, "Figures of Authority," p. 41. [Reprinted in this volume, see p. 108.]
6. Craig Owens, "Representation, Appropriation & Power," *Art in America* 70, no. 5 (May 1982): 9.

significant, forcing us to be self-conscious and self-critical in relation to it. It is not only that the new German painting is in need of explanation, but what we must also explain is why it seems natural to us: we are forced to explain ourselves—to renovate our sense of self. The fact that it comes to us as natural with a question mark gives it enormous critical consequence and enormous power over us. This in part is why the new German painting is an avant-garde art. Like the truly avant-garde, it seems groundless or obscure, yet makes us aware of our unexpectedly compelling relationship to it. Abstract art is no longer compelling or fascinating; it no longer brings us face to face with unexpected forces in ourselves. The new German painting is a compelling and driven art, making us aware of how driven we are. This is why it is not beyond criticism, as abstraction thinks it is.

For abstractionists, expressionism, by reason of its inherent irrationality and unselfconscious extroversion, is the one modern movement that does not originate in self-criticality. At best, it is accepted by them as a feeble attempt to be socially critical and shocking. Yet in the current situation perhaps it is the reconstruction of reality posed by the expressionists that has more critical validity than the deconstructive post-painterly styles of Duchamp and constructivism, and later of Rauschenberg and Manzoni. For Buchloh these are "the two essential instances in modern art when the production process of painting was radically questioned for its claim to organic unity, aura, and presence, and replaced by heterogeneity, mechanical procedures, and seriality."[7] New German painting does not wish to reinstate the old claims of organic unity, aura, and presence of painting, but to let us know that heterogeneity, mechanical procedures, and seriality no longer carry out the subversive function of the modern aesthetic. Nor does the new representationalism accomplish this subversive task since it, too, is heavily dependent on this heterogeneity, mechanical procedures, and seriality, all somewhat forced today, in contrast to their earlier usage.

The issue becomes clear in the current conflict between painting and photography. In the nineteenth century, painting was the dominant art, the carrier of criticality, while photography became, in Baudelaire's words, the means by which "art further diminishes its self-respect by bowing down before external reality." Baudelaire thought of photography as "a cheap method of disseminating a loathing for history and for painting," which meant for him a loathing for tradition and "the domain of the impalpable and the imaginary." Photography, offering us the "fanaticism" of "Narcissus," undermines the "happiness to wonder" and to dream, and so to create "the Beautiful."[8] To Baudelaire, photography was a narcissistic art that eliminated the tragic or elegant—different shapes of critical understanding. Photography, in fact, was altogether incapable of and antithetical to critical artistic understanding, for it celebrated immediate facts that were far from wonderful and, untransformed

7. Buchloh, "Figures of Authority," p. 59. [Reprinted in this volume, see p. 124.]

8. Charles Baudelaire, "The Salon of 1859," in *The Mirror of Art*, ed. Jonathan Mayne (London: Phaidon Press, 1955), pp. 228-231.

by true art, far from meaningful. The heterogeneity disclosed by the mechanical procedures and the seriality of photography was regarded, like other purely material developments of progress, to be detrimental to artistic genius.

The shape of the debate has changed now, for photography is sometimes regarded as potentially more critical than painting. It is more at the center of modern life, so that critically used it can have more subversive impact. Photography usurps art because it shows that all art is destined for the imaginary museum André Malraux wrote of, which "consists of all those works of art that can be submitted to mechanical reproduction and, thus, to the discursive practice that mechanical reproduction has made possible: art history."[9] Photography thus dominates and critically brackets art by changing the way it is situated, and photography used as art can change our understanding of the Beautiful and the dream. As Duchamp put it, photography gives us a freedom, the possibility of a philosophical outlook, that painting, overly bound to its physicality, can hardly imagine. This conception of painting as more physical than mental, and so less likely to aid the understanding of our condition, is at the root of the current rejection of painting, particularly the new German painting, which seems to give itself uncritically to the physical side of painting. The current rejection is an extension and confirmation of the Duchampian rejection, just as Thomas Lawson's attempt to appropriate painting as a subversive method and use its discursive nature to cause trouble[10] is dependent upon Duchamp's attempt to put "painting at the service of the mind" (1946). And just as Duchamp said he was more interested in recreating ideas in painting than in achieving mechanical, cinematic effects through painting, so Lawson acknowledges that some of the most challenging contemporary work uses photography and photographic imagery. Like Duchamp, Lawson wants to escape the photographically "illustrative," but unlike Duchamp, he is dependent upon it.

Neither Lawson nor Crimp in their modernist attacks on new German painting pay serious attention to the Duchamp they cite. Writing to Alfred Stieglitz, Duchamp asserts: "You know exactly what I think of photography. I would like to see it make people despise painting until something else will make photography unbearable."[11] It may be that photography has made itself unbearable by reason of its excessive popularity with both ordinary and avant-garde usage. It may be that it has made a fetish of popularity, in fact, made it the only criterion of significance and a self-justifying end. This is why the authentic avant-garde may despise photography and return to painting, not for its physicality, but for the idea of natural expression that painting might give us. Painting can be seen as the antidote to popular and transparently artificial expression, as it is becoming increasingly clear photography is.

Photographic expression symbolizes what is non-natural—not the same as

9. Crimp, "End of Painting," p. 81.

10. Thomas Lawson, "Last Exit: Painting," *Artforum* 20, no. 2 (October 1981): 40-47. [Reprinted in this volume, pp. 153-165.]

11. Quoted by Crimp, "End of Painting," p. 75.

what is unnatural, although subsuming it—that permeates existence in a technologically and capitalistically advanced society. Photography can function this way because it represents the domination of social authority through its "spying" on our existence. Photographic documentation, seemingly all-pervasive, has come to represent an authoritarian penetration of existence, a manipulation and control of existence to an extent that can be regarded as the rape of its most profound expectations. Photographic penetration of existence summarizes the total availability of our lives for social use, an availability which is no longer even experienced as coercive. It represents the preplotting of life, the predetermination of life's own patterns of self-realization. Photography represents our complete exposure to society, our fraudulent openness to its ministrations, and our lack of critical relationship, i.e., resistance, to its "necessity." The form of that necessity is photographic; it is a form which destroys our otherness and which makes us identifiable with society. Without our potential otherness, the very source of our naturalness, we are merely photographic specimens under a societal microscope. We have become totally and visibly available, and thus totally appropriated, as the radical critics we are discussing would say. They think they can appropriate what has already appropriated them completely, that they can struggle against appropriation by counter-appropriation. But their sad little game—Lawson's game, the game Buchloh thinks Sigmar Polke plays—loses track of the alternatives, which exist only fictionally, in painting, a medium long ago discarded as all too "appropriate."

Photography, with its heterogeneity, mechanical procedures, and seriality, symbolizes the powerful control a technologically advanced society has on existence. When every new photograph of the same thing simply confirms its sameness or reveals another interior perception of its self-identity, existence becomes totally conscious and abstract. It is possessed as a concept as much as a precept. The new German painters work with the idea of an unconscious image and generate a fresh sense of concreteness. They know that very idea is a fiction, but it is presented as the only viable alternative to the supposedly nonfictional photographic image. What Baselitz, Lüpertz, Penck, Immendorff, and Kiefer achieve through their desocialization of imagery is a defeat of the realism of photographic identity, which is the instrument as well as the consequence of our increasing appropriation by the forces of abstraction, ambiguously disclosing themselves as forces of domination as well as liberation.

III.

The fullest critical presentation of the new German painting to date in the American art press has occurred in *Artforum*. It is worthwhile to examine the strategy of this presentation, to note the way the art made itself felt as increasingly radical, and the way it eventually has come to be experienced as avant-garde. This changed awareness of the art shows the way recognition of it became a matter of more than usual importance, requiring more than the usual art-historical techniques. The art showed its complexity through the realm of implications it seemed to evoke and by the way it seemed to require a variety of perspectives to make these implications clear. It is only by surviving this

critical challenge that the new painting showed its sturdiness. Disclosed as major art, its significance became all the more pressing. What became most clear was that its assumed obviousness dissolved as its more problematic ambiguities were revealed. It was more convoluted than the first reviewers of it, including myself, were led to believe.[12]

The initial presentation of the new German painting was the review by Stuart Morgan of the Royal Academy of Arts exhibition, "A New Spirit in Painting." It sounded an ambiguous, hesitant note from the start. There was a querulous, irritated tone that was seldom absent in these articles, a sign of an insistent cross-examination of the art. Quoting Nietzsche's characterization of modernism as "the opposition between external mobility and a certain inner heaviness and fatigue," Morgan characterizes Kiefer's paintings as "bogs of dark impasto" and describes Lüpertz's three *Black, Red, Gold Dithyramb* paintings as having "all the subtlety of a visual gangbang."[13] He asserts that K. H. Hödicke and Rainer Fetting "can produce large, fluent neo-Expressionist works without relying on bombast," and poses a decisive question: "Does some proportional relation exist between external mobility and inner fatigue, between the nervous brushstroke and the burden of the past?" The recognition of this tension, arising from an uncertain handling of a charged subject matter, keynotes most of the discussion of the new German painters. It is a recognition of the way a regressive visual mobility is used dialectically to subsume a regressive, fatiguing, emotionally heavy, or depressing content. It is also an example of how regressive means are used to combat the dead weight of the past so that freedom from the past, however illusory, might be achieved.

In Summer 1981, *Artforum* published a defense of the new German painting by Bazon Brock, an aesthetician at the University of Wuppertal, West Germany. The piece was a response to an exhibition by Baselitz and Kiefer in the German Pavilion of the Venice Biennale, where the works were "almost universally rejected by the German critics."[14] Brock believes the reason for the critics' disdain was that they felt that "Kiefer and Baselitz were using obsolete

12. See Donald B. Kuspit, "Bernd Zimmer at Barbara Gladstone" and "K. H. Hödicke at Annina Nosei," *Art in America* 69, no. 9 (November 1981): 170-71. I do not entirely repudiate the concept of "Pop Expressionism" I spoke of in these reviews, but it would have to be more developed—more fully articulated. I began to take a different view in my "Report from Berlin, 'Bildwechsel': Taking Liberties," *Art in America*, 70, no. 2 (February 1982): 43-49. Finally, in my reviews of "A. R. Penck at Sonnabend" and "Georg Baselitz at Fourcade," *Art in America* 70, no. 2 (February 1982): 139-140, I came to the art more fully. I treated it more comprehensively and analytically in "Acts of Aggression: German Painting Today" (Part I), *Art in America* 70, no. 8 (September 1982): 140-151, and "Acts of Aggression: German Painting Today" (Part II), *Art in America* 71, no. 1 (January 1983): 90-101, 131-135. See also my reviews, "Michael Büthe at Holly Solomon," *Arts Magazine* 57, no. 4 (December 1982): 18, "Jörg Immendorff at Sonnabend," *Artforum* 21, no. 5 (January 1983): 75, and "Painting to Satiety: Franz Hitzler and Troels Wörsel," *Arts Magazine* 57, no. 6 (February 1983): 86-87.

13. Stuart Morgan, "Cold Turkey: 'A New Spirit in Painting' at the Royal Academy of Arts, London," *Artforum* 19, no. 8 (April 1981): 47.

14. Bazon Brock, "The End of the Avant-Garde? And So the End of Tradition. Notes on the Present 'Kulturkampf' in West Germany," *Artforum* 19, no. 10 (June 1981): 62.

methods to promote equally obsolete German mythology." Brock found this objection "untenable," and his brilliant response includes an investigation of the dialectic between tradition and the avant-garde. His argument verges on asserting the Jewishness of Baselitz and Kiefer, as well as Hans-Jürgen Syberberg, the director of the film *Our Hitler.* Brock takes Jewishness to be "the permanent opposition . . . to any literal execution of a myth, a revelation, or a system of thought" in the face of the typical German "idealistic" attempt "to take scientific and artistic system constructs literally, and to enforce their exact execution." [15] The German painters are seen as deconstructing German cultural history and style, in an attempt to restore its strength, which, like that of any cultural thought, exists in the "discrepancy between plan and execution, between idea and practice." If the system construct is applied literally, it is bound to have inhumane and destructive results. The Brock article is immediately followed by six pages devoted to Kiefer's *Gilgamesch* project, which involves the use of photography as much as paint. The subtlety of the two-fisted presentation—explication of theory and demonstration of artistic practice—is that it immediately states the international relevance of the new German artists, who are articulating a universal problem of identity. They are understood to question the extent to which an artist is or is not identified with his culture, i.e., is or is not independent or critical of it: is or is not a form of "discrepancy" within it, the seam by which it comes apart as much as by which it is held together. The power of *Artforum*'s presentation of the new German painters is that it shows them as operational in a larger-than-German context, freshly raising the issue of what culture is and how it functions.

In September 1981, Wolfgang Max Faust dealt with the painting of a number of younger Germans, particularly the work of the Mülheimer Freiheit group and the Berlin students of K. H. Hödicke. Again the painters were presented as confronting the broad issue of culture as well as the specifically German situation. The self-contradictory character of the Mülheimer Freiheit group is emphasized: "Their paintings are blasts of sheer joy in contradiction." [16] They are finally understood as creating a "willful dissociation of the factors of subjectiveness and style," using techniques of *art brut* at one extreme (Peter Bömmels) and at the other "highly eclectic and syncretist images" (Georg Jiri Dokoupil). Their erraticness is understood in social as well as aesthetic terms, and is taken to have general implications for the situation of the artist, who is confronted with popularized, abstracted, appropriated styles and with social uncertainty. It is responsive to a situation of appropriation as well as instability, and by a technique of "both obvious and tricky" quick-changes, the artists take us into their "confidence." They reflect our psycho-political reality in "a realm of proliferating appearances that play with every conceivable reference offered by history as well as by evanescent individual viewpoints and obsessions." [17] Their art is shown to be perhaps the most

15. Ibid., p. 67.

16. Wolfgang Max Faust, " 'Du hast keine Chance. Nutze sie!' With It and Against It: Tendencies in Recent German Art," *Artforum* 20, no. 1 (September 1981): 39.

17. Ibid.

doggedly socially responsive there is, where art itself is understood to be an incendiary political part of the unstable, anxiety-arousing social contract.

With Thomas Lawson's article, "Last Exit: Painting" (October 1981), there is a return to a negative note, with a conceptualist American critic defending the honor of avant-garde criticality against the "pseudo-expressionists . . . part of a last, decadent flowering of the modernist spirit." [18] Lawson comes up with his own dialectical appropriation of painting, while dismissing the expressionists for ingratiating themselves by pretending to be "in awe of history." A warning flag should go up with the word "ingratiate," since we last read it in Michael Fried, who used it to eliminate whole squadrons of artists and to establish a rigid hierarchy of significance which shut out certain categories of art as well. [19] The dialectical intention of Lawson and Fried (the one coming from the left, the other from the right) is betrayed by this attempt to identify a group of artist-pariahs who attempt to be engaging, catering to our populist taste for exhibitionistic entertainment. Because such artists have broad implications, they cannot be critical, thus they cannot be allowed to join the radical elite. The major value of Lawson's article is the question it raises about the relevance of painting to avant-garde art today. His magic act, in which you see painting cut in half and then put whole again, is just that: an insubstantial act to obscure the fact that his own conceptualized brand of painting is heavily dependent upon photography and is thus subject to the objections to photography. But the importance of Lawson's article is that it forcefully raises the issue of "regressive medium," following the issue of cultural regression like a second strong wave.

The new German painters had staying power, even surviving my own working over and through them in the November 1981 issue of *Artforum*. [20] Lawson's attempt to find a progressive and enlightened, if somewhat mechanical, use for painting was for me as little an issue then as was the German critics' attempt to defend the new painters against charges of cultural recidivism. Instead I saw the art as a response to the pressures of popular culture,

18. Lawson, "Last Exit," p. 41. [Reprinted in this volume, see p. 156.]

19. Michael Fried, *Absorption and Theatricality: Painting and Beholder in the Age of Diderot* (Berkeley: University of California Press, 1980), p. 5, distinguishes between "much seemingly difficult and advanced but actually ingratiating and mediocre work" of the 1960s and "the very best recent work—the paintings of Louis, Noland, Olitski, and Stella and the sculptures of Smith and Caro." The ingratiating work is inherently—can never be anything but—mediocre because it seeks "to establish . . . a *theatrical* relation to the beholder," i.e., to, indeed, ingratiate itself with the beholder. The work Fried endorses is inherently great because, in an exemplary way, it is "in essence *anti*-theatrical," i.e., "treat[s] the beholder as if he were not there." It goes without saying that for Fried, expressionist art—and current expressionist art even more—would be theatrical, by reason of its demonstrativeness. In fact, Fried might argue that it makes a fetish of theatricality, broadcasting it not only as the (false) essence of art, but of being. For Fried, who is implicitly a monist, being must—monadically—rest in itself, and antitheatrical art is a demonstration of this in-itselfness of being.

20. Donald B. Kuspit, "The New (?) Expressionism: Art as Damaged Goods," *Artforum* 20, no. 3 (November 1981): 47-55.

synthesizing a traditional modernist childlikeness with a traditional cultural Faustianism. I viewed the intense, forced childlikeness as ethical and political in point, quixotic yet militant, personally psychodramatic, and antiauthoritarian in its depiction of figures of authority. My article was followed by seven pages of a Penck project, "involving the interaction of criticism, poetry, and art." Again, unity of theory and practice, criticism and art was achieved. The art had been disclosed by some of its exemplary practitioners, and the evaluation by some of its most committed critics. A complete, and completely serious, presentation of it had been made. Significant sides of the argument for and against it had been heard, and major examples of the art shown. Its urgency had been met by an urgent critique.

It was now time to deal with the new art in greater detail, since by late 1981 neither theoretical nor art-historical comprehensiveness was at stake. An innovative framework had been created and some of the most serious artists had been located in it. Now other highly individual artists were brought to the public's attention. In March 1982, Sigmar Polke was located art historically by Buchloh, in terms of the avant-garde strategy of parody, in a line from Picabia through pop art.[21]

In the summer of 1982, Siegfried Gohr examined Baselitz's early hero paintings, largely in terms of the need for an image "reconciling the conflict between the realistic tradition of 19th-century art and Modern painting's own epistemological needs."[22]

Critical pressure was kept up in the form of Joseph Kosuth's May 1982 attack on painting in general and the new expressionism in particular. Kosuth implicitly lumped all kinds of painters together in a lower class, much as Lawson did explicitly. They both despair of painting and the latest expressionist attempt to revive it. Kosuth introduces the notion of expressionism as an institutional style and the idea that the best of the neoexpressionists result from "not simply painting but a reference to painting, a kind of visual quotation, as if the artists are using the found fragments of a broken discourse."[23] Painting, like many other customs that can survive as "formal conventions long after they've lost their meaning," lives on as a kind of "device" within a larger, less institutionalized, not yet fully acculturated, enterprise. As in Lawson, painting is allowed if it is used critically, i.e., for nonpainting ends.

Finally, in September 1982, there was an extensive theoretical review of "Documenta 7" by five writers, followed anticlimactically by a group of reviews concerning specific Documenta installations.[24] In general, the writers

21. Benjamin H. D. Buchloh, "Parody and Appropriation in Francis Picabia, Pop, and Sigmar Polke," *Artforum* 20, no. 7 (March 1982): 28-34.

22. Siegfried Gohr, "In the Absence of Heroes: The Early Work of Georg Baselitz," *Artforum* 20, no. 10 (June 1982): 67-68.

23. Joseph Kosuth, "Necrophilia, Mon Amour," *Artforum* 20, no. 9 (May 1982): 60.

24. The articles were by Annelie Pohlen, Kate Linker, Donald B. Kuspit, Richard Flood, and Edit deAk, *Artforum* 21, no. 1 (September 1982): 57-75; the reviews were by Richard Flood, Donald B. Kuspit, Lisa Liebmann, Stuart Morgan, Annelie Pohlen, and Schuldt, *Artforum* 21, no. 2 (October 1982): 81-86.

dismember the ideology but do not deny the validity of the German artists or the reasons for their contemporary recognition. I understand them now in terms of modern traditionalism and the search for an authentic identity in a world which seems to allow for none. I saw them as an exploration of traditional identities accepted as authentic, with the artist like a sandcrab, trying to live in an alien shell in the hope that he or she might gain an understanding of what a home might be (while knowing that they can never actually have their own by the terms of the modern condition). With this understanding came the recognition that the new German expressionism is a true home for radical art today.

Daniel Buren. Exhibition, various locations, New York City (here: 13½ Bleecker Street), October 1970. Stripes in white and violet on board. (Photo: Robert E. Mates and Paul Katz; courtesy The Solomon R. Guggenheim Museum)

Last Exit: Painting

THOMAS LAWSON

> *The paintings have to be dead; that is, from life but not a part of it, in order to show how a painting can be said to have anything to do with life in the first place.*
>
> —David Salle, *Cover*, May 1979

It all boils down to a question of faith. Young artists concerned with pictures and picture-making, rather than sculpture and the lively arts, are faced now with a bewildering choice. They can continue to believe in the traditional institutions of culture, most conveniently identified with easel painting, and in effect register a blind contentment with the way things are. They can dabble in "pluralism," that last holdout of an exhausted modernism, choosing from an assortment of attractive labels—Narrative Art, Pattern and Decoration, New Image, New Wave, Naive Nouveau, Energism—the style most suited to their own, self-referential purposes. Or, more frankly engaged in exploiting the last manneristic twitches of modernism, they can resuscitate the idea of abstract painting. Or, taking a more critical stance, they can invest their faith in the subversive potential of those radical manifestations of modernist art labeled Minimalism and Conceptualism. But what if these, too, appear hopelessly compromised, mired in the predictability of their conventions, subject to an academicism or a sentimentality every bit as regressive as that adhering to the idea of Fine Art?

Such is the confused situation today, and everyone seems to be getting rather shrill about it. At one extreme, Rene Ricard, writing in *Artforum* on Julian Schnabel, has offered petulant self-advertisement in the name of a reactionary expressionism, an endless celebration of the author's importance as a champion of the debasement of art to kitsch, fearful that anything more demanding might be no fun. The writing was mostly frivolous, but noisy, and must be considered a serious apologia for a certain anti-intellectual elite. On the other hand the periodical *October* has been publishing swinging jeremiads condemning, at least by implication, all art produced since the late sixties, save what the editors consider to be permissible, which is to say art that owes a clear and demonstrable debt to the handful of minimal and conceptual artists they lionize as the true guardians of the faith. From a position of high moral superiority these elitists of another sort, intellectual but anti-aesthetic, condemn the practice of "incorrect" art altogether, as an irredeemably bourgeois activity that remains largely beneath their notice. Both approaches, of the aesthete and

Reprinted from *Artforum* 20, no. 2 (October 1981): 40-47.

the moralist, leave distinctions blurred, and art itself is conveniently relegated to an insignificant position as background material serving only to peg the display of self or of theory. From both sides we receive the same hopeless message: that there is no point in continuing to make art since it can only exist insulated from the real world or as an irresponsible bauble. This is only a partial truth. It would be more accurate, although a good deal more complicated, to argue that while there may be no point in continuing to make certain kinds of art, art as a mode of cultural discourse has not yet been rendered completely irrelevant.

> *Today . . . modern art is beginning to lose its powers of negation. For some years now its rejections have been ritual repetitions: rebellion has turned into Procedure, criticism into rhetoric, transgression into ceremony. Negation is no longer creative. I am not saying that we are living the end of art: we are living the end of the idea of modern art.*
> —Octavio Paz, *Children of the Mire: Modern Poetry from Romanticism to the Avant-Garde*

Despite the brouhaha, the numerous painting revivals of the latter part of the seventies, from New Abstraction to Pattern and Decoration, proved to be little more than the last gasps of a long overworked idiom, modernist painting. (The diversionary tactics of so many bemused critics hid this truth under a blanket eventually labeled "pluralism," but as the decade closed that blanket became more and more of a shroud.) These revivals were embalmed and laid to rest in Barbara Rose's poignantly inappropriately titled show "American Painting: The Eighties." That exhibition, presented in 1979, made the situation abundantly clear, and for that we should be thankful. Painter after painter included there had done his or her best to reinvest the basic tenets of modernist painting with some spark of life, while staying firmly within the safe bounds of dogma. The result was predictably depressing, a funereal procession of tired clichés paraded as if still fresh; a corpse made up to look forever young.

While it was still a creative force, modernism worked by taking a programmatic, adversary stance toward the dominant culture. It raged against order, and particularly bourgeois order. To this end it developed a rhetoric of immediacy, eschewing not only the mimetic tradition of Western art, but also the aesthetic distance implied by the structure of representation—the distance necessarily built into anything that is to be understood as a picture of something else, a distance that sanctions the idea of art as a discursive practice. With modernism, art became declarative; we moved into the era of the manifesto and the artist's statement, justifications which brook no dissent.

Modernism's insistence on immediacy and the foreclosure of distance inevitably resulted in a denial of history, in an ever greater emphasis on not just the present, but the presence of the artist. Expressive symbolism gave way to self-expression; art history developed into autobiography. Vanguard art became a practice concerned only with itself, its own rules and procedures. The most startling result was the liberation of technique; the least useful result was the pursuit of novelty. As the modernist idea became debased, its deliberate sparseness worn through overuse, the acting-out of impulse, rather than the

reflective discipline of the imagination, became the measure of satisfaction and value. As a result the modernist insistence on an essential meaninglessness at the center of artistic practice came actually to mean less and less. From being a statement of existential despair it degenerated into an empty, self-pitying, but sensationalist, mannerism. From being concerned with nothingness, it became nothing. The repudiation of mimesis, and the escalating demands for impact, for new experience beyond traditional limits, inevitably loosened the connections between artistic discourse and everyday life. Art became an abstraction, something of meaning only to its practitioners. On the whole, modernist artists acted as though alienated from bourgeois society—it was the only posture that gave their work a significance transcending its own interiority. But for the most part this remained only a posture, rarely developing into a deeper commitment to social change. In a manner that foretold the final decline of the moral authority of modernism, radically individualist artists all too often found comfortable niches in the society they professed to despise, becoming little more than anxious apologists for the system.

Of course there had been one important moment that saw a possibility for a more truly revolutionary activity, and that was in Moscow in the years immediately following the Russian Revolution. This period not only pushed modernism to its logical expression in abstraction, but turned that abstraction away from the personal toward a more significant critique of production. Developing implications nascent in the work of Cézanne and the cubists, it concentrated on the basic ingredients, ideological and material, involved in the production of art. This moment, abandoned by the artists themselves (only partly because of political pressures) in favor of totally reactionary antimodernism, saw the first stirrings of a seed that, when later conjoined with the very different, but equally radical, activity of Marcel Duchamp, came to fruition just as the modernist hegemony seemed unassailable—demonstrating that it was not.

That fruition has been called minimalism, and the minimalist artists subverted modernist theory, at that time most ably articulated by the followers of Clement Greenberg, simply by taking it literally. If modernist art sought to concern itself with its own structures, then the minimalists would have objects made that could refer to nothing but their own making. This absurdist extremism worked by dramatizing the situation, which in turn reinjected a sense of distance, and a critical discourse was once again possible. (It is no accident that it was this generation of artists—Donald Judd, Robert Morris, Robert Smithson, Art & Language, Joseph Kosuth, and Mel Bochner—who reintroduced the idea that an artist might be more than a sensitive person with talent, might in fact be both intelligent and articulate, might have something to say.)

All the while, countless other artists continued as if the ground had not been opened up in front of them, even adopting some of the superficial characteristics of the very modes that were rendering their practice obsolete and moribund. Some, of course, continued to paint, and it was those whom Rose chose to celebrate in her exhibition. And if that show seemed to lack all conviction, Rose's catalogue essay more than compensated with the vehemence of its language. Defending a denatured modernism that had become so divorced from historical reality that it could pretend to celebrate "eternal values,"

she lashed into minimalism and conceptualism as though they were the agents of the Antichrist. Which, for the true believer, they are.

Rose made it clear that procedure had indeed become ritual, and criticism mere rhetoric. Modernism has been totally co-opted by its original antagonist, the bourgeoisie. From adversary to prop, from subversion to bastion of the status quo, it has become a mere sign of individual liberty and enterprise, freed entirely from the particular history that once gave it meaning. It is not just that its tactics and procedures have been borrowed by the propaganda industries—advertising, television, and the movies—it has become a part of them, lending authority and authenticity to the corporate structures that insistently form so much of our daily lives.

> *We need change, we need it fast*
> *Before rock's just part of the past*
> *'Cause lately it all sounds the same to me*
> *Oh-oh . . .*
> *It's the end, the end of the 70's*
> *It's the end, the end of the century*
> —The Ramones,
> from the song, "Do you remember Rock 'n' Roll Radio?" 1979

The end of the century. If modernist formalism seems finally discredited, hopelessly co-opted by the social structures it purportedly sought to subvert, its bastard progeny continue to fill the galleries. We all want to see something new, but it is by no means clear that what we have been getting so far has any merit beyond a certain novelty. As Antonio Gramsci so presciently observed in his prison notebooks, a period lacking certainty is bedeviled by a plethora of morbid symptoms. Following the lead of architectural critics these symptoms have been hailed, rather carelessly, as "postmodern," with that term standing for a nostalgic desire to recover an undifferentiated past. According to this understanding any art that appropriates styles and imagery from other epochs, other cultures, qualifies as "postmodern." Ironically, the group that has been enjoying the most success, to date, as the exemplification of this notion is made up of pseudoexpressionists like Jonathan Borofsky, Luciano Castelli, Sandro Chia, Francesco Clemente, Enzo Cucchi, Rainer Fetting, Salomé, and Julian Schnabel. Despite the woolly thinking behind this usage, the claim does have some merit, but in the end the work of these artists must be considered part of a last, decadent flowering of the modernist spirit. The reasons for this initial success are quite straightforward. The work of these artists looks very different from the severe respectability of recent modernist production in New York, yet it is filled with images and procedures that are easily recognized as belonging to art, or at least to art history. As their champions are quick to point out, their work can be keyed, at least superficially, to a strain of activity that stretches from conceptual art back to dada. And on top of that they appear personal, idiosyncratic in a period during which lip service has been paid to the idea of individual liberty, even as that liberty is being systematically narrowed by the constraints of law and commerce.

These young painters ingratiate themselves by pretending to be in awe of

history. Their enterprise is distinguished by an homage to the past, and in particular by a nostalgia for the early days of modernism. But what they give us is a pastiche of historical consciousness, an exercise in bad faith. (Even Borofsky's integrity becomes implicated here as a result of his relentless mystification.) For by decontextualizing their sources and refusing to provide a new, suitably critical frame for them, they dismiss the particularities of history in favor of a generalizing mythology, and thus succumb to sentimentality.

Chia and Cucchi hanker after the excitements of neoprimitivism, especially as understood by the likes of Marc Chagall, nurturing a taste for assumed naiveté. Castelli, Fetting, and Salomé hark back to the same period, favoring instead the putative boldness of style and content of German expressionism. But whatever their sources, these artists want to make paintings that look fresh, but not too alienating, so they take recognizable styles and make them over, on a larger scale, with brighter color and more pizzazz. Their work may look brash and simple, but it is meant to, and it is altogether too calculated to be as anarchistic as they pretend.

Clemente and Schnabel are both more ambitious, seeking to accommodate a much broader range of references in their work. Both pick up on the neoromantic, pseudosurreal aspects of fashionable French and Italian art of the thirties and forties, and make a great fuss about their wickedly outrageous taste in so doing. But that is only a starting point, albeit one that, with its emphasis on additive collage, sanctions an uncontrolled annexation of material. Renaissance and Baroque painting, Indian miniatures, cheap religious artifacts, a certain type of anything-is-fair-game. And whatever is accepted becomes equivalent to everything else, all distinctions are merged as styles, images, methods, and materials proliferate in a torrent of stuff that is supposedly poetic, and thus removed from mere criticism.

This wider cultural cannibalism is the topic of another essay; the annexation of wide areas of modern art is problematic enough for my purposes here. Concentrating on that alone we have a surfeit of evidence, showing an historicism that pays court to a strain of twentieth-century art that can, superficially, be identified as antimodern. Superficially, because any work produced in a certain period must share essential characteristics with other work of the same period; antimodern, because I am talking about the production of artists of the thirties and forties who openly rebelled against the mainstream of radical modernism—in other words, the sophisticated if often rather mild-mannered art that was recently gathered together as part of the Beaubourg's "Les Réalismes" exposition. The same material also served as an introduction to the revisionist history presented at "Westkunst." This was art that was difficult only in the sense that a naughty child is difficult; that is, art that misbehaved within a strictly defined and protected set of conventions. Art that misbehaved to demonstrate the need for discipline. Art that advocated a forced return to "eternal values," in both the aesthetic and political realms. Art that often declared itself nationalist, always traditionalist. It is possible that recent work appropriating this art could have a critical import. The work of the pseudo-expressionists does play on a sense of contrariness, consistently matching elements and attitudes that do not match, but it goes no further. A *retardataire* mimeticism is presented with expressionist immediacy. The work claims to be

David Salle. *Daemonization,* 1980. Acrylic on canvas, 84 x 120″ (213.4 x 304.8 cm), original altered. (Photo: courtesy Mary Boone Gallery)

Julian Schnabel. *Jump,* 1980. Acrylic on canvas, 84 x 120″ (213.4 x 304.8 cm). (Photo: courtesy Mary Boone Gallery)

personal, but borrows devices and images from others. There is a camp acknowledgment that what was once considered bad art can now be fun; however, that acknowledgment is couched in self-important terms that for the most part steer clear of humor. Appropriation becomes ceremonial, an accommodation in which collage is understood not as a disruptive agent, a device to question perception—but as a machine to foster unlimited growth.

This marriage of early modernism and a fashionable antimodernism can be characterized as camp, and there is definitely a strain of Warholism about the work. It is cynical work with a marketing strategy, and therefore extremely fashion-conscious. It is work that relies on arch innuendo and tailored guest lists—a perfect example is provided by Clemente's series of frescoed portraits of a chic demimonde, although the Germans' concentration on gay subject matter works in an equivalent manner.

But to dismiss this work as belonging to camp is too easy, for something more sinister is at hand. The forced unification of opposites is a well-established rhetorical tactic for rendering discourse immune from criticism. The capacity to assimilate anything and everything offers the prospect of combining the greatest possible tolerance with the greatest possible unity, which becomes a repressive unity. With this art we are presented with what amounts to a caricature of dialectics, in which the telescoping of elements cuts off the development of meaning, creating instead fixed images—clichés—which we are expected to associate with the proper attitudes and institutions (high art fit for museums). With great cynicism this work stands the modernist enterprise on its head, removing the anxious perception of nothingness at the heart of modernist expression, and replacing it with the smug acknowledgment that if the art means nothing it will be all the more acceptable to those who seek only entertainment. Such a debased version of modernist practice is vigorously opposed to the very idea of critical analysis since it is simply a declaration of presence signifying only the ambition of the artist to be noticed.

> *Being in love is dangerous because you talk yourself into thinking you've never had it so good.*
>
> —David Salle, *ArtRite*, Winter 1976-1977

David Salle makes tremendously stylish paintings, paintings that will look good in the most elegant of rooms. His choice of color is brilliant—pale, stained fields, highlighted with bright, contrasting lines and areas of paint. A look of high fashion. And yet the images he presents this way are emotionally and intellectually disturbing. Often his subjects are naked women, presented as objects. Occasionally they are men. At best these representations of humanity are cursory, offhand; at worst they are brutal, disfigured. The images are laid next to one another, or placed on top of one another. These juxtapositions prime us to understand the work metaphorically, as does the diptych format Salle favors, but in the end the metaphors refuse to jell. Meaning is intimated but tantalizingly withheld. It appears to be on the surface, but as soon as it is approached it disappears, provoking the viewer into a deeper examination of prejudices bound inextricably with the conventional representations that express them.

Salle's work is seductive and obscure, and this obscurity is its source of strength, for when we attempt to bring light to the darkness, we illuminate much else as well. Salle follows a strategy of infiltration and sabotage, using established conventions against themselves in the hope of exposing cultural repression.

Salle occupies a central position in this polemic, for he appears to be balancing precariously between an empty formalism of the sort practiced by Clemente and Schnabel, and a critical subversion of such formalism. His work has long shared certain characteristics with the work of these artists, particularly in the deliberately problematic juxtaposition of heterogeneous styles and images. But whereas the work of Clemente and Schnabel remains narcissistic at base, Salle's has always appeared more distant, a calculated infiltration aimed at deconstructing prevalent aesthetic myths. Only now there seems to be a danger that the infiltration has become too complete; the seducer finds himself in love with his intended victim.

This infatuation has become more evident in the months following the so-called collaboration between Salle and Schnabel. This was a collaboration by fiat, a self-conscious gesture on the part of Schnabel (who had been given the painting in an exchange) in which he reversed the order of one of Salle's diptychs and partly covered one panel with a large, roughly painted portrait of Salle. The fabric of the original Salle was metaphorically ripped apart, literally wiped out, its meaning not so much altered as denied. The painting in fact became a Schnabel, a demonstration of the superior power of cannibalism over sabotage as a means of gaining control over one's subject. Lately Salle's paint has become thicker and more freely applied, some of the images clearly recognizable as taken from other art. In short, the ensembles seem less threatening.

Nevertheless, Salle's paintings remain significant pointers indicating the last exit for the radical artist. He makes paintings, but they are dead, inert representations of the impossibility of passion in a culture that has institutionalized self-expression. They take the most compelling sign for personal authenticity that our culture can provide, and attempt to stop it, to reveal its falseness. The paintings look real, but they are fake. They operate by stealth, insinuating a crippling doubt into the faith that supports and binds our ideological institutions.

> Nothing is more unfitting for an intellectual resolved on practicing what was earlier called philosophy, than to wish . . . to be right. The very wish to be right, down to its subtlest form of logical reflection, is an expression of that spirit of self-preservation which philosophy is precisely concerned to break down.
>
> —Theodor Adorno, *Minima Moralia*

I believe that most of the serious critics who are at all interested in the problem of defining that clumsy term "postmodernism" would agree with the gist of my argument so far, would agree that, in the current situation, not only is the viability of any particular medium suspect, but that aesthetic experience itself

has been rendered doubtful. But it is precisely here that we begin to drift apart in the face of the irreconcilable difference. Basically it is a conflict between a certain logical, even doctrinaire, purity and the impurity of real life; a disagreement over what to do about the gap between what ought to be and what is.

A recent and succinct statement of the idealist position is Douglas Crimp's essay "The End of Painting," which appeared in *October*, no. 16 (Spring 1981). Crimp describes the ennervation of modernist painting in terms similar to those I have used, but then attempts to close the argument, by demonstrating "the end." For this purpose he chooses to isolate the work of Daniel Buren as exemplary of the conceptualism that ten years ago sought to contest the myths of fine art. Crimp allows that Buren's work runs the risk of invisibility, that since it is intentionally meaningless in a formal sense, it might fail to operate on a critical level. And indeed it is a problem that the work needs an explanatory text, a handbook of the issues raised, a guide to one's approach. But that is the least of it, for what Crimp fails to acknowledge is that Buren's strategy has, by this time, degenerated into little more than an elegant device, naturalized by the forces it sought to undermine. Worse than looking like decor, the photographic record of his activity makes his work now look very much like the art he despises, recalling as it does the kind of *décollage* popular in Paris in the fifties. So Buren actually finds himself in a quandary similar to that faced by Salle, but since he deliberately reduced his means so severely in the beginning, he now has less to work with, and so has less hope of escaping either failure or co-optation. As a result of this inevitable impasse a good deal of conceptual art has lost its conviction, and thus its ability to provoke thought.

One simply does not believe repeated warnings that the end is nigh, particularly when those issuing the warnings are comfortably settling down as institutions in their own right. Much activity that was once considered potentially subversive, mostly because it held out the promise of an art that could not be made into a commodity, is now as thoroughly academic as painting and sculpture, as a visit to any art school in North America will quickly reveal. And not only academic, but marketable, with "documentation" serving as the token of exchange, substituting for the real thing in a cynical duplication of the larger capitalist marketplace.

In recognition of this state of affairs Sherrie Levine has decided simply to represent the idea of creativity, re-presenting someone else's work as her own in an attempt to sabotage a system that places value on the privileged production of individual talent. In doing so she finalizes Crimp's argument more conclusively than Buren, but that finality is unrealistic. It is also desperate. She articulates the realization that, given a certain set of constraints, those imposed by an understanding of the current situation as much as those imposed by a desire to appear "correct" in a theoretical and political sense, there is nothing to be done, that creative activity is rendered impossible. And so, like any dispossessed victim she simply steals what she needs. Levine's appropriations are the underside of Schnabel's misappropriations, and the two find themselves in a perverse lockstep. The extremity of her position doubles back on her, infecting her work with an almost romantic poignancy as resistant to interpretation as the frank romanticism of her nemesis.

So what is a radical artist to do in the current situation if he or she wants to avoid instant co-optation or enforced inactivity? A clue, paradoxically, is to be found in one of Crimp's passages on Buren: "It is fundamental to Buren's work that it act in complicity with those very institutions that it seeks to make visible as the necessary conditions of the art work's intelligibility. That is the reason not only that his work appears in museums and galleries, but that it poses as painting." It is painting itself, that last refuge of the mythology of individuality, which can be seized to deconstruct the illusions of the present. For since painting is intimately concerned with illusion, what better vehicle for subversion?

> *Cultivated philistines are in the habit of requiring that a work of art "give" them something. They no longer take umbrage at works that are radical, but fall back on the shamelessly modest assertion that they do not understand.*
>
> *—Theodor Adorno, Minima Moralia*

Given the accuracy of Adorno's observation it is clearly necessary to use trickery to pry open that understanding, for the main problem today is to open the channels of critical discourse to a healthy skepticism. Established avenues of protest, the disturbances that are the usual remedies of the disenfranchised and the disenchanted are no longer effective. They are too easily neutralized or bought off by an official "inquiry." But by resorting to subterfuge, using an unsuspecting vehicle as camouflage, the radical artist can manipulate the viewer's faith to dislodge his or her certainty. The intention of that artist must therefore be to unsettle conventional thought from within, to cast doubt on the normalized perception of the "natural," by destabilizing the means used to represent it, even in the knowledge that this, too, must ultimately lead to certain defeat. For in the end some action must be taken, however hopeless, however temporary. The alternative is the irresponsible acquiescence of despairing apathy.

To an unprecedented degree the perception of the "natural" is mediated these days. We know real life as it is represented on film or tape. We are all implicated in an unfolding spectacle of fulfillment, rendered passive by inordinate display and multiplicity of choice, made numb with variety: a spectacle that provides the illusion of contentment while slowly creating a debilitating sense of alienation. The camera, in all its manifestations, is our god, dispensing what we mistakenly take to be truth. The photograph *is* the modern world. We are given little choice: accept the picture and live as shadow, as insubstantial as the image on a television screen, or feel left out, dissatisfied, but unable to do anything about it. We know about the appearance of everything, but from a great distance. And yet even as photography holds reality distant from us, it also makes it seem more immediate, by enabling us to "catch the moment." Right now a truly conscious practice is one concerned above all with the implications of that paradox. Such a practice might be called "postmodern" in a strictly etymological sense because it is interested in continuing modernism's adversary stance, interested in the possibilities of immediate ac-

tion, yet aware of the closure that that immediacy has imposed, in time, on genuine discourse. It is art that reintroduces the idea of aesthetic distance as a thing of value, as something that will allow that discourse to open. It is art that pays attention to the workings of received ideas and methods, and in particular to those of the dominant media, in the hope of demonstrating the rigid, if often hidden, ideology that gives shape to our experience.

The most obvious procedure for this art that plumbs the dark secrets of the photographic question, the public trace of a submerged memory, would be to make use of the photographic media themselves, isolating pieces of information, repeating them, changing their scale, altering or highlighting color, and in so doing revealing the hidden structures of desire that persuade our thoughts. And indeed, it has been this kind of practice, the practice of such artists as Dara Birnbaum, Barbara Bloom, Richard Prince, and Cindy Sherman, working with video, film, and fashion photography, that has received the most considered attention from critics like Crimp and Craig Owens. And yet despite the success of this approach, it remains, in the end, too straightforwardly declarative. What ambiguity there exists in the work is a given of its own inner workings, and can do little to stimulate the growth of a really troubling doubt. The representation remains safe, and the work too easily dismissed as yet another avant-garde art strategy, commentary too easily recognized.

More compelling, because more perverse, is the idea of tackling the problem with what appears to be the least suitable vehicle available, painting. It is perfect camouflage, and it must be remembered that Picasso considered cubism and camouflage to be one and the same, a device of misrepresentation, a deconstructive tool designed to undermine the certainty of appearances. The appropriation of painting as a subversive method allows one to place critical

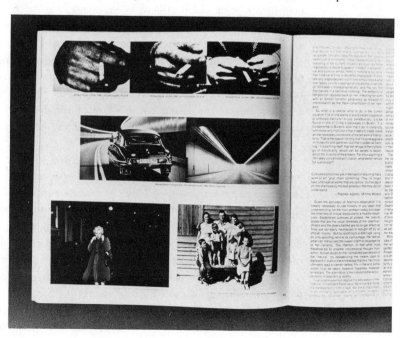

Photo layout from *Artforum* 20, no. 2 (October 1981), page 44, reproducing photographs by Richard Prince, Barbara Bloom, Cindy Sherman, and Sherrie Levine.

aesthetic activity at the center of the marketplace, where it can cause the most trouble. For, as too many conceptual artists discovered, art made on the peripheries of the market remains marginal. To reopen debate, get people thinking, one must be there, and one must be heard. One of the most important of Duchamp's lessons was that the artist who wishes to create a critical disturbance in the calm waters of acceptable, unthinking taste, must act in as perverse a way as possible, even to the point of seeming to endanger his or her own position. And it seems at this point, when there is a growing lack of faith in the ability of artists to continue as anything more than plagiaristic stylists, that a recognition of this state of affairs can only be adequately expressed through the medium that requires the greatest amount of faith.

For it is this question of faith that is central. We are living in an age of skepticism and as a result the practice of art is inevitably crippled by the suspension of belief. The artist can continue as though this were not true, in the naive hope that it will all work out in the end. But given the situation, a more considered position implies the adoption of an ironic mode. However, one of the most troubling results of the co-optation of modernism by mainstream bourgeois culture is that to a certain degree irony has also been subsumed. A vaguely ironic, slightly sarcastic response to the world has now become a clichéd, unthinking one. From being a method that could shatter conventional ideas, it has become a convention for establishing complicity. From being a way of coming to terms with lack of faith, it has become a screen for bad faith. In this latter sense popular movies and television shows are ironic, newscasters are ironic, Julian Schnabel is ironic. Which is to say that irony is no longer easily identified as a liberating mode, but is at times a repressive one, and in art one that is all too often synonymous with camp. The complexity of this situation demands a complex response. We are inundated with information, to the point where it becomes meaningless to us. We can shrug it off, make a joke, confess bewilderment. But our very liberty is at stake, and we are bamboozled into not paying attention.

The most challenging contemporary work using photography and photographic imagery remains illustrative. There is an indication of what might be considered, but no more; our understanding of the reverberations of the camera's picture-making is not advanced in a cohesive and compound form. Important issues are singled out, but they remain singular, strangely disconnected.

Radical artists now are faced with a choice—despair, or the last exit: painting. The discursive nature of painting is persuasively useful, due to its characteristic of being a never-ending web of representations. It does often share the irony implicit in any conscious endeavor these days, but can transcend it, to represent it. The following page, a coda to the argument, reproduces the work of several such artists who have decided to present work that can be classified as painting, or as related to painting, but that must be seen as something other: a desperate gesture, an uneasy attempt to address the many contradictions of current art production by focusing on the heart of the problem—that continuing debate between the "moderns" and the "postmoderns" that is so often couched in terms of the life and death of painting. ⇨

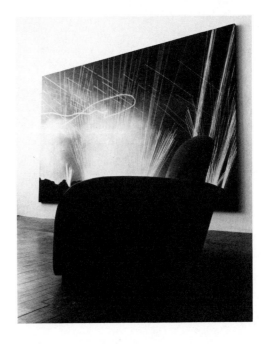

(Above) Allan McCollum. *Surrogates,* 1980. Acrylic on wood, various dimensions. As installed in the collection of Paine, Webber, Inc., New York. (Photo: Maryellen Latella)

(Above right) Thomas Lawson. *Don't Hit Her Again,* 1981. Oil on canvas, 48 x 48″ (122 x 122 cm). (Photo: courtesy Metro Pictures)

(Right) Jack Goldstein. Untitled, 1981. Acrylic on canvas, 7′ x 11′ (2.14 m x 3.36 m). (Photo: Louise Lawler, *Arranged by Janelle Reiring, 1983*)

The artists represented on this page were selected by the author for this publication; individual photographs were selected by the editors. The original publication of this article was accompanied by reproductions of paintings by Thomas Lawson, Walter Robinson, Troy Brauntuch, and Jack Goldstein. On the same page spread was the following note by the editors of *Artforum,* "*Artforum* has always acknowledged the seminal role of artists who are also critics. We are fully confident of Mr. Lawson's position within this tradition. Because such a position can be complex, it must be noted that several of the artists illustrated here exhibit with the same gallery as Mr. Lawson."

IV.

Theorizing Postmodernism

James Welling. *Paris, 1840,* 1977. Black-and-white photograph, 3¾ x 4¾ (9.6 x 12.1 cm).
(Photo: courtesy the artist)

From Work to Text

R O L A N D B A R T H E S

It is a fact that over the last few years a certain change has taken
place (or is taking place) in our conception of language and, consequently, of
the (literary) work, which owes at least its phenomenal existence to this same
language. The change is clearly connected with the current development of
(amongst other disciplines) linguistics, anthropology, Marxism, and psycho-
analysis (the term "connection" is used here in a deliberately neutral way: one
does not decide a determination, be it multiple and dialectical). What is new
and which affects the idea of the work comes not necessarily from the internal
recasting of each of these disciplines, but rather from their encounter in relation
to an object which traditionally is the province of none of them. It is indeed as
though the *interdisciplinarity* which is today held up as a prime value in
research cannot be accomplished by the simple confrontation of specialist
branches of knowledge. Interdisciplinarity is not the calm of an easy security;
it begins *effectively* (as opposed to the mere expression of a pious wish) when
the solidarity of the old disciplines breaks down—perhaps even violently, via
the jolts of fashion—in the interests of a new object and a new language, neither
of which has a place in the field of the sciences that were to be brought
peacefully together: It is precisely this uneasiness with classification which
permits the diagnosis of a certain mutation. The mutation which has seized the
idea of the work must not, however, be overestimated: it is more in the nature
of an epistemological slide [*glissement*] than of a real break [*coupure*]. The
break, as is frequently stressed, is seen to have taken place in the last century
with the appearance of Marxism and Freudianism; since then there has been
no new break, so that in a way it can be said that for a hundred years we have
been living in repetition. What History, our History, allows us today is merely
to slide, to vary, to exceed, to repudiate. Just as Einsteinian science demands
that *the relativity of the frames of reference* be included in the object studied,
so the combined action of Marxism, Freudianism, and structuralism demands,
in literature, the relativization of the relations of writer, reader, and observer

Originally published as "De l'oeuvre au texte," in *Revue d'Esthétique* 3 (1971): 225-
232. This translation by Stephen Heath reprinted from Roland Barthes, *Image-Music-Text*
(New York: Hill and Wang, 1977), pp. 155-164.

(critic). Over against the traditional notion of the *work*, for long—and still—conceived of in a, so to speak, Newtonian way, there is now the requirement of a new object, obtained by the sliding or overturning of former categories. That object is the *Text*. I know the word is fashionable (I am myself often led to use it), and therefore regarded by some with suspicion; but that is exactly why I should like to remind myself of the principal propositions at the intersection of which I see the Text standing. The word "proposition" is to be understood here more in a grammatical than in a logical sense: the following are not argumentations, but enunciations, "touches," as it were, approaches that consent to remain metaphorical. Here then are these propositions: they concern method, genres, signs, plurality, filiation, reading, and pleasure.

(1) The Text is not to be thought of as an object that can be computed. It would be futile to try to separate materially works from texts. In particular, one must avoid the tendency to say: the work is classic, the text avant-garde; it is not a question of drawing up a crude honors list in the name of modernity and declaring certain literary productions "in" and others "out" by virtue of their chronological situation: there may be "text" in a very ancient work, while many products of contemporary literature are in no way texts. The difference is the following: the work is a fragment of substance, occupying a portion of the space of books (in a library, for example); the Text on the other hand is a methodological field. The opposition may recall (without at all reproducing term for term) Lacan's distinction between "reality" and "the real": the one is displayed, the other demonstrated [*La 'réalité' se montre, le 'réel' se démontre*]; likewise, the work can be seen (in bookshops, in catalogues, in exam syllabuses), the text is a process of demonstration, speaks according to certain rules (or against certain rules); the work can be held in the hand, the text is held in language, only exists in the movement of a discourse (or rather, it is Text for the very reason that it knows itself as text); the Text is not the decomposition of the work, it is the work that is the imaginary tail of the Text. Or again: *The Text is experienced only in an activity of production.* It follows that the Text cannot stop (for example, on the library shelf); its constitutive movement is that of *cutting across* [*traversée*] (in particular, it can cut across the work, several works).

(2) In the same way, the Text does not stop at (good) Literature; it cannot be contained in a hierarchy, even in a simple division of genres. What constitutes the Text is, on the contrary (or precisely), its subversive force in respect of the old classifications. How does one classify Georges Bataille? Is this writer a novelist, a poet, an essayist, an economist, a philosopher, a mystic? The answer is so difficult that the literary manuals generally prefer to forget about Bataille who, in fact, wrote texts, perhaps continuously one single text. If the Text poses problems of classification (which is furthermore one of its "social" functions), this is because it always involves a certain experience of limits (to take up an expression from Philippe Sollers). Thibaudet used to speak—but in a very restricted sense—of limit-works (such as Chateaubriand's *Vie de Rancé*, which indeed comes through to us today as a "text": the Text is that which

goes to the limit of the rules of enunciation (rationality, readability, etc.). Nor is this a rhetorical idea, resorted to for some "heroic" effect: the Text tries to place itself very exactly *behind* the limit of the *doxa* (is not general opinion—constitutive of our democratic societies and powerfully aided by mass communications—defined by its limits, its energy of exclusion, its *censorship?*). Taking the word literally, it may be said that the Text is always *paradoxical*.

(3) The Text can be approached, experienced, in reaction to the sign. The work closes on a signified. There are two modes of signification which can be attributed to this signified: either it is claimed to be evident and the work is then the object of a literal science, of philology, or else it is considered to be secret, ultimate, something to be sought out, and the work then falls under the scope of a hermeneutics, of an interpretation (Marxist, psychoanalytic, thematic, etc.); in short, the work itself functions as a general sign and it is normal that it should represent an institutional category of the civilization of the Sign. The Text, on the contrary, practices the infinite deferment of the signified, is dilatory; its field is that of the signifier and the signifier must not be conceived of as "the first stage of meaning," its material vestibule, but, in complete opposition to this, as its *deferred action* [*après-coup*]. Similarly, the *infinity* of the signifier refers not to some idea of the ineffable (the unnameable signified), but to that of a *playing*; the generation of the perpetual signifier (after the fashion of a perpetual calendar) in the field of the text (or better, of which the text is the field) is realized not according to an organic progress of maturation or a hermeneutic course of deepening investigation, but, rather, according to a serial movement of disconnections, overlappings, variations. The logic regulating the Text is not comprehensive (to define "what the work means"), but metonymic; the activity of associations, contiguities, cross-references coincides with a liberation of symbolic energy (lacking it, man would die): The work (in the best of cases) is *moderately* symbolic (its symbolic runs out, comes to a halt); the Text is *radically* symbolic: *a work conceived, perceived, and received in its integrally symbolic nature is a text.* Thus is the Text restored to language; like language, it is structured but decentered, without closure (note, in reply to the contemptuous suspicion of the "fashionable" sometimes directed at structuralism, that the epistemological privilege currently accorded to language stems precisely from the discovery there of a paradoxical idea of structure: a system with neither end nor center).

(4) The Text is plural. Which is not simply to say that it has several meanings, but that it accomplishes the very plural of meaning: an *irreducible* (and not merely an acceptable) plural. The Text is not a coexistence of meanings but a passage, a traversal; thus it answers not to an interpretation, even a liberal one, but to an explosion, a dissemination. The plural of the Text depends, that is, not on the ambiguity of its contents, but on what might be called the *stereographic plurality* of its weave of signifiers (etymologically, the text is a tissue, a woven fabric). The reader of the Text may be compared to someone at loose ends (someone slackened off from the "imaginary"); this passably empty subject strolls (it is what happened to the author of these lines, then it

was that he had a vivid idea of the Text) on the side of a valley, an *oued* flowing down below (*"oued"* is there to attest to a certain feeling of unfamiliarity); what he perceives is multiple, irreducible, coming from a disconnected, heterogeneous variety of substances and perspectives: lights, colors, vegetation, heat, air, slender explosions of noises, scant cries of birds, children's voices from the other side of the valley, passages, gestures, clothes of inhabitants near or far away. All these *incidents* are half-identifiable: they come from codes which are known but their combination is unique, founding the stroll in a difference repeatable only as difference. So the Text: it can be itself only in its difference (which does not mean its individuality), its reading is semelfactive (this rendering illusory any inductive-deductive science of texts—no "grammar" of the text), and nevertheless woven entirely with citations, references, echoes: cultural languages (what language is not?), antecedent or contemporary, which traverse it through and through in a vast stereophony. The intertextual in which every text is held, it itself being the text-between of another text, is not to be confused with some origin of the text: to try to find the "sources," the "influences" of a work, is to fall in with the myth of filiation; the citations which go to make up a text are anonymous, untraceable, and yet *already read* [*déjà-lues*]: they are quotations without quotation marks. The work has nothing disturbing for any monistic philosophy (we know that there are opposing examples of these); for such a philosophy, plural is the Evil. Against the work, therefore, the text could well take as its motto the words of the man possessed by demons (*Mark* 5: 9): "My name is Legion: for we are many." The demonic or plural texture which opposes text to work can bring with it fundamental changes in reading, and precisely in areas where monologism appears to be the Law: certain of the "texts" of the Holy Scriptures traditionally recuperated by theological monism (historical or anagogical) will perhaps offer themselves to a diffraction of meanings (finally, that is to say, to a materialist reading), while the Marxist interpretation of works, so far resolutely monistic, will be able to materialize itself more by pluralizing itself (if, however, the Marxist "institutions" allow it).

(5) The work is caught up in a process of filiation. Postulated here are: a *determination* of the work by the world (by race, then by History), a *consecution* of works amongst themselves, and a *conformity* of the work to the author. The author is reputed the father and the owner of his work: literary science therefore teaches *respect* for the manuscript and the author's declared intentions, while society asserts the legality of the relation of author to work (the *"droit d'auteur"* or "copyright," is in fact fairly recent; it was only really legalized at the time of the French Revolution). As for the Text, it reads without the inscription of the Father. Here again, the metaphor of the Text separates from the metaphor of the work: the latter refers to the image of an *organism* which grows by vital expansion, by "development" (a word which is significantly ambiguous, at once biological and rhetorical); the metaphor of the Text is that of the *network*; if the Text extends itself, it is a result of a combinatory systematic (an image, moreover, close to current biological conceptions of the living being). Hence, no vital "respect" is due to the Text: it can be *broken*

(which is just what the Middle Ages did with two nevertheless authoritative texts, the Holy Scriptures and Aristotle); it can be read without the guarantee of its father, the restitution of the inter-text paradoxically abolishing any legacy. It is not that the Author may not "come back" in the Text, in his text, but he then does so only as a "guest," so to speak. If he is a novelist, he is inscribed in the novel like one of his characters, figured in the carpet; no longer privileged, paternal, aletheological, but ludic. He becomes, as it were, a "paper-author": his life is no longer the origin of his fictions, but a fiction contributing to his work; there is a reversion of the work on to the life (and no longer the contrary); it is the work of Proust, of Genet which allows their lives to be read as a text. The word "bio-graphy" reacquires a strong, etymological sense, and, at the same time, the sincerity of the enunciation—the veritable "cross" borne by literary morality—becomes a false problem: the *I* which writes the text, it too, is never more than a paper *I*.

(6) The work is normally the object of a consumption; I intend no demagogy here in referring to the so-called consumer culture, but it has to be recognized that today it is the "quality" of the work (which supposes finally an appreciation of "taste") and not the operation of reading itself which can differentiate between books: structurally, there is no difference between "cultured" reading and casual reading in trains. The Text (if only by its frequent "unreadability") decants the work (the work permitting) from its consumption and gathers it up as play, activity, production, practice. This means that the Text requires that one try to abolish (or at the very least to diminish) the distance between writing and reading, in no way by intensifying the projection of the reader into the work but by joining them in a single signifying practice. The distance separating reading from writing is historical. In the times of the greatest social division (before the setting up of democratic cultures), reading and writing were equally privileges of class. Rhetoric, the great literary code of those times, taught one to *write* (even if what was then normally produced were speeches, not texts). Significantly, the coming of democracy reversed the word of command: what the (secondary) School prides itself on is teaching to *read* (well) and no longer to write (consciousness of the deficiency is becoming fashionable again today: the teacher is called upon to teach pupils to "express themselves," which is a little like replacing a form of repression by a misconception). In fact, *reading*, in the sense of *consuming*, is far from *playing* with the text. "Playing" must be understood here in all its polysemy: the text itself *plays* (like a door, like a machine with "play") and the reader plays twice over, playing in the Text as one plays a game, looking for a practice which re-produces it, but, in order that that practice not be reduced to a passive, inner *mimesis* (the Text is precisely that which resists such a reduction), also *playing* the Text in the musical sense of the term. The history of music (as a practice, not as an "art") does indeed parallel that of the Text fairly closely: there was a period when practicing amateurs were numerous (at least within the confines of a certain class) and "playing" and "listening" formed a scarcely differentiated activity; then two roles appeared in succession, first that of the *interpreter* to whom the bourgeois public (though still itself able to play a little—the whole history of the

piano) delegated its playing, then that of the (passive) amateur, who listens to music without being able to play (the gramophone record takes the place of the piano). We know that today post-serial music has radically altered the role of the "interpreter," who is called on to be in some sort the coauthor of the score, completing it rather than giving it "expression." The Text is very much a score of this new kind: it asks of the reader a practical collaboration. Which is an important change, for who executes the work? (Mallarmé posed the question: he wanted the audience to *produce* the book). Nowadays only the critic *executes* the work (I admit the play on words). The reduction of reading to a consumption is clearly responsible for the "boredom" experienced by many in the face of the modern ("unreadable") text, the avant-garde film or painting: to be bored means that one cannot produce the text, play it, open it out, *set it going*.

(7) This leads us to pose (to propose) a final approach to the Text: that of pleasure. I do not know whether there has ever been a hedonistic aesthetics (eudaemonist philosophies are themselves rare). Certainly there exists a pleasure of the work (of certain works); I can delight in reading and rereading Proust, Flaubert, Balzac, and even—why not?—Alexandre Dumas. But this pleasure, no matter how keen and even when free from all prejudice, remains in part (unless by some exceptional critical effort) a pleasure of consumption; for if I can read these authors, I also know that I cannot *re-write* them (that it is impossible today to write "like that") and this knowledge, depressing enough, suffices to cut me off from the production of these works, in the very moment their remoteness establishes my modernity (is not to be modern to know clearly what cannot be started over again?). The Text, on the other hand, is bound to *jouissance*, that is, to a pleasure without separation. Order of the signifier, the Text participates in its own way in a social utopia; before History (supposing the latter does not opt for barbarism), the Text achieves, if not the transparency of social relations, that at least of language relations: the Text is that space where no language has a hold over any other, where languages circulate (keeping the circular sense of the term).

These few propositions, inevitably, do not constitute the articulations of a Theory of the Text. This is not simply the result of the failings of the person here presenting them (who in many respects has anyway done no more than pick up what is being developed round about him). Rather, it stems from the fact that a Theory of the Text cannot be satisfied by a metalinguistic exposition: the destruction of metalanguage, or at least (since it may be necessary provisionally to resort to metalanguage) its calling into doubt, is part of the theory itself: the discourse on the Text should itself be nothing other than text, research, textual activity, since the Text is that *social* space which leaves no language safe, outside, nor any subject of the enunciation in position as judge, master, analyst, confessor, decoder. The theory of the Text can coincide only with a practice of writing.

Translated by
Stephen Heath

Pictures

DOUGLAS CRIMP

Pictures *was the title of an exhibition of the work of Troy Brauntuch, Jack Goldstein, Sherrie Levine, Robert Longo, and Philip Smith, which I organized for Artists Space in New York City in the fall of 1977. In choosing the word* pictures *for this show, I hoped to convey not only the work's most salient characteristic—recognizable images—but also and importantly the ambiguities it sustains. As is typical of what has come to be called postmodernism, this new work is not confined to any particular medium; instead, it makes use of photography, film, performance, as well as traditional modes of painting, drawing, and sculpture.* Picture, *used colloquially, is also nonspecific: a picture book might be a book of drawings or photographs, and in common speech a painting, drawing, or print is often called, simply, a picture. Equally important for my purposes,* picture, *in its verb form, can refer to a mental process as well as the production of an aesthetic object.*

The following essay takes its point of departure from the catalogue text for Pictures; *but it focuses on different issues and addresses an aesthetic phenomenon implicitly extending to many more artists than the original exhibition included. Indeed, although the examples discussed and illustrated here are very few, necessitated by the newness and relative obscurity of this work, I think it is safe to say that what I am outlining is a predominant sensibility among the current generation of younger artists, or at least of that group of artists who remain committed to radical innovation.*

> Art and illusion, illusion and art
> Are you really here or is it only art?
> Am I really here or is it only art?
> —Laurie Anderson

In his famous attack against minimal sculpture, written in 1967, the critic Michael Fried predicted the demise of art as we then knew it, that is, the art of modernist abstract painting and sculpture. *"Art degenerates,"* he warned

Reprinted from *October*, no. 8 (Spring 1979): 75-88.

us, "*as it approaches the condition of theater,*" theater being, according to Fried's argument, "*what lies* between *the arts.*"[1] And indeed, over the past decade we have witnessed a radical break with that modernist tradition, effected precisely by a preoccupation with the "theatrical." The work that has laid most serious claim to our attention throughout the seventies *has* been situated between, or outside the individual arts, with the result that the integrity of the various mediums—those categories the exploration of whose essences and limits constituted the very project of modernism—has dispersed into meaninglessness.[2] Moreover, if we are to agree with Fried that "*the concept of art itself . . .* [is] *meaningful, or wholly meaningful, only* within *the individual arts,*" then we must assume that art, too, as an ontological category, has been put in question. What remain are just so many aesthetic activities, but judging from their current vitality we need no longer regret or wish to reclaim, as Fried did then, the shattered integrity of modernist painting and sculpture.

What then are these new aesthetic activities? Simply to enumerate a list of mediums to which "painters" and "sculptors" have increasingly turned— film, photography, video, performance—will not locate them precisely, since it is not merely a question of shifting from the conventions of one medium to those of another. The ease with which many artists managed, some ten years ago, to change mediums—from sculpture, say, to film (Serra, Morris, et al.) or from dance to film (Rainer)—or were willing to "corrupt" one medium with another—to present a work of sculpture, for example, in the form of a photograph (Smithson, Long)—or abjured any physical manifestation of the work (Barry, Weiner) makes it clear that the actual characteristics of the medium, per se, cannot any longer tell us much about an artist's activity.

But what disturbed Fried about minimalism, what constituted, for him, its theatricality, was not only its "perverse" location *between* painting and sculpture,[3] but also its "preoccupation with time—more precisely, with the *duration of experience.*" It was temporality that Fried considered "paradigmatically theatrical," and therefore a threat to modernist abstraction. And in this, too, Fried's fears were well founded. For if temporality was implicit in the way minimal sculpture was experienced, then it would be made thoroughly explicit—in fact the only possible manner of experience—for much of the art that followed. The mode that was thus to become exemplary during the seventies was performance—and not only that narrowly defined activity called

1. Michael Fried, "Art and Objecthood," *Artforum* 5, no. 10 (Summer 1967): 21; reprinted in *Minimal Art: A Critical Anthology*, ed. Gregory Battcock (New York: E. P. Dutton, 1968), pp. 116-147. All subsequent quotations from Fried are from this article; the italics throughout are his.

2. This is not to say that there is not a great deal of art being produced today that can be categorized according to the integrity of its medium, only that that production has become thoroughly academic; take, for example, the glut of so-called pattern painting, a modernist-derived style that has not only been sanctioned with a style name, but has generated a critical commentary, and constituted an entire category of selection for the most recent Whitney Museum biennial exhibition.

3. Fried was referring to Donald Judd's claim that "the best new work in the last few years has been neither painting nor sculpture," made in his article "Specific Objects." *Arts Yearbook*, no. 8 (1964):74-82.

performance art, but all those works that were constituted *in a situation* and *for a duration* by the artist or the spectator or both together. It can be said quite literally of the art of the seventies that "you had to be there." For example, certain of the video installations of Peter Campus, Dan Graham, and Bruce Nauman, and more recently the sound installations of Laurie Anderson not only required the presence of the spectator to become activated, but were fundamentally concerned with that registration of presence as a means toward establishing meaning.[4] What Fried demanded of art was what he called "presentness," a transcendent condition (he referred to it as a state of "grace") in which *"at every moment the work itself is wholly manifest"*; what he feared would replace that condition as a result of the sensibility he saw at work in minimalism—what *has* replaced it—is presence, the sine qua non of theater.

The presence before him was a presence.

–Henry James

An art whose strategies are thus grounded in the literal temporality and presence of theater has been the crucial formulating experience for a group of artists currently beginning to exhibit in New York. The extent to which this experience fully pervades their work is not, however, immediately apparent, for its theatrical dimensions have been transformed and, quite unexpectedly, reinvested in the pictorial image. If many of these artists can be said to have been apprenticed in the field of performance as it issued from minimalism, they have nevertheless begun to reverse its priorities, making of the literal situation and duration of the performed event a tableau whose presence and temporality are utterly psychologized; performance becomes just one of a number of ways of "staging" a picture. Thus the performances of Jack Goldstein do not, as had usually been the case, involve the artist's performing the work, but rather the presentation of an event in such a manner and at such a distance that it is apprehended as representation—representation not, however, conceived as the *re*-presentation of that which is prior, but as the unavoidable condition of intelligibility of even that which is present.

In 1977, Goldstein presented a performance entitled *Two Fencers* at the Salle Patino in Geneva. Distanced some fifty feet from the audience, bathed in the dim red glow of a spotlight, accompanied by the sound of recorded music taken from Hollywood swashbuckler soundtracks, two men in fencing gear enacted their athletic routine.[5] They appeared as if *déjà vu*, remote, spectral, yet just as certainly, present. Like the contortionist and gymnast of Goldstein's earlier performances, they were there, performing in the space of the spectators,

4. Rosalind Krauss has discussed this issue in many of her recent essays, notably in "Video: the Aesthetics of Narcissism," *October*, no. 1 (Spring 1976), and "Notes on the Index: Seventies Art in America," Parts 1 and 2, *October*, no. 3 (Spring 1977) and no. 4 (Fall 1977).

5. Goldstein's phonograph records, intended both as independent works and, in some cases, as soundtracks for performances, are made by splicing together fragments, sometimes no longer than a few seconds, of sound from existing recordings, paralleling his use of stock footage to make films.

Jack Goldstein. Frame shots from *Shane,* 1975. Color film, sound, 16mm, 3 minutes

but they nevertheless looked virtual, dematerialized, like the vivid but nebulous images of holograms. After one fencer had appeared to defeat the other, the spotlight went down, but the performance continued; left in darkness to listen to a replay of the background music, the audience would attempt to remember that image of fencing that had already appeared as if in memory. In this doubling by means of the mnemonic experience, the paradoxical mechanism by which memory functions is made apparent: the image is forgotten, replaced. (*Roget's Thesaurus* gives a child's definition of memory as "the thing I forget with.")

Goldstein's "actors" do not perform prescribed roles; they simply do what they would ordinarily do, professionally, just as the Hollywood-trained German shepherd growls and barks on cue in Goldstein's film *A German Shepherd*, and a ballerina descends from pointe in *A Ballet Shoe*, and a lion framed in a golden logo tosses his head and roars in *Metro-Goldwyn-Mayer*. These films show either simple, split-second gestures that are repeated with little or no difference, or slightly more extended actions that appear to exhaust themselves. Here, for example, is the scenario for *A Ballet Shoe:* the foot of a dancer in toe shoe is shown on pointe; a pair of hands comes in from either side of the film frame and unties the ribbon of the shoe; the dancer moves off pointe; the entire film lasts twenty-two seconds. The sense that its gesture is a complete one is therefore mitigated by its fragmented images (generating multiple psychological and tropological resonances) and its truncated duration; the whole is but a fragment.

The impression of a completed action (one fencer defeats the other) combines with a structure of repetition (the match is one of constant attack and parry) so that no action is really brought to closure; the performance or film stops, but it cannot be said to end. In this respect the recent film entitled *The Jump* is exemplary. Shown as a loop, it is a potentially endless repetition of repetitions. A diver leaps, somersaults, plunges, and disintegrates. This happens very quickly, and then it happens again, and still a third time. The camera follows the courses of the three divers, framing them in tight close-up, so that their trajectories are not graphically discernible. Rather, each diver bursts like fireworks into the center of the frame and within a split second disappears.

The Jump was made by rotoscoping stock super-8 footage of high dives and shooting the animation through a special-effects lens that dispersed the image into jewel-like facets.[6] The resultant image, sometimes recognizable as diver, sometimes amorphous, is a shimmering, red silhouette seen against a black field. Time is extremely compressed (the running time is twenty-six seconds) and yet extremely distended (shown as a loop, it plays endlessly). But the film's temporality as experienced does not reside in its actual duration, nor of course in anything like the synthetic time of narrative. Its temporal mode is the psychological one of *anticipation*. We wait for each dive, knowing more or less when it will appear, yet each time it startles us, and each time it disappears before we can really take satisfaction in it, so we wait for its next appearance;

6. Rotoscopy is a technique of tracing over live-action footage to make an animation.

again we are startled and again it eludes us. In each of Goldstein's films, performances, photographs, and phonograph records, a psychologized temporality is instituted: foreboding, premonition, suspicion, anxiety.[7] The psychological resonance of this work is not that of the subject matter of his pictures, however, but of the way those pictures are presented, *staged*; that is, it is a function of their structure. Goldstein's manner of staging the image is perfectly exemplified by the technique used for *The Jump*, the technique of rotoscopy, a process that is both a trace(ing) and an effacement of the filmed image, a drawing that is simultaneously an erasure. And that is what any staging of the image must always be. The temporality of these pictures is not then a function of the nature of the medium as in itself temporal, but of the manner in which the picture is presented; it can obtain in a still picture as well as a moving one.

Here is a picture:

Cindy Sherman. *Untitled Film Still,* 1978. Black-and-white photograph, 8 x 10″ (21.3 x 26 cm). Collection Arthur and Carol Goldberg, New York. (Photo: courtesy Metro Pictures)

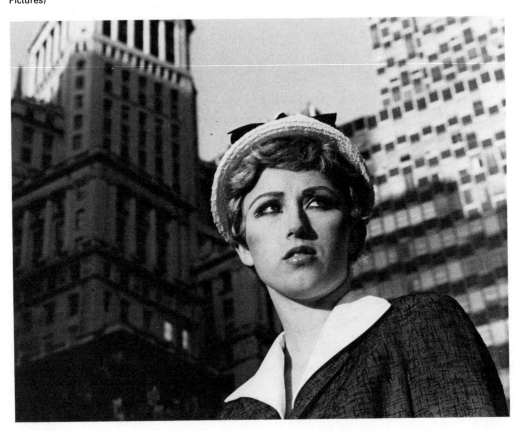

It shows a young woman with close-cropped hair, wearing a suit and hat whose style is that of the 1950s. She looks the part of what was called, in that

7. Each of the artists discussed here might be said to work with the conventions of a particular genre; if that is the case, Goldstein's would be those of the disaster film. In the movie *Earthquake*, for example, the entire first third of the film is nothing but a narration about an impending earthquake; yet when it comes, we are taken completely by surprise.

decade, a career girl, an impression that is perhaps cued, perhaps merely confirmed by the fact that she is surrounded by the office towers of the big city. But those skyscrapers play another role in this picture. They envelop and isolate the woman, reinforcing with their dark-shadowed, looming facades her obvious anxiety, as her eyes dart over her shoulder . . . at something perhaps lurking outside the frame of the picture. Is she, we wonder, being pursued?

But what is it, in fact, that makes this a picture of presentiment, of that which is impending? Is it the suspicious glance? Or can we locate the solicitation to read the picture as if it were fiction in a certain spatial dislocation—the jarring juxtaposition of close-up face with distant buildings—suggesting the cinematic artifice of rear-screen projection? Or is it the details of costume and makeup that might signal disguise? It is perhaps all of these, and yet more.

The picture in question is nothing other than a still photograph of/by the artist Cindy Sherman, one of a recent series in which she dresses in various costumes and poses in a variety of locations that convey highly suggestive though thoroughly ambiguous ambiences. We do not know what is happening in these pictures, but we know for sure that *something* is happening, and that something is a fictional narrative. We would never take these photographs for being anything but staged.

The still photograph is generally thought to announce itself as a direct transcription of the real precisely in its being a spatiotemporal fragment; or, on the contrary, it may attempt to transcend both space and time by contravening that very fragmentary quality.[8] Sherman's photographs do neither of these. Like ordinary snapshots, they appear to be fragments; unlike those snapshots, their fragmentation is not that of the natural continuum, but of a syntagmatic sequence, that is, of a conventional, segmented temporality. They are like quotations from the sequence of frames that constitutes the narrative flow of film. Their sense of narrative is one of its simultaneous presence and absence, a narrative ambience stated but not fulfilled. In short, these are photographs whose condition is that of the film still, that fragment *"whose existence never exceeds the fragment."*[9]

The psychological shock that is registered in this very special kind of picture can best be understood when it appears in relation to normal film time as the syntagmatic disjunction of a freeze frame. The sudden abjuration of narrative time solicits a reading that must remain inside the picture but cannot

8. See, for example, Hollis Frampton, "Impromptus on Edward Weston: Everything in Its Place," *October*, no. 5 (Summer 1978), especially pp. 59-62.

9. Roland Barthes, "The Third Meaning: Research Notes on Some Eisenstein Stills," in *Image-Music-Text*, trans. Stephen Heath (New York: Hill and Wang. 1977), p. 67. The appearance of the film still as an object of particular fascination in recent artistic practice is so frequent as to call for a theoretical explanation. Both Sherman's and Robert Longo's works actually resemble this odd artifact, as does that of John Mendelsohn, René Santos, and James Birrell, among others. Moreover, many of its characteristics as discussed by Barthes are relevent to the concerns of all the work discussed here. In this context, it is also interesting to note that the performances of Philip Smith were called by him "extruded cinema" and had such revealing titles as *Still Stories, Partial Biography*, and *Relinquish Control*. They consisted of multiple projections of 35mm slides in a sequence and functioned as deconstructions of cinematic narrative.

Robert Longo. Still from film for *Sound Distance of a Good Man,* 1978. Black-and-white film, silent, 8mm, 15 minutes.

Rainer Werner Fassbinder. Still from *The American Soldier,* 1970. Black-and-white film, sound, 35mm, 80 minutes

escape the temporal mode of which it is a fragment. It is within this confusion of temporalities that Robert Longo's work is situated. The central image of his three-part tableau performance, *Sound Distance of a Good Man*, presented in April 1978 at Franklin Furnace, was a film, showing, with no motion at all (save for the flickering effect of light that is a constant feature of cinema) the upper torso of a man, body arched and head thrown back as if in convulsion. That posture, registering a quick, jerky motion, is contrasted, in this motionless picture, with the frozen immobility of the statue of a lion. As the film unwound it continued to show only this still image; the entire film consisted of nothing but a freeze frame. But if the film's image does not traverse any temporal distance other than that literal time of the performed events that framed it on either side, its composition followed a rather complex scenario. Longo's movie camera was trained on a photograph, or more precisely a photo-montage whose separate elements were excerpted from a series of photographs, duplicate versions of the same shot. That shot showed a man dressed and posed in imitation of a sculpted aluminum relief that Longo had exhibited earlier that year. The relief was, in turn, quoted from a newspaper reproduction of a fragment of a film still taken from *The American Soldier*, a film by Fassbinder.

The "scenario" of this film, the scenario just described, the spiral of fragmentation, excerptation, quotation that moves from film still to still film is, of course, absent from the film that the spectators of *Sound Distance of a Good Man* watched. But what, if not that absent scenario, can account for the particular presence of that moving still image?

Such an elaborate manipulation of the image does not really transform it; it fetishizes it. The picture is an object of desire, the desire for the signification that is known to be absent. The expression of that desire to make the picture yield a reality that it pretends to contain is the subject of the work of Troy Brauntuch. But, it must be emphasized, his is no private obsession. It is an obsession that is in the very nature of our relationship to pictures. Brauntuch therefore uses pictures whose subject matter is, from a humanist point of view, the most loaded, most charged with meaning, but which are revealed in his work to be utterly opaque.

Here is a picture:

It appeared as an illustration to the memoirs of Albert Speer with the caption "Hitler asleep in his Mercedes, 1934" [10] Brauntuch has reproduced it as the central image of a recent three-part photographic print. The degree to which the image is fetishized by its presentation absolutely prevents its re-presentation; itself photographic, Brauntuch's work cannot in turn be photographically reproduced. Its exacting treatment of the most minute details and qualities of scale, color, framing, relationships of part to part would be completely lost outside the presence of the work as object. The above photograph, for example, is enlarged to a width of eighteen inches, thereby making its halftone screen visible, and printed on the left-hand side of a seven-foot long bloodred field. To the right of this picture is a further enlarged excerpt of it showing the building in the distance seen just above the windshield of the Mercedes. The panel on which these two images appear is flanked by two other panels positioned vertically, so that the ensemble of photographs looks diagrammatically like this:

The two vertical panels are blown up photographs, as well, although they are too abstracted to read as such. They are, in fact, reproductions of a fragment of a photograph of the Nuremberg rally lights shining in parallel streaks against the vast expanse of darkness. They are, of course, no more recognizable than the right-hand figure in the above photograph is recognizable as Hitler, nor do they divulge anything of the history they are meant to illustrate.

Reproduced in one book after another about the holocaust, already excerpted, enlarged, cropped, the images Brauntuch uses are so opaque and

10. Albert Speer, *Inside the Third Reich* (New York: Macmillan Publishing Co., 1970), ill. following p. 166. It was of course Walter Benjamin, a victim of the very history this memoir would recount, who asked, "Is it not the task of the photographer—descendant of the augurs and the haruspices—to uncover guilt and name the guilty in his pictures?" But then he added, " 'The illiterate of the future,' it has been said, 'will not be the man who cannot read the alphabet, but the one who cannot take a photograph.' But must we not also count as illiterate the photographer who cannot read his own pictures? Will not the caption become the most important component of the shot?" in "A Short History of Photography," trans. Stanley Mitchell, *Screen* 13, no. 1 (Spring 1972): 24.

fragmentary as to be utterly mute regarding their supposed subject. And indeed the most opaque of all are the drawings by Hitler himself.[11] What could be less revealing of the pathology of their creator than his perfectly conventional drawings? Every operation to which Brauntuch subjects these pictures represents the duration of a fascinated, perplexed gaze, whose desire is that they disclose their secrets; but the result is only to make the pictures all the more picturelike, to fix forever in an elegant object our distance from the history that produced these images. That distance is all that these pictures signify.

Although the manipulations to which Sherrie Levine subjects her pictures are far less obsessive than Brauntuch's, her subject is the same: the distance that separates us from what those pictures simultaneously proffer and withhold and the desire that is thereby set in motion. Drawn to pictures whose status is that of cultural myth, Levine discloses that status and its psychological resonances through the imposition of very simple strategies. In one tripartite series, for example, Levine cropped three photographs of a mother and child according to the emblematic silhouettes of Presidents Washington, Lincoln, and Kennedy. The currency of the myths with which Levine deals is exemplified by those profiles, taken as they are from the faces of coins; the photographs are cut out of a fashion magazine. The confrontation of the two images is structured in such a way that they must be read *through* each other: the profile of Kennedy *delineates* the picture of mother and child, which in turn *fills in* the Kennedy emblem. These pictures have no autonomous power of signification (pictures do not signify what they picture); they are provided with signification by the manner in which they are presented (on the faces of coins, in the pages of fashion magazines). Levine steals them away from their usual place in our culture and subverts their mythologies.

Shown as a slide projection at the Kitchen, the mother-and-child/ Kennedy picture was magnified to a height of eight feet and diffused through a stream of light. This presentation of the image gave it a commanding, theatrical presence. But what was the *medium* of that presence and thus of the work? Light? A 35-mm. slide? A cut-out picture from a magazine? Or is the medium of this work perhaps its reproduction here in this book? And if it is impossible to locate the physical medium of the work, can we then locate the *original* artwork?[12]

At the beginning of this essay, I said that it was due precisely to this kind of abandonment of the artistic medium *as such* that we had witnessed a break with modernism, or more precisely with what was espoused as modernism by

11. Brauntuch has used these drawings, which have been extensively published, in several of his works. Perhaps even more surprising than the banality of Hitler's drawings is that of the art produced inside the concentration camps; see *Spiritual Resistance: Art from Concentration Camps, 1940-45* (New York: The Jewish Museum, 1978).

12. Levine initially intended that the three parts of the work take three different forms for the purposes of this exhibition: the Kennedy silhouette as a slide projection in the gallery, the Lincoln as a postcard announcement, and the Washington as a poster, thus emphasizing the work's ambiguous relationship to its medium. Only the first two parts were executed, however.

Michael Fried. Fried's is, however, a very particular and partisan conception of modernism, one that does not, for example, allow for the inclusion of cinema ("cinema, even at its most experimental, is not a *modernist* art") or for the preeminently theatrical painting of surrealism. The work I have attempted to introduce here is related to a modernism conceived differently, whose roots are in the symbolist aesthetic announced by Mallarmé,[13] which includes works whose dimension is literally or metaphorically temporal, and which does not seek the transcendence of the material condition of the signs through which meaning is generated.

Nevertheless, it remains useful to consider recent work as having effected a break with modernism and therefore as postmodernist. But if *postmodernism* is to have theoretical value, it cannot be used merely as another chronological term; rather is must disclose the particular nature of a breach with modernism.[14] It is in this sense that the radically new approach to mediums is important. If it had been characteristic of the formal descriptions of modernist art that they were topographical, that they mapped the surfaces or artworks in order to determine their structures, then it has now become necessary to think of description as a stratigraphic activity. Those processes of quotation, excerptation, framing, and staging that constitute the strategies of the work I have been discussing necessitate uncovering strata of representation. Needless to say, we are not in search of sources or origins, but structures of signification: underneath each picture there is always another picture.

A theoretical understanding of postmodernism will also betray all those attempts to prolong the life of outmoded forms. Here, in brief, is an example, chosen because of its superficial resemblance to the pictures discussed here: In 1978, the Whitney Museum mounted an exhibition entitled *New Image Painting*, a show of work whose diversity of quality, intention, and meaning was hidden by its being forced into conjunction for what was, in most cases, its least important characteristic: recognizable images. What was, in fact, most essential about all of the work was its attempt to preserve the integrity of *painting*. So, for example, included were Susan Rothenberg's paintings in which rather abstracted images of horses appear. For the way they function in her painted surfaces, however, those horses might just as well be grids. "The interest in the horse," she explains, "is because it divides right."[15] The most successful painting in the exhibition was one by Robert Moskowitz called *The Swimmer*, in which the blue expanse from which the figure of a stroking swimmer emerges is forced into an unresolvable double reading as both painted

13. For a discussion of this aesthetic in relation to a pictorial medium, see my essay "Positive/Negative: A Note on Degas's Photographs," *October*, no. 5 (Summer 1978): 89-100.

14. There is a danger in the notion of postmodernism which we begin to see articulated, that which sees postmodernism as pluralism, and which wishes to deny the possibility that art can any longer achieve a radicalism or avant-gardism. Such an argument speaks of the "failure of modernism" in an attempt to institute a new humanism.

15. In Richard Marshall, *New Image Painting* (New York: Whitney Museum of American Art. 1978), p. 56.

field and water. And the painting thus shares in that kind of irony toward the medium that we recognize precisely as modernist.

New Image Painting is typical of recent museum exhibitions in its complicity with that art which strains to preserve the modernist aesthetic categories which museums themselves have institutionalized: it is not, after all, by chance that the era of modernism coincides with the era of the museum. So if we now have to look for aesthetic activities in so-called alternative spaces, outside the museum, that is because those activities, those *pictures*, pose questions that are postmodernist.

Sherrie Levine. Untitled, 1978. As reproduced in *October,* no. 8 (Spring 1979), p. 86

Jackson Pollock. *Frieze,* 1953–1955. Oil on canvas, 26 x 86" (66 x 218.5 cm). Collection Mr. and Mrs. Burton Tremaine, Sr. (Photo: Louise Lawler, *Pollock and Tureen,* 1984)

James Rosenquist. *1947, 1948, 1950,* 1960. Oil on masonite, 30 x 87⅜" (76.2 x 224 cm). Collection of the artist. (Photo: Bruce C. Jones; courtesy Leo Castelli Gallery)

Matt Mullican. *Mullican Posters (Fate, God, Angel-Demon, Heaven, Before Birth, Death, Hell),* 1982. Lead paint on paper, each: 60 x 36" (152.4 x 91.5 cm). (Photo: Zindman/Fremont; courtesy Mary Boone Gallery)

Re: Post

HAL FOSTER

"Postmodernism" is a term used promiscuously in art criticism,
often as a mere sign for not-modernism or a synonym for pluralism. As such,
it means little—only, perhaps, that we are in a reactionary period in which
modernism seems distant and revivalism all too near. On the one hand, this
distance is the very precondition of postmodernism; on the other, this reviv-
alism signals the need to conceive it as other than mere antimodernism.

What postmodernism is, of course, depends largely on what modernism
is, i.e., how it is defined. As a chronological term, it is often restricted to the
period 1860-1930 or thereabouts, though many extend it to postwar art or
"late" modernism. As an epistemological term, modernism is harder to specify
(e.g., Ought one to accept the break between classicism and modernity as
defined by Michel Foucault? Ought one to refer to Kantian self-criticism as
Clement Greenberg does?). In any case, postmodernism, articulated in relation
to modernism, tends to reduce it. Is there a modernism that can be so delim-
ited? If so, what would constitute a break with it?

**(Post)
Modernism**

Tactically, theorists of postmodernism in art tend to contain modernism in late
modernism, the ideology of which is extracted from the critical writings of
Clement Greenberg and Michael Fried. On this position, modernism is the
pursuit of "purity"; it holds that *"the concept of art . . . [is] meaningful, or
wholly meaningful, only* within *the individual arts,"* [1] and that "the art object
itself can be substituted (metaphorically) for its referent." [2] It is said to pre-
scribe "specific areas of competence" and to foster, in the artist, a self-critical
formalism in which the inherited "code" of the medium is manipulated and,
in the critic, a historicism that "works on the new and the different to diminish

Reprinted from *Parachute* 26 (Spring 1982): 11-15 with slight changes, and a post-
script, by the author.

1. Michael Fried, "Art and Objecthood," *Artforum* 5, no. 10 (Summer 1967): 21.
Reprinted in Gregory Battcock, ed., *Minimal Art: A Critical Anthology* (New York: E. P.
Dutton 1968), pp. 116-147 (his italics).

2. Craig Owens, "The Allegorical Impulse: Toward a Theory of Postmodernism (Part
2)," *October*, no. 13 (Summer 1980): 79. [Reprinted in this volume, see p. 235.]

newness and mitigate difference."[3] Painting, sculpture, and architecture are thus distinct, and art exists properly only within them; each art has a code or nature, and art proceeds as the code is revealed, the nature purged of the extraneous.

Such (simplified) is the postmodernist reading of modernism, distilled in the term *purity*. Once, this will-to-purity was subversive: in its negations, conventions—social ones encoded in the aesthetic—were delimited if not transgressed, and the artist, immersed in artistic practice, his or her true history, was rendered autonomous, transcendentally critical. However, seen dialectically in retrospect, such a strategy seems decorous and politically retrograde. "Purity" abets a division of labor within culture which, as a result, comes to partake of both the special professionalism of the academy and the commercial commodity-production of industry.[4] It also affirms the idea of art as its own issue, engendered from a special history; and this is indeed how art history is institutionally presented: as a line of works, a lineage of artists, in the historicist terms *(post hoc, ergo propter hoc)* of influence and continuity.

Though historical interventions can be redemptive (as the work of Walter Benjamin attests), they can also be recuperative—and are so, in equal measures, in the avant-garde, defined by Renato Poggioli as "the artistic equivalent of a transcendental historicism."[5] The term "transcendental historicism" here seems a contradiction, but it is one basic to modernism—no matter how "transcendental" or radically new the art, it is usually recouped, rendered familiar by historicism.[6] Late modernism only reworks the contradiction: art is avant-garde insofar as it is radically historicist—the artist delves into art-historical conventions in order to break out of them.

Such historicism (the New as its own Tradition) is both an origin and an end for the avant-garde; and one aim of postmodernism is to retain its radicality but be rid of its historicism.[7] For, as the discourse of the continuous, historicism recoups inherently; it conceives time as a totality (whereby "revolutions are never more than moments of consciousness"[8]) and man as the only subject. Human consciousness is at once posited and revealed as sovereign, and discontinuity is resisted, as is any decentering of the subject (whether by class,

3. Rosalind Krauss, "Sculpture in the Expanded Field," *October*, no. 8 (Spring 1979): 31. Reprinted in Hal Foster, ed., *The Anti-Aesthetic: Essays on Postmodern Culture* (Port Townsend, Wash.: Bay Press, 1983), pp. 31-42.

4. Marxist critics tended to regard the "pure sign" of modernist art (the object of its own referent) as a reflection of the reified, subjectivist nature of life under monolithic monopoly capitalism. Only a few (e.g., T. W. Adorno) were able as well to see it as a negativity—an abstraction posed against the totalizing abstraction of capital.

5. Renato Poggioli, *The Theory of the Avant-Garde* (Cambridge, Mass.: Belknap Press of Harvard University Press, 1981), p. 103.

6. See Krauss, "Expanded Field," pp. 31-33.

7. It is ironic (but not unexpected) that, in an age like the modern that so valorizes breaks and ruptures, the primary critical model would be historicism—whose job is to recoup breaks and ruptures.

8. Michel Foucault, *The Archaeology of Knowledge*, trans. A. M. Sheridan Smith (New York: Pantheon Books, 1976), p. 12.

family, or language). In art, of course, the subject of this historicism is the artist and its space is the museum; there, history is presented as a narrative—continuous, homogeneous, and anthropocentric—of great men and masterworks.

Purity as an end and decorum as an effect; historicism as an operation and the museum as the context; the artist as original and the art work as unique—these are the terms which modernism privileges and against which postmodernism is articulated. In postmodernism, they form a practice now exhausted, whose conventionality can no longer be inflected. Pledged to purity, the mediums have reified—hence, postmodernist art exists between, across, or outside them, or in new or neglected mediums (like video or photography). Historicized by the museum, commodified by the gallery, the art object is neutralized—hence, postmodernist art occurs in alternative spaces and in many forms, often dispersed, textual, or ephemeral. As the place of art is re-formed, so too is the role of the artist, and the values that heretofore authenticated art are questioned. In short, the cultural field is transformed, aesthetic signification opened up.

The field transformed is the first condition of postmodernism. In "Sculpture in the Expanded Field," Rosalind Krauss sketches how modern sculpture passed from a logic of historic place—the monument or statue—to one of autonomous form—the pure, siteless object. Indeed, she argues, by the time of minimalism modern sculpture had entered a condition of "pure negativity: the combination of exclusions . . . [it] was now the category that resulted from the addition of the *not-landscape* to the *not-architecture*." [9] These terms are simply the terms "architecture" and "landscape" inverted; set with others, they form a "quaternary field which both mirrors the original opposition and at the same time opens it." [10] It is in this "logically expanded field," suspended between these terms, that the postmodernist forms—"site-construction," "axiomatic structures," and "marked sites"—exist with sculpture. To Krauss, they break with modernist practice, and so cannot be thought of in terms of historicism. Here, art-historical context will not suffice as meaning, for postmodernism is articulated not within the mediums but in relation to cultural terms. These forms are conceived logically, not derived historically, and so must be regarded in terms of structure.

To be seen as such, postmodernism must posit a break; this one, with the mediums and with historicism, is crucial—it seals modernism and opens the cultural space of postmodernism. Douglas Crimp and Craig Owens also posit such a rupture, though, focused on other artists, they detail its advent somewhat differently. If, for Krauss, the signal of postmodernism is an expanded field of art, for Crimp it is a return of "theater" (tabooed by late modernism), and for Owens an "eruption of language" (also "repressed") and, more importantly, a new postmodernist impulse, "allegorical" or deconstructive in nature.

9. Krauss, "Expanded Field," p. 36 (her italics).
10. Ibid., p. 37.

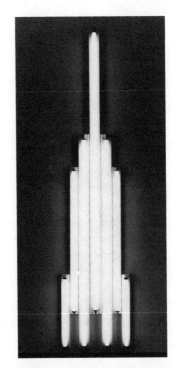

HOW DO YOU FIND THE RIGHT POSITION TO LIE
DOWN WITH A PERSON OR EVEN AN ANIMAL? OFTEN
ONE OF THE PARTNERS IS SMOTHERED OR CON-
TORTED. WHEN DONE PROPERLY, THOUGH,
EVERYONE IS VERY HAPPY.

BY YOUR RESPONSE TO DANGER IT IS EASY TO
SEE IF YOU WANT TO STAY ALIVE, IF YOU THINK
YOU DESERVE TO, IF YOU BELIEVE THAT IT'S ANY
GOOD TO ACT.

(Above left) James Casebere. *Street with Pots,* 1983. Black-and-white photograph, 30 x 24″ (76.2 x 61 cm). Edition of seven. (Photo: courtesy Diane Brown Gallery); (Top left) Robert Longo. Untitled, from *Men in the City* series, 1981. Charcoal and graphite on paper, 8′ x 5′ (2.44 x 1.53 m), and, Untitled, from *Men in the City* series, 1981. Lacquer on cast aluminum bonding, three pieces, each: 60 x 40″ (152.4 x 102 cm). (Photo: Louise Lawler, *Arranged by Janelle Reiring (Robert Longo),* 1982); (Top right) Dan Flavin. *Monument (For V. Tatlin),* 1967. Cool white, fluorescent light, 98 x 36″ (250 x 91.5 cm). Edition of five. (Photo: courtesy Leo Castelli Gallery); (Above right) Jenny Holzer. (Both) From *The Living Series,* 1983. Trans Lux News Jet, each: 24 x 87 x 16″ (61 x 221 x 40.6 cm). Edition of three. (Photo: courtesy Barbara Gladstone Gallery)

Again, these critics first pose postmodernism against late modernism, whose classic text is seen as the essay "Art and Objecthood" by Michael Fried.[11] Therein, Fried objects to the implicit "theater" of minimalist sculpture: *"art degenerates as it approaches the condition of theater,"* runs the often-quoted line, with "theater" defined as *"what lies between the arts."* To Crimp, this intuition signals modernism's demise: the important work of the seventies exists precisely between the arts; moreover, such work—especially video and performance—exploits the very "theater" (or "preoccupation with time—more precisely, with the duration of experience") that Fried deemed degenerate. In effect, minimalism's implicit "theater" becomes explicit. Much contemporary art can be derived by this extrapolation, or so Crimp asserts in the essay "Pictures":

> *If many of these artists can be said to have been apprenticed in the field of performance as it issued from minimalism, they have nevertheless begun to reverse its priorities, making of the literal situation and duration of the performed event a tableau whose presence and temporality were utterly psychologized; performance becomes just one of a number of ways of "staging" a picture.*[12]

Owens also cites the Fried dictum as late-modernist law, which he relates, as a "belief in the absolute *difference* of verbal and visual art," to the neoclass-ical order (i.e., the temporal arts, poetry, etc., *over* the spatial arts, painting, etc.).[13] Such a hierarchy is based on a "linguistic criterion," one which the modernist visual arts repressed. The emergence of time, intuited by Fried, is then marked by an "emergence of discourse":

11. This essay was and is of prime importance—a catalyst. (For Smithson's reaction, see his "Letter to the Editor," *Artforum* 6, no. 2 [October 1967]: 4, reprinted in Robert Smithson, *The Writings of Robert Smithson*, ed. Nancy Holt [New York: New York University Press, 1979], p. 38.) Fried objected to the "perversity" of minimalism—its deviation from the late-modernist will to "purity." Other, less perspicacious, critics regard minimalism as the *ne plus ultra* of modernist reduction. That it should enfold such a contradiction—the modernist impulse to the thing-itself and the postmodernist impulse toward "theatricality" or "perversity"—might in fact make minimalism the scene of a shift in sensibility, the very *brisure* of (post)modernism. See also Michael Fried, *Absorption and Theatricality: Painting and Beholder in the Age of Diderot* (Berkeley: University of California Press, 1980).

12. Douglas Crimp, "Pictures," *October*, no. 8 (Spring 1979): 77. [Reprinted in this volume, see p. 177.] Here, Crimp retains an (oblique) historicism, though the passage shows that it need not be centered on any one medium.

13. Craig Owens, "Earthwords," *October*, no. 10 (Fall 1979): 125-26. And yet modernism is seen, at least originally, as a revolt *against* the neoclassical order as congealed in the academy. Romantic confusion of genres, symbolist syncretism, surrealism . . . Granted these are episodes, they nevertheless question any characterization of modernism as a doctrine of *decorum* alone. Indeed, the "critique of representation" is originally a modernist impera-tive.

*The eruption of language into the aesthetic field—an eruption signalled
by, but by no means limited to the writings of Smithson, Morris, Andre,
Judd, Flavin, Rainer, LeWitt—is coincident with, if not the definitive
index of, the emergence of postmodernism. This "catastrophe" disrupted
the stability of modernist partitioning of the aesthetic field into discrete
areas of specific competence; one of its most deeply felt shocks dislodged
literary activity from the enclaves into which it had settled only to
stagnate—poetry, the novel, the essay . . . —and dispersed it across the
entire spectrum of aesthetic activity.*[14]

Owens regards much of the work that ensued (e.g., conceptual, story,
even site-specific art) as textual; here Roland Barthes is cited: "a text is not a
line of words releasing a single 'theological' meaning (the 'message' of the
Author-God) but a multi-dimensional space in which a variety of writings,
none of them original, blend and clash."[15] Such "textuality" is a poststructur-
alist notion, based on the idea that the sign is not stable, i.e., that it does not
enclose one signifier and signified as such. Similarly, the postmodernist work is
seen less as a "book" sealed by original author and final meaning than as a
"text" read as a polysemous tissue of codes. So, as Barthes writes of "the
death of the author," postmodernists infer "the death of the artist," at least as
originator of unique meaning.

(Post) Struc- turalism

To an extent, then, the postmodernist line retraces the poststructuralist line,[16]
for both describe a culture that is utterly coded.[17] "Within the situation of
postmodernism," Krauss writes, "practice is not defined in relation to a given
medium . . . but rather in relation to the logical operations on a set of cultural
terms, for which any medium—photography, books, lines on walls, or sculpture
itself—might be used."[18] In effect, the artist manipulates old signs in a new
logic: he or she is a rhetorician who transforms rhetoric (even the mediums are

14. Ibid., pp. 126-27.

15. Roland Barthes, "The Death of the Author," in *Image-Music-Text*, trans. Stephen
Heath (New York: Hill and Wang, 1977), p. 146.

16. See Fredric Jameson, *Fables of Aggression: Wyndham Lewis, the Modernist as
Fascist* (Berkeley: University of California Press, 1979), p. 20: "The contemporary post-
structuralist aesthetic . . . signals the dissolution of the modernist paradigm—with its valori-
zation of myth and symbol, temporality, organic form and the concrete universal, the identity
of the subject and the continuity of linguistic expression—and foretells the emergence of some
new, properly postmodernist or schizophrenic conception of the cultural artifact—now strate-
gically reformulated as 'text' or '*écriture*,' and stressing discontinuity, allegory, the mechani-
cal, the gap between signifier and signified, the lapse in meaning, the syncope in the
experience of the subject."

17. If the last generation of artists was the first (to a great degree) to attend college
and even graduate school, this is the first born into a totally (mass-) mediated world. This
has affected many of today's artists no less than many of today's film directors. Indeed, the
first field of reference for these artists is often the media, not art history.

18. Krauss, "Expanded Field," p. 42.

used as readymades to be reinscribed). To Crimp, postmodernist practice is concerned not with modernist autonomy but with "strata of representation"— "we are not in search of sources or origins, but of structures of signification: underneath each picture there is always another picture." [19] In such "pictures," artistic modes (e.g., performance) may be transposed, generic signs or types collided, so that aesthetic limits are transgressed as cultural codes are opened up—with these tactics: "quotation, excerptation, framing and staging." To Owens, not only are mediums collided, but levels of representation and reading are too: an "allegorical impulse" deconstructs the symbol-paradigm of modernism. "Appropriation, site specificity, impermanence, accumulation, discursivity, hybridization—these diverse strategies characterize much of the art of the present and distinguish it from its modernist predecessors." [20]

Much modernist art is based on a given form or public sign. In the star and cross paintings of Frank Stella, for instance, "the logic of the deductive structure is . . . shown to be inseparable from the logic of the sign." [21] This is not the case with much postmodernist art: the sign's stability, the medium's code, are rendered problematic. [22] For example, the expanded field is "generated by problematizing the set of oppositions between which the modernist category *sculpture* is suspended." [23] Signification is thus opened: the work is freed of the term "sculpture" . . . but only to be bound by other terms, "landscape," "architecture," etc. Though no longer defined in one code, practice remains within a *field*. Decentered, it is recentered: the field is (precisely) "expanded" rather than "deconstructed." The model for this field is a structuralist one, as is the activity of the Krauss essay: "to reconstruct an 'object' in such a way as to manifest thereby the rules of functioning (the 'functions') of this object." [24] "The Expanded Field" thus posits a logic of cultural oppositions questioned by poststructuralism—and also, it would seem, by postmodernism.

Rather than "map" a "field," Crimp uncovers "strata" of "pictures." This recalls Barthes, for whom the cultural type or "myth" is a composite of signs, and in fact Crimp notes how these pictures often re-present types in a way that "subverts their mythologies." [25] But postmodernist art must do more than merely demystify, for demystification is now mythological too—not only a doxa of its own, [26] but one that posits a truth (and an agent of truth, the critic) *beyond* ideology. Not only must art today question the "ideological signified,"

19. Crimp, "Pictures," p. 87. [Reprinted in this volume, see p. 186.]

20. Craig Owens, "The Allegorical Impulse: Toward a Theory of Postmodernism (Part 1)," *October*, no. 12 (Spring 1980): 75. [Reprinted in this volume, see p. 209.]

21. Rosalind Krauss, "Sense and Sensibility: Reflections on Post '60s Sculpture," *Artforum* 12, no. 3 (November 1973): 47.

22. Much late-modernist and postmodernist art, however, is related in this: meaning is conceived as external, not expressive of an "inner self."

23. Krauss, "Expanded Field," p. 38.

24. Roland Barthes, "The Structuralist Activity," trans. Richard Howard, *Partisan Review* 34, no. 1 (Winter 1967): 83.

25. Crimp, "Pictures," p. 85. [Reprinted in this volume, see p. 185.]

26. Roland Barthes, "Change the Object Itself," in *Image-Music-Text*, pp. 166-167. This is a danger of critical doxa in general.

but it must also "shake" the sign itself. (The picture-underneath-the-picture thus has more to do with Derrida's grammatology: the notion that the sign is "always already" articulated by another sign.)

To change the object itself: this, to Owens, is the mandate of postmodernist art. Contingent, this art exists in (or as) a web of references, not necessarily located in any one form, medium, or site. As the object is destructured, so is the subject (viewer) dislocated,[27] and the modernist order of the arts decentered. Such art is thus "allegorical" in nature.[28] Temporal and spatial at once, it dissolves the old order; so too, it opposes the "pure sign" of late-modernist art and plays, instead, on the "distance which separates signifier from signified, sign from meaning."[29] But to what does such allegorical art finally tend if not to a dispersal of the subject and a melancholic resignation in the face of a fragmented and reified history?

Figures and Fields

Postmodernism is thus posed as a rupture with the aesthetic order of modernism. And yet the concept of the field remains—even if only as a term to define its own dispersal. That is, postmodernism is seen within a given problematic of representation—in terms of types and codes, rhetorical figures and cultural fields. As a discourse, in a space. Its very "illegibility" is "allegorical," its very schizophrenia is strategic. Is it necessary to think in terms of fields and figures of representation? No doubt; and yet criticism thereby remains recuperative. As a textual practice, postmodernist art cannot be translated: criticism, then, would not be its supplement. But then what would it be? What does criticism *do* vis-à-vis such art? Does it enter as another code in the text of the art? Or does it initiate the very play of signs that *is* the text? My question, finally, is simple: Do critics today engage postmodernist art as its textual nature would seem to demand? "As soon as one seeks to demonstrate in this way," Derrida writes, "that there is no transcendental or privileged signified and that the domain or play of signification henceforth has no limit, one must reject even

27. Of Smithson, Owens writes: "Unintelligible at close range, the spiral form of the *Jetty* is completely intuitable only from a distance, and that distance is most often achieved by imposing a *text* between viewer and work. Smithson thus accomplishes a radical dislocation of the notion of point-of-view, which is no longer a function of physical position, but of the *mode* (photographic, cinematic, textual) of confrontation with the work of art" ("Earthwords," p. 128).

28. This is not, of course, the allegory of the levels of reading (literal, allegorical, moral, anagogic) ordered by a logos, Christian or otherwise. That transcendental signified is precisely what is lacking. As a result, the "levels" collide—no total reading is possible. "In allegorical structure, then, one text is *read through* another, however fragmentary, intermittent, or chaotic their relationship may be; the paradigm for the allegorical work is thus the palimpsest." Owens, "Allegorical Impulse (Part 1)," p. 69. [Reprinted in this volume, see pp. 204-205.]

29. Owens, "Allegorical Impulse (Part 2)," p. 63. [Reprinted in this volume, see p. 222.] It is tactical, as it is forced, to pose an "allegorical" postmodernism against a "symbolic" modernism. In practice these modes are never so distinct, though the tendency of twentieth-century art *is* toward a greater and greater immanence.

the concept and word 'sign' itself—which is precisely what cannot be done."[30] (Should one add: "even the concept and *critique* itself"?) But this is precisely what cannot be done—such is the epistemological bind of poststructuralism *and* postmodernism. Clearly, this "catastrophe" is marked in theory too.

Now, postmodernist art is often termed "deconstructive," which is to say that it enfolds a contradiction: it must use, as methodological tools at least, the very concepts that it calls into question. It may be too much to assert that such complicity is a conspiracy, but a convention, form, tradition, etc., *is* only deconstructed from within. Deconstruction thus becomes reinscription, for there is no "outside" (except in the positivist sense of "outside the mediums"— a transgression that reasserts the limit). That is, there is no way *not* to be in a field of cultural terms, for these terms inform us presumptively.

So if postmodernist art is referential, it refers only "to problematize the activity of reference."[31] For example, it may "steal" types and images in an "appropriation" that is seen as critical—both of a culture in which images are commodities and of an aesthetic practice that holds (nostalgically) to an art of originality. And yet, can a critique be articulated within the very forms under critique? Again, yes: how else could it be articulated? Such a critique, however, cannot hope to displace these forms; at best, it indicts them as "mythological" and stresses the need to think and represent otherwise. Another question is not so obvious: are the given mediums *not* mediated? That is to say, is a medium such as painting given as static and neutral, or is it in fact re-formed, re-presented, in and by the very forms that it mediates?

Appropriation, textuality . . . these tactics seem to preclude mediums whose logic is based on authenticity and originality. Painting per se is regarded by many critics as problematic, and even photography is seen to hold a vestige of aura—an aura that is elaborated or expunged by many artists today. (Indeed, a certain aura or even cult of inauthenticity is active today: the purloined image is now the law.) Such denials, when extreme, are of more interest to analysts than artists and critics. However, it remains true that the mediums are informed by historically specific logics—of productivism, say, or expressionism (the first of which may be complicitous with a superseded political economy,[32] the second now with a pop psychology of the most ideological sort).

Recently, of course, we have witnessed a resurgence in painting, not only a revival of old modes as if they were new, but also a retreat to old values as if they were necessary. Much of it is regressive—or rather, defensive. In the midst of society suffused with "information," many seem to regard painting—its specificity—as critical. Old avatars (creative artists, authentic art) are returned, precisely because they are untimely, as forces to resist complete mediation (which is to say, complete absorption in the consumerist program of mass

30. Jacques Derrida, "Structure, Sign, and Play," in *Writing and Difference*, trans. Alan Bass (Chicago: The University of Chicago Press, 1978), p. 281.

31. Owens, "Allegorical Impulse (Part 2)," p. 80. [Reprinted in this volume, see p. 235.]

32. Jean Baudrillard, *The Mirror of Production*, trans. Mark Poster (St. Louis: Telos Press, 1975).

Jasper Johns

Three Flags, 1958
Encaustic on canvas

Acquired 1959 Leo Castelli
Gallery

Whitney Museum
of American Art, NY.
50th-Anniversary
Gift of The Gilman
Foundation, Inc.,
The Lauder Foundation,
A. Alfred Taubman,
Anonymous Donor (and
purchase). 80.32

Jasper Johns. *Three Flags,* 1958 (detail). Encaustic on canvas, 30⅞ x 45½ x 5″ (78.5 x 115.5 x 12.7 cm). The Whitney Museum of American Art, New York. (Photo: Louise Lawler, *Detail/Acquired from Leo Castelli Gallery,* 1984)

Robert Morris. Untitled, from the *Firestorm* series, 1983. Paint on Hydrocal with watercolor and pastel on paper, 84 x 100 x 4″ (213.4 x 254 x 10.2 cm). As reproduced simultaneously on the April 1984 covers of *Art in America* and *Arts magazine.* (Photo: Louise Lawler)

media). Such a position, a nostalgic one, would regard postmodernism as complicitous with, not critical of, the media forms that engulf us.[33]

To a different degree, both these positions simplify, for both seem to imply that art mediums as representations or institutions are somehow apart from other representations or institutions, and so unable to engage them in any critique.[34] In postmodernist criticism, this is seen in a tendency to reduce painting to "pure" painting, now regarded as reified, and, in general, in a tendency to rehearse the "positivism of the medium" of late modernism and so to seal a formalist image of modernism that is relatively easy to displace.

Postmodernism does exploit late-modernist dogma, only to reconfirm its reduction, to which late modernism is then subjected. This is clearest as regards the mediums: identified with modernism, they are foreclosed with it. The fallacy here is to derive a logic of a medium from historical examples and then to see it (the logic) apart from the examples as somehow essential to the medium. A formalism of sorts, this operation first asserts the immanence or mediation of art, only to deny it later. And, in practical terms, it runs awry of the many modernist displacements of the mediums.

This leads to a second question about postmodernism: to expand the aesthetic field, to transgress formal closures, to steal images, to denature given signs, to question cultural myths, to problematize the activity of reference, etc. . . . how alien are these tactics to modernism? Picasso, Pollock, and Smithson all destructure the modes of signification that they inherit. Magritte, Johns, and Laurie Anderson all pose forms of rhetorical interference. They cannot all be recouped as postmodernist or proto-postmodernist. The strategy of appropriation, as seen in Duchamp and again in Rauschenberg, is modernist in origin, as is the deconstructive impulse—we are told often that modern art arose in metaphysics' fall (the question is, did art then serve as a substitute?).

"The deconstructive impulse," Owens writes, "must be distinguished from the self-critical tendency of modernism."[35] This is crucial to the postmodernist break, and no doubt the two operations are different: self-criticism, centered on a medium, does tend (at least under the aegis of formalism) to the essential or "pure," whereas deconstruction, on the contrary, decenters, and

33. This remark is representative: "That art which commits itself self-consciously to radicality—which usually means the technically and materially radical, since only technique and not the content of the mind advances—is a mirror of the world as it is and not a critique of it." Barbara Rose, *American Painting: The Eighties* (Buffalo: Thorney-Sidney Press, 1979), p. [12].

34. This may not even be true of "pure" painting. The will to purity is not merely about autonomy—it also serves to denature essences that are mere conventions. As such, it is at least an analogue to a much broader critique (it may even be argued that aesthetic conventions encode social ones and thus that the will to purity actually partakes in this critique). In late-modernist art, the critique centers on each medium less by an imperative of decorum than by the necessity of a received language. For, again, without such, how can any critical or deconstructive enterprise be articulated? Again, it is a question of the definition of the "field" of art.

35. Owens, "Allegorical Impulse (Part 2)," p. 79. [Reprinted in this volume, see p. 235.]

exposes the "impurity" of meaning. And yet unlike self-reflexivity (with which it is often conflated), self-criticism does not enforce a closure. It may, in fact, issue in deconstruction (such is really the recent history of critical theory), so that if postmodernism is truly deconstructive of modernism, it would seem to be a discursivity within it.

Certainly, to be regarded as an epistemological break and not merely a stylistic or chronological term, postmodernism must be based on a form of knowledge—and thus on material conditions—substantially different from modernism's. (A new technique, for example, may enable—but not initiate—a new way of seeing.) Perhaps such a form does exist: to know it will require a Foucauldean archaeology; to posit it now, on the basis of aesthetic effects, seems precarious. Recent practice has effected a defamiliarization, an estrangement (quintessentially modernist terms) that, in turn, stresses the historical, i.e., conditional, nature of art. And it is no doubt important to insist upon the cultural specificity of modernism (for it is determinate). But again: to delimit it now in terms of an absolute break seems problematic.

And yet postmodernism is defined as a rupture. In this it is like modernism which, despite historicism, often speaks a rhetoric of discontinuity. Like modernism too, postmodernism is posed against a past perceived as inert; it thus relies, in part, on the old imperative of the avant-garde and its language of crisis (in the sense of both judgment and separation). As noted, such crises in art tend to be recouped institutionally (in the museum and in art history), a recuperation which, along with pluralism, is the main problem of contemporary art. Clearly, a revision of the historicism that recoups and reduces even as it provokes the extreme is necessary, one in which the series of breaks, characteristic of modernism, are "seen not as an avant-garde succession—in which an evolution of discontinuity is substituted for the evolutionism of continuity—but in the form of a problematic constellation, whose systematics set off the 20th century as a deconstructive synchrony."[36]

Proponents of postmodernism tend to be highly conscious of historical moment. In effect, they would displace modernism, which, pushed back into the book of culture, is posed in its own reduction, foreclosed more than deconstructed. Rather than reduction, what is needed is a revision of modernism: an opening of its supposed closure. And perhaps postmodernism is this too. Though it reconfirms late-modernist dogma, it also reorders modernist discourses (for example, artists like Duchamp and Klee are favored, as are critics like Baudelaire and Benjamin). As such, it may be less a break with modernism than an advance in a dialectic in which modernism is re-formed. Certainly, any serious notion of postmodernism must be proffered on the conviction "that a system calling for corrections, translations, openings, and negations is more useful than an unformulated absence of system—one may then avoid the immobility of prattle and connect to the historical chain of discourses, the progress *(progressus)* of discursivity."[37]

36. Jean-Claude Lebensztejn, "Star," *October*, no. 1 (Spring 1976): 99.
37. Roland Barthes, "Writers, Intellectuals, Teachers," in *Image-Music-Text*, p. 200.

Postscript This essay, first written in Winter 1980, bears the marks of a time in New York when Art, with a graft from poststructuralism, seemed reborn as Text—with little critical regard then for its social uses and discursive affiliations. But if this piece is too rarefied, it is also too specific—a local riposte to a local advocacy.

"Postmodernism" was and still is a conflicted concept. Its rupture with modernism is dubious, and yet clearly many modernist paradigms have eroded. And though the term may seem anachronistically avant-gardist, it was also already in use in a discourse in which so-called postmodern styles seemed the cover for actively antimodern agendas. In the midst of all this, I wanted to argue against a modernism sealed in its own debased (formalist) image and for a conception of postmodernism that was not merely instrumental.

By and large, postmodernism is conceived in parochial (stylistic) or recuperative (historicist) terms—or grandiosely as the index of a new *épisteme*, a new discursive formation distinct from the modern (with its stress on a historicity specific to each discipline and governed by Man). The problem is that this model can account for postmodernism only as a rupture, not as a "restructuration." It thus seems necessary to periodize it in more materially textual ways—in Marxian terms, perhaps, as a conjuncture of specific problematics. (In this light, the rejection of postmodernism on the grounds that its elements are to be found in modernism may be countered with the argument that they now exist in a new order, transformed in place and effectivity.)

In any case, the very limits of this essay pushed me to consider the problem of postmodernism more broadly (one result of which was the collection *The Anti-Aesthetic: Essays on Postmodern Culture*). This in turn has led to a new project—to see in (post)modernism not the rule of one major mode but the conflict of many "minor" forms—and a new imperative—to think beyond the limits of *critique*.

GOVERNORS STATE UNIVERSITY
UNIVERSITY PARK
IL. 60466

(Top) Robert Smithson. *Partially Buried Woodshed,* 1970. One woodshed and twenty truckloads of raw earth, 10′ 2″ x 45′ x 18′ 6″ (3.1 x 13.73 x 5.64 m). Kent State University, Kent, Ohio; (Above left) Robert Smithson. *Partially Buried Woodshed,* 1970 (detail, interior); (Above right) Robert Smithson. *Island Project,* 1970. Pencil on paper, 19 x 24″ (48.3 x 61 cm). (Photo: Nathan Rabin; courtesy John Weber Gallery)

The Allegorical Impulse:
Toward a Theory of Postmodernism

CRAIG OWENS

> *Every image of the past that is not recognized by the present as one of its*
> *own concerns threatens to disappear irretrievably.*
> —Walter Benjamin, *"Theses on the Philosophy of History"*

In a review of Robert Smithson's collected writings, published in

I. *October* in Fall 1979, I proposed that Smithson's "genius" was an allegorical one, involved in the liquidation of an aesthetic tradition which he perceived as more or less ruined. To impute an allegorical motive to contemporary art is to venture into proscribed territory, for allegory has been condemned for nearly two centuries as aesthetic aberration, the antithesis of art. In *Aesthetic* Croce refers to it as "science, or art aping science"; Borges once called it an "aesthetic error." Although he surely remains one of the most allegorical of contemporary writers, Borges nevertheless regards allegory as an outmoded, exhausted device, a matter of *historical* but certainly not critical interest. Allegories appear in fact to represent for him the distance between the present and an irrecoverable past:

> *I know that at one time the allegorical art was considered quite*
> *charming . . . and is now intolerable. We feel that, besides being*
> *intolerable, it is stupid and frivolous. Neither Dante, who told the story*
> *of his passion in the* Vita nuova; *nor the Roman Boethius, writing his*
> De consolatione *in the tower of Pavia, in the shadow of his executioner's*
> *sword, would have understood our feeling. How can I explain that*
> *difference in outlook without simply appealing to the principle of*
> *changing tastes?* [1]

This statement is doubly paradoxical, for not only does it contradict the allegorical nature of Borges' own fiction, it also denies allegory what is most proper to it: its capacity to rescue from historical oblivion that which threatens to disappear. Allegory first emerged in response to a similar sense of estrangement from tradition; throughout its history it has functioned in the gap between a present and a past which, without allegorical reinterpretation, might have remained foreclosed. A conviction of the remoteness of the past, and a desire to redeem it for the present—these are its two most fundamental impulses. They

Reprinted from *October*, no. 12 (Spring 1980): 67-86, and no. 13 (Summer 1980): 59-80.

1. Jorge Luis Borges, "From Allegories to Novels," in *Other Inquisitions, 1937-1952*, trans. Ruth L. C. Simms (Austin: University of Texas Press, 1964), pp. 155-156.

account for its role in psychoanalytic inquiry, as well as its significance for Walter Benjamin, the only twentieth-century critic to treat the subject without prejudice, philosophically.[2] Yet they fail to explain why allegory's *aesthetic* potential should appear to have been exhausted long ago; nor do they enable us to locate the historical breach at which allegory itself receded into the depths of history.

Inquiry into the origins of the modern attitude toward allegory might appear as "stupid and frivolous" as its topic were it not for the fact that an unmistakably allegorical impulse has begun to reassert itself in various aspects of contemporary culture: in the Benjamin revival, for example, or in Harold Bloom's *The Anxiety of Influence*. Allegory is also manifest in the historical revivalism that today characterizes architectural practice, and in the revisionist stance of much recent art-historical discourse: T. J. Clark, for example, treating mid-nineteenth-century painting as political "allegory." In what follows, I want to focus this reemergence through its impact on both the practice and the criticism of the visual arts. There are, as always, important precedents to be accounted for: Duchamp identified both the "instantaneous state of Rest" and the "extra-rapid exposure," that is, the photographic aspects,[3] of the *Large Glass* as "allegorical appearance"; *Allegory* is also the title of one of Rauschenberg's most ambitious combine paintings from the fifties. Consideration of such works must be postponed, however, for their importance becomes apparent only after the suppression of allegory by modern theory has been fully acknowledged.

In order to recognize allegory in its contemporary manifestations, we first require a general idea of what in fact it is, or rather what it *represents*, since allegory is an attitude as well as a technique, a perception as well as a procedure. Let us say for the moment that allegory occurs whenever one text is doubled by another; the Old Testament, for example, becomes allegorical when it is read as a prefiguration of the New. This provisional description—which is not a definition—accounts for both allegory's origin in commentary and exegesis, as well as its continued affinity with them: as Northrop Frye indicates, the allegorical work tends to prescribe the direction of its own commentary. It is this metatextual aspect that is invoked whenever allegory is attacked as interpretation merely appended *post facto* to a work, a rhetorical ornament or flourish. Still, as Frye contends, "genuine allegory is a structural element in literature; it has to be there, and cannot be added by critical interpretation alone."[4] In allegorical structure, then, one text is *read through* another, however fragmentary, intermittent, or chaotic their relationship may be; the para-

2. On allegory and psychoanalysis, see Joel Fineman, "The Structure of Allegorical Desire," *October*, no. 12 (Spring 1980): 47-66. Benjamin's observations on allegory are to be found in the concluding chapter of *The Origin of German Tragic Drama*, trans. John Osborne (London: New Left Books, 1977).

3. See Rosalind Krauss, "Notes on the Index: Seventies Art in America," *October*, no. 3 (Spring 1977): 68-81.

4. Northrop Frye, *Anatomy of Criticism* (Princeton: Princeton University Press, 1957), p. 54.

digm for the allegorical work is thus the palimpsest. (It is from here that a reading of Borges' allegorism might be launched, with "Pierre Menard, Author of the *Quixote*" or several of the *Chronicles of Bustos Domecq*, where the text is posited by its own commentary.)

Conceived in this way, allegory becomes the model of all commentary, all critique, insofar as these are involved in rewriting a primary text in terms of its figural meaning. I am interested, however, in what occurs when this relationship takes place *within* works of art, when it describes their structure. Allegorical imagery is appropriated imagery; the allegorist does not invent images but confiscates them. He lays claim to the culturally significant, poses as its interpreter. And in his hands the image becomes something other (*allos* = other + *agoreuei* = to speak). He does not restore an original meaning that may have been lost or obscured; allegory is not hermeneutics. Rather, he adds another meaning to the image. If he adds, however, he does so only to replace: the allegorical meaning supplants an antecedent one; it is a supplement. This is why allegory is condemned, but it is also the source of its theoretical significance.

The first link between allegory and contemporary art may now be made: with the appropriation of images that occurs in the works of Troy Brauntuch, Sherrie Levine, Robert Longo, and others—artists who generate images through the reproduction of other images. The appropriated image may be a film still, a photograph, a drawing; it is often itself already a reproduction. However, the manipulations to which these artists subject such images work to empty them of their resonance, their significance, their authoritative claim to meaning. Through Brauntuch's enlargements, for example, Hitler's drawings, or those of concentration camp victims, exhibited without captions, become resolutely opaque:

> *Every operation to which Brauntuch subjects these pictures represents the duration of a fascinated, perplexed gaze, whose desire is that they disclose their secrets; but the result is only to make the pictures all the more picturelike, to fix forever in an elegant object our* distance from the history *that produced these images.* That distance is all that these pictures signify.[5]

Brauntuch's is thus that melancholy gaze which Benjamin identified with the allegorical temperament:

> *If the object becomes allegorical under the gaze of melancholy, if melancholy causes life to flow out of it and it remains dead, but eternally secure, then it is exposed to the allegorist, it is unconditionally in his power. That is to say it is now quite incapable of emanating any meaning or significance of its own; such significance as it has, it*

5. Douglas Crimp, "Pictures," *October*, no. 8 (Spring 1979): 85 (emphasis added). [Reprinted in this volume, see p. 185.]

acquires from the allegorist. He places it within it, and stands behind it; not in a psychological but in an ontological sense.[6]

Brauntuch's images simultaneously proffer and defer a promise of meaning; they both solicit and frustrate our desire that the image be directly transparent to its signification. As a result, they appear strangely incomplete—fragments or runes which must be *deciphered.*

Allegory is consistently attracted to the fragmentary, the imperfect, the incomplete—an affinity which finds its most comprehensive expression in the ruin, which Benjamin identified as the allegorical emblem par excellence. Here the works of man are reabsorbed into the landscape; ruins thus stand for history as an irreversible process of dissolution and decay, a progressive distancing from origin:

> *In allegory the observer is confronted with the* facies hippocratica *of history as a petrified, primordial landscape. Everything about history that, from the very beginning, has been untimely, sorrowful, unsuccessful, is expressed in a face—or rather in a death's head. And although such a thing lacks all "symbolic" freedom of expression, all classical proportion, all humanity—nevertheless, this is the form in which man's subjection to nature is most obvious and it significantly gives rise to not only the enigmatic question of the nature of human existence as such, but also of the biographical historicity of the individual. This is the heart of the allegorical way of seeing. . . .*[7]

With the allegorical cult of the ruin, a second link between allegory and contemporary art emerges: in site-specificity, the work which appears to have merged physically into its setting, to be embedded in the place where we encounter it. The site-specific work often aspires to a prehistoric monumentality; Stonehenge and the Nazca lines are taken as prototypes. Its "content" is frequently mythical, as that of the *Spiral Jetty,* whose form was derived from a local myth of a whirlpool at the bottom of the Great Salt Lake; in this way Smithson exemplifies the tendency to engage in a *reading* of the site, in terms not only of its topographical specifics but also of its psychological resonances. Work and site thus stand in a dialectical relationship. (When the site-specific work is conceived in terms of land reclamation, and installed in an abandoned mine or quarry, then its "defensively recuperative" motive becomes self-evident.)

Site-specific works are impermanent, installed in particular locations for a limited duration, their impermanence providing the measure of their circumstantiality. Yet they are rarely dismantled but simply abandoned to nature; Smithson consistently acknowledged as part of his works the forces which erode and eventually reclaim them for nature. In this, the site-specific work becomes an emblem of transience, the ephemerality of all phenomena; it is the *memento*

6. Benjamin, *German Tragic Drama,* pp. 183-184.
7. Ibid., p. 166.

mori of the twentieth century. Because of its impermanence, moreover, the work is frequently preserved only in photographs. This fact is crucial, for it suggests the allegorical potential of photography. "An appreciation of the transience of things, and the concern to rescue them for eternity, is one of the strongest impulses in allegory."[8] And photography, we might add. As an allegorical art, then, photography would represent our desire to fix the transitory, the ephemeral, in a stable and stabilizing image. In the photographs of Atget and Walker Evans, insofar as they self-consciously preserve that which threatens to disappear, that desire becomes the *subject* of the image. If their photographs are allegorical, however, it is because what they offer is only a fragment, and thus affirms its own arbitrariness and contingency.[9]

We should therefore also be prepared to encounter an allegorical motive in photomontage, for it is the "common practice" of allegory "to pile up fragments ceaselessly, without any strict idea of a goal."[10] This method of construction led Angus Fletcher to liken allegorical structure to obsessional neurosis[11]; and the obsessiveness of the works of Sol LeWitt, say, or Hanne Darboven suggests that they too may fall within the compass of the allegorical. Here we encounter yet a third link between allegory and contemporary art: in strategies of accumulation, the paratactic work composed by the simple placement of "one thing after another"—Carl Andre's *Lever* or Trisha Brown's *Primary Accumulation*. One paradigm for the allegorical work is the mathematical progression:

> *If a mathematician sees the numbers 1, 3, 6, 11, 20, he would recognize that the "meaning" of this progression can be recast into the algebraic language of the formula: X plus 2^x, with certain restrictions on X. What would be a random sequence to an inexperienced person appears to the mathematician a meaningful sequence. Notice that the progression can go on ad infinitum. This parallels the situation in almost all allegories. They have no inherent "organic" limit of magnitude. Many are unfinished like* The Castle *and* The Trial *of Kafka.*[12]

Allegory concerns itself, then, with the projection—either spatial or temporal or both—of structure as sequence; the result, however, is not dynamic,

8. Ibid., p. 223.

9. "Neither Evans nor Atget presumes to put us in touch with a pure reality, a thing in itself; their cropping always affirms its own arbitrariness and contingency. And the world they characteristically picture is a world *already made over into a meaning* that precedes the photograph; a meaning inscribed by work, by use, as inhabitation, as artifact. Their pictures are *signs representing signs*, integers in implicit chains of signification that come to rest only in major systems of social meaning: codes of households, streets, public places." Alan Trachtenberg. "Walker Evans's *Message from the Interior:* A Reading," *October*, no. 11 (Winter 1979): 12 (italics added).

10. Benjamin, *German Tragic Drama*, p. 178.

11. Angus Fletcher, *Allegory: The Theory of a Symbolic Mode* (Ithaca, N.Y.: Cornell University Press, 1964), pp. 279-303.

12. Ibid., p. 174.

but static, ritualistic, repetitive. It is thus the epitome of counter-narrative, for it arrests narrative in place, substituting a principle of syntagmatic disjunction for one of diegetic combination. In this way allegory superinduces a vertical or paradigmatic reading of correspondences upon a horizontal or syntagmatic chain of events. The work of Andre, Brown, LeWitt, Darboven, and others, involved as it is with the externalization of logical procedure, its projection as a spatiotemporal experience, also solicits treatment in terms of allegory.

This projection of structure as sequence recalls the fact that, in rhetoric, allegory is traditionally defined as a single metaphor introduced in continuous series. If this definition is recast in structuralist terms, then allegory is revealed to be the projection of the metaphoric axis of language onto its metonymic dimension. Roman Jakobson defined this projection of metaphor onto metonymy as the "poetic function," and he went on to associate metaphor with poetry and romanticism, and metonymy with prose and realism. Allegory, however, implicates *both* metaphor and metonymy; it therefore tends to "cut across and subtend all such stylistic categorizations, being equally possible in either verse or prose, and quite capable of transforming the most objective naturalism into the most subjective expressionism, or the most determined realism into the most surrealistically ornamental baroque." [13] This blatant disregard for aesthetic categories is nowhere more apparent than in the reciprocity which allegory proposes between the visual and the verbal: words are often treated as purely visual phenomena, while visual images are offered as script to be deciphered. It was this aspect of allegory that Schopenhauer criticized when he wrote:

> *If the desire for fame is firmly and permanently rooted in a man's mind . . . and if he now stands before the Genius of Fame* [by Annibale Caracci] *with its laurel crowns, then his whole mind is thus excited, and his powers are called into activity. But the same thing would also happen if he suddenly saw the word "fame" in large clear letters on the wall.* [14]

As much as this may recall the linguistic conceits of conceptual artists Robert Barry and Lawrence Weiner, whose work is in fact conceived as large, clear letters on the wall, what it in fact reveals is the essentially pictogrammat-

13. Fineman, "Allegorical Desire," p. 51. "Thus there are allegories that are primarily perpendicular, concerned more with structure than with temporal extension. . . . On the other hand, there is allegory that is primarily horizontal. . . . Finally, of course, there are allegories that blend both axes together in relatively equal proportions. . . . Whatever the prevailing orientation of any particular allegory, however—up and down through the declensions of structure, or laterally developed through narrative time—it will be successful as allegory only to the extent that it can suggest the authenticity with which the two coordinating poles bespeak each other, with structure plausibly unfolded in time, and narrative persuasively upholding the distinctions and equivalences described by structure" (p. 50).

14. Arthur Schopenhauer, *The World as Will and Representation*, vol. 1, Book 3, §50. Quoted in Benjamin, *German Tragic Drama*, p. 162.

ical nature of the allegorical work. In allegory, the image is a hieroglyph; an allegory is a rebus—writing composed of concrete images.[15] Thus we should also seek allegory in contemporary works which deliberately follow a discursive model: Rauschenberg's *Rebus*, or Twombly's series after the allegorical poet Edmund Spenser.

This confusion of the verbal and the visual is however but one aspect of allegory's hopeless confusion of all aesthetic mediums and stylistic categories (hopeless, that is, according to any partitioning of the aesthetic field on essentialist grounds). The allegorical work is synthetic; it crosses aesthetic boundaries. This confusion of genres, anticipated by Duchamp, reappears today in hybridization, in eclectic works which ostentatiously combine previously distinct art mediums.

Appropriation, site-specificity, impermanence, accumulation, discursivity, hybridization—these diverse strategies characterize much of the art of the present and distinguish it from its modernist predecessors. They also form a whole when seen in relation to allegory, suggesting that postmodernist art may in fact be identified by a single, coherent impulse, and that criticism will remain incapable of accounting for that impulse as long as it continues to think of allegory as aesthetic error. We are therefore obliged to return to our initial questions: When was allegory first proscribed, and for what reasons?

The critical suppression of allegory is one legacy of romantic art theory that was inherited uncritically by modernism. Twentieth-century allegories— Kafka's, for example, or Borges' own—are rarely *called* allegories, but parables or fables; by the middle of the nineteenth century, however, Poe—who was not himself immune to allegory—could already accuse Hawthorne of "allegorizing," of appending moral tags to otherwise innocent tales. The history of modernist painting is begun with Manet and not Courbet, who persisted in

15. This aspect of allegory may be traced to the efforts of humanist scholars to decipher hieroglyphs: "In their attempts they adopted the method of a pseudo-epigraphical *corpus* written at the end of the second, or possibly even the fourth century A.D., the *Hieroglyphica* of Horapollon. Their subject . . . consists entirely of the so-called symbolic or enigmatic hieroglyphs, mere pictorial signs, such as were presented to the hierogrammatist, aside from the ordinary phonetic signs, in the context of religious instruction, as the ultimate stage in a mystical philosophy of nature. The obelisks were approached with memories of this reading in mind, and a misunderstanding thus became the basis of the rich and infinitely widespread form of expression. For the scholars proceeded from the allegorical exegesis of Egyptian hieroglyphs, in which historical and cultic data were replaced by natural-philosophical, moral, and mystical commonplaces, to the extension of this new kind of writing. The books of iconology were produced, which not only developed the phrases of this writing, and translated whole sentences 'word for word by special pictorial signs,' but frequently took the form of lexica. 'Under the leadership of the artist-scholar, Albertus, the humanists thus began to write with concrete images *(rebus)* instead of letters; the word "rebus" thus originated on the basis of the enigmatic hieroglyphs, and medallions, columns, triumphal arches, and all the conceivable artistic objects produced by the Renaissance, were covered with such enigmatic devices' " Benjamin, *German Tragic Drama*, pp. 168-169. (Benjamin's quotations are drawn from Karl Giehlow's monumental study "Die Hieroglyphenkunde des Humanismus in der Allegorie der Renaissance," *Jahrbuch der Kunsthistorischen Sammlungen des allerhochsten Kaiserhauses* 32, no. 1 [1915]: 36.)

painting "real allegories." Even the most supportive of Courbet's contemporaries (Proudhon and Champfleury) were perplexed by his allegorical bent; one was either a realist *or* an allegorist, they insisted, meaning that one was either modernist or historicist.

In the visual arts, it was in large measure allegory's association with history painting that prepared for its demise. From the Revolution on, it had been enlisted in the service of historicism to produce image upon image of the present *in terms of* the classical past. This relationship was expressed not only superficially, in details of costume and physiognomy, but also structurally, through a radical condensation of narrative into a single, emblematic instant— significantly, Barthes calls it a hieroglyph[16]—in which the past, present, and future, that is, the *historical* meaning, of the depicted action might be read. This is of course the doctrine of the most pregnant moment, and it dominated artistic practice during the first half of the nineteenth century. Syntagmatic or narrative associations were compressed in order to compel a vertical reading of (allegorical) correspondences. Events were thus lifted out of a continuum; as a result, history could be recovered only through what Benjamin has called "a tiger's leap into the past":

> *Thus to Robespierre ancient Rome was a past charged with the time of the now which he blasted out of the continuum of history. The French Revolution viewed itself as Rome reincarnate. It evoked ancient Rome the way fashion evokes costumes of the past. Fashion has a flair for the topical, no matter where it stirs in the thickets of long ago; it is a tiger's leap into the past.*[17]

Although for Baudelaire this allegorical interpenetration of modernity and classical antiquity possessed no small theoretical significance, the attitude of the avant-garde which emerged at mid-century into an atmosphere rife with historicism was succinctly expressed by Proudhon, writing of David's *Leonidas at Thermopylae*:

> *Shall one say . . . that it is neither Leonidas and the Spartans, nor the Greeks and Persians who one should see in this great composition; that it is the enthusiasm of '92 which the painter had in view and Republican France saved from the Coalition? But why this allegory? What need to pass through Thermopylae and go backward twenty-three centuries to reach the heart of Frenchmen? Had we no heroes, no victories of our own?*[18]

16. Roland Barthes, "Diderot, Brecht, Eisenstein," in *Image-Music-Text*, trans. Stephen Heath (New York: Hill and Wang, 1977), p. 73

17. Walter Benjamin, "Theses on the Philosophy of History," in *Illuminations*, trans. Harry Zohn (New York: Schocken Books, 1969), p. 255.

18. Quoted in George Boas, "Courbet and His Critics," in *Courbet in Perspective*, ed. Petra ten-Doesschate Chu (Englewood Cliffs, N.J.: Prentice-Hall, 1977), p. 48.

So that by the time Courbet attempted to rescue allegory for modernity, the line which separated them had been clearly drawn, and allegory, conceived as antithetical to the modernist credo *Il faut être de son temps*, was condemned, along with history painting, to a marginal, purely historical existence.

Baudelaire, however, with whom that motto is most closely associated, never condemned allegory; in his first published work, the *Salon of 1845*, he defended it against the "pundits of the press": "How could one hope . . . to make them understand that allegory is one of the noblest branches of art?" [19] The poet's endorsement of allegory is only apparently paradoxical, for it was the relationship of antiquity to modernity that provided the basis for his theory of modern art, and allegory that provided its form. Jules Lemaître, writing in 1895, described the "specifically Baudelairean" as the "constant combination of two opposite modes of reaction . . . a past and a present mode"; Claudel observed that the poet combined the style of Racine with that of a Second Empire journalist. [20] We are offered a glimpse into the theoretical underpinnings of this amalgamation of the present and the past in the chapter "On the Heroism of Modern Life" from the *Salon of 1846*, and again in "The Painter of Modern Life," where modernity is defined as "the transient, the fleeting, the contingent; it is one half of art, the other being the eternal and the immovable." [21] If the modern artist was exhorted to concentrate on the ephemeral, however, it was *because* it was ephemeral, that is, it threatened to disappear without a trace. Baudelaire conceived modern art, at least in part, as the rescuing of modernity for eternity.

In "The Paris of the Second Empire in Baudelaire," Benjamin emphasizes this aspect of Baudelaire's project, linking it with Maxime Du Camp's monumental study, *Paris, ses organes, ses fonctions et sa vie dans la seconde moitié du XIXe siècle* (significantly, Du Camp is best known today for his photographs of ruins):

> *It suddenly occurred to the man who had travelled widely in the Orient,*
> *who was acquainted with the deserts whose sand is the dust of the dead,*
> *that this city, too, whose bustle was all around him, would have to die*
> *some day, the way so many capitals had died.*
> *It occurred to him how extraordinarily interesting an accurate*
> *description of Athens at the time of Pericles, Carthage at the time of*
> *Barca, Alexandria at the time of the Ptolemies, and Rome at the time of*
> *the Caesars would be to us today. . . . In a flash of inspiration, of the*
> *kind that occasionally brings one an extraordinary subject, he resolved*

19. Charles Baudelaire, "Salon of 1845," in *Art in Paris 1845-1862*, ed. and trans. Jonathan Mayne (New York: Phaidon Publishers, 1965), p. 14.

20. Cited in Walter Benjamin, "The Paris of the Second Empire in Baudelaire," *Charles Baudelaire: A Lyric Poet in the Era of High Capitalism*, trans. Harry Zohn (London: New Left Books, 1973), p. 100. Lemaître's remark appears on p. 94 of the same text.

21. Charles Baudelaire, "The Painter of Modern Life," *Selected Writings on Art and Artists*, trans. P. E. Charvet (Baltimore: Penguin Books, 1972), p. 403.

to write the kind of book about Paris that the historians of antiquity
failed to write about their cities.[22]

For Benjamin, Baudelaire is motivated by an identical impulse, which explains his attraction to Charles Meyron's allegorical engravings of Paris, which "brought out the ancient face of the city without abandoning one cobblestone."[23] In Meyron's views, the antique and the modern were superimposed, and from the will to preserve the traces of something that was dead, or about to die, emerged allegory: in a caption the renovated Pont Neuf, for example, is transformed into a *memento mori.*[24]

Benjamin's primary insight—"Baudelaire's genius, which drew its nourishment from melancholy, was an allegorical one"[25]—effectively situates an allegorical impulse at the origin of modernism in the arts and thus suggests the previously foreclosed possibility of an alternate reading of modernist works, a reading in which their allegorical dimension would be fully acknowledged. Manet's manipulation of historical sources, for example, is inconceivable without allegory; was it not a supremely allegorical gesture to reproduce in 1871 the *Dead Toreador* as a wounded Communard, or to transpose the firing squad from the *Execution of Maximilian* to the Paris barricades? And does not collage, or the manipulation and consequent transformation of highly significant fragments, also exploit the atomizing, disjunctive principle which lies at the heart of allegory? These examples suggest that, in practice at least, modernism and allegory are *not* antithetical, that it is in theory alone that the allegorical impulse has been repressed. It is thus to theory that we must turn if we are to grasp the full implications of allegory's recent return.

Near the beginning of "The Origin of the Work of Art," Heidegger introduces two terms which define the "conceptual frame" within which the work of art is conventionally located by aesthetic thought:

> *The art work is, to be sure, a thing that it made, but it says something*
> *other than the mere thing itself is,* allo agoreuei. *The work makes public*
> *something other than itself; it manifests something other; it is an*
> *allegory. In the work of art something other is brought together with the*
> *thing that is made. To bring together is, in Greek,* sumballein. *The work*
> *is a symbol.*[26]

22. Paul Bourget, "Discours académique du 13 juin 1895. Succession à Maxime Du Camp," *L'anthologie de l'Académie française* (Paris, 1921), vol. 2., pp. 191ff. Quoted in Benjamin, *Charles Baudelaire,* p. 86.

23. Benjamin, *Charles Baudelaire,* p. 87.

24. Benjamin quotes the caption; in translation it reads: "Here lies the exact likeness of the old Pont Neuf, all recaulked like new in accordance with a recent ordinance. O learned physicians and skillful surgeons, why not do with us as was done with this stone bridge" (*Charles Baudelaire,* p. 88).

25. Walter Benjamin, "Paris—the Capital of the Nineteenth Century," trans. Quintin Hoare, in *Charles Baudelaire,* p. 170.

26. Martin Heidegger, "The Origin of the Work of Art," *Poetry, Language, Thought,* trans. Albert Hofstadter (New York: Harper & Row, 1971), pp. 19-20.

By imputing an allegorical dimension to every work of art, the philosopher appears to repeat the error, regularly lamented by commentators, of generalizing the term *allegory* to such an extent that it becomes meaningless. Yet in this passage Heidegger is reciting the litanies of philosophical aesthetics only in order to prepare for their dissolution. The point is ironic, and it should be remembered that irony itself is regularly enlisted as a variant of the allegorical; that words can be used to signify their opposites is in itself a fundamentally allegorical perception.

Allegory and symbol—like all conceptual pairs, the two are far from evenly matched. In modern aesthetics, allegory is regularly subordinated to the symbol, which represents the supposedly indissoluble unity of form and substance which characterizes the work of art as pure presence. Although this definition of the art work as informed matter is, we know, as old as aesthetics itself, it was revived with a sense of renewed urgency by romantic art theory, where it provided the basis for the philosophical condemnation of allegory. According to Coleridge, "The Symbolical cannot, perhaps, be better defined in distinction from the Allegorical, than that it is always itself *a part of* that, of the whole of which it is the representative."[27] The symbol is a synecdoche, a part representing the whole. This definition is possible, however, if and only if the relationship of the whole to its parts be conceived in a particular manner. This is the theory of expressive causality analyzed by Althusser in *Reading Capital:*

> *[The Leibnizian concept of expression] presupposes in principle that the whole in question be reducible to an* inner essence, *of which the elements of the whole are then no more than the phenomenal forms of expression, the inner principle of the essence being present at each point in the whole, such that at each moment it is possible to write the immediately adequate equation:* such and such an element . . . = the inner essence of the whole. *Here was a model which made it possible to think the effectivity of the whole on each of its elements, but if this category—inner essence/outer phenomenon—was to be applicable everywhere and at every moment to each of the phenomena arising in the totality in question, it presupposed that the whole had a certain nature, precisely the nature of a 'spiritual' whole in which each element was expressive of the entire totality as a 'pars totalis.'*[28]

Coleridge's is thus an expressive theory of the symbol, the presentational union of "inner essence" and outward expression, which are in fact revealed to be identical. For essence is nothing but that element of the whole which has been hypostasized as its essence. The theory of expression thus proceeds in a circle: while designed to explain the effectivity of the whole on its constituent elements, it is nevertheless those elements themselves which react upon the

27. Samuel Taylor Coleridge, *Coleridge's Miscellaneous Criticism*, ed. Thomas Middleton Raysor (Cambridge, Mass.: Harvard University Press, 1936), p. 99 (italics added).

28. Louis Althusser and Etienne Balibar, *Reading Capital*, trans. Ben Brewster (London: New Left Books, 1970), pp. 186-187 (emphasis added).

The Allegorical Impulse 213

whole, permitting us to conceive the latter in terms of its "essence." In Coleridge, then, the symbol is precisely that part of the whole to which it may be reduced. The symbol does not represent essence; it *is* essence.

On the basis of this identification, the symbol becomes the very emblem of artistic *intuition:* "Of utmost importance to our present subject is this point, that the latter (the allegory) cannot be other than spoken consciously; whereas in the former (the symbol) it is very possible that the general truth represented may be working unconsciously in the writer's mind during the construction of the symbol."[29] The symbol is thus a motivated sign; in fact, it represents linguistic motivation as such. For this reason Saussure substituted the term *sign* for *symbol*, for the latter is "never wholly arbitrary; it is not empty, for there is the rudiment of a natural bond between the signifier and the signified."[30] If the symbol is a motivated sign, then allegory, conceived as its antithesis, will be identified as the domain of the arbitrary, the conventional, the unmotivated.

This association of the symbol with aesthetic intuition, and allegory with convention, was inherited uncritically by modern aesthetics; thus Croce in *Aesthetic:*

> Now if the symbol be conceived as inseparable from the artistic
> intuition, it is a synonym for the intuition itself, which always has an
> ideal character. There is no double bottom to art, but one only; in art
> all is symbolical because all is ideal. But if the symbol be conceived as
> separable—if the symbol can be on one side, and on the other the thing
> symbolized, we fall back into the intellectualist error: the so-called
> symbol is the exposition of an abstract concept, an allegory; it is science,
> or art aping science. But we must also be just towards the allegorical.
> Sometimes it is altogether harmless. Given the Gerusalemme liberata, *the*
> allegory was imagined afterwards; given the Adone of Marino, *the poet*
> of the lascivious afterwards insinuated that it was written to show how
> "immoderate indulgence ends in pain"; given a statue of a beautiful

29. Coleridge, *Miscellaneous Criticism*, p. 99. This passage should be compared with Goethe's famous condemnation of allegory: "It makes a great difference whether the poet starts with a universal idea and then looks for suitable particulars, or beholds the universal *in* the particular. The former method produces allegory, where the particular has status merely as an instance, an example of the universal. The latter, by contrast, is what reveals poetry in its true nature: it speaks forth a particular without independently thinking of or referring to a universal, but in grasping the particular in its living character *it implicitly apprehends the universal along with it.*" Quoted in Philip Wheelwright, *The Burning Fountain* (Bloomington: Indiana University Press, 1968), p. 89 (italics added). This recalls Borges' view of allegory: "The allegory is a fable of abstractions, as the novel is a fable of individuals. The abstractions are personified; therefore in every allegory there is something of the novel. The individuals proposed by novelists aspire to be generic (Dupin is Reason, Don Segundo Sombra is the Gaucho); an allegorical element inheres in novels." (Borges, "From Allegories to Novels," p. 157).

30. Ferdinand de Saussure, *Course in General Linguistics*, trans. Wade Baskin (New York: McGraw-Hill Book Co., 1966), p. 68.

woman, the sculptor can attach a label to the statue saying that it represents Clemency *or* Goodness. *This allegory that arrives attached to a finished work* post festum *does not change the work of art. What is it then? It is an expression externally added to another expression.*[31]

In the name of "justice," then, and in order to preserve the intuitive character of every work of art, including the allegorical, allegory is conceived as a *supplement*, "an expression externally added to another expression." Here we recognize that permanent strategy of Western art theory which excludes from the work everything which challenges its determination as the unity of "form" and "content."[32] Conceived as something added or superadded to the work after the fact, allegory will consequently be detachable from it. In this way modernism can recuperate allegorical works for itself, on the condition that what makes them allegorical be overlooked or ignored. Allegorical meaning does indeed appear supplementary; we can appreciate Bellini's *Allegory of Fortune*, for example, or read *Pilgrim's Progress* as Coleridge recommended, without regard for their iconographic significance. Rosemond Tuve describes the viewer's "experience of a genre-picture—or so he had thought it—turning into . . . [an] allegory before his eyes, by something he learns (usually about the history and thence the deeper significance of the image)."[33] Allegory *is* extravagant, an expenditure of surplus value; it is always *in excess.* Croce found it "monstrous" precisely because it encodes two contents within one form.[34] Still, the allegorical supplement is not only an addition, but also a replacement. It takes the place of an earlier meaning, which is thereby either effaced or obscured. Because allegory usurps its object it comports within itself a danger, the possibility of perversion: that what is "merely appended" to the work of art be mistaken for its "essence." Hence the vehemence with which modern aesthetics—formalist aesthetics in particular—rails against the allegorical supplement, for it challenges the security of the foundations upon which aesthetics is erected.

If allegory is identified as a supplement, then it is also aligned with writing, insofar as writing is conceived as supplementary to speech. It is of course within the same philosophic tradition which subordinates writing to speech that allegory is subordinated to the symbol. It might be demonstrated, from another perspective, that the suppression of allegory is identical with the suppression of writing. For allegory, whether visual or verbal, is essentially a form of script—this is the basis for Walter Benjamin's treatment of it in *The*

31. Benedetto Croce, *Aesthetic*, trans. Douglas Ainslie (New York: The Noonday Press, 1966), pp. 34-35.

32. This is what sanctioned Kant's exclusion, in the *Critique of Judgment*, of color, drapery, framing . . . as ornament merely appended to the work of art and not intrinsic parts of it. See Jacques Derrida, "The Parergon," *October*, no. 9 (Summer 1979): 3-40, as well as my afterword, "Detachment/from the *parergon*," pp. 42-49.

33. Rosemond Tuve, *Allegorical Imagery: Some Medieval Books and their Posterity* (Princeton: Princeton University Press, 1966), p. 26.

34. Cited in Borges, "From Allegories to Novels," p. 155.

Origin of German Tragic Drama: "At one stroke the profound vision of allegory transforms things and works into stirring writing."[35]

Benjamin's theory of allegory, which proceeds from the perception that "any person, any object, any relationship can mean absolutely anything else,"[36] defies summary. Given its centrality to this essay, however, a few words concerning it are in order. Within Benjamin's oeuvre, *The Origin of German Tragic Drama*, composed in 1924-25 and published in 1928, stands as a seminal work; in it are assembled the themes that will preoccupy him throughout his career: progress as the eternal return of the catastrophe; criticism as redemptive intervention into the past; the theoretical value of the concrete, the disparate, the discontinuous; his treatment of phenomena as script to be deciphered. This book thus reads like a prospectus for all of Benjamin's subsequent critical activity. As Anson Rabinbach observes in his introduction to the recent issue of *New German Critique* devoted to Benjamin, "His writing forces us to think in correspondences, to proceed through allegorical images rather than through expository prose."[37] The book on baroque tragedy thus throws into relief the essentially allegorical nature of all of Benjamin's work—the "Paris Arcades" project, for example, where the urban landscape was to be treated as a sedimentation in depth of layers of meaning which would gradually be unearthed. For Benjamin, *inter*pretation is dis*inter*ment.

The Origin of German Tragic Drama is a treatise on critical method; it traces not only the origin of baroque tragedy, but also of the critical disapprobation to which it has been subject. Benjamin examines in detail the romantic theory of the symbol; by exposing its theological origins, he prepares for its supersedure:

> *The unity of the material and the transcendental object, which constitutes the paradox of the theological symbol, is distorted into a relationship between appearance and essence. The introduction of this distorted conception of the symbol into aesthetics was a romantic and destructive extravagance which preceded the desolation of modern art criticism. As a symbolic construct it is supposed to merge with the divine in an unbroken whole. The idea of the unlimited immanence of the moral world in the world of beauty is derived from the theosophical aesthetics of the romantics. But the foundations of this idea were laid long before.*[38]

In its stead, Benjamin places the (graphic) sign, which represents the distance between an object and its significance, the progressive erosion of meaning, the absence of transcendence from within. Through this critical maneuver he is able to penetrate the veil which had obscured the achievement

35. Benjamin, *German Tragic Drama*, p. 176.

36. Ibid., p. 175.

37. Anson Rabinbach, "Critique and Commentary/Alchemy and Chemistry: Some Remarks on Walter Benjamin and this Issue," *New German Critique*, no. 17 (Spring 1979): 3.

38. Benjamin, *German Tragic Drama*, p. 160.

of the baroque, to appreciate fully its theoretical significance. But it also enables him to liberate writing from its traditional dependency on speech. In allegory, then, "written language and sound confront each other in tense polarity. . . . The division between signifying written language and intoxicating spoken language opens up a gulf in the solid massif of verbal meaning and forces the gaze into the depths of language."[39]

We encounter an echo of this passage in Robert Smithson's appeal for both an allegorical practice and an allegorical criticism of the visual arts in his text "A Sedimentation of Mind: Earth Projects":

> *The names of minerals and the minerals themselves do not differ from each other, because at the bottom of both the material and the print is the beginning of an abysmal number of fissures. Words and rocks contain a language that follows a syntax of splits and ruptures. Look at any* word *long enough and you will see it open up into a series of faults, into a terrain of particles each containing its own void. . . .*
>
> *Poe's* Narrative of A. Gordon Pym *seems to me excellent art criticism and prototype for rigorous "non-site" investigations. . . . His descriptions of chasms and holes seem to verge on proposals for "earthwords." The shapes of the chasms themselves become "verbal roots" that spell out the difference between darkness and light.*[40]

Smithson refers to the alphabetic chasms described at the conclusion of Poe's novel; in a "Note" appended to the text, the novelist unravels their allegorical significance, which "has beyond doubt escaped the attention of Mr. Poe."[41] Geological formations are transformed by commentary into articulate script. Significantly, Poe gives no indication as to how these ciphers, Ethiopian, Arabic, and Egyptian in origin, are to be pronounced; they are purely graphic facts. It was here, where Poe's text doubles back on itself to provide its own commentary, that Smithson caught a glimpse of his own enterprise. And in that act of self-recognition there is embedded a challenge to both art and criticism, a challenge which may now be squarely faced.

II. *We write in order to forget our foreknowledge of the total opacity of words and things or, perhaps worse, because we do not know whether things have or do not have to be understood.*

—Paul de Man, *Allegories of Reading*

39. Ibid., p. 201.

40. Robert Smithson, "A Sedimentation of Mind: Earth Projects," *The Writings of Robert Smithson*, ed. Nancy Holt, (New York: New York University Press, 1979), pp. 87-88. On Smithson's allegorism, see my review, "Earthwords," *October*, no. 10 (Fall 1979): 121-130.

41. Edgar Allan Poe, *The Narrative of Arthur Gordon Pym . . .* (New York: Hill and Wang, 1960), p. 197.

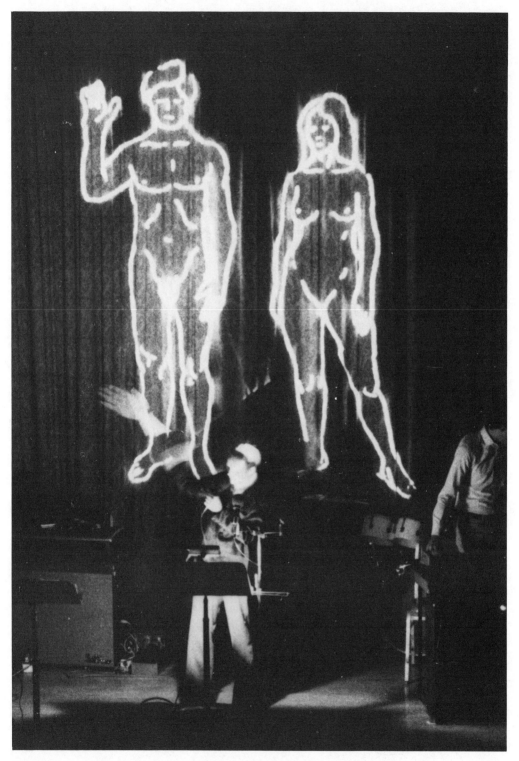

Laurie Anderson. Scene from *Americans on the Move,* Parts I and II, 1979, The Kitchen, New York.
(Photo: Marcia Resnick)

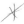

Here is the beginning of an allegory, a brief parable of reading from the opening of Laurie Anderson's *Americans on the Move*:

> *You know when you're driving at night like this it can suddenly occur to you that maybe you're going in completely the wrong direction. That turn you took back there . . . you were really tired and it was dark and raining and you took the turn and you just started going that way and then the rain stops and it starts to get light and you look around and absolutely everything is completely unfamiliar. You know you've never been here before and you pull into the next station and you feel so awkward saying, "Excuse me, can you tell me where I am?" . . .*[42]

This passage, with its images of driving (Anderson's metaphor for consciousness: "I am in my body the way most people drive in their cars") and obscurity, is reminiscent of the opening of *The Divine Comedy* ("Nel mezzo del cammin di nostra vita/mi ritrovai per una selva oscura/che la diritta via era smarrita. . . . Io non so ben ridir com' io v'entrai,/tant'era pieno di sonno a quel punto/che la verace via abbondonai"[43]), or rather of that state of perplexity which initiates so many allegories. And Anderson's night driver soon encounters her Virgil in the guise of a grease monkey, who reveals that her befuddlement is the result of her failure to "read the signs"—a failure which is not, however, attributed to a subject who has either neglected or misread directional signals, but to the fundamental unreadability of the signs themselves. Commenting on a projection of the image that was emblazoned on the Apollo 10 spacecraft—a nude man and woman, the former's right arm raised at the elbow, palm proffered—her Virgil in overalls inquires: "In our country, we send pictures of our sign language into outer space. They are speaking our sign language in these pictures. Do you think they will think his hand is permanently attached that way? Or do you think they will read our signs? In our country, good-bye looks just like hello."

Two alternatives: either the extraterrestrial recipient of this message will assume that it is simply a picture, that is, an analogical likeness of the human figure, in which case he might logically conclude that male inhabitants of Earth walk around with their right arms permanently raised. Or he will somehow divine that this gesture is addressed to him and attempt to read it, in which case he will be stymied, since a single gesture signifies both greeting and farewell, and any reading of it must oscillate between these two extremes. The same gesture could also mean "Halt!" or represent the taking of an oath, but if Anderson's text does not consider these alternatives that is because it is not

42. *Americans on the Move*, a performance by Laurie Anderson, was presented at The Kitchen in New York in April 1979. Several texts from it were published in *October*, no. 8 (Spring 1979): 45-57. All quotations are taken from this source.

43. "In the middle of the journey of our life I came to myself within a dark wood where the straight way was lost. . . . I cannot rightly tell how I entered there, I was so full of sleep at that moment when I left the true way . . ." *The Divine Comedy of Dante Alighieri*, vol. 1, *Inferno*, trans. John D. Sinclair (New York: Oxford University Press, 1939), p. 23.

concerned with ambiguity, with multiple meanings engendered by a single sign; rather, two *clearly defined but mutually incompatible* readings are engaged in blind confrontation in such a way that it is impossible to choose between them. It is, of course, in allegory that "one and the same object can just as easily signify a virtue as a vice,"[44] and this works to problematize the activity of reading, which must remain forever suspended in its own uncertainty.

"In the illusory babels of language," Robert Smithson wrote, "an artist might advance specifically to get lost."[45] Anderson is such an artist, and her performances are narratives of losing one's way in labyrinths of signs. Although she employs, in addition to lyrics and spoken texts, photographs, drawings, films, and music, all of these are implicated in a general thematics of reading that extends far beyond the limits of the written text. For Anderson, the world is a vast network of signs and, as such, continually elicits reading, interpretation. Consciousness, being in the world, is in fact identified with reading—an identification which is not, however, unproblematic, for the legibility of signs is always uncertain. And it is to the problem of *illegibility* that Anderson's work is addressed.

Americans on the Move continually returns to the fundamental ambivalence of signs and to the barrier they thereby erect in the path of understanding. A photograph of a woman shrugging her shoulders, palms turned upwards, elicits the conundrum: "Does this woman think it's raining? Or do you think it's all the same to her?" An earlier version of the work included the following story about consulting a palmist (a *Reader* and Advisor) in Albuquerque:

> *The odd thing about the reading was that everything she told me was totally wrong. She took my hand and said, "I see here by these lines that you are an only child . . ." (I have seven brothers and sisters) ". . . I read here that you love to fly . . ." (I'm totally terrified of planes) and so on. But she seemed so sure of this information that eventually I began to feel like I'd been walking around for years with these false documents permanently tattooed to my hands. It was very noisy in the house, family members kept walking in and out speaking a high clicking kind of language that sounded like Arabic. Books and magazines in Arabic were strewn all over the carpet. Suddenly I realized that maybe it was a translation problem—maybe she had been reading from right to left instead of left to right—and thinking of mirrors, I gave her my other hand. She didn't take it, but instead, held out her own hand. We sat there for a minute or two in what I assumed was some sort of strange participatory, invocatory ritual. Finally I realized that her hand was out because she was waiting . . . waiting for money.*

44. Karl Giehlow, "Die Hieroglyphenkunde . . . ," p. 127, quoted in Walter Benjamin, *German Tragic Drama*, p. 174.

45. Robert Smithson, "A Museum of Language in the Vicinity of Art," in *Writings of Robert Smithson*, p. 67. I discuss the centrality of this passage to Smithson's enterprise in my review, "Earthwords."

In this passage, which treats the metaphor of communication as economic exchange—the exchange of meaning balanced by an exchange of currency—Anderson proposes that the same "text" read backwards and forwards might engender antithetical meanings. It thus recalls her palindromes, which rarely read the same in both directions: in her *Song for Juanita*, the first syllable "Juan-" is reversed into "no," producing a rhythmic oscillation "no-one-no-one"; morphemes are thus revealed to contain the seed of their own contradiction.[46] Palindromes, puns, and "translation problems" recur throughout Anderson's works, allowing us to identify them as what Paul de Man, in his recent *Allegories of Reading*, calls "allegories of unreadability." De Man recognizes allegory as the structural interference of two distinct levels or usages of language, literal and rhetorical (metaphoric), one of which denies precisely what the other affirms. In most allegories a literal reading will "deconstruct" a metaphorical one; recalling medieval schemas of textual exegesis, de Man identifies such readings as tropological. Yet because literal language is itself rhetorical, the product of metaphoric substitutions and reversals, such readings are inevitably implicated in what they set out to expose, and the result is allegory:

> *The paradigm for all texts consists of a figure (or a system of figures) and its deconstruction. But since this model cannot be closed off by a final reading, it engenders, in its turn, a supplementary figural superposition which narrates the unreadability of the prior narration. As distinguished from primary deconstructive narratives centered on figures and ultimately always on metaphor, we can call such narratives to the second (or third) degree allegories. Allegorical narratives tell the story of the failure to read whereas tropological narratives . . . tell the story of the failure to denominate. The difference is only a difference in degree and the allegory does not erase the figure. Allegories are always allegories of metaphor and, as such, they are always allegories of the impossibility of reading—a sentence in which the genitive "of" has itself to be read as a metaphor.*[47]

De Man illustrates his thesis of allegorical illegibility with examples drawn from both literary and philosophical discourse (although allegory tends to blur this distinction), from Rilke and Proust to Rousseau and Nietzsche. The way in which attention to the incongruence of literal and figurative language upsets our presumed mastery of canonical texts is succinctly demonstrated in his introductory reading of Yeats' "Among School Children," which concludes with the famous line "How can we know the dancer from the dance?"—a line frequently quoted as testimony to the indissoluble unity of sign and meaning that characterizes the (symbolic) work of art. Yet this "meaning" hinges upon

46. Laurie Anderson, "Song for Juanita," *Airwaves* (record album), (New York: One Ten Records, 1977). Liner notes by the artist.

47. Paul de Man, *Allegories of Reading* (New Haven: Yale University Press, 1979), p. 205 (emphasis added).

reading the line as a rhetorical question, that is, as a rhetorical *statement* of their indissolubility. But what if we read it literally, de Man asks; and the result, not surprisingly, is allegory—the distance which separates signifier from signified, sign from meaning:

> *It is equally possible, however, to read the last line literally rather than figuratively, as asking with some urgency the question we asked earlier in the context of contemporary criticism: not that the sign and referent are so exquisitely fitted to each other that all difference between them is at times blotted out but, rather, since the two essentially different elements, sign and meaning, are so intricately intertwined in the imagined "presence" that the poem addresses, how can we possibly make the distinctions that would shelter us from the error of identifying what cannot be identified? The clumsiness of the paraphrase reveals that it is not necessarily the literal reading which is simpler than the figurative one . . .; here the figural reading, which assumes the question to be rhetorical, is perhaps naive, whereas the literal reading leads to greater complication of themes and statement. For it turns out that the entire schema set up by the first reading can be undermined, or deconstructed, in terms of the second, in which the final line is read literally as meaning that, since the dancer and the dance are not the same, it might be useful, perhaps even desperately necessary—for the question can be given a ring of urgency, "Please tell me, how can I know the dancer from the dance"—to tell them apart. But this will replace the reading of each symbolic detail by a divergent interpretation. . . . This hint should suffice to suggest that two entirely coherent but entirely incompatible readings can be made to hinge on one line, whose rhetorical mode turns the mood as well as the mode of the poem upside down. Neither can we say . . . that the poem simply has two meanings that exist side by side. The two readings have to engage each other in direct confrontation, for the one reading is precisely the error denounced by the other and has to be undone by it. Nor can we in any way make a valid decision as to which of the readings can be given priority over the other; none can exist in the other's absence. There can be no dance without a dancer, no sign without a referent. On the other hand, the authority of the meaning engendered by the grammatical structure is fully obscured by the duplicity of a figure that cries out for the differentiation that it conceals.*[48]

I have quoted this lengthy passage in full not only because it illuminates the structure of Laurie Anderson's art and allows us to identify it as allegorical, but also because it demonstrates that modernist texts such as Yeats' contain within themselves the seed of their own allegorization. Allegory can no longer be condemned as something merely appended to the work of art, for it is

48. Ibid., pp. 11-12.

revealed as a structural possibility inherent in every work. In modernism, however, the allegory remains *in potentia* and is actualized only in the activity of reading, which suggests that the allegorical impulse that characterizes post-modernism is a direct consequence of its preoccupation with reading. It is not surprising, then, that we should encounter Robert Rauschenberg, on the threshold of postmodernism, executing works which transform our experience of art from a visual to a textual encounter, and entitling these works *Obelisk, Rebus, Allegory.*

The displacement enacted by Rauschenberg's art was first acknowledged by Leo Steinberg, who identified it as a shift from nature to culture.[49] But Steinberg presumes the nature/culture opposition to be a stable one, a presup-position that postmodern artists—not to mention their poststructuralist counter-parts—are determined to subvert. In postmodernist art, nature is treated as wholly domesticated by culture; the "natural" can be approached only through its cultural representation. While this does indeed suggest a shift from nature to culture, what it in fact demonstrates is the impossibility of accepting their opposition. This is the point of an allegorical project by Sherrie Levine, who selected, mounted, and framed Andreas Feininger's photographs of natural subjects. When Levine wants an image of nature, she does not produce one herself but appropriates another image, and this she does in order to expose the degree to which "nature" is always already implicated in a system of cultural values which assigns it a specific, culturally determined position. In this way she reinflects Duchamp's readymade strategy, utilizing it as an unset-tling deconstructive instrument.

This reference to Duchamp suggests that the postmodernist "shift" should not be characterized as from nature to culture, but as a shift in elocu-tionary mode, from history to discourse, the terms which Émile Benveniste uses to distinguish between impersonal, third-person narration and direct address, which he associates with the personal pronouns *I* and *you.*[50] In her "Notes on the Index . . ." Rosalind Krauss demonstrates that this shift of pronominal emphasis is characteristic of all of Duchamp's work, and that it signals a "tremendous arbitrariness with regard to meaning, a breakdown of . . . the linguistic sign."[51] All of Duchamp's works read as messages addressed to the spectator—explicitly in *Anemic Cinema* and *Tu m'* and *To be Looked At (from the Other Side of the Glass) with One Eye, Close to, for Almost an Hour;*

49. Leo Steinberg, "Other Criteria," in *Other Criteria: Confrontations with Twen-tieth-Century Art* (New York: Oxford University Press, 1972), pp. 55-91.

50. Émile Benveniste, "Les relations de temps dans le verbe français," in *Problèmes de linguistique générale* (Paris: Editions Gallimard, 1966), pp. 237-250. There is an inter-esting application of Benveniste's distinction to film theory in Christian Metz, "Histoire/discours (Note sur deux voyeurismes)," in *Langue, discours, société, pour Émile Benveniste,* ed. Julia Kristeva et al. (Paris: Editions du Seuil, 1975), pp. 301-306; translated by Celia Britton and Annwyl Williams as "Story/Discourse (A Note on Two Kinds of Voyeurism)," in Christian Metz, *The Imaginary Signifier: Psychoanalysis and Cinema* (Bloomington: Indiana University Press, 1982), pp. 91-98.

51. Krauss, "Notes on the Index," p. 77.

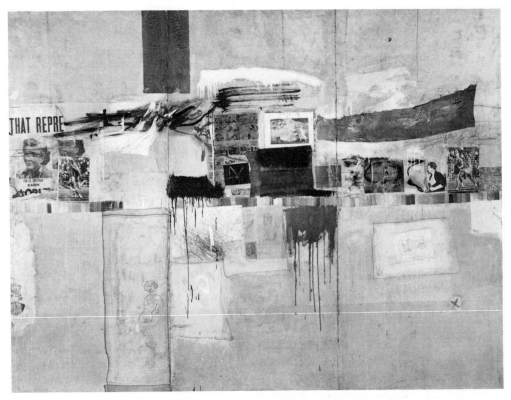

Robert Rauschenberg. *Rebus,* 1955. Combine painting: oil, pencil, paper, and fabric on canvas, 96 x 130½ x 1¾"
(243.8 x 331.5 x 4.5 cm). Collection Mr. and Mrs. Victor W. Ganz, New York. (Photo: courtesy Leo Castelli Gallery)

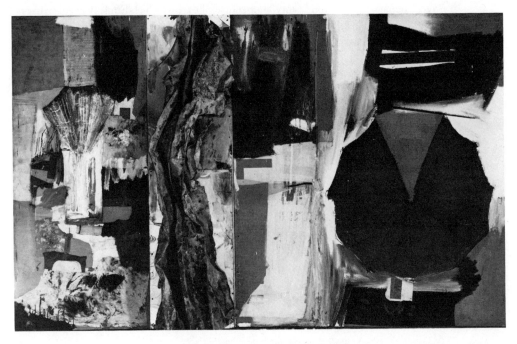

Robert Rauschenberg. *Allegory,* 1959–1960. Combine painting: oil, fabric, paper on canvas, plus buttons, mirror,
with metal, sand, and glue, 72¼ x 114½ x 11¾" (183.5 x 292.8 x 29.9 cm). Museum Ludwig, Cologne.
(Photo: Nationalmuseum, Stockholm; courtesy Leo Castelli Gallery)

implicitly in the readymades *Fountain* and *Trébuchet*[52]—and it should be re-membered that allegories are frequently exhortative, addressed to the reader in an attempt to manipulate him or to modify his behavior. It is on the basis of this shift to a discursive mode that a reading of what Duchamp himself iden-tified as the "allegorical appearance" of the *Large Glass*—itself an elaborate *psychomachia*—should proceed.

This shift from history to discourse, from a third- to a second-person mode of address, also accounts for the centrality which postmodernist art assigns to the reader/spectator;[53] significantly, Steinberg frequently refers to Rauschenberg's reorientation of the conventional picture field from a horizontal to a "flatbed" position as a form of "spectator modification." Krauss observed that Rauschenberg's art follows a discursive model by compelling a part-by-part, image-by-image reading that is temporal in character.[54] Yet it remains impossible to read a Rauschenberg, if by reading we mean the extraction from a text of a coherent, monological message. All attempts to decipher his works testify only to their own failure, for the fragmentary, piecemeal combination of images that initially impels reading is also what blocks it, erects an impenetrable barrier to its course. Rauschenberg thus confounds the attitude towards reading as an unproblematic activity—which persists, as we know, under the dubious banner "iconography" in art-critical and art-historical discourse, which are thereby paralyzed when confronted with his work, and with postmodernism in general—substituting for it something remarkably similar to Roland Barthes' "stereographic" view of the text:

A text is made of multiple writings, drawn from many cultures and entering into mutual relations of dialogue, parody, contestation, but there is one place where this multiplicity is focused and that place is the

52. In *Passages in Modern Sculpture*, Rosalind Krauss describes the readymades' interrogative structure: "The readymades became . . . part of Duchamp's project to make certain kinds of strategic moves—moves that would raise questions about what exactly is the nature of the work in the term 'work of art.' Clearly, one answer suggested by the ready-mades is that a work might not be a physical object but rather a question, and that the making of art might, therefore, be reconsidered as taking a perfectly legitimate form in the speculative act of posing questions" (New York: The Viking Press, 1977), pp. 72-73.

53. Consider Krauss' treatment, in *Passages*, of the emblem in abstract expressionism: "All these qualities—frontality, centralization, and literal size and surface—characterize the developed work of most of the abstract-expressionist painters; even those who, like Pollock and Newman, eventually dropped some of these emblematic features continued to work with the most central aspect of the sign or emblem. And that is its mode of address. For while we can think of a traditional picture or a photograph as creating a relationship between author and object that exists independent of an audience, addressing no one in particular, we must think of a sign or emblem as existing specifically in relation to a receiver. It takes the form of a directive addressed *to* someone, a directive that exists, so to speak, in the space of confron-tation between the sign or emblem and the one who views it" (pp. 150, 152). Like de Man's reading of "Among School Children," Krauss' passage suggests that abstract expressionist painting may indeed contain the seed of its own allegorization.

54. Rosalind Krauss, "Rauschenberg and the Materialized Image," *Artforum* 13, no. 4 (December 1974): 37.

reader, not, as was hitherto said, the author. The reader is the space on which all the quotations that make up a writing are inscribed without any of them being lost; a text's unity lies not in its origin but in its destination. Yet this destination can no longer be personal: the reader is without history, biography, psychology; he is simply that someone who holds together in a single field all the traces by which the written text is constituted.[55]

Here, then, is Rauschenberg's *Allegory*, a "combine painting" executed in 1959-60, exactly one year after the artist began his series of illustrations for *The Divine Comedy* (the project during which the transfer process characteristic of his subsequent work was "discovered"). Couched in its flatbed surface there is a random collection of heterogeneous objects: a red umbrella, stripped from its frame and splayed like a fan; rusted sheet metal, crumpled into a cascade of metallic drapery and mounted on mirrors; red block lettering, apparently from a broadside that has been ripped apart and dispersed; swatches of fabric; bits of clothing. It is difficult, if not impossible to discover in this inventory any common property that might coherently link these things, justify their bedding down together. The only metaphor that suggests itself is that of a dumping ground, and it is hardly a new one: with his customary precision of language, Steinberg described Rauschenberg's typical picture surface as "dump, reservoir, switching center." Krauss also characterizes Rauschenberg's art in terms of place: discussing the "equal density" which disparate images acquire in *Small Rebus*, she is "struck by the fact that the surface of this painting is a *place*, a *locale*, where this kind of equalization can happen."[56] Both Steinberg and Krauss describe the work in this way in order to analogize it to the human mind; Rauschenberg's works thus become allegories of consciousness or, perhaps, the unconscious.

Is this then what makes *Allegory* an allegory? By making works which read as *sites*, however, Rauschenberg also seems to be declaring the fragments embedded there to be beyond recuperation, redemption; this is where everything finally comes to rest. *Allegory* is thus also an emblem of mortality, of the inevitable dissolution and decay to which everything is subject. But can we in fact be certain that this is an allegorical image; might it not be an image of allegory itself, of the disrepute into which it has fallen? All three readings are correct, but only in part; if, however, we were to superimpose them then the work would become the narrative—the allegory—of its own fundamental illegibility.

In his essay "On the Museum's Ruins," Douglas Crimp proposes another locale suggested by Rauschenberg's art: the museum, the dumping grounds of culture.[57] If we accept for the moment—and I believe we must—this identifica-

55. Roland Barthes, "The Death of the Author," in *Image-Music-Text*, p. 148.

56. Krauss, "Rauschenberg," p. 41 (italics added).

57. Douglas Crimp, "On the Museum's Ruins," *October*, no. 13 (Summer 1980): 41–57. Reprinted in Hal Foster, ed., *The Anti-Aesthetic: Essays on Postmodern Culture* (Port Townsend, Wash.: Bay Press, 1983), pp. 43-56.

tion of Rauschenberg's works as "museum paintings," in the sense that Michel Foucault attributes to Manet—painting as "a manifestation of the existence of museums and the particular reality and interdependence that paintings acquire in museums"[58]—then it follows that they will acquire their fullest measure of significance only when seen *in situ*. Rauschenberg's art remains *in potentia* until it is seen in the museum, where it opens a dazzling *mise en abyme* reminiscent of Husserl's Dresden Gallery passage in *Ideas*:

> *A name on being mentioned reminds us of the Dresden Gallery and of our last visit there: we wander through the rooms, and stand before a picture of Teniers which represents a picture gallery. When we consider that pictures of the latter would in their turn portray pictures which on their part exhibited readable inscriptions and so forth, we can measure what interweaving of presentations, and what links of connexion between the discernible features in the series of pictures, can really be set up.*[59]

The illegibility of a Rauschenberg, however, works to deny the possibility of precisely such "links of connexion" as Husserl proposes, which hinge on the *readability* of the "inscriptions." There is no escape from this situation, no clear route back to the "reality" it purports to describe, as Jacques Derrida, in his Borgesian critique of this passage indicates: "The gallery is the labyrinth which includes in itself its own exits."[60] The acquisition of Rauschenberg's canvases by museums of modern art is thus their final, ironic triumph. They become that term in the series of works exhibited there that permits the allegorization of the entire series. But this triumph is ultimately an equivocal one, for in order to function as deconstructions of the discourse of the museum, of its claim to coherence, homogeneity—the ground of its alleged intel-legibility —they must also declare themselves to be part of the dumping ground they describe. They thus relapse into the "error" they denounce, and this is what allows us to identify them as allegorical.

What I am imputing to Rauschenberg, then, is a peculiar form of site-specificity: museum painting for the museum. This gesture is both economic and strategic, for if, in his works, Rauschenberg enacts a deconstruction of the museum, then his own deconstructive discourse—like Daniel Buren's—can take place only within the museum itself. It must therefore provisionally accept the terms and conditions it sets out to expose. This is of course the constraint to which any deconstructive discourse is subject, as the deconstructors themselves frequently remind us: Derrida, for example, speaks of the methodological

58. Michel Foucault, "Fantasia of the Library," in *Language, Counter-Memory, Practice*, ed. and trans. Donald F. Bouchard and Sherry Simon (Ithaca, N.Y.: Cornell University Press, 1977), p. 92.

59. Edmund Husserl, *Ideas*, trans. W. R. B. Gibson (New York: Collier, 1962), p. 270.

60. Jacques Derrida, *Speech and Phenomena*, trans. David B. Allison (Evanston, Ill.: Northwestern University Press, 1973), p. 104.

necessity of preserving as an instrument a concept whose truth value is being questioned. (Significantly, his example is Claude Lévi-Strauss' ethnographic discourse, which must utilize the nature/culture opposition even while rejecting it.[61]) There is thus a danger inherent in deconstruction: unable to avoid the very errors it exposes, it will continue to perform what it denounces as impossible and will, in the end, affirm what it set out to deny. Deconstructive discourses thus leave "a margin of error, a residue of logical tension" frequently seized upon by critics of deconstructionism as its failure. But this very failure is what raises the discourse, to use de Man's terminology, from a tropological to an allegorical level:

> *Deconstructive readings can point out the unwarranted identifications achieved by substitution, but they are powerless to prevent their recurrence even in their own discourse, and to uncross, so to speak, the aberrant exchanges that have taken place. Their gesture merely reiterates the rhetorical disfiguration that caused the error in the first place. They leave a margin of error, a residue of logical tension that prevents the closure of the deconstructive discourse and accounts for its narrative and allegorical mode.*[62]

Reading Rousseau's *Second Discourse* as the narrative of its own deconstruction, de Man concludes:

> *To the extent that it never ceases to advocate the necessity for political legislation and to elaborate the principles on which such a legislation could be based, it resorts to the principles of authority that it undermines. We know this structure to be characteristic of what we have called allegories of unreadability. Such an allegory is metafigural; it is an allegory of a figure (for example, metaphor) which relapses into the figure it deconstructs. The* Social Contract *falls under this heading to the extent that it is structured like an aporia: it persists in performing what it has shown to be impossible to do. As such, we can call it an allegory.*[63]

The "figure," then, deconstructed in Rauschenberg's work is that which proposes the substitution of the "heap of meaningless and valueless fragments of objects [contained within the museum] . . . either metonymically for the original objects or metaphorically for their representations."[64] Exposing this

61. Jacques Derrida, "Structure, Sign, and Play in the Discourse of the Human Sciences," in *Writing and Difference*, trans. Alan Bass (Chicago: University of Chicago Press, 1978), pp. 282–293.

62. De Man, *Allegories of Reading*, p. 242.

63. Ibid., p. 275.

64. Eugenio Donato. "The Museum's Furnace: Notes toward a Contextual Reading of *Bouvard and Pécuchet*," *Textual Strategies*, ed. Josué V. Harari (Ithaca, N.Y.: Cornell University Press, 1979), p. 223.

substitution to be impossible, Rauschenberg imputes the same impossibility to his own work, thereby opening it to criticism that it merely perpetuates the confusion it sets out to expose. Postmodernist art is frequently attacked on exactly this point; for example, it is said of Troy Brauntuch's reproductions of Hitler's drawings that, because they lack captions or identifying labels that might inform us of their origin, the work remains mute, meaningless. It is, however, precisely this opacity that Brauntuch sets out to demonstrate, and this is what enables us to identify his works as allegories. Whether or not we will ever acquire the key necessary to unlock their secret remains a matter of pure chance, and this gives Brauntuch's work an undeniable *pathos*, which is also the source of its strength.

Similarly, Robert Longo's work, which treats the aestheticization of violence in contemporary society, participates of necessity in the activity it denounces. In a recent series of aluminum reliefs, entitled *Boys Slow Dance* and generated from film stills, Longo presents three images of men locked in . . . deadly combat? amorous embrace? Like Anderson's parables, Longo's images resist ambiguity; they might, in fact, serve as emblems of that blind confrontation of antithetical meanings which characterizes the allegory of unreadability. Suspended in a static image, a struggle to the death is transformed into something that "has all the elegance of a dance." [65] Yet it is precisely this ambivalence that allows violence to be transformed into an aesthetic spectacle in photographs and films, and on television.

Longo's manipulation of film stills calls attention to the fact that, despite its suppression by modern theory—or perhaps because of it—allegory has never completely disappeared from our culture. Quite the contrary: it has renewed its (ancient) alliance with popular art forms, where its appeal continues undiminished. Throughout its history allegory has demonstrated a capacity for widespread popular appeal, suggesting that its function is social as well as aesthetic; this would account for its frequent appropriation for didactic and/or exhortative purposes. Just as Lévi-Strauss' structural (allegorical) analysis of myths reveals that the function of myth is to resolve the conflicts which confront primitive societies by maintaining them in paralogical suspension,[66] so too allegory may well be that mode which promises to resolve the contradictions which confront modern society—individual interest versus general well-being, for example—a promise which must, as we know, be perpetually deferred. The withdrawal of the modernist arts from allegory may thus be one factor in their ever-accelerating loss of audience.

65. Douglas Crimp, *Pictures* (New York: Artists Space, 1977), p. 26.

66. Claude Lévi-Strauss, "The Structural Study of Myth," in *Structural Anthropology*, trans. Claire Jacobson and B. G. Schoepf (New York: Basic Books, 1963), p. 229. Lévi-Strauss, however, seems to consider this suspension of contradiction to be perfectly logical: "The purpose of myth is to provide a logical model capable of overcoming a contradiction (an impossible achievement if, as it happens, the contradiction is real)." Rosalind Krauss, however, has properly described it as "para-logical" in "Grids," *October*, no. 9 (Summer 1979): 55. On the allegorical character of structuralist analysis, see Fineman, "Allegorical Desire."

The Western, the gangster saga, science fiction—these are the allegories of the twentieth century. They are also genres most intimately associated with film; that film should be the primary vehicle for modern allegory may be attributed not only to its unquestioned status as the most popular of contemporary art forms, but also to its mode of representation. Film composes narratives out of a succession of concrete images, which makes it particularly suited to allegory's essential pictogrammatism. Film is not, of course, the only medium to do so, as Barthes has indicated:

> There are other "arts" which combine still (or at least drawing) and story, diegesis—namely the photo-novel and the comic-strip. I am convinced that these "arts," born in the lower depths of high culture, possess theoretical qualifications and present a new signifier . . . This is acknowledged as regards the comic-strip but I myself experience this slight trauma of significance *faced with certain photo-novels:* "their stupidity touches me." . . . *There may thus be a future—or a very ancient past—truth in these derisory, vulgar, foolish, dialogical forms of consumer subculture.*[67]

Borges condemned allegory as "stupid and frivolous"; yet for Barthes its very stupidity functions as an index to its potential "truth." He goes on to designate a new object for aesthetic investigation: "And there is an autonomous 'art' (a 'text'), that of the *pictogram* ('anecdotalized' images, obtuse meanings placed in a diegetic space); this art taking across historically and culturally heteroclite productions: ethnographic pictograms, stained glass windows, Carpaccio's *Legend of Saint Ursula, images d'Epinal*, photo-novels, comic-strips."[68]

These remarks on the pictogram occur in a footnote to the essay "The Third Meaning: Research Notes on Some Eisenstein Stills," in which Barthes attempts to locate and define the specifically "filmic," which he discovers not in the movement of images, but in the still. Despite the essentialist undertones of this project, and whether or not we agree with Barthes' characterization of film as static in essence, or with his interpretation of Eisenstein's work, this essay remains extremely important because, in order to describe the still, Barthes elaborates a three-fold schema of interpretation highly reminiscent of the three- and four-fold schemas of medieval textual exegesis—a parallel of which Barthes himself is not unaware. This schema is necessitated by a description of the still in terms traditionally associated with allegory: it is a fragment, a quotation, and the meaning it engenders is supplementary, excessive, "parodic and disseminatory." An arbitrary cut, the still suspends not only motion but also story, diegesis; engendered by the syntagmatic disjunction of images, it compels a vertical or paradigmatic reading.

67. Roland Barthes, "The Third Meaning: Research Notes on Some Eisenstein Stills," in *Image-Music-Text*, p. 66n.

68. Ibid.

In Barthes' allegorical schema, the first level of meaning is informational, referential, to make its parallel with exegesis more apparent, *literal*. This is the level of anecdote, and it comprises setting, costume, characters, and their relations. It unproblematically assumes the reality of what it denotes, that is, that the sign is transparent to a referent. The second level is *symbolic*—Barthes calls it obvious, relating it to theology, in which, "we are told, the obvious meaning is that 'which presents itself quite naturally to the mind.' "[69] Significantly, Barthes describes this level in terms that allow us to identify it as *rhetorical:* "Eisenstein's 'art' is not polysemous, it chooses the meaning, imposes it, hammers it home. . . . The Eisensteinian meaning devastates ambiguity. How? By the addition of an aesthetic value, emphasis, Eisenstein's 'decorativism' has an economic function: it proffers the truth."[70] Rhetoric, which is always emphatic, is both decorative and persuasive, a system of tropes frequently employed in oratory to manipulate the listener, to incite him to action. All of the Eisenstein stills analyzed by Barthes function simultaneously on both rhetorical levels: a clandestinely clenched fist, for example, a metaphoric synecdoche for the proletariat, is meant to inspire revolutionary determination.

In contradistinction to the literal and rhetorical meanings, the third, or "obtuse" meaning is difficult to formulate; Barthes' description of it is elusive, vague:

> *The obtuse meaning is a signifier without a signified, hence the difficulty in naming it.* My reading remains suspended *between the image and its description, between definition and approximation. If the obtuse meaning cannot be described, that is because, in contrast to the obvious meaning, it does not copy anything—how do you describe something that does not represent anything?*[71]

Nevertheless, the third meaning, Barthes tells us, has "something to do" with disguise; he identifies it with isolated details of makeup and costume (which properly belong to the literal level) which, through excess, proclaim their own artifice. If Barthes refuses to assign such details a referent, he does accord them a function: they work to expose the image as *fiction*. Barthes' reluctance, even inability, to specify obtuse meaning cannot be considered an evasion, a ruse; it is a theoretical necessity. For as de Man observes:

> *What makes a fiction a fiction is not some polarity of fact and representation. Fiction has nothing to do with representation but is the absence of any link between utterance and a referent, regardless of whether this link be causal, encoded, or governed by any other conceivable relationship that could lend itself to systematization. In*

69. Ibid., p. 54.
70. Ibid., p. 56.
71. Ibid., p. 61, (emphasis added.)

fiction thus conceived the "necessary link" of the metaphor [of the symbol, we might add, recalling Coleridge] has been metonymized beyond the point of catachresis, and the fiction becomes the disruption of the narrative's referential illusion.[72]

The obtuse meaning differs not only in kind (since it refers to nothing, copies nothing, symbolizes nothing) from the literal and the symbolic; it is also *sited* differently: "Take away the obtuse meaning and communication and signification still remain, still circulate, still come through."[73] The *absence* of obtuse meaning is, in fact, the very condition of communication and signification, but its presence works to problematize these activities. Since the obtuse meaning has no objective, independent existence, it depends upon the literal and the rhetorical, which it nevertheless undoes. An unwelcome supplement, it exposes the literal level of the image to be a fiction, implicating it in the web of substitutions and reversals properly characteristic of the symbolic. The actor is revealed as the (metaphoric) substitute for character; his facial contortions, the emblem of grief, not its direct expression. Hence every image that participates in what photography criticism calls the directorial, as opposed to the documentary, mode is open to the intervention of obtuse meaning. And the symbolic dimension of the image, which depends upon the univocity of the literal, is thereby disfigured; erected upon an unstable base of substitutions and displacements, it becomes metafigural, the figure of a figure. The "necessary link" which characterized it as metaphoric is rendered contingent, "metonymized," as de Man has it. The projection of metaphor as metonymy is one of the fundamental strategies of allegory, and through it the symbolic is revealed for what it truly is—a rhetorical manipulation of metaphor which attempts to program response.

> *The presence of an obtuse, supplementary, third meaning . . . radically recasts the theoretical status of the anecdote: the story (the diegesis) is no longer just a strong system (the millennial system of narrative) but also and contradictorily a simple space, a field of permanences and permutations. It becomes that configuration, that stage, whose false limits multiply the signifier's permutational play, the vast trace which, by difference, compels . . . a* vertical *reading, that* false *order which permits the turning of the pure series, the aleatory combination (chance is crude, a signifier on the cheap) and the attainment of a structuration which slips away from the inside.*[74]

Insofar as Barthes claims that the third meaning is that in the image which is "purely image," and because he identifies it with the "free play" of the signifier, he is open to charges that he is merely reiterating, in semiological

72. De Man, *Allegories of Reading*, p. 292.
73. Barthes, "The Third Meaning," p. 60.
74. Ibid., p. 64.

jargon, aesthetic pleasure in the Kantian sense, delight in the form of a representation apart from the representation of any object whatsoever. And since the concept of a "signifier without a signified" presupposes that the referential function of language can, in fact, be suspended or bracketed, Barthes in fact repeats the postulate that lies at the base of every formalist aesthetic. The obtuse meaning does indeed appear reducible to the aesthetic; but I am interested in what motivates Barthes to insert it into the slot left vacant by the allegorical in an ancient interpretive scheme.

Barthes' interest in the theoretical value of the film still is paralleled today by several artists who derive their imagery from stills—Longo and James Birrell, who work to isolate that in the image which is purely image—or whose works deliberately resemble stills—Suzan Pitt's Disneyesque treatments of surrealism; Cindy Sherman's "untitled studies for film stills." These latter treat the subject of mimesis, not simply as an aesthetic activity, but as it functions in relation to the constitution of the self. Sherman's works are all self-portraits, but in them the artist invariably appears masked, disguised: she first costumes herself to resemble familiar female stereotypes—career girl, ingenue, sex object . . . —and then photographs herself in poses and settings reminiscent of the cinematic culture of the 1950s and 1960s. Her "characters" frequently glance anxiously outside the frame at some unspecified menace, thereby implying the presence of a narrative even while withholding it. This—the "still"—effect prevents us from mistaking Sherman's women for particular human subjects caught up in narrative webs of romance or intrigue (a reading which would correspond to Barthes' first, or literal level, which indicates the position of the image in the anecdote). Instead it compels a typological reading: Sherman's women are not women but images of women, specular models of femininity projected by the media to encourage imitation, identification; they are, in other words, tropes, figures. (In works which appropriate images of maternity from popular magazines, Sherrie Levine deals with the same rhetorical function of images: it is the picture which inspires imitation, mimesis, not the other way around.)

And yet the uncanny precision with which Sherman represents these tropes, the very perfection of her impersonations, leaves an unresolved margin of incongruity in which the image, freed from the constraints of referential and symbolic meaning, can accomplish its "work." That work is, of course, the deconstruction of the supposed innocence of the images of women projected by the media, and this Sherman accomplishes by *re*constructing those images so painstakingly, and identifying herself with them so thoroughly, that artist and role appear to have merged into a seamless whole in such a way that it seems impossible to distinguish the dancer from the dance. It is, however, the urgent necessity of making such a distinction that is, in fact, at issue.

For in Sherman's images, disguise functions as parody; it works to expose the identification of the self with an image as its dispossession, in a way that appears to proceed directly from Jacques Lacan's fundamental tenet that the self is an Imaginary construct, "and that this construct disappoints all [the subject's] certitudes. For in the labor with which he undertakes to reconstruct this construct *for another*, he finds again the fundamental alienation which has made him construct it *like another one*, and which has always destined it to be

(Above left) Roy Lichtenstein. *Seductive Girl,* 1964. Acrylic on canvas, 24 x 30" (61 x 76.2 cm). Collection William Zierler, New York. (Photo: courtesy Leo Castelli Gallery); (Top left) Hans Haacke. *The Right to Life (American Cyanamid),* 1979. Mounted and framed colored photograph and silkscreen, 50¼ x 40¼" (127.6 x 102.2 cm). Edition of two. Collection Allen Memorial Art Museum, Oberlin, Ohio. (Photo: courtesy John Weber Gallery); (Top right) Richard Prince. Untitled, 1980. Color photograph, one of three parts 20 x 24" (50.8 x 61 cm). (Photo: courtesy Metro Pictures); (Middle right) Richard Prince. Untitled (Laoura), 1982. Color photograph (C-print), 50 x 99" (127 x 251.5 cm). (Photo: courtesy Baskerville & Watson); (Bottom right) Cindy Sherman. *Untitled Film Still,* 1978. Black-and-white photograph, 10 x 8" (25.4 x 20.3 cm), and, *Untitled Film Still,* 1979. Black-and-white photograph, 8 x 10" (20.3 x 25.4 cm). (Photo: Louise Lawler, *Arranged by Carl Lobell at Weil, Gotshal, and Manges,* 1982)

stripped from him *by another.*"[75] (Significantly, in *The Four Fundamental Concepts of Psychoanalysis*, Lacan describes mimicry, mimesis, as the mechanism whereby the subject transforms himself into a picture.) By implicating the mass media as the false mirror which promotes such alienating identifications, Sherman registers this "truth" as both ethical and political.

But there is also an impossible complicity inscribed within Sherman's works, a complicity which accounts for their allegorical mode. For if mimicry is denounced in these images, it is nevertheless through mimetic strategies that this denunciation is made. We thus encounter once again the unavoidable necessity of participating in the very activity that is being denounced *precisely in order to denounce it.* All of the work discussed in this essay is marked by a similar complicity, which is the result of its fundamentally deconstructive impulse. This deconstructive impulse is characteristic of postmodernist art in general and must be distinguished from the self-critical tendency of modernism. Modernist theory presupposes that mimesis, the adequation of an image to a referent, can be bracketed or suspended, and that the art object itself can be substituted (metaphorically) for its referent. This is the rhetorical strategy of self-reference upon which modernism is based, and from Kant onwards it is identified as the source of aesthetic pleasure. For reasons that are beyond the scope of this essay, this fiction has become increasingly difficult to maintain. Postmodernism neither brackets nor suspends the referent but works instead to problematize the activity of reference. When the postmodernist work speaks of itself, it is no longer to proclaim its autonomy, its self-sufficiency, its transcendence; rather, it is to narrate its own contingency, insufficiency, lack of transcendence. It tells of a desire that must be perpetually frustrated, an ambition that must be perpetually deferred; as such, its deconstructive thrust is aimed not only against the contemporary myths that furnish its subject matter, but also against the symbolic, totalizing impulse which characterizes modernist art. As Barthes has written elsewhere:

> *It is no longer the myths which need to be unmasked (the doxa now takes care of that), it is the sign itself which must be shaken; the problem is not to reveal the (latent) meaning of an utterance, of a trait, of a narrative, but to fissure the very representation of meaning, is not to change or purify the symbols, but to challenge the symbolic itself.*[76]

75. Jacques Lacan, "The Function of Language in Psychoanalysis," in *The Language of the Self*, trans. Anthony Wilden (New York: Delta, 1975), p. 11.

76. Roland Barthes, "Change the Object Itself," in *Image-Music-Text*, p. 167.

V.

The Fictions of Mass Media

Steven Spielberg.
Still from *Close
Encounters of the
Third Kind,* 1977.
Color film, sound,
35mm, 139 minutes

Stanley Kubrick. Still
from *2001: A Space
Odyssey,* 1968. Color
film, sound, 35mm,
135 minutes

Fritz Lang. Still from
Metropolis, 1926.
Black-and-white film,
silent, 35mm, 120
minutes

Progress Versus Utopia;
or, Can We Imagine the Future?

FREDRIC JAMESON

It will then turn out that the world has long dreamt of that of which it had only to have a clear idea to possess it really.

Karl Marx to Arnold Ruge, 1843

A storm is blowing from Paradise; it has got caught in his wings with such violence that the angel can no longer close them. The storm irresistibly propels him into the future to which his back is turned, while the pile of debris before him grows skyward. This storm is what we call progress.

Walter Benjamin, *Theses on the Philosophy of History*, 1939

What if the "idea" of progress were not an idea at all but rather the symptom of something else? This is the perspective suggested, not merely by the interrogation of cultural texts, such as science fiction, but by the contemporary discovery of the Symbolic in general. Indeed, following the emergence of psychoanalysis, of structuralism in linguistics and anthropology, of semiotics together with its new field of "narratology," of communications theory, and even of such events as the emergence of a politics of "surplus consciousness" (Rudolf Bahro) in the 1960s, we have come to feel that abstract ideas and concepts are not necessarily intelligible entities in their own right. This was of course already the thrust of Marx's discovery of the dynamics of ideology; but while the older terms in which that discovery was traditionally formulated–"false consciousness" versus "science"–remain generally true, the Marxian approach to ideology, itself fed by all the discoveries enumerated above, has also become a far more sophisticated and non-reductive form of analysis than the classical opposition tends to suggest.

From the older standpoint of a traditional "history of ideas," however, ideology was essentially grasped as so many *opinions* vehiculated by a narrative text such as a science-fiction novel, from which, as Lionel Trilling once put it, like so many raisins and currants they are picked out and exhibited in isolation. Thus Jules Verne is thought to have "believed" in progress,[1] while the originality of H. G. Wells was to have entertained an ambivalent and agonizing

Reprinted from *Science-Fiction Studies* 9, no. 2 (July 1982): 147-158.
1. See, on Jules Verne, Pierre Macherey's stimulating chapter in *For a Theory of Literary Production*, trans. Geoffrey Wall (London: Routledge & Kegan Paul, 1978).

love-hate relationship with this "value," now affirmed and now denounced in the course of his complex artistic trajectory.[2]

The discovery of the Symbolic, however, suggests that for the individual subject as well as for groups, collectivities, and social classes, abstract opinion is but a symptom or an index of some vaster *pensée sauvage* about history itself, whether personal or collective. This thinking, in which a particular conceptual enunciation such as the "idea" of progress finds its structural intelligibility, may be said to be of a more properly *narrative* kind, analogous in that respect to the constitutive role played by master-fantasies in the Freudian model of the Unconscious. Nevertheless, the analogy is misleading to the degree to which it may awaken older attitudes about objective truth and subjective or psychological "projection," which are explicitly overcome and transcended by the notion of the Symbolic itself. In other words, we must resist the reflex which concludes that the narrative fantasies which a collectivity entertains about its past and its future are "merely" mythical, archetypal, and projective, as opposed to "concepts" like progress or cyclical return, which can somehow be tested for their objective or even scientific validity. This reflex is itself the last symptom of that dissociation of the private and the public, the subject and the object, the personal and the political, which has characterized the social life of capitalism. A theory of some narrative *pensée sauvage*—what I have elsewhere termed the political unconscious[3]—will, on the contrary, want to affirm the epistemological priority of such "fantasy" in theory and praxis alike.

The task of such analysis would then be to detect and to reveal—behind such written *traces* of the political unconscious as the narrative texts of high or mass culture, but also behind those other symptoms or traces which are opinion, ideology, and even philosophical systems—the outlines of some deeper and vaster narrative movement in which the groups of a given collectivity at a certain historical conjuncture anxiously interrogate their fate, and explore it with hope or dread. Yet the nature of this vaster collective subtext, with its specific structural limits and permutations, will be registered above all in terms of properly narrative categories: closure, recontainment, the production of episodes, and the like. Once again, a crude analogy with the dynamics of the individual unconscious may be useful. Proust's restriction to the windless, cork-lined room, for instance, the emblematic eclipse of his own possible relationships to any concrete personal or historical future, determines the formal innovations and wondrous structural subterfuges of his now exclusively retrospective narrative production. Yet such narrative categories are themselves fraught with contradiction: in order for narrative to project some sense of a totality of experience in space and time, it must surely know some closure (a

2. The literature on H. G. Wells is enormous: for an introduction and select bibliography, see Darko Suvin, *Metamorphoses of Science Fiction* (New Haven: Yale University Press, 1979). This work is a pioneering theoretical and structural analysis of the genre, to which I owe a great deal.

3. See Fredric Jameson, *The Political Unconscious* (Ithaca, N.Y.: Cornell University Press, 1981).

narrative must have an ending, even if it is ingeniously organized around the structural repression of endings as such). At the same time, however, closure or the narrative ending is the mark of that boundary or limit beyond which thought cannot go. The merit of science fiction is to dramatize this contradiction on the level of plot itself, since the vision of future history cannot know any punctual ending of this kind, at the same time that its novelistic expression demands some such ending. Thus Isaac Asimov has consistently refused to complete or terminate his *Foundation* series; while the most obvious ways in which a science-fiction novel can wrap its story up—as in an atomic explosion that destroys the universe, or the static image of some future totalitarian world-state—are also clearly the places in which our own ideological limits are the most surely inscribed.

It will, I trust, already have become clear that this ultimate "text" or object of study—the master-narratives of the political unconscious—is a *construct*: it exists nowhere in "empirical" form, and therefore must be re-constructed on the basis of empirical "texts" of all sorts, in much the same way that the master-fantasies of the individual unconscious are reconstructed through the fragmentary and symptomatic "texts" of dreams, values, behavior, verbal free-association, and the like. This is to say that we must necessarily make a place for the formal and textual *mediations* through which such deeper narratives find a partial articulation. No serious literary critic today would suggest that content—whether social or psychoanalytic—inscribes itself immediately and transparently on the works of "high" literature: instead, the latter find themselves inserted in a complex and semi-autonomous dynamic of their own—the history of forms—which has its own logic and whose relationship to content per se is necessarily mediated, complex, and indirect (and takes very different structural paths at different moments of formal as well as social development). It is perhaps less widely accepted that the forms and texts of mass culture are fully as mediated as this: and that here too, collective and political fantasies do not find some simple transparent expression in this or that film or TV show. It would in my opinion be a mistake to make the "apologia" for science fiction in terms of specifically "high" literary values—to try, in other words, to recuperate this or that major text as exceptional, in much the same way as some literary critics have tried to recuperate Dashiell Hammett or Raymond Chandler for the lineage of Dostoyevsky, say, or Faulkner. Science fiction is a sub-genre with a complex and interesting formal history of its own, and with its own dynamic, which is not that of high culture, but which stands in a complementary and dialectical relationship to high culture or modernism as such. We must therefore first make a detour through the dynamics of this specific form, with a view to grasping its emergence as a formal and historical event.

1. Whatever its illustrious precursors, it is a commonplace of the history of science fiction that it emerged, virtually full-blown, with Jules Verne and H. G. Wells, during the second half of the nineteenth century, a period also characterized by the production of a host of utopias of a more classical type. It

would seem appropriate to register this generic emergence as the symptom of a mutation in our relationship to historical time itself: but this is a more complex proposition than it may seem, and demands to be argued in a more theoretical way.

I will suggest that the model for this kind of analysis, which grasps an entire genre as a symptom and reflex of historical change, may be found in Georg Lukács' classical study, *The Historical Novel* (1936). Lukács began with an observation that should not have been particularly surprising; it was no accident, he said, that the period which knew the emergence of historical thinking, of historicism in its peculiarly modern sense—the late eighteenth and early nineteenth century—should also have witnessed, in the work of Sir Walter Scott, the emergence of a narrative form peculiarly restructured to express that new consciousness. Just as modern historical consciousness was preceded by other, for us now archaic, forms of historiography—the chronicle or the annals—so the historical novel in its modern sense was certainly preceded by literary works which evoked the past and recreated historical settings of one kind or another: the history plays of Shakespeare or Corneille, *La Princesse de Clèves*, even Arthurian romance: yet all these works in their various ways affirm the past as being essentially the same as the present, and do not yet confront the great discovery of the modern historical sensibility, that the past, the various pasts, are culturally original, and radically distinct from our own experience of the object-world of the present. That discovery may now be seen as part of what may in the largest sense be called the *bourgeois cultural revolution*, the process whereby the definitive establishment of a properly capitalist mode of production as it were reprograms and utterly restructures the values, life rhythms, cultural habits, and temporal sense of its subjects. Capitalism demands in this sense a different experience of temporality from that which was appropriate to a feudal or tribal system, to the polis or to the forbidden city of the sacred despot: it demands a *memory* of qualitative social change, a concrete vision of the past which we may expect to find completed by that far more abstract and empty conception of some future terminus which we sometimes call "progress." Sir Walter Scott can in retrospect be seen to have been uniquely positioned for the creative opening of literary and narrative form to this new experience: on the very meeting place between two modes of production, the commercial activity of the Lowlands and the archaic, virtually tribal system of the surviving Highlanders, he is able to take a distanced and marginal view of the emergent dynamics of capitalism in the neighboring nation-state from the vantage point of a national experience—that of Scotland—which was the last arrival to capitalism and the first semi-peripheral zone of a foreign capitalism all at once.[4]

What is original about Lukács' book is not merely this sense of the historical meaning of the emergence of this new genre, but also and above all a more difficult perception: namely, of the profound historicity of the genre itself, its increasing incapacity to register its content, the way in which, with

4. An important discussion of Scotland's unique place in the development of capitalism can be found in Tom Nairn, *The Break-Up of Britain* (London: New Left Books, 1977).

Flaubert's *Salammbô* in the mid-nineteenth century, it becomes emptied of its vitality and survives as a dead form, a museum piece, as "archeological" as its own raw materials, yet resplendent with technical virtuosity. A contemporary example may dramatize this curious destiny: Stanley Kubrick's *Barry Lyndon*, with its remarkable reconstruction of a whole, vanished eighteenth-century past. The paradox, the historical mystery of the devitalization of form, will be felt by those for whom this film, with its brilliant images and extraordinary acting, is somehow profoundly *gratuitous*, an object floating in the void which could just as easily not have existed, its technical intensities far too great for any merely formal exercise, yet somehow profoundly and disturbingly unmotivated. This is to say something rather different from impugning the content of the Kubrick film: it would be easy to imagine any number of discussions of the vivid picture of eighteenth-century war, for example, or of the grisly instrumentality of human relationships, which might establish the relevance and the claims of this narrative on us today. It is rather the relationship to the past which is at issue, and the feeling that any other moment of the past would have done just as well. The sense that this determinate moment of history is, of organic necessity, precursor to the present has vanished into the pluralism of the Imaginary Museum, the wealth and endless variety of culturally or temporally distinct forms, all of which are now rigorously equivalent. Flaubert's Carthage and Kubrick's eighteenth century, but also the industrial turn of the century or the nostalgic 1930s or 1950s of the American experience, find themselves emptied of their necessity, and reduced to pretexts for so many glossy images. In its (post-) contemporary form, this replacement of the historical by the nostalgic, this volatilization of what was once a *national* past, in the moment of emergence of the nation-states and of nationalism itself, is of course at one with the disappearance of historicity from consumer society today, with its rapid media exhaustion of yesterday's events and of the day-before-yesterday's star players (who was Hitler anyway? who was Kennedy? who, finally, was Nixon?).

The moment of Flaubert, which Lukács saw as the beginning of this process, and the moment in which the historical novel as a genre ceases to be functional, is also the moment of the emergence of science fiction, with the first novels of Jules Verne. We are therefore entitled to complete Lukács' account of the historical novel with the counter-panel of its opposite number, the emergence of the new genre of science fiction as a form which now registers some nascent sense of the future, and does so in the space on which a sense of the past had once been inscribed. It is time to examine more closely the seemingly transparent ways in which science fiction registers fantasies about the future.

2. The common-sense position on the anticipatory nature of science fiction as a genre is what we would today call a *representational* one. These narratives are evidently for the most part not modernizing, not reflexive and self-undermining and deconstructing affairs. They go about their business with the full baggage and paraphernalia of a conventional realism, with this one difference:

that the full "presence"—the settings and actions to be "rendered"—are the merely possible and conceivable ones of a near or far future. Whence the canonical defense of the genre: in a moment in which technological change has reached a dizzying tempo, in which so-called "future shock" is a daily experience, such narratives have the social function of accustoming their readers to rapid innovation, of preparing our consciousness and our habits for the otherwise demoralizing impact of change itself. They train our organisms to expect the unexpected and thereby insulate us, in much the same way that, for Walter Benjamin, the big city modernism of Baudelaire provided an elaborate shock-absorbing mechanism for the otherwise bewildered visitor to the new world of the great nineteenth-century industrial city.

If I cannot accept this account of science fiction, it is at least in part because it seems to me that, for all kinds of reasons, we no longer entertain such visions of wonder-working, properly "science fiction" futures of technological automation. These visions are themselves now historical and dated—streamlined cities of the future on peeling murals—while our lived experience of our greatest metropolises is one of urban decay and blight. That particular utopian future has in other words turned out to have been merely the future of one moment of what is now our own past. Yet, even if this is the case, it might at best signal a transformation in the historical function of present-day science fiction.

In reality, the relationship of this form of representation, this specific narrative apparatus, to its ostensible content—the future—has always been more complex than this. For the apparent realism, or representationality, of science fiction has concealed another, far more complex temporal structure: not to give us "images" of the future—whatever such images might mean for a reader who will necessarily predecease their "materialization"—but rather to defamiliarize and restructure our experience of our own *present*, and to do so in specific ways distinct from all other forms of defamiliarization. From the great intergalactic empires of an Asimov, or the devastated and sterile Earth of the post-catastrophe novels of a John Wyndham, all the way back in time to the nearer future of the organ banks and space miners of a Larry Niven, or the conapts, auto-fabs, or psycho-suitcases of the universe of Philip K. Dick, all such apparently full representations function in a process of distraction and displacement, repression and lateral perceptual renewal, which has its analogies in other forms of contemporary culture. Proust was only the most monumental "high" literary expression of this discovery: that the present—in this society, and in the physical and psychic dissociation of the human subjects who inhabit it—is inaccessible directly, is numb, habituated, empty of affect. Elaborate strategies of indirection are therefore necessary if we are somehow to break through our monadic insulation and to "experience," for some first and real time, this "present," which is (after all) all we have. In Proust, the retrospective fiction of memory and rewriting after the fact is mobilized in order for the intensity of a now merely remembered present to be experienced in some time-released and utterly unexpected posthumous actuality.

Elsewhere, with reference to another sub-genre or mass-cultural form, the detective story, I have tried to show that at its most original, in writers like

Raymond Chandler, the ostensible plots of this peculiar form have an analogous function.[5] What interested Chandler was the here-and-now of the daily experience of the now historical Los Angeles: the stucco dwellings, cracked sidewalks, tarnished sunlight, and roadsters in which the curiously isolated yet typical specimens of an unimaginable, Southern-Californian social flora and fauna ride in the monadic half-light of their dashboards. Chandler's problem was that his readers—ourselves—desperately needed not to see that reality: humankind, as T. S. Eliot's magical bird sang, is able to bear very little of the unmediated, unfiltered experience of the daily life of capitalism. So, by a dialectical sleight-of-hand, Chandler formally mobilized an "entertainment" genre to distract us in a very special sense: not from the real life of private and public worries in general, but very precisely from our own defense mechanisms against that reality. The excitement of the mystery story plot is, then, a blind, fixing our attention on its own ostensible but in reality quite trivial puzzles and suspense, in such a way that the intolerable space of Southern California can enter the eye laterally, with its intensity undiminished.

It is an analogous strategy of indirection that science fiction now brings to bear on the ultimate object and ground of all human life, History itself. How to fix this intolerable present of history with the naked eye? We have seen that in the moment of the emergence of capitalism the present could be intensified, and prepared for individual perception, by the construction of a historical past from which as a process it could be felt to issue slowly forth, like the growth of an organism. But today the past is dead, transformed into a packet of well-worn and thumbed glossy images. As for the future, which may still be alive in some small heroic collectivities on the Earth's surface, it is for us either irrelevant or unthinkable. Let the Wagnerian and Spenglerian world dissolutions of J. G. Ballard stand as exemplary illustrations of the ways in which the imagination of a dying class—in this case the canceled future of a vanished colonial and imperial destiny—seeks to intoxicate itself with images of death that range from the destruction of the world by fire, water, and ice to lengthening sleep or the berserk orgies of high-rise buildings or superhighways reverting to barbarism.

Ballard's work—so rich and corrupt—testifies powerfully to the contradictions of a properly representational attempt to grasp the future directly. I would argue, however, that the most characteristic science fiction does not seriously attempt to imagine the "real" future of our social system. Rather, its multiple mock futures serve the quite different function of transforming our own present into the determinate past of something yet to come. It is this present moment—unavailable to us for contemplation in its own right because the sheer quantitative immensity of objects and individual lives it comprises is untotalizable and hence unimaginable, and also because it is occluded by the density of our private fantasies as well as of the proliferating stereotypes of a media culture that penetrates every remote zone of our existence—that upon our return from the imaginary constructs of science fiction is offered to us in the form of some

5. Fredric Jameson, "On Raymond Chandler," *Southern Review* 6, no. 3 (Summer 1970): 624-650.

future world's remote past, as if posthumous and as though collectively remembered. Nor is this only an exercise in historical melancholy: there is, indeed, something also at least vaguely comforting and reassuring in the renewed sense that the great supermarkets and shopping centers, the garish fast-food stores and ever more swiftly remodeled shops and store-front businesses of the near-future of Chandler's Los Angeles, the burnt-out-center cities of small mid-Western towns, nay even the Pentagon itself and the vast underground networks of rocket-launching pads in the picture postcard isolation of once-characteristic North American "natural" splendor, along with the already cracked and crumbling futuristic architecture of newly built atomic power plants—that all these things are not seized, immobile forever, in some "end of history," but move steadily in time towards some unimaginable yet inevitable "real" future. Science fiction thus enacts and enables a structurally unique "method" for apprehending the present as history, and this is so irrespective of the "pessimism" or "optimism" of the imaginary future world which is the pretext for that defamiliarization. The present is in fact no less a past if its destination proves to be the technological marvels of Verne or, on the contrary, the shabby and maimed automata of P. K. Dick's near-future.

We must therefore now return to the relationship of science fiction and future history and reverse the stereotypical description of this genre: what is indeed authentic about it, as a mode of narrative and a form of knowledge, is not at all its capacity to keep the future alive, even in imagination. On the contrary, its deepest vocation is over and over again to demonstrate and to dramatize our incapacity to imagine the future, to body forth, through apparently full representations which prove on closer inspection to be structurally and constitutively impoverished, the atrophy in our time of what Marcuse has called the *utopian imagination*, the imagination of otherness and radical difference; to succeed by failure, and to serve as unwitting and even unwilling vehicles for a meditation, which, setting forth for the unknown, finds itself irrevocably mired in the all-too-familiar, and thereby becomes unexpectedly transformed into a contemplation of our own absolute limits.

This is indeed (since I have pronounced the word) the unexpected rediscovery of the nature of utopia as a genre in our own time.[6] The overt utopian text or discourse has been seen as a sub-variety of science fiction in general. What is paradoxical is that at the very moment in which utopias were supposed to have come to an end, and in which that asphyxiation of the utopian impulse alluded to above is everywhere more and more tangible, science fiction has in recent years rediscovered its own utopian vocation, and given rise to a whole series of powerful new works—utopian and science fiction all at once—of which Ursula Le Guin's *The Dispossessed*, Joanna Russ' *The Female Man*, Marge Piercy's *Woman on the Edge of Time*, and Samuel Delany's *Triton* are only

6. A fuller discussion of these propositions and some closer analyses of More's *Utopia* in particular, will be found in my review of Louis Marin's *Utopiques*, "Of Islands and Trenches," *diacritics* 7, no. 2 (Summer 1977): 2-21. See also the related discussion in my "World Reduction in Le Guin: The Emergence of Utopian Narrative," *Science-Fiction Studies* 2, no. 3 (November 1975): 221-230.

the most remarkable monuments. A few final remarks are necessary, therefore, on the proper use of these texts, and the ways in which their relationship to social history is to be interrogated and decoded.

3. After what has been said about science fiction in general, the related proposition on the nature and the political function of the utopian genre will come as no particular surprise: namely, that its deepest vocation is to bring home, in local and determinate ways, and with a fullness of concrete detail, our constitutional inability to imagine utopia itself, and this, not owing to any individual failure of imagination but as the result of the systemic, cultural, and ideological closure of which we are all in one way or another prisoners. This proposition, however, now needs to be demonstrated in a more concrete analytical way, with reference to the texts themselves.

It is fitting that such a demonstration should take as its occasion not American science fiction, whose affinities with the dystopia rather than the utopia, with fantasies of cyclical regression or totalitarian empires of the future, have until recently been marked (for all the obvious political reasons); but rather Soviet science fiction, whose dignity as a "high" literary genre and whose social functionality within a socialist system have been, in contrast, equally predictable and no less ideological. The renewal of the twin Soviet traditions of utopia and science fiction may very precisely be dated from the publication of Ivan Efremov's *Andromeda* (1958), and from the ensuing public debate over a work which surely, for all its naiveté, is one of the most single-minded and extreme attempts to produce a full representation of a future, classless, harmonious, world-wide utopian society. We may measure our own resistance to the utopian impulse by means of the boredom the sophisticated American reader instinctively feels for Efremov's culturally alien "libidinal apparatus":

> '*We began,*' *continued the beautiful historian,* '*with the complete redistribution of Earth's surface into dwelling and industrial zones.*
>
> '*The brown stripes running between thirty and forty degrees of North and South latitude represent an unbroken chain of urban settlements built on the shores of warm seas with a mild climate and no winters. Mankind no longer spends huge quantities of energy warming houses in winter and making himself clumsy clothing. The greatest concentration of people is around the cradle of human civilization, the Mediterranean Sea. The subtropical belt was doubled in breadth after the ice on the polar caps had melted. To the north of the zone of habitation lie prairies and meadows where countless herds of domestic animals graze. . . .*
>
> '*One of man's greatest pleasures is travel, an urge to move from place to place that we have inherited from our distant forefathers, the wandering hunters and gatherers of scanty food. Today the entire planet is encircled by the Spiral Way whose gigantic bridges link all the continents. . . . Electric trains move along the Spiral Way all the time*

and hundreds of thousands of people can leave the inhabited zone very speedily for the prairies, open fields, mountains or forests.'[7]

The question one must address to such a work—the analytical way into the utopian text in general from Thomas More all the way down to this historically significant Soviet novel—turns on the status of the *negative* in what is given as an effort to imagine a world without negativity. The repression of the negative, the place of that repression, will then allow us to formulate the essential contradiction of such texts, which we have expressed in a more abstract fashion above, as the dialectical reversal of intent, the inversion of representation, the "ruse of history" whereby the effort to imagine utopia ends up betraying the impossibility of doing so. The content of such repressed "semes" of negativity will then serve as an indicator of the ways in which a narrative's contradiction or antinomy is to be formulated and reconstructed.

Efremov's novel is predictably enough organized around the most obvious dilemma the negative poses for a utopian vision: namely, the irreducible fact of death. But equally characteristically, the anxiety of individual death is here "recontained" as a collective destiny, the loss of the starship *Parvus*, easily assimilable to a whole rhetoric of collective sacrifice in the service of mankind. I would suggest that this facile *topos* functions to displace two other, more acute and disturbing, forms of negativity. One is the emotional fatigue and deep psychic depression of the administrator Darr Veter, "cured" by a period of physical labor in the isolation of an ocean laboratory; the other is the *hubris* and crime of his successor, Mven Mass, whose personal involvement with an ambitious new energy program results in a catastrophic accident and loss of life. Mven Mass is "rehabilitated" after a stay on "the island of oblivion," a kind of idyllic Ceylonese Gulag on which deviants and anti-socials are released to work out their salvation in any way they choose. We will say that these two episodes are the nodal points or symptoms at which the deeper contradictions of the *psychiatric* and the *penal*, respectively, interrupt the narrative functioning of the Soviet utopian imagination. Nor is it any accident that these narrative symptoms take spatial and geographical form. Already in Thomas More, the imagining of Utopia is constitutively related to the possibility of establishing some spatial *closure* (the digging of the great trench which turns "Utopia" into a self-contained island).[8] The lonely oceanographic station and the penal island thus mark the return of devices of spatial closure and separation which, formally required for the establishment of some "pure" and positive utopian space, thus always tend to betray the ultimate contradictions in the production of utopian figures and narratives.

Other people's ideologies always being more "self-evident" than our own, it is not hard to grasp the ideological function of this kind of non-conflictual utopia in a Soviet Union in which, according to Stalin's canonical formula, class struggle was at the moment of "socialism" supposed to have come to an

7. Ivan Efremov, *Andromeda: A Space-Tale*, trans. George Hanna (Moscow: Foreign Languages Publishing House, 1959), pp. 54-55.

8. Compare Jameson, "Of Islands and Trenches."

end. Is it necessary to add that no intelligent Marxist today can believe such a thing, and that the process of class struggle is if anything exacerbated precisely in the moment of socialist construction, with its "primacy of the political"? I will nevertheless complicate this diagnosis with the suggestion that what is ideological for the Soviet reader may well be utopian for us. We may indeed want to take into account the possibility that alongside the obvious qualitative differences between our own First World culture (with its dialectic of modernism and mass culture) and that of the Third World, we may want to make a place for a specific and original culture of the Second World, whose artifacts (generally in the form of Soviet and East European novels and films) have generally produced the unformulated and disquieting impression on the Western reader or spectator of a simplicity indistinguishable from naive sentimentalism. Such a renewed confrontation with Second World culture would have to take into account something it is hard for us to remember within the ahistorical closure of our own *"société de consommation"*: the radical strangeness and freshness of human existence and of its object world in a non-commodity atmosphere, in a space from which that prodigious saturation of messages, advertisements, and packaged libidinal fantasies of all kinds, which characterizes our own daily experience, is suddenly and unexpectedly stilled. We receive this culture with all the perplexed exasperation of the city dweller condemned to insomnia by the oppressive silence of the countryside at night; for us, then, it can serve the defamiliarizing function of those wondrous words which William Morris inscribed under the title of his own great utopia, "an epoch of rest."

All of this can be said in another way by showing that, if Soviet images of utopia are ideological, our own characteristically Western images of *dystopia* are no less so, and fraught with equally virulent contradictions.[9] George Orwell's classical and virtually inaugural work in this sub-genre, *1984*, can serve as a textbook exhibit for this proposition, even if we leave aside its more obviously pathological features. Orwell's novel, indeed, set out explicitly to dramatize the tyrannical omnipotence of a bureaucratic elite, with its perfected and omnipresent technological control. Yet the narrative, seeking to reinforce this already oppressive closure, subsequently overstates its case in a manner which specifically undermines its first ideological proposition. For, drawing on another topos of counterrevolutionary ideology, Orwell then sets out to show how, without freedom of thought, no science or scientific progress is possible, a thesis vividly reinforced by images of squalor and decaying buildings. The contradiction lies of course in the logical impossibility of reconciling these two propositions: if science and technological mastery are now hampered by the lack of freedom, the absolute technological power of the dystopian bureaucracy vanishes along with it and "totalitarianism" ceases to be a dystopia in Orwell's sense. Or the reverse: if these Stalinist masters dispose of some perfected scientific and technological power, then genuine freedom of inquiry must exist

9. In other words, to adapt Claudel's favorite proverb, "Le pire n'est pas toujours sur, non plus!"

somewhere within this state, which was precisely what was not to have been demonstrated.

4. The thesis concerning the structural impossibility of utopian representation outlined above now suggests some unexpected consequences in the aesthetic realm. It is by now, I hope, a commonplace that the very thrust of literary modernism—with its *public introuvable* and the breakdown of traditional cultural institutions, in particular the social "contract" between writer and reader—has had as one significant structural consequence the transformation of the cultural text into an *auto-referential* discourse, whose content is a perpetual interrogation of its own conditions of possibility.[10] We may now show that this is no less the case with the utopian text. Indeed, in the light of everything that has been said, it will not be surprising to discover that as the true vocation of the utopian narrative begins to rise to the surface—to confront us with our incapacity to imagine Utopia—the center of gravity of such narratives shifts towards an auto-referentiality of a specific, but far more concrete type: such texts then explicitly or implicitly, and as it were against their own will, find their deepest "subjects" in the possibility of their own production, in the interrogation of the dilemmas involved in their own emergence as utopian texts.

Ursula Le Guin's only "contemporary" science fiction novel, the underrated *Lathe of Heaven* (1971), may serve as documentation for this more general proposition. In this novel, which establishes Le Guin's home city of Portland, Oregon, alongside Berkeley and Los Angeles, as one of the legendary spaces of contemporary science fiction, a hapless young man finds himself tormented by the unwanted power to dream "effective dreams," those which in other words change external reality itself, and reconstruct the latter's historical past in such a way that the previous "reality" disappears without a trace. He places himself in the hands of an ambitious psychiatrist, who then sets out to use his enormous proxy power to change the world for the benefit of mankind. But reality is a seamless web: change one detail and unexpected, sometimes monstrous transformations occur in other, apparently unrelated zones of life, as in the classical time-travel stories where one contemporary artifact, left behind by accident in a trip to the Jurassic age, transforms human history like a thunderclap. The other archetypal reference is the dialectic of "wishes" in fairy tales, where one gratification is accompanied with a most unwanted secondary effect, which must then be wished away in its turn (its removal bringing yet another undesirable consequence, and so forth).

The ideological content of Le Guin's novel is clear, although its political resonance is ambiguous: from the central position of her mystical Taoism, the effort to "reform" and to ameliorate, to transform society in a liberal or revolutionary way is seen, after the fashion of Edmund Burke, as a dangerous expression of individual *hubris* and a destructive tampering with the rhythms of "nature." Politically, of course, this ideological message may be read either

10. See Fredric Jameson, *The Prison House of Language* (Princeton: Princeton University Press, 1972), pp. 203-205.

as the liberal's anxiety in the face of a genuinely revolutionary transformation of society or as the expression of more conservative misgivings about the New-Deal-type reformism and do-goodism of the welfare state.[11]

On the aesthetic level, however—which is what concerns us here—the deeper subject of this fascinating work can only be the dangers of imagining utopia and more specifically of writing the utopian text itself. More transparently than much other science fiction, this book is "about" its own process of production, which is recognized as impossible: George Orr cannot dream utopia; yet in the very process of exploring the contradictions of that production, the narrative gets written, and "utopia" is "produced" in the very movement by which we are shown that an "achieved" utopia—a full representation—is a contradiction in terms. We may thus apply to *The Lathe of Heaven* those prophetic words of Roland Barthes about the dynamics of modernism generally, that the latter's monuments "linger as long as possible, in a sort of miraculous suspension, on the threshold of Literature [read in this context: Utopia], in this anticipatory situation in which the breadth of life is given, stretched but not yet destroyed by this crowning phase, an [institutionalized] order of signs."[12]

It is, however, more fitting to close this discussion with another science fiction-utopian text from the Second World today, one of the most glorious of all contemporary Utopias, the Strugatsky Brothers' astonishing *Roadside Picnic* (1977; first serialized in 1972).[13] This text moves in a space beyond the facile and obligatory references to the two rival social systems; and it cannot be coherently decoded as yet another *samizdat* message or expression of liberal political protest by Soviet dissidents.[14] Nor, although its figural material is accessible and rewritable in a way familiar to readers who live within the rather different constraints of either of the two industrial and bureaucratic systems, is it an affirmation or demonstration of what is today called "convergence" theory. Finally, while the narrative turns on the mixed blessings of wonder-working technology, this novel does not seem to me to be programmed by the category of "technological determinism" in either the Western or the Eastern style: that is, it is locked neither into a Western notion of infinite industrial progress of a non-political type, nor into the Stalinist notion of socialism as the "development of the forces of production."

On the contrary, the "zone"—a geographical space in which, as the result of some inexplicable alien contact, artifacts can be found whose powers transcend the explanatory capacities of human science—is at one and the same time

11. That the author of *The Dispossessed* is also capable of indulging in a classical Dostoyevskian and counterrevolutionary antiutopianism may be documented by her nasty little fable, "The Ones Who Walk Away from Omelas," in *The Wind's Twelve Quarters* (New York: Harper and Row, 1975), pp. 275-284.

12. Roland Barthes, *Writing Degree Zero*, trans. Annette Lavers and Colin Smith (New York: Hill and Wang, 1967), p. 39.

13. Arkady Strugatsky and Boris Strugatsky, *Roadside Picnic*, trans. Antonia W. Bouis (New York: Macmillan Publishing Co., 1977).

14. This is not to say that the Strugatskys have not had their share of personal and publishing problems.

the object of the most vicious bootlegging and military-industrial Greed, and of the purest religious—I would like to say utopian—Hope. The "quest for narrative," to use Todorov's expression,[15] is here very specifically the quest for the Grail; and the Strugatskys' deviant hero—marginal, and as "antisocial" as one likes; the Soviet equivalent of the ghetto or countercultural anti-heroes of our own tradition—is perhaps a more sympathetic and human figure for us than Le Guin's passive-contemplative and mystical innocent. No less than *The Lathe of Heaven*, then, *Roadside Picnic* is self-referential, its narrative production determined by the structural impossibility of producing that utopian text which it nonetheless miraculously becomes. Yet what we must cherish in this text—a formally ingenious collage of documents, an enigmatic cross-cutting between unrelated characters in social and temporal space, a desolate reconfirmation of the inextricable relationship of the utopian quest to crime and suffering, with its climax in the simultaneous revenge-murder of an idealistic and guiltless youth and the apparition of the Grail itself—is the unexpected emergence, as it were, beyond "the nightmare of History" and from out of the most archaic longings of the human race, of the impossible and inexpressible utopian impulse here nonetheless briefly glimpsed: "Happiness for everybody! . . . HAPPINESS FOR EVERYBODY, FREE, AND NO ONE WILL GO AWAY UNSATISFIED!"

The Strugatskys subsequently butchered their own novel, turning it into a heavy-handed allegorical script for Tarkovsky's film *Stalker*, in the process transforming the trickster-hero into a lugubrious Christ-figure. This adaptation, however, had the merit of revealing the dystopian features of the text more clearly: in particular the relationship, even within the novelistic version, of gratification and sacrifice. Even the miraculous Grail, then, must be secured by a murder (in this case, the revenge-murder, by the hero, of his rival's son). It is then logical that in the film one of the protagonists should seek to blow up the zone altogether (with a portable atomic bomb), in order to eradicate Hope (and with it the violence they now attribute to utopian projects—that is to say, presumably, to socialism). Yet this post-utopian message reckons without Freud's "antithetical meaning of primal words," and I am tempted to suggest that the very intensity of its assault on the utopian idea has the unexpected result of reinventing it for us.

15. Tzvetan Todorov, *The Poetics of Prose*, trans. Richard Howard (Ithaca, N.Y.: Cornell University Press, 1977).

The Precession of Simulacra

JEAN BAUDRILLARD

The simulacrum is never that which conceals the truth—it is the truth which conceals that there is none.
The simulacrum is true.

Ecclesiastes

If we were able to take as the finest allegory of simulation the Borges tale where the cartographers of the Empire draw up a map so detailed that it ends up exactly covering the territory (but where the decline of the Empire sees this map become frayed and finally ruined, a few shreds still discernible in the deserts—the metaphysical beauty of this ruined abstraction, bearing witness to an imperial pride and rotting like a carcass, returning to the substance of the soil, rather as an aging double ends up being confused with the real thing)—then this fable has come full circle for us, and now has nothing but the discrete charm of second-order simulacra.[1]

Abstraction today is no longer that of the map, the double, the mirror, or the concept. Simulation is no longer that of a territory, a referential being or a substance. It is the generation by models of a real without origin or reality: a hyperreal. The territory no longer precedes the map, nor survives it. Henceforth, it is the map that precedes the territory—**PRECESSION OF SIMU-LACRA**—it is the map that engenders the territory and if we were to revive the fable today, it would be the territory whose shreds are slowly rotting across the map. It is the real, and not the map, whose vestiges subsist here and there, in the deserts which are no longer those of the Empire, but our own: *The desert of the real itself.*

In fact, even inverted, the fable is useless. Perhaps only the allegory of the Empire remains. For it is with the same imperialism that present-day simulators try to make the real, all the real, coincide with their simulation models. But it is no longer a question of either maps or territory. Something has disappeared: the sovereign difference between them that was the abstraction's charm. For it is the difference which forms the poetry of the map and the charm of the territory, the magic of the concept and the charm of the real. This representational imaginary, which both culminates in and is engulfed by the cartographer's mad project of an ideal coextensivity between the map and the territory, disappears with simulation—whose operation is nuclear and ge-

Reprinted from *Art & Text*, no. 11 (September 1983): 3-47; also available in Jean Baudrillard, *Simulations*, trans. Paul Foss and Paul Patton (New York: Semiotext(e), 1983).

1. Cf., Jean Baudrillard, *L'échange symbolique et la mort* ("L'ordre des simulacres"), (Paris: Gallimard, 1975).

netic, and no longer specular and discursive. With it goes all of metaphysics. No more mirror of being and appearances, of the real and its concept. No more imaginary coextensivity: rather, genetic miniaturization is the dimension of simulation. The real is produced from miniaturized units, from matrices, memory banks, and command models—and with these it can be reproduced an infinite number of times. It no longer has to be rational, since it is no longer measured against some ideal or negative instance. It is nothing more than operational. In fact, since it is no longer enveloped by an imaginary, it is no longer real at all. It is a hyperreal, the product of an irradiating synthesis of combinatory models in a hyperspace without atmosphere.

In this passage to a space whose curvature is no longer that of the real, nor of truth, the age of simulation thus begins with a liquidation of all referentials—worse: by their artificial resurrection in systems of signs, a more ductile material than meaning, in that it lends itself to all systems of equivalence, all binary oppositions, and all combinatory algebra. It is no longer a question of imitation, nor of reduplication, nor even of parody. It is rather a question of substituting signs of the real for the real itself, that is, an operation to deter every real process by its operational double, a metastable, programmatic, perfect descriptive machine which provides all the signs of the real and short-circuits all its vicissitudes. Never again will the real have to be produced—this is the vital function of the model in a system of death, or rather of anticipated resurrection which no longer leaves any chance even in the event of death. A hyperreal henceforth sheltered from the imaginary, and from any distinction between the real and the imaginary, leaving room only for the orbital recurrence of models and the simulated generation of difference.

The Divine Irreference of Images

To dissimulate is to feign not to have what one has. To simulate is to feign to have what one hasn't. One implies a presence, the other an absence. But the matter is more complicated, since to simulate is not simply to feign: "Someone who feigns an illness can simply go to bed and make believe he is ill. Someone who simulates an illness produces in himself some of the symptoms." (Littre) Thus, feigning or dissimulating leaves the reality principle intact: the difference is always clear, it is only masked; whereas simulation threatens the difference between "true" and "false," between "real" and "imaginary." Since the simulator produces "true" symptoms, is he ill or not? He cannot be treated objectively either as ill, or as not-ill. Psychology and medicine stop at this point, before a thereafter undiscoverable truth of the illness. For if any symptom can be "produced," and can no longer be accepted as a fact of nature, then every illness may be considered as simulatable and simulated, and medicine loses its meaning since it only knows how to treat "true" illnesses by their objective causes. Psychosomatics evolves in a dubious way on the edge of the illness principle. As for psychoanalysis, it transfers the symptom from the organic to the unconscious order: once again, the latter is held to be true, more true than the former—but why should simulation stop at the portals of the unconscious? Why couldn't the "work" of the unconscious be "produced" in the same way as any other symptom in classical medicine? Dreams already are.

The alienist, of course, claims that "for each form of the mental alienation there is a particular order in the succession of symptoms, of which the simulator is unaware and in the absence of which the alienist is unlikely to be deceived." This (which dates from 1865) in order to save at all cost the truth principle, and to escape the specter raised by simulation—namely that truth, reference and objective causes have ceased to exist. What can medicine do with something which floats on either side of illness, on either side of health, or with the reduplication of illness in a discourse that is no longer true or false? What can psychoanalysis do with the reduplication of the discourse of the unconscious in a discourse of simulation that can never be unmasked, since it isn't false either? [2]

What can the army do with simulators? Traditionally, following a direct principle of identification, it unmasks and punishes them. Today, it can reform an excellent simulator as though he were equivalent to a "real" homosexual, heart-case, or lunatic. Even military psychology retreats from the Cartesian clarities and hesitates to draw the distinction between true and false, between the "produced" symptom and the authentic symptom. "If he acts crazy so well, then he must be mad." Nor is it mistaken: in the sense that all lunatics are simulators, and this lack of distinction is the worst form of subversion. Against it classical reason armed itself with all its categories. But it is this today which again outflanks them, submerging the truth principle.

Outside of medicine and the army, favored terrains of simulation, the affair goes back to religion and the simulacrum of divinity: "I forbad any simulacrum in the temples because the divinity that breathes life into nature cannot be represented." Indeed it can. But what becomes of the divinity when it reveals itself in icons, when it is multiplied in simulacra? Does it remain the supreme authority, simply incarnated in images as a visible theology? Or is it volatilized into simulacra which alone deploy their pomp and power of fascination—the visible machinery of icons being substituted for the pure and intelligible Idea of God? This is precisely what was feared by the iconoclasts, whose millenial quarrel is still with us today.[3] Their rage to destroy images arose precisely because they sensed this omnipotence of simulacra, this facility they have of effacing God from the consciousness of men, and the overwhelming, destructive truth which they suggest: that ultimately there has never been any God, that only the simulacrum exists, indeed that God himself has only ever been his own simulacrum. Had they been able to believe that images only occulted or masked the Platonic idea of God, there would have been no reason to destroy them. One can live with the idea of a distorted truth. But their metaphysical despair came from the idea that the images concealed nothing at all, and that in fact they were not images, such as the original model would have made them, but actually perfect simulacra forever radiant with their own fascination. But this death of the divine referential has to be exorcised at all cost.

2. And which is not susceptible to resolution in transference. It is the entanglement of these two discourses which makes psychoanalysis interminable.

3. Cf., Mario Perniola, "Icones, Visions, Simulacres," *Traverses*, no. 10 (February 1978): 39-49. Translated by Michel Makarius.

It can be seen that the iconoclasts, who are often accused of despising and denying images, were in fact the ones who accorded them their actual worth, unlike the iconolaters, who saw in them only reflections and were content to venerate God at one remove. But the converse can also be said, namely that the iconolaters were the most modern and adventurous minds, since underneath the idea of the apparition of God in the mirror of images, they already enacted his death and his disappearance in the epiphany of his representations (which they perhaps knew no longer represented anything, and that they were purely a game, but that this was precisely the greatest game—knowing also that it is dangerous to unmask images, since they dissimulate the fact that there is nothing behind them).

This was the approach of the Jesuits, who based their politics on the virtual disappearance of God and on the worldly and spectacular manipulation of consciences—the evanescence of God in the epiphany of power—the end of transcendence, which no longer serves as alibi for a strategy completely free of influences and signs. Behind the baroque of images hides the grey eminence of politics.

Thus perhaps at stake has always been the murderous capacity of images, murderers of the real, murderers of their own model as the Byzantine icons could murder the divine identity. To this murderous capacity is opposed the dialectical capacity of representations as a visible and intelligible mediation of the Real. All of Western faith and good faith was engaged in this wager on representation: that a sign could refer to the depth of meaning, that a sign could *exchange* for meaning, and that something could guarantee this exchange—God, of course. But what if God himself can be simulated, that is to say, reduced to the signs which attest his existence? Then the whole system becomes weightless, it is no longer anything but a gigantic simulacrum—not unreal, but a simulacrum, never again exchanging for what is real, but exchanging in itself, in an uninterrupted circuit without reference or circumference.

So it is with simulation, insofar as it is opposed to representation. The latter starts from the principle that the sign and the real are equivalent (even if this equivalence is utopian, it is a fundamental axiom). Conversely, simulation starts from the *utopia* of this principle of equivalence, *from the radical negation of the sign as value*, from the sign as reversion and death sentence of every reference. Whereas representation tries to absorb simulation by interpreting it as false representation, simulation envelops the whole edifice of representation as itself a simulacrum.

These would be the successive phases of the image:
—it is the reflection of a basic reality
—it masks and perverts a basic reality
—it masks the *absence* of a basic reality
—it bears no relation to any reality whatever: it is its own pure simulacrum.

In the first case, the image is a *good* appearance—the representation is of the order of sacrament. In the second, it is an *evil* appearance—of the order of malefice. In the third, it *plays at being* an appearance—it is of the order of sorcery. In the fourth, it is no longer in the order of appearance at all, but of simulation.

The transition from signs which dissimulate something to signs which dissimulate that there is nothing marks the decisive turning point. The first implies a theology of truth and secrecy (to which the notion of ideology still belongs). The second inaugurates an age of simulacra and simulation, in which there is no longer any God to recognize his own, nor any last judgment to separate true from false, the real from its artificial resurrection, since everything is already dead and risen in advance.

When the real is no longer what it used to be, nostalgia assumes its full meaning. There is a proliferation of myths of origin and signs of reality; of secondhand truth, objectivity, and authenticity. There is an escalation of the true, of the lived experience; a resurrection of the figurative where the object and substance have disappeared. And there is a panic-stricken production of the real and the referential, above and parallel to the panic of material production: this is how simulation appears in the phase that concerns us—a strategy of the real, neo-real, and hyperreal, whose universal double is a strategy of deterrence.

Rameses, or Rose-Colored Resurrection

Ethnology almost met a paradoxical death that day in 1971 when the Phillipine government decided to return to their primitive state the few dozen Tasaday discovered deep in the jungle, where they had lived for eight centuries undisturbed by the rest of mankind, out of reach of colonists, tourists, and ethnologists. This was at the initiative of the anthropologists themselves, who saw the natives decompose immediately on contact, like a mummy in the open air.

For ethnology to live, its object must die. But the latter revenges itself by dying for having been "discovered," and defies by its death the science that wants to take hold of it.

Doesn't every science live on this paradoxical slope to which it is doomed by the evanescence of its object in the very process of its apprehension, and by the pitiless reversal this dead object exerts on it? Like Orpheus, it always turns around too soon, and its object, like Eurydice, falls back into Hades.

It was against this hades of paradox that the ethnologists wanted to protect themselves by cordoning off the Tasaday with virgin forest. Nobody now will touch it: the vein is closed down, like a mine. Science loses a precious capital, but the object will be safe—lost to science, but intact in its "virginity." It isn't a question of sacrifice (science never sacrifices itself; it is always murderous), but of the simulated sacrifice of its object in order to save its reality principle. The Tasaday, frozen in their natural element, provide a perfect alibi, an eternal guarantee. At this point begins a persistent anti-ethnology to which Jaulin, Castaneda, and Clastres variously belong. In any case, the logical evolution of a science is to distance itself ever further from its object until it dispenses with it entirely: its autonomy ever more fantastical in reaching its pure form.

The Indian thereby driven back into the ghetto, into the glass coffin of virgin forest, becomes the simulation model for all conceivable Indians *before ethnology*. The latter thus allows itself the luxury of being incarnate beyond

itself, in the "brute" reality of these Indians it has entirely reinvented—savages who are indebted to ethnology for still being Savages: what a turn of events, what a triumph for this science which seemed dedicated to their destruction!

Of course, these particular savages are posthumous: frozen, cryogenized, sterilized, protected *to death*, they have become referential simulacra, and the science itself a pure simulation. Same thing at Creusot where, in the form of an "open" museum exhibition, they have "museumized" on the spot, as historical witnesses to their period, entire working-class *quartiers*, living metallurgical zones, a complete culture including men, women, and children and their gestures, languages, and habits—living beings fossilized as in a snapshot. The museum, instead of being circumscribed in a geometrical location, is now everywhere, like a dimension of life itself. Thus ethnology, now freed from its object, will no longer be circumscribed as an objective science but is applied to all living things and becomes invisible, like an omnipresent fourth dimension, that of the simulacrum. *We are all Tasaday*. Or Indians who have once more become "what they used to be," or at least that which ethnology has made them—simulacra Indians who proclaim at last the universal truth of ethnology.

We all become living specimens under the spectral light of ethnology, or of anti-ethnology which is only the pure form of triumphal ethnology, under the sign of dead differences, and of the resurrection of differences. It is thus extremely naive to look for ethnology among the savages or in some Third World—it is here, everywhere, in the metropolis, among the whites, in a world completely catalogued and analyzed and then *artificially revived as though real*, in a world of simulation: of the hallucination of truth, of blackmail by the real, of the murder and historical (hysterical) retrospection of every symbolic form—a murder whose first victims were, *noblesse oblige*, the savages, but which for a long time now has been extended to all Western societies.

But at the same moment ethnology gives up its final and only lesson, the secret which kills it (and which the savages understood much better): the vengeance of the dead.

The confinement of the scientific object is the same as that of the insane and the dead. And just as the whole of society is hopelessly contaminated by that mirror of madness it has held out for itself, so science can only die contaminated by the death of the object which is its inverse mirror. It is science which ostensibly masters the object, but it is the latter which deeply invests the former, following an unconscious reversion, giving only dead and circular replies to a dead and circular interrogation.

Nothing changes when society breaks the mirror of madness (abolishes asylums, gives speech back to the mad, etc.) nor when science seems to break the mirror of its objectivity (effacing itself before its object, as Castaneda does, etc.) and to bow down before "differences." Confinement is succeeded by an apparatus which assumes a countless and endlessly diffractable, multipliable form. As fast as ethnology in its classical institution collapses, it survives in an anti-ethnology whose task is to reinject fictional difference and savage-ry everywhere, in order to conceal the fact that it is this world, our own, which in its way has become savage again, that is to say devastated by difference and death.

It is in this way, under the pretext of saving the original, that the caves of Lascaux have been forbidden to visitors and an exact replica constructed 500 meters away, so that everyone can see them (you glance through a peephole at the real grotto and then visit the reconstituted whole). It is possible that the very memory of the original caves will fade in the mind of future generations, but from now on there is no longer any difference: the duplication is sufficient to render both artificial.

In the same way the whole of science and technology were recently mobilized to save the mummy of Rameses II, after it had been left to deteriorate in the basement of a museum. The West was panic-stricken at the thought of not being able to save what the symbolic order had been able to preserve for forty centuries, but away from the light and gaze of onlookers. Rameses means nothing to us: only the mummy is of inestimable worth since it is what guarantees that accumulation means something. Our entire linear and accumulative culture would collapse if we could not stockpile the past in plain view. To this end the pharaohs must be brought out of their tombs, and the mummies out of their silence. To this end they must be exhumed and given military honors. They are prey to both science and the worms. Only absolute secrecy ensured their potency throughout the millenia—their mastery over putrefaction, which signified a mastery over the total cycle of exchange with death. *We* know better than to use our science for the *reparation* of the mummy, that is, to restore a *visible* order, whereas embalming was a mythical labor aimed at immortalizing a *hidden* dimension.

We need a visible past, a visible continuum, a visible myth of origin to reassure us as to our ends, since ultimately we have never believed in them. Whence that historic scene of the mummy's reception at Orly airport. All because Rameses was a great despot and military figure? Certainly. But above all because the order which our culture dreams of, behind that defunct power it seeks to annex, could have had nothing to do with it, and it dreams thus because it has exterminated this order by exhuming it *as if it were our own past*.

We are fascinated by Rameses just as Renaissance Christians were by the American Indians: those (human?) beings who had never known the word of Christ. Thus, at the beginning of colonization, there was a moment of stupor and amazement before the very possibility of escaping the universal law of the Gospel. There were two possible reponses: either to admit that this law was not universal, or to exterminate the Indians so as to remove the evidence. In general, it was enough to convert them, or even simply to discover them, to ensure their slow extermination.

Thus it would have been enough to exhume Rameses to ensure his extermination by museumification. For mummies do not decay because of worms: they die from being transplanted from a prolonged symbolic order, which is master over death and putrescence, on to an order of history, science, and

President Ronald Reagan addresses the Republican National Convention in Dallas, August 22, 1984, via closed-circuit television. Caption in *The New York Times* read: "President and Mrs. Reagan making the most of video technology." (Photo: Paul Hosefros/The New York Times)

museums—our own, which is no longer master over anything, since it only knows how to condemn its predecessors to death and putrescence and their subsequent resuscitation by science. An irreparable violence towards all secrets, the violence of a civilization without secrets. The hatred by an entire civilization for its own foundations.

And just as with ethnology playing at surrendering its object the better to establish itself in its pure form, so museumification is only one more turn in the spiral of artificiality. Witness the cloister of St. Michel de Cuxa, which is going to be repatriated at great expense from the Cloisters in New York to be reinstalled on "its original site." And everyone is supposed to applaud this restitution (as with the "experimental campaign to win back the sidewalks" on the Champs-Élysées!). However, if the exportation of the cornices was in effect an arbitrary act, and if the Cloisters of New York is really an artificial mosaic of all cultures (according to a logic of the capitalist centralization of value), then reimportation to the original location is even more artificial: it is a total simulacrum that links up with "reality" by a complete circumvolution.

The cloister should have stayed in New York in its simulated environment, which at least would have fooled no one. Repatriation is only a supplementary subterfuge, in order to make out as though nothing had happened and to indulge in a retrospective hallucination.

In the same way Americans flatter themselves that they brought the number of Indians back to what it was before their conquest. Everything is obliterated only to begin again. They even flatter themselves that they went one better, by surpassing the original figure. This is presented as proof of the superiority of civilization: it produces more Indians than they were capable of themselves. By a sinister mockery, this overproduction is yet again a way of destroying them: for Indian culture, like all tribal culture, rests on the limitation of the group and prohibiting any of its "unrestricted" growth, as can be seen in the case of Ishi. Demographic "promotion," therefore, is just one more step towards symbolic extermination.

We too live in a universe everywhere strangely similar to the original—here things are duplicated by their own scenario. But this double does not mean, as in folklore, the imminence of death—they are already purged of death, and are even better than in life; more smiling, more authentic, in light of their model, like the faces in funeral parlors.

Hyperreal and Imaginary

Disneyland is a perfect model of all the entangled orders of simulation. To begin with it is a play of illusions and phantasms: Pirates, the Frontier, Future World, etc. This imaginary world is supposed to be what makes the operation successful. But what draws the crowds is undoubtedly much more the social microcosm, the miniaturized and *religious* reveling in real America, in its delights and drawbacks. You park outside, queue up inside, and are totally abandoned at the exit. In this imaginary world the only phantasmagoria is in the inherent warmth and affection of the crowd, and in that sufficiently excessive number of gadgets used there specifically to maintain the multitudinous

affect. The contrast with the absolute solitude of the parking lot—a veritable concentration camp—is total. Or rather: inside, a whole range of gadgets magnetize the crowd into direct flows—outside, solitude is directed onto a single gadget: the automobile. By an extraordinary coincidence (one that undoubtedly belongs to the peculiar enchantment of this universe), this deep-frozen infantile world happens to have been conceived and realized by a man who is himself now cryogenized: Walt Disney, who awaits his resurrection at minus 180 degrees centigrade.

The objective profile of America, then, may be traced throughout Disneyland, even down to the morphology of individuals and the crowd. All its values are exalted here, in miniature and comic strip form. Embalmed and pacified. Whence the possibility of an ideological analysis of Disneyland (Louis Marin does it well in *Utopies, jeux d'espaces*): digest of the American way of life, panegyric to American values, idealized transposition of a contradictory reality. To be sure. But this conceals something else, and that "ideological" blanket exactly serves to cover over a *third-order simulation*: Disneyland is there to conceal the fact that it is the "real" country, all of "real" America, which *is* Disneyland (just as prisons are there to conceal the fact that it is the social in its entirety, in its banal omnipresence, which is carceral). Disneyland is presented as imaginary in order to make us believe that the rest is real, when in fact all of Los Angeles and the America surrounding it are no longer real, but of the order of the hyperreal and of simulation. It is no longer a question of a false representation of reality (ideology), but of concealing the fact that the real is no longer real, and thus of saving the reality principle.

The Disneyland imaginary is neither true nor false; it is a deterrence machine set up in order to rejuvenate in reverse the fiction of the real. Whence the debility, the infantile degeneration of this imaginary. It is meant to be an infantile world, in order to make us believe that the adults are elsewhere, in the "real" world, and to conceal the fact that real childishness is everywhere, particularly amongst those adults who go there to act the child in order to foster illusions to their real childishness.

Moreover, Disneyland is not the only one. Enchanted Village, Magic Mountain, Marine World: Los Angeles is encircled by these "imaginary stations" which feed reality, reality-energy, to a town whose mystery is precisely that it is nothing more than a network of endless, unreal circulation—a town of fabulous proportions, but without space or dimensions. As much as electrical and nuclear power stations, as much as film studios, this town, which is nothing more than an immense script and a perpetual motion picture, needs this old imaginary made up of childhood signals and faked phantasms for its sympathetic nervous system.

Political Incantation

Watergate. Same scenario as Disneyland (an imaginary effect concealing that reality no more exists outside than inside the bounds of the artificial perimeter): though here it is a scandal effect concealing that there is no difference between the facts and their denunciation (identical methods are employed by the CIA and the *Washington Post* journalists). Same operation, though this time tend-

ing towards scandal as a means to regenerate a moral and political principle, towards the imaginary as a means to regenerate a reality principle in distress.

The denunciation of scandal always pays homage to the law. And Watergate above all succeeded in imposing the idea that Watergate *was* a scandal—in this sense it was an extraordinary operation of intoxication. The reinjection of a large dose of political morality on a global scale. It could be said along with Bourdieu that: "The specific character of every relation of force is to dissimulate itself as such, and to acquire all its force only because it is so dissimulated," understood as follows: capital, which is immoral and unscrupulous, can only function behind a moral superstructure, and whoever regenerates this public morality (by indignation, denunciation, etc.) spontaneously furthers the order of capital, as did the *Washington Post* journalists.

But this is still only the formula of ideology, and when Bourdieu enunciates it, he takes "relation of force" to mean the *truth* of capitalist domination, and he *denounces* this relation of force as itself a *scandal*—he therefore occupies the same deterministic and moralistic position as the *Washington Post* journalists. He does the same job of purging and reviving moral order, an order of truth wherein the genuine symbolic violence of the social order is engendered, well beyond all relations of force, which are only its indifferent and shifting configuration in the moral and political consciousness of men.

All that capital asks of us is to receive it as rational or to combat it in the name of rationality, to receive it as moral or to combat it in the name of morality. For they are *identical*, meaning *they can be read another way:* before, the task was to dissimulate scandal; today, the task is to conceal the fact that there is none.

Watergate is not a scandal: this is what must be said at all cost, for this is what everyone is concerned to conceal, this dissimulation masking a strengthening of morality, a moral panic as we approach the primal (mise-en-) scene of capital: its instantaneous cruelty, its incomprehensible ferocity, its fundamental immorality—this is what is scandalous, unaccountable for in that system of moral and economic equivalence which remains the axiom of leftist thought, from Enlightenment theory to communism. Capital doesn't give a damn about the idea of the contract which is imputed to it—it is a monstrous unprincipled undertaking, nothing more. Rather, it is "enlightened" thought which seeks to control capital by imposing rules on it. And all that recrimination which replaced revolutionary thought today comes down to reproaching capital for not following the rules of the game. "Power is unjust, its justice is a class justice, capital exploits us, etc."—as if capital were linked by a contract to the society it rules. It is the left which holds out the mirror of equivalence, hoping that capital will fall for this phantasmagoria of the social contract and fulfill its obligation towards the whole of society (at the same time, no need for revolution: it is enough that capital accept the rational formula of exchange).

Capital in fact has never been linked by a contract to the society it dominates. It is a sorcery of the social relation, it is a *challenge to society* and should be responded to as such. It is not a scandal to be denounced according to moral and economic rationality, but a challenge to take up according to symbolic law.

**Moebius-
Spiraling
Negativity**

Hence Watergate was only a trap set by the system to catch its adversaries—a simulation of scandal to regenerative ends. This is embodied by the character called "Deep Throat," who was said to be a Republican grey eminence manipulating the leftist journalists in order to get rid of Nixon—and why not? All hypotheses are possible, although this one is superfluous: the work of the right is done very well, and spontaneously, by the left on its own. Besides, it would be naive to see an embittered good conscience at work here. For the right itself also spontaneously does the work of the left. All the hypotheses of manipulation are reversible in an endless whirligig. For manipulation is a floating causality where positivity and negativity engender and overlap with one another, where there is no longer any active or passive. It is by putting an *arbitrary* stop to this revolving causality that a principle of political reality can be saved. It is by the *simulation* of a conventional, restricted perspective field, where the premises and consequences of any act or event are calculable, that a political credibility can be maintained (including, of course, "objective" analysis, struggle, etc.). But if the entire cycle of any act or event is envisaged in a system where linear continuity and dialectical polarity no longer exist, in a field *unhinged by simulation*, then all determination evaporates, every act terminates at the end of the cycle having benefited everyone and been scattered in all directions.

Is any given bombing in Italy the work of leftist extremists, or of extreme right-wing provocation, or staged by centrists to bring every terrorist extreme into disrepute and to shore up its own failing power, or again, is it a police-inspired scenario in order to appeal to public security? All this is equally true, and the search for proof, indeed the objectivity of the fact does not check this vertigo of interpretation. We are in a logic of simulation which has nothing to do with a logic of facts and an order of reasons. Simulation is characterized by a *precession of the model*, of all models around the merest fact—the models come first, and their orbital (like the bomb) circulation constitutes the genuine magnetic field of events. Facts no longer have any trajectory of their own, they arise at the intersection of the models; a single fact may even be engendered by all the models at once. This anticipation, this precession, this short circuit, this confusion of the fact with its model (no more divergence of meaning, no more dialectical polarity, no more negative electricity or implosion of poles) is what each time allows for all the possible interpretations, even the most contradictory—all are true, in the sense that their truth is exchangeable, in the image of the models from which they proceed, in a generalized cycle.

The communists attack the Socialist party as though they wanted to shatter the union of the left. They sanction the idea that their reticence stems from a more radical political exigency. In fact, it is because they don't want power. But do they not want it at this conjuncture because it is unfavorable for the left in general, or because it is unfavorable for them within the union of the left—or do they not want it by definition? When Berlinguer declares: "We mustn't be frightened of seeing the communists seize power in Italy," this means simultaneously:

—that there is nothing to fear, since the communists, if they come to power, will change nothing in its fundamental capitalist mechanism,

—that there isn't any risk of their ever coming to power (for the reason that they don't want to)—and even if they did take it up, they will only ever wield it by proxy,

—that in fact power, genuine power, no longer exists, and hence there is no risk of anybody seizing it or taking it over,

—but more: I, Berlinguer, am not frightened of seeing the communists seize power in Italy—which might appear evident, but not that much, since

—this can also mean the contrary (no need of psychoanalysis here): *I am frightened* of seeing the communists seize power (and with good reason, even for a communist).

All the above is simultaneously true. This is the secret of a discourse that is no longer only ambiguous, as political discourses can be, but that conveys the impossibility of a determinate position of power, the impossibility of a determinate position of discourse. And this logic belongs to neither party. It traverses all discourses without their wanting it.

Who will unravel this imbroglio? The Gordian knot can at least be cut. As for the Moebius strip, if it is split in two, it results in an additional spiral without there being any possibility of resolving its surfaces (here the reversible continuity of hypotheses). Hades of simulation, which is no longer one of torture, but of the subtle, maleficent, elusive twisting of meaning[4]—where even those condemned at Burgos are still a gift from Franco to Western democracy, which finds in them the occasion to regenerate its own flagging humanism, and whose indignant protestation in return consolidates Franco's regime by uniting the Spanish masses against foreign intervention? Where is the truth in all that, when such collusions admirably knit together without their authors even knowing it?

The conjunction of the system and its extreme alternative like two ends of a curved mirror, the "vicious" curvature of a political space henceforth magnetized, circularized, reversibilized from right to left, a torsion that is like the evil demon of commutation, the whole system, the infinity of capital folded back over its own surface: transfinite? And isn't it the same with desire and libidinal space? The conjunction of desire and value, of desire and capital. The conjunction of desire and the law—the ultimate joy and metamorphosis of the law (which is why it is so well received at the moment): only capital takes pleasure, Lyotard said, before coming to think that *we* take pleasure in capital. Overwhelming versatility of desire in Deleuze, an enigmatic reversal which brings this desire that is "revolutionary by itself, and as if involuntarily, in wanting what it wants," to want its own repression and to invest paranoid and fascist systems? A malign torsion which reduces this revolution of desire to the same fundamental ambiguity as the other, historical revolution.

All the referentials intermingle their discourses in a circular, Moebian compulsion. Not so long ago sex and work were savagely opposed terms: today both are dissolved into the same type of demand. Formerly the discourse on

4. This does not necessarily result in a despair of meaning, but just as much in an improvisation of meaning, of nonsense, or of several simultaneous senses which cancel each other out.

history took its force from opposing itself to the one on nature, the discourse on desire to the one on power—today they exchange their signifiers and their scenarios.

It would take too long to run through the whole range of operational negativity, of all those scenarios of deterrence which, like Watergate, try to regenerate a moribund principle by simulated scandal, phantasm, murder—a sort of hormonal treatment by negativity and crisis. It is always a question of proving the real by the imaginary, proving truth by scandal, proving the law by transgression, proving work by the strike, proving the system by crisis, and capital by revolution, as for that matter proving ethnology by the dispossession of its object (the Tasaday)—without counting:

—proving theater by anti-theater
—proving art by anti-art
—proving pedagogy by anti-pedagogy
—proving psychiatry by anti-psychiatry, etc., etc.

Everything is metamorphosed into its inverse in order to be perpetuated in its purged form. Every form of power, every situation speaks of itself by denial, in order to attempt to escape, by simulation of death, its real agony. Power can stage its own murder to rediscover a glimmer of existence and legitimacy. Thus with the American presidents: the Kennedys are murdered because they still have a political dimension. Others—Johnson, Nixon, Ford—only had a right to puppet attempts, to simulated murders. But they nevertheless needed that aura of an artificial menace to conceal that they were nothing other than mannequins of power. In olden days the king (also the god) had to die—that was his strength. Today he does his miserable utmost to pretend to die, so as to preserve the *blessing* of power. But even this is gone.

To seek new blood in its own death, to renew the cycle by the mirror of crisis, negativity and anti-power: this is the only alibi of every power, of every institution attempting to break the vicious circle of its irresponsibility and its fundamental nonexistence, of its *déjà-vu* and its *déjà-mort*.

Strategy of the Real

Of the same order as the impossibility of rediscovering an absolute level of the real is the impossibility of staging an illusion. Illusion is no longer possible, because the real is no longer possible. It is the whole *political* problem of the parody, of hypersimulation or offensive simulation, which is posed here.

For example: it would be interesting to see whether the repressive apparatus would not react more violently to a simulated holdup than to a real one. For the latter only upsets the order of things, the right of property, whereas the other interferes with the very principle of reality. Transgression and violence are less serious, for they only contest the *distribution* of the real. Simulation is infinitely more dangerous, however, since it always suggests, over and above its object, that *law and order themselves might really be nothing more than a simulation.*

But the difficulty is in proportion to the peril. How to feign a violation and put it to the test? Go and simulate a theft in a large department store: how do you convince the security guards that it is a simulated theft? There is

no "objective" difference: the same gestures and the same signs exist as for a real theft; in fact the signs incline neither to one side nor the other. As far as the established order is concerned, they are always of the order of the real.

Go and organize a fake holdup. Be sure to check that your weapons are harmless, and take the most trustworthy hostage, so that no life is in danger (otherwise you risk committing an offense). Demand ransom, and arrange it so that the operation creates the greatest commotion possible—in brief, stay close to the "truth," so as to test the reaction of the apparatus to a perfect simulation. But you won't succeed: the web of artificial signs will be inextricably mixed up with real elements (a police officer will really shoot on sight; a bank customer will faint and die of a heart attack; they will really turn the phony ransom over to you)—in brief, you will unwittingly find yourself immediately in the real, one of whose functions is precisely to devour every attempt at simulation, to reduce everything to some reality—that's exactly how the established order is, well before institutions and justice come into play.

In this impossibility of isolating the process of simulation must be seen the whole thrust of an order that can only see and understand in terms of some reality, because it can function nowhere else. The simulation of an offense, if it is patent, will either be punished more lightly (because it has no "consequences") or be punished as an offense to public office (for example, if one triggered off a police operation "for nothing")—but *never as simulation*, since it is precisely as such that no equivalence with the real is possible, and hence no repression either. The challenge of simulation is irreceivable by power. How can you punish the simulation of virtue? Yet as such it is as serious as the simulation of crime. Parody makes obedience and transgression equivalent, and that is the most serious crime, since it *cancels out the difference upon which the law is based*. The established order can do nothing against it, for the law is a second-order simulacrum whereas simulation is third-order, beyond true and false, beyond equivalences, beyond the rational distinctions upon which function all power and the entire social. Hence, *failing the real*, it is here that we must aim at order.

This is why order always opts for the real. In a state of uncertainty, it always prefers this assumption (thus in the army they would rather take the simulator as a true madman). But this becomes more and more difficult, for it is practically impossible to isolate the process of simulation, through the force of inertia of the real which surrounds us, the inverse is also true (and this very reversibility forms part of the apparatus of simulation and of power's impotency): namely, *it is now impossible to isolate the process of the real*, or to prove the real.

Thus all holdups, hijacks, and the like are now as it were simulation holdups, in the sense that they are inscribed in advance in the decoding and orchestration rituals of the media, anticipated in their mode of presentation and possible consequences. In brief, where they function as a set of signs dedicated exclusively to their recurrence as signs, and no longer to their "real" goal at all. But this does not make them inoffensive. On the contrary, it is as hyperreal events, no longer having any particular contents or aims, but indefinitely refracted by each other (for that matter like so-called historical events:

strikes, demonstrations, crises, etc.[5]), that they are precisely unverifiable by an order which can only exert itself on the real and the rational, on ends and means: a referential order which can only dominate referentials, a determinate power which can only dominate a determined world, but which can do nothing about that indefinite recurrence of simulation, about that weightless nebula no longer obeying the law of gravitation of the real—power itself eventually breaking apart in this space and becoming a simulation of power (disconnected from its aims and objectives, and dedicated to *power effects* and mass simulation).

The only weapon of power, its only strategy against this defection, is to reinject realness and referentiality everywhere, in order to convince us of the reality of the social, of the gravity of the economy, and the finalities of production. For that purpose it prefers the discourse of crisis, but also—why not?—the discourse of desire. "Take your desires for reality!" can be understood as the ultimate slogan of power, for in a nonreferential world even the confusion of the reality principle with the desire principle is less dangerous than contagious hyperreality. One remains among principles, and there power is always right.

Hyperreality and simulation are deterrents of every principle and of every objective; they turn against power this deterrence which is so well utilized for a long time itself. For, finally, it was capital which was the first to feed throughout its history on the destruction of every referential, of every human goal, which shattered every ideal distinction between true and false, good and evil, in order to establish a radical law of equivalence and exchange, the iron law of its power. It was the first to practice deterrence, abstraction, disconnection, deterritorialization, etc.; and if it was capital which fostered reality, the reality principle, it was also the first to liquidate it in the extermination of every use value, of every real equivalence, of production and wealth, in the very sensation we have of the unreality of the stakes and the omnipotence of manipulation. Now, it is this very logic which is today hardened even more *against* it. And when it wants to fight this catastrophic spiral by secreting one last glimmer of reality, on which to found one last glimmer of power, it only multiplies the *signs* and accelerates the play of simulation.

As long as it was historically threatened by the real, power risked deterrence and simulation, disintegrating every contradiction by means of the production of equivalent signs. When it is threatened today by simulation (the threat of vanishing in the play of signs), power risks the real, risks crisis, it gambles on remanufacturing artificial, social, economic, political stakes. This is a question of life or death for it. But it is too late.

Whence the characteristic hysteria of our time: the hysteria of production and reproduction of the real. The other production, that of goods and commodities, that of *la belle époque* of political economy, no longer makes any

5. The energy crisis, the ecological setting, by and large, are themselves a *disaster film*, in the same style (and of the same value) as those which currently do so well for Hollywood. It is pointless to interpret these films laboriously by their relationship with an "objective" social crisis, or even with an "objective" phantasm of disaster. It is in the other direction that we must say it is *the social itself which*, in contemporary discourse, *is organized according to a script for a disaster film*. (Cf., Michel Makarius, "La stratégie de la catastrophe," *Traverses*, no. 10 (February 1978): 115-124.

sense of its own, and has not for some time. What society seeks through production, and overproduction, is the restoration of the real which escapes it. That is why contemporary *"material" production is itself hyperreal.* It retains all the features, the whole discourse of traditional production, but it is nothing more than its scaled-down refraction (thus the hyperrealists fasten in a striking resemblance a real from which has fled all meaning and charm, all the profundity and energy of representation). Thus the hyperrealism of simulation is expressed everywhere by the real's striking resemblance to itself.

Power, too, for some time now produces nothing but signs of its resemblance. And at the same time, another figure of power comes into play: that of a collective demand for *signs* of power–a holy union which forms around the disappearance of power. Everybody belongs to it more or less in fear of the collapse of the political. And in the end the game of power comes down to nothing more than the *critical* obsession with power–an obsession with its death, an obsession with its survival, the greater the more it disappears. When it has totally disappeared, logically we will be under the total spell of power–a haunting memory already foreshadowed everywhere, manifesting at one and the same time the compulsion to get rid of it (nobody wants it any more, everybody unloads it on others) and the apprehensive pining over its loss. Melancholy for societies without power: this has already given rise to fascism, that overdose of a powerful referential in a society which cannot terminate its mourning.

But we are still in the same boat: none of our societies knows how to manage its mourning for the real, for power, for the *social itself,* which is implicated in this same breakdown. And it is by an artificial revitalization of all this that we try to escape it. *Undoubtedly this will even end up in socialism.* By an unforeseen twist of events and an irony which no longer belongs to history, it is through the death of the social that socialism will emerge–as it is through the death of God that religions emerge. A twisted coming, a perverse event, an unintelligible reversion to the logic of reason. As is the fact that power is no longer present except to conceal that there is none. A simulation which can go on indefinitely, since–unlike "true" power which is, or was, a structure, a strategy, a relation of force, a stake–this is nothing but the object of a social *demand,* and hence subject to the law of supply and demand, rather than to violence and death. Completely expunged from the *political* dimension, it is dependent, like any other commodity, on production and mass consumption. Its spark has disappeared–only the fiction of a political universe is saved.

Likewise with work. The spark of production, the violence of its stake no longer exists. Everybody still produces, and more and more, but work has subtly become something else: a need (as Marx ideally envisaged it, but not at all in the same sense), the object of a social "demand," like leisure, to which it is equivalent in the general run of life's options. A demand exactly proportional to the loss of stake in the work process.[6] The same change in fortune as for power: the *scenario* of work is there to conceal the fact that the work-real,

6. To this flagging investment in work corresponds a parallel declining investment in consumption. Goodbye to use value or prestige of the automobile, goodbye to the amorous discourse which made a clear-cut distinction between the object of enjoyment and the object

the production-real, has disappeared. And for that matter so has the strike-real too, which is no longer a stoppage of work, but its alternative pole in the ritual scansion of the social calendar. It is as if everyone has "occupied" their workplace or workpost, after declaring the strike, and resumed production, as is the custom in a "self-managed" job, in exactly the same terms as before, by declaring themselves (and virtually being) in a state of permanent strike.

This isn't a science-fiction dream: everywhere it is a question of a doubling of the work process. And of a double or locum for the strike process—strikes which are incorporated like obsolescence in objects, like crisis in production. Then there are no longer *either* strikes or work, but both simultaneously, that is to say something else entirely: a *wizardry of work*, a *trompe l'oeil*, a scenodrama (not to say melodrama) of production, collective dramaturgy upon the empty stage of the social.

It is no longer a question of the *ideology* of work—of the traditional ethic that obscures the "real" labor process and the "objective" process of exploitation—but of the scenario of work. Likewise, it is no longer a question of the ideology of power, but of the *scenario* of power. Ideology only corresponds to a betrayal of reality by signs; simulation corresponds to a short circuit of reality and to its reduplication by signs. It is always the aim of ideological analysis to restore the objective process; it is always a false problem to want to restore the truth beneath the simulacrum.

This is ultimately why power is so in accord with ideological discourses and discourses on ideology, for these are all discourses of *truth*—always good, even and especially if they are revolutionary, to counter the mortal blows of simulation.

The End of the Panopticon

It is again to this ideology of the lived experience, of exhumation, of the real in its fundamental banality, in its radical authenticity, that the American TV-*vérité* experiment on the Loud family in 1971 refers: seven months of uninterrupted shooting, 300 hours of direct nonstop broadcasting, without script or scenario, the odyssey of a family, its dramas, its joys, ups and downs—in brief, a "raw" historical document, and the "best thing ever on television, comparable, at the level of our daily existence, to the film of the lunar landing." Things are complicated by the fact that this family came apart during the shooting: a crisis flared up, the Louds went their separate ways, etc. Whence that insoluble controversy: was TV responsible? What would have happened *if TV hadn't been there?*

More interesting is the phantasm of filming the Louds *as if TV wasn't*

of work. Another discourse takes over, which is a *discourse of work on the object of consumption* aiming at an active, compelling, puritan reinvestment (use less gas, look to your security, speed is obsolete, etc.), to which automobile specifications pretend to be adapted: rediscovering a stake by transposition of the poles. Thus work becomes the object of a need, the car becomes the object of work—no better proof of the inability to distinguish the stakes. It is by the very swing of voting "rights" to electoral "duties" that the disinvestment of the political sphere is signaled.

there. The producer's trump card was to say: "They lived as if we weren't there." An absurd, paradoxical formula—neither true, nor false: but utopian. The "as if *we* weren't there" is equivalent to "as if *you* were there." It is this utopia, this paradox that fascinated 20 million viewers, much more than the "perverse" pleasure of prying. In this "truth" experiment, it is neither a question of secrecy nor of perversion, but of a kind of thrill of the real, or of an aesthetics of the hyperreal, a thrill of vertiginous and phony exactitude, a thrill of alienation and of magnification, of distortion in scale, of excessive transparency all at the same time. The joy in an excess of meaning, when the bar of the sign slips below the regular waterline of meaning: the nonsignifier is elevated by the camera angle. Here the real can be seen never to have existed (but "as if you were there"), without the distance which produces perspective space and our depth vision (but "more true than nature"). Joy in the microscopic simulation which transforms the real into the hyperreal. (This is also a little like what happens in porno, where fascination is more metaphysical than sexual.)

This family was in any case already somewhat hyperreal by its very selection: a typical, California-housed, three-garage, five-children, well-to-do, professional, upper-middle-class, ideal American family, with an ornamental housewife. In a way, it is this statistical perfection which dooms it to death. This ideal heroine of the American way of life is chosen, as in sacrificial rites, to be glorified and to die under the fiery glare of the studio lights, a modern fatum. For the heavenly fire no longer strikes depraved cities, it is rather the lens which cuts through ordinary reality like a laser, putting it to death. "The Louds: simply a family who agreed to deliver themselves into the hands of television, and to die from it," said the producer. So it is really a question of a sacrificial process, of a sacrificial spectacle offered to 20 million Americans. The liturgical drama of a mass society.

TV-*vérité*. Admirable ambivalent term: does it refer to the truth of this family, or to the truth of TV? In fact, it is TV which is the Louds' truth, it is it which is true, it is it which renders true. A truth which is no longer the reflexive truth of the mirror, nor the perspective truth of the panoptic system and of the gaze, but the manipulative truth of the test which probes and interrogates, of the laser which touches and then pierces, of computer cards which retain your punched-out sequences, of the genetic code which regulates your combinations, of cells which inform your sensory universe. It is to this kind of truth that the Loud family is subjected by the TV medium, and in this sense it really amounts to a death sentence (but is it still a question of truth?).

The end of the panoptic system. The eye of TV is no longer the source of an absolute gaze, and the ideal of control is no longer that of transparency. The latter still presupposes an objective space (that of the Renaissance) and the omnipotence of a despotic gaze. This is still, if not a system of confinement, at least a system of scrutiny. No longer subtle, but always in a position of exteriority, playing on the opposition between seeing and being seen, even if the focal point of the panopticon may be blind.

It is entirely different when with the Louds. "You no longer watch TV, TV watches you (live)," or again: "You no longer listen to *Pas de Panique*,

Sarah Charlesworth. *Figures,* 1983. Color photographs (cibachrome), diptych, each: 40 x 30″ (101.6 x 76.2 cm); overall: 40 x 60″ (101.6 x 152.4 cm). (Photo: courtesy the artist)

Laurie Simmons. *Tourism, Rio de Janeiro,* 1984. Color photograph (cibachrome), 40 x 60″ (101.6 x 152.4 cm). (Photo: courtesy the artist)

Pas de Panique listens to you"—switching over from the panoptic apparatus of surveillance (of *Discipline and Punish*) to a system of deterrence, where the distinction between active and passive is abolished. No longer is there any imperative to submit to the model, or to the gaze. "YOU are the model!" "YOU are the majority!" Such is the slope of a hyperrealist sociality, where the real is confused with the model, as in the statistic operation, or with the medium, as in the Louds' operation. Such is the later stage of development of the social relation, our own, which is no longer one of persuasion (the classical age of propaganda, ideology, publicity, etc.) but one of dissuasion or deterrence: "YOU are news, you are the social, the event is you, you are involved, you can use your voice, etc." A turnabout of affairs by which it becomes impossible to locate an instance of the model, of power, of the gaze, of the medium itself, since *you* are always already on the other side. No more subject, focal point, center, or periphery: but pure flexion or circular inflection. No more violence or surveillance: only "information," secret virulence, chain reaction, slow implosion, and simulacra of spaces where the real-effect again comes into play.

We are witnessing the end of perspective and panoptic space (which remains a moral hypothesis bound up with every classical analysis of the "objective" essence of power), and hence the *very abolition of the spectacular*. Television, in the case of the Louds for example, is no longer a spectacular medium. We are no longer in the society of spectacle which the situationists talked about, nor in the specific types of alienation and repression which this implied. The medium itself is no longer identifiable as such, and the merging of the medium and the message (McLuhan[7]) is the first great formula of this new age. There is no longer any medium in the literal sense: it is now intangible, diffuse, and diffracted in the real, and it can no longer even be said that the latter is distorted by it.

7. The medium/message confusion, of course, is a correlative of the confusion between sender and receiver, thus sealing the disappearance of all the dual, polar structures which formed the discursive organization of language, referring to the celebrated grid of functions in Jakobson, the organization of all determinate articulation of meaning. "Circular" discourse must be taken literally: that is, it no longer goes from one point to the other but describes a circle that *indistinctly* incorporates the positions of transmitter and receiver, henceforth unlocatable as such. Thus there is no longer any instance of power, any transmitting authority—power is something that circulates and whose source can no longer be located, a cycle in which the positions of dominator and the dominated interchange in an endless reversion which is also the end of power in its classical definition. The circularization of power, knowledge and discourse brings every localization of instances and poles to an end. Even in psychoanalytic interpretation, the "power" of the interpreter does not come from any external authority, but from the interpreted themselves. This changes everything, for we can always ask the traditional holders of power where they get their power from. Who made you Duke? The King. And who made the King? God. God alone does not reply. But to the question: Who made the psychoanalyst? the analyst quite easily replies: You. Thus is expressed, by an inverse simulation, the passage from the "analyzed" to the "analysand," from active to

Such immixture, such a viral, endemic, chronic, alarming presence of the medium, without our being able to isolate its effects—spectralized, like those publicity holograms sculptured in empty space with laser beams, the event filtered by the medium—the dissolution of TV into life, the dissolution of life into TV—an indiscernible chemical solution: we are all Louds, doomed not to invasion, to pressure, to violence, and to blackmail by the media and the models, but to their induction, to their infiltration, to their illegible violence.

But we must be careful of the negative twist discourse gives this: it is a question neither of an illness nor of a viral complaint. Rather, we must think of the media as if they were, in outer orbit, a sort of genetic code which controls the mutation of the real into the hyperreal, just as the other, micromolecular code controls the passage of the signal from a representative sphere of meaning to the genetic sphere of the programmed signal.

The whole traditional mode of causality is brought into question: the perspective, deterministic mode, the "active," critical mode, the analytical mode—the distinction between cause and effect, between active and passive, between subject and object, between ends and means. It is in this mode that it can be said: TV watches us, TV alienates us, TV manipulates us, TV informs us . . . Throughout all this one is dependent on the analytical conception whose vanishing point is the horizon between reality and meaning.

passive, which only goes to describe the swirling, mobile effect of the poles, its effect of circularity in which power is lost, is dissolved, is resolved into complete manipulation (this is no longer of the order of the directive authority and the gaze, but of the order of personal contact and commutation). See, also, the State/family circularity secured by the floating and metastatic regulation of images of the social and the private. (Jacques Donzelot, *The Policing of Families*, trans. Robert Hurley [New York: Pantheon Books, 1979].)

From now on, it is impossible to ask the famous question:

"From what position do you speak?"—

"How do you know?"—

"From where do you get the power?" without immediately getting the reply: "But it is *of* (from) you that I speak"—meaning, it is you who speaks, it is you who knows, power is you. A gigantic circumvolution, circumlocution of the spoken word, which amounts to irredeemable blackmail and irremovable deterrence of the subject supposed to speak, but left without a word to say, responseless, since to questions asked can come the inevitable reply: but *you are* the reply, or: your question is already an answer, etc.—the whole sophistical stranglehold of word-tapping, forced confession disguised as free expression, trapping the subject in his own questioning, the precession of the reply about the question (the whole violence of interpretation is there, and the violence of the conscious or unconscious self-management of "speech").

This simulacrum of inversion or involution of poles, this clever subterfuge which is the secret of the whole discourse of manipulation and hence, today, in every domain, the secret of all those new powers sweeping clean the stage of power, forging the assumption of all speech from which comes that fantastic silent majority characteristic of our times—all this undoubtedly began in the political sphere with the democratic simulacrum, that is to say with the substitution of the instance of the people for the instance of God as source of power, and the substitution of power as *representation* for power as *emanation*. An anti-Copernican revolution: no longer any transcendent instance nor any sun nor any luminous source of power and knowledge—everything comes from and returns to the people. It is through this magnificent *recycling* that the universal simulacrum of manipulation, from the scenario of mass suffrage to present-day and illusory opinion polls, begins to be installed.

On the contrary, we must imagine TV on the DNA model, as an effect in which the opposing poles of determination vanish according to a nuclear contraction or retraction of the old polar schema which has always maintained a minimal distance between a cause and an effect, between the subject and an object: precisely, the meaning gap, the discrepancy, the difference, the smallest possible margin of error, irreducible under penalty of reabsorption in an aleatory and indeterminable process which discourse can no longer even account for, since it is itself a determinable order.

It is this gap which vanishes in the genetic coding process, where indeterminacy is less a product of molecular randomness than a product of the abolition, pure and simple, of the *relation*. In the process of molecular control, which "goes" from the DNA nucleus to the "substance" it "informs," there is no more traversing of an effect, of an energy, of a determination, of any message. "Order, signal, impulse, message": all these attempt to render the matter intelligible to us, but by analogy, retranscribing in terms of inscription, vector, decoding, a dimension of which we know nothing—it is no longer even a "dimension," or perhaps it is the fourth (that which is defined, however, in Einsteinian relativity, by the absorption of the distinct poles of space and time). In fact, this whole process only makes sense to us in the negative form. But nothing separates one pole from the other, the initial from the terminal: there is just a sort of contraction into each other, a fantastic telescoping, a collapsing of the two traditional poles into one another: an IMPLOSION—an absorption of the radiating model of causality, of the differential mode of determination, with its positive and negative electricity—an implosion of meaning. *This is where simulation begins.*

Everywhere, in whatever political, biological, psychological, media domain, where the distinction between poles can no longer be maintained, one enters into simulation, and hence into absolute manipulation—not passivity, but the *non-distinction of active and passive.* DNA realizes this aleatory reduction at the level of the living substance. Television itself, in the example of the Louds, also attains this *indefinite* limit where the family vis-à-vis TV are no more or less active or passive than is a living substance vis-à-vis its molecular code. In both there is only a nebula indecipherable into its simple elements, indecipherable as to its truth.

Orbital and Nuclear

The nuclear is the apotheosis of simulation. Yet the balance of terror is nothing more than the spectacular slope of a system of deterrence that has crept from the *inside* into all the cracks of daily life. The nuclear cliffhanger only seals the trivialized system of deterrence at the heart of the media, of the inconsequential violence that reigns throughout the world, of the aleatory contrivance of every choice which is made for us. The slightest details of our behavior are ruled by neutralized, indifferent, equivalent signs, by zero-sum signs like those which regulate "game strategy" (but the genuine equation is elsewhere, and the unknown is precisely that variable of simulation which makes the atomic arsenal itself a hyperreal form, a simulacrum which dominates us all and reduces all "ground-level" events to mere ephemeral scenarios, transforming

the only life left to us into survival, into a wager without takers—not even into a death policy: but into a policy devaluated in advance).

It isn't that the direct menace of atomic destruction paralyzes our lives. It is rather that deterrence leukemizes us. And this deterrence comes from the very situation which *excludes the real atomic clash*—excludes it beforehand like the eventuality of the real in a system of signs. Everybody pretends to believe in the reality of this menace (one understands it from the military point of view, the whole seriousness of their exercise, and the discourse of their "strategy," is at stake): but there are precisely no strategic stakes at this level, and the whole originality of the situation lies in the improbability of destruction.

Deterrence excludes war—the antiquated violence of expanding systems. Deterrence is the neutral, implosive violence of metastable or involving systems. There is no subject of deterrence any more, nor adversary, nor strategy—it is a planetary structure of the annihilation of stakes. Atomic war, like that of Troy, will not take place. The risk of nuclear atomization only serves as a pretext, through the sophistication of arms—but this sophistication exceeds any possible objective to such an extent that it is itself a symptom of nonexistence—to the installation of a universal system of security, linkup, and control whose deterrent effect does not aim for atomic clash at all (the latter has never been a real possibility, except no doubt right at the beginning of the cold war, when the nuclear posture was confused with conventional war) but really the much larger probability of any real event, of anything which could disturb the general system and upset the balance. The balance of terror is the terror of balance.

Deterrence is not a strategy. It circulates and is exchanged between the nuclear protagonists exactly like international capital in that orbital zone of monetary speculation, whose flow is sufficient to control all global finance. Thus *kill money* (not referring to *real* killing, any more than floating capital refers to real production) circulating in nuclear orbit is sufficient to control all violence and potential conflict on the globe.

What stirs in the shadow of this posture, under the pretext of a maximal "objective" menace and thanks to that nuclear sword of Damocles, is the perfection of the best system of control which has never existed. And the progressive satellization of the whole planet by that hypermodel of security.

The same goes for *peaceful* nuclear installations. Pacification doesn't distinguish between the civil and the military: wherever irreversible apparatuses of control are elaborated, wherever the notion of security becomes absolute, wherever the *norm* of security replaces the former arsenal of laws and violence (including war), the system of deterrence grows, and around it grows a historical, social, and political desert. A huge involution makes every conflict, every opposition, every act of defiance contract in proportion to this blackmail which interrupts, neutralizes, and freezes them. No mutiny, no history can unfurl any more according to its own logic since it risks annihilation. No strategy is even possible anymore, and escalation is only a puerile game left to the military. The political stake is dead. Only simulacra of conflict and carefully circumscribed stakes remain.

The "space race" played exactly the same role as the nuclear race. This is why it was so easily able to take over from it in the 1960s (Kennedy/

Khrushchev), or to develop concurrently in a mode of "peaceful coexistence." For what is the ultimate function of the space race, of lunar conquest, of satellite launchings, if not the institution of a model of universal gravitation, of satellization, whose perfect embryo is the lunar module: a programmed microcosm, where *nothing can be left to chance?* Trajectory, energy, computation, physiology, psychology, the environment—nothing can be left to contingency, this is the total universe of the norm—the Law no longer exists, it is the operational immanence of every detail which is law. A universe purged of every threat to the senses, in a state of asepsis and weightlessness—it is this very perfection which is fascinating. For the exaltation of the masses was not in response to the lunar landing or the voyage of man in space (this is rather the fulfillment of an earlier dream)—no, we are dumbfounded by the perfection of their planning and technical manipulation, by the immanent wonder of programmed development. Fascinated by the maximization of norms and by the mastery of probability. Unbalanced by the model, as we are by death, but without fear or impulse. For if the law, with its aura of transgression, if order, with its aura of violence, still taps a perverse imaginary, then the norm fixes, hypnotizes, dumbfounds, causing every imaginary to involve. We no longer fantasize about every minutia of a program. Its observance alone unbalances. The vertigo of a flawless world.

The same model of planned infallibility, of maximal security and deterrence, now governs the spread of the social. That is the true nuclear fallout: the meticulous operation of technology serves as a model for the meticulous operation of the social. Here, too, *nothing will be left to chance;* moreover, this is the essence of socialization, which has been going on for some centuries but which has now entered into its accelerated phase, towards a limit people imagined would be explosive (revolution), but which currently results in an inverse, irreversible, *implosive* process: a generalized deterrence of every chance, of every accident, of every transversality, of every finality, of every contradiction, rupture, or complexity in a sociality illuminated by the norm and doomed to the transparency of detail radiated by data-collecting mechanisms. In fact, the spatial and nuclear models do not even have their own ends: neither has lunar exploration, nor military and strategic superiority. Their truth lies in their being models of simulation, vector models of a system of planetary control (where even the superpowers of this scenario are not free—the whole world is satellized).[8]

Reject the evidence: with satellization, the one who is satellized is not who you might think. By the orbital inscription of a space object, the planet earth becomes a satellite, the terrestrial principle of reality becomes eccentric, hyperreal, and insignificant. By the orbital establishment of a system of control like peaceful coexistence, all terrestrial microsystems are satellized and lose their autonomy. All energy, all events are absorbed by this eccentric gravitation, everything condenses and implodes on the micro-model of control alone (the orbital satellite), as conversely, in the other, biological dimension everything

8. Paradox: all bombs are clean—their only pollution is the system of control and security they radiate *when they are not detonated.*

converges and implodes on the molecular micro-model of the genetic code. Between the two, caught between the nuclear and the genetic, in the simultaneous assumption of the two fundamental codes of deterrence, every principle of meaning is absorbed, every deployment of the real is impossible.

The simultaneity of two events in July 1975 illustrates this in a striking way: the linkup in space of the two American and Soviet supersatellites, apotheosis of peaceful existence—and the suppression by the Chinese of character writing and conversion to the Roman alphabet. This latter signifies the "orbital" establishment of an abstract and model system of signs, into whose orbit will be reabsorbed all those once remarkable and singular forms of style and writing. The satellization of their tongue: this is the way the Chinese enter the system of peaceful coexistence, which is inscribed in their sky at the very same time by the docking of the two satellites. The orbital flight of the Big Two, the neutralization and homogenization of everybody else on earth.

Yet, despite this deterrence by the orbital authority—the nuclear code or molecular—events continue at ground level, mishaps are increasingly more numerous, despite the global process of contiguity and simultaneity of data. But, subtly, these events no longer make any sense; they are nothing more than a duplex effect of simulation at the summit. The best example must be the Vietnam war, since it was at the crossroads of a maximal historical or "revolutionary" stake and the installation of this deterrent authority. What sense did that war make, if not that its unfolding sealed the end of history in the culminating and decisive event of our age?

Why did such a difficult, long, and arduous war vanish overnight as if by magic?

Why didn't the American defeat (the greatest reversal in its history) have any internal repercussions? If it had truly signified a setback in the planetary strategy of the USA, it should have necessarily disturbed the internal balance of the American political system. But no such thing happened.

Hence something else took place. Ultimately this war was only a crucial episode in a peaceful coexistence. It marked the advent of China to peaceful coexistence. The long sought-after securing and concretizing of China's non-intervention, China's apprenticeship in a global *modus vivendi*, the passing from a strategy of world revolution to one of a sharing of forces and empires, the transition from a radical alternative to political alternation in a now almost settled system (normalization of Peking-Washington relations): all this was the stake of the Vietnam war, and in that sense, the USA pulled out of Vietnam, but they won the war.

And the war "spontaneously" came to an end when the objective had been attained. This is why it was deescalated, demobilized so easily.

The effects of this same remolding are legible in the field. The war lasted as long as there remained unliquidated elements irreducible to a healthy politics and a discipline of power, even a communist one. When finally the war passed from the resistance to the hands of regular Northern troops, it could stop: it had attained its objective. Thus the stake was a political relay. When the

Vietnamese proved they were no longer bearers of an unpredictable subversion, it could be handed over to them. That this was communist order wasn't fundamentally serious: it had proved itself, it could be trusted. They are even more effective than capitalists in liquidating "primitive" precapitalist and antiquated structures.

Same scenario as in the Algerian war.

The other aspect of this war and of all wars since: behind the armed violence, the murderous antagonism between adversaries—which seems a matter of life and death, and which is played as such (otherwise you could never send out people to get smashed up in this kind of trouble), behind this simulacrum of a struggle to death and of ruthless global stakes, the two adversaries are fundamentally as one against that other, unnamed, never-mentioned thing, whose objective outcome in war, with equal complicity between the two adversaries, is total liquidation. It is tribal, communal, precapitalist structures, every form of exchange, language, and symbolic organization which must be abolished. Their murder is the object of war—and in its immense spectacular contrivance of death, war is only the medium of this process of terrorist rationalization by the social—the murder through which sociality can be founded, no matter what allegiance, communist or capitalist. The total complicity or division of labor between two adversaries (who can even make huge sacrifices to reach that) for the very purpose of remolding and domesticating social relations.

"The North Vietnamese were advised to countenance a scenario of the liquidation of the American presence through which, of course, honor must be preserved."

The scenario: the extremely heavy bombardment of Hanoi. The intolerable nature of this bombing should not conceal the fact that it was only a simulacrum to allow the Vietnamese to seem to countenance a compromise and Nixon to make the Americans swallow the retreat of their forces. The game was already won, nothing was objectively at stake but the credibility of the final montage.

Moralists about war, champions of war's exalted values should not be greatly upset: a war is not any the less heinous for being a mere simulacrum— the flesh suffers just the same, and the dead ex-combatants count as much there as in other wars. That objective is always amply accomplished, like that of the partitioning of territories and of disciplinary sociality. What no longer exists is the adversity of adversaries, the reality of antagonistic causes, the ideological seriousness of war—also the reality of defeat or victory, war being a process whose triumph lies quite beyond these appearances.

In any case, the pacification (or deterrence) dominating us today is beyond war and peace, the simultaneous equivalence of peace and war. "War is peace," said Orwell. Here, also, the two differential poles implode into each other, or recycle one another—a simultaneity of contradictions that is both the parody and the end of all dialectic. Thus it is possible to miss the truth of a war: namely, that it was well over before reaching a conclusion, that at its very

core, war was brought to an end, and that perhaps it never ever began. Many other such events (the oil crisis, etc.) *never began*, never existed, except that artificial mishaps—abstracts, ersatzes of troubles, catastrophes, and crises intended to maintain a historical and psychological investment under hypnosis. All media and the official news service only exist to maintain the illusion of actuality—of the reality of the stakes, of the objectivity of the facts. All events are to be read in reverse, where one perceives (as with the Communists "in power" in Italy, the posthumous, "nostalgic" rediscovery of gulags and Soviet dissidents like the almost contemporary rediscovery, by a moribund ethnology, of the lost "difference" of savages) that all these things arrive too late, with an overdue history, a lagging spiral, that they have exhausted their meaning long in advance and only survive on an artificial effervescence of signs, that all these events follow on illogically from one another, with a total equanimity towards the greatest inconsistencies, with a profound indifference to their consequences (but this is because there are none anymore: they burn out in their spectacular promotion)—thus the whole newsreel of "the present" gives the sinister impression of kitsch, retro, and porno all at the same time—doubtless everyone knows this, and nobody really accepts it. The reality of simulation is unendurable—more cruel than Artaud's Theater of Cruelty, which was still an attempt at a dramaturgy of life, the last flickering of an ideal of the body, blood, and violence in a system already sweeping towards a reabsorption of all the stakes without a trace of blood. For us the trick has been played. All dramaturgy, and even all real writing of cruelty has disappeared. Simulation is master, and nostalgia, the phantasmal parodic rehabilitation of all lost referentials, alone remains. Everything still unfolds before us, in the cold light of deterrence (including Artaud, who is entitled like all the rest to his revival, to a second existence as the *referential* of cruelty).

This is why nuclear proliferation increases neither the chance of atomic clash nor of accident—save in the interval where "young" powers could be tempted to use them for nondeterrent or "real" purposes (as the Americans did on Hiroshima—but precisely they alone were entitled to this "use value" of the bomb, while all those who have since acquired it are deterred from using it by the very fact of its possession). Entry into the atomic club, so amusingly named, very rapidly removes (like syndicalization for the working world) any inclination towards violent intervention. Responsibility, control, censorship, self-deterrence always increase faster than the forces or weapons at our disposal: this is the secret of the social order. Thus the very possibility of paralyzing a whole country with the flick of a switch *makes* it impossible that electrical engineers will ever utilize this weapon: the entire myth of the revolutionary and total strike collapses at the very moment when the means to do so are available—but alas, *exactly because* the means to do so are available. This is deterrence in a nutshell.

Therefore it is altogether likely that one day we shall see the nuclear powers exporting atomic reactors, weapons, and bombs to every latitude. After control by threat will succeed the much more effective strategy of pacification by the bomb and by its possession. "Small" powers, hoping to buy their independent strike force, will only buy the virus of deterrence, of their own

deterrence. The same goes for the atomic reactors we have already sent them: so many neutron bombs knocking out all historical virulence, all risk of explosion. In this sense, the nuclear system institutes a universally accelerated process of *implosion*, it conceals everything around it, it absorbs all living energy.

The nuclear system is both the culminating point of available energy and the maximization of systems controlling all energy. Lockdown and control grow as fast as (and undoubtedly even faster than) liberating potentialities. This was already the aporia of modern revolutions. It is still the absolute paradox of the nuclear system. Energies freeze by their own fire power, they deter themselves. One can't really see what project, what power, what strategy, what subject could possibly be behind this enclosure, this vast saturation of a system by its own hereafter neutralized, unusable, unintelligible, nonexplosive forces—except the possibility of *an explosion towards the center*, or an *implosion* where all these energies are abolished in a catastrophic process (in the literal sense, that is to say in the sense of a reversion of the whole cycle towards a minimal point, of a reversion of energies towards a minimal threshold).

Translated by
Paul Foss
and Paul Patton

Gretchen Bender. *AT&T in Slow Motion,* 1984 (from *Dumping Core,* a work in progress). Black-and-white video, sound, 1 minute 13 seconds

Eclipse of the Spectacle

JONATHAN CRARY

The pervasive imagery now enveloping us—a rationalized world of
digitized life and languages mediated by video display screens—is in part pre-
figured in Nicola Tesla's 1901 plan for a World System of totally interconnect-
ing, planetary communications. Although bound up with other futurist dreams
of simultaneity, Tesla's ideas had more of an affinity with the needs of state
and corporate power than other modes of modernism. He believed he could
engineer a globe unified by the universal registration of time and fully traversed
by flows of language, images, and money—all reduced to an undifferentiated
flux of electrical energy.[1] Backed by J. P. Morgan, Tesla's first transmission
station rose on the North Shore of Long Island; two hundred feet high, the
Wardenclyffe Tower stood only from 1901 to 1903, never capped by the
immense copper dome Tesla planned for it. No piece of sculpture better em-
bodied the synchronous, history-rending aspirations of modernism than this
tower. It could well be posed alongside Tatlin's *Monument to the Third Inter-
national* and Brancusi's *Endless Column* to represent the three variants of
modernist absolutism: corporate, historicist, and aestheticist.

Although Tesla's vision was to prove the most durable of these three, its
full realization was postponed for over eight decades. A major oil discovery at
Spindletop, Texas, also in 1902, helped assure the continued dominance of the
extensive, vehicular space traversed by the railroad and then the automobile
well into the twentieth century. Nonetheless, Tesla's achievement was to trans-
form Edison's relatively pedestrian notion of electricity as a commodity to be
sold in units to consumers into an apprehension of electricity as an immanent
substance into which anything was transcodable and which could instanta-
neously intervene anywhere, even to literally occupy the full body of the earth
and atmosphere.[2]

1. For the text of Tesla's Wardenclyffe Plan see John J. O'Neill, *Prodigal Genius: The
Life of Nikola Tesla* (New York: David McKay, 1944), pp. 210-211. See also Margaret
Cheney, *Tesla: Man Out of Time* (Englewood Cliffs, N.J.: Prentice-Hall, 1981).

2. Compare Tesla's plan for arrogating earth and atmosphere as natural conductors
with a Nazi scheme for a war-winning weapon through transforming the atmosphere into a
high-voltage conductor, recounted in Albert Speer, *Infiltration*, trans. Joachim Neugroschel
(New York: Macmillan Publishing Co., 1981), pp. 146-147.

Tesla's was a primal understanding of the totalizing logic of capital, and television would emerge as a key component of the "world system" whose outlines he foresaw so keenly.

Today all of us are implicated in the practice of giving a conceptual solidity and unity to the evasive and seemingly ubiquitous entity that is television. We maintain an illusory coherence around what is a shifting coalescence of powers, objects, effects, and relations. Even though all that is subsumed by television has historical specificity, technological underpinnings, and lines into multiple economies, we have mystified it and situated it beyond the grasp of critical analysis, while at the same time endowing it with a despotic identity insulated from the vicissitudes of social processes. Television has always been an aggregate of bodies, institutions, and transmissions in continual transformation. We could more clearly apprehend television if, instead of seeking an elusive formal structure, we identify the conjunctions it forges, the circulations it controls, and, more importantly, the accelerating mutations it is currently undergoing.

Because of the increasing adjacency of television to telecommunications and computers, any investigation of its prospects can easily become entwined with an ideology of technological determinism and with a discourse of prefabricated futures that ultimately serve present powers. This essay seeks to relocate the problem of television and its metamorphosis, not merely within the realm of technological change, but in relation to the larger remapping of other zones: cultural, economic, geo-political. Addressed here is the extent to which television, as a system which functioned from the 1950s into the 1970s, is now disappearing, to be reconstituted at the heart of another network in which what is at stake is no longer representation, but distribution and regulation.

Modernist habits led many critics to seek out properties deemed intrinsic to television, to articulate it as a medium like painting or sculpture, and to isolate a new entity called "video art." Television was conceptually stabilized as a semiotic system one could "read," or as a superstructural element *through* which power was exercised.[3] Yet developments in recent years have controverted accounts that once seemed permanent. Marshall McLuhan's famous formulations of the sixties, for example, show how one discourse about television was founded on features that proved to be transient peculiarities of a technology still in its infancy. Television was "cool" because of the low definition of its image and its small size: its image quality effectively blurred intellectual and perceptual distinctions on the part of the viewer.[4] Yet, as is well known, the ongoing refinement of high-resolution TV and of large home screens promises soon to obliterate significant experiential differences between film and television.

For other critics, television is so thoroughly constitutive of the social that

3. See, for example, John Fiske and John Hartley, *Reading Television* (London: Methuen, 1978) and Colin McArthur, *Television and History* (London: British Film Institute, 1978).

4. Marshall McLuhan, *Understanding Media: The Extensions of Man* (New York: McGraw-Hill, 1965), pp. 22-27 and 317-319.

its operations are indistinguishable from those of an entire hegemonic order. But no matter how pervasive and inwrought are the mechanisms of television, one danger is to totalize it. Of course television is a global tracery of linkages that produces truth and that increasingly dominates the arena of the lived; but, at the same time, as with any deployment of power, the surface that television mobilizes also encompasses barely visible alcoves, striations, and folds. Thus, on one hand, we can consider the moment in July 1982, when 2.5 billion people watched the World Cup soccer final, welded together in real time before the same image, and participating for two hours in a perfectly regulated mega-circuitry. But, on the other hand, there also exist very different kinds of circuits that may be defective or contingent: when television is conjoined with multiple events exterior to it, when television becomes an object like a piece of furniture, when it functions as no more than an architectural aperture, or when it is simply a metronome of the quotidian.[5] These, then, are the overlapping spaces to be comprehended: a circuit of power that can be uniform and seamless as a macrophenomenon, but that is broken, diversified, and never fully controllable in its local usage.

The totalizing response to television grew in part out of Frankfurt School texts on the "culture industry." Adorno and Horkheimer, as exiles in Los Angeles, unveiled the "ruthless unity" of a "system that is uniform and whole in every part," an inescapable and voracious web that absorbs and commodifies everything according to a logic that, for them, was perilously close to fascism.[6] This model, retuned and disseminated by Marcuse, merged in the United States with indigenous left-holistic ideas to produce books like Jerry Mander's *Four Arguments for the Elimination of Television* (1977). But the most influential stepchild of the Frankfurt School is Jean Baudrillard, who has relentlessly revitalized an unconditional vision of the irredeemability of contemporary (consumer) culture.[7]

Like science fiction about new ice ages or the crystalization of organic life, Baudrillard's recent texts narrate a related triumph of the inanimate. As in an updated version of Caspar David Friedrich's *The Wreck of the Hope*, Baudrillard paints the specter of implosion. A kind of negative eschatology, Baudrillard's implosion announces the nullity of all opposition, the dissolution of history, the neutralization of difference, and the erasure of any possible figu-

5. Paul Virilio proposes an architectural model for television in "La troisième fenêtre: Entretien avec Paul Virilio," *Cahiers du Cinéma*, no. 322 (April 1981): 35-40. In the late 1960s Jean Baudrillard insisted on television's status as physical object in "Sign Function and Class Logic," in his *For a Critique of the Political Economy of the Sign*, trans. Charles Levin (St. Louis: Telos, 1981).

6. Max Horkheimer and Theodor Adorno, *Dialectic of Enlightenment*, trans. John Cumming (New York: Seabury, 1972), pp. 120-124.

7. See, in particular, Jean Baudrillard, "The Ecstasy of Communication," in Hal Foster, ed., *The Anti-Aesthetic* (Port Townsend, Wash.: Bay Press, 1983); *Simulations* (New York: Semiotext(e), 1983); *In the Shadow of the Silent Majorities* (New York: Semiotext(e), 1983); and *Les Stratégies fatales* (Paris: Grasset, 1983).

ration of alternate actuality. And, at the cold, superdense core of this anti-finale is not absolute knowledge, but rather the absolute dominion of digitized memory-storage banks, not even dimly fathomable through the aqueous screens of video display terminals. Philip K. Dick, in his novel *A Scanner Darkly*, touched on what is also crucial in Baudrillard's work: "Biological life goes on, everything else is dead. A reflex machine. Like some insect. Repeating doomed patterns over and over. A single pattern."[8]

For Baudrillard, television is a paradigm of implosive effects: it collapses any distinction between receiver or sender or between the medium and the real. Like Mallarmé's Herodiade caught in a sterile closed circuit with her mirror, Baudrillard's subject is locked into an "uninterrupted interface" with the video screen in a universe of "fascination." Television, for Baudrillard, exists as a purely abstract and invariant function, from which any principle of disorder is excluded. The materiality of both viewer and television apparatus dissolves, along with any multiple or contradictory layers of institutional texture. His perfect circuit of viewer-TV, then, subsists on a single, formalized plane solely as an index of the nonworking of power and of the illusory essence of all signification.

Implosion announces the collapse of capital's ability to expand: it is an unprecedented social contraction and paralysis, the last unmasking of a long sequence of representational illusions in operation since the Renaissance. But perhaps it is not even a question of "the end of capitalism" or of "late capitalism." Deleuze and Guattari, for example, propose that capitalism is by its very nature always "neo-capitalism."[9] While Baudrillard sees technological miniaturization as a symptom of implosion, Deleuze and Guattari read it as part of the reorganization of a global system of domination and circulation.[10] Following from their model, geographical frontiers no longer exist and in their place are being manufactured vast microelectronic territories for expansion. Telecommunications is the new arterial network, analogous in part to what railroads were for capitalism in the nineteenth century. And it is this electronic substitute for geography that corporate and national entities are now carving up. Information, structured by automated data processing, becomes a new kind of raw material—one that is not depleted by use.[11] Patterns of accumula-

8. Philip K. Dick, *A Scanner Darkly* (New York: Doubleday, 1977), p. 83.

9. Gilles Deleuze and Félix Guattari, *Milles Plateaux* (Paris: Minuit, 1980), p. 30.

10. Ibid, pp. 572-575. Deleuze and Guattari outline an unfolding cybernetic phase of capitalism in which telecommunications and computers are part of a world apparatus of "generalized enslavement." They cite Lewis Mumford, *The Myth of the Machine*, 2 vols. (New York: Harcourt Brace Jovanovich, 1967-1970) for his account of the "mega-machine."

11. Ernest Mandel's distinction between commodity production and a services sector is no longer tenable. He saw distribution of gas, electricity, and water as part of the former and the distribution of "communications" part of the latter, in *Late Capitalism*, trans. Joris De Bres (London: New Left Books, 1978), pp. 401-403. The emergence, for example, of information "utilities" and their circulation of what Fredric Jameson calls "nonphysical and nonmeasurable 'commodities'" demand analysis outside of Mandel's categories. See, for example, Jacques Attali, *Les trois mondes* (Paris: Fayard, 1981), pp. 342-364.

tion and consumption now shift onto new surfaces. Against *this* scenario, implosion, in all its sublimity, seems like the death wish of a failed humanism, in which capitalism and mass culture are guilty—above all else—of the "liquidation of tragedy."[12]

However, Baudrillard is not wrong to proclaim the end of what Guy Debord called "the society of the spectacle." Clearly, a certain period in the initial deployment of television is over, a phase roughly coinciding with post-World War II U.S. hegemony. It is in the mid-1970s that the transformation of television and its insertion into a wholly different set of structures begins, alongside the reorganization of world markets on a non-bipolar model.[13] The convergence of home computer, television, and telephone lines as the nexus of a new social machinery testifies to an undoing of the spectacular consumption of the commodity. And paradoxically, television, which had elevated the commodity to the height of spectacular space, is now implicated in the collapse of that space and the consequent evaporation of aura around the body of the commodity.

For Debord, writing in 1967, at the last high tide of the "Pax Americana," the auratic presence of the commodity was bound up with the illusion of its utter tangibility.[14] But since that time, we have witnessed the gradual displacement of aura from images of possessible objects to digitized flows of data, to the glow of the VDT and the promise of access embodied there. It is a reversal of the process indicated by Debord, in which the seeming self-sufficiency of the commodity was a "congealment" of forces that were essentially mobile and dynamic. Now, however, with pure flux itself a commodity, a spectacular and "contemplative" relation to objects is undermined and supplanted by new kinds of investments. There is no more opposition between the abstraction of money and the apparent materiality of commodities; money and what it can buy are now fundamentally of the same substance. And it is the potential dissolution of any language of the market or of desire into binarized pulses of light or electricity that unhinges the fictive unity of spectacular representation. Figurative images lose their transparence and are consumed as simply one more code.

Consider *General Hospital*, allegedly the most widely watched afternoon soap opera. It is consumed essentially as strings of representations that never surpass their functioning as an abstract code. In its construction and effects, *General Hospital* announces the disappearance of the visual and narrative space that might seem to have authorized it and points toward a fully pro-

12. Horkheimer and Adorno, *Dialectic of Enlightenment*, p. 154.

13. See Immanuel Wallerstein, "Crisis as Transition," and Giovanni Arrighi, "A Crisis of Hegemony," in Samir Amin et al., *Dynamics of Global Crisis* (New York: Monthly Review, 1982). See also the overview in Jean-François Lyotard, *The Postmodern Condition* (Minneapolis: University of Minnesota Press, 1984), pp. 3-6.

14. Guy Debord, *Society of the Spectacle* (Detroit: Black and Red, 1977). Original French publication in 1967.

Ant Farm. *Media Burn,* 1975. The Phantom Dream Car crashes through a wall of burning television sets before a cheering crowd at the Cow Palace in San Francisco, July 4, 1975. (Photo: John Frederick Turner)

grammable calculus of continually switching syntheses of figural and narrative units. The consistent repetition of "formulas" is no longer even a possibility. In *General Hospital* any character, relationship, identity, or situation is reversible, exchangeable, convertible into its opposite. With the eradication of any simulation of interiority, one invests not *into* images of actors but *onto* the formal management of those images. Discontinuities, substitutions, and duplications shatter the illusion which once would have been called bourgeois verisimilitude. More and more the so-called "content" of television shifts in this direction: it is not at all a question of the replication of life, but of its reduction to abstract and manipulable elements ready to be harmonized with a plethora of other electronic flows. Television was not destined finally for analogic tasks, but when it first appeared how could the networks in which it is now positioned have been foreseen? It seemed then, according to what McLuhan calls "rear view mirrorism," like one more refinement in five centuries of space-simulating techniques. Yet as reproductive technology attains new parameters of mimetic "fidelity" (holography, high-resolution TV) there is an inverse move of the image toward pure surface, so that whatever drifts across the screen of either television or home computer is part of the same homogeneity.[15]

Up through the 1960s television collaborated with the automobile in sustaining the dominant machinery of capitalist representation: in the virtual annexation of all spaces and the liquidation of any unified signs that had occupied them. The TV screen and car windshield reconciled visual experience with the velocities and discontinuities of the marketplace.[16] As windows they seemed to open onto a visual pyramid of extensive space in which autonomous movement might be possible; instead, both were apertures that framed the subject's transit through streams of disjunct objects and affects, across disintegrating and hyperabundant surfaces. These latter are the trajectories that run through Straub and Huillet's *History Lessons* and so many of Godard's films. Although both car and TV were primary disciplinary instruments for the production of normalized subjects, the subject they produced also had to be competent to consume and co-exist with a tremendous field of free-floating signs that has previously been grounded. Privatization and control on one hand and deterritorialization on the other were engineered by the same machines. But the channeling horizontality of the highway (e.g., the conclusion of Godard's *Made in U.S.A.*) and the sequentiality of TV images masked the actual disorganization and nonlinearity of these networks. The vortex of overlapping

15. Video art, paradoxically, depends for its intelligibility on its isolation from television. It can exist only in the cloister of gallery-museum space or wherever the video monitor claims autonomy and independence from major networks of distribution. A case in point was the fate of Nam June Paik's *Good Morning Mr. Orwell*, broadcast January 1, 1984, on network TV. Its insertion into that system rendered it invisible, indistinguishable from the adjacent texture of flow. Yet, as if to preserve its identity and visibility, a "live" viewing was organized at the art gallery space of The Kitchen in New York.

16. Virilio alludes to the affinity of windshield and TV screen in "La troisième fenêtre." See also his discussion of the automobile as an instrument of mass mobilization. in *Vitesse et Politique* (Paris: Galilée, 1977), pp. 33-37.

cloverleaf interchanges and the delirious circularity of the channel dial are more authentic concretions of the impacted itineraries perpetually available on both roadway and TV: an infinity of routes and the equivalence of all destinations.

This was the proliferating field of post-World War II capitalism in the United States: the car defined a dominant socioeconomic mapping: it shaped forms of labor and temporality; codified a primary experience of space, its margins, and of access to the social; was the site of multiple intensities; and spawned a mass culture of its own. But beginning in the 1970s, this vehicular space began to lose its predominance. Television, which had seemed an ally of the automobile in the maintenance of the commodity-filled terrain of the spectacle, began to be grafted onto other networks. And now the screens of home computer and word processor have succeeded the automobile as "core products" in an on-going relocation and hierarchization of production processes.[17] Video games may initially have dominated consumer software sales, but in the early 1900s the automobile was also originally inserted as a recreational form until the infrastructure of gas stations, parking lots, and the massive reshaping of urban spaces made car ownership synonymous with social participation. Similarly, the establishment of data services and information "utilities" has only just begun. But video games have been crucial in the reeducation and formation of a new subject ready to assume "interactive" links with VDTs, links altogether different from the prosthesis of body and automobile.

The charade of technological "revolution" is founded on the myth of the rationality and inevitability of a computer-centered world. From all sides, a postindustrial society is depicted that renders invisible the very unworkability and disorder of present "industrial" systems of distribution and circulation. Telecommunications and Paul Virilio's world of absolute speed will not supplant highway/railroad space, but instead these two domains will co-exist side by side in all their radical incompatibility. It is within the dislocation of this "unthinkable" interfacing that the present must be conceived: a planetary data-communications network physically implanted into the decaying, digressive terrain of the automobile-based city. One of the key roles of the expanding electronic "grid" (how this image of modernity endures) is exclusionary—to articulate a new social and geo-political stratification based on immediacy of access to transmitted data.[18] And it is precisely the interstices of this grid, the diversity of rifts within its net, that its totalizing pretensions would disown and efface.

But it is the very persistence and immediacy of the rotting edifices of a previous theater of modernization that Baudrillard eliminates from his panorama of a flawlessly self-regulating world. His virtuoso delineation of the utterly monolithic surfaces of contemporaneity becomes complicit, at a certain point, in the maintenance of the myths of the same cybernetic omnipotence he intends

17. See André Gunder Frank, *Reflections on the World Economic Crisis* (New York: Monthly Review Press, 1981), pp. 111-142.

18. See Juan F. Rada, "A Third World Perspective," in Günter Friedrichs and Adam Schaff, eds., *Microelectronics and Society: A Report to the Club of Rome* (Elmsford, N.Y.: Pergamon, 1982), pp. 213-242.

to deplore. What his texts exclude is any sense of breakdown, of faulty circuits, of systemic malfunction; or of a body that cannot be fully colonized or pacified, of disease, and of the colossal dilapidation of everything that claims infallibility or sleekness. This is the particular importance of the novels of Philip Dick and the films of David Cronenberg: they describe a world no less congested with the technology of everyday life than Baudrillard's, but they insist on a threshold at which the social domestication of the body produces unmanageable disruption, as in psychosis or contagion. For both, television and the sovereignty of the hyperreal are so effective in building a fully delusional world that the mechanisms of social rationalization rapidly corrode, including even Baudrillard's "circularity of media effects."

Another work signaling a limit to the hyperreality of spectacular space is J. G. Ballard's *The Atrocity Exhibition* (1969).[19] In this exemplary psychotic text Ballard details the collapse of a landscape through which lines of deterritorialization have proceeded to absolute tolerances. Ballard explores fractured zones in which sheer contiguity replaces syntax and which extend only in terms of the ceaseless conjugation of bodies, architecture, and images that briefly abut, then detach to make new connections. *The Atrocity Exhibition* coincides with a dissolution of legibility generated by the very efficacy and supremacy of the spectacle. Ballard's landscape, the city interpenetrated by image/events of car crashes, assassinations, celebrities, astronauts, and war crimes, demands an unremitting effort of decipherment, an effort rendered impossible, however, by the equivalence of everything glutting the field. A fully saturated spectacular space neutralizes the interpretive delirium of paranoia at the very moment of inciting it. And for Ballard the events of the 1960s, those which authenticated the spectacle and guaranteed its transparency (Kennedy assassination, moon landing, Vietnam War, Zapruder frames, etc.) become part of an opaque text that cannot be read and no longer claims significance.

For Ballard, the crisis of the spectacle in the late 1960s follows from the disengagement of desire, its desultory floating-free from anchoring structures. His space explodes the possibility of cathecting with anything because every surface is available for investment. "Sex is now a conceptual act," says the omnipresent Dr. Nathan. "The perversions are completely neutral—in fact, most of the ones I've tried are out of date. We need to invent a series of imaginary perversions just to keep the activity alive." And it was the schizo interregnum of those years that compelled the consolidation of new networks in which to discipline potentially dangerous flows and to reinvest them productively. The late 1960s, whether in China or the West, witnessed a situation requiring more efficient management and the imposition of new regulatory grids: in China it necessitated recontainment of the forces unleashed by the Cultural Revolution; in the West it demanded a rationalization of the spectacle.

19. J. G. Ballard, *The Atrocity Exhibition* (London: Jonathan Cape, 1970). Many parts of the book were published separately between 1966 and 1969. Ballard has called it "a collection of partially linked condensed novels." The first American edition was *Love and Napalm: Export U.S.A.* (New York: Grove Press, 1972), with preface by William Burroughs.

The lists running through *The Atrocity Exhibition* are like Foucault's description of Borges' Chinese Encyclopedia: they testify to the absence of any "homogeneous and neutral space in which things could be placed so as to display at the same time the continuous order of their identities or differences as well as the semantic field of their denomination."[20] The violence of Ballard's text occurs in this kind of absence. Founded on the heterotopia of television, it presents a space in which relations of proximity and of resemblance are hopelessly convoluted onto a single plane. For Ballard empirical and quantitative practices become the flip side of psychosis and its loss of identities. The simulation of coherence for him results only from the blank accumulations of clinical data, laboratory recording techniques, and the "objective" observations of scientific research. And as we now know, the computer was to be central to the remaking of the spectacle by offering the semblance of a "homogenous and neutral" table on which one could know and manipulate the contents of the world without reference to the visible.

When Ballard writes, "The obsession with the specific activity of quantified functions is what science shares with pornography," he anticipates features of *Gravity's Rainbow;* but Pynchon's work is also important here for its exhaustive disclosure of the processes and lines of force which remade the world after World War II, producing the very landscape of *The Atrocity Exhibition.* When Pynchon particularizes the chemical and armaments industries and the German film industry, they stand for a much wider range of technologies and institutions which sought to render any subject or substance controllable, manipulable, and exchangeable, whether it was languages, raw materials, or neural reflexes. "How alphabetic is the nature of molecules . . . These are our letters, our words: they too can be modulated, broken, recoupled, redefined, co-polymerized one to the other in world wide chains that will surface now and then over long molecular silences like the seen part of a tapestry."[21] For Deleuze and Guattari, this is a shift from a linguistics of the signifier to a linguistics of flow. It is a transition coinciding with the processes of rationalization that Pynchon describes, the abstract coding of anything that would claim singularity, and also with television's annihilation of the "semantic field" in Ballard. What *Gravity's Rainbow* tells us better than any other text is how World War II was above all an operation of modernization: how it was the necessary crucible for the obliteration of outdated territories, languages, filiations, of any boundaries or forms that impeded the installation of cybernetics as the model for the remaking of the world as pure instrumentality. And it cannot be overemphasized how the development of cybernetics ("a theory of messages and their control") is intertwined with the commodification of all information and with the hegemony of what Pynchon calls the "meta-cartel."[22]

20. Michel Foucault, *The Order of Things* (New York: Random House, 1970), pp. xv-xiv. Also relevant here is Roman Jakobson's "Two Aspects of Language and Two Types of Aphasic Disturbances," in Roman Jakobson and Morris Halle, *Fundamentals of Language* (The Hague: Mouton, 1971).

21. Thomas Pynchon, *Gravity's Rainbow* (New York: Viking, 1973).

22. Ibid., pp. 239 and 566.

The masquerade television performed is over; we can no longer privilege as an independent agency what has now become primarily a switching device, one which derives meaning solely from the connections it makes, breaks, or modifies. The operation of television suggests similarities with the semiconductor, that quintessential object of 1980s capitalism. A product of "postindustrial" industry, the semiconductor chip is a conductive solid with infinitely alterable logical properties that amplifies and codifies flows of power. Unique specifications are produced, as Pynchon's German chemists would have understood, by actually rearranging the atoms of the substances. And recently it has become clear how some semiconductor materials (e.g., gallium arsenide) are optically as well as electronically active: circuits of light and circuits of electricity are interchangeable, subject to the same digitation, dollar quantification, and maximizations of speed. According to the same axioms, television and the semiconductor operate by decomposing and remaking a field to achieve optimum patterns of circulation. Both intensify distribution flows while at the same time imposing intricate circuitries of control.

The liquefaction of signs and commodities has advanced to a point where liquidity no longer spawns the nomadic or the fugitive. The repositioning of television within the web of telecommunications both facilitates the reduction of commodities to pure flux and simultaneously reroutes these flows, previously managed haphazardly and partially, into more easily controllable channels. The passive consumption of images that characterized the sixties spectator is over. If television then still allowed aleatory experiences of drift and anomie, the VDT imposes a highly articulated, coercive apparatus, a prescriptive mode of activity and corporal regimentation. Yet this more developed form of sedentarization, of cellular space mapped out on a global scale, is less the consequence of new technologies and inventions, than the banal legacy of the nineteenth century, and the dream fabricated then of the complete bureaucratization of society.[23]

The compulsory, even carceral underpinning of cellular space is obscured by the overwhelming mass-marketing of the computer and its sham of "interactive" technology, of the "extensions of man," and the fraudulent homology between the computer "revolution" and the advent of printing.[24] But in rejoinder to critics like Enzensberger, who prematurely celebrated the egalitarian and emancipatory potential of "interactive" media, stands Barthes' contention

23. Michel Foucault writes: "Never, I think, in the history of human societies—even in the old Chinese society—has there been such a tricky combination in the same political structures of individualization techniques, and of totalization procedures." See "The Subject and Power," *Critical Inquiry* 8 (Summer 1982): 777-795. [Reprinted in this volume, pp. 417-433.]

24. See, for example, Douglas Hofstadter, *Gödel, Escher, Bach* (New York: Basic Books, 1979). This Pulitzer Prize sanctioned work is typical of hundreds of current books in its thorough mystification of the words "language," "systems," and "knowledge," and its rhapsodic assertion of the "natural" compatibility of mind and machine. Hofstadter's own account of human intelligence is founded on the terms "hardware" and "software."

that whatever compels speech is intrinsically fascist.[25] Most often advocacy of "alternative" uses of telecommunications and computers goes hand in hand with a naive belief in the neutrality of digital languages and a blindness to the immanence of binary notation within a specific system of technocratic domination.[26] The imperatives of that system were disclosed by Herman Kahn in identifying the key vocation of the future: "the extraction of the maximum information from whatever data is on hand."[27]

Perhaps the most fragile component of this future, however, lies in the immediate vicinity of the terminal screen. We must recognize the fundamental incapacity of capitalism ever to rationalize the circuit between body and computer keyboard, and realize that this circuit is the site of a latent but potentially volatile disequilibrium. The disciplinary apparatus of digital culture poses as a self-sufficient, self-enclosed structure without avenues of escape, with no outside. Its myths of necessity, ubiquity, efficiency, of instantaneity require dismantling: in part, by disrupting the separation of cellularity, by refusing productivist injunctions, by inducing slow speeds and inhabiting silences.

Edward Ruscha. Artist's books: *Thirty-four Parking Lots,* 1967, and *Nine Swimming Pools and a Broken Glass,* 1968

25. See "Constituents of a Theory of the Media," in Hans Magnus Enzensberger, *Critical Essays,* trans. Stuart Hood (New York: Continuum, 1982). For Barthes, see "Lecture," *October,* no. 8 (Spring 1979), pp. 5-16.

26. See "Meaning and Power," in Félix Guattari, *Molecular Revolution,* trans. Rosemary Sheed (Harmondsworth, Eng.: Penguin Books, 1984).

27. Herman Kahn, *The Coming Boom* (New York: Simon and Schuster, 1982), p. 73.

VI.

Cultural Politics

John Heartfield. *Hurrah, die Butter ist alle!*, 1935. Photomontage in *A-I-Z* (December 19, 1935). Text reads: "Hurrah, the butter is gone! Goering in his Hamburg speech: 'Iron has always made a country strong; butter and lard have at most made the people fat.'"

The Author as Producer

WALTER BENJAMIN

The task is to win over the intellectuals to the working class by making them aware of the identity of their spiritual enterprises and of their conditions as producers.

—Ramón Fernandez

You will remember how Plato, in his model state, deals with poets.

He banishes them from it in the public interest. He had a high conception of the power of poetry, but he believed it harmful, superfluous—in a *perfect* community, of course. The question of the poet's right to exist has not often, since then, been posed with the same emphasis; but today it poses itself. Probably it is only seldom posed in this *form*, but it is more or less familiar to you all as the question of the autonomy of the poet, of his freedom to write whatever he pleases. You are not disposed to grant him this autonomy. You believe that the present social situation compels him to decide in whose service he is to place his activity. The bourgeois writer of entertainment literature does not acknowledge this choice. You must prove to him that, without admitting it, he is working in the service of certain class interests. A more advanced type of writer does recognize this choice. His decision, made on the basis of a class struggle, is to side with the proletariat. That puts an end to his autonomy. His activity is now decided by what is useful to the proletariat in the class struggle. Such writing is commonly called *tendentious*.

There you have the catchword around which has long circled a debate familiar to you. Its familiarity tells you how unfruitful it has been, for it has not advanced beyond the monotonous reiteration of arguments for and against: *on the one hand*, the correct political line is demanded of the poet; *on the other*, it is justifiable to expect his work to have quality. Such a formulation is of course unsatisfactory as long as the connection between the two factors, political line and quality, has not been *perceived*. Of course, the connection can be asserted dogmatically. You can declare: a work that shows the correct political tendency need show no other quality. You can also declare: a work that exhibits the correct tendency must of necessity have every other quality.

This second formulation is not uninteresting, and, moreover, it is correct. I make it my own. But in doing so I abstain from asserting it dogmatically. It must be *proved*. And it is in order to attempt to prove it that I now claim your

This essay was originally delivered as an address to the Institute for the Study of Fascism in Paris on April 27, 1934. This translation is reprinted from *Reflections: Essays, Aphorisms, Autobiographical Writings*, ed. Peter Demetz (New York: Harcourt Brace Jovanovich, 1978), pp. 220-238.

attention. This is, you will perhaps object, a very specialized, out-of-the-way theme. And how do I intend to promote the study of fascism with such a proof? That is indeed my intention. For I hope to be able to show you that the concept of political tendency, in the summary form in which it usually occurs in the debate just mentioned, is a perfectly useless instrument of political literary criticism. I should like to show you that the tendency of a literary work can only be politically correct if it is also literarily correct. That is to say, the politically correct tendency includes a literary tendency. And, I would add straightaway, this literary tendency, which is implicitly or explicitly contained in every *correct* political tendency of a work, includes its literary quality *because* it includes its literary *tendency*.

This assertion—I hope I can promise you—will soon become clearer. For the moment I should like to interject that I might have chosen a different starting point for my reflections. I started from the unfruitful debate on the relationship between tendency and quality in literature. I could have started from an even older and no less unfruitful debate: what is the relationship between form and content, particularly in political poetry? This kind of question has a bad name; rightly so. It is the textbook example of the attempt to explain literary connections with undialectical clichés. Very well. But what, then, is the dialectical approach to the same question?

The dialectical approach to this question—and here I come to my central point—has absolutely no use for such rigid, isolated things as work, novel, book. It has to insert them into the living social context. You rightly declare that this has been done time and again among our friends. Certainly. Only they have often done it by launching at once into large, and therefore necessarily often vague, questions. Social conditions are, as we know, determined by conditions of production. And when a work was criticized from a materialist point of view, it was customary to ask how this work stood vis-à-vis the social relations of production of its time. This is an important question, but also a very difficult one. Its answer is not always unambiguous. And I should like now to propose to you a more immediate question, a question that is somewhat more modest, somewhat less far-reaching, but that has, it seems to me, more chance of receiving an answer. Instead of asking, "What is the attitude of a work to the relations of production of its time? Does it accept them, is it reactionary—or does it aim at overthrowing them, is it revolutionary?"—instead of this question, or at any rate before it, I should like to propose another. Rather than ask, "What is the *attitude* of a work to the relations of production of its time?" I should like to ask, "What is its *position* in them?" This question directly concerns the function the work has within the literary relations of production of its time. It is concerned, in other words, directly with the literary *technique* of works.

In bringing up technique, I have named the concept that makes literary products directly accessible to a social, and therefore a materialist analysis. At the same time, the concept of technique provides the dialectical starting point from which the unfruitful antithesis of form and content can be surpassed. And furthermore, this concept of technique contains an indication of the correct determination of the relation between tendency and quality, the question raised

at the outset. If, therefore, I stated earlier that the correct political tendency of a work includes its literary quality, because it includes its literary tendency, I can now formulate this more precisely by saying that this literary tendency can consist either in progress or in regression in literary technique.

You will certainly approve if I now pass on, with only an appearance of arbitrariness, to very concrete literary conditions. Russian conditions. I should like to direct your attention to Sergei Tretiakov and to the type, defined and embodied by him, of the "operating" writer. This operating writer provides the most tangible example of the functional interdependency that always, and under all conditions, exists between the correct political tendency and progressive literary technique. I admit, he is only one example; I hold others in reserve. Tretiakov distinguishes the operating from the informing writer. His mission is not to report but to struggle; not to play the spectator but to intervene actively. He defines this mission in the account he gives of his own activity. When, in 1928, at the time of the total collectivization of agriculture, the slogan "Writers to the *Kolkhoz!*" was proclaimed, Tretiakov went to the "Communist Lighthouse" commune and there, during two lengthy stays, set about the following tasks: calling mass meetings; collecting funds to pay for tractors; persuading independent peasants to enter the *kolkhoz* [collective farm]; inspecting the reading rooms; creating wall newspapers and editing the *kolkhoz* newspaper; reporting for Moscow newspapers; introducing radio and mobile movie houses, etc. It is not surprising that the book *Commanders of the Field*, which Tretiakov wrote following these stays, is said to have had considerable influence on the further development of collective agriculture.

You may have a high regard for Tretiakov and yet still be of the opinion that his example does not prove a great deal in this context. The tasks he performed, you will perhaps object, are those of a journalist or a propagandist; all this has little to do with literature. However, I did intentionally quote the example of Tretiakov in order to point out to you how comprehensive is the horizon within which we have to rethink our conceptions of literary forms or genres, in view of the technical factors affecting our present situation, if we are to identify the forms of expression that channel the literary energies of the present. There were not always novels in the past, and there will not always have to be; not always tragedies, not always great epics; not always were the forms of commentary, translation, indeed, even so-called plagiarism, playthings in the margins of literature; they had a place not only in the philosophical but also in the literary writings of Arabia and China. Rhetoric has not always been a minor form, but set its stamp in antiquity on large provinces of literature. All this to accustom you to the thought that we are in the midst of a mighty recasting of literary forms, a melting down in which many of the opposites in which we have been used to think may lose their force. Let me give an example of the unfruitfulness of such opposites, and of the process of their dialectical transcendence. And we shall remain with Tretiakov. For this example is the newspaper.

"In our writing," a left-wing author writes, "opposites that in happier periods fertilized one another have become insoluble antinomies. Thus science and belles-lettres, criticism and production, education and politics, fall apart in

disorder. The theater of this literary confusion is the newspaper, its content 'subject-matter,' which denies itself any other form of organization than that imposed on it by the readers' impatience. And this impatience is not just that of the politician expecting information, or of the speculator on the lookout for a tip; behind it smolders that of the man on the sidelines who believes he has the right to see his own interests expressed. The fact that nothing binds the reader more tightly to his paper than this impatient longing for daily nourishment has long been exploited by the publishers, who are constantly opening new columns to his questions, opinions, protests. Hand in hand, therefore, with the indiscriminate assimilation of facts, goes the equally indiscriminate assimilation of readers who are instantly elevated to collaborators. In this, however, a dialectic moment is concealed: the decline of writing in the bourgeois press proves to be the formula for its revival in that of Soviet Russia. For as writing gains in breadth what it loses in depth, the conventional distinction between author and public, which is upheld by the bourgeois press, begins in the Soviet press to disappear. For the reader is at all times ready to become a writer, that is, a describer, but also a prescriber. As an expert—even if not on a subject but only on the post he occupies—he gains access to authorship. Work itself has its turn to speak. And the account it gives of itself is a part of the competence needed to perform it. Literary qualification is founded no longer on specialized but, rather, on polytechnic education, and is thus public property. It is, in a word, the literarization of the conditions of living that masters the otherwise insoluble antinomies, and it is in the theater of the unbridled debasement of the word—the newspaper—that its salvation is being prepared."

I hope to have shown by means of this quotation that the description of the author as a producer must extend as far as the press. For through the press, at any rate through the Soviet Russian press, one recognizes that the mighty process of recasting that I spoke of earlier not only affects the conventional distinction between genres, between writer and poet, between scholar and popularizer, but also revises even the distinction between author and reader. Of this process the press is the decisive example, and therefore any consideration of the author as producer must include it.

It cannot, however, stop at this point. For the newspaper in Western Europe does not constitute a serviceable instrument of production in the hands of the writer. It still belongs to capital. Since, on the one hand, the newspaper, technically speaking, represents the most important literary position, but, on the other, this position is controlled by the opposition, it is no wonder that the writer's understanding of his dependent position, his technical possibilities, and his political task has to grapple with the most enormous difficulties. It has been one of the decisive processes of the last ten years in Germany that a considerable proportion of its productive minds, under the pressure of economic conditions, have passed through a revolutionary development in their attitudes, without being able simultaneously to rethink their own work, their relation to the means of production, their technique, in a really revolutionary way. I am speaking, as you see, of the so-called left-wing intellectuals, and will limit myself to the bourgeois left. In Germany the leading politico-literary movements of the last decade have emanated from this left-wing intelligentsia. I shall mention two of

them, Activism and New Matter-of-factness, to show with these examples that a political tendency, however revolutionary it may seem, has a counterrevolutionary function as the writer feels his solidarity with the proletariat only in his attitudes, not as a producer.

The catchword in which the demands of Activism are summed up is "logocracy"; in plain language, rule of the mind. This is apt to be translated as rule of the intellectuals. In fact, the concept of the intellectual, with its attendant spiritual values, has established itself in the camp of the left-wing intelligentsia, and dominates its political manifestoes from Heinrich Mann to Döblin. It can readily be seen that this concept has been coined without any regard for the position of the intellectuals in the process of production. Hiller, the theoretician of Activism, himself means intellectuals to be understood not as "members of certain professions" but as "representatives of a certain characterological type." This characterological type naturally stands as such between the classes. It encompasses any number of private individuals without offering the slightest basis for organizing them. When Hiller formulates his denunciation of the party leaders, he concedes them a good deal; they may be "in important matters better informed . . . , have more popular appeal . . . , fight more courageously" than he, but of one thing he is sure: that they "think more defectively." Probably, but where does this lead him, since politically it is not private thinking but, as Brecht once expressed it, the art of thinking in other people's heads that is decisive. Activism attempted to replace materialistic dialectics by the—in class terms unquantifiable—notion of common sense. Its intellectuals represent at best a social group. In other words, the very principle on which this collective is formed is reactionary; no wonder that its effect could never be revolutionary.

However, this pernicious principle of collectivization continues to operate. This could be seen three years ago, when Döblin's *Wissen und Verändern* [*Know and Change*] came out. As is known, this pamphlet was written in reply to a young man—Döblin calls him Herr Hocke—who had put to the famous author the question "What is to be done?" Döblin invites him to join the cause of socialism, but with reservations. Socialism, according to Döblin, is "freedom, a spontaneous union of men, the rejection of all compulsion, indignation at injustice and coercion, humanity, tolerance, a peaceful disposition." However this may be, on the basis of this socialism he sets his face against the theory and practice of the radical workers' movement. "Nothing," Döblin declares, "can come out of anything that was not already in it—and from a murderously exacerbated class war justice can come, but not socialism." Döblin formulates the recommendation that, for these and other reasons, he gives Herr Hocke: "You, my dear sir, cannot put into effect your agreement in principle with the struggle (of the proletariat) by joining the proletarian front. You must be content with an agitated and bitter approval of this struggle, but you also know that if you do more, an immensely important post will remain unmanned . . . : the original communistic position of human individual freedom, of the spontaneous solidarity and union of men. . . . It is this position, my dear sir, that alone falls to you." Here it is quite palpable where the conception of the "intellectual," as a type defined by his opinions, attitudes,

Docklands
Community Post
Project (Loraine
Leeson and Peter
Dunn). *The Changing
Picture of Docklands*
(three stages), 1983.
Black-and-white
photomontage
billboard with
applied color, 18′ x
12′ (5.49 x 3.66 m). A
community wall
poster located at
Wapping Lane and
other sites in
Docklands, London.
(Photos: courtesy
Loraine Leeson and
Peter Dunn)

or dispositions, but not by his position in the process of production, leads. He must, as Döblin puts it, find his place *beside* the proletariat. But what kind of place is that? That of a benefactor, of an ideological patron—an impossible place. And so we return to the thesis stated at the outset: the place of the intellectual in the class struggle can be identified, or, better, chosen, only on the basis of his position in the process of production.

For the transformation of the forms and instruments of production in the way desired by a progressive intelligentsia—that is, one interested in freeing the means of production and serving the class struggle—Brecht coined the term *Umfunktionierung* [functional transformation]. He was the first to make of intellectuals the far-reaching demand not to supply the apparatus of production without, to the utmost extent possible, changing it in accordance with socialism. "The publication of the *Versuche*," the author writes in introducing the series of writings bearing this title, "occurred at a time when certain works ought no longer to be individual experiences (have the character of works) but should, rather, concern the use (transformation) of certain institutes and institutions." It is not spiritual renewal, as fascists proclaim, that is desirable: technical innovations are suggested. I shall come back to these innovations. I should like to content myself here with a reference to the decisive difference between the mere supplying of a productive apparatus and its transformation. And I should like to preface my discussion of the "New Matter-of-factness" with the proposition that to supply a productive apparatus without—to the utmost extent possible—changing it would still be a highly censurable course even if the material with which it is supplied seemed to be of a revolutionary nature. For we are faced with the fact—of which the past decade in Germany has furnished an abundance of examples—that the bourgeois apparatus of production and publication can assimilate astonishing quantities of revolutionary themes, indeed, can propagate them without calling its own existence, and the existence of the class that owns it, seriously into question. This remains true at least as long as it is supplied by hack writers, even if they be revolutionary hacks. I define the hack writer as the man who abstains in principle from alienating the productive apparatus from the ruling class by improving it in ways serving the interests of socialism. And I further maintain that a considerable proportion of so-called left-wing literature possessed no other social function than to wring from the political situation a continuous stream of novel effects for the entertainment of the public. This brings me to the New Matter-of-factness. Its stock in trade was reportage. Let us ask ourselves to whom this technique was useful.

For the sake of clarity I shall place its photographic form in the foreground, but what is true of this can also be applied to the literary form. Both owe the extraordinary increase in their popularity to the technology of publication: the radio and the illustrated press. Let us think back to dadaism. The revolutionary strength of dadaism consisted in testing art for its authenticity. Still lifes put together from tickets, spools of cotton, cigarette butts, that were linked with painted elements. The whole thing was put in a frame. And thereby the public was shown: look, your picture frame ruptures time; the tiniest authentic fragment of daily life says more than painting. Just as the bloody fingerprint of a murderer on the page of a book says more than the text. Much

of this revolutionary content has gone on into photomontage. You need only think of the work of John Heartfield, whose technique made the book cover into a political instrument. But now follow the path of photography further. What do you see? It becomes ever more *nuancé*, ever more modern, and the result is that it can no longer depict a tenement block or a refuse heap without transfiguring it. It goes without saying that photography is unable to say anything about a power station or a cable factory other than this: what a beautiful world! *A Beautiful World*—that is the title of the well-known picture anthology by Renger-Patzsch, in which we see New Matter-of-fact photography at its peak. For it has succeeded in transforming even abject poverty, by recording it in a fashionably perfected manner, into an object of enjoyment. For if it is an economic function of photography to restore to mass consumption, by fashionable adaptation, subjects that had earlier withdrawn themselves from it—springtime, famous people, foreign countries—it is one of its political functions to renew from within—that is, fashionably—the world as it is.

Here we have a flagrant example of what it means to supply a productive apparatus without changing it. To change it would have meant to overthrow another of the barriers, to transcend another of the antitheses, that fetter the production of intellectuals, in this case the barrier between writing and image. What we require of the photographer is the ability to give his picture the caption that wrenches it from modish commerce and gives it a revolutionary useful value. But we shall make this demand most emphatically when we—the writers—take up photography. Here, too, therefore, technical progress is for the author as producer that foundation of his political progress. In other words, only by transcending the specialization in the process of production that, in the bourgeois view, constitutes its order can one make this production politically useful; and the barriers imposed by specialization must be breached jointly by the productive forces that they were set up to divide. The author as producer discovers—in discovering his solidarity with the proletariat—simultaneously his solidarity with certain other producers who earlier seemed scarcely to concern him. I have spoken of the photographer; I shall very briefly insert a word of Eisler's on the musician: "In the development of music, too, both in production and in reproduction, we must learn to perceive an ever-increasing process of rationalization. . . . The phonograph record, the sound film, jukeboxes can purvey top-quality music . . . canned as a commodity. The consequence of this process of rationalization is that musical reproduction is consigned to ever-diminishing, but also ever more highly qualified groups of specialists. The crisis of the commercial concert is the crisis of an antiquated form of production made obsolete by new technical inventions." The task therefore consisted of an *Umfunktionierung* of the form of the concert that had to fulfill two conditions: to eliminate the antithesis firstly between performers and listeners and secondly between technique and content. On this Eisler makes the following illuminating observation: "One must beware of overestimating orchestral music and considering it the only high art. Music without words gained its great importance and its full extent only under capitalism." This means that the task of changing the concert is impossible without the collaboration of the word. It alone can effect the transformation, as Eisler formulates it, of a concert into a

political meeting. But that such a transformation does indeed represent a peak of musical and literary technique, Brecht and Eisler prove with the didactic play *The Measures Taken.*

If you look back from this vantage point on the recasting of literary forms that I spoke of earlier, you can see how photography and music, and whatever else occurs to you, are entering the growing, molten mass from which the new forms are cast. You find it confirmed that only the literarization of all the conditions of life provides a correct understanding of the extent of this melting-down process, just as the state of the class struggle determines the temperature at which—more or less perfectly—it is accomplished.

I spoke of the procedure of a certain modish photography whereby poverty is made an object of consumption. In turning to New Matter-of-factness as a literary movement, I must take a step further and say that it has made the *struggle against poverty* an object of consumption. The political importance of the movement was indeed exhausted in many cases by the conversion of revolutionary impulses, insofar as they occurred among bourgeoisie, into objects of amusement that found their way without difficulty into the big-city cabaret business. The transformation of the political struggle from a compulsion to decide into an object of contemplative enjoyment, from a means of production into a consumer article, is the defining characteristic of this literature. A perceptive critic has explained this, using the example of Erich Kästner, as follows: "With the workers' movement this left-wing radical intelligentsia has nothing in common. It is, rather, as a phenomenon of bourgeois decomposition, a counterpart of the feudalistic disguise that the Second Empire admired in the reserve officer. The radical-life publicists of the stamp of Kästner, Mehring, or Tucholsky are the proletarian camouflage of decayed bourgeois strata. Their function is to produce, from the political standpoint, not parties but cliques; from the literary standpoint, not schools but fashions; from the economic standpoint, not producers but agents. Agents or hacks who make a great display of their poverty, and a banquet out of yawning emptiness. One could not be more totally accommodated in an uncozy situation."

This school, I said, made a great display of its poverty. It thereby shirked the most urgent task of the present-day writer: to recognize how poor he is and how poor he has to be in order to begin again from the beginning. For that is what is involved. The Soviet state will not, it is true, banish the poet like Plato, but it will—and this is why I recalled the Platonic state at the outset—assign him tasks that do not permit him to display in new masterpieces the long-since-counterfeit wealth of creative personality. To expect a renewal in terms of such personalities and such works is a privilege of fascism, which gives rise to such scatterbrained formulations as that with which Günter Gründel in his *Mission of the Young Generation* rounds off the section on literature: "We cannot better conclude this . . . survey and prognosis than with the observation that the *Wilhelm Meister* and the *Green Henry* of our generation have not yet been written." Nothing will be further from the author who has reflected deeply on the conditions of present-day production than to expect, or desire, such works. His work will never be merely work on products but always, at the same time, on the means of production. In other words, his products must

have, over and above their character as works, an organizing function, and in no way must their organizational usefulness be confined to their value as propaganda. Their political tendency alone is not enough. The excellent Lichtenberg has said, "A man's opinions are not what matters, but the kind of man these opinions make of him." Now it is true that opinions matter greatly, but the best are of no use if they make nothing useful out of those who have them. The best political tendency is wrong if it does not demonstrate the attitude with which it is to be followed. And this attitude the writer can only demonstrate in his particular activity: that is, in writing. A political tendency is the necessary, never the sufficient condition of the organizing function of a work. This further requires a directing, instructing stance on the part of the writer. And today this is to be demanded more than ever before. *An author who teaches writers nothing, teaches no one.* What matters, therefore, is the exemplary character of production, which is able first to induce other producers to produce, and second to put an improved apparatus at their disposal. And this apparatus is better the more consumers it is able to turn into producers—that is, readers or spectators into collaborators. We already possess such an example, to which, however, I can only allude here. It is Brecht's epic theater.

Tragedies and operas are constantly being written that apparently have a well-tried theatrical apparatus at their disposal, but in reality they do nothing but supply a derelict one. "The lack of clarity about their situation that prevails among musicians, writers, and critics," says Brecht, "has immense consequences that are far too little considered. For, thinking that they are in possession of an apparatus that in reality possesses them, they defend an apparatus over which they no longer have any control and that is no longer, as they still believe, a means for the producers, but has become a means against the producers." This theater, with its complicated machinery, its gigantic supporting staff, its sophisticated effects, has become a "means against the producers" not least in seeking to enlist them in the hopeless competitive struggle in which film and radio have enmeshed it. This theater—whether in its educating or its entertaining role; the two are complementary—is that of a sated class for which everything it touches becomes a stimulant. Its position is lost. Not so that of a theater that, instead of competing with newer instruments of publication, seeks to use and learn from them, in short, to enter into debate with them. This debate the epic theater has made its own affair. It is, measured by the present state of development of film and radio, the contemporary form.

In the interest of this debate Brecht fell back on the most primitive elements of the theater. He contented himself, by and large, with a podium. He dispensed with wide-ranging plots. He thus succeeded in changing the functional connection between state and public, text and performance, director and actor. Epic theater, he declared, had to portray situations, rather than develop plots. It obtains such situations, as we shall see presently, by interrupting the plot. I remind you here of the songs, which have their chief function in interrupting the action. Here—in the principle of interruption—epic theater, as you see, takes up a procedure that has become familiar to you in recent years from film and radio, press and photography. I am speaking of the procedure of montage: the superimposed element disrupts the context in which

it is inserted. But that this procedure has here a special right, perhaps even a perfect right, allow me briefly to indicate. The interruption of action, on account of which Brecht described his theater as *epic*, constantly counteracts an illusion in the audience. For such illusion is a hindrance to a theater that proposes to make use of elements of reality in experimental rearrangements. But it is at the end, not the beginning, of the experiment that the situation appears—a situation that, in this or that form, is always ours. It is not brought home to the spectator but distanced from him. He recognizes it as the real situation, not with satisfaction, as in the theater of naturalism, but with aston-ishment. Epic theater, therefore, does not reproduce situations; rather, it dis-covers them. This discovery is accomplished by means of the interruption of sequences. Only interruption here has not the character of a stimulant but an organizing function. It arrests the action in its course, and thereby compels the listener to adopt an attitude vis-à-vis the process, the actor vis-à-vis his role. I should like to show you through an example how Brecht's discovery and use of the *gestus* is nothing but the restoration of the method of montage decisive in radio and film, from an often merely modish procedure to a human event. Imagine a family scene: the wife is just about to grab a bronze sculpture to throw it at her daughter; the father is opening the window to call for help. At this moment a stranger enters. The process is interrupted; what appears in its place is the situation on which the stranger's eyes now fall: agitated faces, open window, disordered furniture. There are eyes, however, before which the more usual scenes of present-day existence do not look very different: the eyes of the epic dramatist.

To the total dramatic artwork he opposes the dramatic laboratory. He makes use in a new way of the great, ancient opportunity of the theater—to expose what is present. At the center of his experiment is man. Present-day man; a reduced man, therefore, chilled in a chilly environment. Since, how-ever, this is the only one we have, it is in our interest to know him. He is subjected to tests, examinations. What emerges is this: events are alterable not at their climaxes, not by virtue and resolution, but only in their strictly habitual course, by reason and practice. To construct from the smallest elements of behavior what in Aristotelian dramaturgy is called "action" is the purpose of epic theater. Its means are therefore more modest than those of traditional theater; likewise its aims. It is less concerned with filling the public with feelings, even seditious ones, than with alienating it in an enduring manner, through thinking, from the conditions in which it lives. It may be noted, by the way, that there is no better start for thinking than laughter. And, in particular, convulsion of the diaphragm usually provides better opportunities for thought than convulsion of the soul. Epic theater is lavish only in occasions for laughter.

It has perhaps struck you that the train of thought that is about to be concluded presents to the writer only one demand, the demand *to think*, to reflect on his position in the process of production. We may depend on it: this reflection leads, sooner or later, for the writers who *matter*—that is, for the best technicians in their subject—to observations that provide the most factual foun-dation for solidarity with the proletariat. I should like to conclude by adducing

a topical illustration in the form of a small extract from a journal published here, *Commune. Commune* circulated a questionnaire: "For whom do you write?" I quote from the reply of René Maublanc and from the comment added by Aragon. "Unquestionably," says Maublanc, "I write almost exclusively for a bourgeois public. Firstly, because I am obliged to"—here Maublanc is alluding to his professional duties as a grammar-school teacher—"secondly, because I have bourgeois origins and a bourgeois education and come from a bourgeois milieu, and so am naturally inclined to address myself to the class to which I belong, which I know and understand best. This does not mean, however, that I write in order to please or support it. I am convinced, on the one hand, that the proletarian revolution is necessary and desirable and, on the other, that it will be the more rapid, easy, successful, and the less bloody, the weaker the opposition of the bourgeoisie. . . . The proletariat today needs allies from the camp of the bourgeoisie, exactly as in the eighteenth century the bourgeoisie needed allies from the feudal camp. I wish to be among those allies."

On this Aragon comments: "Our comrade here touches on a state of affairs that affects a large number of present-day writers. Not all have the courage to look it in the face. . . . Those who see their own situation as clearly as René Maublanc are few. But precisely from them more must be required. . . . It is not enough to weaken the bourgeoisie from within, it is necessary to fight them *with* the proletariat. . . . René Maublanc and many of our friends among the writers who are still hesitating, are faced with the example of the Soviet Russian writers who came from the Russian bourgeoisie and nevertheless became pioneers of the building of socialism."

Thus Aragon. But how did they become pioneers? Certainly not without very bitter struggles, extremely difficult debates. The considerations I have put before you are an attempt to draw some conclusions from these struggles. They are based on the concept to which the debate on the attitude of the Russian intellectuals owes its decisive clarification: the concept of the specialist. The solidarity of the specialist with the proletariat—herein lies the beginning of this clarification—can only be a mediated one. The Activists and the representatives of New Matter-of-factness could gesticulate as they pleased: they could not do away with the fact that even the proletarianization of an intellectual hardly ever makes a proletarian. Why? Because the bourgeois class gave him, in the form of education, a means of production that, owing to educational privilege, makes him feel solidarity with it, and still more it with him. Aragon was thereby entirely correct when, in another connection, he declared, "The revolutionary intellectual appears first and foremost as the betrayer of his class of origin." This betrayal consists, in the case of the writer, in conduct that transforms him from a supplier of the productive apparatus into an engineer who sees it as his task to adapt this apparatus to the purposes of the proletarian revolution. This is a mediating activity, yet it frees the intellectual from that purely destructive task to which Maublanc and many of his comrades believe it necessary to confine him. Does he succeed in promoting the socialization of the intellectual means of production? Does he see how he himself can organize the intellectual workers in the production process? Does he have proposals

for the *Umfunktionierung* of the novel, the drama, the poem? The more completely he can orient his activity toward this task, the more correct will be the political tendency, and necessarily also the higher the technical quality, of his work. And at the same time, the more exactly he is thus informed on his position in the process of production, the less it will occur to him to lay claim to "spiritual" qualities. The spirit that holds forth in the name of fascism *must* disappear. The spirit that, in opposing it, trusts in its own miraculous powers *will* disappear. For the revolutionary struggle is not between capitalism and spirit, but between capitalism and the proletariat.

Translated by Edmund Jephcott

Carole Condé and Karl Beveridge. *Work in Progress,* 1980–1981. Color photograph, 16 x 20″ (40.6 x 50.8 cm). From a series of eight

The Author as Producer 309

(Above) Exhibition signage at The Metropolitan Museum of Art, New York. (Photo: Louise Lawler); (Top) Installation of photographs in the photography galleries of The Museum of Modern Art, New York. (Photo: Louise Lawler); (Bottom right) Dorothea Lange. *Shipyard Construction Workers, Richmond, California,* 1942. Black-and-white photograph, 10 x 8″ (25.5 x 20.3 cm). Collection Dorothea Lange Archives, The Oakland Museum, Oakland, Calif. (Photo: courtesy The Oakland Museum)

Lookers, Buyers, Dealers, and Makers:
Thoughts on Audience

MARTHA ROSLER

Prelude *The purpose of this article is to encircle rather than to define the question of audience. It is discursive rather than strictly theoretical. The analytic entity "audience" is meaningful only in relation to the rest of the art system of which it is a part, and as part of the society to which it belongs. This is not to say that the question of audience must disappear in a welter of other considerations, but rather that there are certain relationships that must be scrutinized if anything interesting is to be learned.*

Photography has made what seems to be its final Sisyphean push up the hill into the high art world, and therefore the photography audience must be considered in terms of its changing relation to the art-world system that has engulfed it. The most important distinctions among members of the art audience are those of social class, the weightiest determinant of one's relation to culture. In the mediating role played by the market in the relationship between artist and audience, the network of class relations similarly determines the relation between those who merely visit cultural artifacts and those who are in a position to buy them.

Historical determinants of the artist's present position in the art system include the loss of direct patronage with the decline of the European aristocracy and artists' resulting entry into free-market status. One ideological consequence of modernity was Romanticism and its outgrowths, which are a major source of current attitudes about the artist's proper response to the public. Unconcern with audience has become a necessary feature of art producers' professed attitudes and a central element of the ruling ideology of Western art set out by its critical discourse. If producers attempt to change their relationship to people outside the given "art world," they must become more precise in assessing what art can do and what they want their art to do. This is particularly central to overtly political art.

Reprinted from *Exposure* 17, no. 1 (Spring 1979): 10-25 with slight revisions by the author. For a somewhat different version of this article, see Martha Rosler, "The System of the Postmodern in the Decade of the Seventies," in *The Idea of the Post-Modern: Who Is Teaching It?*, ed. Joseph N. Newland (Seattle: Henry Art Gallery, 1981), pp. 25-51. For corrections and commentary, please see the postscript.

In writing this article I have avoided assuming a close knowledge of the material on the part of readers; I hope impatience won't turn the more knowledgeable ones away.

After wrestling with these questions artists must still figure out how to reach an audience. Here a discussion of art-world institutions is appropriate. As photography enters the high art world of shows, sales, and criticism, people involved in its production, publicization, and distribution must struggle with its changed cultural meaning.

Some Features of the Audience

It seems appropriate to begin a discussion of "audience" by taking note of the fact that there is anything to discuss. There are societies, after all, in which the social positioning of (what we call) art is not in question. But segmentation is apparent in the culture of late capitalism, where the myths and realities of social life can be seen to diverge and where there is an unacknowledged struggle between social classes over who determines "truth." In our society the contradictions between the claims made for art and the actualities of its production and distribution are abundantly clear. While cultural myth actively claims that art is a human universal–transcending its historical moment and the other conditions of its making, and above all the class of its makers and patrons– and that it is the highest expression of spiritual and metaphysical truth, high art is patently exclusionary in its appeal, culturally relative in its concerns, and indissolubly wedded to big money and "upper class" life in general.

See

Tables 1, 2, 3,

pp. 314-317

A mere statistical survey of high-culture consumership will delineate the audience and outline its income level, types of occupation, and attitudes toward the ownership of "culture," serving quite nicely to show how limited the audience really is to definable segments of the educated bourgeoisie,[1] and a minimally sophisticated opinion poll will suggest how excluded and intimidated lower-class people feel.[2] There are, however, no *explanations* in the brute facts of income and class; only a theory of culture can account for the composition of the audience. Further, there is a subjective, ideologically determined element in the very meaning of the idea of art that is essential to people's relations to the various forms of art in their culture. The truth is that like all forms of connoisseurship, the social value of high art depends *absolutely* on the existence of a distinction between a high culture and a low culture.[3] Although it is part of the logic of domination that ideological accounts of the meaning of high culture proclaim it as the self-evident, the natural, the *only* real culture of civilized persons, its distinctive features are distinguishable only against the backdrop of the rest of culture. What is obscured is the *acquired* nature of the attitudes necessary for partaking in that culture, the *complexity* of the condi-

1. Hans Haacke's surveys at various locations indicated that the audience for contemporary work seems to be made up of a very high percentage of people who are occupationally involved in art–museum and gallery professionals, artists, art teachers, art students, critics, and art historians. See Haacke, *Framing and Being Framed* (Halifax: The Press of the Nova Scotia College of Art and Design, 1975).

2. Pierre Bourdieu and Alain Darbel, *L'Amour de l'art: Les musées d'art européens et leur public* (Paris: Les Éditions de minuit, 1969).

3. There is a dynamic between high and low culture, as well, in which elements within each represent either incorporations or rejections of corresponding elements within the other, though that does not affect the argument here.

tions under which one may acquire them, and the *restrictedness* of access to the means for doing so.

It can be meaningfully claimed that virtually the entire society is part of the art audience, but in making that claim we should be aware of what we are saying. The widest audience is made up of onlookers—people *outside* the group generally meant by the term "audience." They know of high culture mostly through rumor and report. The vast majority of people in the traditional working class are in this group, as are people in most office, technical, and service jobs; they were probably taught the "value" of high art in school and retain a certain churchly feeling[4] about art but have little real relation to it. Yet their knowledge of the bare lineaments of high culture plays a part in underlining the seeming naturalness of class distinctions—that is, in maintaining capitalist social order—for the transcendental loftiness that is attributed to art artifacts seems attached as well to those who "understand" and own them, the *actual* audience. It helps keep people in their place to know that they intrinsically do not qualify to participate in high culture.

As to who does own high culture: Everyone knows who they are, those men in white ties and tuxes, those women in floor-length furs, the Rockefellers, the Whitneys, the Kennedys, Russian ballet dancers, the international jet set, the Beautiful People, the men who run the world of high finance, government, and giant corporations, and their wives and daughters. They are very good at sniffing the wind, and every time a cultural practice is developed that tries to outrun them and their ability to turn everything into money, they manage to buy it out sooner or later and turn it into investments. In their own cultural arena they are, by definition, unbeatable.

Between the people who own and define the meaning of art as high culture and those who are intimidated by it are those who actively cultivate an "appreciation" of art as evidence of elevated sensibilities. The new "professional and managerial class," sometimes called the new petty bourgeoisie, is marked by strong consciousness of its advantages vis-à-vis the wage-enslaved working class and is just as strongly marked by its aspirations toward the cultural privileges of its class superiors, the big bourgeoisie. Although the dimensions of independence that once characterized this class position have been dramatically reduced, the professional and managerial class is still inclined to count its blessings when it compares itself with the working class, and it clings to its cultural pretensions as proof of its unfetteredness in relation to the workaday world.

The Market as Mediator Between Artist and Audience

It is useful to make a further distinction among members of the actual audience for high culture—that between the audience simple and the market, a smallish subset of that audience. Such a distinction was of little meaning in Western societies when patronage relations existed between the dominant classes and artists, for then buyers closely controlled art production; there was no other audience for secular works until late in the eighteenth century. But artists

4. Bourdieu and Darbel, *L'Amour de l'art*, p. 18.

Table 1. National Endowment Budget, 1978 and 1979[a]

Category	1978	1979	Change[b]
Architecture	$ 4,018,268	$ 3,718,000	−8%
Dance	6,939,231	7,783,700	+11
Exhibition Arts	7,201,210	8,005,000	+11
Folk Arts	1,532,428	2,376,500	+36
Literature	3,772,800	4,000,070	+6
Media Arts	8,077,281	8,412,400	+4
Museum Aid	11,501,155	11,377,000	−2
Music	14,642,364	12,570,000	−15[c]
Opera	4,074,320	4,774,000	+15
Theater	6,577,686	7,098,300	+8
Visual Arts	4,884,750	4,533,000	−8
Education	5,074,172	5,559,000	+9
Federal-State Partnership	18,946,060	22,678,500	+17
Intergovernmental Activities . .	–	1,250,000	
Special Projects	2,973,002	3,369,000	+12

SOURCE: Adapted from "NEA to Ask $200M for FY 1980 . . . ," *Art Workers News* (New York, January 1979): 1, 11.

[a] Data furnished by the National Endowment for the Arts, Office of the Northeast Regional Coordinator. The columns do not add up to the total figures supplied; presumably, administrative costs account for the difference.

[b] 1979 showed a 20 percent increase over 1978–from $121 million to $149.6 million–and about a 60 percent increase over 1977's budget of $94 million.

[c] Drop reflects money taken out of Music category for establishing Opera-Music/Theater category.

NOTE: The *Art Workers News* article clarified that the NEA was *expected* to *request* between $180 and $200 million, and the latter figure, if accepted, would mean a 34 percent increase over the 1979 budget of $149.6 million. "A spokesman . . . said that the Endowment expects at least a modest increase . . . though declined to speculate on the chances of receiving the full amount requested." The Carter administration had earlier asked government agencies to limit increases to 7 percent. (The 1979 budget increase of 20 percent in 1978 was 1 percent *below* that proposed by Carter.)

Note the sizes of music, media and museum allocations and the grants to states, and compare the relatively small amount available in total to all visual-arts producers and critics. Symphony, Opera, and Dance lobbies are reputedly very powerful.

Table 2. Museum Attendance and Educational Attainment[a]

Educational Level Attained	Percentage of Each Category Who Visit Museums			
	Greece	Poland	France	Holland
Less than primary	0.02	9.12	0.15	—
Primary education	0.30	1.50	0.45	0.50
Secondary education	10.5	10.4	10	20
Post-secondary education	11.5	11.7	12.5	17.3

SOURCE: Adapted from John Berger et. al., *Ways of Seeing* (London and Harmondsworth: BBC and Penguin, 1972), p. 24; data originally drawn from Pierre Bourdieu and Alain Darbel, *L'Amour de l'art* (Paris: Editions de Minuit, 1969), Appendix 5, Table 4.

[a] The data, drawn from European surveys conducted over 10 years ago, can only be suggestive with respect to the United States, but it seems clear that having completed a secondary education (a higher level of education in the societies studied than in the United States) predisposes a person to attend art museums. Taking the opposite tack—querying art audiences about educational background—Hans Haacke polled visitors to the John Weber Gallery in Manhattan's Soho (art district) in 1972. Of about 820 people responding, 80 percent were in or had graduated from college (84% of artists, 77% of others with a professional art interest, and 73% of those without such interest). Of 4,547 replies to Haacke's query at the Milwaukee Art Center in 1971, 39 percent of people with a professional interest in art and 59 percent of those without were in or had graduated from college. See Hans Haacke, *Framing and Being Framed* (Halifax and New York: The Press of the Nova Scotia College of Art and Design and New York University Press, 1975).

Table 3. Occupation and Attitudes to the Museum[a]

Of the places listed below, which does a museum remind you of most?	Manual Workers	Skilled and White Collar Workers	Professional and upper Managerial
Church	66%	45%	30.2%
Library	9	34	28
Lecture Hall	–	4	4.5
Department Store or entrance hall in public building	–	7	2
Church and library	9	2	4.5
Church and lecture hall . .	4	2	–
Library and lecture hall . .	–	–	2
None of these	4	2	19.5
No reply	8	4	9
	100 (*n* = 53)	100(*n* = 98)	100 (*n* = 99)

SOURCE: Adapted from John Berger et. al.. *Ways of Seeing* (London and Harmondsworth: BBC and Penguin. 1972). p. 24: data originally drawn from Pierre Bourdieu and Alain Darbel. *L'Amour de l'art* (Paris: Editions de Minuit. 1969), Appendix 4. Table 8.

[a] Presumably in France. The occupational categories given do not reflect clearcut class divisions. to my way of thinking, except that "manual workers" clearly represent the traditional working class.

Legend
- ▤ Stairs
- ⊠ Elevator
- Ⓔ Escalator
- ？ Information
- Ladies' Room
- Men's Room
- Coat Check
- Telephone
- Smoking
- Ⓐ Audioguides
- Restaurant
- Handicapped
- Bicycles
- Closed to the Public
- Special Exhibitions

2 Second Floor

Peter Nagy. *Intellectual History*, 1984 (detail). Black-and-white photocopy, entire: 11 x 8½" (28 x 21.6 cm)

When Hans Haacke polled visitors to the John Weber Gallery in Soho (see Table 2 for a complete reference) in 1973, he asked about their *parents'* estimated "socioeconomic background" (offering a vague set of categories having more relation to income than to social class). Of the 1,324 replies, 3 percent chose "poverty"; 18 percent, "lower middle income"; 34 percent, "upper middle income"; 4 percent, "wealthy"; 11 percent gave no answer (65% reported their own 1972 gross income as under $10,000.) In the 1973 poll and in one Haacke carried out in the same circumstances in 1972 (858 replies), the following responses were obtained with respect to occupation (46% reported an annual gross income under $10,000):

1972

artists	30%
professional, technical, and kindred workers (including art professionals other than dealers)	28
managers, officials, proprietors (including dealers)	4
clerical workers	b
salesworkers	0
craftsmen and foremen	1
operatives	b
housewives	3
students	19
others	2
none	1
no answer	6

b under 1 percent

Peter Nagy. *Intellectual History,* 1984 (detail). Black-and-white photocopy, entire: 11 x 8½″ (28 x 21.6 cm)

developed a rhetoric of productive emancipation as patronage declined and they entered into a condition approximating the competitive free market—of which I'll say more later. Once again, ideological accounts tend to obscure the contours of both audience and market, suggesting that Everyone may choose to belong to either or both, equipped with the right inclinations. The meaning of art (roughly, its "use value") is held to transcend or even contradict its material existence, and discussions of the economics of art (its exchange relations) are confined to professional seminars and business journals (and there is a formulaic ending for such discussions that is meant to rescue them from philistinism: taste is the ultimate judge, buy only what you *like*). The actual effects of the market have thus been made mysterious. But we can trace some of the parameters.

Certainly the very rich collectors (including corporate ones) are still the constant substructural support of the art world. Big collectors, now including photo collectors, aside from keeping the cash flowing, have a great deal of leverage with museum and gallery directors and curators and often are trustees or board members of museums and granting agencies. They also donate (or sell) contemporary works to museums, securing windfall tax savings and driving up the monetary value of their other holdings by the same artists. In photography, what is now cast in relief is the ability of collectors to engineer the historiography of the medium to suit their financial advantage. These are clear-cut influences of market on audience at large.

There are, however, many people below the high bourgeoisie who buy art for decoration, entertainment, and status—and very much because of art's investment value. Their influence is not formative, yet they constitute a vital layer of the market. This market segment is far more subject to the fluctuations in capitalist economies than is big money, though both are affected by boom-and-bust cycles.

As capitalist economies experience downward swings, changes occur in buying patterns that bring about specifiable changes in what the audience at large gets to see. For example, dealers have lately supported (by means of shows and even artists' salaries) certain types of trendy art, including performance, which sell little or not at all but which get reviewed because of their art-world currency and which therefore enhance the dealer's reputation for patronage and knowledgeability. Bread and butter comes from back-room sales of, say, American Impressionist paintings. When money is tight, the volume of investment declines and investors fall back further on market-tested items, usually historical material. This, as well as the general fiscal inflation, may cause dealers to decrease support to nonsellers.[5] But when economic conditions are uncertain over a longer term and investors worry about economic and governmental stability—as now—many investors, including institutions with millions of dollars to invest, put their money in art. Small investors avoid the stock market and savings accounts and buy "collectibles" or "tangibles."[6]

5. Except on the part of the limited-life dealerships that exist to lose money and therefore provide tax shelters.

6. For this army of small collectors, the project of the late Nelson Rockefeller to produce fancy-priced imitations held out the promise of limited-edition, classy-looking art

Tangibles encompass gems, gold (notoriously, the *krugerrand*), real estate, old luggage, and objets d'art: vases, antiques, classy craft items such as silver and ceramics, and old art by dead artists—lately including "vintage" photo prints. People unconcerned with art discourse can be comfortable with such work, especially when, thanks to the effects of the big collectors, brand-name paintings and sculpture seem far too pricey. Thus, the level of safe, purely investment, buying may rise dramatically while patronage buying diminishes.[7] With the falling dollar, investors from other countries find tried-and-true U.S. art and collectibles to be good buys, thus also enlarging the market for those items —and skewing it toward *their* particular favorites, such as Photo Realist paintings. (At the same time, countries such as Britain that are in worse financial shape are experiencing an outflow of old-master paintings to high bidders from everywhere else.)

As dealers concentrate on work that sells and decrease their support of the less salable, museums and noncommercial galleries also show it less. Artists then make less of it, though the newer sorts of institutional funding—teaching jobs and government grants—keep a shrunken volume of nonselling work in production and circulation, at least in the short run. The balance begins to tip toward ideologically safe work. At any time, the nonbuying audience seems to have a negligible effect on what kind of contemporary art gets supported and produced and therefore on what it gets to see. Popular response no doubt has somewhat more effect on the planning for cultural-artifact museum shows, such as the King Tut and People's Republic exhibits, providing a convenient support for any move that granting agencies and corporate sponsors make toward these pseudo-populist projects and away from exhibits of contemporary work.

Art World Attitudes

So far I've talked about the actual audience as relatively homogeneous and as beyond the artist's power to determine. But artists may want to reach a different audience from the usual high-culture-consuming public or different audiences at different times. The idea of discriminating among publics is rare in art conversation (though hardly so in marketing), with historical underpinnings. A certain lack of concern with audience took hold with the Romantic movement in early nineteenth-century Europe, an unconcern which was linked to the loss of secure patronage from the declining aristocracy and the state. The

objects with the tantalizing combination of imaginary and real ownership: imaginary company with the very rich, the hint of solid investment bound to rise in value.

7. To underline this point: Investment in art has been discussed increasingly often in business and other magazines addressing people with money, especially in light of the stock market's "October massacre" of 1978. In "The Art Market: Investors Beware," in the *Atlantic Monthly* for January 1979, Deborah Trustman addresses the market's incredible boom: "Art is big business. Sotheby Parke Bernet, the international auction house, . . . announced sales [in America] of $112 million for . . . 1977-78, an increase of $32 million over the previous year. . . . More Americans have become wary of inflation and have begun putting more capital into works of art." She quotes a vice-president of Sotheby's in New York who cited a market survey showing that "the young professionals, the high-salaried lawyers and business executives," make up a large segment of the newer buyers.

new conception of the artist was of someone whose production cannot be rationally directed toward any particular audience. In one version the artist is a visionary whose springs of creativity, such as Genius and Inspiration (or, in mid-twentieth-century America, internal psychic forces), lie beyond his conscious control and whose audience is "himself."[8] Alternatively, the artist is a kind of scientist, motivated to perform "investigations," "explorations," or "experiments" to discover objective facts or capabilities of, variously, art, taste, perception, the medium itself, and so on, for presentation to similarly invested peers. Production clearly predominated, and marketing was treated as a necessary accommodation to vulgar reality.

A revolt against the canons of high-art production of the earlier, aristocratic order helped clear the way for artists to choose their subjects and styles more freely. But artists, as a class now petty bourgeois, "naturally" tended toward a range of subjects and treatments that was more in tune with the outlook of the new bourgeois audience-market than with that of any other class. Yet artists' marginality in that class, and their new estrangement from government elites, contributed to a struggle against the wholesale adoption of the bourgeois world view and against the increasing commodification of culture. Although the new mythology of art denied the centrality of the market, questions of showing and sales remained of great importance, even if successive waves of artists tried to answer them with rejection. The language of liberation began to be heard at just the historical moment in which all social relations were on the verge of domination by market relations. The various bohemian-avant-gardist trends in nineteenth- and twentieth-century art have constituted a series of rejections and repatriations with respect to bourgeois culture, a series united by their initial contempt for the market and the bourgeois audience at large. The art movements of the late nineteenth and early twentieth centuries often were part of a larger oppositional culture (and sometimes related to more direct political practice). That was true of a number of versions of "modernism," as most post-cubist art came to be called. Yet, for the most restricted versions of formalist modernism, such as that propounded by the American critic Clement Greenberg at mid-century, there can be no recoverable relation between the work of art and its context other than that composed of similar objects within the aesthetic tradition and the answering faculty of taste.

In the United States, the dominant high-art discourse from, say, the 1940s on has distorted the history of all forms of oppositional culture, whether explicitly part of a revolutionary project or not, into one grand form-conscious trend, with a relentless inattention to the formative influences of larger society and, thus, of the audience. Artists with working-class audiences or who otherwise showed solidarity with revolutionary and proletarian struggles (or, indeed, their opposites, those who produced for the flourishing Academic or "bourgeois realist" market) are neutralized in this history. At most it concedes that (passing over the strident thirties in America, against which this history constitutes a reaction) art and politics were fruitfully linked only in revolutionary France

8. "Herself" was very rare.

and the Soviet Union, and then but briefly, in the transient, euphorically anarchic moment of liberation.

The proscription against a clear-eyed interest in the audience is part of an elaborated discourse on the nature of art that was developed in the period of consolidation of industrial capitalism. Resting on the philosophy of Immanuel Kant, the eighteenth-century German idealist philosopher, modernism has built its house on the base of "artistic freedom" from the audience-market and used as its architect the faculty of taste. "Taste" is the construct Kant used (in *The Critique of Judgment*) to distinguish the response to art from all other human responses, including appetite and sexual desire, morality, and religious sentiments. In the Kantian tradition, the aesthetic has no object or effect other than the satisfaction of taste, and all other concerns are excluded as contaminants. For the present topic, the signal issue is the impossibility of a sense of responsibility to any audience, a ban that was related to the Romantic figure of the artist as utterly alone, perhaps a rebel, unassimilable within bourgeois social order, and, finally, uncomfortable in his own existence. In the folklore of advanced capitalism this figure lies behind the unsympathetic mass-culture view of the average artist as a kook and a misfit, or at best a lucky (because financially successful) fraud, reinforcing the confinement of a positive relation to high art to the socially elite, specialized audience.

The protocols of taste involve a curious attitude toward judgment; judgment becomes a kind of noncalculated, innate response to the work, almost a resonance with it. Normal standards of judgment about the *meaning* of what one sees before one's eyes are negated, and in particular the referential ties between the work and the world—especially the social world—are broken. The signal system itself becomes the proper subject of conversation. Mass audiences know that there is a restricted body of knowledge that must be used to interpret the codes of art at the same time that they recognize their outsider status. One is left confronting a void of permissible responses out of which the exit line is often an apologetic and self-derogating "I don't know anything about art but I know what I [don't] like." For the art-world audience, the *knowledge* that informs their taste recedes into unimportance compared with the compliment to their inborn "sensibilities" (taste) that an appreciation of high art offers.

Modernist American critics with the power to define a discourse and an art practice, such as Clement Greenberg, posited an opposition between bourgeois high culture and a more widely comprehensible culture as that between avant-garde and kitsch and imagined avant-gardism to be magically revolutionary through a liberation of imagination without any need to change social structures; others, like Harold Rosenberg, derided the value of art informed by "Community Criticism," instead favoring idiosyncrasy and *un*willed art; and scores and hundreds of critical hacks have emulated, embellished, and popularized these dogmas.[9] Informing this critical line was a militant anti-Stalinist reaction against thirties' art-world progressivism.

9. From a randomly selected book and page: ". . . critics and historians are tempted to blame the [unsatisfactory] situation on the dominance of collectors' or tastemakers' whims.

The Concerns of Art

How might artists and other cultural workers abrogate the gospel of genius, isolation, and formalist concerns? Once we even think to pose the question of how to construct an audience, we are confronted by questions that intervene.[10] We must, for example, ask ourselves what the point of our art is (despite the injunction against this). For instance: to entertain, amuse, divert, confuse, defuse, inculcate, educate, edify, mystify, beautify, satisfy, tickle the sensibilities, alienate, make strange, terrorize, socialize. Some of these are incidental to other art-world purposes, such as turning a profit, getting grants, or making a reputation.

All art, from the crassest mass-media production to the most esoteric art-world practice, has a political existence, or, more accurately, an ideological existence. It either challenges or supports (tacitly perhaps) the dominant myths a culture calls Truth. There was a dry period in the United States, from about the Second World War through the McCarthy period to the mid-sixties, during which the art world slammed shut to socially invested work.[11] But after the cultural heresies of the sixties, art with a conscious political orientation was able to breach the neutralist cultural monolith. Theories of culture, as opposed to mere ideologies and journalistic promotion, have captured attention and are useful in developing an informed art practice.

Following a taxonomy of politicized art developed during the brief period of Soviet cultural experimentation, we may categorize art according to its intentions: to agitate about immediate issues, such as particular strikes, health hazards, tenants' struggles; to propagandize about more general questions, such as personal liberties, institutionalized violence against women, right-wing insurgency; or broad theoretical education, such as the meaning of inflation, the structure of the economy, the strategies of cultural forms. The words "agitation" and "propaganda" evoke a familiar negative response in us, having already been used to discredit earlier appearances of socially engaged art. They call up pictures of clenched-fist posters, yet it should go without saying that only crude works of agitation and propaganda are crude, and only those that offend our ideological precepts are dismissed out of hand. Propagandistic and agitational works from earlier periods are often recuperated for the ruling ideology; photography provides unending examples in the wholesale legitima-

Yet while these factors can have considerable effect on momentary prices and popularity, they have never had much effect on the real artist. Rembrandt and Cézanne are famous for their disdain of social pressures . . . sculptor David Hare has remarked, 'It is a classical complaint that the artist is forced into certain actions by society. The artist need not be so forced, unless it is his desire to be so for motives outside art.' " (John P. Sedgwick, Jr., *Discovering Modern Art: The Intelligent Layman's Guide to Painting from Impressionism to Pop* [New York: Random House, 1966], p. 199.)

10. There are as always plenty of people who have their markets well staked out. It remains to be seen who the *pompier* photographers will be, beyond the predictable panderers like David Hamilton and Helmut Newton.

11. "The art of Ben Shahn or Leonard Baskin may have a quicker and easier appeal, but in time it seems to have less 'content'—that is, less meaningful experience—than the paintings of Mark Rothko or Clyfford Still, which at first glance might look almost empty." (Sedgwick, *Discovering Modern Art*, p. 196.)

tion of past photographic practice. State-propagandist enterprises theoretically should be most objectionable but in reality may be the most easily recuperated; it is those propagandizing *against* the state that are the least acceptable. The gigantic state-propagandist Farm Security Administration corpus, or, to choose a less momentous but more recent example, the courthouse survey, are readily recovered for art—usually in dismembered form, *auteur* by *auteur*.

The theoretical, which is most similar to the art-theoretical modernist project, has the greatest snob appeal and is most easily assimilable into high culture. It is notoriously prone to turn back on itself and vanish into form-conscious academicism. Yet there are fundamental theoretical issues that should be brought up before a mass audience; even making the point in one's art that ideology is rooted in real social relations is to deal with theory, the theory of culture.

The audiences for each type of work depend not on the category but on the content, including the form. The "audience," then, is a shifting entity whose composition depends not only on who is out there but on whom you want to reach with a particular type of work, and why. There is an enforced passivity in art-world artists' relation to the audience, however, built into the structure of the art world.

Art World Institutions and Supports

The "art world" (revealing term!) includes the producers of high art, a segment of its regular consumers and supporters, the institutions that bring the consumers and work together, including specialized publications and physical spaces, and the people who run them. Since the art world is fundamentally a set of relations, it also encompasses all the transactions, personal and social, between the sets of participants. The gallery system remains basic to the art world. The conception of the gallery is tailored to the still pervasively modernist view of high art: The gallery is a space apart from any concern other than Art, just as art's only rightful milieu is Art. The gallery is a secular temple of Art, just as the art within it is the secular replacement for religion. The invisible motto above the gallery door reads, "Abandon worldly concerns (except if you're buying), ye who enter here." The paradigm is one in which work is made apart from an audience and in which a space is then secured, at the sufferance of an intermediary, where the audience may "visit" the work (and where the few may appropriate it physically). This sequential network paradigm of artist/artwork/gallery/audience severs any sense of responsibility or commitment to an audience, and political artists must seriously question whether it isn't against their interests to perpetuate it.

The art journals—they are actually trade magazines—a main arena for art discourse, have played the utterly vital role of unifying information (and therefore have helped nail the coffin lid shut on true "regionalism," which could not persist in the face of internationalized communication and marketing). Both the front and the back of the book—both criticism and reviews—are essential. In the early seventies the major attention given to photography by *Artforum*, the paramount journal, forged a mighty link in the chain tying photography to the art world. The relations between journals and galleries are

close, and too often covertly monetary. I will pass lightly over the fact that the field of art criticism and reviewing is peppered with puff pieces written by people on the dole from dealers, a fact too well known to be belabored, and which may be more widespread in Europe than in America. But journals patently live on their advertising—gallery advertising. The "new" *Artforum* of 1975-1976, which lionized photography and began a hesitant but injudiciously trumpeted foray into cultural criticism, was slammed by the art world powers-that-be (who literally seemed to fear a Marxian takeover of the editorial policy), and was immediately faced with the danger of destruction by the withdrawal of gallery advertising. Dealers felt that reviews, which are what bring the buyers, were becoming sparse and sloppy and that in any case the journal was jeopardizing its imperiously aesthetic vantage point. Exit the editors.

In addition to commercial galleries there are other places where art is exhibited. There are the museums of course, but such institutions as large corporations, schools, and even some unions run noncommercial galleries as well. These galleries typically play only a small part in those organizations; their reasons for existing are ideological. Large corporations consciously avoid controversial work, wanting to appear as patrons of Art-in-general, not as promoters of this or that trend; they want to brand the work rather than have it brand them: this is not patronage but sales and hype.[12] The audience that corporate galleries attract is much like the general gallery-going public, though it may include the more marginal members. The ticket of entry remains some previous inculcation in the social import of high art.

State and municipally funded art museums play an intermediate role. Having a democratic mandate, they cater to the broadest audiences they can safely attract but have special slots for each level of culture. In the disquiet of the sixties, many museums opened token "community oriented" galleries to show melanges of local work, mass culture, ethnic heritage, and folk-art remnants. But the "Harlem on My Mind" fiasco of Thomas P. F. Hoving's tenure at the Metropolitan Museum of Art in New York demonstrates what trouble high-culture denizens can cause themselves when they attempt large-scale interpretations of minority culture.

Museums of modern art address a more restricted audience than municipal ones. New York's Museum of Modern Art, a project of the Rockefeller family and the Kremlin of modernism, is the prototype in terms of its architecture, its ideology, and the social group it addresses.[13] Its domination extends to

12. The invention of minimal art in the sixties proved fortunate; having no generally intelligible meaning and looking remarkably like nothing other than stray bits of modular architecture, it has sold very well to big companies as appropriate decoration for corporate offices and lobbies, which reflect the same Bauhaus-derived sensibilities. It seems as though there ought to be appropriately lofty photographs to serve where smaller work is desired—the Minor White style of weak-kneed surrealism, say, might be the right choice.

13. For one instigation of the ideological role of the museum, see Carol Duncan and Alan Wallach, "Ritual and Ideology at the Museum," in *Proceedings of the Caucus for Marxism and Art* (Los Angeles, January 1978). For a more extensive treatment by the same authors, see Duncan and Wallach's "Museum of Modern Art as Late Capitalist Ritual: An Iconographic Analysis," *Marxist Perspectives* 1, no. 4 (Winter 1978): 28-51.

contemporary photography and its putative antecedents as well, thanks to the efforts of John Szarkowski, curator of photography.

Museums and noncommercial galleries are under the Damoclean sword of censorship in the form of dismissal of curators and directors or reduced monetary support from donors or board members with conservative tastes. As I suggested earlier, the cultural climate for the showing of "advanced" (thus, low market value) work disappears in times of economic constriction. As donations from individuals diminish, the bureaucratization of art proceeds.[14] Museums are generally conceded to be in some trouble, and many have even opened boutiques selling copies and cultural artifacts within their walls; these thriving businesses create rips in the seamless ideology of museology, and have upset many art-world observers. The December 6, 1976, issue of *Newsweek* reported that: "*New York Times* art critic Hilton Kramer has accused them of destroying the 'sacred hush' that should pervade museums by distracting patrons with 'counterfeit materials.' "[15] The advancing bureaucratization in its corporate-sponsorship form is ominous, for here audience taste may have its strongest negative influence. Corporate sponsors want their names to reach the widest museum-going audience and, as in their own galleries, wish to support only sure winners, art that poses the least challenge to entrenched ideology. Corporations sponsor exhibitions of the most heavily commodified art and that which is most acceptable to mass culture.[16]

14. On a panel about funding at the 1979 meeting of the College Art Association held in Washington, D.C., some of the human meaning of art emerged. On the panel were a representative of Exxon, Robert Kingsley (now dead), needled by Hans Haacke in his work *On Social Grease* for calling art a "social lubricant" necessary for the maintenance of business executives in big cities; someone from the Rockefeller Foundation; someone from the National Endowment for the Arts (NEA); someone from a state granting agency; and a gallery director at a huge California state university. The Exxon and Rockefeller men suavely offered facts, figures, and descriptions of their expanding underwriting of art. The woman from NEA was positive but cautious; the federal art budget wasn't running much ahead of inflation. The audience shared her pleasure over the fact that President Carter's budgetary stringency hadn't affected the arts, and everyone refrained from mentioning what *did* feel that ax: social services and aid to cities. But the gallery director acidly sketched a picture of slashes in state and local art budgets, of canceled shows, of museum and gallery closings, of abrupt firings. The session encapsulated the workings of the fiscal crisis, in which federal control may be consolidated at the expense of state and local control and in which the public sector—with municipalities like New York and Cleveland experiencing the crisis most acutely—must cede a wide range of funding, services, and jobs to the "private" sector. For a powerful analysis of the more general relationship between the State and the private sector in advanced capitalist society, see James O'Connor, *The Fiscal Crisis of the State* (New York: St. Martin's Press, 1973).

15. Think of the uproar over the traitorous project of simulacrum production that *Newsweek* headlined as "Rocky's Art Clones" (October 16, 1978). *Fortune* had it as their cover story, captioning the cover photo "Nelson Rockefeller, Salesman" (October 23, 1978).

16. The largest corporate sponsors include giant conglomerates and multinationals, among them Xerox, Mobil, Exxon, Rothmans, and Philip Morris, for whom patronage is part of a campaign to counter negative publicity by constructing a corporate "personality," replacing a threatening facelessness with a human image. Philip Morris has also used art to create a culturally valorized workplace to "motivate" and pacify workers. I will dwell on this awhile, because it represents in concrete form the instrumental relation that corporations have

Perhaps only the few union-run and community spaces, especially those of and for "third world" communities regularly draw audiences that are solidly working class. In many cases the art shown is art made within the community (which of course is also true of the art world "community"), and the work has some chance of being topical or even polemical. Of all gallery situations it may be here that radical, oppositional work has the best likelihood of realization. Although junior-college and library galleries may also take chances, most are more likely to show work that reveals a missionary intention to bring a warmed-over high art down to the viewers.

In general the gallery system helps keep art directed toward the making

to art, here not merely for "image building" but also in attempting to manage productivity and workers' satisfaction.

In 1974, when massive corporate monetary incursions into art had become a subject of talk, a pair of articles by Marylin Bender appeared side by side in the Sunday *New York Times* (October 20, 1974): "Business Aids the Arts. . . . And Itself" and "Blending Automation and Aesthetics." The first ties the rise of corporate spending to the severe effects of the bearish market on the portfolios of arts foundations and museums during a period of rapidly rising profits in certain industries. The second describes Philip Morris' new plant in Richmond, Virginia, designed around Pop art. It provides, among other lessons, a textbook example of how a shift in audiences immediately destroys irony. The loss of the art-world frame (which had occurred long before 1974, with the reincorporation of postmodern, pop imagery in its new, validated form back into mass culture) meant an airlessness between the visual artifact and its representation, a collapse that destroyed the whispered *critique* of mass culture apprehended by high-art audiences and replaced it with adulatory monumentalization. Oversize graphics as art were, at the Philip Morris plant—"the world's biggest and most highly automated cigarette factory"—strategically placed to contradict the utilitarian character of the jobs done within; to drown out symbolically workers' alienation and its psychological manifestations; to argue the existence of a shared cultural unity between owners, managers, and workers; and to slap a veneer of civilized decor over material issues of health and safety, monetary demands, and the desire for self-determination. Bender writes, "The plant represents a striving for maximum aesthetic return to help attain such mundane business objectives as increasing productivity and edging out competitors in a tight labor market."

To quote Robert W. Sarnoff, collector of contemporary art, vice chairman of the Business Committee for the Arts, council member of the Cooper-Hewitt Museum, formerly a trustee of the Whitney Museum of American Art and currently of the John F. Kennedy Library Corporation, as well as former chairman of the board and past chief executive officer of both NBC and RCA, who has numbered among his positions directorships of the New York Stock Exchange, the American Home Products Corporation, the Planning Research Foundation, the American Arbitration Association, and the Roper Public Service Opinion Research Center, and executive positions at Cowles Publications, and directorships of Manufacturers Hanover Trust, Random House, Banquet Foods, and Hertz; who is a board member of the Institute of Judicial Administration and of several colleges and universities, including Harvard and UCLA; and who has many other business and cultural affiliations, speaking in Toronto in an interview broadcast in March, 1979: "The history of Western civilization is that business has been patron and sponsor of the arts. What's happening in *our* country is that it's a new phenomenon. Business is *beginning* to be a major support of the arts, particularly over the past decade, and it's taking the place of the individual patron, because, frankly, of size and cost. . . ."

The force of pop-as-art-form is summarized in the 15-story "pop obelisk" (designed by Ivan Chermayeff of Chermayeff & Geismar Associates) converting the plant's merely artily designed sign covered with corporate trademarks into a cultural monument. Art's role here is to add its implacable authority to that of the corporation.

of products, toward individual authorship, toward a consistency of media and style, and toward a generalized content. In the art world of the mid-sixties, there was a wholesale rejection of the tiny but hegemonic New York gallery system. Work using social imagery of various kinds—though generally avoiding social partisanship was reduced. Some artists attempted to contradict the commodity status of art by making work that seemed unsalable or that was multiply reproducible. Some began doing "performance" art.[17] But in the succeeding years, the scores of new commercial galleries that opened, and the older ones that reoriented themselves (later opening outposts in Soho, and so on), to cash in on the boom in the art market provided potent reminders of how closely art has remained tied to commodity production.

Efforts to bypass the gallery system included the formation of militantly insurgent artists' cooperative galleries especially by women; the increasing use of electronic and print media, which can be distributed by artists themselves; and the emergence of "alternative spaces" for showing work. The formation of cooperatives was spurred by feminists' resolve to reach audiences both outside and within the art world, despite their exclusion from established institutions, evidenced by the minuscule gallery and museum quotas for women. More importantly, they meant to shake the profoundly male-supremacist orthodoxies of the art world. Cooperatives avoid the domination of an intermediary but often require a prohibitive amount of time and money; and some are simply alternate routes to glory—and the same old audience. As to electronic and print media, they can be quite expensive and are also now well along in the process of commodification. Although these moves have by now been absorbed in varying degrees, their potential isn't exhausted.

So-called alternative spaces embodied a reaction against curatorial hierarchies, often a contempt for the glamorous upper reaches of the audience, and, outside New York, sometimes a rejection of New York domination. Begun as a democratized way of circulating work and ideas among a smaller rather than a larger audience (producers rather than shoppers or browsers—they are sometimes called "artists' spaces"), they pose no inherent challenge to art-world ideologies and have already undergone a fair degree of institutionalization, having been adapted to provide a funnel for government grant money. Those run by artists tend to have a more-or-less explicit though enervated

17. The rejection was of art's commodity status and its consequent vulnerability to market domination far more than of the ideology of art as a specialized entity within culture. Formalism moved away from the stress on composition and transcendence symbolized by Bauhaus aesthetics to the formalism of the Duchampian art-as-idea. There was little overt politicization of the idea of art or much attention to the role of art within class society. And except for a sector of the organized feminists, few artists really went after audiences with less art education. Finally, the fact that the formation of true *work collectives* or collaborations was hardly ever seriously considered reveals much about the retention of auteurship.

It can be argued that the turn away from commodity production was an inevitable further move into the "twentieth century," since handicrafts had long been superseded in the culture at large by industrial objects and images whose existence and power were unrelated to their salability as artifacts and depended, rather, on their existence as texts, bodies of signifiers. Thus, pop appears as a continuation of artists' preoccupation with the process of signification.

anarchic philosophy but, contradictorily rest on state support. They often serve as testing ground for dealers and generate publicity that may lead to sales. They can be manipulated, by clever dealers and others playing on the issue of artistic freedom, into showing work too controversial for a more mainstream gallery.[18] But again, fiscal conservatism is taking its toll on alternative spaces (a number of which have perpetrated astounding overexpenditures with small results), which may become less brave as they also become less numerous and hungrier.

The Assimilation of Photography

The late sixties and early seventies were the high period of the insurgency efforts I just described, which were fueled by a largely antiwar, antiracist, and feminist rebelliousness. That was also the moment in which photography entered the art world. Conceptual and pop artists who wanted to avoid the deadening preciousness and finish of high art and who were moving toward a narrative literalism brought photography and video into the galleries; for pop artists, photography was a form of quotation from mass culture, no more intrinsically respectable than comic books. Conceptual artists, moving away from "object making," also were attracted by the anonymity and negative valuation attaching to these media. But, never far behind, dealers learned to capitalize on the unsellable by inventing the category "documentation," which relies most heavily on photography and written material.

In the early seventies the lack of an established new style, the skyrocketing prices of traditional art objects, the weakening of the stranglehold of the modernist critics, and the consequent faltering of the commercial galleries helped direct attention toward photography as art form. On a more basic level of society we can seek explanation in the restructuring of culture in this period of advanced capitalism into a more homogeneous version of "the society of the spectacle,"[19] a process accelerated by the increasing importance of electronic media (in which all traditional art is represented rather than seen) and the consequent devaluation of craft skills, forms of high social status into celebrityhood, or "stardom." All collapse and dominant cultural forms are increasingly able to absorb all instances of oppositional culture after a brief moment and convert them into mere stylistic mannerisms, thus recuperating them for the market and the celebration of the what-is. In the enterprise of celebrity promotion—of increasing importance in the art world from the time of the

18. Recently, for example, an alternative space showed nastily sadomasochistic photos by a well-connected and, until recently, little-known photographer who was simultaneously showing photos of flowers at a commercial gallery and a museum in the same area. The show later moved on to an alternative space in another city; his powerful backer is, not coincidentally, a photo collector who is accumulating greater and greater power. This is simply art-world business-as-usual looking a little naked in the context of the still-small worlds of photography and alternative spaces.

19. See Guy Debord, *Society of the Spectacle* (revised English translation, Detroit: Black & Red, 1977), and Walter Benjamin, "The Work of Art in the Age of Mechanical Reproduction," in *Illuminations*, ed. Hannah Arendt, trans. Harry Zohn (New York: Schocken Books, 1969).

abstract expressionists onward and now central to the social meaning of art—the role of photography is fundamental.

It is still possible that the meaning structure of art has been undergoing reorganization while the market merely faltered briefly and then regained its stride. The late seventies may turn out to have been a revanchist period in which the controlling interests within the audience and market elites regrouped to reestablish the stratification of the audience and its objects, thereby reasserting, for example, the preeminence of painting as artifactual meaning bearer and as tangible investment. In any case, photography's position is neither threatened nor threatening but rather rationalized within the system.

Whatever its causes, the rapid assimilation of photography into high art has occasioned a continuing series of changes in the place of photography within our entire culture as well as in the meaning assigned to photography as a force within art. The intermingled "history" of photography and painting, formerly disavowed, is now paraded by both sides, though more so by photography people. The following chance quotation from a review reveals the occasional absurdity of using these media to validate each other with no attention to conditioning factors outside the oeuvre of particular producers: "For all his critical sobriety, [Walker Evans] was one of the fathers of pop art . . . Evans' famous print of a small-town photographic studio . . . looks forward to Andy Warhol's hundreds of Campbell soup cans, each painted in its little niche on the canvas."[20] As photography has moved closer in and farther out and then back again to the charmed circle of high art, it has replicated the ideology and many of the gambits of the more established arts. In the current phase of art-world acceptance, the "history of photography" (old prints) is doing better than present work, a fact that seems unarguably market-determined. Photography is selling well and getting regular critical attention (and therefore art-literate audience attention); art-world interest still tends to be confined to dead photographers, to a few unassailably established living ones, and to those closest to conceptual art. There is little interest, indeed, in the photographic discourse that was craft-oriented or a pale version of abstract expressionism, and a new discourse is being developed that can be better assimilated to art-world discourse. Photo critics are retiring in disgust, outclassed by New York art critics working hard to create, borrowing from this or that European school of literary or cultural criticism, a mystified language of comment and analysis in which to couch their increasingly esoteric accounts of the "essence" of photography.

For most of the art world the acceptance of photography seems tied to a vision of it conceived in terms of the modernism now moribund in the other arts. That is not accidental; it was necessary to the process of its legitimation that photography pick up the torch of formalism and distantiation from real-world concerns, for photography had to reengineer its own high-culture/low-culture split: a central matter for photography, which has penetrated daily life and informed our sense of culture as no form of visual representation has

20. Alfred Frankenstein, *San Francisco Examiner & Chronicle Sunday World* magazine (January 21, 1979), p. 56.

before. Photographers are very conscious of Szarkowski's controlling influence, as regnant photo czar, in determining whose career shall be advanced and what gets said about contemporary work. Aside from his responsibility for the course of the careers of Arbus, Winogrand, and Friedlander, his recent elevation of William Eggleston from virtually nowhere in order to corner color photography before mass-media photographers like Ernst Haas or postcard artists like Eliot Porter might be slipped into top spot has chagrined many interested observers. The specifics of his influence on discourse affect the most fundamental relations between the work, the photographer, and the world. They include an insistence on the private nature of photographic meaning (its ineffable mysteriousness) and on the disjuncture between the photo itself and the occasion for its making—old-fashioned art-world commonplaces. It can be argued that these elements of an older art-world discourse still dominate most photographic production and sales promotion while the new art-critical enterprise is restricted to art journals and anti-Szarkowskian production.

Concomitantly with the elaboration of the received doctrines of photography, the picture of the quintessential modern (art) photographer as a marginally socialized person has firmed its outlines. It stands in contradistinction to the conception of photojournalists and documentarians as hardbitten, still artisanal, and rational and to that of fashion photographers as sycophantic (except the few with good publicity).

I can recapture my astonishment at Dorothea Lange, in an interview filmed very near her death, describing a forgotten wartime photo she had rediscovered when preparing her retrospective at MoMA (held in 1966). Szarkowski hovers through the film. We see the photo, showing many men and women filling the frame, frozen in the artificial ranks provided by a broad but unseen staircase; they are dressed as workers and seem to be going off shift. The meaning of the photo, Lange says, is not that all those people were united in a common purpose but that each was looking off into a private internal world. There was a terrible appropriateness in this: for someone who had just survived the fifties, the period of the most deeply enforced artistic passivity and withdrawal into a phantasmic universe, so to rethink the meaning of her project as to stand it on its head, converting a tight, utilitarian nationalism into a grossly atomized individualism. There was no gun at Lange's head; the role of cultural commissar was diffused into the multivoiced propagandizers—including Szarkowski. In a fundamental way Lange's account reproduces the changed account of the documentary enterprise itself, from an outward-looking, reportorial, partisan, and collective one to a symbolically expressive, oppositional, and solitary one; the lionizing of Robert Frank marks this shift from metonymy to metaphor.

Artistic solipsism has now advanced farther than the Lange narrative suggests, yet the incident baldly represents a turning, within the biography of a single artist, into the psychological interior. The art photographer has taken on the figure of the familiar romantic artist, in this case one bound to the use of *apparatuses* to mediate between himself or herself and the world and whose ultimate concern is simply that self. More and more clearly, the subject of all high art has become the self, subjectivity, and what this has meant for photography is that all photographic practice being hustled into galleries must be

reseen in terms of its revelatory character not in relation to its iconic subject but in relation to its "real" subject, the producer.

Levels of Audience and Market for Photography

For most of the art audience and especially for buyers who want investment that will appreciate in value, the *certainty* attaching to elevated sentiments, to the Kantian rhetoric of removal and formal values, to the denial of the relevance of subject and context, offers the reassuring familiarity of a discourse that sounds like art-ten-years-ago, dishing up again the ruling ideas of painting from the late fifties through the sixties. Many photographers produce for this market, and young ones are trained to do so, learning as quickly as young professionals in any field what the road is to success.

So photography penetrated the high-art audience in its moment of hesitation and raised its sights above its previous audience of other, often amateur, photographers. The older, hobby-oriented photo magazines may still concentrate on craft: printing papers, films, lenses, exposure times; but elsewhere the new "semiologic" discourse appears. The new photo journals are being constructed on the model of art journals and the newer, cheaper newspaper-format publications. A great urge for respectability emanates from their very typefaces and layouts. Nevertheless, the smallness and newness of the field is betrayed by the existence of an academic journal calling itself "The History of Photography."

In the realm of production, a theory-inspired approach, referred to as "structuralism," a latter-day minimalist modernism borrowed from small filmmaking, appears in art-photo galleries whereas it could never have entered the photo galleries of an earlier epoch; it has not made it into the controlling commercial dealerships such as New York's Light Gallery or Marlborough Gallery, although the pussy porn of Robert Heinecken is now being marketed by Light. It is usually art audiences and dying-to-be-hip fringes of the photo audience—mostly interested professionals, including curators and critics—that are the audience and potential market for such work.

While art photography was divorcing its old audience and romancing a classier one, the industry was increasing its pursuit for the amateurs.[21] Reports of the new status of photography are disseminated in versions appropriate to ever-widening circles of the audience. The value of the categories of photographic practice, from high art to advertising to family commemorative, is raised, and all the corresponding markets swell in response. Photo exhibitions and art-world attention to photography sell camera and darkroom equipment

21. "For a wild week in December *photokina* packed a dozen halls in Cologne. . . . While commerce reigned supreme in the football-field-sized halls, the aesthetic side of the medium was revealed across the Rhine with photography exhibitions at the city's art museum and at other galleries. The growth of *photokina*, from sleepy trade show to big-time world's fair, reflects the surge in popularity of photography itself. Today photography is a boundless industry with millions of dollars in annual sales. . . . Indeed, it is hard to imagine a more insatiable buying public than that existing in today's photographic marketplace." (John von Hartz, "*Photokina*: World's Fair of Photography," in the "Marketplace" section of Pan Am/Intercontinental Hotel's *Clipper magazine*, January 1979.) Art and commerce are here seen to march in step.

like painting shows never sold brushes and paint. What accident can there be in the fact that the Museum of Modern Art started promoting color photography just when the industry started pushing *home* color darkroom equipment in a big way? One can imagine the bonanza of one-dimensionality in store for us if photo corporations like Kodak can sponsor prestigious exhibitions of auratic prints from photographic history which will not only serve as terrific p.r. but will also lead to an immediate leap in corporate profits. Perhaps Eastman House can have itself declared a national shrine as well.

A new intelligentsia of photography is now being manufactured in universities to dispense the correct cultural line on the meaning of the events being used to mark the march of photography, and to control the received utterances about current work. There is a mutual legitimation at work here: people are engaged in inventing a body of knowledge the study of which will lead to the status-conferring professional credentialing of persons who will thereby be empowered to grant, by their public utterances and other forms of publicity, a legitimacy to that reified cultural entity "the history of photography" and to specific works within it. As the enterprise of art history (itself invented precisely to validate works for collectors) has amply proven, the effect of this legitimation on the market is direct and immediate.[22]

One may be sure that the pantheon of past greats will continue to be enlarged with new "discoveries," for the exhaustion of the stock of vintage prints seems in sight, and new stocks must be added to keep the market up. One may also be sure that photographers will have to attend parties at which they can meet art and occasionally photo critics, may have to read a few art journals, and will have to learn to control public statements about their work. One may be sure also that the firmer the hold photography gains in the art world, the more regular will be the attack on photography's truth-telling ability and on its instrumentality. Already there is little distinction between Winogrand, Arbus, and Avedon in their relation to a truth above the street. Further, a belief in the truth value of photography will be ever more explicitly assigned to the uncultured, the naive, the philistine and will serve to define them out of the audience of art photography.

I confess to looking at the transformation of photography with a mixture of amusement, frustration, and awe. I have no sentimental longings for the clubby days before the surge of the market swept the photo world away;[23] but I am pained to see the mass-hypnotic behavior of those who thought they lived

22. Dealers and buyers look up artists and works, past and present, to see what if anything has been said about them, for example. A tiny further example of the day-to-day relations within a system: At the recent College Art Association meeting (see note 14), there was a scholarly session called "Atget and Today," two of whose participants were Szarkowski and Alan Trachtenberg, a respected social historian with an interest in turn-of-the-century photography. At the back of the hall a young woman handed out discreetly printed cards announcing "EUGENE ATGET, An exhibition of vintage prints, Reception in honor of the delegates [*sic*] to the College Art Association. . . , Lunn Gallery/Graphics International Ltd.," with address.

23. For precisely this lament see Shelley Rice, "New York: What Price Glory" (*Afterimage* January 1978), from which this excerpt is drawn: "It's intimidating to walk into an opening where everyone is over 60 and wearing mink, and photographers are justified in

in a comfortable backwater but now find themselves at the portals of discovery with only a halting knowledge of the language of utopia. I won't forget the theory-terror exhibited at the last meeting of the SPE (my first), or people's fear of offending anyone at all, on the chance that a job, a show, or a critical notice might walk away with them; I both understand and don't understand the pull of fame as it roars near. Artists have had a longer time to learn the game.[24]

There is a sense in which photography, the most reifying of representational forms, verbal or visual, is a sitting duck for the big guns of art. Even in the earlier moments of photography's gallery life, the craft orientation was pervasive; the tradition of single fine prints in white overmats merely replicated the presentational style of paintings and graphics. In Stieglitz's universe art had to be a *propter hoc* motive, not a belated discovery in work originally meant for use. The conversion of photographs that once did "work" into noninstrumental ones marked the next great leap into art. In the historical moment of its utterance, as I tried to show earlier, this insistence on the uselessness of art was meant as a cry of the producers' liberation from the object relations of their product. In an ironic reversal, the denial that the meaning of photographs rests on their rootedness in the stream of social life preserves the photography at the level of object, a mere item of value hanging on a wall.

It requires quite a lot of audience training to transform the relation between a viewer and a photograph to one primarily of mysteriousness, though the gallery dislocation helps. The dual questions of art's instrumentality and of its truth are particularly naked in relation to photography, which can be seen everyday outside the gallery in the act of answering to a utilitarian purpose, in assertions of truth from legal cases to advertising to news reports to home album. This cultural disjunction, made possible by commodity fetishism, accounts for the desperation with which young photographers snatch at the vulgarism that only lies are art and that the truth of photography must therefore be that it is all artful lies, constructions outside the understanding of the common mind. There is an exquisiteness to this hermeneutic, a quiet ecstasy that accompanies the purported lift in understanding that sees beyond the world of appearances through the agency of mere light, magical light, in a leaden culture gone increasingly object-bound. But the art world's sleight of hand consists in substituting another mystificatory veil of meaninglessness for the naive one of transparency.

Let us now imagine a relation between viewer and photographic project

feeling co-opted. From this point on the creative individuals are only the grist for the economic mills. Collectors and potential collectors are now the stars of the show. . ."

24. This would be the place to point to the outrageous sexism and white-skin privilege of the photo establishment, despite the large number of women involved in photography and the far greater number of nonwhites than we ever get to know about professionally. There is also the further problem that the tokenistic partial incorporation of some of women's photography into art-world photography is used to obscure both the question of *oppositional* practice and the dismal inattention to minority-culture photography. That is, a superficial acceptance of some basic feminist demands is used to divert attention from the retrograde practices that prevail. But in these matters photography seems about equal to art; again, the art world has had the time to contruct a better defended facade.

in which the producer actively shares a community with the audience in a different way from the community she/he shares with other producers. I will not make an argument here for a practice that comes far closer to this understanding of art and its place in the world.[25] As a polar situation we can imagine the disappearance of the idea of audience, and perhaps with the ubiquitous standard of the single producer. In the real world we can maintain the movement toward this pole as a tendency. Imagine the implication of the audience in the *formation* of work: it is just this implication of community that is profoundly embedded in the meaning of art. Its present appearance of disconnectedness is more polemical than real, and it has left producers at the mercy of everyone but their nonpurchasing audience. Arnold Hauser observed that the doctrine of art's uselessness was the result of the fear of the upper classes after the French Revolution that they would lose control of art.

The lie of official culture is that society-invested art is sullied, deficient in its conception, deformed in its gestation, brutalized by the conditions of its birth, and abused in its lifetime. To rescue ourselves from this damaging fiction surely requires a new emancipation from market relations, and it demands a re-thinking of all the facets of the production of art within culture. The leveling effect of money, of commodity relations, so that all photographs are equal regardless of what they depict and in which standards of quality are external to iconographic statement and intent, must be challenged at every turn:

> [T]o supply a productive apparatus without trying . . . to change it is a highly disputable activity even when the material supplied appears to be of a revolutionary nature. For we are confronted with the fact . . . that the bourgeois apparatus of production and publication is capable of assimilating, indeed, of propagating, an astonishing amount of revolutionary themes without ever seriously putting into question its own continued existence or that of the class which owns it.[26]

To make this argument is not to call for artists to change masters but to effect a break with preceding practice in a strong and meaningful way. We are in a period in which oppositional practice is regaining its strength and taking on international aspects. We must inventively expand our control over production and showing, and we must simultaneously widen our opportunities to work with and for people outside the audiences for high art, not as annunciatory angels bearing the way of thought of the *haute monde*, but to rupture the false boundaries between ways of thinking about art and ways of actively changing the world.

25. Instead I refer you to Allan Sekula's "Dismantling Modernism, Reinventing Documentary (Notes on the Politics of Representation)," *Massachusetts Review* 19, no. 4 (Winter 1978): 859-883, which defines an oppositional practice emerging from a conscious break with the late-modernist paradigm.

26. Walter Benjamin, "The Author as Producer," translated by Anna Bostock in *Understanding Brecht* (London: New Left Books, 1973), pp. 93-94. [An alternate translation is reprinted in this volume, pp. 297-309.]

Postscript In 1979 I was asked by the editor of *Exposure* magazine, which is published for its members by the Society for Photographic Education, to write something about the audience for photography. Interest in this question was high because photography in the 1970s had greatly expanded its public appearance as a high art and cultural good. It had begun to seem worthy of all kinds of attention, from artists and art students as well as from journalists and their publics, art writers, collectors and investors, curators and museum acquisitions boards, and scholars. More than just a past, present, and future, photography appeared to possess a specific historical presence or "tradition," one that—who knows?—might make it a rival of the other fine arts. What were the limits to photography's command?

Descriptions of its meanings and possibilities offered in art schools and the press were likely to differ from any I might give. Despite the complexities of interpretation and explanation in most other fields, photography's tended to concentrate on the psyche, on the one hand, and on technical change, on the other. Writing on photography was usually belletristic or reductively formalist, a weave of modern shibboleths. The perspective on photographic history would likely see only an upward spiral into aesthetic significance. I did not intend in my article to counter these approaches or propose alternative theories of motivation and intention. Instead, I wanted to open up the question of audience to include some essential factors typically overlooked in such accounts. I wanted to look at some of the institutions and processes governing distribution and helping to direct production—some of the things I thought people using photographic media with some relation to the art world might find interesting, something on the order of a mild sociology and economic report.

What strikes me most strongly now about this essay is its sneaking optimism. I overestimated the power of consistency and memory, both personal and collective, in fashioning behavior, and I underestimated the pressure for cultural change. Things might well have been different if a corporatist like Jimmy Carter had been reelected president in 1980, but the conservative sweep that was the response of the eighties to the worldwide crisis of capital set the tone for a corresponding change in cultural as well as political and social discourses and institutions. It might be interesting to trace some of these changes and their effects on the art world.

Although this essay's prediction of a restored production hierarchy in art and the revalorization an elite culture for social elites proved correct, I could not have guessed the dimensions of the neoexpressionist juggernaut. Nor did I foresee the degree of incorporation of at least the images of dissidence and difference (often a bedrock of urban ghetto culture) into the newly revitalized art-cash nexus.

Still, this incorporation may make sense during such a period of restratification. After all, Reaganism in triumph meant to usher in a new age, with a totalizing philosophy not only of governance but of existence, and thus a new Chain of Being: a new order of social relations and a new account of their contents. Despite the magnification of a "privilege differential" between rich and poor, all must be symbolically incorporated as "types" into that chain. Thus, aspects of urban ghetto culture and of political dissent—even including

remnants of the rhetoric of revolution-as-liberation—win acceptance, in a kind of symbolic lottery, into high culture's "style avant-garde."

But in such a period, in which the fortunes of the rich and acquiescent are tended by the State while everyone else takes her or his chances, those whose dissidence is substantive rather than ornamental will be granted little acceptance and less funding.

The move to the right has skewed rightward the spectrum of public discourse, making the Right's positions the touchstone of debate and common sense and bringing a new respectability to its fringes. The press and the electronic media push the range of Rightist opinion, parading an array of "commentators," characters, think-tank analysts, and advocates of dictators and counterrevolutionaries, military adventurists, and marauders, all for the State's sake. The open elevation of principles of me-firstism and "might makes right" above the rule of law does nothing for the spirit of justice. (Even Jimmy Carter said that life wasn't fair.) Since the late seventies the preferred facial pose for models and some pop celebrities combines a narcissistic pout with a narrow-eyed stare.

In the arts, funders, sponsors, and curators beat a prudent retreat in the face of Hilton Kramer's barrages from the safe haven provided him by the very rich and very right-wing John M. Olin Foundation and the Scaife Family Charitable Trusts. Despite this lone assassin's potential clout with the National Endowments, the outright tampering with those agencies' grant-giving mechanisms is, of course, mainly the work of the Reagan team players who head the Endowments. With their lead, support not only for dissidence but for difference suffers a chill. Curators, investors, and museum boards, who, after all, *are* the rich as well as tending the culture of the rich, grow impatient with the experiments of bohemia and with seemingly egalitarian, sociological, or critical work. Small museums and the remaining "alternative spaces," even if not terrorized by ideological thunder, can hardly afford to back them on their own.

The mass media of course played a vital role in the cycle of change, heralding the appearance of Reaganism with a new coat of paint on the latest model of the gray flannel suit. As the *New York Times* was informing its readers of the jubilation in certain foreign, particularly Latin American, capitals upon Reagan's accession, it was also proclaiming "A New Opulence Triumphs in Capital" and (notoriously) "Living Well Is Still the Best Revenge." The limousines and ball gowns packed away for the duration of down-dressing populism came out of the closets, and ostentatiousness was touted as the pinnacle of tastefulness. Aggressive-looking white folks in cashmere business suits and horn rims became the TV hucksters of choice for drugs, magazines, computers, underwear, and "financial services." Competitiveness in the battle for "fitness" (to better one's chances of survival?) invaded leisure, and executives and executive trainees dressed their babies in pin-striped pajamas and enrolled them at birth in the ivy-league colleges of their choice. Strongly Nordic types, in family formation, suddenly debuted in the *Times'* sections and in pages-long advertisements for "in" designers like Ralph Lauren. Black faces vanished from clothing and lifestyle ads. But as in the Great Depression, all America

hoped to strike it rich—most of them through the purchase of lottery tickets—or dress like the rich. In New York's Harlem, East and West, Ralph Lauren is also "in." Even for the rich, the word "wealthy" is out, and "rich" is in.

For us now, style—sartorial and rhetorical—suffices where reality cannot. The symbolic expressions of political dissidence likely to receive the widest attention during this period of cultural reintegration (however fleeting) will also be those played out in the arena of commodity culture. Sure enough, the most visible and successful in this period have been associated with New York's style avant-garde, with New York's street culture, and with reworkings of mass-media photographic imagery, returned to the marketplace as low-ticket art commodities and wearables. Notwithstanding accompanying claims of subversive intervention, the irony here is that the project of the historical avant-garde, to merge art into life, has been interpreted as the achievement of a status of near-indistinguishability from other designer goods.

The cheerleader optimism that Reagan introduced makes its mark in the art world as a display of energy, of "energetic-ness," in art—heat instead of coolness, perpetual motion in place of stability—as a marker that floats free of content. Upscale and upbeat walk hand in hand. Yet much of the art in question is down-side: images of torment and decay, destruction and apocalypse. (The return of the repressed? Or just the price those on top pay for the constant reminders of life below—and the danger posed by those who live it.) In the East Village galleries the fashionable cynicism that leads graffiti (etc.) artists to claim they are just "ripping off the rich" is less interesting than the petty-bourgeois entrepreneurialism distinguishing them from the bohemianism of the (former) avant-garde.

The market and the press for large-scale, flamboyant expressionism add up to big business. Capital-gains tax laws have been adjusted under Reagan stewardship to favor traditional investments once again; the magic ingredient, "investor confidence," has returned to the stock-and-bond market; inflation is moderating; and the U.S. dollar has—disastrously for the rest of the world, but never mind—reached a new high. As I noted in the article proper, the economic contractions of the seventies were already helping destroy the para-economic counterculture, severely dampening its art-world manifestations and causing art production to retreat to major urban centers, especially New York. These changes helped pave the way for the incorporation I described a bit earlier. The recent new recapitalization in art means an intensive working of these urban centers along with a demand for investments with rapid, high return—as Lower East Side real estate goes, so goes its art, or so dealers and investors hope. With respect to neoexpressionism, from the point of view of the investor all the institutions of the art world have conjoined to create a fully legitimated and therefore safe investment that nevertheless has the necessary appearance of ideological risk and—that most favored intangible of conservative eras—"creativity." The tangibles and collectibles market could not stand up to the economic pressures (let alone the ideological ones) generated by these attractive prospects and the tremendous oversupply of new lower-end (East Village-type) production they have engendered.

Performance has left its marginal status as quirky ephemera, non-capital-

generating, artist-oriented art, and found a new life as a type of theatrical extravaganza with guaranteed upscale entertainment appeal, a kind of late-twentieth-century avant-garde opera or virtuoso vehicle.

Needless to say, the neoexpressionist revival and the accompanying shelving of the communication model in art have not been good for photography. Photography has come to seem rather lukewarm, to investors and young artists (and art schools) alike. Why fool around at the low end of things when big prices, big reputations, and big investments are in the offing? But photography, although no longer a glamor item, still lives. New lines of production are being pursued, while criticism and museumization also continue. This year (1984) a major study facility was established in Southern California at the J. Paul Getty Museum, best known for its huge budget and its hide-bound conservatism. The new collection is based on those of at least two major collectors, Arnold Crane and Samuel Wagstaff, who have thereby dramatically elevated their influence; and the museum has wooed away the photo curator of New York's Metropolitan Museum, all of which erodes the power of MoMA's John Szarkowski.

In showing and collecting, high-brow aestheticism, from Stieglitz to more contemporary color-field photographers, has gotten more play. The other popular line is also art-derived (for want of a better term), but it stands in sharp contrast to fine-print or other straight photography. This work, which art writers call "appropriation" because it uses media images directly, links representation and power, drawing on media theory and semiotics, and often feminism as well. Ultimately, it is a child of Pop Art, one more sanguine than its parent, perhaps, but still suffering from Pop's deceptive transparency: the immediacy with which its surface offers itself for consumption by a mass audience mutes or liquidates its potential for open criticism. Allegory and aestheticism become attractive or even imperative in times of repression or despair. Here the situation is made more problematic by the felt need to employ mass syntax whereas the apparent readability of the ensuing work almost ensures misunderstanding. Yet this work's ability to engage with social and political issues cannot be overlooked.

It may be that such work stands for mass culture in the broadest sense but does so in the form of mass-media images; another indication of the seeming totality of cultural incorporation, its complete inclusiveness that makes representation in mass-media images seem the lowest-rung requirement for anything meaningful to exist, the one at which the circulation of the copy justifies the existence of the original. In video (aside from traditional documentary) the biggest successes are also scored by work that sticks close to the broadcast image or uses the editing paths and displays the "production values" identifiable in network or corporate logos, commercials, or music television (itself a teasing out of the surrealism basic to other kinds of advertising). The universe presented by the media, with its own focus on the problematic relation of representation to truth, becomes the reference point for practically everything. This ultimately enhances photography's prospects, if not now, then later —but not necessarily for fine-print work. Many formerly straight photographers have turned to making collages and tableaux or other "made-to-be-photo-

graphed" work, acknowledging the self-referentiality of photographic form. The investigation of representation and power and other, more direct politicizations of art have assisted new forms of photo documentary to find audiences both in and outside the art world.

The art world has indeed changed since 1979, when this article was written. But the transitory feel of the social and political scene lends the cultural one a fragile air. Far-Right Reaganism has already receded, leaving behind a dull-as-normal Statism. If "yuppies" are the future, as they and their supporters claim, more change will come. Young urban professionals are, or grow up to be, the professional and managerial (and technical) sectors referred to in the opening sections of this article. As productive labor continues to decline in importance and the middle-class wage to become rarer, these sectors will pull more social and cultural weight. They are not moss-backed conservatives or patriarchal Bible-thumpers, but their buoyant philosophy of entrepreneur-led growth to solve the nation's ills makes them no friend of the poor and even less of the technologically unemployed. Their antimilitarism, profeminism, and what might be called therapeutic environmentalism put them strongly at odds with Administration policies. What their tastes in art will turn out to be remains to be seen, though at present they like photography because it satisfies their taste for technical control and seeming aesthetic neutrality.

This postscript serves as another illustration of how social configurations enfold and constrain art production. What we still need, of course, is even the beginning of a theory of motivation in the production of art.

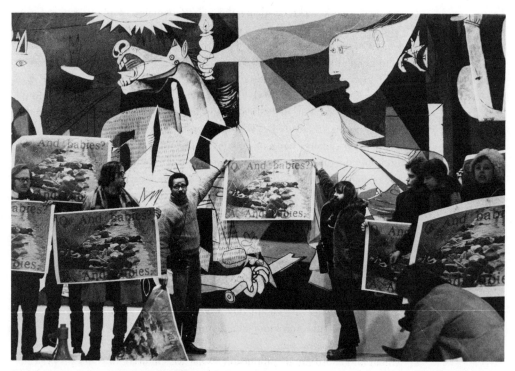

Demonstration by the Art Workers' Coalition and the Guerilla Art Action Group at The Museum of Modern Art (before Picasso's *Guernica*), January 3, 1970. (Photo: © Jan van Raay)

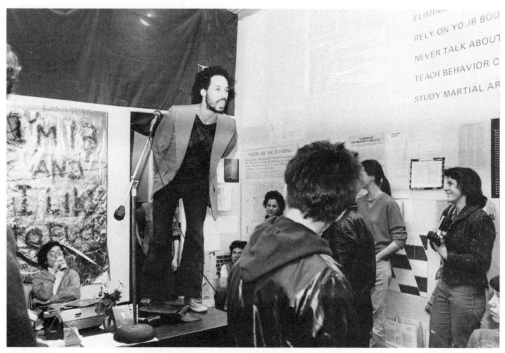

The Manifesto Show, organized by Jenny Holzer and Colen Fitzgibbon, 5 Bleecker Street, New York, Spring 1979. Joe Lewis performing. (Photo: Vincent Falci)

Trojan Horses: Activist Art and Power

L U C Y R . L I P P A R D

Maybe the Trojan Horse was the first activist artwork. Based in sub-version on the one hand and empowerment on the other, activist art operates both within and beyond the beleaguered fortress that is high culture or the "art world." It is not a new art form so much as it is a massing of energies, suggesting new ways for artists to connect with the sources of energy in their own experience. Today, in 1984, there is a renewed sense of the power of culture to affect how people see the world around them. Activist art—sometimes called "the movement for cultural democracy"—then provides "a developing, shared consciousness whose impact we can't predict. . . . a kind of consensus in practice that is now at a stage of consciousness-raising and organizing." [1]

Given the evolving, pragmatic nature of activist art, the following is less a survey or history than simply an attempt to place activist art in relation to the art world and to political organizing. The essay is divided into four parts: an argument for activist art; thoughts on the power of art; some of the sources of recent activist art; and some examples of various art strategies and practices from 1980 to the present. I want to make it clear that I don't think it's necessary for all artists to make activist art (although I *would* like to see every artist—like every other citizen—be politically informed and responsible). Activist art is simply the subject of this essay, which happens also to be the subject of most of my activities. I'm as happy as the next art type to be overtaken by sheer aesthetic pleasure and surprise. Though I remain partial to a culture that leads us not into the valley of thoughtlessness but to the moving of mountains, I'd be a hell of a cultural democrat if I didn't spend a lot of time and energy looking and thinking about all the other kinds of art. I only wish the process went both ways more often. Much activist art is innovative and expansive and the mainstream could learn from it, just as activists learn from the mainstream.

1. Arlene Goldbard and Don Adams, "From the Ground Up: Cultural Democracy as a National Movement," *Upfront*, no. 8 (Winter 1983-84): 6. Goldbard and Adams were for several years the prime movers of NAPNOC (Neighborhood Arts Programs National Organizing Committee), which has now been renamed the Alliance for Cultural Democracy; it is a national liaison between progressive community groups for all the arts. Goldbard and Adams' developing theory of cultural policy is invaluable; other articles by them are to be found in *Art in America* 70, no. 4 (April 1982): 21-25; *Fuse* 6, nos. 1-2 (May-June 1982): 11–16; and in all back issues of *Cultural Democracy*.

I. Argument

The movement for cultural democracy is a critique of the homogeneity of the corporate, dominant culture, which serves very few of us while affecting all of us. We see this culture melting (or microwaving) down the multiracial, multicultural differences that are this country's greatest strength and its greatest hope for understanding and communicating with the rest of the world before we destroy it. Thus art reflecting lived experience in different constituencies will differ. This is both an advantage and a disadvantage as the Black, Latin, and Asian art communities know well.

Cultural democracy is a right just like economic and political democracy, the right to make and to be exposed to the greatest diversity of expression. It is based on a view of the arts as communicative exchange. A true cultural democracy would encourage artists to speak for themselves and for their communities, and it would give all of us access to audiences both like and unlike ourselves. We have learned from Amilcar Cabral that self-expression is a prerequisite for self-empowerment. This doesn't mean that everyone has to make art any more than creating a politically aware populace means everyone has to become a politician. It means simply that the power of art is curtailed unless it is understood in the broadest sense and accepted as a possibility by everyone.

Activist art is confined to no particular style and is probably best defined in terms of its functions, which also cover a broad span. It does not, for the most part, limit itself to the traditional art media: it usually abandons frames and pedestals. It is an art that reaches *out* as well as *in*. To varying degrees it takes place simultaneously in the mainstream and outside of accepted art contexts. In practice, activist art might include teaching, publishing, broadcasting, filmmaking, or organizing—in or out of the art community. It often incorporates many different media within a single, long-term project. Most activist artists are trying to be synthesizers as well as catalysts; trying to combine social action, social theory, and the fine arts tradition, in a spirit of multiplicity and integration, rather than one of narrowing choices.

Activist art is not only "oppositional," although it is usually critical in some sense. As an art of contact, it is often hybrid, the product of different cultures communicating with each other. Activist artists do not expect, say, to change Ronald Reagan's values (if he has any), but to oppose his views of war and de-humanism by providing alternative images, metaphors, and information formed with humor, irony, outrage, and compassion, in order to make heard and seen those voices and faces hitherto invisible and powerless. Sure, this is idealistic. Art is hardly a pragmatic vocation. Of course, each artist's motivation is different, but a deep frustration with the limited functions and outlets for art in Western culture and a sense of alienation from audiences is why most of us have become activists.

It all begins with that other idealism—the one we are fed in schools—about art being some exalted "gift" to society and artists being lone, superior geniuses, whooping it up in their ivory garrets. However, when students get out, they often find it is hard to give their "gifts" away: some succeed, some get bitter, and some try to demythologize the role of art and to change the system in which it operates. For those who need to see immediate results (a large check and/or instant fame), such a long haul is highly unsatisfying. But

rewards come precisely in the *process* of that engagement. Activist artists tend to see art as a mutually stimulating dialogue, rather than as a specialized lesson in beauty or ideology coming from the top down. It is unhealthy, though, to call these artists (either condescendingly or admiringly) "watchdogs" or "the consciences of the art world," as if their presence precluded the need for general or individual responsibility.

Activist art is, above all, process-oriented. It has to take into consideration not only the formal mechanisms within art itself, but also how it will reach its context and audience and *why*. For example, Suzanne Lacy's feminist dinner/ organizing/performance/media events culminate in recognizable "art pieces," but in fact the real work includes the yearlong organizing and workshops that led up to it, as well as film and documentation that may follow. These considerations have led to a radically different approach to artmaking. Tactics, or strategies of communication and distribution, enter into the creative process, as do activities usually considered separate from it, such as community work, meetings, graphic design, postering. The most impressive contributions to current activist art are those that provide not only new images and new forms of communication (in the avant-garde tradition), but also delve down and move out into social life itself, through long-term activities.

A few more examples:

• Tim Rollins' ongoing work in collaboration with his learning-disabled high school students in the South Bronx, including objects as well as huge collage-paintings, produced in class but derived from the students' experiences of the world.

• Mierle Laderman Ukeles' five-year involvement with the New York City Department of Sanitation, a project which includes exhibitions and public and private performances.

• Carnival Knowledge's ongoing collective work on feminism, reproductive rights, and sexuality, which takes the form of street bazaars, exhibitions, and other public events.

• Judy Baca's still-expanding mural, *The Great Wall of Los Angeles*, in which the history of Third World residents of California is painted, but also *taught* to local youth; it also incorporates "social work" with local teenage gangs and provides economic support in beleaguered Chicano communities.

• Loraine Leeson and Peter Dunn's posters and inventive multipanel, changing photomontage billboards in East London, which have become not only part of the local landscape but of the local political scene, covering recent hospital closures, housing and labor issues, and gentrification.

• Public performance groups, such as the Waitresses, Mother Art, and Sisters of Survival (SOS) (all daughters of the Woman's Building in Los Angeles) which concentrate on specific issues, such as labor relations, nuclear disarmament, and the sexism inherent in the "kids or career" choice.

• In Australia, Vivienne Binns and Annie Newmarch are professional, government-sponsored "community artists" who show in museums their own and collaborative artworks generated in rural and suburban

neighborhoods. Peter Kennedy's long-term work on Australian history centers on the governmental coup of November 11, 1975, and takes the form of elaborate embroidered banners and documentary film and video.

And so forth. Subjects and mediums are so varied that it is very difficult to generalize about activist art.

What these diverse works *do* share is the way style and aesthetic are deeply entwined in the social structures in which they operate. These artists often work in series—not autonomous series for exhibition, but ongoing sequences of learning, communication, integration, and then relearning from the responses of the chosen audience. When Jerry Kearns, for instance, became interested in racial and sexual stereotypes in the media in 1980, the way he made "studies" for eventual paintings was to work in the South Bronx with the Committee Against *Fort Apache* (a citywide coalition protesting the racist and sexist representations of Blacks, Hispanics, and women in the film)[2] and in Brooklyn with the Black United Front, then to organize a travelling group show on the subject. Sometimes the process goes the other way: Greg Sholette moved from making an acerbic artist's book on the way in which Citibank "puts neighborhoods to rest," to working actively in the community with Political Art Documentation/Distribution's "Not for Sale" Project, against gentrification on New York's Lower East Side, while continuing to make "exhibitable" art on related issues.

Two frequent criticisms of activist art run as follows: "Art can't change anything, so if you care about politics you should be a politician instead of an artist." (This plays in tandem with another act called, "It's not art, it's sociology.") Next comes "Social-change art is rendered useless when co-opted by exhibitions and sales within the mainstream art world."

Activist artists are not as naive as their critics. Few labor under the illusion that their art will change the world directly or immediately. Rudolf Baranik has pointed out that art may not be the best didactic tool available, but it can be a powerful partner to the didactic statement, speaking its own language (and, incidentally, sneaking subversively into interstices where didacticism and rhetoric can't pass). With the deepening and broadening of activist art practice in the United States during the past five years, this partnership is receiving more consideration from political groups as well as from the mainstream. It is also crucial to remember that grassroots activism begins at home. We tend to forget that organizing within the art community is also "effective." Artists alone can't change the world. Neither can anyone else, *alone*. But we can choose to be part of the world that is changing. There is no reason why visual art should not be able to reflect the social concerns of our day as naturally as novels, plays, and music.

As for co-optation, the more sophisticated activist artists become, the more they are able to make art that works on several levels. They can make

2. See Lucy R. Lippard and Jerry Kearns, "Cashing a Wolf Ticket (Activist Art and *Fort Apache: The Bronx*)," *Artforum* 20, no. 2 (October 1981): 64–73, for an account of this media campaign and its relationship to activist art.

specific artworks for specific audiences and situations, or they can try to have their cake and eat it too, with one work affecting art audiences one way and general audiences another. They will try to do so without sacrificing complexity or aesthetic integrity, and without being assimilated into and manipulated by the dominant culture. Art that is not confined to a single context under the control of market and ruling-class taste is much harder to neutralize. And it is often quite effective when seen within the very citadels of power it criticizes. Beware of artists baring their gifts.

Because activist art is rarely taught in schools, there are few known models and it is important that the extant ones are made as visible as possible. For example, Carole Condé and Karl Beveridge's color photomontage series, made after collaborative processes with unionized steel workers and auto workers in Canada, offer the high art audience technically brilliant and original art about unfamiliar lives and issues, while in the workplace the same works are organizing tools, reinforcing solidarity as well as telling mutually significant stories. Such works may not be for sale, or they may be sold and still remain in the public sector, in that they continue to exist in other contexts after they are "bought." And if the private establishment enjoys owning unflattering mirrors or thinks their ownership defuses the political effect of the work, they are nonetheless supporting further opposition. Given capitalism, it's not a bad tradeoff.

II. Power

The power of art is subversive rather than authoritarian, lying in its connection of the ability to make with the ability to see—and then in its power to make others see that they too can make something of what they see . . . and so on. Potentially powerful art is almost by definition oppositional—that work which worms its way out of the prescribed channels and is seen in a fresh light.

Despite art's public image of haughty powerlessness and humiliating manipulatability, a growing number of activists in and out of the cultural sphere are beginning to confront its potential power. However, the culture that is potentially powerful is not necessarily the culture that those in cultural power think will or should be powerful. Power is generally interpreted as control—control over one's own and others' actions. The myth of culture's powerlessness stems from a misunderstanding of the basis of art's authority and authenticity. Art is suggestive. The motions it inspires are usually e-motions. In the art world, a powerful artist is one whose name can be used. Name, not art. ("I bought a Starr," like "I bought a piece of Starr," dangerously close to "I bought Starr.")

Or perhaps it's more accurate to say the power of the artist is separated from the power of the object. Once art objects had literal power—magical, political power—and the artist shared in this because s/he was needed by the community. (Who needs artists today? What for? Who decided the art object was to have such a limited function?)

If the first ingredient of art's power is its ability to communicate what is seen—from the light on an apple to the underlying causes of world hunger—the second is control over the social and intellectual contexts in which it is distributed and interpreted. The real power of culture is to join individual and

Christy Rupp. *Making Visible During the Day Something Which is Nocturnal* (formerly *Rat Patrol*), 1979. Posters: offset printing on paper, each 6 x 18″ (15.4 x 46.2 cm). Various sites in New York City

John Fekner. *The Remains of Industry,* from *Queensites,* 1981. Paint stenciled on brick wall, Trunz Meat Factory, Greenpoint, New York

communal visions, to provide "examples" and "object lessons" as well as the pleasures of sensuous recognition. Ironically, those artists who try to convey their meanings directly are often accused of being propagandists, and their accessibility is thus limited to those not afraid of taking a stand. The ability to produce visions is impotent unless it's connected to a means of communication and distribution.

Political realism is usually labeled propaganda. Yet racism, sexism, and classism are not invisible in this society. The question of why they should be generally invisible in visual art is still a potato too hot to pick up. Because it is so embedded in context, activist art often eludes art critics who are neither the intended audience nor as knowledgeable about the issues and places as the artists themselves have become. The multiple, drawn-out forms can also be confusing because innovation in the international art world is understood as brand-name, stylistic, and short-term, geared to the market's brief attention span. Conventionally, artists are not supposed to go so far beneath the surface as to provoke changed attitudes; they are merely supposed to embellish, observe, and reflect the sites, sights, and systems of the status quo.

Artists have an unprecedented kind of control over their own production, but most lose it immediately in the post-production phase. They lose control not only of the object, but of its objective. When a work of art is out of the artist's hands it gets out of hand in several senses. Touch, or connection (described by some artists—not just women—as an umbilical or parental connection) to a work, can be lost at this point. Like a child, the work is abandoned to an independent existence in a world that may transform it beyond recognition—framing it wrong, hanging it in bad light, mystifying it, stripping it of its ideology or, conversely, using it to prove other political points.[3] At this stage, the artist surrenders the power of the object to the dealer, museum, or new owner, turning back to the studio, to new work over which s/he still has the illusion of control.

Some of those who insist that art is powerless feel that its power lies precisely in that powerlessness—that art escapes social pressures by being above it all or below it all. There's some truth in this, but it tends to encourage irresponsibility. Others see power as it is defined by the dominant culture—in terms of money, prestige, media coverage, and the possibility of telling people what to do—definitions that by definition exclude conventional notions of art, but not necessarily activist art.

It helps to look at those power struggles in which most artists become embroiled in spite of themselves. Ask yourself—who is more powerful? Is it the famous mainstream artist whose work is seen by thousands in museums and occasionally by millions in *Time* magazine, who enjoys all the symbols of power

3. The classic case is the use of abstract expressionism (the New York School) as a cold war weapon by the U.S. government, first documented by Max Kozloff, "American Painting During the Cold War," *Artforum* 11, no. 9 (May 1973): 43-54; William Hauptman, "The Suppression of Art in the McCarthy Decade," *Artforum* 12, no. 2 (October 1973): 48-52; and Eva Cockcroft, "Abstract Expressionism, Weapon of the Cold War," *Artforum* 12, no. 10 (June 1974): 39-41.

bestowed by the high art establishment (grants, sales, exhibitions, articles, awards)? Or is it the relatively-unknown-in-those-circles artist (usually of conservative bent) whose constituency may be larger and who may be just as rich, but who is denied the validating touch of the "quality" wand by those in cultural power? Or is it the mass-media artist who reaches millions daily but whose name is unknown to those s/he is reaching? Or is it the militant feminist or socialist artist who has chosen invisibility in the art world in favor of a limited but self-determined visibility in the "real world" of community, schools, demonstrations, and other specific audiences? Or could it even be the humble "folk artist" and hobbyist whose audiences are their neighbors, whose art reflects inaudible voices and invisible lives within the small arenas where those voices are heard and those lives familiar?

III. Sources

Today's activist art is the product of both external and internal circumstances. Even though most art is not directly affected by the external social situation, most artists as people are. The government's domestic and foreign policies and consequent waves of bureaucratic funding and defunding have obviously affected the market, exhibiting, and educational structures within which all art operates. Internally, today's activist art is the product of three separate camps of artists which came together around 1980, at a time of increasing conservatism, economic crisis, and growing fear of World War III. These three camps had similar concerns but very different styles and contexts, and only sporadic intercommunication. They were: (1) experimental or avant-garde artists working in the mainstream or "high art" community; (2) progressive or so-called "political artists" working together or within political organizations, often simultaneously in and out of the mainstream art world; and (3) community artists working primarily outside the art world with grassroots groups.

Although this situation is paralleled to lesser degrees elsewhere in the United States and in other parts of the world, this essay focuses on my own local experience in New York City. That experience has often been fueled by networking with other parts of the country and the world (especially England and Australia, sources of some of our major activist art models). However, the entire history of this movement has yet to be written and, at the moment, would probably be limited to those areas where urban experience, political consciousness, and a fairly healthy art scene overlap.

For better or worse, it all starts in the mainstream, where more and less experimental artists have tended to identify directly with oppressed and rebellious people as artists, but not in their artwork. Mainstream or potentially mainstream artists are likely to be wary of group activity, which is often seen as weakening individual expression and damaging careers. Though there is little enthusiasm for, or knowledge about, art activism in this milieu, there is genuine, if occasional, support for good causes.

"Political" artists are inaccurately assumed to be exclusively creatures of the left, as though anarchy and establishmentarian neutrality were not also "political." (One succinct definition of a non-political artist: "It is just an-

other way of saying, 'My politics are someone else's.' " [4]) For present purposes, I'd describe a political artist as someone whose subjects and sometimes contexts reflect social issues, usually in the form of ironic criticism. Although "political" and "activist" artists are often the same people, "political" art tends to be socially *concerned* and "activist" art tends to be socially *involved*—not a value judgment so much as a personal choice. The former's work is a commentary or analysis, while the latter's art works *within* its context, *with* its audience. During the 1970s, "political" and "activist" artists, working with feminist groups or organized dissenting artists' groups (such as the Art Workers' Coalition, Artists Meeting for Cultural Change, the Anti-Imperialist Cultural Union) were traditionally alienated from the mainstream, though individual degrees of belligerence and isolation varied, depending on what kind of organizing was going on within the art world at any one time.

Community artists vary in degrees of politicization, and in the past have most often shunned and been shunned by the high art world. They work naturally in groups, most often as muralists, performers, teachers, or artists-in-residence in community centers. Some community art reflects its local situation, some stimulates active participation in its situation, some criticizes and mobilizes for change in that situation. Cityarts Workshop was New York's best-known community arts group in the 1970s, working primarily on organizing mural projects in neighborhoods throughout the city.

I could keep on drawing lines until I had a web that would provide a more accurate (if still more confusing) picture than the oversimplifications above. I've chosen categorization not to be divisive, but because it seems necessary to understand the three interrelated strands of current activist art. Increasingly, they overlap and are harder and harder to distinguish from each other. For example, are the youngish New Wave artists who run ABC No Rio—a chaotic and energetic storefront space on the Lower East Side—community artists, experimental artists, or political artists? Either one, or all three, depending on whether one looks at their style, their intent, their content, their effect.

Perhaps the general nature of these quasi-definitions will be clearer with a little internal history to back them up. Most of us were raised to see painting and sculpture as powerless to communicate except on specialized levels. They were separate not only from the rest of the world but from the rest of culture. Since the late fifties, however, the visual art world has been increasingly open to marriage (or at least affairs) with music, dance, theater, philosophy, fiction, and sometimes sociology and politics. During the last twenty years, there has been a gradual recognition that forcing artists to choose between rigidly defined mediums and roles, or between art world and "real" world, is a classic way of keeping everybody in their places. Divisiveness through division of labor—still reflected in remaining taboos against the interdisciplinary—is a vestige of early-sixties, Greenbergian formalism, in which a medium was claustrophobically

4. Hélène Cixous, "Castration or Decapitation?" *Signs* 7, no. 1 (Autumn 1981): 51; quoted by Nancy Spero in interview with Kate Horsfield, "On Art and Artists: Nancy Spero," *Profile* 3, no. 1 (January 1983): 17.

understood to be "best" when most "refined"—or confined—to its defining characteristics; e.g., painting is a flat, decorated surface and that is all it can be.

Today's activist art has its roots in the later sixties, in rebellions against such simplistic views of art. It comes not so much from the raised fists and red stars of the "revolutionary" left as from the less consciously subversive reactions against the status quo that took place in the mainstream—primarily in minimal and conceptual art. These blunt and blatantly noncommunicative styles harbored a political awareness characteristic of the times, which even the isolated art world finally couldn't escape. "Fabrication" and "dematerialization" were two strategies minimalists and conceptualists used, respectively, to offset the mythification and commodification of artist and artwork. These strategies didn't work and didn't "get art out of the galleries," but they did set the stage for the TV generation's preference for information and analysis over monumental scale and originality.

In the late sixties, the Artists' and Writers' Protest, the Art Workers' Coalition (AWC), the Black Emergency Cultural Coalition, and Women Artists in Revolution (WAR) brought together artists with very diverse aesthetics and varying degrees of success and political awareness to protest the Vietnam War and racism and sexism in the art world. Group actions, planned collectively by Blacks and whites, Europeans and Latin and North Americans, painters and sculptors, differed from the agitprop of the thirties and forties—the last major wave of political art in the U.S.—in their fusion of cliché and sophistication. The anti-institutional street skits of the Guerrilla Art Action Group (GAAG) owed something to Fluxus and European proto-performance art; the manufacture of a Museum of Modern Art membership card overtly rubber-stamped with the AWC logo was inspired by conceptualism; the rhetorical demands made of the museums were written by artists who had shown in them.[5] In addition, the general counterculture spawned within the art world a new swell of co-op galleries, small presses, artist-run exhibitions and publications, streetworks, mail art, small video companies, and independent filmmaking, all of which enabled artists to continue to speak out and speak for themselves in the cooled-out seventies.

While few individual artists used their political experiences directly in their work (though several used their work in their experiences), everyone who participated learned a lot about how the art world runs, about the relationships between artists' power and institutional power, and about the interrelationships between cultural institutions and those controlling the world.[6] By 1971-1972, those artists who had participated in the antiwar movement as an adventure or as a temporary necessity had dropped back into the mainstream. The Black

5. See my "The Art Workers' Coalition: Not a History," *Studio International* 180, no. 927 (November 1970): 171-174. This and a lot of related material is reprinted in my book, *Get the Message? A Decade of Art for Social Change* (New York: E. P. Dutton, 1984).

6. Hans Haacke was one artist who did use this material in his work, and his art and his articles continue to explore, thoroughly and effectively, the internecine manipulations of the "consciousness industry." See his *Framing and Being Framed* (Halifax: The Press of the Nova Scotia College of Art and Design, 1975), and "Working Conditions," *Artforum* 19, no. 10 (June 1981): 56-61.

Liberation movement, which had inspired student and feminist breakouts, was back on simmer, and the women's movement had inherited the front burner of rage and radical re-viewing process. Feminist art broadened and deepened the whole notion of "political art" by incorporating the element of the personal, autobiography, consciousness-raising, and social transformation, which led eventually to the still broader notion of "the political is personal"–i.e., an awareness of how local, national, and international events affect our individual lives.

By the mid-seventies, the issues of race, sex, and class, though hardly popular in the art world, had all made it "up" to West Broadway. When, in 1975, Artists Meeting for Cultural Change (AMCC) was formed to protest the Whitney Museum's ironic Bicentennial offering (a Rockefeller's private collection), veterans of the antiwar movement were joined by a new generation who had been educated in the sixties by university radicals. Often less action-oriented than the AWC, but far more firmly based in political theory and media analysis, the AMCC became primarily a huge discussion group, several of its most eloquent members being conceptual artists who turned to the mass-reproductive mediums to convey their messages about the social roles of culture and its controllers. Like the AWC, the group's major contribution was consciousness-raising in the art community. Also important was the publication of *The Anti-Catalog*, which looked at the Rockefeller collection with a scholarly but revisionist eye. Some members of the AMCC were also involved in publishing *The Fox* and its successor, *Red Herring*–influential vehicles for more-or-less Marxist views of art and art production. Other members helped found *Heresies: A Feminist Publication on Art and Politics* in 1976.

In 1977, the AMCC fell victim to internal and sometimes sectarian bickering. Several participants turned their backs entirely on the art world to join the Anti-Imperialist Cultural Union (AICU), headed by Amiri Baraka. In the AICU, avant-garde artists worked directly with (instead of about) Black people and "communities" on their own turf, in forms unlike those sanctioned or tolerated by the art world's forays into "outreach."[7] In fact, over the last decade, a larger portion of the art world than is generally recognized has been struggling with its isolation. A practical theory of culture (sometimes touching on so-called "postmodernism") is slowly emerging from several angles. Visual art is only part of it–or, for once, it *is* part of it. The often cautious pluralism of the seventies, coming on top of the underdeveloped rebellions of the sixties, provided more fertile soil for outgrowth than any of us realized at the time. In 1979-80, an impetus fueled partly from politics and partly from style began to come together in New York. It was happening elsewhere in North America, too, though we weren't then much mutually aware.

IV. From 1980 On . . .

By 1980, some veterans of AMCC, AICU, and the feminist movement, many now in their mid- to late thirties, began tentatively to reestablish contact with the peripheries of the art world through the multi-generational Political Art

7. Their publication, *Main Trend*, was a lively documentation of the conflicts involved in being "politically correct" and aesthetically ambitious.

IF WE CAN SIMPLY WITNESS THE DESTRUCTION OF
ANOTHER CULTURE, WE ARE SACRIFICING OUR OWN
RIGHT TO MAKE CULTURE. ANYONE WHO HAS
PROTESTED U.S. INTERVENTION SHOULD CONSIDER
OUR RESPONSIBILITY TO DEFEND THE CULTURE AND
THE RIGHTS OF THE CENTRAL AMERICAN PEOPLE.

ARTISTS CALL *Against U.S. Intervention in Central America* is a nationwide mobilization of artists, workers, and intellectuals organizing out of New York City. A gigantic series of exhibitions and events will be centered around January 22, 1984—the International Day of Solidarity with El Salvador. The date marks the 52nd anniversary of the 1932 massacre which began the systematic destruction of Salvadorean indigenous culture. Today, such destruction is actively underway in Guatemala, undermining the resurrection of Nicaraguan culture, and threatening the Caribbean.

ARTISTS CALL consists of art from Central America, art about Central America, and art in support of Central America. It is an integrated esthetic and political strategy to call attention to the Reagan administration's disastrous military policies. The benefits of this campaign will be threefold: to raise consciousness, to raise money, and to make visible artists' outrage.

To participate, and for further information, write

(Top left) Artists Call Against U.S. Intervention in Central America advertisement, 1984; (Top right) Juan Sanchez.
Viva Puerto Rico Libre, 1982. Oil and mixed media, 66 x 52″ (167.7 x 132 cm). (Photo: Fred McDarrah); (Above)
Group Material. *Time Line: U.S. Intervention in Central America,* 1984. Installation for Artists Call, at P.S. 1, Queens,
New York, January 1984. (Photo: Andrew Moore)

Documentation/Distribution (PADD). At the same time, a mostly younger generation had begun to create a new style of dissent based on collaboration and a cross-cultural immersion in pop (and punk) culture. The mainstream's hostility toward art with any overt social focus began to break down as it became clear that new energy was not only desperately needed, but was already rumbling away in the subways, in the South Bronx, on the Lower East Side, and in the growing realization of what Reaganomics would do to the country—and to its artists. At the same time, those community cultural activists who had been making murals and working with the disenfranchised since the sixties, and who had been totally invisible in the art world, began to attract new attention via association with the graffitists and a newly visible Latin culture. Despite the decline of organized activity in the Third World and feminist communities, their activist models were not forgotten. Groups like the Taller Boricua in the *barrio*, JAM in midtown (later downtown), AIR in Soho, and the Basement Workshop in Chinatown made Hispanic, Black, feminist, and Asian art available to those willing to go "out of their way."

A key factor in these developments, especially among the younger artists, was punk culture, imported from the British working class and Americanized into a middle-class rebellion retaining a vague need for social change. At the same time, a complex merger of "high" and "low" culture was taking place, arising from connections between art-school art, rock music and the club scene, murals, street theater, performance, documentary film, photography, and video, and feminist, racial liberation, and labor groups. A grassroots left cultural movement had been growing quietly from the plowed-under mulch of sixties activism. It was catalyzed by the influx of belligerently disillusioned and/or idealistic young artists, well-trained and ambitious, but dissatisfied with the narrowness and elitism of the art world into which they were supposed to blend seamlessly, like their publicized predecessors.

Popular culture seems to many different kinds of artists the obvious way to understand how most people see the world. A more and less informed populism underlay the way advertising, rock and rap music, comics, and fashion infiltrated "high art" in the early eighties. A broader view of art's function led in turn to a broader rejection of the politics of liberal neutralism—the avoidance of social responsibility because in art "anything goes, and artists are powerless anyway, right?" This in turn led some to reject the socialized notion that you have to choose between art and social action, that anyone who wants art to be communicative and effective is either a sappy idealist, a lousy artist, or a dangerous red.[8]

Rejecting the pristine spaces of Soho and the slick pages of the trade magazines, many younger artists got together as Collaborative Projects (Colab); they held scruffy, open, theme shows in storefronts and derelict spaces, and published raw, grainy, newsprint "zines," pioneering a new and chaotic aesthetic of display and independent distribution. Also in 1979-80,

8. Cf., Hilton Kramer's fulminations in *The New Criterion*, especially "A Note on the New Criterion," *The New Criterion* 1, no. 1 (September 1982): 1-5; and "Turning back the clock: Art and politics in 1984," *The New Criterion* 2, no. 8 (April 1984): 68-73.

Fashion Moda was founded in the South Bronx—not as a community art center or an avant-garde alternate space (both of which it resembled), but as a "cultural concept" of exchange (which, among other contributions, helped graffiti enter the art world for the second time in a decade). Group Material, a young collective with more structured socialist politics, also opened a storefront —on East 13th Street—and developed a vivid exhibition technique combining didacticism and mass culture.

On New Year's Day 1980, a group from Colab extralegally occupied an abandoned city-owned building on Delancey Street and held "The Real Estate Show," a group exhibition about housing, property, real-estate development. This led to the creation of another storefront gallery—ABC No Rio on Rivington Street. PADD (which I work with) was formed in 1979 "to give artists an organized relationship to society," to sustain left culture (which it continues to do via exhibitions), and to develop an Archive of Socially Concerned Art, plus public events, a monthly forum, and two publications—*Upfront* and *Red Letter Days*. Gallery 345 opened during this period to show specifically "political" art, and the San Francisco Poster Brigade circulated nationally its wildly designed and heterogeneous "Anti-WW 3" show, with work from some fifty countries.

Theme shows, in which the individual works blended into the overall installation, became popular, and with them came a surge of overtly political content (often fairly anarchistic and uninformed). Colab began this trend in 1979 with "The Manifesto Show," rapidly followed by "The Sex and Death Show," "The Dog Show," and "The Income and Wealth Show," peaking in the extravagant "Times Square Show" in the summer of 1980. Group Material had the "Alienation" show, the "It's a Gender" show, "Facere/Fascis" (on fashion), and "Arroz con Mango," a show of "favorite art possessions" from the residents on the gallery's block. Contemporary Urbicultural Documentation (CUD) specialized in topical (i.e., recent) archaeology, unearthing and reconstructing a Bronx courthouse, a fallout shelter, and a psychiatric hospital. PADD's "Death and Taxes" show took place all over the city: in restrooms, telephone booths, and store windows, on walls, and at the IRS building. PADD also concentrates on demonstration art, and on the conception of political demonstrations *as* art.

Through such collective activities, many young, so-called "New Wave" artists reached out to their contemporaries in the ghettos, motivated less by political consciousness than by common emotional needs. In doing so, they brought downtown art to the South Bronx and vice versa; even more unprecedented, they sometimes succeeded in bringing downtown art audiences to the South Bronx (though in this case, not much vice versa). Fragile cross-class, cross-cultural alliances began to be formed, sometimes resulting in a new kind of art star—the former (or still active) graffiti writer welcomed into and partially transforming the world of downtown gutter-chic (and later, penthouse-chic).

In the early 1980s, tentative coalitions also began to form among the regrouping leftist artists and the younger generations, within or through the efforts of PADD and Group Material. Initially, the more organized cultural left was wary of the "New Wave" as possibly exploitative, manipulative, chic, or

opportunist, while the left itself was viewed by most younger artists as old-fashioned, moralistic, and rhetorical. Gradually, these prejudices were broken down on both sides. A renewed openness in the left to popular culture and elements of the avant-garde has coincided with a renewed (and no doubt temporary) openness in the mainstream to a certain degree of explicit political content. Aided by the Reagan administration's domestic and military antics, violence, fear, alienation, and survival have become universal topics, surfacing in innumerable different styles and mediums within the walls of the Trojan art establishment.

As more artists began to work directly in the public, as shows in the streets and in the subways, or works inside abandoned buildings became relatively common (following the graffitists and community activists), a new, hybrid subcultural art was formed. Under the influences of music, politics, and Black and Hispanic culture, strange bedfellows met and mated. The East Village and the Lower East Side (Alphaville and Loisaida) were and are still the principal centers of activity. These rapidly changing communities of mixed economies and ethnicities, where artists have been at home for over a century, are now endangered by gentrification or "Sohoization," ironically brought on by the very phenomena discussed above. Similarly, "political art" is being gentrified by the high art world. Yet, as it becomes more respectable, it does not necessarily become less effective, in part because activist artists continue to straddle the barricade, offering models for further integration of art and social change.

Much activist work is collaborative or participatory and its meaning is directly derived from its use-value to a particular community. The needs of a community provide artists with both outlets and boundaries. While straddling the fence between mainstream and outreach is a way of avoiding co-optation, it's not a comfortable position. Accessibility to "a broader audience" is a conscious if not often realized component of activist art. It takes years to develop formally effective ways to exchange powers with one's chosen audience. As many have discovered, it is impossible just to drop into a "community" and make good activist art. The task is specialized (though not in the same ways high art is) and it demands discipline and dedication (as high art does). To be out of touch, unanalytical, or uninformed is disastrous (maybe this too, in a different arena, goes for high art).

The intricately structural quality that characterizes activist art results from the complexity of the position these artists find themselves in, fraught as it is with economic, aesthetic, and political contradictions. Community or political work can and often does restrict the artist's own need to go further out, or further in, to experiment past the bounds of immediate necessity. The burnout rate among fine artists working with groups is high because the rewards for such activities are seen as entirely separate from the development of the art and are less likely to be appreciated by peers within the art world.

On the other hand, I have yet to see an artist who ventured out of the art world to work in unfamiliar contexts come back empty-handed. Such experience enriches *any* art. Leaving the safety of one's home base—the context in which one was trained to act—one learns a great deal not only about the world,

but about oneself, one's art and imagery, and their communicative effects. New symbols can emerge from these new experiences. An art that takes on activism as its driving force must emphasize clarity of meaning and communication. But this does not mean it has to be simplistic, which implies a condescending approach toward the audience. In addition, what may appear simple or stereotyped to one audience may be rich and meaningful to another that is more involved in specific issues.[9]

Since 1980, an increased number of connections have been made nationally and internationally (England, Canada, Australia, Cuba, and Nicaragua have played roles) between organized visual artists and socially concerned and/ or involved cultural workers. The most recent and visible symptom has been Artists Call Against US Intervention in Central America—a uniquely broadbased and diverse campaign of cultural protest that began in January 1984, when Artists Call mobilized workers from all the arts, with thirty-one exhibitions and 1100 artists participating in New York City alone. Thousands more continue to take part in some thirty cities in the United States and Canada. Artists Call challenged the notion that artists were apolitical and ineffective. Aside from raising money and raising consciousness about the increasing militarization of Central America by the Reagan administration, it encouraged international solidarity among artists, set up an ongoing national network of socially conscious artists, and provided a model for other cultural and professional groups. Perhaps as important, Artists Call widened the spectrum of artists who learned about the Central American situation and who realized that such issues could be part of their art.[10]

Organizing and networking are crucial elements in activist art, despite the fact that they are not usually considered part of the creative process. Art grows from art as well as from the artists' experiences of life, so providing an atmosphere of access to each other's art and ideas is one of the major goals of cultural activism in the U.S. today. Art with political content is still covered only perfunctorily, if at all, in big museum or travelling exhibitions, in the mass media, and in the large-circulation trade magazines—where, if covered, it tends to be tucked into special sections or neutralized by writers who ignore or are ignorant of its content. At the same time, visual art has been similarly neglected in the left media, though that too seems to be changing somewhat. Because of such double prejudice, the number of newsletters and publications devoted to or including left culture has mushroomed.[11]

9. Even Harold Rosenberg once wrote, "responding to political struggles can do much for art" (quoted by Jamey Gambrell, in "Art Against Intervention," *Art in America* 72, no. 5 [May 1984]:15).

10. For further information on Artists Call, see *Art & Artists* 13, no. 4 (January 1984), special issue; *Art in America* 72, no. 5 (May 1984): 9-19; *High Performance*, no. 25 (1984): 8-14; all with major articles on it.

11. To list a few: *Cultural Correspondence, Art & Artists, Upfront, Cultural Democracy,* and *Heresies* (New York); *Community Murals* and *Left Curve* (San Francisco); *Fuse* and *Incite* (Toronto); *Afterimage* (Rochester); *911 Reports* (Seattle); *Red Bass* (Tallahassee); *Cultural Workers News* (Minneapolis); *Block* and *Artery* (London); *Art Network* (Sydney) . . . not to mention film and literary magazines and all the artists' publications with some

Experience in the alternative media has stylistically affected the art itself, as well as offering the possibility of reconstructing communications as political intervention. Imagery drawn from the (mostly bad) news of the day and from techniques or styles deriving from or commenting on the commercial media is ubiquitous across the aesthetic/political spectrum. This dependence (for both aesthetic and economic reasons) on mass-reproductive techniques coupled with the need to reconnect with "real life" has resulted in what I call the "journalization of art." In the graphic arts and in painting it includes the grit and grain of the artist-as-reporter tradition, not coincidentally recalling much art from the 1930s, when the political situation bore ominous parallels to today's massive unemployment and looming war clouds. Documentary photography and film, comics, and illustrated books have also been resurrected as key tools for activism, even as their own conventions and clichés are subjected to increased scrutiny. The same modernist self-consciousness that encourages new uses of old radicalisms is evident in another branch of the journalization of art—that which either challenges or assumes the hypocrisy and subliminal messages of slick magazines, Hollywood films, and TV commercials. An overview of this phenomenon reveals some artists who are wholly concerned with media *style*, divorced from all but hermetic or ambiguous content. Others, who make up the more left-leaning, formalist, and ideologically aware branch of postmodernism, focus more on theories of representation and "cannibalism" of found images. (This interestingly recalls the mid- to late-sixties program of conceptual art which scorned the "hand-of-the-artist" and the introduction of "any more objects into the world.") Others are populists or activists who see mass-culture techniques as ways to reach more people with both a narrative hook and a seductive familiarity: keep the image, change the message.

The increased political sophistication of 1980s activist and "political" art, as compared to that of the 1960s, is due to the gradual development of a theory of left culture woven from the diverse threads mentioned here, a theory that reflects the attention being paid in 1984 to electoral as well as to confrontational politics. Nurtured by the global climate of anger and anxiety, there is a growing acknowledgment on the left of the mythic and psychological components of ideology and art. Activist artists are still trying to communicate internal, communal, and worldwide fears about the future (not to mention the present) without nuking people to death with Big Bad Ronnie images. Communicating these fears makes us and others realize we are not alone in our search for an imagery that combines the ingredients of analysis, resistance, and hope. Between naiveté and experience, heavy commitment and dawning consciousness, there has to be room for a lot of different things to happen.

The degree to which an activist art is integrated with the artist's beliefs is crucial to its effectiveness. Much well-meaning progressive and activist art does not truly reflect the artist's lived experience, and often the artist's lived experi-

political content, such as *Real Life, High Performance, Wedge, Bomb, Cover, Red Tape* and *Just Another Asshole* . . . Among them, they report on a multiplicity of events from music to performance to conferences to street actions, union work, demonstration, exhibitions, mail art, artists' books, and so forth.

ence bears little resemblance to that of most other people. Work with tenant's organizations, feminist, radical, or solidarity groups, labor unions, or in the cultural task forces of the many small left parties, or with environmental, pacifist, and anti-nuclear groups offers ways to connect with those who are interested. Another option is to see the changing self as a symbol of social change, using personal histories (not necessarily one's own) to illuminate world events and larger visions. In this process local, ethnic, gender, and class iden- tifications can augment individual obsessions. The extraordinary Afro-Brazilian film *Jom* shows the *griot* (storyteller, historian, shaman, artist) as the backbone of daily political consciousness in the community, the source of continuity through which power is maintained or lost.

I like to keep reminding myself that the root of the word "radical" is the word "root." Grassroots then means not only propagation—spreading the word —but is based on the fact that each blade of grass has its own roots. Power means "to be able"—the ability to act vigorously with "strength, authority, might, control, spirit, divinity." And the word "craft" comes from Middle English and means strength *and* power, which later became "skill." Neither the word "art" nor the word "culture" bear these belligerent connotations. Art originally meant "to join or fit together," and "culture" comes from cultivation and growth. An artist can function like a lazy gardener who cuts off the weeds as a temporary holding action. Or s/he can go under the surface to the causes. Social change can happen when you tear things up by the roots, or—to collage metaphors—when you go back to the roots and distinguish the weeds from the blossoms and vegetables . . . the Trojan horses from the four horses of the Apocalypse.

Portions of this essay have appeared previously in my columns in *The Village Voice*, in particular "Power/Control" (October 18, 1983). It also owes a good deal to dialogue with members of Political Art Documentation/Distribution (PADD), Heresies, and The Alliance for Cultural Democracy, especially my working partner, Jerry Kearns.

VII.

Gender / Difference / Power

Marilyn Monroe, publicity photograph

Visual Pleasure and Narrative Cinema

LAURA MULVEY

I. Introduction

A. A Political Use of Psycho- analysis

This paper intends to use psychoanalysis to discover where and how the fascination of film is reinforced by preexisting patterns of fascination already at work within the individual subject and the social formations that have molded him. It takes as starting point the way film reflects, reveals, and even plays on the straight, socially established interpretation of sexual difference that controls images, erotic ways of looking, and spectacle. It is helpful to understand what the cinema has been, how its magic has worked in the past, while attempting a theory and a practice that will challenge this cinema of the past. Psychoanalytic theory is thus appropriated here as a political weapon, demonstrating the way the unconscious of patriarchal society has structured film form.

The paradox of phallocentrism in all its manifestations is that it depends on the image of the castrated woman to give order and meaning to its world. An idea of woman stands as linchpin to the system: it is her lack that produces the phallus as a symbolic presence, it is her desire to make good the lack that the phallus signifies. Recent writing in *Screen* about psychoanalysis and the cinema has not sufficiently brought out the importance of the representation of the female form in a symbolic order in which, in the last resort, it speaks castration and nothing else. To summarize briefly: the function of woman in forming the patriarchal unconscious is twofold; she first symbolizes the castra- tion threat by her real absence of a penis and second thereby raises her child into the symbolic. Once this has been achieved, her meaning in the process is at an end, it does not last into the world of law and language except as a memory that oscillates between memory of maternal plenitude and memory of lack. Both are posited on nature (or on "anatomy" in Freud's famous phrase). Woman's desire is subjected to her image as bearer of the bleeding wound; she can exist only in relation to castration and cannot transcend it. She turns her child into the signifier of her own desire to possess a penis (the condition, she imagines, of entry into the symbolic). Either she must gracefully give way to the word, the Name of the Father and the Law, or else struggle to keep her

Reprinted from *Screen* 16, no. 3 (Autumn 1975): 6-18. This essay is a reworked version of a paper given in the French Department of the University of Wisconsin, Madison, in Spring 1973.

child down with her in the half-light of the imaginary. Woman, then, stands in patriarchal culture as signifier for the male other, bound by a symbolic order in which man can live out his fantasies and obsessions through linguistic command by imposing them on the silent image of woman still tied to her place as bearer of meaning, not maker of meaning.

There is an obvious interest in this analysis for feminists, a beauty in its exact rendering of the frustration experienced under the phallocentric order. It gets us nearer to the roots of our oppression, it brings an articulation of the problem closer, it faces us with the ultimate challenge: how to fight the unconscious structured like a language (formed critically at the moment of arrival of language) while still caught within the language of the patriarchy. There is no way in which we can produce an alternative out of the blue, but we can begin to make a break by examining partriarchy with the tools it provides, of which psychoanalysis is not the only but an important one. We are still separated by a great gap from important issues for the female unconscious that are scarcely relevant to phallocentric theory: the sexing of the female infant and her relationship to the symbolic, the sexually mature woman as nonmother, maternity outside the signification of the phallus, the vagina . . . But, at this point, psychoanalytic theory as it now stands can at least advance our understanding of the status quo, of the patriarchal order in which we are caught.

B. Destruction of Pleasure as a Radical Weapon

As an advanced representation system, the cinema poses questions of the ways the unconscious (formed by the dominant order) structures ways of seeing and pleasure in looking. Cinema has changed over the last few decades. It is no longer the monolithic system based on large capital investment exemplified at its best by Hollywood in the 1930s, 1940s, and 1950s. Technological advances (16mm, etc.) have changed the economic conditions of cinematic production, which can now be artisanal as well as capitalist. Thus it has been possible for an alternative cinema to develop. However self-conscious and ironic Hollywood managed to be, it always restricted itself to a formal mise-en-scène reflecting the dominant ideological concept of the cinema. The alternative cinema provides a space for a cinema to be born that is radical in both a political and an aesthetic sense and challenges the basic assumptions of the mainstream film. This is not to reject the latter moralistically, but to highlight the ways in which its formal preoccupations reflect the psychical obsessions of the society that produced it, and, further, to stress that the alternative cinema must start specifically by reacting against these obsessions and assumptions. A politically and aesthetically avant-garde cinema is now possible, but it can still only exist as a counterpoint.

The magic of the Hollywood style at its best (and of all the cinema that fell within its sphere of influence) arose, not exclusively but in one important aspect, from its skilled and satisfying manipulation of visual pleasure. Unchallenged, mainstream film coded the erotic into the language of the dominant patriarchal order. In the highly developed Hollywood cinema it was only through these codes that the alienated subject, torn in his imaginary memory by a sense of loss, by the terror of potential lack in fantasy, came near to finding a glimpse of satisfaction: through its formal beauty and its play on his own formative obsessions. This essay will discuss the interweaving of that erotic

pleasure in film, its meaning, and in particular the central place of the image of woman. It is said that analyzing pleasure, or beauty, destroys it. That is the intention of this essay. The satisfaction and reinforcement of the ego that represent the high point of film history hitherto must be attacked; not in favor of a reconstructed new pleasure, which cannot exist in the abstract, or of intellectualized unpleasure, but to make way for a total negation of the ease and plenitude of the narrative fiction film. The alternative is the thrill that comes from leaving the past behind without rejecting it, transcending outworn or oppressive forms, or daring to break with normal pleasurable expectations in order to conceive a new language of desire.

II. Pleasure in Looking–Fascination with the Human Form

A. The cinema offers a number of possible pleasures. One is scopophilia. There are circumstances in which looking itself is a source of pleasure, just as, in the reverse formation, there is pleasure in being looked at. Originally, in his *Three Essays on Sexuality*, Freud isolated scopophilia as one of the component instincts of sexuality that exists as drives quite independently of the erotogenic zones. At this point he associated scopophilia with taking other people as objects, subjecting them to a controlling and curious gaze. His particular examples center around the voyeuristic activities of children, their desire to see and make sure of the private and the forbidden (curiosity about other people's genital and bodily functions, about the presence or absence of the penis and, retrospectively, about the primal scene). In this analysis scopophilia is essentially active. (Later, in *Instincts and Their Vicissitudes*, Freud developed his theory of scopophilia further, attaching it initially to pregenital autoeroticism, after which the pleasure of the look is transferred to others by analogy. There is a close working here of the relationship between the active instinct and its further development in a narcissistic form.) Although the instinct is modified by other factors, in particular the constitution of the ego, it continues to exist as the erotic basis for pleasure in looking at another person as object. At the extreme, it can become fixated into a perversion, producing obsessive voyeurs and Peeping Toms, whose only sexual satisfaction can come from watching, in an active controlling sense, an objectified other.

At first glance, the cinema would seem to be remote from the undercover world of the surreptitious observation of an unknowing and unwilling victim. What is seen of the screen is so manifestly shown. But the mass of mainstream film, and the conventions within which it has consciously evolved, portray a hermetically sealed world that unwinds magically, indifferent to the presence of the audience, producing for them a sense of separation and playing on their voyeuristic fantasy. Moreover, the extreme contrast between the darkness in the auditorium (which also isolates the spectators from one another) and the brilliance of the shifting patterns of light and shade on the screen helps to promote the illusion of voyeuristic separation. Although the film is really being shown, is there to be seen, conditions of screening and narrative conventions give the spectator an illusion of looking in on a private world. Among other things, the position of the spectators in the cinema is blatantly one of repression of their exhibitionism and projection of the repressed desire onto the performer.

Dan Graham. Project for a cinema, 1981. Photographs of the model, exterior and interior. (Photos: Martha Cooper)

CINEMA, 1981
A cinema, the ground-level of a modern office building, is sited on a busy corner. Its facade consists of two-way mirrored glass which allows viewers on whichever side is darker at any particular moment to see through and observe the other side (without being seen by people on that side). From the other side, the window appears as a mirror. When the light illuminates the surface of both sides more or less equally, the glass facade is both semi-reflective and partially transparent. Spectators on both sides observe both the opposing space *and* a reflection of their own look within their own space.

Stage 1: The Film is Projected; The Interior is Dark
A two-way mirror is substituted for the conventional screen. Because of the properties of the two-way mirror, when a film is projected, the mirror functions as a normal screen for the interior filmgoer and also projects the film image so that it can be seen in reverse, from the street through the building's facade. Further, when viewed from the street, the screen's image can be looked through to see the frontal gaze of the audience watching the screen. During the film's showing to the interior audience, occasional images from the external, real environment intrude through the side windows mixing with the film's images reflected on the side walls. These external reflected images interfere with the film spectator's identification of his consciousness with the filmic illusion.
Stage 2: The Film is not Projected; House Lights Are Up
The house lights in the cinema are turned on after (or before) a film is projected. Interior spectators see the screen, as well as the side windows, as reflective mirrors—reminiscent of mirrored cinema lobbies. Where a few seconds previously the Renaissance framing of the screen had been a "mirror" for the spectator's subjective projection of his own body ("lost" to his immediate environment through identification with the film), now the screen and the sides of the theater become literal mirrors, reflecting the real space and bodies and looks of the spectators. The spectator sees represented in the mirror his real position relative to the presence of the rest of the audience, whereas previously, in the fictional world of the film, he was the phenomenological center of an illusionary world. He also sees himself looking and in relation to the looks of others in the audience. Outside, the psychological position of the spectator/pedestrian also reverses; now he is able to look through the window while remaining unseen himself. Awareness of *his* body and *his* environment is lost. His position as voyeur becomes akin to that of the movie audience in the previous moment.

B. The cinema satisfies a primordial wish for pleasurable looking, but it also goes further, developing scopophilia in its narcissistic aspect. The conventions of mainstream film focus attention on the human form. Scale, space, stories are all anthropomorphic. Here, curiosity and the wish to look intermingle with a fascination with likeness and recognition: the human face, the human body, the relationship between the human form and its surroundings, the visible presence of the person in the world. Jacques Lacan has described how the moment when a child recognizes its own image in the mirror is crucial for the constitution of the ego. Several aspects of this analysis are relevant here. The mirror phase occurs at a time when the child's physical ambitions outstrip his motor capacity, with the result that his recognition of himself is joyous in that he imagines his mirror image to be more complete, more perfect than he experiences his own body. Recognition is thus overlaid with misrecognition: the image recognized is conceived as the reflected body of the self, but its misrecognition as superior projects this body outside itself as an ideal ego, the alienated subject, which, reintrojected as an ego ideal, gives rise to the future generation of identification with others. This mirror moment predates language for the child.

Important for this essay is the fact that it is an image that constitutes the matrix of the imaginary, of recognition/misrecognition and identification, and hence of the first articulation of the "I," of subjectivity. This is a moment when an older fascination with looking (at the mother's face, for an obvious example) collides with the initial inklings of self-awareness. Hence it is the birth of the long love affair/despair between image and self-image that has found such intensity of expression in film and such joyous recognition in the cinema audience. Quite apart from the extraneous similarities between screen and mirror (the framing of the human form in its surroundings, for instance), the cinema has structures of fascination strong enough to allow temporary loss of ego while simultaneously reinforcing the ego. The sense of forgetting the world as the ego has subsequently come to perceive it (I forgot who I am and where I was) is nostalgically reminiscent of that presubjective moment of image recognition. At the same time the cinema has distinguished itself in the production of ego ideals as expressed in particular in the star system, the stars centering both screen presence and screen story as they act out a complex process of likeness and difference (the glamorous impersonates the ordinary).

C. Sections II. A and B have set out two contradictory aspects of the pleasurable structures of looking in the conventional cinematic situation. The first, scopophilic, arises from pleasure in using another person as an object of sexual stimulation through sight. The second, developed through narcissism and the constitution of the ego, comes from identification with the image seen. Thus, in film terms, one implies a separation of the erotic identity of the subject from the object on the screen (active scopophilia), the other demands identification of the ego with the object on the screen through the spectator's fascination with and recognition of his like. The first is a function of the sexual instincts, the second of ego libido. This dichotomy was crucial for Freud. Although he saw the two as interacting and overlaying each other, the tension between instinc-

tual drives and self-preservation continues to be a dramatic polarization in terms of pleasure. Both are formative structures, mechanisms not meanings. In themselves they have no signification, they have to be attached to an idealization. Both pursue aims in indifference to perceptual reality, creating the imagized, eroticized concept of the world that forms the perception of the subject and makes a mockery of empirical objectivity.

During its history, the cinema seems to have evolved a particular illusion of reality in which this contradiction between libido and ego has found a beautifully complementary fantasy world. In *reality* the fantasy world of the screen is subject to the law that produces it. Sexual instincts and identification processes have a meaning within the symbolic order that articulates desire. Desire, born with language, allows the possibility of transcending the instinctual and the imaginary, but its point of reference continually returns to the traumatic moment of its birth: the castration complex. Hence the look, pleasurable in form, can be threatening in content, and it is woman as representation/image that crystallizes this paradox.

III. Woman as Image, Man as Bearer of the Look

A. In a world ordered by sexual imbalance, pleasure in looking has been split between active/male and passive/female. The determining male gaze projects its fantasy onto the female figure, which is styled accordingly. In their traditional exhibitionist role women are simultaneously looked at and displayed, with their appearance coded for strong visual and erotic impact so that they can be said to connote *to-be-looked-at-ness*. Women displayed as sexual object is the leitmotiv of erotic spectacle: from pinups to striptease, from Ziegfeld to Busby Berkeley, she holds the look, plays to, and signifies male desire. Mainstream film neatly combined spectacle and narrative. (Note, however, how in the musical song-and-dance numbers break the flow of the diegesis.) The presence of woman is an indispensable element of spectacle in normal narrative film, yet her visual presence tends to work against the development of a story line, to freeze the flow of action in moments of erotic contemplation. This alien presence then has to be integrated into cohesion with the narrative. As Budd Boetticher has put it:

> What counts is what the heroine provokes, or rather what she represents. She is the one, or rather the love or fear she inspires in the hero, or else the concern he feels for her, who makes him act the way he does. In herself the woman has not the slightest importance.[1]

(A recent tendency in narrative film has been to dispense with this problem altogether; hence the development of what Molly Haskell has called the "buddy movie," in which the active homosexual eroticism of the central male figures can carry the story without distraction.) Traditionally, the woman displayed

1. Quoted in Peter Wollen, "Boetticher's World-View," in Jim Kitses, comp., *Budd Boetticher: The Western* (London: British Film Institute, 1970), p. 33—Ed. note.

has functioned on two levels: as erotic object for the characters within the screen story, and as erotic object for the spectator within the auditorium, with a shifting tension between the looks on either side of the screen. For instance, the device of the showgirl allows the two looks to be unified technically without any apparent break in the diegesis. A woman performs within the narrative, the gaze of the spectator and that of the male characters in the film are neatly combined without breaking narrative verisimilitude. For a moment the sexual impact of the performing woman takes the film into a no-man's-land outside its own time and space; thus Marilyn Monroe's first appearance in *The River of No Return* and Lauren Bacall's songs in *To Have and Have Not.* Similarly, conventional close-ups of legs (Dietrich, for instance) or a face (Garbo) integrate into the narrative a different mode of eroticism. One part of a fragmented body destroys the Renaissance space, the illusion of depth demanded by the narrative; it gives flatness, the quality of a cutout or icon rather than verisimilitude to the screen.

B. An active/passive heterosexual division of labor has similarly controlled narrative structure. According to the principles of the ruling ideology and the psychical structures that back it up, the male figure cannot bear the burden of sexual objectification. Man is reluctant to gaze at his exhibitionist like. Hence the split between spectacle and narrative supports the man's role as the active one of forwarding the story, making things happen. The man controls the film fantasy and also emerges as the representative of power in a further sense: as the bearer of the look of the spectator, transferring it behind the screen to neutralize the extradiegetic tendencies represented by woman as spectacle. This is made possible through the processes set in motion by structuring the film around a main controlling figure with whom the spectator can identify. As the spectator identifies with the main male[2] protagonist, he projects his look onto that of his like, his screen surrogate, so that the power of the male protagonist as he controls events coincides with the active power of the erotic look, both giving a satisfying sense of omnipotence. A male movie star's glamorous characteristics are thus not those of the erotic object of the gaze, but those of the more perfect, more complete, more powerful ideal ego conceived in the original moment of recognition in front of the mirror. The character in the story can make things happen and control events better than the subject/spectator, just as the image in the mirror was more in control of motor coordination. In contrast to woman as icon, the active male figure (the ego ideal of the identification process) demands a three-dimensional space corresponding to that of the mirror recognition in which the alienated subject internalized his own representation of this imaginary existence. He is a figure in a landscape. Here the function of film is to reproduce as accurately as possible the so-called

2. There are films with a woman as main protagonist, of course. To analyze this phenomenon seriously here would take me too far afield. Pam Cook and Claire Johnston's study of *The Revolt of Mamie Stover* in Phil Hardy, ed., *Raoul Walsh* (Edinburgh: Edinburgh Film Festival Publication, 1974), shows in a striking case how the strength of this female protagonist is more apparent than real.

natural conditions of human perception. Camera technology (as exemplified by deep focus in particular) and camera movements (determined by the action of the protagonist), combined with invisible editing (demanded by realism), all tend to blur the limits of screen space. The male protagonist is free to command the stage, a stage of spatial illusion in which he articulates the look and creates the action.

C. 1 Sections III. A and B have set out a tension between a mode of representation of woman in film and conventions surrounding the diegesis. Each is associated with a look: that of the spectator in direct scopophilic contact with the female form displayed for his enjoyment (connoting male fantasy) and that of the spectator fascinated with the image of his like set in an illusion of natural space, and through him gaining control and possession of the woman within the diegesis. (This tension and the shift from one pole to the other can structure a single text. Thus both in *Only Angels Have Wings* and *To Have and Have Not* the film opens with the woman as object of the combined gaze of spectator and all the male protagonists in the film. She is isolated, glamorous, on display, sexualized. But as the narrative progresses, she falls in love with the main male protagonist and becomes his property, losing her outward glamorous characteristics, her generalized sexuality, her showgirl connotations; her eroticism is subjected to the male star alone. By means of identification with him, through participation in his power, the spectator can indirectly possess her too.)

But in psychoanalytic terms, the female figure poses a deeper problem. She also connotes something that the look continually circles around but disavows: her lack of a penis, implying a threat of castration and hence unpleasure. Ultimately, the meaning of woman is sexual difference, the absence of the penis is visually ascertainable, the material evidence on which is based the castration complex essential for the organization of entrance to the symbolic order and the Law of the Father. Thus the woman as icon, displayed for the gaze and enjoyment of men, the active controllers of the look, always threatens to evoke the anxiety it originally signified. The male unconscious has two avenues of escape from this castration anxiety: preoccupation with the reenactment of the original trauma (investigating the woman, demystifying her mystery), counterbalanced by the devaluation, punishment, or saving of the guilty object (an avenue typified by the concerns of the *film noir*); or else complete disavowal of castration by the substitution of a fetish object or turning the represented figure itself into a fetish so that it becomes reassuring rather than dangerous (hence overvaluation, the cult of the female star). This second avenue, fetishistic scopophilia, builds up the physical beauty of the object, transforming it into something satisfying in itself. The first avenue, voyeurism, on the contrary, has associations with sadism: pleasure lies in ascertaining guilt (immediately associated with castration), asserting control, and subjecting the guilty person through punishment or forgiveness. This sadistic side fits in well with narrative. Sadism demands a story, depends on making something happen, forcing a change in another person, a battle of will and strength, victory/defeat, all occurring in a linear time with a beginning and an end. Fetishistic scopophilia, on the other hand, can exist outside linear time as the erotic instinct is focused

on the look alone. These contradictions and ambiguities can be illustrated more simply by using works by Hitchcock and von Sternberg, both of whom take the look almost as the content or subject matter of many of their films. Hitchcock is the more complex, as he uses both mechanisms. Von Sternberg's work, on the other hand, provides many pure examples of fetishistic scopophilia.

C. 2 It is well known that von Sternberg once said he would welcome his films being projected upside down so that story and character involvement would not interfere with the spectator's undiluted appreciation of the screen image. This statement is revealing but ingenuous. Ingenuous in that his films do demand that the figure of the woman (Dietrich, in the cycle of films with her, as the ultimate example) should be identifiable. But revealing in that it emphasizes the fact that for him the pictorial space enclosed by the frame is paramount rather than narrative or identification processes. Whereas Hitchcock goes into the investigative side of voyeurism, von Sternberg produces the ultimate fetish, taking it to the point where the powerful look of the male protagonist (characteristic of traditional narrative film) is broken in favor of the image in direct erotic rapport with the spectator. The beauty of the woman as object and the screen space coalesce; she is no longer the bearer of guilt but a perfect product, whose body, stylized and fragmented by close-ups, is the content of the film and the direct recipient of the spectator's look. Von Sternberg plays down the illusion of screen depth; his screen tends to be one-dimensional, as light and shade, lace, steam, foliage, net, streamers, etc., reduce the visual field. There is little or no mediation of the look through the eyes of the main male protagonist. On the contrary, shadowy presences like La Bessière in *Morocco* act as surrogates for the director, detached as they are from audience identification. Despite von Sternberg's insistence that his stories are irrelevant, it is significant that they are concerned with situation, not suspense, and cyclical rather than linear time, while plot complications revolve around misunderstanding rather than conflict. The most important absence is that of the controlling male gaze within the screen scene. The high point of emotional drama in the most typical Dietrich films, her supreme moments of erotic meaning, take place in the absence of the man she loves in the fiction. There are other witnesses, other spectators, watching her on the screen; their gaze is one with, not standing in for, that of the audience. At the end of *Morocco*, Tom Brown has already disappeared into the desert when Amy Jolly kicks off her gold sandals and walks after him. At the end of *Dishonored*, Kranau is indifferent to the fate of Magda. In both cases, the erotic impact, sanctified by death, is displayed as a spectacle for the audience. The male hero misunderstands and, above all, does not see.

In Hitchcock, by contrast, the male hero does see precisely what the audience sees. However, in the films I shall discuss here, he takes fascination with an image through scopophilic eroticism as the subject of the film. Moreover, in these cases the hero portrays the contradictions and tensions experienced by the spectator. In *Vertigo* in particular, but also in *Marnie* and *Rear Window*, the look is central to the plot, oscillating between voyeurism and fetishistic fascination. As a twist, a further manipulation of the normal viewing

Alfred Hitchcock. Publicity still from *Rear Window,* 1954. Color film, sound, 35mm, 112 minutes

John Huston. Still from *The Misfits,* 1961. Color film, sound, 35mm, 124 minutes

Unidentified film still

Alfred Hitchcock. Still from *The Birds,* 1963. Color film, sound, 35mm, 120 minutes

Dara Birnbaum. Still from *Technology/ Transformation: Wonder Woman,* 1979. Color video, sound, 7 minutes

process, which in some sense reveals it, Hitchcock uses the process of identification normally associated with ideological correctness and the recognition of established morality and shows up its perverted side. Hitchcock has never concealed his interest in voyeurism, cinematic and noncinematic. His heroes are exemplary of the symbolic order and the law—a policeman *(Vertigo)*, a dominant male possessing money and power *(Marnie)*—but their erotic drives lead them into compromised situations. The power to subject another person to the will sadistically or to the gaze voyeuristically is turned onto the woman as the object of both. Power is backed by a certainty of legal right and the established guilt of the woman (evoking castration, psychoanalytically speaking). True perversion is barely concealed under a shallow mask of ideological correctness—the man is on the right side of the law, the woman on the wrong. Hitchcock's skillful use of identification processes and liberal use of subjective camera from the point of view of the male protagonist draw the spectators deeply into his position, making them share his uneasy gaze. The audience is absorbed into a voyeuristic situation within the screen scene and diegesis that parodies his own in the cinema.

In his analysis of *Rear Window*[3] Douchet takes the film as a metaphor for the cinema. Jeffries is the audience, the events in the apartment block opposite correspond to the screen. As he watches, an erotic dimension is added to his look, a central image to the drama. His girlfriend Lisa had been of little sexual interest to him, more or less a drag, so long as she remained on the spectator side. When she crosses the barrier between his room and the block opposite, their relationship is reborn erotically. He does not merely watch her through his lens, as a distant meaningful image; he also sees her as a guilty intruder exposed by a dangerous man threatening her with punishment, and thus finally saves her. Lisa's exhibitionism has already been established by her obsessive interest in dress and style, in being a passive image of visual perfection; Jeffries' voyeurism and activity have also been established through his work as a photojournalist, a maker of stories and captor of images. However, his enforced inactivity, binding him to his seat as a spectator, puts him squarely in the fantasy position of the cinema audience.

In *Vertigo*, subjective camera predominates. Apart from one flashback from Judy's point of view, the narrative is woven around what Scottie sees or fails to see. The audience follows the growth of his erotic obsession and subsequent despair precisely from his point of view. Scottie's voyeurism is blatant: he falls in love with a woman he follows and spies on without speaking to. Its sadistic side is equally blatant: he has chosen (and freely chosen, for he had been a successful lawyer) to be a policeman, with all the attendant possibilities of pursuit and investigation. As a result, he follows, watches, and falls in love with a perfect image of female beauty and mystery. Once he actually confronts her, his erotic drive is to break her down and force her to tell by persistent cross-questioning. Then, in the second part of the film, he reenacts his obsessive involvement with the image he loved to watch secretly. He reconstructs Judy

3. Jean Douchet, "Hitch et son public," *Cahiers du Cinéma* 113 (November 1960): 7-15.

as Madeleine, forces her to conform in every detail to the actual physical appearance of his fetish. Her exhibitionism, her masochism, make her an ideal passive counterpart to Scottie's active sadistic voyeurism. She knows her part is to perform, and only by playing it through and then replaying it can she keep Scottie's erotic interest. But in the repetition he does break her down and succeeds in exposing her guilt. His curiosity wins through and she is punished. In *Vertigo*, erotic involvement with the look is disorienting: the spectator's fascination is turned against him as the narrative carries him through and entwines him with the processes that he is himself exercising. The Hitchcock hero here is firmly placed within the symbolic order, in narrative terms. He has all the attributes of the patriarchal superego. Hence the spectator, lulled into a false sense of security by the apparent legality of his surrogate, sees through his look and finds himself exposed as complicit, caught in the moral ambiguity of looking. Far from being simply an aside on the perversion of the police, *Vertigo* focuses on the implications of the active/looking, passive/looked-at split in terms of sexual difference and the power of the male symbolic encapsulated in the hero. Marnie, too, performs for Mark Rutland's gaze and masquerades as the perfect to-be-looked-at image. He, too, is on the side of the law until, drawn in by obsession with her guilt, her secret, he longs to see her in the act of committing a crime, make her confess and thus save her. So he, too, becomes complicit as he acts out the implications of his power. He controls money and words, he can have his cake and eat it.

IV. Summary

The psychoanalytic background that has been discussed in this essay is relevant to the pleasure and unpleasure offered by traditional narrative film. The scopophilic instinct (pleasure in looking at another person as an erotic object) and, in contradistinction, ego libido (forming identification processes) act as formations, mechanisms, which this cinema has played on. The image of woman as (passive) raw material for the (active) gaze of men takes the argument a step further into the structure of representation, adding a further layer demanded by the ideology of the patriarchal order as it is worked out in its favorite cinematic form—illusionistic narrative film. The argument returns again to the psychoanalytic background in that woman as representation signifies castration, inducing voyeuristic or fetishistic mechanisms to circumvent her threat. None of these interacting layers is intrinsic to film, but it is only in the film form that they can reach a perfect and beautiful contradiction, thanks to the possibility in the cinema of shifting the emphasis of the look. It is the place of the look that defines cinema, the possibility of varying it and exposing it. This is what makes cinema quite different in its voyeuristic potential from, say, striptease, theater, shows, etc. Going far beyond highlighting a woman's to-be-looked-at-ness, cinema builds the way she is to be looked at into the spectacle itself. Playing on the tension between film as controlling the dimension of time (editing, narrative) and film as controlling the dimension of space (changes in distance, editing), cinematic codes create a gaze, a world, and an object, thereby producing an illusion cut to the measure of desire. It is these cinematic codes and their relationship to formative external structures that must

be broken down before mainstream film and the pleasure it provides can be challenged.

To begin with (as an ending), the voyeuristic-scopophilic look that is a crucial part of traditional filmic pleasure can itself be broken down. There are three different looks associated with cinema: that of the camera as it records the profilmic event, that of the audience as it watches the final product, and that of the characters at each other within the screen illusion. The conventions of narrative film deny the first two and subordinate them to the third, the conscious aim being always to eliminate intrusive camera presence and prevent a distancing awareness in the audience. Without these two absences (the material existence of the recording process, the critical reading of the spectator), fictional drama cannot achieve reality, obviousness, and truth. Nevertheless, as this essay has argued, the structure of looking in narrative fiction film contains a contradiction in its own premises: the female image as a castration threat constantly endangers the unity of the diegesis and bursts through the world of illusion as an intrusive, static, one-dimensional fetish. Thus the two looks materially present in time and space are obsessively subordinated to the neurotic needs of the male ego. The camera becomes the mechanism for producing an illusion of Renaissance space, flowing movements compatible with the human eye, an ideology of representation that revolves around the perception of the subject; the camera's look is disavowed in order to create a convincing world in which the spectator's surrogate can perform with verisimilitude. Simultaneously, the look of the audience is denied an intrinsic force: as soon as fetishistic representation of the female image threatens to break the spell of illusion, and the erotic image on the screen appears directly (without mediation) to the spectator, the fact of fetishization, concealing as it does castration fear, freezes the look, fixates the spectator, and prevents him from achieving any distance from the image in front of him.

This complex interaction of looks is specific to film. The first blow against the monolithic accumulation of traditional film conventions (already undertaken by radical filmmakers) is to free the look of the camera into its materiality in time and space and the look of the audience into dialectics, passionate detachment. There is no doubt that this destroys the satisfaction, pleasure, and privilege of the "invisible guest," and highlights how film has depended on voyeuristic active/passive mechanisms. Women, whose image has continually been stolen and used for this end, cannot view the decline of the traditional film form with anything much more than sentimental regret.

Advertisement for Fritz Lang's
The Blue Gardenia, 1953

Alfred Hitchcock. Still from *The Birds,* 1963. Color film, sound, 35mm, 120 minutes

"A Certain Refusal of Difference": Feminism and Film Theory

CONSTANCE PENLEY

Looking back over ten years of feminist theoretical writing on film,
it is possible to pick out one distinct and insistently polemical strain that has
had pervasive effects on the ideas and methods of film theory, as well as
feminist filmmaking. While taking film theory on its own terms–semiology,
psychoanalysis, textual analysis, theories of the cinematic apparatus–this is an
approach which, nonetheless, questions those "terms of analysis" on one spe-
cific issue: the way in which each takes up the problem of sexual difference in
the cinema. For, the feminist film theory that I am citing here has discerned in
the work of film theory in general "a certain refusal of difference,"[1] a partic-
ular understanding of the functioning of women in film which prematurely
closes off sexual difference as a problem or question for film *and* theory. To
keep the issue of sexual difference problematic and questionable, feminists have
reread some of the privileged objects of analysis of film theory, and have begun
to examine some of the working assumptions of the earlier semiological and
psychoanalytic approaches to film.

Even in the pioneering work done in England in the mid-1970s by Pam
Cook, Claire Johnston, and Laura Mulvey, there was a clearly polemical rec-
ognition that the classical film text had always been in trouble over the question
of sexual difference. For Cook and Johnston[2] this discord took the form of a
symptomatic instability in the text caused by the film's failure to resolve the
female figure as simultaneously castrated and phallic, or because of that figure's
inherent resistance to being reduced to the status of a "sign" exchanged by
men. Although this textual disorder is apparent in the work of male directors
like Raoul Walsh or Jacques Tourneur, they claimed that it was even more
pronounced in the case of a woman directing Hollywood films–Dorothy Arz-
ner. In Arzner's films, however, the dominant textual contradiction results

1. Jacqueline Rose, *The Cinema in the Eighties: Proceedings of the Meeting* (Venice:
Edizioni "La Biennale di Venezia," 1980), p. 24.

2. Claire Johnston, "Dorothy Arzner: Critical Strategies," and Pam Cook, "Ap-
proaching the Work of Dorothy Arzner," in *The Work of Dorothy Arzner: Towards a
Feminist Cinema*, ed. Claire Johnston (London: British Film Institute, 1975); Pam Cook
and Claire Johnston, "The Place of Women in the Cinema of Raoul Walsh," in *Raoul Walsh*,
ed. Phil Hardy (Edinburgh: Edinburgh Film Festival Publication, 1974).

from her attempt, as a woman, to locate and convey the "discourse of a woman" in a representational form which is entirely male. The discourse of the woman in Arzner films like *Christopher Strong* (1933) or *Dance, Girl, Dance* (1940) gives the filmic system its structural coherence, "while at the same time rendering the dominant discourse of the male fragmented and incoherent."[3]

A similar attention to the trouble caused in the classical film text by the female figure is seen in Laura Mulvey's "Visual Pleasure and Narrative Cinema,"[4] an article which established the grounds of the feminist inquiry into sexual difference in relation to cinematic pleasure. A clear sexual dichotomy exists in looking: men look and women are to-be-looked-at. "The determining male gaze projects its phantasy on to the female figure which is styled accordingly."[5] A similar active/passive division of labor controls the narrative structure because it is the man who makes the story happen at every textual level. Through identification with the male character, the spectator, then, is privileged both as the viewer of the woman exhibited as spectacle, and as controller of those events on the screen which unfailingly lead to the male's possession of the female. But at the level of the spectator's unconscious, the female figure is associated with a potential danger. Although the woman in the film has been objectified by the male gaze, and is thus iconically secure as a full image, she also connotes "something that the look continually circles around but disavows: her lack of a penis, implying a threat of castration and hence unpleasure."[6] The female figure as spectacle can therefore provoke the very anxiety it was intended to contain. Again, as with Cook and Johnston, we see the idea of a symptomatic turbulence that results from the presence of the woman in the film: "The structure of looking in narrative fiction film contains a contradiction in its own premises: the female image as a castration threat constantly endangers the unity of the diegesis and bursts through the world of illusion as an intrusive, static, one-dimensional fetish."[7]

This critique, however, thematizing femininity or female discourse as a disturbance in the film text, began to be challenged in a major way by significant work in the area of textual analysis of film by such theorists as Raymond Bellour, Thierry Kuntzel, and Stephen Heath.[8] In their attempts to provide an

3. Johnston, "Dorothy Arzner," p. 4.

4. Laura Mulvey, "Visual Pleasure and Narrative Cinema," *Screen* 16, no. 3 (Autumn 1975): 6-18. [Reprinted in this volume, pp. 361-373.]

5. Ibid., p. 11. [Reprinted in this volume, p. 366.]

6. Ibid., p. 13. [Reprinted in this volume, p. 368.]

7. Ibid., p. 18. [Reprinted in this volume, p. 373.]

8. Selected articles on the textual analysis of film: Raymond Bellour, "Le blocage symbolique" (on *North by Northwest*), *Communications* (special issue on psychoanalysis and cinema), no. 23 (1975): 235-350; Thierry Kuntzel, "The Film-Work, 2" (on *The Most Dangerous Game*), *Camera Obscura*, no. 5 (Spring 1980): 7-68; Stephen Heath, "Film and System: Terms of Analysis" (on *Touch of Evil*), *Screen* 16, no. 1 (Spring 1975): 7-77, and no. 2 (Summer 1975): 91-113. For an incisive criticism of the "rupture thesis" in Claire Johnston's film analyses from the point of view of the work in the textual analysis of film, see Janet Bergstrom, "Rereading the Work of Claire Johnston," *Camera Obscura*, nos. 3-4 (Summer 1979): 21-31.

increasingly more systematic description of the workings of classical film, they sought to shed some light on the extreme tendency of the classical film to incorporate repetition, overdetermination, and redundancy, but, above all, on the necessity for that text to rupture and fissure itself *in order to* satisfy its intrinsic function of smoothing over division, splits, differences. Thus the contradictions and gaps that the feminists had been positivistically ascribing to the attempt to stage a feminine discourse in a patriarchal form or to the specific difficulty that the woman's image entails, were for the male theorists no more than necessary components of the classical film's illusionistic economy. In setting forth a description of the classical economy as one of rupture and resolution, textual analyses of films like *The Birds* (Bellour), *North by Northwest* (Bellour), and *Touch of Evil* (Heath)[9] also stressed the positive outcome of that economy–its formal *success*. Classical film aims toward homogeneity and closure and, for all practical purposes, attains it. According to the textual theorists, then, a feminine look, a female discourse, a woman's desire–everything that feminist film criticism had been concerned to establish and describe–exist in the film only to be annexed by the male character and hence the male spectator. As Janet Bergstrom said of Raymond Bellour's work on Hitchcock, his most "insidious" argument is that which proposes the female character's desire as crucial and pervasive to the logic of the enunciation of classical film.[10] And for the female spectator, Bellour offers a bleak interpretation of her narrow role: "I think that a woman can love, accept and give a positive value to these films only from her own masochism, and from a certain sadism that she can exercise in return on the masculine subject, within a system loaded with traps."[11] What sort of feminist reply or response would it be possible to make to this massively elaborate and detailed description of classical film that allows no place for a woman's desire or discourse, nor any position for the woman "outside" the film as spectator which is not an alienated one?

If the response claims that the male privilege in the classical film cannot be as total as the textual theorists contend, then it must meet head on the warning that Freud, in his "Dostoevsky's knife" footnote in "Female Sexuality," issued to the defenders of women's interests: it is an argument that cuts both ways. That is, if feminists maintain that there is some masculine interest

9. There is, however, a notable difference of emphasis in Bellour and Heath's textual analyses. Bellour insists throughout his work on the classical film's striking ability to "resolve" itself, primarily through what he calls the "repetition-resolution" effect. Heath, while adding considerably to the argument for the aim of classical film toward achieving "homeostasis" through the resolution of textual contradictions, prefers to characterize this tendency as an illusionistic effect of the economy of classical film rather than a fact of its textual organization. For Heath, following Barthes, believes that there is always an excess that escapes any narrative system, a loss that is nonetheless fundamental to the movement or narrative progression of the film. He is also concerned to show how the woman in the film comes to represent, through the problem of defining and containing her sexuality, the contradictions and difficulties of the textual system itself.

10. Janet Bergstrom, "Enunciation and Sexual Difference," *Camera Obscura*, nos. 3-4 (Summer 1979): 47.

11. Janet Bergstrom, "Alternation, Segmentation, Hypnosis: Interview with Raymond Bellour," *Camera Obscura*, nos. 3-4 (Summer 1979): 97.

or prejudice at stake in the theoretical "fact" that female sexuality in the classical film serves only to mirror or be subsumed by that of the male, then opponents can say that this feminist objection is a natural one, that it has no basis other than an instinctive, feminine refusal of a view that is unflattering to them. This is a good point, and one that clearly has been taken to heart in the feminist writing on classical film. For, rather than repudiate the work of the textual theorists and the psychoanalytic theory on which it is largely based (the defense against the narcissistic wound), these feminist film theorists have chosen to work within those terms, while at the same time trying to understand why indeed a certain image of woman comes to serve as a *guarantee* of both textual system and film theory:

> *What is central here is that cinema appears as an apparatus which tries to close itself off as a system of representation, but that there is always a certain refusal of difference, of any troubling of the system, an attempt to run away from that moment of difference, and to bind it back into the logic or perfection of the film system itself. . . . This is the crucial point within the theory. The system is constituted as system only as a function of what it is attempting to evade. . . . The psychoanalytic approach to these questions parallels or echoes those analyses of cinema which have addressed themselves to this question of the way the woman gets set up, not simply as a certain* image *(which can be very easily criticized sociologically or historically) but as a* guarantee *against the difficulties of the cinematic system itself. –Jacqueline Rose* [12]

A further problem posed for the feminists writing about classical film, and one that had already suggested itself in the earlier work, was how to argue that there was a contradiction between the "feminine" and the classical system, without falling back on an essentialist notion of "femininity" or "Woman" as an eternal and *naturally* subversive element. There would be no feminist advantage to positing either a historically unchanging feminine essence or a monolithic patriarchal repression of that essence. The idea of an essence is ahistorical and asocial, and suggests a set of traits not amenable to change, while the "repression" thesis (visible in Cook and Johnston's work) fosters the belief that, once liberated from patriarchal constraints, femininity would finally assume its uncontaminated and naturally given forms. In the examples that follow, we will see various attempts to deal with this troublesome issue, one that is common to feminist theory in general.

In her study of *The Birds*, "Paranoia and the Film System," [13] Jacqueline Rose offered one of the first feminist criticisms of semiological and psychoanalytical film theory by suggesting that the textual theorists had too hastily assimilated the structure of classical film to an orthodox psychoanalytic description of the male's negotiation of the Oedipus complex, in other words, his

12. Rose, *Cinema in the Eighties*, p. 24.

13. Jacqueline Rose, "Paranoia and the Film System," *Screen* 17, no. 4 (Winter 1976-77): 85-104.

"integration into the Symbolic through a successful Oedipal trajectory."[14] When Rose points to Melanie Daniels' catatonic state at the end of *The Birds*, she does so in order to say something about the place of the woman in the Hitchcockian system, but also to emphasize the way contemporary film theory has understood and described that place. Her article is a direct response to Raymond Bellour's important study of *The Birds* ("*Les Oiseaux:* analyse d'une séquence"),[15] an essay which, in its rigorous attention to sets of binary oppositions within the text and their common pattern of alternation, repetition, and rhyming, established the terms for all future work on the textual operations of cinematic codes. It is equally a reply to "Le blocage symbolique,"[16] Bellour's exhaustive analysis of the effects of the Oedipal structuring in *North by Northwest*, from its smallest signifying elements to larger narrative and symbolic movements. While agreeing with Bellour that *North by Northwest* exhibits perfectly the ideal psychoanalytic scenario for the male character, Rose objects to extending this same analysis to a film like *The Birds* in which the Oedipal narrative closure is not as clearly and easily achieved as in *North by Northwest*, and in which that closure depends on relegating the woman either to catatonia or infantile speechlessness. In Bellour's version—that is, in his answer to the question "Why do the birds attack Bodega Bay/Melanie?"—he argues that the birds, as representatives of the men in the film, and ultimately its director (as a figurative stand-in for all men in the culture), attack Melanie as a punishment for her sexual aggressiveness (bringing the love birds to Bodega Bay as a lure for Mitch). In Rose's reading of the film, however, the birds "emanate" from an inherent instability in the film's own system which releases an "aggressivity" that focuses around the woman, one that finally cannot be contained by the film. This systematic instability allows Mitch to resolve his Oedipal task "successfully" only at the cost of Melanie's sanity and sexuality.

Where does this aggressivity come from? For Rose, it originates in the point of view structure of the film, particularly in the system of shot/reverse-shot whose ubiquity in the film is a Hitchcockian signature. Bellour describes the shot/reverse-shot system in Melanie's motorboat trip out and back across Bodega Bay in order to show how her look appears to predominate, but is actually circumscribed and contained by the looks of the male characters (and Hitchcock's, and the male spectator's). What seems to be symmetry is actually dissymmetry: women look only in order to be looked at while looking. But Rose adds another element to the shot/reverse-shot structure of Mitch and Melanie's specular reciprocity. She reminds us that the Lacanian description of the mirror-phase not only accounts for this kind of structure but also characterizes it as paranoid and aggressive. Because it is a specular image, cause and effect are reversible (the gull attacks Melanie because she brought the love birds

14. Ibid., p. 85.

15. Raymond Bellour, "*Les Oiseaux:* analyse d'une séquence," *Cahiers du Cinéma*, no. 219 (October 1969): 24-39. A translation, "*The Birds:* Analysis of a Sequence," is available in mimeographed form from the British Film Institute, Educational Advisory Service.

16. Bellour, "Le blocage symbolique," (see footnote 8).

Alfred Hitchcock.
Stills from *The Birds,*
showing the shot/
reverse-shot
technique used by
Hitchcock to
structure Mitch's
observation of
Melanie's boat trip
across the bay and
the attack by a gull

to Bodega Bay), while the reciprocity of the structure provides for mutual aggression (the attacking birds are associated with *both* Mitch and Melanie). The birds, then, are not representatives of Mitch and the other men in the film but the *sign* of the aggressivity released by the filmic reproduction of the Imaginary in the shot/reverse-shot system. Rose argues that the aggressivity focuses around the woman because of her privileged relation to the Imaginary deriving from the strength of the pre-Oedipal bond between the mother and the girl. An important point being made here (albeit implicitly), and one vital to subsequent feminist work, is that the "disruption" of the text is not the result of a feminine essence rubbing against the patriarchal grain of the film, but rather the conflation of two separate elements: a contradiction or lack in the textual system of the film itself (e.g., the aggressivity released by the miming of the Imaginary in the shot/reverse-shot structure) and the traits of the female character (e.g., Melanie's sexual aggressiveness). The significance of Rose's argument is that the woman *comes to represent* through the textual work of the film both the difficulty of sexual difference *and* the problems of cinema as a representational form. This question of how and why the woman in the film comes to bear such a heavy representational load constitutes the focus of later feminist readings of classical film.

Rose's complaint against Bellour's reading of *The Birds* is twofold. On the one hand, she questions his application of the psychoanalytic model to classical film—*The Birds* does not represent a smooth, Oedipal outcome for the man. On the other hand, she questions the psychoanalytic model itself, or rather Bellour's understanding of that model. His is not only a wishfulfilling version of psychoanalysis—one that assumes the possibility of a stable sexual identity, and thus a real "resolution" for the Oedipal male subject—but also a use of psychoanalysis which neglects the difficulties specific to feminine sexuality (for example, the greater strength of the pre-Oedipal bond of the girl to the mother), and thus to related difficulties within the film (Melanie's final infantilization). In a later article, on *Psycho* ("Psychosis, Neurosis, Perversion"),[17] Bellour took the opportunity to reply to Rose, presenting his case in even stronger terms. He agrees that the reciprocity of looks in the alternation of shot/reverse-shots evokes the "structure of the cinematographic apparatus, and thereby of the primitive apparatus it imitates, namely the mirror wherein the subject structures himself, through a mode of narcissistic identification of which aggressivity is an indelible component." However, he goes on to say that

> *this reference only makes sense . . . within the global system in which it has been constructed [Hitchcock's films, classical American cinema in general], that is, a system in which the aggressive element can never be separated from the inflection it receives from sexual difference, and in the attribution of this difference to the signifier that governs it. In other words, it is directed from the man towards the woman, and that*

17. Raymond Bellour, "Psychosis, Neurosis, Perversion," *Camera Obscura*, nos. 3-4 (Summer 1979): 105-132.

difference which appears due to woman is nothing but the mirror-effect of the narcissistic doubling that makes possible the constitution of the male subject through the woman's body . . .[18]

Bellour supports his argument that cinema reduces femininity to the narcissistic mirroring of masculinity by taking up Luce Irigaray's similar observation about psychoanalysis, that it always collapses sexual difference into one, masculine sexuality:

The American cinema is entirely dependent, as is psychoanalysis, on a system of representations in which the woman occupies a central place only to the extent that it's a place assigned to her by the logic of masculine desire.[19]

The feminist analyses of classical film that have followed this exchange between Bellour and Rose have dealt with the questions raised there in two ways. The first approach concentrates on psychoanalytic theory itself and offers another, more complicated, reading of it. Thus, in various articles discussed here, the writers have reexamined such crucial psychoanalytic concepts as identification, object relations, fetishism, voyeurism, fantasy, and the Imaginary, in order to understand the full complexity of their original theoretical application. This rereading is undertaken in the belief that psychoanalytic theory can help to give an account of the difficult path of cinematic sexual difference for *both* the man and the woman. The second approach deliberately selects films like *The Birds* to study, films which do not comfortably accommodate a male Oedipal scenario or ones in which the difficulties specific to feminine sexuality figure prominently. In actual practice, the two approaches overlap.

One of the ways in which the psychoanalytic model has been redefined in its application to film can be seen very strikingly in Janet Bergstrom's reading of another of Bellour's favored theoretical objects, *Psycho*.[20] Whereas Bellour argues that the woman is always the object of the man's look (and thereby adopts the basic Freudian fetishistic schema of the little boy's look onto the mother's body), Bergstrom's more complex counter-version of looking and identification in *Psycho* is taken from Freud's description of the structure of fantasy. For Bellour, the active male gaze (Norman's eye-phallus-camera) is directed towards Marion's body which passively receives it (her *jouissance* in the shower serving only to excite his desire), in exactly the same way that the little boy enacts a fetishistic disavowal around the mother's "penis" (he knows that it is not there, but *believes* it to be there nonetheless): the mother's body serving as the site of the little boy's narcissistic fantasy. In trying to move beyond this limited fetishistic interpretation, Bergstrom cites the multiple and successive identificatory positions found in fantasies like those reported to

18. Ibid., pp. 118-119.
19. Bergstrom, "Alternation, Segmentation, Hypnosis," p. 93.
20. Bergstrom, "Enunciation and Sexual Difference."

Freud, primarily by female patients, and which are summarily expressed in the words "A child is being beaten." In the analysis, the patient reveals the progressive stages of the fantasy. At first, she says, "My father is beating the child"; then, "behind" that scenario is a more masochistic one consisting of "I am being beaten by my father." Finally, she reports, "I am probably looking on." As Freud puts it, the situation of being beaten, 'which was originally simple and monotonous ['a child is being beaten'], may go through the most complicated alterations and elaborations." [21] In this fantasy, then, the woman respectively identifies, during its three stages, with the adult doing the beating, the child being beaten, and with herself as a spectator viewing the beating. She can thus be both subject or object, or identify with the entire scene itself. In addition to pointing out the intricate subject/object permutations found in the structure of fantasy, Bergstrom also cites Freud's case studies of the Wolf Man and Dora to show just how complex "identification" can be. Dora, for example, can love Frau K. only through a masculine identification, thus demonstrating once again the bisexuality of the unconscious (and also considerably complicating our Freudian understanding of "woman's desire"). Perceiving the multiple unconscious possibilities for the exchange and doubling of roles in fantasy, Bergstrom offers the following alternative reading of *Psycho:*

> *Wouldn't Norman's scenario have to read something like this? When he meets Marion, it is as the son to an available woman. When he watches her in the shower, Norman is the son watching the mother (Marion), imagining himself as the mother's lover ("the imaginary and ungraspable relation of the primal scene"). When Norman, impersonating his mother, kills Marion, it is as the mother killing a rival for her son's affection. . . . Each shift necessitates corresponding changes in the imaginary identifications of the other characters in the scenario.* [22]

Bergstrom concludes by insisting that it is now "possible and absolutely necessary to complicate the question of identification as it functions in the classical film, first of all in terms of the realization that spectators are able to take up multiple identificatory positions, whether successively or simultaneously." [23]

Mary Ann Doane, in her study of the "women's films" or "woman's pictures" of the forties ("*Caught* and *Rebecca:* The Inscription of Femininity as Absence"), [24] films intended for a predominantly female audience, also

21. Sigmund Freud, " 'A Child is Being Beaten': A Contribution to the Study of the Origin of Sexual Perversions" (1919), in *The Standard Edition of the Complete Psychological Works of Sigmund Freud*, ed. and trans. James Strachey (London: The Hogarth Press, 1958), vol. 17, p. 186.

22. Bergstrom, "Enunciation and Sexual Difference," p. 57-58.

23. Ibid., p. 58.

24. Mary Ann Doane, "*Caught* and *Rebecca*: The Inscription of Femininity as Absence," *enclitic* 5, no. 2 (Fall 1981); 6, no. 1 (Spring 1982). Similarly to Doane's attempt to give an account of films where the problems specific to feminine sexuality predominate,

argues against the theoretical assumption that the spectator is implicitly male and against the accompanying stress on psychical mechanisms related primarily to the male spectator—voyeurism, fetishism, and even identification. In the course of examining the specular and narrative problems of these films for women, she tries to show how the standard theoretical model cannot fully account for films explicitly constructed for a female spectator. If Hollywood narratives are analyzed simply as "compensatory structures designed to defend the male psyche against the threat offered by the image of the woman," and if classical cinema's appeal to male voyeurism or fetishism is infinite or exhaustive, then how are these "women's films" able to construct a position of female spectatorship (and how, theoretically, are we to make an argument for it)? Doane argues that the "women's films" nonetheless attempt to do so by basing themselves on an idea of female fantasy that they both "anticipate" and "construct." [25] As for the fantasies themselves, it is interesting that they are the very ones which have been typically associated with the female—masochism, hysteria, and paranoia. Although these films claim to deal directly with female subjectivity and desire, "certain contradictions within patriarchal ideology" become apparent within the film text because classical Hollywood film—in its forms and conventions—is intrinsically geared toward masculine fantasies and cannot sustain such an exploration.

Doane agrees, then, with the conclusion of film analysts like Mulvey and Bellour that the classical film is constructed with a male spectator in mind, that in Hollywood cinema, the "male protagonists [act] as relays in a complex process designed to insure the ego-fortification of the male spectator." [26] But she believes that the "women's films" attempt to do the same with the female spectator, "obsessively centering and recentering a female protagonist." Because of their effort to mirror the structure of classical film by constructing the scene/the film for a woman to look at, the "women's films" offer a crucial counter-example to an analysis which insists on the passive specularity of the woman, her objectification as spectacle by and for the masculine gaze. When a woman looks in these films, she too is given an objectified image of a woman to look at: in Ophul's *Caught*, the image is that of a woman in a mink coat; in Hitchcock's *Rebecca*, that of "a woman of thirty-six dressed in black satin with a string of pearls" (each woman is seen looking at these images in a

see Laura Mulvey's "Afterthoughts on 'Visual Pleasure and Narrative Cinema' Inspired by *Duel in the Sun*," *Framework* 6, nos. 15-17 (1981). In this "postscript" to her seminal article, Mulvey questions her own earlier idea that the modes of cinematic pleasure and identification of Hollywood film impose a masculine point of view on the spectator. She now argues that the female spectator is much more than a simply alienated one. She demonstrates her point by discussing films in which a central female protagonist struggles and finally fails to achieve a stable feminine sexual identity (e.g., Pearl as a tomboy in *Duel in the Sun*). This struggle mirrors that of the female spectator in her attempt to find a stable feminine identity, based as her sexuality is in the perpetual possibility of regression to the phallic phase. She concludes that the female spectator is a transvestite, an idea which can be interestingly compared to Mary Ann Doane's notion of femininity as "masquerade" (see note 28).

25. Doane, "*Caught* and *Rebecca*," p. 75.
26. Ibid.

fashion magazine). Significantly, the woman in the film cannot keep her distance from the proffered image of objectified desire: in *Caught* Leonora makes the social leap from carhop to millionaire's wife in order to *become* the picture of the woman in the fur coat; the Joan Fontaine character in *Rebecca* transforms herself into the image of the woman she had promised Maxim she would never be: a woman "dressed in black satin with a string of pearls." Not only does the woman become the image that she desires (being it rather than having it), but her desiring look is interrupted in the film by a masculine gaze that recasts the image of her desire into a desire to be desired.

In common with Bellour, Doane assumes the extreme circumscription of the woman's point of view and desire in the classical film. She does, however, agree with Jacqueline Rose that this process is threatened by the latent paranoia activated by the shot/reverse-shot system; the relevant interest here is to show how this paranoia is exacerbated by the film's attempt to construct a female spectator. For the subject matter of the films—a woman's near-destruction at the hands of a deranged husband—accelerates the paranoiac collapse of subject and object positions of looking, and swallows up the distance between the woman (character and spectator) and the image presented to her. What consequences does this paranoiac structure have for the film? On the one hand, Doane, like Rose, argues that the film is driven to act out or represent its own contradictions. In each of her examples there is a scene of a film being projected (Leonora's husband's documentary of his business exploits, Maxim's home movie of their honeymoon) in which the "normal" viewing situation of classical film is recreated: controlling male auteur and spectator, alienated female spectator. Not only does the film within the film stand in marked contrast to the "impossible" project of the "women's film," it also manages to recuperate the image of feminine desire found in the larger film, returning the woman, by the end of the film, to the confines of an image and/or the standard couple.

Doane, like Bergstrom, is dissatisfied with the adoption of the fetishistic scenario as the basic model for cinematic looking and identification, and as the vindication of the division of male look/female look into an active/passive dichotomy. For the woman, to possess the image (fashion magazine photograph) is to become it. Doane points out that in "becoming the image, the woman can no longer have it. For the female spectator, the image is *too* close—it cannot be projected far enough." [27] The heroines can either accept or reject the imaged offered to them; the scenario gives them no other choice. In other words, they do not partake of the fetishism of male spectators who can "have their cake and eat it too" (as Laura Mulvey describes Sean Connery's position in *Marnie*). The male spectator does not have to choose between accepting or rejecting the image; only men can maintain the proper fetishistic distance. In another article, in which Doane characterizes the position of the female spectator as a "masquerade," [28] she emphasizes that it is not an essential trait of woman to lack distance, to be too close and present to herself, but that this

27. Ibid., p. 83.
28. Mary Ann Doane, "Film and the Masquerade—Theorising the Female Spectator," *Screen* 23, nos. 3-4 (September-October 1982): 74-87.

nearness is the delimitation of a *place* culturally assigned to women (and especially so by films such as the woman's pictures of the forties). Equally, Doane wants to argue that, even though the woman's gaze and desire is radically circumscribed and even staged by the films as "impossible," it is not repressed in the sense of *no longer existing.* She cites Michel Foucault's critique of the "repressive hypothesis," the idea that repression is always total and fully effective:

> *[It] entails a very limited and simplistic notion of the working of power. . . . In theories of repression there is no sense of the productiveness and positivity of power. Femininity is produced very precisely as a position within a network of power relations.*[29]

Doane makes her point about the resistant tendencies of classical film by taking up Foucault's hypothesis concerning repression and power. It can, however, be argued equally well from a psychoanalytic perspective which acknowledges that repression is never complete. For, in fact, we only know of repression through its failures; if repression were total nothing would remain to make us aware of what had been repressed or the act of repression itself.

Although it is theoretically necessary to establish that these points of resistance are linked to the problem of sexual difference in the classical film, we must consider the possibility that, as far as the feminist interest in film is concerned, the most vital sites of opposition lie elsewhere. In fact, with the exception of the early work of Claire Johnston and Pam Cook, the feminist work on classical cinema did not seek to study Hollywood film in order either to legitimize its pleasures for feminism or reform it. Rather, the movement has been away from the discussion of classical film's equivocal efforts to contain the discord of sexual difference and toward a polemical consideration of films made by women *and* men that attempt to do what classical film (and sometimes the theories of classical film) suggest or even insist is structurally impossible: run counter to the Oedipal structuring of Western narrative form and the imaginary and fetishistic imperatives of the cinematic apparatus. The movement *away* from classical film includes, however, a frequent and strategic *return* to it. Not only do the feminist critics discussed here[30] feel it necessary to write concurrently about both classical and more experimental forms of film, but the experimental films themselves often insist on their own critical and aesthetic relation to classical film, the necessity of understanding and acknowledging its powers and effects in order more effectively to displace them. Although a great deal of important and vital work is being done in the realm of "personal,"

29. Ibid., p. 87.

30. I have not mentioned in this article the important feminist critiques of the theories of the "apparatus" which are complementary to the work on point of view, identification, and narrative discussed here. For a discussion of these critiques, see my "Feminism, Film Theory and the Bachelor Machines," in *Marxism and the Interpretation of Culture*, eds. Cary Nelson and Lawrence Grossberg (University of Illinois Press, forthcoming 1985).

even abstract, film which attempts to engage or depict a woman's consciousness or vision, the area of work of most concern here is exactly those films which try to rework or thwart what we have come to expect from classical film in terms of narrative organization, point of view, and identification. For if, as the feminist studies of classical cinema claim, woman in the textual system of classical film comes to represent both the difficulty of sexual difference *and* the problems of classical cinema as a representational form (its lacks and contradictions), then the newer, experimental work will have to address itself simultaneously to sexual difference as a psychical and social phenomenon, and to the *specifically cinematic* forms and ideas of that difference.

The films of Chantal Akerman furnish a prominent example. In *News from Home* (1976) or *Jeanne Dielman, 23 Quai du Commerce, 1080 Bruxelles* (1975) the absence of reverse shots coupled with the use of extremely long sequences serve to give an unusually strong emphasis to the positions of implied spectator and narrator. Here, for example, the spectator is not "included" in the film through a character's adoption and relay of his or her look. Both the spectator and the narrator (implied in *Jeanne Dielman*, an off-screen woman's voice in *News from Home*) are designated as being "outside" the scene, allowed to look at it with a controlled and fascinated gaze, one which is not caught up in or radically circumscribed by a masculine gaze or logic of desire.[31] Similarly, Yvonne Rainer's *Film About a Woman Who . . .* (1975) offers the viewer, including the female spectator, the possibility of a strategically *distanced* look at a woman's body, a body that is offered not as an icon of what the woman character or spectator should *become*, but a body to be looked at and thought about in relation to the "phenomenon of male dominance/female submission."[32] And even when Rainer's film begins to cut up both body and language, this fragmentation—"devices to break-up, slow-down, and de-intensify the narrative"[33]—leads not to the fetishistic comfort of the spectator but, rather, to a more concrete understanding of the vicissitudes of sexual hierarchy.

But it is perhaps Marguerite Duras' *India Song* (1974) that takes on the most "impossible" task of all when it attempts to accomplish what women "theoretically" and from the perspective of classical cinema cannot do: create a representation of lack, the precondition of all symbolic activity, the engagement with language and culture. Psychoanalysis, which along with semiotics is the founding theory of the textual analysis of classical film, suggests that women are not capable of representing lack because they have never possessed and then been threatened with the loss of that which allows one symbolically to depict lack—the penis. Classical film in its turn positions women characters (and, implicitly, female spectators) as *being* the image, and not as *having* it or

31. For a discussion of enunciation and point of view in the films of Chantal Akerman, see Janet Bergstrom, "Jeanne Dielman, 23 Quai du Commerce, 1080 Bruxelles," *Camera Obscura*, no. 2 (Fall 1977): 114-121; Janet Bergstrom, "The Avant-Garde: Histories and Theories" (Part I), *Screen* 19, no. 3 (Autumn 1978): 126-127.

32. Janet Bergstrom, "Yvonne Rainer: An Introduction," *Camera Obscura*, no. 1 (Fall 1976): 62.

33. Ibid., p. 66.

Yvonne Rainer. Still from *Film About a Woman Who . . . ,* 1974. Black-and-white film, sound, 16 mm, 105 minutes

Marguerite Duras. Still from *India Song,* 1975. Color film, sound, 35mm, 120 minutes

Chantal Akerman. Still from *Jeanne Dielman, 23 Quai du Commerce, 1080 Bruxelles,* 1975. Color film, sound, 35mm, 198 minutes

not having it (as Mary Ann Doane says, the woman is too close to the image, she has no choice but to become it). *India Song*, nevertheless, through its deployment of off-screen voices and their ambivalent and impossibly desiring relation to the inaccessible image on the screen of Anne-Marie Stretter—a woman who, the film tells us, is already dead—stages a representation that is fundamentally about loss and distance. In enacting a fantasy of loss and distance, then, it is also, and necessarily so, a fantasy of desire, specifically a desire that cannot be satisfied, and finally a desire for an unsatisfied desire. *India Song*, as "the *mise en scène* of this impossibility,"[34] thus leaves open the question of desire, and of a feminine position in relation to it, refusing, in contrast to classical film, to "answer" it with an assured definition of the nature of both masculine and feminine desire, and of desire itself.

In offering these few brief and selective examples of films that have received a great deal of feminist critical interest, my intention is to suggest the necessary affinity or continuity of two projects: an analysis of constructions of sexual difference in classical cinema and the way those ideas have been taken up or elided in film theory, and alongside that, an equally polemical attention to films that experimentally seek to reorder the relations of power and difference at work in classical film and its theory.

34. For a discussion of fantasy, desire, and sexual difference in *India Song*, see Elisabeth Lyon, "The Cinema of Lol V. Stein," *Camera Obscura*, no. 6 (Fall 1980): 7-41. Joan Copjec describes how repetition works very differently from Bellour's description of it in classical film in *India Song* and its "remake" *Son nom de Venise dans Calcutta désert*, in "*India Song/Son nom de Venise dans Calcutta désert:* The Compulsion to Repeat," *October*, no. 17 (Summer 1981): 37-52.

Silvia Kolbowski. *Model Pleasure, Part 7,* 1984. Black-and-white photograph, 25 x 35" (63.5 x 90 cm). (Photo: courtesy the artist)

Representation and Sexuality

KATE LINKER

Over the past decade there has occurred, across a body of dis-
courses, a significant shift in the way we conceive of the text. The demise of
the author as transcendent self or bearer of meaning has borne along a rejection
of the text as discrete or self-contained object; attention has been focused,
instead, on a model that poses meaning as constructed in the discourses that
articulate it, in an interactive context of reader and text. Against the expres-
sionist model, based on an expressive self and an empathic reader, who redu-
plicates preconstituted meanings, recent theory has proposed a reader who is
positioned to receive and construct the text, a historically formed reader shaped
in and through language. The shift is hardly unprecedented: it was in the
thirties, after all, that Brecht insisted on the work's incompleteness without the
viewer's active participation, and on the determining role of social conditions
in the process of meaning production.[1] Moreover, the direction merely confirms
an age-old awareness that texts "read" differently at different periods, accord-
ing to the discursive formations in effect. They are dependent for meaning on
given conditions of reception, on relations of context and use, on social forma-
tions that are laid into place—on what Hans Robert Jauss has referred to as the
"horizon of reception of the audience."[2] It is ideology's work that fixes such
meanings as timeless and immutable, above the field of material conditions,
rather than as shifting, in process. The movement from analysis of artistic

Reprinted from *Parachute*, no. 32 (Fall 1983): 12-23.

1. See Sylvia Harvey, "Whose Brecht? Memories for the Eighties," *Screen* 23, no. 1
(May-June 1982): 55-56, for a discussion of Brecht and reader-text relations in general.
Throughout this essay, my analysis is informed by a variety of sources of which the most
central are Jane Gallop, *The Daughter's Seduction: Feminism and Psychoanalysis* (Ithaca,
N.Y.: Cornell University Press, 1982); Juliet Mitchell and Jacqueline Rose, editors and
translators, *Feminine Sexuality: Jacques Lacan and the École freudienne* (London: R. W.
Norton, 1982); Annette Kuhn, *Women's Pictures* (London: Routledge & Kegan Paul, 1982);
Judith Mayne's several essays in *New German Critique* and the photographic criticism of
Victor Burgin, notably as collected in Burgin, ed., *Thinking Photography* (London: The
Macmillan Press, 1982).

2. Hans Robert Jauss, *Toward an Aesthetic of Reception*, trans. Timothy Bahti (Min-
neapolis: University of Minnesota Press, 1982).

products toward consideration of the production of meaning, then, can be seen to stem from awareness that consumption completes production—that there is, in any discursive situation, a "reader in the text."

The term "reader" could be replaced by "viewer," just as "text" could be exchanged for "photograph," "film," "advertisement," or any other cultural form whose circulation produces meanings. For what has become apparent is the role of these varied representations, founded on but not identical to language, in constructing what we know as reality. Since reality can be known only through the forms that articulate it, there can be no reality outside of representation. With its synonyms, truth and meaning, it is a fiction produced by its cultural representations, a construction discursively shaped and solidified through repetition. And this process by which reality is defined as an effect of signification has tremendous import for that necessary reader, or subject, implicated in its web.

Indeed, critical discussion has come to view as the correlate of this cultural formation of reality that social relations and the available forms of subjectivity are produced in and by representation. It has become axiomatic that questions of signification cannot be divided from questions of subjectivity, from the processes by which viewing subjects are *caught up in, formed by,* and *construct* meanings. Central among these is the process of suturing, by which the subject is "bound in" to the representation,[3] filling its constitutive absence or gap so as to complete the production of meaning. In this manner, the subject is the constant point of appropriation by the discourse and, in this sense, all representation can be said to entail subject positioning; the subject is at once placed in, or by, the discourse and constructed in, or by, the discourse. However, since the fabrication of reality depends on repetition to fix or stabilize meanings, most texts within cultural circulation serve to confirm and reduplicate subject positions. Representation, hardly neutral, acts to regulate and define the subjects it addresses, positioning them by class or by sex, in active or passive relations to meaning. Over time these fixed positions acquire the status of identities and, in their broadest reach, of categories. Hence the forms of discourse are at once forms of definition, means of limitation, modes of power.

The most impressive recent work concerning subjectivity has confronted a notorious absence—the question of sexuality. Examining its relation to questions of meaning and language, this work has exposed the way in which dominant discourses (and indeed, the discourses of supposedly neutral institutions) address spectators as gendered subjects, at once positioning and constructing subjectivity and securing patriarchal organization. What is at issue is a critique of patriarchy which, Freud noted, is equivalent to human civilization.[4] For it is patriarchal relations that set the terms for the forms of subjectiv-

3. For the central discussion on suturing attention is directed to Stephen Heath, *Questions of Cinema* (Bloomington: Indiana University Press, 1981) and Stephen Heath and Teresa de Lauretis, eds., *The Cinematic Apparatus* (New York: St. Martin's Press, 1980). For an attack on Heath's formulations that draws heavily on the concept of suture, see Noël Carroll, "Address to the Heathen," *October*, no. 23 (Winter 1982): 89-163.

4. See Juliet Mitchell, *Psychoanalysis and Feminism: Freud, Reich, Laing and Women* (New York: Vintage Books, 1975).

ity available in reader-text relations,[5] serving to ratify existing interests and echoing a history of feminine oppression. Throughout representation there are abundant—even preponderant—forms in which the apparatus works to constitute the subject as male, denying subjectivity to woman. Woman, within this structure, is unauthorized, illegitimate: she does not represent but is, rather, represented. Placed in a passive rather than active role, as object rather than subject, she is the constant point of masculine appropriation in a society in which representation is empowered to construct identity.

The visual material garnered through this project offers ample evidence of the controlling of feminine sexuality. Consider, for example, women's subordination to reproduction, to the family, and to the masculine libidinal economy as advanced through advertising and TV. Or consider the deployment of the fashion model as an idealized image for the male gaze, or for woman's narcissistic identification. Cinema studies have attended to the use of stars and stereotypes and to the function, in narrative, of these passive signs of masculine desire. This constitution of identity such that man is viewer, woman viewed, and the viewing process a mode of domination and control[6] has been applied to the tradition of the female nude; art history has turned, although belatedly, to confront the marginalization of women and the definition of creativity as male.[7] What we are given, then, is abundant evidence of a masculine ideal that directs and reinforces behavior; one which, by posing as a norm, impels adaptation to a constructed situation. Thus, "framed" against this background, women have begun to argue against the truth or reality of sexuality to interrogate the role of representation in their oppression.

This perspective is corroborated by Jacques Lacan, who remarked in 1958 that "images and symbols *for* the woman cannot be isolated from images and symbols *of* the woman. . . . It is representation, the representation of feminine sexuality . . . which conditions how it comes into play."[8] Woman is placed, and learns to take her (negative) place, according to it. For this reason, sexual difference should not be seen as a function of gender—as a pre-given or biological identity, as in the somatic model—but as a historical formation, continually produced, reproduced and rigidified in signifying practices. As Stephen Heath has written, sexuality is *in consequence of* the Symbolic.[9] And it is ideology, working through repetition, identification, and the illusionism

5. See Kuhn, *Women's Pictures, passim,* for a discussion of this topic.

6. A reversal of the terms applied in an example in Judith Mayne, "The Woman at the Keyhole: Women's Cinema and Feminist Criticism," *New German Critique,* no. 23 (Spring-Summer 1981): 31.

7. For a re-examination of art history's absences and the strategies underlying them, see Rozsika Parker and Griselda Pollock, *Old Mistresses: Women, Art and Ideology* (New York: Pantheon Books, 1981).

8. Jacques Lacan, "Guiding Remarks for a Congress on Feminine Sexuality" (1958), reprinted in Mitchell and Rose, *Feminine Sexuality,* pp. 86-98; other quotations from Lacan in this essay are drawn from *Ecrits: A Selection,* edited by Alan Sheridan (London: Tavistock and New York: Norton, 1975).

9. Stephen Heath, *The Sexual Fix* (London: The Macmillan Press, 1982), p. 154.

characterizing bourgeois society that naturalizes its cultural and variable categories as immutable essences or truths.

The prevalence of these images, their power in prescribing subject positions, and their use in constructing identity within the patriarchal order indicate that an exemplary political practice should take as its terrain representation, working to challenge its oppressive structures. However, these discoveries have also revealed the inadequacy of the equal rights or gender equity strategies that informed cultural politics of the seventies. These strategies, based in the elimination of discrimination and in equal access to institutional power, in no way attempt to account for the ideological structures of which discrimination is but a symptom; as Jane Gallop observes, they aim to recover, in the direction of complementarity and symmetry, the structured appropriation of woman to the order of the same, to the standard of masculine sexuality.[10] They leave untouched, in this manner, the integrated value system through which feminine oppression is enacted. And it is with the aim of understanding the construction of sexed subjectivity so as to disarm the positioning of the phallocentric order that artists have turned to psychoanalysis.

But to psychoanalytic theory of a very particular kind. The model to which contemporary practice has turned is not that of twenties-thirties theory, based on genital identity and "natural" preference, and directed toward patterns of normative sexuality. The trend comprised by Horney, Jones, and a host of other analysts, which conceived of a potentially unified subject channeled, through analysis, into conformity with society's codes, has been countered by one primed against this humanist conception. The latter model conceives of a human subject in process, in perpetual formation; it is one that views the unconscious and sexuality as constructed through language, through modes of representation that characterize our relation with others. Sexuality, in this approach, cannot be understood outside of the symbolic structures that articulate it, and prescribe society's laws. The model employs what is most forceful in Freud's theory—his analysis of the construction of the psychological categories of sexuality—using the sciences of linguistics and semiotics that were unavailable to him. It is generally associated with the radical rereading of Freud undertaken by Lacan.

In surveying the way in which such questions are addressed it is important to grasp the basis of this theory, for its pivotal terms recur throughout the artists' work, much as Lacan's late writings, with their stress on the fantasy construct of woman, provide a framework for recent political practice. What has been accomplished in recent years is a displacement of previous biologistic and reductionistic readings of Freud in favor of a radically contemporary model. Central to this process are Freud's statements on the psychological structures of sexuality—as opposed to anatomical difference—and on the intrinsic bisexuality of "the sexes." Resisting the notions of "masculine" and "fem-

10. Gallop, *Daughter's Seduction*, offers a remarkable discussion of this failing. See, in particular, Chapter 2; see also Parker and Pollock for a discussion of equal access strategies.

inine" ("among the most confused that occur in science"), Freud was to argue for "active" and "passive" relations, connecting sexuality to the *situation* of the subject."[11] The role of "places," here, is essential, for sexuality is determined by the direction of the drive, a drive that oscillates, historically, between both. This mobility is confirmed in actual observation which, Freud writes in a footnote added to *Three Essays on the Theory of Sexuality* in 1915,

> . . . shows that in human beings pure masculinity or femininity is not
> to be found either in a psychological or a biological sense. Every
> individual on the contrary displays a mixture of the character traits
> belonging to his own and to the opposite sex; and he shows a
> combination of activity and passivity whether or not these last
> character-traits tally with his biological ones.[12]

Therefore, "pure masculinity or femininity" can only be conventionally assigned, as meanings determined *by* the social order.

Freud and, after him, Lacan, were to find the key to "socio-sexual" identity in the presence or absence of the penis; in a critical moment before the Oedipal state, the child's look establishes its mother, or another, as without a penis, as lacking the masculine organ and inherently "less than" the male. This absence, which structures woman as castrated within the patriarchal order, is based on the privileging of vision over other senses, but what saves the concept from anatomical determinism is its reference to an existing system of meaning. For, as has been noted, "the presence or absence of a penis . . . is only important insofar as it signifies, insofar as it already has meaning within a particular formation of sexual difference."[13] The cultural formation of patriarchy prescribes in advance such sexual positions, ascribing the penis as that to which value accrues and its absence as . . . lack. Lacan goes beyond Freud, describing the penis as the inadequate physical stand-in for the phallus, the privileged signifier in our society. The phallus, in his system, is the mark around which subjectivity, social law, and the acquistion of language turn; human sexuality is assigned and consequently, lived, according to the position one assumes as either having or not having the phallus and with it, access to its symbolic structures. In this manner the Freudian notion of the look is rewritten, establishing the possession or lack of the penis as prototypical for language as the play of presence and absence as differential articulation. Within this structure the phallus assumes the role of a signifier or bearer of meaning, in relation to its absence, to lack. The latter position is occupied by the girl-child, who can thus be said to hold a gender-specific, and inherently problematic, relation to language in the phallocentric order. By demonstrating the way

11. See Heath, *Sexual Fix*, Chapter 9 for an excellent study of the concept of bisexuality in Freud.

12. Sigmund Freud, *Three Essays on the Theory of Sexuality* (1905), *The Standard Edition of the Complete Psychological Works of Sigmund Freud*, ed. and trans. James Strachey (London: The Hogarth Press, 1962), vol. 7, p. 220.

13. Gallop, *Daughter's Seduction, passim*.

in which absence serves to assert and reinforce the power of presence, the Lacanian system indicates something of the problem of woman, constructed as a category around the phallic term.

What is offered in this Freud-employed-by-Lacan is a differential account of sexuality, refuting the fixity of biological oppositions. A central role in this argument is accorded to looking, to otherness, for identity is constructed only through images acquired from elsewhere. Lacan firmly states that sexuality is not an absolute or "signified" but, rather, the *effect* of a signifier, derived from external social determinations. The foundation of his theory is that the human subject is formed in language, by a series of divisions that constitute sexed subjectivity and whose repressions comprise the unconscious. Central among these is the Oedipus complex, which serves to place the child within the social and sexual structures of patriarchy. For Freud and Lacan, it is through the Oedipus complex that the order structuring society is internalized; as Juliet Mitchell has written, the Oedipus complex implies that "the reproduction of the ideology of human society is thus assured in the acquisition of the law by each individual." [14]

The Lacanian version of the Oedipus complex entails a rewriting of the Freudian myth according to a linguistic model, by which the son assumes the Name of the Father, insuring the perpetuation of patriarchal culture through control over its symbolic structures. For this model, Lacan draws on Freud's account of Oedipal positioning. According to this account, both boy-child and girl-child initially share the same history, a bisexual history prior to the fixing of gender identity. Both share as object of desire their mother, which is equivalent, in fantasy, to having the phallus that is the object of the mother's desire. [15] This phallic phase, moored in the illusion of sexual completeness, is ended by the incest prohibition instituted in the Name of the Father; thus the father represents the intervention of culture to break up the "natural" biological dyad, acting to repress desire through threat of castration. According to a successful Oedipal resolution each child will choose as love object a member of the opposite sex and identify with one of the same: in this sense, sexuality can be seen as the displaced, and retrospectively deferred, *consequence* of this early action. Threatened by castration, the boy will transfer his Oedipal love for his mother onto another feminine subject, while the girl will transfer her love to her father, who appears to have the phallus, identifying with her mother, who has not. The girl will struggle to "have" the phallus, instituting the play of heterosexual sexuality (that culminates in the phallic substitute of the child), while the boy will work to "represent" it. The desires of the Oedipus complex are repressed into the unconscious, and of these the central, significant one—the object of primal repression—is the phallic mother herself. Hence meaning, or a "place" in patriarchal structure, is attained only at the price of the lost

14. Mitchell, *Psychoanalysis and Feminism*, p. 413.

15. My discussion of the Oedipal complex is taken almost entirely and quite "to the letter" from Mitchell's excellent resumé. Particularly pertinent to the topic of this essay is her treatment of the male child's "struggle to represent" the phallus, Mitchell and Rose, *Feminine Sexuality*, p. 7.

object. Castration consists of the surrender of satisfaction *necessary* to assume sexual identity.[16] It is in this lack, the effect of a primordial absence (the dyadic union with the mother) that Lacan bases the instigation of desire, which is distinguished from want in that its satisfaction is never attained. Desire, then, is deviation; it is ex-centric, constantly "forced away from the aim and into displacements."[17]

According to Lacan, the castration complex ". . . has the function of a knot . . . in . . . the installation in the subject of an unconscious position" that predisposes future identifications. It provides a structural account of how the subject becomes securely placed in patriarchy, assuming an identity as "he" or "she" that serves to represent its sexuality. Sexual difference can be seen to be assigned and structured through language, operating in the Name of the Father; for this reason, it operates in the register of the symbolic, leading to the interminable circulation of institutionalized identities, of psychic categories of sexuality, founded on primal repression.

Phallic castration, however, is but the central instance of this subjection to external law. Parturition and loss thread their way through subjectivity, through the positioning of sexuality, the acquisition of language, and the sense of self necessary for conscious reflection. Lacan locates as a site of this division those language games that signal the infant's entry into the order of language, marking the transition from a world of pure unmediated experience to one of objects ordered by words. Of central importance is the *fort-da* game commentated by Freud,[18] in which the child's attempt to master the experience of its mother's absence is expressed in a phonemic opposition, her disappearance and reappearance being symbolized by the absence and presence of a toy reel. In this opposition Lacan locates a necessary condition for symbolization, enabling communication with others: it is only through absence, through loss of the experiential plenitude associated with the maternal body prior to subjection to the paternal order, that representation can occur. Representation, then, is loss, is lack, and with it is initiated the play of desire. Lacan encapsulates these relations in a triplicate series of terms, designating as the Real that unattainable immediacy that eludes the hold of the Symbolic, the order of language and representation, and whose return is conjured, through fantasy and projection, in the Imaginary.

Throughout his texts, Lacan returns to the subject's circling around this fantasy of unity, emphasizing the subject's divided and uncohesive status, its fundamental dependency on the signifier. And its inherent instability, for Lacan stresses that this subject is in process, produced in and through the modalities

16. Gallop, *Daughter's Seduction*, p. 28.

17. Freud's works on the topic as quoted in Gallop, *Daughter's Seduction*, p. 28, where the author, in a complex play on words, also quotes Lacan on the "excentricity" of desire. My own navigation through these terms is based on hers.

18. The *fort-da* game has been widely commentated. This account is based on one by Victor Burgin, who links it to Barthes' citation of the *tuche* or "encounter with the real" in *Camera Lucida*, and shows its relations to the Lacanian terms of Real, Symbolic, and Imaginary: "Re-Reading *Camera Lucida*," *Creative Camera*, no. 215 (November 1982): 731.

of language: if it is constituted through the formative stages that underly the acquisition of language, this structuring is not definitive, the subject is constantly formed and re-formed, positioned and re-positioned in every speech act. This flux in the subject has important implications for ideology, which aims to produce the appearance of a unified subject, masking or covering division. And in a manner with significant bearing on the visual arts, Lacan returns repeatedly to the role played by specularity, and to the look as guarantee of imaginary self-coherence.

In looking at an object in the world outside its own body, Annette Kuhn has written, "the subject begins to establish that body as separate from and autonomous of the world outside,"[19] affording the split between subject and object that is the condition for entry into language. But the privileged moment in the process of self-consciousness is the mirror phase, which occurs between the ages of six and eight months, when the infant child perceives its reflection as an independent and cohesive identity, locating itself in an order outside itself, and providing the basis for further identifications. Lacan, however, stresses that the apparent unity is a multiple fiction (". . . this form situates the instance of the *ego*, before its social determinations, in a fictional direction . . ."): on one hand it covers or masks the infant's fragmentation and lack of coordination ("still sunk in his motor capacity and nursling dependency") in the wholeness of an image, just as the very image that places the child cleaves its identity in two, into self and objectified other. And on the other hand, this specular self is conferred only through the mediation of a third term, the mother, an other, whose presence conveys meaning, insuring its reality. Hence the mother "grants" an image to the child in a process of "referring"[20] that erodes the supposed unity of the subject. If the mirror image, in its cohesiveness, provides a model for the ego-function, if it locates the self within language, then it places it in a relation of dependency to an external order, shifting according to placement, lacking fixed identity. The subject is both "excluded from the signifying chain and 'represented' in it."[21] This specular self, then, is the social self; Lacan's human subject, as Juliet Mitchell has written, is not "an entity with an identity"; whatever identity it appears to have is derived only "by identifying with others' perceptions of it."[22] The self is always *like* another.

The mirror stage is important to Lacan because it reveals the fictional nature of the centered, "whole," subject, showing the image of our first recognitions to be a misrecognition, a falsity. Soon language replaces this image, as the signifier assumes ascendancy over the subject, enabling the subject to be represented within the matrix of social communication. Division and loss, as recounted before: primal repression, Monique David-Ménard writes, again

19. Kuhn, *Women's Pictures*, p. 47.

20. Mitchell and Rose, *Feminine Sexuality*, pp. 30-31, contains the clearest elucidation of the role of the mirror stage in the subject's location in language.

21. Anika Lemaire, *Jacques Lacan* (London: Routledge & Kegan Paul, 1977), p. 68.

22. Mitchell and Rose, *Feminine Sexuality*, p. 5.

underscores this operation in which "the existential situation, overshadowed by the symbol, falls into oblivion, and with it the subject's truth."[23] But such wholeness persists at the level of fantasy as that truth, or point of certainty to which the subject would appeal to complete its divided status. Lacan designates this site of the subject's demand as the Other, holding it up as a fantasy against the mobility of language as the place of meaning production and against the signifier's rule over the subject. For if the meaning of each unit can only be determined differentially, by reference to another, there can be no ultimate meaning or certainty for the subject. And if sexuality is structured in language there can be, through a similar logic, no fixed sexual identity. Only through a false essentialism can the instability or "difficulty" of sexuality be resolved: only when (as Jacqueline Rose remarks) "the categories male and female are seen to represent an absolute and complementary division . . . [do] they fall prey to a mystification in which the difficulty of sexuality instantly disappears: 'to disguise this gap by relying on the virtue of the "genital," to resolve it through the maturation of tenderness . . . however piously intended, is none-theless a fraud.' (Lacan, *Meaning of the Phallus*, p. 81)."[24] And it is against this false essentialism, this "spirit" opposed to the "matter" of language, that Lacan's late writings are addressed.

Lacan's last texts return again and again to the question, unanswerable for Freud, of "What does woman want?" And what is most radical, most "desirable" in them for feminist thinking is his insistence on the plurality of positions that crosses language as its constantly produced effect, countering the conventional opposition used to represent difference. In this, Lacan is following Freud, who opposed the notion of symmetry in the cultural formation of the sexes, arguing that the place of woman within patriarchy precluded comple-mentarity. The denial of polymorphous sexual urges under Oedipal prohibition insured that the father's dominant place in society could be assumed only by the male, by the cultural heir to its laws. Lacan, however, will go Freud further, "barring" Woman (*la Femme*), declaring her nonexistence, her nonuniversal-ization within the phallocentric economy.[25] "There is no woman but is ex-cluded by the order of words which is the order of things . . . ," he writes. And throughout these texts he will call fraud the subjection of woman to those laws which construct the subject as masculine, revealing the arbitrariness, the imposture of that position.

Two things are at issue here: one, the unjust accommodation of woman to the masculine standard; the other, the specific role as fantasy she performs in the sustenance of that very arbitrary accord.

Evident in Lacan's writing and before it, in that of Freud, is that the framework for the expression of "sexual complementarity" is masculine.

23. Monique David-Ménard, "Lacanians Against Lacan," *Social Text*, no. 6 (Fall 1982): 95.

24. Mitchell and Rose, *Feminine Sexuality*, p. 33.

25. This best discussion on this "non-existence" of woman, her appropriation to the masculine standard and the phallic "dis-proportion" discussed in the next paragraphs is Gallop's.

Woman is defined (or "derived," as Stephen Heath terms it) [26] as the difference *from* man, judged against his determining maleness. This definition of woman as not male, as "other," consists in the renunciation of feminine specificity; it precludes heterogeneity—or true heterosexuality—through homogeneity, the rule of the One.[27] Defined as "negative" through the terms of sexual polarity, woman functions as a category against which masculine privilege attains to presence: it is through her negative place that the value of dominion accrues. And this reduction of plurality to the phallomorphic standard prescribes that woman will never be able to represent her difference but will serve as a mirror for the masculine subject, divesting otherness to the same. This is why, according to Lacan, there can be no "relation" between the sexes, but only "the union of opposites, difference resolved into one," in the masculine dream of symmetry.

In a manner impossible to Freud, Lacan, with his mooring in language, will attribute this unreasonable privilege of the phallus to its function as a signifier which rules over (produces) the subject. And with the same gesture he will expose the misreading on which that privilege rests. The phallus, he writes, is "the signifier intended to designate as a whole the effects of a signified, in that the signifier conditions them by its presence as a signifier." In this sense man *as well as* woman is castrated, is partial, as a condition of subjectivity: both are subjected to the same "whole" or standard. As Jane Gallop formulates it, the phallus

> . . . *is both the (dis)proportion between the sexes, and the*
> *(dis)proportion between any sexed being by virtue of being sexed*
> *(having parts, being partial) and human totality. So the man is*
> *"castrated" by not being total, just as the woman is "castrated" by not*
> *being a man. Whatever relation of lack man feels, lack of wholeness,*
> *lack in/of being, is projected onto woman's lack of phallus, lack of*
> *maleness. Woman is then the figuration of phallic "lack"; she is a hole.*
> *By these means and extreme phallic proportions, the whole is to man as*
> *man is to the hole.*[28]

In the Lacanian system this "ultimate signifier" is the signifier for union underlying desire. Associated with the object lost in primal repression, its privileged image is the phallic mother, the pre-Oedipal mother, "apparently omnipotent" prior to the discovery of her significant lack.[29] It is to this first object that man will return in fantasy, through the displacement of desire along the metonymic chain, attempting to recuperate wholeness, to rediscover plenitude, to disavow his own necessary partiality through projection onto the feminine substitute. Lacan designates this object as *objet a*, in reference to

26. Heath, *Sexual Fix*, p. 114.
27. Gallop, *Daughter's Seduction*, p. 66.
28. Ibid., p. 22.
29. Ibid.

l'Autre, the Other, that point of certainty toward which subjectivity strains. Within the play of desire, then, women is a fetish—"the filler for the void," as Gallop calls it—used to dam up the absence of the original object. Bridge toward union, toward *denial* of separation, woman is thus employed to comprise the stable, unified masculine subject in disavowal of its constitutive contingency. The relation of man to *objet a* is fantasy: as the projection of lack, woman, writes Rose, functions as a *symptom* for the man.[30]

What Lacan does, in emphasizing the subjection of woman under patriarchal law, is to reveal the dependence of masculine authority on that very negative status. And in demonstrating the arbitrariness of the assumption, based on "seeming" or visible value, he indicates its unfounded nature. For woman can only be negatively defined, elevated to truth and made to support the onus of masculine fantasy when the terms of sexual identity become fixed by that very rigid opposition. As such, she becomes the mystified object, the mythical Other, an essence opposed to the material product of language. However, given the arbitrary construction of sexual identity, given the intersubjective network on which it rests, and given the unability of the phallus to all, any speaking being, regardless of sex, is entitled to assume the phallus,[31] to position itself on either side of its divide. As a subject in process, in language, woman is at liberty to counter anatomy and with it, the claims of essential femininity, freeing her self from the fixed terms of identity by recognition of its textual production. And it is against this mobility that Lacan "places" the hypostasis of Western phallocentric culture, with its enshackling, oppressive "effects," and calls it fraud.

Lacan's project has been taken by many artists as an injunction to "dephallicize," to assume the phallus critically so as to erode its powers, revealing the arbitrary privilege on which they rest. This practice is based on the assumption of a theoretical position classically denied to women in Western society; it should be noted, however, that a number of its practitioners are men aware of the role of their own sexuality in the relations between representation and power. The following four artists are only several of those engaged in examining purposefully hidden areas within the field of subjectivity.

Central for its theoretical breadth, textual complexity and thoroughness of analysis is Mary Kelly's *Post-Partum Document* (1973-79), a six-section, 135-part multimedia record of the first six years in the mother-child relationship. Taking as its material the artist's own son, the work begins with the infant's birth and ends with inscription into the human order, tracing the formation of language, selfhood, and sexual positioning as defined by patriarchal society. In its ordered arrangements of feeding charts and diapers, of baby vests, diaries, and imprints of words, the *Document* could be regarded as a simple, if obsessive, record of child development. However, Kelly's theoretical notes and the place accorded to maternal fantasies install it in another context,

30. Mitchell and Rose, *Feminine Sexuality*, p. 48.

31. On the "assumption" of the phallus, or "de-phallicization" as an imperative for feminists, see Gallop, *Daughter's Seduction*, Chapter 8.

(Top left) Mary Kelly and son, Kelly Barrie, in recording session for *Post-Partum Document, Documentation II,* 1975. (Photo: Ray Barrie); (Top right) Mary Kelly. *Documentation IV* (detail), 1975, from *Post-Partum Document.* Plaster mold, cloth, paper, one of eight units, each: 14 x 11″ (35.6 x 27.9 cm). Kunsthaus, Zurich; (Bottom) Mary Kelly. *Documentation VI* (detail), 1979, from *Post-Partum Document.* Etched slate and resin, two of fifteen units, each: 10 x 8″ (20.3 x 25.4 cm). Arts Council of Great Britain

arguing for motherhood as a specific *moment* of femininity constructed within social processes.[32]

Throughout the six parts the associations of mother and child, their social and psychical positioning, shift across the structure of their relationship in reciprocal patterns according to internal and external factors. Hence the separate stages of the *Document* map the constitution of feminine identity through moments in the development of the child; just as the child is seen as socially formed, as positioned within the human network through decisive processes of language acquisition, so Kelly's treatment of her self suggests that feminine subjectivity cannot be viewed outside the intersubjective framework of its formation.

Kelly's decision to employ no direct representations of the female body serves a dual purpose: on one hand, it provides a protest against the body's use as an object, and against its appropriation to the sexist doctrine of essential femininity. And on the other, it acts to locate femininity within the field of desire, played out across a series of psychic investments. The myriad verbal and visual representations—the animal specimens and comforter fragments, the foot molds, baby vests, and samples of childish scrawl—function as emblems of the mother's desire; in conjunction with the analytic discourse, they trace and elucidate the shifting flow of plenitude, parturition, and loss that comprises the maternal relation to the child.

Indeed, the *Document* locates maternal femininity in the narcissistic pleasure of identification with the child, an identification which, through the phallus, serves to supplement her negative place. The experience of "having the phallus" pertains to the Imaginary, resulting from the mis-recognition of the child as belonging to the mother's body. This fantasy of union is ruptured by the ultimate necessity of division, required both by the processes of the child's maturation and by the Oedipal prohibition of the Father and the Law. Thus there is instability in the relationship—and difficulty, occasioned by the mother's inability to accept the child as a "whole," as a-part from, rather than part of, herself. To the mother the child's loss represents the relinquishment of plenitude, and the reaffirmation of her own lack, for which she will aim to compensate by substituting, for the Imaginary object, varied emblems of desire.

In a cryptogram of maternal femininity, Kelly rewrites Lacan's diagram $\frac{S}{s}$ as $\frac{\text{What do you want?}}{s}$, installing the mother in the position of the Other who is privileged to answer the child's demands. As she remarks in her annotations, this formula is an unconscious symptom of the mother's desire to remain the Omnipotent Other of the pre-Oedipal period; dependency to the Signifier is gradually relinquished in the first three sections of the *Document*

32. Informative analyses of Kelly's project are provided in an interview with Paul Smith, *Parachute*, no. 26 (Spring 1982): 31-35; Margaret Iverson, "The Bride Stripped Bare by her Own Desire: Reading Mary Kelly's Post-Partum Document," *Discourse*, no. 4 (1981-82): 75-88; and, in particular, Elizabeth Cowie, "Introduction to the Post-Partum Document," *m/f*, nos. 5-6 (1981): 115-123.

which rehearse postpartum separation as described by Lacan.[33] Weaning from the breast, for example, is documented in the Analyzed Fecal Stains, which measure the gradual ingestion of solid food. Part II traverses weaning from the holophrase, in which early, intersubjective, inherently dependent discourse, where the mother completes and interprets the child's single-word utterances, cedes to the formation of independent patterned speech. Physical separation (weaning from the dyad) is documented in Part III, first through the father's intervention, then as the child begins nursery school, leaving the mother on a daily basis. The three parts imply an interrelated sequence of divisions spanning sexuality, representation, and language. Weaning from the holophrase, for example, culminates in the child's recorded full-sentence utterance, "See the Baby (looking in the mirror)," marking the end of his imaginary identification with his mother. As Margaret Iverson has noted, the formation of an independent ego in this phase entails a triple series of identifications with another—with the mirror phase, with another's language, and with the father, expressed in the (male) child's desire to occupy his father's place.[34] All of these signs mark the child's differentiation. All can be perceived as threats to the narcissistic identification of the mother.

The remaining Documentations encompass the progressive externalization of the child and the reciprocal loss, and sublimation of loss, by the other. The process culminates in Part VI which records the child's efforts to read and write, and ends with his writing his own name, designating both his acquisition of language and his awareness of his place within the symbolic order. In this final part mother and child receive their definitive positions in a framework of social rather than psychic relations, a framework marked by wholeness and definitive loss. According to Lacan, the maternal situation consists in a reactivation of the childhood experience of castration; it is a phasal replay of the feminine passage through the Oedipal moment, and through the recognition of her negative position. Hence Kelly's work demonstrates the psychic shifts across language and representation that determine subjectivity, defeating the fixity of identity. But what is most important in this process is what the *Document* brings to bear on the nature and function of representation.

According to psychoanalytic theory, the fetish is a substitutive object, employed to disavow and, in so doing, acknowledge the fact of woman's castration. Normally conceived as a masculine practice, fetishism is figured here as a feminine project, for the hand molds, scraps of comforters, and word imprints represent an attempt to disavow, through psychic investments, the loss of the child-as-phallus. The substitutive objects intervene as an effort to suture that loss, to bind up, or psychologically allay, the anxiety of castration. Yet Kelly places this practice in a larger context, arguing for the fetishistic nature of *all* representation, based in the inevitable division between subject and object. And since it is across such representations that child and mother come to be placed, the latter in her definitive situation of lack, so the *Document*

33. See Iverson, "Bride Stripped Bare," pp. 81-84.
34. Ibid., p. 81.

presents an analogue to the processes of representation by which the individual subject is socially positioned.[35] Although the early Documents describe the psychical positioning of the mother across family relations, showing their grounding in the unconscious structure of fantasy, the footnotes to Part VI describe her construction across social institutions and discourses—across bad schools, housing, problems of economy and health that define her responsibilities as mother. Implicit in Kelly's remarkably contained analytic work is an argument for the social construction of subjectivity in a striking indictment of essential femininity.

Kelly's practice must be located in the Women's Movement's history, and in the particular moment in the mid-seventies when British feminists turned to psychoanalysis. In a similar manner, Victor Burgin's work has been historically formed, both by conceptualist and postconceptualist practices and by discussions, centered around British cinematic journals, into the place of the individual subject in representation. Although Burgin had been involved during the mid-seventies in a critique of class relations and ideological structures, that activity has more recently been "displaced" to the terrain of sexuality and to an examination of the relations between sexuality and power.[36] His project entails an extended analysis, constructed across the signifying practice of photography, of the role of psychic structures in the formation of daily reality, and of the particular part played by photography as a central ideological apparatus. Two elements are important to this study: one, the degree to which the detours of memory, fantasy, and other primary process operations infiltrate the process of looking, defining its discursive dimension; the other, the way the photographic apparatus itself reflects unconscious structures of fascination, constructing and reinforcing the subject in a masculine position. Implicit in this practice, then, is a contestation of the neutrality of representation, an exposure of the extent to which the "male-coded voice of sexual oppression [is] the archetype of all oppressive discourses"[37] inscribed in the dominant signifying practice of our society.

Indeed, Burgin's practice is directed against a conception, inherently formalist in nature, which would conceive of photography as a "purely visual" medium, and of the photograph as a transparent reflection of its subject. This notion provides the framework of photographic neutrality, based in the adequation of image and meaning; it is countered, here, by the image conceived as a discursive form whose "reading" emits, intervolves and variously engages psychic, social, and institutional "texts." Supporting this approach is attention to the production of meaning and to the relation of photography to language: ". . . even when one looks at a photograph with no writing on or alongside it," Burgin notes in a recently published interview, "a text always intrudes—in a fragmentary form, in the mind, in association. Mental processes exchange

35. See Cowie, "Introduction to the Post-Partum Document," pp. 120-122.

36. Claude Gintz, essay on Burgin's *Gradiva*, unpublished.

37. Tony Godfrey, "Sex, Text, Politics: An Interview with Victor Burgin," *Block*, no. 7 (1982): 15.

images for words and words for images . . . ,[38] engaging with latent registers of fantasy to amplify and transform the "visual form." Photographs are apprehended *through* language, either through the radicular operations by which we "make sense" of images, or through more complicated unconscious trajectories that inevitably establish contact. This "scripto-visual" nature defines the photograph in its social use,[39] outside of the visual or formal constraints that characterize its artistic practice. And what this indicates is that meaning cannot be located within the image, as a preexisting or expressed characteristic, but is continually displaced to an intertextual fabric whose elaborations parallel the mechanisms of dreams.

Freud described the dream as a rebus, in which the operations of condensation and displacement, of considerations of representation and secondary revision insured that visual elements could be deciphered for their inscribed unconscious forms. From the laconic structure of the manifest elements unfold chains of association and fluxive references which ". . . spread out . . . into the intricate network of our world of thought: consciousness, subliminal revery, preconscious thought, the unconscious—the way of phantasy" (Burgin, from one of his texts). It is in this context that Burgin employs black-and-white images, stressing the photograph as a text to be read, and places image and superposed copy in a shifting or ex-centric relation. This skewed relation is both informed by, and critical of, the use of photographs in advertising and media, where the verbal text serves to fix or regulate meaning, producing the image as reality *for* the subject. The direct, redundant relation between image and text situates the reader in a passive, rather than active, relationship, as consumer—not producer—of meaning. This confirmation and reinforcement of subject positions has made photography a prime instrument of ideology, working to enforce the order of dominance. The evasive, intrinsically disjunctive structure of Burgin's texts works to engage the very intertextuality productive of meaning, enjoining the reader to intervene actively in the work.

Negating the fixed, self-sufficient object which is the photographic image, Burgin also places under denial its complement, the transcendent subject. And with it, the author: ". . . it is the component meanings of this [intricate psychic] network that an image must *re-present*, reactivate and reinforce, . . . it is the pre-constituted field of discourse which is the substantial 'author' here, photograph and photographer alike are its products; and, in the act of seeing, so is the viewer."[40] Meaning and the subject are produced through representation, as a function of textual operations: we are returned to the now-familiar theme of the subject as *effect* of the signifier.

Consideration of the construction of this subject, however, must address the complicity in the process of the system of representation itself. The suturing

38. Ibid., p. 8.

39. Quotations and descriptive framework (in particular, Burgin's involvement in Freudian theory) in the following paragraphs are taken from interviews and critical essays, in particular those in Burgin, *Thinking Photography*.

40. Burgin, "Photography, Phantasy, Function," in *Thinking Photography*, pp. 206-207.

activity by which the subject is bound in to the discourse in a moment of identification is always inherent in the technical system as a precondition of its efficacy. And Burgin's project interrogates both the means by which the discourse of photography and its representational apparatus, the camera, construct the subject, and the specific form of subjectivity composed. A cursory glance reveals this to be the singular, unified, centered subject of humanist discourse, which is placed in a position of mastery or control over the depicted scene. Based on the *camera obscura* of the Renaissance, photographic representation implies both a framed scene or object and a controlling point of view: through a "systematic deception," the single-point perspective in the lens ". . . arranges all information according to the laws of projection which place the subject as geometric point of origin of the scene in an *imaginary relationship* with *real space* . . ." (italics mine). The scene both radiates from and returns to this controlling position, occupied by the camera and conferred, in looking, on the viewer. it is the medium's putative transparency that bestows the illusion of naturalness, effacing the image's fabrication under guise of objectivity. Hence Burgin can state that "the perspectival system of representation represents, before all else, a *look*," [41] implying subject and objectified other.

As with the viewer's relation to this object, so his relation to ideology is similarly prescribed. For this subject, as a historical production, is intimately bound up with the ideology and development of capitalism. The sense of controlling individuality, of the subject who masters through technological, legal, and social apparatuses, informs the capitalist approach to nature and after it, to humanity. And, hence, it is not surprising to find this perspectival system inscribed within those very reproductive apparatuses—photography and the cinema—which coincide with and support the ideology of capitalism. As Laura Mulvey observes, the camera is a means to produce the "illusion of Renaissance space," thus subjecting it to the controlling male gaze and to "an ideology of representation that revolves around the perception of the subject." [42] But the clue to this efficacy, to the social predominance of objectifying modes of mastery, is to be found far earlier in psychic structures of fascination.

Looking, Freud tells us, is not indifferent; it is always implicated in a system of control. Freud designated the sexual pleasures of looking as an independent drive, scopophilia, which assumed both active and passive forms. In *Three Essays on the Theory of Sexuality*, he noted their coexistence and alternation in children, as well as the social predominance of one. Thus voyeurism denotes a pleasure in positioning oneself against another—in submitting the other to a distanced and controlling gaze—while the desire to be both object and subject of the gaze characterizes exhibitionism. What constitutes, or differentiates, the drive is the way the subject positions itself within its circuit. These psychic implications are elaborated in Lacan's discussion of the scopic, in which he distinguishes between the narcissistic movement of the mirror phase, con-

41. Ibid., p. 187.

42. Laura Mulvey, "Visual Pleasure and Narrative Cinema," *Screen* 16, no. 3 (Autumn 1975): 18. Mulvey's essay remains the central source for the analysis of the structures of fascination in film. [Reprinted in this volume, pp. 361-373.]

sisting of erotic investment in one's unified image, and the inherently sadistic drive of the voyeur. However, the two are conjoined in their imaginary or imagistic function of fending off lack through the investment of self-coherence; in this they can be seen to confirm an inherently fetishistic role.

The social shaping of the scopic is manifest in the regimes of specularity enforced through ideology; one can note, for example, the narcissistic investments of consumption, which invoke an ideal self-image through acquisition of objects, and exploit the specular brilliance of photographic surfaces to the structural fascination of the mirror. And one can also note, on the other hand, the ideology of the spectacle as authorized by the dominant order, in which one part of society represents itself to the other, reinforcing class domination.[43] According to the division of labor in society, it is women who assume this position of "otherness"; the structures of seeing and being seen, with their implications of ego preservation and gratification, become aligned with sexual difference. Their construction in and through representation is documented in studies of the cinema, in which the masculine look inscribed through stars and stereotypes, the dyad of silent woman and active male, articulates woman as spectacle, as image, as *writing* of masculine desire. Yet their compass is immeasurably broader. Through advertising and fashion photography, through photojournalism, the institutions of art and the prescriptions of social decorum is woven an insistent pattern, the cultural inscription of subject positions. Writes John Berger, describing the im-position of the masculine gaze, "*Men act and women appear*. Men look at women. Women watch themselves being looked at."[44] This eviction of the female spectator has parallels in the exclusion of woman from language. Across the social screen, then, is constructed a series of repetitions, between subject and object and surveyor and surveyed, between power and oppression and speaker and spoken.

Burgin's awareness of the camera's complicity in this negative representation of woman is evident in *Olympia* (1982), one of whose images repeats, in an internal play, Lacan's famous diagram on the social designation of difference. Of the two sexually scored bathroom doors, the women's has been opened to expose the photographer with camera reflected in a mirror, conferring on the photographic apparatus the attributes of voyeurism. The specular brilliance of the mirror plays with the narcissistic potential inherent in photographs, just as its framing repeats their authorizing function; the opened door indicates woman's openness, in patriarchal society, to penetration and subjection by the masculine gaze. A series of references articulates this position in literature and painting: in one, Burgin appropriates a detail from Manet's *Olympia*, indicating the use of the female nude as an object to be surveyed and possessed; in another, allusion is made to the mechanical doll and voyeur in Hoffmann's *The Sand-Man*, as discussed by Freud. What *Olympia* addresses, then, is the role played by woman, under phallocentric order and through its technical apparatuses, in insuring masculine unity.

43. See Kuhn, *Women's Pictures*.
44. John Berger, *Ways of Seeing* (London: Penguin, 1977), p. 47.

Burgin has played elsewhere on this equation between surveillance and the voyeur's sadistic drive. In *Grenoble* (1981), the photographed text in one image describes this subjection, as well as woman's masochistic assumption of the masculine position: ". . . in the large factories the seamstresses were under surveillance. The *forewoman* and the noise permitted neither singing nor conversation" (italics mine). A earlier series, *Zoo 78*, employs this vigilance over women as "the most visible, socially sanctioned form of the more covert surveillance of society-in-general by the agencies of the state." Schlovski's *Zoo, or letters not about love*, written in Berlin in the twenties, supplies the textual reference for these works which superpose the current, divided Berlin on the sexually charged, prewar city. Both titles evoke Berlin's central urban section, called "Zoo" for *Zoologischer Garten*, an area now surrounded by the red-light, peepshow district and tangential to the Wall, an edifice punctuated by surveillance slits. The left photograph in *Zoo IV* cites/sights a naked woman on a revolving stage, surrounded by surveillance booths, while the superposed text refers to Foucault's description of a Panopticon prison. In this way Burgin addresses the mastering, sexually gratifying implications of the look, "framing" woman, its central object under capitalism, as the archetype of (masculine) oppression. However, the look's role within the circulation of desire is also addressed in the right photograph depicting a framed painting of the Brandenburg Gate, the symbol of prewar, undivided Berlin. As an image powerfully inscribed in the popular imaginary, the Gate serves as a lost object; hence its image functions as a fetish, acting to commemorate, and disavow, political division. Burgin's plays on framing link this fantasy of completion to its sexual complement, for the apertures of booth and wall, the keyhole perspectives, and repeated internal elements establish woman and gate as serving similar roles in sexuality and politics. Through a process of analogy, then, Burgin designates woman as object of desire, a fantasy object acting to close the rent, to complete the lack of masculine subjectivity.

Silvia Kolbowski also deals with the cultural production of subject positions. Her appropriations and manipulations of media images, largely drawn from fashion photography, foreground, in a critical reading, the daily construction and reinforcement of sexuality through society's sexual "models." The supposed immediacy of the image—its "naturalness" or "real-seemingness"—is countered by the mediating strategies underlying it, which point towards the mediations of ideology and unconscious psychic structures. Constructed across sequences of discrete, but related photographs, Kolbowski's plays with images are the analogues of verbal play, showing a common foundation in language, a common subjection to its arbitrary laws.

The feminine body, as seen throughout this work, is never neutral, never natural; it is always marked out, claimed, and figured with language, always inscribed in a system of difference as defined by the dominant masculine order. In the first of a series fragmenting the female body (*Model Pleasure*), Kolbowski frames the issue of positionality within the context of looking, showing woman as subject to the controlling masculine gaze. Woman is shown, as Lacan has written, to be "inscribed in an order of exchange of which she is the object," an order that "literally submits her"; the connection of the figure

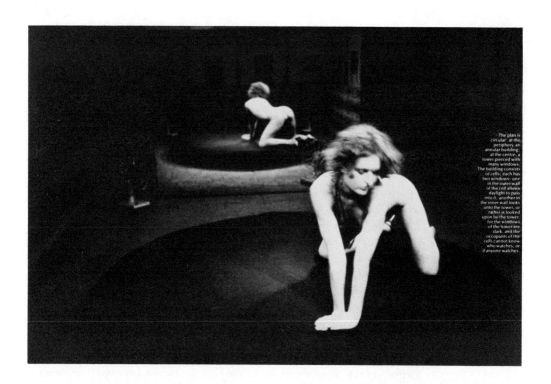

The plan is
circular: at the
periphery, an
annular building;
at the centre, a
tower pierced with
many windows.
The building consists
of cells; each has
two windows: one
in the outer wall
of the cell allows
daylight to pass
into it; another in
the inner wall looks
onto the tower, or
rather is looked
upon by the tower,
for the windows
of the tower are
dark, and the
occupants of the
cells cannot know
who watches, or
if anyone watches.

Victor Burgin. *Zoo 78,* 1978. Black-and-white photographs on boards, two panels, each: 29 x 38″ (73.7 x 97.5 cm).
(Photos: courtesy the artist)

of woman with the condition of being-looked-at thus serves as an index of the unavailability of subjectivity to woman. Different fashion photographs, repositioned within this analytic context, demonstrate the common, naturalized, representational reinforcement of a constructed sexual condition. Five of seven are images of woman veiled, one behind venetian blinds, the others behind delicate traceries of net. This scoring or mapping of the feminine face defines its surface as a site of ideological operations, while the gratelike, window quality of the veil draws attention to the condition of object of the gaze. This definition of woman within the compass of masculine specularity is made explicit in a single shot of a man staring at a woman, her own vision occluded (veiled) by dark glasses. That woman can receive but not return the look—that she is its bearer rather than its origin—is evident in the way her veiled eyes are directed outside the frame, are cut by it or, in the sixth image, are entirely shut, denoting the mystification of woman by man. The frame here signifies the authority of the other, performing the function of insuring masculine coherence. And the dominance of the one position is reasserted in the seventh and final image, in which a male hand brushes a woman's veiled and smiling mouth, inverted to shape an analogy between the feminine gaze and the woman spoken. Inherent in Kolbowski's work, then, is that woman within the patriarchal order does not speak but is variously looked at, imaged, and objectified,[45] serving as a signifier for *her* other. However, Kolbowski also implies that this voyeurism is transformed, in the case of the female viewer of fashion photography, into narcissism, as the viewer identifies with the object of the gaze to mirror the constitutive narcissism of feminine sexuality.

Kolbowski has dealt elsewhere with this desire to become "the image which captures the male gaze."[46] In an untitled sequence from 1983, again drawn from fashion magazines, views of women redoubled in mirrors are intercut with images of figured sexual division. That such splitting in the subject is executed in the shadow of the masculine ego is evident from the male hands, shadows, or feet (the classic substitute for the penis) that occupy the peripheries of the frame. A single photograph, repeated but sequentially elided, displays, in the third image, a division between void and masculine shadow and, in the fifth, the shadow counterposed to a woman's face, her eyes cast down and closed. That Kolbowski is dealing with the *cultural* implacement of woman, which assigns her to a "submitted" position, is apparent from the first and final images showing woman marked, verbally defined or otherwise externally scored by the masculine term.

Lacan defined woman's relation to the phallic term (and with it, to sexuality in general) as masquerade: the very process which, by constructing femininity in reference to the masculine sign, insured its nonidentity, impelled a corresponding effort to cover or *disguise* that fundamental lack. In this

45. Abigail Solomon-Godeau, "The Stolen Image and Its Uses," essay for exhibition, Syracuse, New York, 1983.

46. Reference by Kolbowski to critical work by Mary Ann Doane on female spectatorship.

manner, we are told in *The Meaning of the Phallus*, ". . . the intervention of an 'appearing' . . . gets substituted for the 'having' so as to protect it on one side and to mask its lack on the other, with the effect that the ideal or typical manifestations of behavior in both sexes . . . are entirely propelled into comedy." Woman's desire to be the phallus, the signifier of the other's desire, leads her to "take refuge in this mask" with the "strange consequence" that "virile display itself appears as feminine." Hence the flaunting or foregrounding of femininity involved in dressing up or "disguising" oneself as object of the masculine gaze evokes, through covering, the constitutive absence of woman in the patriarchal order.

The implications of masquerade as a representation of male desire can be grasped in Kolbowski's third work on partial objects, *The Everything Chain* (1982). In this three-part sequence of photographs encompassing, but not confined to, imagery of the foot, Kolbowski deals with the way the feminine subject will "fit herself up" (*s'appareiller*) through reference to that "with which bodies may be paired off" (*s'appairer*).[47] Lacan's pun, playing between appearance, apparatus, and the pairing function underlying differentiation underlies the first panel of the triptych in which a series of female parts—two feet, a neck, a hand—are decorated, disguised, or generally "feminized" by a looping chain. The range of body parts indicates the range of substitutive objects through which desire, in its narcissistic investment, circulates, as well as the origin of desire in the (eternally absent) masculine sign. Implicit in this panel, then, is the manner in which meaning is fixed or erected in the order of the symbolic. But in the third panel this "ordering" of sexuality is contrasted to its perpetual instability or slippage in the unconscious—to the simultaneous movement within language away from such positions of coherence that Lacan designates as *significance*. A sequence of fashion photographs shows high-heeled feet sliding, elided under the hem of a dress, or precariously slipping in the street, in the shadow of masculine feet. Hence Kolbowski's two panels can be seen to expose the double and "difficult" dimension of sexuality within language—its construction and reinforcement on the one hand, and its continual evanescence on the other.

That desire is always masculine, operating through a sequence of metonymic displacements, is manifest in the central panel: just as desire moves along the chain of signifiers from hand to neck to foot as substitutive·objects, so it traces a course from "cast" leg to "carved" leg to that which ultimately "craved." These objects are only stand-ins, signifiers for the ultimate signifier, the phallus, which, as Lacan states, "can play its role when veiled," when displaced from its original aim. A letter in the lower left corner turns on the impression of veiled meaning: "There was something she carved craved; something which cost cast its spill spell upon me, while it still remaimed remained unseene unseen . . ." Turning on the phallus, the letter phrases the discourse of the hysteric who, in refuting the fixity of difference, oscillates between masculine and feminine positions, threatening, through her heterogeneity, the

47. See discussion by Joan Copjec on Lacan's pun in "The Anxiety of the Influencing Machine," *October*, no. 23 (Winter 1982): 48-49.

homogeneous phallocentric order. She speaks through her body/language of the phallus which "casts" its spell, but only at the cost of feminine specificity, and at the sacrifice of satisfaction; of that which, in its "unseen" or veiled activity, serves to violate or maim woman, excluded (barred) under phallocentric doctrine. And she also speaks of the privileging through vision of the masculine order, of the "seen" over unseene genitalia, which defines woman as a hole, not whole, lacking. That the discourse is a feminine one, articulated from a position of instability, is apparent from the image of a woman reading a letter in the third (or unstable) panel. But it can also be viewed as a repetition of Lacan's injunction to attend to the materiality of discourse—to the "letter" rather than to the "spirit"—avoiding the fixed oppositions of essential sexuality. Hence Kolbowski's sequence phrases an injunction to women to affront the representational strategies that construct sexuality, constituting woman as a set of meanings, and the violence thereby incurred.

Barbara Kruger also aims to dephallicize, revealing the obscene privilege of masculine authority. Her large black-and-white photographic works, based on posters, billboards, and varied tabloid media images, employ graphic and social conventions against themselves to unmask the patriarchal structure supporting oppression. Implicit are plays on the codes at work in both mass communication and social constructions, so as to rupture what has been naturalized, through photography, as a stable meaning, a truth. The accusative tone of the superposed texts works to erode the modes of identification established by dominant discourse, challenging its construction of the unitary masculine subject and permitting a repositioning of feminine subjectivity. Hence Kruger's project can be seen to pertain to a common attack on those institutionalized conventions that advance masculine subjectivity as the only available position, working to control women's sexuality by reducing it to patriarchal patterns.

A brief description is in order. All of Kruger's works employ images appropriated from varied media sources which have been cropped and enlarged to often threatening proportions. Their black/white, generally planar quality accentuates their function as texts to be read, defining, in a manner similar to Burgin's, the linguistic nature of representation. The images show women "displayed" according to the clichéd conventions of popular representation—as icon, as spectacle or prose, as the "silent stereotypical figure that settles the male gaze."[48] Woman is figured here as constructed by the social "other"; what is inherent in these supine or static forms, often glamorized according to "fashion femininity," is the fetishization of woman to allay castration, and the role of masculine fantasies in forming a feminine ideal. Texts superposed on images articulate, in boldface type, a feminine injunction, opposing a female "we" to a male "you" (i.e., "we won't play nature to your culture," "you construct the category of missing persons," "your gaze hits the side of my face"), and working to disrupt the masculine pleasures of voyeurism. Red frames surround the graphic perimeters, acting as ingratiating devices

48. Barbara Kruger, "Virtue and Vice on 65th Street," *Artforum* 21, no. 5 (January 1983): 66.

to lure the spectator into the pointedly problematic depths, and to frame the terrain of the authorized (or unauthorized) image. Implicit in these formal devices, then, is a larger strategic "design" at once to construct, deconstruct, and subvert the positionality of woman under patriarchy.

Kruger's use of stereotypes is aimed at exposing the practices by which ideology fixes the production of meaning, reducing its plurality to a limited number of signifieds which are equated with truth within the social economy. That this process is partisan, reflecting the interests of patriarchal society, is evident in the way these images direct and reinforce behavior; in this sense, Kruger would argue that this gender-specific relation to language is patriarchy's main controlling structure, performing the function (as Freud had said) of getting woman into place. The works are all structured by binomial oppositions —by we vs. you, nature vs. culture, passive vs. active, supine vs. standing— repeating, so as to rupture, those operations which construct the woman as other.

The media's slick naturalizing effect is joined here to the specular lures of the photograph as guarantee of self-coherence, of masculine identification. However, Kruger's critique of signifiying conventions is specifically informed by cinematic theory. In cinema, the two main instances of controlling perspective are voyeurism and the narrator's authoritative voice. It is the male voice-over that affords the conventional vantage on spectacle, a position occupied in advertising by the masculine-phrased text, or by the female rehearsing the male perspective. Language serves to regulate the viewer's position through the disembodied stance of authority or knowledge, much as it serves to anchor and stabilize meaning, binding image to text. And Kruger's use of the female voice is primed by the absence in cinema (and, with it, in other media) of the female voice that analyzes, reflects, or assumes an active relation to the narrative. The assertive, assaultive tone in her work counters the sham transparency of the masculine code. The disparity between text and the masculine phrasing of the image acts to fissure the process of identification, driving a wedge between image and referent and defeating the closure of meaning. A refusal of suture, then, which opens points of intrusion within dominant ideology; which works to unmoor the unity of the masculine perspective, leading to the proliferation of meanings, none of them subjectively centered. And within the gap between image and text, between illusioned object and assaultive, contradictory voice, is cleared a space for the participation of a feminine subjectivity long denied by its subjected status.

What Kruger's disjunctive practices produce, within the register of sexuality, is an analogue of the Brechtian "noticing of the knots." The means of representation are foregrounded and disrupted so as to defeat the signifier's naturalized illusion, and to reveal the specific interests on which its authority and power rest. However, Kruger's use of literal language indicates her attention to the social construction of *all* identity. Her pronominal manipulations demonstrate that there is no basic self[49] or fixed identity, but only a construc-

49. See Jane Weinstock, "A Lass, A Laugh and a Lad," *Art in America* 71, no. 6 (Summer 1983): 9.

tion in process. "Position" is an effect of language, produced in an intersubjective network—through the determinations that put "me" against "you," "us" against "them," or construct a self in relation to another. These oscillations indicate the evanescence of the subject, its continuous repositioning and restructuring in the process of signification. What they point to, in Kruger's and in other artists' work, is the subject's mobility within those myriad representations, based on but not identical to language, which comprise our putative reality. And in that mobility lies the prospect of a counterlanguage, aimed against language's shackling rigidification.

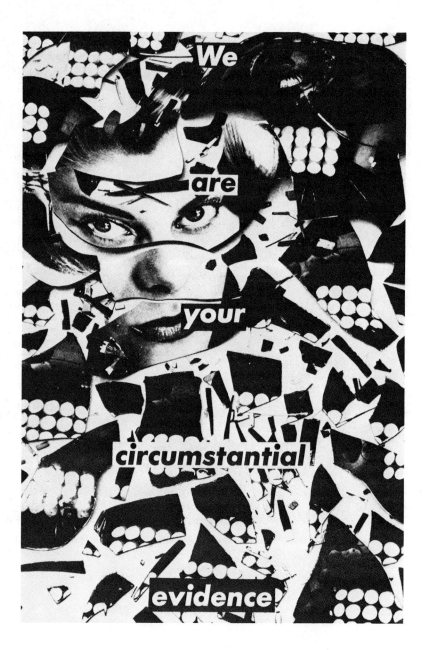

Barbara Kruger.
We Are Your Circumstantial Evidence, 1984. Photomontage, 72 x 48″ (183 x 122 cm). (Photo: courtesy the artist)

Representation and Sexuality 415

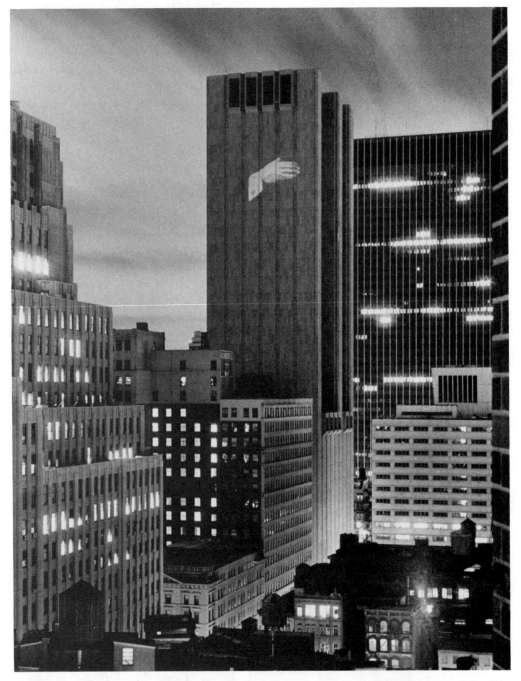

Krzysztof Wodiczko. Projection on the AT&T Building, Tribeca, New York City, November 2, 1984 (during U.S. Presidential election campaign). Organized by The Kitchen, with the assistance of Lower Manhattan Cultural Council, and in cooperation with AT&T

The Subject and Power

MICHEL FOUCAULT

The ideas which I would like to discuss here represent neither a
theory nor a methodology.

Why Study Power? The Question of the Subject

I would like to say, first of all, what has been the goal of my work during the last twenty years. It has not been to analyze the phenomena of power, nor to elaborate the foundations of such an analysis.

My objective, instead, has been to create a history of the different modes by which, in our culture, human beings are made subjects. My work has dealt with three modes of objectification which transform human beings into subjects.

The first is the modes of inquiry which try to give themselves the status of sciences; for example, the objectivizing of the speaking subject in *grammaire générale*, philology, and linguistics. Or again, in this first mode, the objectivizing of the productive subject, the subject who labors, in the analysis of wealth and of economics. Or, a third example, the objectivizing of the sheer fact of being alive in natural history or biology.

In the second part of my work, I have studied the objectivizing of the subject in what I shall call "dividing practices." The subject is either divided inside himself or divided from others. This process objectivizes him. Examples are the mad and the sane, the sick and the healthy, the criminals and the "good boys."

Finally, I have sought to study—it is my current work—the way a human being turns himself into a subject. For example, I have chosen the domain of sexuality—how men have learned to recognize themselves as subjects of "sexuality."

Thus, it is not power but the subject which is the general theme of my research.

It is true that I became quite involved with the question of power. It soon appeared to me that, while the human subject is placed in relations of produc-

This essay was written by Michel Foucault as an afterword to *Michel Foucault: Beyond Structuralism and Hermeneutics* by Hubert L. Dreyfus and Paul Rabinow. "Why Study Power? The Question of the Subject" was written in English by Foucault; "How Is Power Exercised?" was translated from the French by Leslie Sawyer. Reprinted from *Critical Inquiry* 8 (Summer 1982): 777-795.

tion and of signification, he is equally placed in power relations which are very complex. Now, it seemed to me that economic history and theory provided a good instrument for relations of production and that linguistics and semiotics offered instruments for studying relations of signification; but for power relations we had no tools of study. We had recourse only to ways of thinking about power based on legal models, that is: What legitimates power? Or, we had recourse to ways of thinking about power based on institutional models, that is: What is the state?

It was therefore necessary to expand the dimensions of a definition of power if one wanted to use this definition in studying the objectivizing of the subject.

Do we need a theory of power? Since a theory assumes a prior objectification, it cannot be asserted as a basis for analytical work. But this analytical work cannot proceed without an ongoing conceptualization. And this conceptualization implies critical thought—a constant checking.

The first thing to check is what I shall call the "conceptual needs." I mean that the conceptualization should not be founded on a theory of the object—the conceptualized object is not the single criterion of a good conceptualization. We have to know the historical conditions which motivate our conceptualization. We need a historical awareness of our present circumstance.

The second thing to check is the type of reality with which we are dealing.

A writer in a well-known French newspaper once expressed his surprise: "Why is the notion of power raised by so many people today? Is it such an important subject? Is it so independent that it can be discussed without taking into account other problems?"

This writer's surprise amazes me. I feel skeptical about the assumption that this question has been raised for the first time in the twentieth century. Anyway, for us it is not only a theoretical question but a part of our experience. I'd like to mention only two "pathological forms"—those two "diseases of power"—fascism and Stalinism. One of the numerous reasons why they are, for us, so puzzling is that in spite of their historical uniqueness they are not quite original. They used and extended mechanisms already present in most other societies. More than that: in spite of their own internal madness, they used to a large extent the ideas and the devices of our political rationality.

What we need is a new economy of power relations—the word "economy" being used in its theoretical and practical sense. To put it in other words: since Kant, the role of philosophy is to prevent reason from going beyond the limits of what is given in experience; but from the same moment—that is, since the development of the modern state and the political management of society—the role of philosophy is also to keep watch over the excessive powers of political rationality, which is a rather high expectation.

Everybody is aware of such banal facts. But the fact that they're banal does not mean they don't exist. What we have to do with banal facts is to discover—or try to discover—which specific and perhaps original problem is connected with them.

The relationship between rationalization and excesses of political power is

evident. And we should not need to wait for bureaucracy or concentration camps to recognize the existence of such relations. But the problem is: What to do with such an evident fact?

Shall we try reason? To my mind, nothing would be more sterile. First, because the field has nothing to do with guilt or innocence. Second, because it is senseless to refer to reason as the contrary entity to nonreason. Last, because such a trial would trap us into playing the arbitrary and boring part of either the rationalist or the irrationalist.

Shall we investigate this kind of rationalism which seems to be specific to our modern culture and which originates in *Aufklärung?* I think that was the approach of some of the members of the Frankfurt School. My purpose, however, is not to start a discussion of their works, although they are most important and valuable. Rather, I would suggest another way of investigating the links between rationalization and power.

It may be wise not to take as a whole the rationalization of society or of culture but to analyze such a process in several fields, each with reference to a fundamental experience: madness, illness, death, crime, sexuality, and so forth.

I think that the word "rationalization" is dangerous. What we have to do is analyze specific rationalities rather than always invoke the progress of rationalization in general.

Even if the *Aufklärung* has been a very important phase in our history and in the development of political technology, I think we have to refer to much more remote processes if we want to understand how we have been trapped in our own history.

I would like to suggest another way to go further toward a new economy of power relations, a way which is more empirical, more directly related to our present situation, and which implies more relations between theory and practice. It consists of taking the forms of resistance against different forms of power as a starting point. To use another metaphor, it consists of using this resistance as a chemical catalyst so as to bring to light power relations, locate their position, and find out their point of application and the methods used. Rather than analyzing power from the point of view of its internal rationality, it consists of analyzing power relations through the antagonism of strategies.

For example, to find out what our society means by sanity, perhaps we should investigate what is happening in the field of insanity.

And what we mean by legality in the field of illegality.

And, in order to understand what power relations are about, perhaps we should investigate the forms of resistance and attempts made to dissociate these relations.

As a starting point, let us take a series of oppositions which have developed over the last few years: opposition to the power of men over women, of parents over children, of psychiatry over the mentally ill, of medicine over the population, of administration over the ways people live.

It is not enough to say that these are anti-authority struggles; we must try to define more precisely what they have in common.

1. They are "transversal" struggles; that is, they are not limited to one country. Of course, they develop more easily and to a greater extent in certain

countries, but they are not confined to a particular political or economic form of government.

2. The aim of these struggles is the power effects as such. For example, the medical profession is not criticized primarily because it is a profit-making concern but because it exercises an uncontrolled power over people's bodies, their health, and their life and death.

3. These are "immediate" struggles for two reasons. In such struggles people criticize instances of power which are the closest to them, those which exercise their action on individuals. They do not look for the "chief enemy" but for the immediate enemy. Nor do they expect to find a solution to their problem at a future date (that is, liberations, revolutions, end of class struggle). In comparison with a theoretical scale of explanations or a revolutionary order which polarizes the historian, they are anarchistic struggles.

But these are not their most original points. The following seem to me to be more specific.

4. They are struggles which question the status of the individual: on the one hand, they assert the right to be different, and they underline everything which makes individuals truly individual. On the other hand, they attack everything which separates the individual, breaks his links with others, splits up community life, forces the individual back on himself, and ties him to his own identity in a constraining way.

These struggles are not exactly for or against the "individual" but rather they are struggles against the "government of individualization."

5. They are an opposition to the effects of power which are linked with knowledge, competence, and qualification: struggles against the privileges of knowledge. But they are also an opposition against secrecy, deformation, and mystifying representations imposed on people.

There is nothing "scientistic" in this (that is, a dogmatic belief in the value of scientific knowledge), but neither is it a skeptical or relativistic refusal of all verified truth. What is questioned is the way in which knowledge circulates and functions, its relations to power. In short, the *régime du savoir*.

6. Finally, all these present struggles revolve around the question: Who are we? They are a refusal of these abstractions, of economic and ideological state violence, which ignore who we are individually, and also a refusal of a scientific or administrative inquisition which determines who one is.

To sum up, the main objective of these struggles is to attack not so much "such or such" an institution of power, or group, or elite, or class but rather a technique, a form of power.

This form of power applies itself to immediate everyday life which categorizes the individual, marks him by his own individuality, attaches him to his own identity, imposes a law of truth on him which he must recognize and which others have to recognize in him. It is a form of power which makes individuals subjects. There are two meanings of the word "subject": subject to someone else by control and dependence; and tied to his own identity by a conscience or self-knowledge. Both meanings suggest a form of power which subjugates and makes subject to.

Generally, it can be said that there are three types of struggles: either

against forms of domination (ethnic, social, and religious); against forms of exploitation which separate individuals from what they produce; or against that which ties the individual to himself and submits him to others in this way (struggles against subjection, against forms of subjectivity and submission).

I think that in history you can find a lot of examples of these three kinds of social struggles, either isolated from each other or mixed together. But even when they are mixed, one of them, most of the time, prevails. For instance, in the feudal societies, the struggles against the forms of ethnic or social domination were prevalent, even though economic exploitation could have been very important among the revolt's causes.

In the nineteenth century, the struggle against exploitation came into the foreground.

And nowadays, the struggle against the forms of subjection—against the submission of subjectivity—is becoming more and more important, even though the struggles against forms of domination and exploitation have not disappeared. Quite the contrary.

I suspect that it is not the first time that our society has been confronted with this kind of struggle. All those movements which took place in the fifteenth and sixteenth centuries and which had the Reformation as their main expression and result should be analyzed as a great crisis of the Western experience of subjectivity and a revolt against the kind of religious and moral power which gave form, during the Middle Ages, to this subjectivity. The need to take a direct part in spiritual life, in the work of salvation, in the truth which lies in the Book—all that was a struggle for a new subjectivity.

I know what objections can be made. We can say that all types of subjection are derived phenomena, that they are merely the consequences of other economic and social processes: forces of production, class struggle, and ideological structures which determine the form of subjectivity.

It is certain that the mechanisms of subjection cannot be studied outside their relation to the mechanisms of exploitation and domination. But they do not merely constitute the "terminal" of more fundamental mechanisms. They entertain complex and circular relations with other forms.

The reason this kind of struggle tends to prevail in our society is due to the fact that, since the sixteenth century, a new political form of power has been continuously developing. This new political structure, as everybody knows, is the state. But most of the time, the state is envisioned as a kind of political power which ignores individuals, looking only at the interests of the totality or, I should say, of a class or a group among the citizens.

That's quite true. But I'd like to underline the fact that the state's power (and that's one of the reasons for its strength) is both an individualizing and a totalizing form of power. Never, I think, in the history of human societies— even in the old Chinese society—has there been such a tricky combination in the same political structures of individualization techniques and of totalization procedures.

This is due to the fact that the modern Western state has integrated in a new political shape an old power technique which originated in Christian institutions. We can call this power technique the pastoral power.

First of all, a few words about this pastoral power.

It has often been said that Christianity brought into being a code of ethics fundamentally different from that of the ancient world. Less emphasis is usually placed on the fact that it proposed and spread new power relations throughout the ancient world.

Christianity is the only religion which has organized itself as a church. And as such, it postulates in principle that certain individuals can, by their religious quality, serve others not as princes, magistrates, prophets, fortunetellers, benefactors, educationalists, and so on but as pastors. However, this word designates a very special form of power.

1. It is a form of power whose ultimate aim is to assure individual salvation in the next world.

2. Pastoral power is not merely a form of power which commands; it must also be prepared to sacrifice itself for the life and salvation of the flock. Therefore, it is different from royal power, which demands a sacrifice from its subjects to save the throne.

3. It is a form of power which does not look after just the whole community but each individual in particular, during his entire life.

4. Finally, this form of power cannot be exercised without knowing the inside of people's minds, without exploring their souls, without making them reveal their innermost secrets. It implies a knowledge of the conscience and an ability to direct it.

This form of power is salvation oriented (as opposed to political power). It is oblative (as opposed to the principle of sovereignty); it is individualizing (as opposed to legal power); it is coextensive and continuous with life; it is linked with a production of truth—the truth of the individual himself.

But all this is part of history, you will say; the pastorate has, if not disappeared, at least lost the main part of its efficiency.

This is true, but I think we should distinguish between two aspects of pastoral power—between the ecclesiastical institutionalization, which has ceased or at least lost its vitality since the eighteenth century, and its function, which has spread and multiplied outside the ecclesiastical institution.

An important phenomenon took place around the eighteenth century—it was a new distribution, a new organization of this kind of individualizing power.

I don't think that we should consider the "modern state" as an entity which was developed above individuals, ignoring what they are and even their very existence, but, on the contrary, as a very sophisticated structure, in which individuals can be integrated under one condition: that this individuality would be shaped in a new form and submitted to a set of very specific patterns.

In a way, we can see the state as a modern matrix of individualization or a new form of pastoral power.

A few more words about this new pastoral power.

1. We may observe a change in its objective. It was no longer a question of leading people to their salvation in the next world but rather ensuring it in this world. And in this context, the word "salvation" takes on different meanings: health, well-being (that is, sufficient wealth, standard of living), security, protection against accidents. A series of "worldly" aims took the place of the

religious aims of the traditional pastorate, all the more easily because the latter, for various reasons, had followed in an accessory way a certain number of these aims; we only have to think of the role of medicine and its welfare function assured for a long time by the Catholic and Protestant churches.

2. Concurrently the officials of pastoral power increased. Sometimes this form of power was exerted by state apparatus or, in any case, by a public institution such as the police. (We should not forget that in the eighteenth century the police force was not invented only for maintaining law and order, nor for assisting governments in their struggle against their enemies, but for assuring urban supplies, hygiene, health, and standards considered necessary for handicrafts and commerce.) Sometimes the power was exercised by private ventures, welfare societies, benefactors, and generally by philanthropists. But ancient institutions, for example the family, were also mobilized at this time to take on pastoral functions. It was also exercised by complex structures such as medicine, which included private initiatives with the sale of services on market economy principles. but which also included public institutions such as hospitals.

3. Finally, the multiplication of the aims and agents of pastoral power focused the development of knowledge of man around two roles: one, globalizing and quantitative, concerning the population; the other, analytical, concerning the individual.

And this implies that power of a pastoral type, which over centuries—for more than a millennium—had been linked to a defined religious institution, suddenly spread out into the whole social body; it found support in a multitude of institutions. And, instead of a pastoral power and a political power, more or less linked to each other, more or less rival, there was an individualizing "tactic" which characterized a series of powers: those of the family, medicine, psychiatry, education, and employers.

At the end of the eighteenth century, Kant wrote, in a German newspaper —the *Berliner Monatschrift*—a short text. The title was "Was heisst Aufklärung?" It was for a long time, and it is still, considered a work of relatively small importance.

But I can't help finding it very interesting and puzzling because it was the first time a philosopher proposed as a philosophical task to investigate not only the metaphysical system or the foundations of scientific knowledge but a historical event—a recent, even a contemporary event.

When in 1784 Kant asked, Was heisst Aufklärung?, he meant, What's going on just now? What's happening to us? What is this world, this period, this precise moment in which we are living?

Or in other words: What are we? as *Aufklärer*, as part of the Enlightenment? Compare this with the Cartesian question: Who am I? I, as a unique but universal and unhistorical subject? I, for Descartes, is everyone, anywhere at any moment?

But Kant asks something else: What are we? in a very precise moment of history. Kant's question appears as an analysis of both us and our present.

I think that this aspect of philosophy took on more and more importance. Hegel, Nietzsche . . .

The other aspect of "universal philosophy" didn't disappear. But the task

of philosophy as a critical analysis of our world is something which is more and more important. Maybe the most certain of all philosophical problems is the problem of the present time and of what we are in this very moment.

Maybe the target nowadays is not to discover what we are but to refuse what we are. We have to imagine and to build up what we could be to get rid of this kind of political "double bind," which is the simultaneous individualization and totalization of modern power structures.

The conclusion would be that the political, ethical, social, philosophical problem of our days is not to try to liberate the individual from the state and from the state's institutions but to liberate us both from the state and from the type of individualization which is linked to the state. We have to promote new forms of subjectivity through the refusal of this kind of individuality which has been imposed on us for several centuries.

How Is Power Exercised?

For some people, asking questions about the "how" of power would limit them to describing its effects without ever relating those effects either to causes or to a basic nature. It would make this power a mysterious substance which they might hesitate to interrogate in itself, no doubt because they would prefer *not* to call it into question. By proceeding this way, which is never explicitly justified, they seem to suspect the presence of a kind of fatalism. But does not their very distrust indicate a presupposition that power is something which exists with three distinct qualities: its origin, its basic nature, and its manifestations?

If, for the time being, I grant a certain privileged position to the question of "how," it is not because I would wish to eliminate the questions of "what" and "why." Rather, it is that I wish to present these questions in a different way: better still, to know if it is legitimate to imagine a power which unites in itself a what, a why, and a how. To put it bluntly, I would say that to begin the analysis with a "how" is to suggest that power as such does not exist. At the very least it is to ask oneself what contents one has in mind when using this all-embracing and reifying term; it is to suspect that an extremely complex configuration of realities is allowed to escape when one treads endlessly in the double question: What is power? and Where does power come from? The little question, What happens?, although flat and empirical, once scrutinized is seen to avoid accusing a metaphysics or an ontology of power of being fraudulent; rather, it attempts a critical investigation into the thematics of power.

> *"How," not in the sense of "How does it manifest itself?" but "By what means is it exercised?" and "What happens when individuals exert (as they say) power over others?"*

As far as this power is concerned, it is first necessary to distinguish that which is exerted over things and gives the ability to modify, use, consume, or destroy them—a power which stems from aptitudes directly inherent in the body or relayed by external instruments. Let us say that here it is a question of "capacity." On the other hand, what characterizes the power we are analyzing is that it brings into play relations between individuals (or between

groups). For let us not deceive ourselves; if we speak of the structures or the mechanisms of power, it is only insofar as we suppose that certain persons exercise power over others. The term "power" designates relationships between partners (and by that I am not thinking of a zero-sum game but simply, and for the moment staying in the most general terms, of an ensemble of actions which induce others and follow from one another).

It is necessary also to distinguish power relations from relationships of communication which transmit information by means of a language, a system of signs, or any other symbolic medium. No doubt communicating is always a certain way of acting upon another person or persons. But the production and circulation of elements of meaning can have as their objective or as their consequence certain results in the realm of power; the latter are not simply an aspect of the former. Whether or not they pass through systems of communication, power relations have a specific nature. Power relations, relationships of communication, and objective capacities should not therefore be confused. This is not to say that there is a question of three separate domains. Nor that there is on one hand the field of things, of perfected technique, work, and the transformation of the real; on the other that of signs, communication, reciprocity, and the production of meaning; and finally, that of the domination of the means of constraint, of inequality, and the action of men upon other men.[1] It is a question of three types of relationships which in fact always overlap one another, support one another reciprocally, and use each other mutually as means to an end. The application of objective capacities in their most elementary forms implies relationships of communication (whether in the form of previously acquired information or of shared work); it is tied also to power relations (whether they consist of obligatory tasks, of gestures imposed by tradition or apprenticeship, of subdivisions and the more or less obligatory distribution of labor). Relationships of communication imply finalized activities (even if only the correct putting into operation of elements of meaning) and, by virtue of modifying the field of information between partners, produce effects of power. They can scarcely be dissociated from activities brought to their final term, be they those which permit the exercise of this power (such as training techniques, processes of domination, the means by which obedience is obtained) or those, which in order to develop their potential, call upon relations of power (the division of labor and the hierarchy of tasks).

Of course, the coordination between these three types of relationships is neither uniform nor constant. In a given society there is no general type of equilibrium between finalized activities, systems of communication, and power relations. Rather, there are diverse forms, diverse places, diverse circumstances or occasions in which these interrelationships establish themselves according to a specific model. But there are also "blocks" in which the adjustment of abilities, the resources of communication, and power relations constitute regulated and concerted systems. Take, for example, an educational institution: the disposal of its space, the meticulous regulations which govern its internal life,

1. When Jürgen Habermas distinguishes between domination, communication, and finalized activity, I do not think that he sees in them three separate domains but rather three "transcendentals."

the different activities which are organized there, the diverse persons who live there or meet one another, each with his own function, his well-defined character—all these things constitute a block of capacity-communication-power. The activity which ensures apprenticeship and the acquisition of aptitudes or types of behavior is developed there by means of a whole ensemble of regulated communications (lessons, questions and answers, orders, exhortations, coded signs of obedience, differentiation marks of the "value" of each person and of the levels of knowledge) and by the means of a whole series of power processes (enclosure, surveillance, reward and punishment, the pyramidal hierarchy).

These blocks, in which the putting into operation of technical capacities, the game of communications, and the relationships of power are adjusted to one another according to considered formulae, constitute what one might call, enlarging a little the sense of the word, "disciplines." The empirical analysis of certain disciplines as they have been historically constituted presents for this very reason a certain interest. This is so because the disciplines show, first, according to artificially clear and decanted systems, the manner in which systems of objective finality and systems of communication and power can be welded together. They also display different models of articulation, sometimes giving preeminence to power relations and obedience (as in those disciplines of a monastic or penitential type), sometimes to finalize activities (as in the disciplines of workshops or hospitals), sometimes to relationships of communication (as in the disciplines of apprenticeship). sometimes also to a saturation of the three types of relationship (as perhaps in military discipline, where a plethora of signs indicates, to the point of redundancy, tightly knit power relations calculated with care to produce a certain number of technical effects).

What is to be understood by the disciplining of societies in Europe since the eighteenth century is not, of course, that the individuals who are part of them become more and more obedient, nor that they set about assembling in barracks, schools, or prisons; rather, that an increasingly better invigilated process of adjustment has been sought after—more and more rational and economic—between productive activities, resources of communication, and the play of power relations.

To approach the theme of power by an analysis of "how" is therefore to introduce several critical shifts in relation to the supposition of a fundamental power. It is to give oneself, as the object of analysis, power relations and not power itself—power relations which are distinct from objective abilities as well as from relations of communication. This is as much as saying that power relations can be grasped in the diversity of their logical sequence, their abilities, and their interrelationships.

What constitutes the specific nature of power? The exercise of power is not simply a relationship between partners, individual or collective; it is a way in which certain actions modify others. Which is to say, of course, that something called Power, with or without a capital letter, which is assumed to exist universally in a concentrated or diffused form, does not exist. Power exists only when it is put into action, even if, of course, it is integrated into a disparate field of possibilities brought to bear upon permanent structures. This also means that power is not a function of consent. In itself it

is not a renunciation of freedom, a transference of rights, the power of each and all delegated to a few (which does not prevent the possibility that consent may be a condition for the existence or the maintenance of power); the relationship of power can be the result of a prior or permanent consent, but it is not by nature the manifestation of a consensus.

Is this to say that one must seek the character proper to power relations in the violence which must have been its primitive form, its permanent secret, and its last resource, that which in the final analysis appears as its real nature when it is forced to throw aside its mask and to show itself as it really is? In effect, what defines a relationship of power is that it is a mode of action which does not act directly and immediately on others. Instead, it acts upon their actions: an action upon an action, on existing actions or on those which may arise in the present or the future. A relationship of violence acts upon a body or upon things; it forces, it bends, it breaks on the wheel, it destroys, or it closes the door on all possibilities. Its opposite pole can only be passivity, and if it comes up against any resistance, it has no other option but to try to minimize it. On the other hand, a power relationship can only be articulated on the basis of two elements which are each indispensable if it is really to be a power relationship: that "the other" (the one over whom power is exercised) be thoroughly recognized and maintained to the very end as a person who acts; and that, faced with a relationship of power, a whole field of responses, reactions, results, and possible inventions may open up.

Obviously the bringing into play of power relations does not exclude the use of violence any more than it does the obtaining of consent; no doubt the exercise of power can never do without one or the other, often both at the same time. But even though consensus and violence are the instruments or the results, they do not constitute the principle or the basic nature of power. The exercise of power can produce as much acceptance as may be wished for: it can pile up the dead and shelter itself behind whatever threats it can imagine. In itself the exercise of power is not violence; nor is it a consent which, implicitly, is renewable. It is a total structure of actions brought to bear upon possible actions; it incites, it induces, it seduces, it makes easier or more difficult; in the extreme it constrains or forbids absolutely; it is nevertheless always a way of acting upon an acting subject or acting subjects by virtue of their acting or being capable of action. A set of actions upon other actions.

Perhaps the equivocal nature of the term "conduct" is one of the best aids for coming to terms with the specificity of power relations. For to "conduct" is at the same time to "lead" others (according to mechanisms of coercion which are, to varying degrees, strict) and a way of behaving within a more or less open field of possibilities.[2] The exercise of power consists in guiding the possibility of conduct and putting in order the possible outcome. Basically power is less a confrontation between two adversaries or the linking of one to the other than a question of government. This word must be allowed the very

2. Foucault is playing on the double meaning in French of the verb *conduire*, "to lead" or "to drive," and *se conduire*, "to behave" or "to conduct oneself"; whence *la conduite*, "conduct" or "behavior."–Translator's note.

broad meaning which it had in the sixteenth century. "Government" did not refer only to political structures or to the management of states; rather, it designated the way in which the conduct of individuals or of groups might be directed: the government of children, of souls, of communities, of families, of the sick. It did not only cover the legitimately constituted forms of political or economic subjection but also modes of action, more or less considered or calculated, which were destined to act upon the possibilities of action of other people. To govern, in this sense, is to structure the possible field of action of others. The relationship proper to power would not, therefore, be sought on the side of violence or of struggle, nor on that of voluntary linking (all of which can, at best, only be the instruments of power), but rather in the area of the singular mode of action, neither warlike nor juridical, which is government.

When one defines the exercise of power as a mode of action upon the actions of others, when one characterizes these actions by the government of men by other men—in the broadest sense of the term—one includes an important element: freedom. Power is exercised only over free subjects, and only insofar as they are free. By this we mean individual or collective subjects who are faced with a field of possibilities in which several ways of behaving, several reactions and diverse comportments, may be realized. Where the determining factors saturate the whole, there is no relationship of power; slavery is not a power relationship when man is in chains. (In this case it is a question of a physical relationship of constraint.) Consequently, there is no face-to-face confrontation of power and freedom, which are mutually exclusive (freedom disappears everywhere power is exercised), but a much more complicated interplay. In this game freedom may well appear as the condition for the exercise of power (at the same time its precondition, since freedom must exist for power to be exerted, and also its permanent support, since without the possibility of recalcitrance, power would be equivalent to a physical determination).

The relationship between power and freedom's refusal to submit cannot, therefore, be separated. The crucial problem of power is not that of voluntary servitude (how could we seek to be slaves?). At the very heart of the power relationship, and constantly provoking it, are the recalcitrance of the will and the intransigence of freedom. Rather than speaking of an essential freedom, it would be better to speak of "agonism" [2]—of a relationship which is at the same time reciprocal incitation and struggle, less of a face-to-face confrontation which paralyzes both sides than a permanent provocation.

How is one to analyze the power relationship?

One can analyze such relationships, or rather I should say that it is perfectly legitimate to do so, by focusing on carefully defined institutions. The latter constitute a privileged point of observation, diversified, concentrated, put in order, and carried through to the highest point of their efficacity. It is here

3. Foucault's neologism is based on the Greek αγώνισμα meaning "a combat." The term would hence imply a physical contest in which the opponents develop a strategy of reaction and of mutual taunting, as in a wrestling match.—Translator's note.

that, as a first approximation, one might expect to see the appearance of the form and logic of their elementary mechanisms. However, the analysis of power relations as one finds them in certain circumscribed institutions presents a certain number of problems. First, the fact that an important part of the mechanisms put into operation by an institution are designed to ensure its own preservation brings with it the risk of deciphering functions which are essentially reproductive, especially in power relations between institutions. Second, in analyzing power relations from the standpoint of institutions, one lays oneself open to seeking the explanation and the origin of the former in the latter, that is to say, finally, to explain power to power. Finally, insofar as institutions act essentially by bringing into play two elements, explicit or tacit regulations and an apparatus, one risks giving to one or the other an exaggerated privilege in the relations of power and hence to see in the latter only modulations of the law and of coercion.

This does not deny the importance of institutions on the establishment of power relations. Instead, I wish to suggest that one must analyze institutions from the standpoint of power relations, rather than vice versa, and that the fundamental point of anchorage of the relationships, even if they are embodied and crystallized in an institution, is to be found outside the institution.

Let us come back to the definition of the exercise of power as a way in which certain actions may structure the field of other possible actions. What, therefore, would be proper to a relationship of power is that it be a mode of action upon actions. That is to say, power relations are rooted deep in the social nexus, not reconstituted "above" society as a supplementary structure whose radical effacement one could perhaps dream of. In any case, to live in society is to live in such a way that action upon other actions is possible—and in fact ongoing. A society without power relations can only be an abstraction. Which, be it said in passing, makes all the more politically necessary the analysis of power relations in a given society, their historical formation, the source of their strength or fragility, the conditions which are necessary to transform some or to abolish others. For to say that there cannot be a society without power relations is not to say either that those which are established are necessary or, in any case, that power constitutes a fatality at the heart of societies, such that it cannot be undermined. Instead, I would say that the analysis, elaboration, and bringing into question of power relations and the "agonism" between power relations and the intransitivity of freedom is a permanent political task inherent in all social existence.

The analysis of power relations demands that a certain number of points be established concretely:

1. *The system of differentiations* which permits one to act upon the actions of others: differentiations determined by the law or by traditions of status and privilege; economic differences in the appropriation of riches and goods, shifts in the processes of production, linguistic or cultural differences, differences in know-how and competence, and so forth. Every relationship of power puts into operation differentiations which are at the same time its conditions and its results.

2. *The types of objectives* pursued by those who act upon the actions of

others: the maintenance of privileges, the accumulation of profits, the bringing into operation of statutory authority, the exercise of a function or of a trade.

3. *The means of bringing power relations into being:* according to whether power is exercised by the threat of arms, by the effects of the word, by means of economic disparities, by more or less complex means of control, by systems of surveillance, with or without archives, according to rules which are or are not explicit, fixed or modifiable, with or without the technological means to put all these things into action.

4. *Forms of institutionalization:* these may mix traditional predispositions, legal structures, phenomena relating to custom or to fashion (such as one sees in the institution of the family); they can also take the form of an apparatus closed in upon itself, with its specific *loci,* its own regulations, its hierarchical structures which are carefully defined, a relative autonomy in its functioning (such as scholastic or military institutions); they can also form very complex systems endowed with multiple apparatuses, as in the case of the state, whose function is the taking of everything under its wing, the bringing into being of general surveillance, the principle of regulation, and, to a certain extent also, the distribution of all power relations in a given social ensemble.

5. *The degrees of rationalization:* the bringing into play of power relations as action in a field of possibilities may be more or less elaborate in relation to the effectiveness of the instruments and the certainty of the results (greater or lesser technological refinements employed in the exercise of power) or again in proportion to the possible cost (be it the economic cost of the means brought into operation or the cost in terms of reaction constituted by the resistance which is encountered). The exercise of power is not a naked fact, an institutional right, nor is it a structure which holds out or is smashed: it is elaborated, transformed, organized; it endows itself with processes which are more or less adjusted to the situation.

One sees why the analysis of power relations within a society cannot be reduced to the study of a series of institutions, not even to the study of all those institutions which would merit the name "political." Power relations are rooted in the system of social networks. This is not to say, however, that there is a primary and fundamental principle of power which dominates society down to the smallest detail; but, taking as point of departure the possibility of action upon the action of others (which is coextensive with every social relationship), multiple forms of individual disparity, of objectives, of the given application of power over ourselves or others, of, in varying degrees, partial or universal institutionalization, of more or less deliberate organization, one can define different forms of power. The forms and the specific situations of the government of men by one another in a given society are multiple; they are superimposed, they cross, impose their own limits, sometimes cancel one another out, sometimes reinforce one another. It is certain that in contemporary societies the state is not simply one of the forms or specific situations of the exercise of power—even if it is the most important—but that in a certain way all other forms of power relation must refer to it. But this is not because they are derived from it; it is rather because power relations have come more and more under state control (although this state control has not taken the same form in

pedagogical, judicial, economic, or family systems). In referring here to the restricted sense of the word "government," one could say that power relations have been progressively governmentalized, that is to say, elaborated, rationalized, and centralized in the form of, or under the auspices of, state institutions.

<div style="margin-left: 2em">

Relations of power and relations of strategy

</div>

The word "strategy" is currently employed in three ways. First, to designate the means employed to attain a certain end; it is a question of rationality functioning to arrive at an objective. Second, to designate the manner in which a partner in a certain game acts with regard to what he thinks should be the action of the others and what he considers the others think to be his own; it is the way in which one seeks to have the advantage over others. Third, to designate the procedures used in a situation of confrontation to deprive the opponent of his means of combat and to reduce him to giving up the struggle; it is a question, therefore, of the means destined to obtain victory. These three meanings come together in situations of confrontation—war or games—where the objective is to act upon an adversary in such a manner as to render the struggle impossible for him. So strategy is defined by the choice of winning solutions. But it must be borne in mind that this is a very special type of situation and that there are others in which the distinctions between the different senses of the word "strategy" must be maintained.

Referring to the first sense I have indicated, one may call power strategy the totality of the means put into operation to implement power effectively or to maintain it. One may also speak of a strategy proper to power relations insofar as they constitute modes of action upon possible action, the action of others. One can therefore interpret the mechanisms brought into play in power relations in terms of strategies. But most important is obviously the relationship between power relations and confrontation strategies. For, if it is true that at the heart of power relations and as a permanent condition of their existence there is an insubordination and a certain essential obstinacy on the part of the principles of freedom, then there is no relationship of power without the means of escape or possible flight. Every power relationship implies, at least *in potentia*, a strategy of struggle, in which the two forces are not superimposed, do not lose their specific nature, or do not finally become confused. Each constitutes for the other a kind of permanent limit, a point of possible reversal. A relationship of confrontation reaches its term, its final moment (and the victory of one of the two adversaries), when stable mechanisms replace the free play of antagonistic reactions. Through such mechanisms one can direct, in a fairly constant manner and with reasonable certainty, the conduct of others. For a relationship of confrontation, from the moment it is not a struggle to the death, the fixing of a power relationship becomes a target—at one and the same time its fulfillment and its suspension. And in return, the strategy of struggle also constitutes a frontier for the relationship of power, the line at which, instead of manipulating and inducing actions in a calculated manner, one must be content with reacting to them after the event. It would not be possible for power relations to exist without points of insubordination which, by definition, are means of escape. Accordingly, every intensification, every extension of power relations to make the insubordinate submit can only result in the limits of

power. The latter reaches its final term either in a type of action which reduces the other to total impotence (in which case victory over the adversary replaces the exercise of power) or by a confrontation with those whom one governs and their transformation into adversaries. Which is to say that every strategy of confrontation dreams of becoming a relationship of power, and every relationship of power leans toward the idea that, if it follows its own line of development and comes up against direct confrontation, it may become the winning strategy.

In effect, between a relationship of power and a strategy of struggle there is a reciprocal appeal, a perpetual linking and a perpetual reversal. At every moment the relationship of power may become a confrontation between two adversaries. Equally, the relationship between adversaries in society may, at every moment, give place to the putting into operation of mechanisms of power. The consequence of this instability is the ability to decipher the same events and the same transformations either from inside the history of struggle or from the standpoint of the power relationships. The interpretations which result will not consist of the same elements of meaning or the same links or the same types of intelligibility, although they refer to the same historical fabric, and each of the two analyses must have reference to the other. In fact, it is precisely the disparities between the two readings which make visible those fundamental phenomena of "domination" which are present in a large number of human societies.

Domination is in fact a general structure of power whose ramifications and consequences can sometimes be found descending to the most recalcitrant fibers of society. But at the same time it is a strategic situation more or less taken for granted and consolidated by means of a long-term confrontation between adversaries. It can certainly happen that the fact of domination may only be the transcription of a mechanism of power resulting from confrontation and its consequences (a political structure stemming from invasion); it may also be that a relationship of struggle between two adversaries is the result of power relations with the conflicts and cleavages which ensue. But what makes the domination of a group, a caste, or a class, together with the resistance and revolts which that domination comes up against, a central phenomenon in the history of societies is that they manifest in a massive and universalizing form, at the level of the whole social body, the locking together of power relations with relations of strategy and the results proceeding from their interaction.

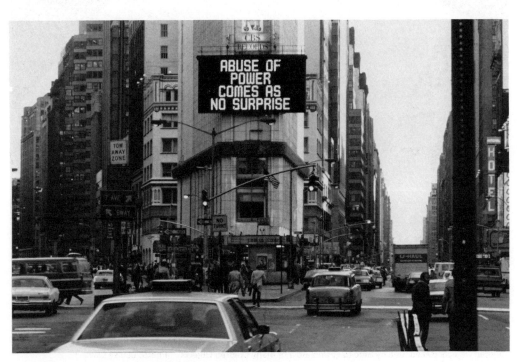

Jenny Holzer. *Times Square Spectacolor Board,* 1982

Lawrence Weiner. Wrapper band for *Documenta 7* catalogues, 1982. Text in German and English reads: "Many Colored Objects Placed Side by Side to Form a Row of Many Colored Objects." (Photo: Louise Lawler)

Bibliography

Adams, Parveen. "Representation and Sexuality." *m/f*, no. 1 (1979): 65-82.

Adorno, Theodor. *Prisms.* Translated by Samuel Weber and Shierry Weber. Cambridge, Mass.: The MIT Press, 1981.

——————. *Minima Moralia: Reflections from Damaged Life.* Translated by E. F. N. Jephcott. London: New Left Books, 1974.

Albright-Knox Art Gallery, Buffalo, N.Y. *American Painting of the 1970s.* Essay by Linda L. Cathcart. Exhibition December 8, 1978-January 14, 1979.

Allen Memorial Art Museum, Oberlin, Ohio. *Art and Social Change.* Essays by William Olander, Lucy Lippard, Craig Owens, and others. Exhibition April 19-May 30, 1983.

Althusser, Louis. "Ideology and Ideological State Apparatuses (Notes Towards an Investigation)." In *Lenin and Philosophy and Other Essays.* Translated by Ben Brewster. London: New Left Books, 1971, pp. 121-173.

——————. *For Marx.* Translated by Ben Brewster. London: New Left Books, 1969.

Antin, David. "Television: Video's Frightful Parent, Part 1." *Artforum* 14, no. 4 (December 1975): 36-45.

Arato, Andrew, and Eike Gebhardt, eds. *The Essential Frankfurt School Reader.* New York: Urizen Books, 1978.

Artists Space, New York City. *Pictures.* Essay by Douglas Crimp. Exhibition September 24, 1977-October 29, 1977.

Barnouw, Erik. *History of Broadcasting.* Vol. 1: *Tower in Babel: To 1933.* Vol. 2: *Golden Web:* *1933-53.* Vol. 3: *Image Empire: From 1950.* New York: Oxford University Press, 1970.

Barrow, Thomas F.; Shelley Armitage; and William Tydeman, eds. *Reading into Photography.* Albuquerque: University of New Mexico Press, 1982.

Barry, Judith, and Sandy Flitterman. "Textual Strategies: The Politics of Artmaking." *Screen* 21, no. 2 (Summer 1980): 35-48.

Barthes, Roland. *The Fashion System.* Translated by Matthew Ward and Richard Howard. New York: Hill and Wang, 1984.

——————. *Camera Lucida: Reflections on Photography.* Translated by Richard Howard. New York: Hill and Wang, 1981.

——————. "Upon Leaving the Movie Theater." In *Apparatus.* Edited by Theresa Hak Kyung Cha. New York: Tanam Press, 1981, pp. 1-4.

——————. *Image/Music/Text.* Translated by Stephen Heath. New York: Hill and Wang, 1977.

——————. *The Pleasure of the Text.* Translated by Richard Miller. New York: Hill and Wang, 1975.

——————. *S/Z: An Essay.* Translated by Richard Miller. New York: Hill and Wang, 1974.

——————. *Mythologies.* Translated by Annette Lavers. London: Jonathan Cape, 1972.

Baudrillard, Jean. *In the Shadow of the Silent Majorities . . . or, The End of the Social.* Translated by Paul Foss et al. Foreign Agents Series. New York: Semiotext(e), 1983.

----------. "Implosion of Meaning in the Media." Translated by John Johnston. *All Area*, no. 2 (1983): 118-121.

----------. "The Beaubourg Effect." Translated by Rosalind Krauss and Annette Michaelson. *October*, no. 20 (Spring 1982): 3-13.

----------. *For a Critique of the Political Economy of the Sign.* Translated by Charles Levin. St. Louis, Mo.: Telos Press, 1981.

----------. *The Mirror of Production.* Translated by Mark Poster. St. Louis, Mo.: Telos Press, 1975.

Baudry, Jean-Louis. "The Apparatus." Translated by Jean Andrews and Bertrand Augst. *Camera Obscura*, no. 1 (Fall 1976): 102-126.

----------. "Ideological Effects of the Basic Cinematographic Apparatus." Translated by Alan Williams. *Film Quarterly* 28, no. 2 (1974-1975): 39-47.

Bell, Tiffany. "Responses to Neo-Expressionism." *Flash Art*, no. 112 (May 1983): 40-46.

Benamov, Michel, and Charles Caramello, eds. *Performance in Postmodern Culture.* Madison, Wis.: CODA Press, 1977.

Benjamin, Walter. *Reflections.* Edited by Peter Demetz. Translated by E. F. N. Jephcott. New York: Harcourt Brace Jovanovich, 1978.

----------. "A Short History of Photography." Translated by Stanley Mitchell. *Screen* 13, no. 1 (Spring 1972): 5-26. Translated by Philip Patton. *Artforum* 15, no. 6 (February 1977): 46-51.

----------. *Illuminations.* Translated by Harry Zohn. Edited by Hannah Arendt. New York: Schocken Books, 1969. See, in particular, "The Work of Art in the Age of Mechanical Reproduction," pp. 217-251.

Berger, John. *About Looking.* New York: Pantheon Books, 1980.

----------. *Ways of Seeing.* New York: Viking Press, 1973.

Bleckner, Ross. "Transcendent Anti-Fetishism." *Artforum* 17, no. 7 (March 1979): 50-55.

Bloch, Ernst et al. *Aesthetics and Politics: Debates between Ernst Bloch, Georg Lukacs, Bertolt Brecht, Walter Benjamin, Theodor Adorno.* London: New Left Books, 1977.

Bovenschen, Silvia. "Is There a Feminine Aesthetic?" *New German Critique*, no. 10 (Winter 1977): 111-137.

Breder, Hans, and Stephen C. Foster, eds. *Intermedia.* Iowa City: University of Iowa, 1980.

Brett, Guy. "Just What is 'Modernism'?" *Art Monthly*, no. 32 (December-January 1979-1980): 32-33.

Bronson, A. A., and Peggy Gale, eds. *Performance by Artists.* Toronto: Art Metropole, 1979.

Brooks, Peter. *The Melodramatic Imagination: Balzac, Henry James, Melodrama and the Mode of Excess.* New Haven: Yale University Press, 1976.

Bryson, Norman. *Vision and Painting: The Logic of the Gaze.* New Haven: Yale University Press, 1983.

Buchloh, Benjamin H. D. "Allegorical Procedures: Appropriation and Montage in Contemporary Art." *Artforum* 21, no. 1 (September 1982): 43-56.

----------. "Parody and Appropriation in Francis Picabia, Pop, and Sigmar Polke." *Artforum* 20, no. 7 (March 1982): 28-34.

Burch, Noël. "Charles Baudelaire vs. Dr. Frankenstein." *Afterimage* (G.B.), nos. 8-9 (Spring 1981): 4-22.

----------. *Theory of Film Practice.* Translated by Helen R. Lane. New York: Praeger Publishers, 1973.

Bürger, Peter. *Theory of the Avant-Garde.* Translated by Michael Shaw. Foreword by Jochen Schulte-Sasse. Minneapolis: University of Minnesota Press, 1984.

Burgin, Victor, ed. *Thinking Photography.* London and Basingstoke: The Macmillan Press, Ltd., 1982.

----------. "Re-reading Camera Lucida." *Creative Camera* (November 1982): 730-734.

----------. "Modernism in the *Work* of Art." *20th Century Studies*, nos. 15-16 (1976): 34-55.

Carrier, David. "Recent Esthetics and the Criticism of Art." *Artforum* 18, no. 2 (October 1979): 41-47.

Caughie, John, ed. *Theories of Authorship.* London and Boston: Routledge & Kegan Paul, 1981.

————, ed. *Television: Ideology and Exchange.* London: British Film Institute, 1978.

Caws, Mary Ann. *The Eye in the Text: Essays on Perception, Mannerist to Modern.* Princeton, N.J.: Princeton University Press, 1981.

Charlesworth, Sarah. "On Camera Lucida." *Artforum* 20, no. 8 (April 1982): 72-73.

Chodorow, Nancy. *The Reproduction of Mothering: Psychoanalysis and the Sociology of Gender.* Berkeley: University of California Press, 1978.

Clark, T. J. "Clement Greenberg's Theory of Art." *Critical Inquiry* 9, no. 1 (September 1982): 139-156.

Clay, Jean. "Painting in Shreds." *Sub-stance,* no. 31 (1981): 49-74.

Cohen, Ronnie H. "Energism: An Attitude." *Artforum* 19, no. 1 (September 1980): 16-23.

Comolli, Jean, and Paul Narboni. "Cinema/Ideology/Criticism." *Screen* 12, no. 1 (Spring 1971): 27-35.

Cork, Richard. "Collaboration without Compromise." *Studio International* 195, no. 990 (1980): 4-19.

Courtivron, Isabelle de, and Elaine Marks, eds. *New French Feminisms.* New York: Schocken Books, 1982.

Coward, Rosalind. "Lacan and Signification: An Introduction." *Edinburgh Magazine,* no. 1 (1976): 6-20.

————, and John Ellis. *Language and Materialism: Developments in Semiology and the Theory of the Subject.* London: Routledge & Kegan Paul, 1977.

Crary, Jonathan. "Psychopathways: Horror Movies and the Technology of Everyday Life." *wedge,* no. 2 (Fall 1982): 8-15.

Craven, David. "Hans Haacke and the Aesthetics of Legitimation." *Parachute,* no. 23 (Summer 1981): 4-11.

Crimp, Douglas. "On the Museum's Ruins." In *The Anti-Aesthetic: Essays on Postmodern Culture.* Edited by Hal Foster. Port Townsend, Wash.: Bay Press, 1983, pp. 43-56.

————. "The End of Painting." *October,* no. 16 (Spring 1981): 69-86.

————. "The Museum's Old/The Library's New Subject." *Parachute,* no. 22 (Spring 1981): 32-37.

————. "The Photographic Activity of Postmodernism." *October,* no. 15 (Winter 1980-1981): 91-101.

D'Agostino, Peter, and Antonio Muntadas, eds. *The Un/Necessary Image.* New York: Tanam Press, 1982.

Danto, Arthur C. *The Transfiguration of the Commonplace.* Cambridge, Mass.: Harvard University Press, 1981.

Davis, Douglas. "Post-Performancism." *Artforum* 20, no. 2 (October 1981): 31-39.

————. "Post-Everything." *Art in America* 68, no. 2 (February 1980): 11, 13-14.

DeAk, Edit, and Diego Cortez. "Baby Talk." *Flash Art* 16, no. 107 (May 1982): 34-38.

Debord, Guy. *Society of the Spectacle* (1967). Detroit: Black and Red Press, 1983.

DeJong, Constance. "In Between the Dark and the Light (Television/Society/Art: A Symposium)." *Artforum* 19, no. 5 (January 1981): 25-29.

Deitch, Jeffrey. "Report from Times Square." *Art in America* 68, no. 7 (September 1980): 58-63.

De Lauretis, Teresa; Andreas Huyssen; and Kathleen Woodward, eds. *The Technological Imagination: Theories and Fictions.* Madison, Wis.: CODA Press, 1980.

————, and Stephen Heath, eds. *The Cinematic Apparatus.* New York: St. Martin's Press, 1980.

De Man, Paul. *Allegories of Reading.* New Haven: Yale University Press, 1979.

Derrida, Jacques. "The Parergon." Translated by Craig Owens. *October,* no. 9 (Summer 1979): 3-41.

————. *Writing and Difference.* Translated, with an introduction, by Alan Bass. Chicago: University of Chicago Press, 1978.

————. *Of Grammatology.* Translated by Gayatri Spivak. Baltimore and London: Johns Hopkins University Press, 1976.

Doane, Mary Ann. "Film and the Masquerade: Theorising the Female Spectator." *Screen* 23, nos. 3-4 (Fall 1982): 74-88.

————. "Woman's Stake: Filming the Female Body." *October*, no. 17 (Summer 1981): 23-36.

Documenta 7; Katalog. 2 vols. Essays by Rudi Fuchs et al. Exhibition at the Museum Fridericianum, Kassel, June 19-September 26, 1982.

Donzelot, Jacques. *The Policing of Families.* Translated by Robert Hurley. New York: Pantheon Books, 1979.

Eagleton, Terry. *Literary Theory: An Introduction.* Minneapolis: University of Minnesota Press, 1983.

————. "Aesthetics and Politics." *New Left Review*, no. 107 (1978): 21-34.

————. *Marxism and Literary Criticism.* Berkeley: University of California Press, 1976.

Eco, Umberto. *The Role of the Reader.* Bloomington: Indiana University Press, 1983.

————. *A Theory of Semiotics.* Bloomington: Indiana University Press, 1976.

Edelman, Bernard. *Ownership of the Image: Elements for a Marxist Theory of Law.* Translated by E. Kingdom. London: Routledge & Kegan Paul, 1975.

Elsaesser, Thomas. "*Lili Marleen:* Fascism and the Film Industry." *October*, no. 21 (Summer 1982): 115-140.

Enzensberger, Hans Magnus. *Critical Essays.* Edited by Reinhold Grimm and Bruce Armstrong. New York: Continuum, 1982.

————. *The Consciousness Industry.* New York: Seabury Press, 1974.

Ewen, Stuart. *Captains of Consciousness.* New York: McGraw Hill, 1976.

"Expressionism Today: An Artists' Symposium." *Art in America* 70, no. 11 (December 1982): 58-75.

Fineman, Joel. "The Structure of Allegorical Desire." *October*, no. 12 (Spring 1980): 47-66.

Flitterman, Sandy. "Woman, Desire and the Look: Feminism and the Enunciative Apparatus in Cinema." *Cine-Tracts* 2, no. 1 (Fall 1978): 63-68.

Foster, Hal. "For a Concept of the Political in Art." *Art in America* 72, no. 4 (April 1984): 17-25.

————, ed. *The Anti-Aesthetic: Essays on Postmodern Culture.* Port Townsend, Wash.: Bay Press, 1983.

————. "The Expressive Fallacy." *Art in America* 71, no. 1 (January 1983): 80-83, 137.

————. "Between Modernism and the Media." *Art in America* 70, no. 6 (Summer 1982): 13-17.

Foucault, Michel. *Discipline and Punish: The Birth of the Prison.* Translated by Alan Sheridan. New York: Vintage Books, 1979.

————. "The Eye of Power." Translated by Mark Seem. *Semiotext(e)* 3, no. 2 (1978): 6-19.

————. *The History of Sexuality.* Vol. 1: *An Introduction.* Translated by Robert Hurley. New York: Pantheon Books, 1978.

————. *Language, Counter-Memory, Practice.* Edited by D. F. Bouchard. Oxford: Basil Blackwell, 1977.

————. *Madness and Civilization: A History of Insanity in the Age of Reason.* Translated by Richard Howard. New York: Vintage Books, 1973.

————. *The Archeology of Knowledge.* Translated by Alan Sheridan. New York: Pantheon Books, 1972.

————. *The Order of Things.* New York: Vintage Books, 1970.

Frampton, Kenneth, ed. *Modern Architecture and the Critical Present.* New York: St. Martin's Press, 1982.

Freud, Sigmund. *The Standard Edition of the Complete Psychological Works of Sigmund Freud.* 24 vols. Translated by James Strachey. London: Hogarth Press, 1953.

————. "A Child is Being Beaten." *Standard Edition*, vol. 17. London: Hogarth Press, 1955.

————. *Civilization and Its Discontents. Standard Edition*, vol. 21. London: Hogarth Press, 1960.

————. *Dora: A Case History. Standard Edition*, vol. 7. London: Hogarth Press, 1953.

————. "Fetishism." *Standard Edition*, vol. 21. London: Hogarth Press, 1961.

————. "Mourning and Melancholia." *Standard Edition*, vol. 14. London: Hogarth Press, 1957.

————. *Three Essays on the Theory of Sexuality. Standard Edition*, vol. 7. London: Hogarth Press, 1953.

Fried, Michael. *Absorption and Theatricality: Painter and Beholder in the Age of Diderot.* Berkeley and Los Angeles: University of California Press, 1980.

Fuchs, Rudi, et al. *documenta 7.*

Gablik, Suzi. "Art Under the Dollar Sign." *Art in America* 69, no. 10 (December 1981): 13-19.

Gallop, Jane. *The Daughter's Seduction.* Ithaca, N.Y.: Cornell University Press, 1982.

Gardner, Carl, ed. *Media, Politics, and Culture: A Socialist View.* London: The Macmillan Press, Ltd., 1979.

Godfrey, Tony. "Sex, Text, Politics: An Interview with Victor Burgin." *Block*, no. 7 (1982): 2-26.

Goffman, Erving. *Gender Advertisements.* Cambridge, Mass.: Harvard University Press, 1978.

Goldberg, RoseLee. *Performance: Live Art from 1909 to the Present.* New York: Abrams, 1979.

Golub, Leon. "What Works?" *Art Criticism* 1, no. 2 (1979): 29-48.

Graham, Dan. "Not Post-Modernism, History as Against Historicism: European Archetypal Vernacular in Relation to American Commercial Vernacular, and the City as Opposed to the Individual Building." *Artforum* 20, no. 4 (December 1981): 50-58.

————. *Video-Architecture-Television: Writings on Video and Video Works, 1970-78.* Edited by Benjamin H. D. Buchloh. New York: New York University Press, 1979.

Greenberg, Clement. "Modern and Post-Modern." *Arts Magazine* 54, no. 6 (February 1980): 64-66.

————. "Looking for the Avant-Garde." *Arts Magazine* 52, no. 3 (November 1977): 86-87.

————. *Art and Culture.* New York: Beacon, 1967.

Grey Art Gallery, New York City. *American Painting, The Eighties: A Critical Interpretation.* Essay by Barbara Rose. Exhibition September 5-October 13, 1979.

Grundberg, Andy. "Towards a Critical Pluralism." *Afterimage* 8. no. 3 (October 1980): 5.

Guattari, Félix. *Molecular Revolution: Psychiatry and Politics.* Translated by Rosemary Sheed. Harmondsworth: Penguin, 1984.

Guilbaut, Serge, Benjamin H. D. Buchloh, and Solkin, David A., eds. *Modernism and Modernity.* Halifax: Nova Scotia College of Art and Design, 1984.

Gurevitch, Michael, et al., eds. *Culture, Society and the Media.* New York: Methuen, Inc., 1982.

Haacke, Hans. "Working Conditions." *Artforum* 19, no. 10 (June 1981): 56-61.

————. *Framing and Being Framed.* Halifax: The Press of the Nova Scotia College of Art and Design/New York University Press, 1975.

Habermas, Jürgen. *Legitimation Crisis.* Translated by Thomas McCarthy. Boston: Beacon Press, 1973.

————. *Knowledge and Human Interests.* Translated by Jeremy J. Shapiro. Boston: Beacon Press, 1971.

Hadjincolaou, Nicos. "On the Ideology of Avant-Gardism." *Praxis*, no. 6 (1982): 39-70.

Hafif, Marcia. "Beginning Again." *Artforum* 17, no. 1 (September 1978): 34-40.

Harari, Josué V., ed. *Textual Strategies: Perspectives in Post-Structuralist Criticism.* Ithaca, N.Y.: Cornell University Press, 1979.

Harvey, Sylvia. *May '68 and Film Culture.* London: British Film Institute, 1978.

Hawkes, Terence. *Structuralism and Semiology.* New York: Methuen, Inc.. 1977.

Heath, Stephen. *Questions of Cinema.* Bloomington: Indiana University Press, 1981.

————. "Difference." *Screen* 19, no. 3 (Autumn 1978): 51-112.

————. "On Screen, in Frame: Film and Ideology." *Quarterly Review of Film Studies* 1, no. 3 (1976): 251-265.

Hebdige, Dick. *Subculture: The Meaning of Style.* New York: Methuen, Inc., 1979.

Hennessey, Richard. "What's All This About Photography?" *Artforum* 17, no. 9 (May 1979): 22-25.

Hoberman, J. "Vulgar Modernism." *Artforum* 20, no. 6 (February 1982): 71-76.

————. "American Abstract Sensationalism." *Artforum* 19, no. 6 (February 1981): 42-49.

Horkheimer, Max, and Theodor Adorno. *Dialectic of Enlightenment.* Translated by John Cumming. New York: Herder and Herder, 1972.

Huyssen, Andreas. "The Search for Tradition: Avant-garde and Postmodernism in the 1970's." *New German Critique,* no. 22 (Winter 1981): 23-40.

Institute for Art and Urban Resources, Long Island City, N.Y. *Critical Perspectives.* Essays by Linda Burnham et al. Exhibition January 17, 1982-March 14, 1982.

Institute of Contemporary Art, University of Pennsylvania, Philadelphia, Pa. *Image Scavengers: Painting.* Essay by Janet Kardon. *Image Scavengers: Photography.* Essays by Douglas Crimp and Paula Marincola. Exhibitions December 8, 1982-January 30, 1983.

————. *Urban Encounters: Art, Architecture, Audience.* Exhibition March 19, 1980-April 30, 1980.

————. *The Decorative Impulse.* Essay by Janet Kardon. Exhibition June 13, 1979-July 21, 1979.

Jameson, Fredric, *The Political Unconscious.* Ithaca, N.Y.: Cornell University Press, 1981.

————. "Reification and Utopia in Mass Culture." *Social Text* 1, no. 1 (Winter 1979): 130-148.

————. *The Prison-House of Language: A Critical Account of Structuralism and Russian Formalism.* Princeton, N.J.: Princeton University Press, 1972.

————. *Marxism and Form.* Princeton, N.J.: Princeton University Press, 1971.

Johnston, Claire. "The Subject of Feminist Film Theory/Practice." *Screen* 21, no. 2 (Summer 1980): 27-34.

————. "Towards a Feminist Film Practice: Some Theses." *Edinburgh Magazine,* no. 1 (1976): 50-59.

————, ed. *Notes on Women's Cinema.* London: Society for Education in Film and Television, 1973.

Kaplan, E. Ann. *Women and Film: Both Sides of the Camera.* New York: Methuen, Inc., 1983.

————, ed. *Women in Film Noir.* London: British Film Institute, 1978.

Kelly, Mary. *Post-Partum Document.* London: Routledge & Kegan Paul, 1983.

————. "On Femininity." *Control,* no. 11 (November 1979): 14-15.

Kertess, Klaus. "Figuring it Out." *Artforum* 19, no. 3 (November 1980): 30-35.

Kolbowski, Silvia, ed. *Sexuality: Re/Positions.* Special issue, *wedge,* no. 6 (Winter 1984).

Kramer, Hilton. "A Note on the New Criterion." *The New Criterion* 1, no. 1 (September 1982): 1-5.

Krauss, Rosalind. *The Originality of the Avant-Garde.* Cambridge, Mass.: The MIT Press, 1984.

————. "Grids." *October,* no. 9 (Summer 1979): 51-64.

————. "Sculpture in the Expanded Field." *October,* no. 8 (Spring 1979): 31-44.

————. "Notes on the Index: Seventies Art in America." *October,* no. 3 (Winter 1976-1977): 68-81.

Kristeva, Julia. *Desire in Language: A Semiotic Approach to Literature and Art.* Edited by Leon S. Roudiez. Translated by Thomas Gora et al. New York: Columbia University Press, 1980.

———. "The Position of the Subject." *Semiotext(e)* 3, no. 2 (1978).

Kruger, Barbara. "Work and Money." *Appearances*, no. 7 (Fall 1982): 30.

Kuspit, Donald B. "Authoritarian Aesthetics and the Elusive Alternative," *Journal of Aesthetics and Art Criticism* 41, no. 3 (Spring 1983): 271-288.

———. "Audience and the Avant-Garde." *Artforum* 21, no. 4 (December 1982): 36-38.

———. "The New Expressionism: Art as Damaged Goods." *Artforum* 20, no. 3 (November 1981): 47-55.

———. "The Unhappy Consciousness of Modernism." *Artforum* 19, no. 5 (January 1981): 53-57.

———. "The Necessary Dialectical Critic." *Art Criticism* 1, no. 1 (Spring 1979): 13-31.

Lacan, Jacques. *Feminine Sexuality.* Edited by Juliet Mitchell and Jacqueline Rose. Translated by Jacqueline Rose. New York: Norton, 1982.

———. *The Four Fundamental Concepts of Psycho-analysis.* Edited by Jacques-Alain Miller, translated by Alan Sheridan. New York: Norton, 1978.

———. *Écrits: A Selection.* Translated by Alan Sheridan. New York: Norton, 1966.

Lavin, Maud. "Gordon Matta-Clark and Individualism," *Arts Magazine* 58, no. 5 (January 1984): 138-141.

Lawson, Thomas. "The Dark Side of the Bright Light." *Artforum* 21, no. 3 (November 1982): 62-66.

———. "Too Good to be True." *Real Life Magazine*, no. 7 (Autumn 1981): 3-7.

———. "The Uses of Representation: Making Some Distinctions." *Flash Art*, nos. 88-89 (March-April 1979): 37-39.

Levin, Charles. "Baudrillard, Critical Theory and Psychoanalysis." *Canadian Journal of Political and Social Theory* 8, nos. 1-2 (Winter-Spring 1984): 35-52.

Levin, Kim. "The State of the Art: 1980." *Art Journal* 40, nos. 1-2 (Fall-Winter 1980): 366-368.

———. "Farewell to Modernism." *Arts Magazine* 54, no. 2 (October 1979): 90-92.

Linker, Kate. "On Richard Prince's Photographs." *Arts Magazine* 57, no. 3 (November 1982): 120-122.

———. "Melodramatic Tactics." *Artforum* 21, no. 1 (September 1982): 30-32.

———. "Public Sculpture: The Pursuit of the Pleasurable and Profitable Paradise." *Artforum* 19, no. 7 (March 1981): 64-73. "Public Sculpture II: Provisions for the Paradise." *Artforum* 19, no. 10 (June 1981): 37-42.

Lippard, Lucy R. *Get the Message? A Decade of Art for Social Change.* New York: E. P. Dutton, 1984.

———. *Overlay: Contemporary Art and the Art of Prehistory.* New York: Pantheon Books, 1983.

———, and Jerry Kearns. "Cashing in a Wolf Ticket (Activist Art and *Fort Apache: The Bronx).*" *Artforum* 20, no. 2 (October 1981): 64-73.

———. "Sweeping Exchanges: The Contribution of Feminism to the Art of the 1970s." *Art Journal* 40, nos. 1-2 (Fall-Winter 1980): 362-365.

———. "Projecting a Feminist Criticism." *Art Journal* 35, no. 4 (Summer 1976): 337-339.

[Lippard, Lucy R.] Ominous, Anne. "Sex and Death and Shock and Schlock: A Long Review of the Times Square Show." *Artforum* 19, no. 2 (October 1980): 50-55.

Lyotard, Jean-François. *The Postmodern Condition: A Report on Knowledge.* Translated by Geoff Bennington and Brian Massumi. Foreword by Fredric Jameson. Minneapolis: University of Minnesota Press, 1984.

———. *Driftworks.* Edited by Roger McKeon. Foreign Agents Series. New York: Semiotext(e), 1984.

———. "The Works and Writings of Daniel Buren: An Introduction to the Philosophy of Contemporary Art." *Artforum* 19, no. 6 (February 1981): 56-64.

McEvilley, Thomas. "Heads it's Form, Tails it's not Content." *Artforum* 21, no. 3 (November 1982): 50-61.

Macksey, Richard, ed. *Velocities of Change.* Baltimore: Johns Hopkins University Press, 1974.

————, and Eugenio Donato. *The Structuralist Controversy: The Language of Criticism and the Sciences of Man.* Baltimore: Johns Hopkins University Press, 1970.

Margolies, Joseph. *Art and Philosophy.* Atlantic Highlands, N.J.: Humanities Press, 1980.

Marin, Louis. "Disneyland: A Degenerate Utopia." *Glyph* 1 (1977): 50-66.

Marshall, Stuart. "Television/Video: Technology/Forms." *Afterimage* (G.B.), nos. 8-9 (Spring 1981): 70-85.

Marx, Karl. *Capital.* 3 vols. Edited by Frederick Engels, translated from the third German edition by Samuel Moore and Edward Aveling. London: Lawrence and Wishart, 1974.

————, and Frederick Engels. *The German Ideology.* Edited by C. J. Arthur. New York: International Publishers Co., Inc., 1981.

————. *Grundrisse: Foundations of the Critique of Political Economy.* Translated by Martin Nicolaus. Harmondsworth: Penguin, 1973.

Masheck, Joseph. "Iconicity." *Artforum* 17, no. 5 (January 1979): 30-41.

Mattelart, Armand, and Seth Siegelaub, eds. *Communication and Class Struggle.* 2 vols. New York: International General, 1979-1982.

Mattelart, Armand. *Multinationals and Systems of Communications.* London: Harvester, 1978.

Mayne, Judith. "Women's Cinema and Feminist Criticism." *New German Critique*, no. 23 (Fall 1980): 68-84.

Metz, Christian. *The Imaginary Signifier: Psychoanalysis and Cinema.* Translated by Celia Britton et al. Bloomington: Indiana University Press, 1982.

————. *Film Language: A Semiotics of the Cinema.* Translated by Michael Taylor. New York: Oxford University Press, 1974.

————. *Language and Cinema.* Translated by Donna J. Umiker-Sebeok. The Hague: Mouton, 1974.

Mitchell, Juliet. *Psychoanalysis and Feminism.* New York: Random House, 1974.

Monk, Philip. "Coming to Speech: The Role of the Viewer in Performance." In *Performance Text(e)s & Documents.* Edited by Chantal Pontbriand. Montreal: Les éditions parachute, 1981, pp. 145-148.

————. "Reading and Representation in Political Art." *Parachute*, no. 16 (Fall 1979).

Morris, Robert. "American Quartet." *Art in America* 69, no. 10 (December 1981): 92-105.

————. "The Present Tense of Space." *Art in America* 66, no. 1 (January-February 1978): 70-81.

Mosco, Vincent and Andrew Herman. "Critical Theory and Electronic Media," *Theory and Society* 10, no. 6 (November 1981): 869-896.

Mulvey, Laura. "On *Duel in the Sun:* Afterthoughts on 'Visual Pleasure and Narrative Cinema'." *Framework*, nos. 15-17 (1981): 12-15.

————. "Women and Representation: A Discussion with Laura Mulvey." *Wedge* (London), no. 2 (1979): 46-53.

————. "Notes on Sirk and Melodrama." *Movie*, nos. 25-26 (1976-1977): 53-56.

Museum of Art, University of California, Santa Barbara, Calif. *Dialogue/Discourse/Research: David Antin, Eleanor Antin, Helen Mayer Harrison, Newton Harrison, Fred Lonidier, Barbara Strassen.* Essays by the artists. Exhibition September 1, 1979-October 28, 1979.

Neale, Stephen. "Propaganda." *Screen* 18, no. 3 (Autumn 1977): 9-40.

Neuberger Museum, Purchase, N.Y. *10 Artists/Artists Space.* Essays by Helene Winer and Irving Sandler. Exhibition September 9, 1979-October 15, 1979.

The New Museum of Contemporary Art, New York. *Difference: On Representation and Sexuality.* Edited by Kate Linker. Exhibition December 8, 1984-February 10, 1985.

————. *Not Just for Laughs: The Art of Subversion.* Essay by Marcia Tucker. Exhibition November 21, 1981-January 21, 1982.

————. *"Bad" Painting.* Essay by Marcia Tucker. Exhibition January 14, 1978-February 28, 1978.

Newcomb, Horace. *Television: The Critical View.* 2d ed. New York: Oxford University Press, 1979.

Nichols, Bill. *Ideology and the Image: Social Representation in the Cinema and Other Media.* Bloomington: Indiana University Press, 1981.

Oliva, Achille Bonito. *Trans Avant Garde International.* Milan: Giancarlo Politi, 1982.

Owens, Craig. "Representation, Appropriation & Power." *Art in America* 70, no. 5 (May 1982): 9-21.

—————. "Back to the Studio." *Art in America* 70, no. 1 (January 1982): 99-107.

—————. "Earthwords." *October*, no. 10 (Fall 1979): 121-130.

Parker, Rozsika. "Feminist Art Practices." *Art Monthly*, no. 43 (February 1981): 16-18.

Patton, Philip. "Other Voices, Other Rooms: The Rise of the Alternative Space." *Art in America* 65, no. 4 (July-August 1977): 80-89.

Perrault, John. "Issues in Pattern Painting." *Artforum* 16, no. 3 (November 1977): 32-36.

Perrone, Jeff. "Boy Do I Love Art or What?" *Arts Magazine* 56, no. 1 (September 1981): 72-78.

Pincus-Witten, Robert. *Entries (Maximalism).* New York: Out of London Press, 1983.

—————. "Entries: Styles of Artists and Critics." *Arts Magazine* 54, no. 3 (November 1979): 127-129.

Plottel, Jeanine Parisier, and Hanna Charney, eds. *Intertextuality: New Perspectives in Criticism.* New York: New York Literary Forum, 1978.

Pollock, Griselda. "Artists, Mythologies and Media—Genius, Madness and Art History." *Screen* 21, no. 3 (1980): 57-96.

—————. Geoffrey Nowell-Smith, and Stephen Heath. "Dossier on Melodrama." *Screen* 18, no. 2 (Summer 1977): 105-119.

Pontbriand, Chantal, ed. *Performance Text(e)s & Documents.* Montreal: Les éditions parachute, 1981.

"Post-Modernism: A Symposium." *Real Life Magazine*, no. 6 (Summer 1981): 4-10.

Ratcliff, Carter. "Contemporary American Art." *Flash Art* 16, no. 108 (Summer 1982): 32-35.

—————. "Modernism and Melodrama." *Art in America* 69, no. 2 (February 1981): 105-109.

Reason, Rex [pseud.]. "Democratism or, I went to see *Chelsea Girls* and ended up thinking about Jenny Holzer." *Real Life Magazine*, no. 8 (Spring-Summer 1982): 5-13.

Renaissance Society of the University of Chicago, Chicago, Ill. *A Fatal Attraction: Art and the Media.* Essay by Thomas Lawson. Exhibition May 2-June 12, 1982.

Ricard, Rene. "The Radiant Child." *Artforum* 20, no. 4 (December 1981): 35-43.

—————. "Not About Julian Schnabel." *Artforum* 19, no. 10 (June 1981): 74-80.

Rickey, Carrie. "Naive Nouveau and its Malcontents." *Flash Art*, nos. 98-99 (May-June 1980): 36-42.

Rosenthal, Mark. "From Primary Structures to Primary Imagery." *Arts Magazine* 53, no. 2 (October 1978): 106-107.

Rosler, Martha. "Notes on Quotes." *wedge*, no. 2 (Fall 1982): 68-73.

—————. "Theses on Defunding." *Afterimage* 10, nos. 1-2 (Summer 1982): 6-7.

Ryan, Michael. *Marxism and Deconstruction.* Baltimore: Johns Hopkins University Press, 1982.

Said, Edward W. *The World, the Text, and the Critic.* Cambridge, Mass.: Harvard University Press, 1983.

—————. *Orientalism.* New York: Vintage Books, 1979.

—————. "The Problem of Textuality: Two Exemplary Positions." *Critical Inquiry* 4, no. 4 (Summer 1978): 673-714.

Salle, David. "New Image Painting." *Flash Art*, nos. 88-89 (March-April 1979): 40-41.

Saussure, Ferdinand de. *A Course in General Linguistics.* Translated by Wade Baskin. New York: McGraw Hill, 1966.

Schiller, Herbert. *Communication and Cultural Domination.* White Plains, N.Y.: International Arts and Sciences Press, 1976.

—————. *The Mind Managers.* Boston: Beacon Press, 1973.

Schneider, Ira, and Beryl Korot, eds. *Video Art.* New York: Harcourt Brace Jovanovich, 1976.

Screen Reader 1: Cinema/Ideology/Politics. London: Society for Education in Film and Television, Ltd., 1977.

Screen Reader 2: Cinema and Semiotics. London: Society for Education in Film and Television, Ltd., 1981.

Scruton, Roger. "Photography and Representation." *Critical Inquiry* 7, no. 3 (Spring 1981): 577-603.

Sekula, Allan. *Photography Against the Grain: Essays and Photo Works 1973-1983.* Halifax: Nova Scotia College of Art and Design Press, 1984.

—————. "The Traffic in Photographs." *Art Journal* 41, no. 1 (Spring 1981): 15-25.

—————. "Dismantling Modernism, Reinventing Documentary (Notes on the Politics of Representation)." *Massachusetts Review* 19, no. 4 (Winter 1978): 859-883.

Sollers, Philippe. "Art and Artists in Lacan's Work." *Flash Art,* nos. 98-99 (May-June 1980): 48-55.

Solomon-Godeau, Abigail. "The Armed Vision Disarmed: Radical Formalism from Weapon to Style." *Afterimage* 10, no. 6 (January 1983): 9-14.

—————. "Playing in the Fields of the Image." *Afterimage* 10, nos. 1-2 (Summer 1982): 10-13.

Sontag, Susan. *On Photography.* New York: Delta Books, 1977.

Spence, Jo et al. *Photography/Politics: One.* London: Photography Workshop, 1979.

Spivak, Gayatri Chakravorty. "French Feminism in an International Frame." *Yale French Studies* 62 (1981): 154-184.

Squiers, Carol. "The Picture Perfect War." *Village Voice* (August 31, 1982): 76-77.

—————. "Framing History." *Village Voice* (August 17, 1982): 75.

Starenko, Michael. "What's an Artist to Do? A Short History of Postmodernism and Photography." *Afterimage* 10, no. 6 (January 1983): 4-5.

Stedelijk Museum, Amsterdam. *'60-'80: Attitudes/Concepts/Images.* Statements by artists. Exhibition April 9, 1982-July 12, 1982.

Sturrock, John, ed. *Structuralism and Since: From Lévi-Strauss to Derrida.* Oxford: Oxford University Press, 1979.

Suleiman, Susan, and Inge Crosman, eds. *The Reader in the Text: Essays on Audience and Interpretation.* Princeton, N.J.: Princeton University Press, 1980.

Tafuri, Manfredo. *Architecture and Utopia: Design and Capitalist Development.* Cambridge, Mass.: MIT Press, 1976.

Tompkins, Jane P., ed. *Reader-Response Criticism: From Formalism to Post-Structuralism.* Baltimore: Johns Hopkins University Press, 1981.

Tucker, Marcia. "An Iconography of Recent Figurative Painting: Sex, Death, Violence, and the Apocalypse." *Artforum* 20, no. 10 (Summer 1982): 70-75.

Valdes, Mario J., and Owen J. Miller, eds. *Interpretation of Narrative.* Toronto: University of Toronto Press, 1981.

Virilio, Paul, and Sylvere Lotringer. *Pure War.* Translated by Mark Polizotti. Foreign Agents Series. New York: Semiotext(e), 1983.

Walker Art Center, Minneapolis, Minn. *Eight Artists: The Anxious Edge.* Essay by Lisa Lyons. Exhibition April 25, 1982-June 13, 1982.

Wallach, Alan. "The Avant-Garde of the Eighties." *Art Criticism* 1, no. 3 (1981): 41-47.

Weinstock, Jane. "She Who Laughs First, Laughs Last." *Camera Obscura,* no. 5 (Spring 1980): 100-110.

White, Hayden. "The Value of Narrativity in the Representation of Reality." *Critical Inquiry* 7, no. 1 (Autumn 1980): 5-27.

—————. *The Tropics of Discourse: Essays in Cultural Criticism.* Baltimore: Johns Hopkins University Press, 1978.

White, Robin. "Great Expectations: Artists' TV Guide." *Artforum* 20, no. 10 (Summer 1982): 40-47.

Whitney Museum of American Art, New York City. *New Image Painting*. Essay by Richard Marshall. Exhibition December 5, 1978-January 28, 1979.

Williams, Raymond. *Television: Technology and Cultural Form*. New York: Schocken Books, 1974.

—————. *Culture and Society, 1780-1950*. Reprint. New York: Columbia University Press, 1983.

Williamson, Judith. *Decoding Advertisement: Ideology and Meaning in Advertising*. London and Boston: Marion Boyars Publishers, 1978.

Wollen, Peter. *Readings and Writings: Semiotic Counterstrategies*. London: Verso Editions, 1982.

—————. "Photography and Aesthetics." *Screen* 19, no. 4 (Winter 1978-1979): 28.

—————. "The Two Avant-Gardes." *Studio International* 190, no. 978 (November-December 1975): 77-85.

—————. *Signs and Meaning in the Cinema*. 3d ed. Bloomington: Indiana University Press, 1973.

Woodward, Kathleen, and Anthony Wilden et al., eds. *The Myths of Information: Technology and Postindustrial Culture*. Madison, Wis.: CODA Press, 1980.

Matt Mullican.
Bulletin Board, 1982.
Mixed media on
board, 97 x 49″ (246.4
x 124.7 cm). (Photo:
courtesy Mary Boone
Gallery)

Index

ABC No Rio, 349, 354

abstract expressionism, 88, 127, 133–134, 328, 347n

abstraction: lack of criticality, 143; and late modernism, 92; and neoexpressionism, 137, 139, 142

Activism, 301

activist art, 341–358; characteristics of, 342–344; as critique of dominant culture, 342; survey of, 348–358

Adams, Don, 341

Adams, Robert, 77

Adorno, Theodor, 160, 162, 190n, 285

aesthetic categories: integrity of, in modernist discourse, 175–176, 189–190, 191, 193; and postmodernism, 186

Agam, Yaacov, 54

aggressivity: and women in film, 380–381

agonism: and power, 428–429

Ahearn, Charlie, 69, 71

A.I.R. Gallery, 353

Akerman, Chantal, 67, 73; *The Golden Eighties*, 72; *Jeanne Dielman*, 387, *388*

Albers, Josef, 19

allegorical modes: melancholy, 108–109, 205–206

allegorical procedures: fragmentation, 206–207; and postmodern art, 191, 195, 196, 203–234; sequential structure, 207–208; synthesis of visual and verbal, 208–209

allegory: described, 204–205; essentially fragmented, 206–207; suppression of in modernist discourse, 203–204, 209–215, 229

already-made, 76; *see also* Barthes, Roland, *déjà-lu*

alternative space: institutionalization of, 327–328; and postmodern art, 187, 191

Althusser, Louis, 66, 213

Alvarez, Santiago, 68

American Painting: The Eighties, 154

Anderson, Laurie, 175, 177, 199, 222, 229; *Americans on the Move*, *218*, 219–221

Andre, Carl, 18, 194, 207, 208

Anger, Kenneth, 61; *Scorpio Rising*, 62, 69

Anthology Film Archives, 65, 69

Anti-Catalog, The (AMCC), 351

Anti-Imperialist Cultural Union (AICU), 349, 351

Antonioni, Michelangelo, 69, 71; *Blow Up*, 70

appropriation: as strategy of postmodern art production, 81, 197, 199

Aragon, Louis, 308

Arbus, Diane, 330, 332

architecture: postmodern, 117, 123

art: activist, 341–358; affecting social conditions, 297–309, 344; commodity character of, 99, 320; fascist politics of, 108–109, 113n; as institution, 82, 127; investment in, 318–319; production, and class interests, 297, 312–313, 321; and productive apparatus, 297–309; and publicity, 48–49; rejection of commodity status of, 326–327; and social context, 99, 320–321

Art & Language, 155

art brut, 148

art criticism. *See* criticism, art

art history, 393

art informel, 127

art market. *See* market, art

Art News, 48

Art of the Real, 92, 96

art photography. *See* photography, art

Art Workers' Coalition (AWC), 349, 350, 351

Artaud, Antonin, 280

Arte Cifra. *See* neoexpressionism, Italian

Artforum, 52, 65, 153, *163*, 165, 323–324; coverage of New German painting, 146–151

artist: activist, versus political artist, 348–349; autonomy of, versus political responsibility, 108, 297; avant-garde, as clown, 118; avant-garde, as heroic male, 121; as commodity, 95; isolation of, in Romantic discourse, 319–320, 321, 330; role of, in

artist (cont.)
 work, 95; status of, 297–309; see also
 author; master artist
artistic genius: relevance of modernism, 93,
 320; see also master artist
Artists' and Writers' Protest, 350
artists' books, 101
Artists Call Against U.S. Intervention in Central
 America, 352, 356
Artists Meeting for Cultural Change (AMCC),
 349, 351
Artists Space, 175
artists' writings: as signifiers of authorial status,
 94
Arzner, Dorothy, 375–376
Asimov, Isaac, 241, 244
Atget, Eugène, 14, 207, 332n
audience, 304, 311–339; determinants of, 311;
 and film, 373, 383–386; and political art,
 322–323; proscription of, 319–321; and
 taste, 321; and theory of culture, 312, 322;
 see also market, art
aura, 77, 95, 124; of commodity, 287
Austen, Jane, 23, 25
authenticity: 14–15, 17, 101; and authorship,
 94, 95; and historicism, 124, 127, 131
author: death of, 81, 194, 391; as producer,
 297–309
authoritarianism: and the eternal, 111; and
 historicism, 113–115; and traditional modes
 of representation, 107–134
authorship, 3–11; and copyright, 172; crisis of,
 91–99; and exhibition catalogue, 100; and
 marketplace, 91; and photography, 17, 77,
 80, 81; and postmodern art, 80, 81; and
 work, 172–173; see also authenticity;
 originality
avant-garde: bourgeois concept of heroic male
 in, 121; concept of, 190; death of, 53, 108–
 109, 175–176; and denial of expression, 90;
 and German neoexpressionism, 144, 148;
 institutionalization of, 65; in the 1960s and
 1970s, 53, 96, 99; and photography, 145,
 303–305; postmodern arguments against,
 115–117; relevance of painting to, 149; see
 also modernism
avant-garde practice: characteristics of, 115;
 and originality, 17–22; and notion of purity,
 19, 21, 190; and radicality, 54
avant-garde strategies: the grid, 18, 19–21;
 marginalization, 88–89; novelty, 115;
 parody, 137–138, 150; transgression, 108
Avedon, Richard, 44, 332

B, Beth and Scott, 69, 71
Baca, Judy, 343
Bacall, Lauren, 367
Baldessari, John, 80

Ballard, J. G., 245; The Atrocity Exhibition,
 291–292
Balthus, 121, 132
Balzac, Honoré de, 174
Baraka, Amiri, 351
Baranik, Rudolf, 344
Barrès, Auguste Maurice, 9
Barry, Judith, 97
Barry, Robert, 176, 208
Barthes, Roland, 27, 66, 94, 195, 210, 225–
 226, 234, 235, 251, 293–294, 377n; "The
 Death of the Author," 81, 194; déjà-lu, 75,
 102, 172; on the film still, 181, 230–231,
 232–233
Baselitz, Georg, 124, 129, 133, 137, 140, 146,
 147–148, 150; First Study for a Sculpture,
 127
Basement Workshop, 353
Baskin, Leonard, 322n
Bataille, Georges, 170
Baudelaire, Charles, 8, 144, 200, 210, 211–
 212, 244
Baudrillard, Jean, 285–287, 290–291
Bauhaus, 324n, 327n
Beaubourg, 157
Becher, Bernd, 78, 80
Becher, Hilla, 78, 80
Beckman, Ericka, 58; You The Better, 72
Beckmann, Max, 118n, 126, 127, 129
Bellini, Giovanni: Allegory of Fortune, 215
Bellour, Raymond, 66, 376, 377, 379–382,
 384, 385, 389n; "Le blocage symbolique,"
 379; "Psychosis, Neurosis, Perversion," 381–
 382; "The Unattainable Text," 102
Bender, Gretchen, 282
Benjamin, Walter, 14, 60, 66, 75n, 184n, 190,
 200, 239, 244, 334; on allegory, 109, 203–
 206, 215–217; "Arcades" project, 216;
 concept of aura, 77, 95; on Baudelaire, 212;
 on history, 210; The Origin of German
 Tragic Drama, 109, 215–216
Benning, James, 67n
Benveniste, Émile, 223
Berger, John, 408
Bergstrom, Janet, 59, 377, 382–383, 385
Berlinguer, Enrico, 264, 265
Bersani, Leo, 112
Bertin, Jacques, 93n
Beveridge, Karl, 309, 345
Binns, Vivienne, 343
Birnbaum, Dara, 73, 163, 370; Kiss the Girls:
 Make Them Cry, 72
Birrell, James, 181n, 233
Blanc, Charles, 25
Black Emergency Cultural Coalition, 350
Bloom, Barbara, 163
Bloom, Harold, 83, 204
Blunt, Anthony, 111
Bochner, Mel, 155

body art, 96–98; *see also* performance
Boetticher, Budd, 366
Bömmels, Peter, 148
Borden, Lizzie, 71
Borges, Jorge Luis, 253, 292; and allegory,
 203, 205, 209, 230
Borofsky, Jonathan, 156, 157
bourgeois aesthetics, 108, 121, 320
Brakhage, Stan, *58*, 61, 62–63, 64, 65, 66;
 Anticipation of the Night, 62
Brancusi, Constantin, 18, 283
Brauntuch, Troy, 80, 165, 175, 183–185, *184,*
 205–206, 229
Brecht, Bertolt, 67, 301, 303, 305–307, 391,
 414
Breer, Robert, 62
Brock, Bazon, 147–148
Brown, Trisha, 207, 208
Buchloh, Benjamin H. D., 137–138, 142–143,
 144, 146, 150
Buckner, Barbara, 73
buddy movies, 366
Bunnell, Peter, 79
Buñuel, Luis: *Un Chien Andalou,* 61; *L'Age
 d'Or,* 61
Bunyan, John: *Pilgrim's Progress,* 215
Burch, Noël, 59
Buren, Daniel, *152,* 161–162, 227
Burgin, Victor, 80, 405–407, 408–409;
 Grenoble, 409; *Olympia,* 408;
 "Photography, Phantasy, Function," 92;
 Zoo 78, 409, *410*

Cabral, Amilcar, 342
Cale, John, 47
Callahan, Harry, 77
Camera Work, 110
Campus, Peter, 177
capitalism: implosion of, 286–287; and
 modernism, 108–109, 190n; and ownership
 of art, 312, 313, 318–319; and production
 of the subject, 407; and representation, 283–
 294; and science fiction, 242–243
Capote, Truman, 48
Carnival Knowledge, 343
Carpaccio, Vittore, 230
Carpenter, John, 68
Carrà, Carlo, *106,* 110, 112, 113, 123, 124
Carroll, Noël, 66n, 70
Carter, Jimmy, 325n, 335, 336
Cartier-Bresson, Henri, 14
Castaneda, Carlos, 257, 258
Castelli, Luciano, 156, 157
castration: anxiety, male modes of escape, 368;
 complex, 396–397; in symbolic order, 361;
 and unpleasure in film, 376
Celant, Germano, 96
Céline, Louis Ferdinand, 11
Cendrars, Blaise, 110

Cervantes, Miguel de, 5–10
Cézanne, Paul, 155, 322n
Chagall, Marc, 53, 157
Champfleury (Jules Fleury-Husson), 210
Chandler, Raymond, 241, 245–246
Charlesworth, Sarah, 80, *272*
Chesneau, Edouard, 26
Chevreul, Michel-Eugène, 25
Chia, Sandro, 123, 156, 157
de Chirico, Giorgio, 112, 113, 125, *126,* 132
Christianity: and power, 422–423
CIA, 262
cinema: anthropomorphism of, 364; and
 audience, 373; conditions of viewing, 363; as
 representational system, 362, 378, 381; and
 scopophilia, 363; and spectator, 363
cinema, classical, 62, 63, 68, 366;
 characteristics of, 377; and closure, 377,
 379; and criticism, 375–389; female
 audience for, 383–386; and male privilege
 in, 377; role of star in, 365, 393; role of
 women in, 375–389; as text, 375–389; and
 visual pleasure, 362
cinema, narrative, 361–373; active/passive
 division in, 367; concepts of, 376; formations
 of, 372; Oedipal structure in, 386; and
 sadism, 368
cinema of structure. See structural film
cinematic codes: and desire, 372; textual
 analysis of, 379
Cityarts Workshop, 349
Clair, Jean, 113n
Clark, T. J., 204
Clarke, Shirley, 62
classicism. *See* representation, traditional modes
 of
Clastres, Pierre, 257
Claudel, Paul, 211
Clemente, Francesco, 123, *136,* 156, 157, 159,
 160
cliché: and repetition, 124; use of, in art
 criticism, 128–129
closure: in classical cinema, 377, 379
clown, 118
Cocteau, Jean, 67, 111, 115; *Le Sang d'un
 Poète,* 61
Colab (Collaborative Projects), 353, 354
Coleridge, Samuel Taylor, 213–214, 215, 232
conceptualism, 153, 156, 161, 163, 328, 350,
 357
Condé, Carole, *309,* 345
Conner, Bruce, 62
Conrad, Tony, 63
Constable, John, 26
constructivism, 122, 123
consumer: changed to producer, 306; and
 production of ideology, 391–392
Contemporary Urbicultural Documentation
 (CUD), 354

Cook, Pam, 367n, 375, 376, 378, 386
Copjec, Joan, 389n
Coplans, John, 52
copy: in nineteenth century, 25–26; repression in modernism, 26–27
copyright, 13–17; and authorship, 172
Cornell, Joseph, 18; *Rose Hobart*, *58*, 61, 65, 72
Courbet, Gustave, 209, 210
Crane, Arnold, 338
Crimp, Douglas, 76, 138, 145, 191, 193, 195, 226; "The End of Painting," 161–162, 163
critical language: regressive, 128–132
criticism: and its audience, 101; production of new forms of, 100
criticism, art: crisis of, 99; and devaluation of oppositional culture, 320–321; and modernism, 87–103; and production of the artist, 91; and postmodernism, 196; use of cliché in, 128–129; and valorization of individualism, 129–130
criticism, Marxist, 108, 137, 139
criticism, modernist: and audience, 88; and minimalism, 94; and performance art, 95; practices of, 93, 94, 100
Croce, Benedetto, 203, 214–215
Crone, Rainer, 52
Cronenberg, David, 291
cubism, 110–111, 115, 117, 155
Cucchi, Enzo, 156, 157
culture, theory of: and composition of audience, 312; and political art, 322

dada, 114n, 125; and photography, 303
Dali, Salvador, 48, 49; *Un Chien Andalou*, 61
Damisch, Hubert, 99, 102
D'Annunzio, Gabriele, 4
Dante Alighieri: *The Divine Comedy*, 219
Dante, Joe, 68
Darboven, Hanne, 128, 207, 208
Daudet, Alphonse, 5
David, Jacques-Louis, 210
David-Ménard, Monique, 398–399
Davis, Stuart, 45
Debord, Guy, 287
deconstruction: and feminist theory, 80; and postmodernism, 80, 81, 191, 195, 197, 199, 227–228, 235
Deep Throat, 264
déjà-lu. See Barthes, Roland
de Kooning, Willem, 133
Delacroix, Eugène, 25
DeLanda, Manuel: *Raw Nerves: A Lacanian Thriller*, 67n, 71n
Delany, Samuel, 246
Deleuze, Gilles, 265, 286, 292
de Man, Paul, 217, 221–222, 228, 231–232
De Palma, Brian, 68, 70–71; *Blow-Out*, 70
Derain, André, 110, 118

Deren, Maya, 61, 62; *Meshes of the Afternoon*, 60
Derrida, Jacques, 196, 227–228
Descartes, René, 4, 423
desire: in relation to body art, 98; and the castration complex, 366; masculine, 382, 393; woman's, 361, 384–385, 399
detective story, 244–245
Devo, 69
Dick, Philip K., 244, 246, 285, 291
Dick, Vivienne, *58*; *Guérillère Talks*, 69; *Liberty's Booty*, 70; *She Had Her Gun All Ready*, 69–70
Dietrich, Marlene, 367, 369
difference: and power, 429; *see also* sexual difference
disciplines, 426; breakdown of, 169
Disneyland, 261–262
distribution, of art, 100; control of, by producer, 346–348; institutional control of, 101
Dix, Otto, 114n
Doane, Mary Ann, 389; "*Caught* and *Rebecca*: The Inscription of Femininity as Absence," 383–386
Döblin, Alfred: *Wissen und Verändern*, 301–302
Documenta 7: criticism of, 150–151
documentation: of artwork, 101–102
Dokoupil, Georg Jiri, 148
Don Quixote (Cervantes), 5–10
Douchet, Jean, 371
Du Camp, Maxime, 211
Duchamp, Marcel, 76, 83, 110, 122, 123, 144, 145, 155, 164, 199, 200, 204, 209, 223–225
Dufy, Raoul, 132
Dulac, Germaine, 59
Dumas, Alexandre, 174
Duncan, Carol, 122
Dunn, Peter, *302*, 343
Duras, Marguerite: *India Song*, 387–389, *388*
dystopia, 249–250

eclecticism: in aesthetic production, 117–118, 124, 156–157
Edelman, Bernard, 90–91
Efremov, Ivan, 247–248
Eggleston, William, 330
ego libido. *See* identification
Eisenstein, Sergei, 60, 230, 231
Eisler, Hanns, 304–305
Eliot, T. S. 114n, 245
Emerson, Eric, 47
Enzensberger, Hans Magnus, 293
Ernst, Max, 119n
eroticism: and the spectacle, 369
Evans, Walker, 77, 83, 85, 207, 329

exhibition, art, 87, 100–101; and catalogue, 100–101

expanded field, 191

experimental film. *See* underground movie

Exposures (Warhol), 46–47, 54, 56

expressionism: and alienation/loss, 120–121; and artist's body, 96; and painterly gesture, 120; repression of psychosexual in, 121–123

expressionism, German: relation to neoexpressionism, 125, 142

expressiveness: as criteria in aesthetic production, 120

Fabro, Luciano, 128

Factory, The, 47, 56, 76

fantasy, 382–383, 384

fascism: and cult of personality, 305; and traditional modes of representation, 108–109, 113n

Fashion Moda, 354

Fassbinder, Rainer Werner, 68, *182*, 183

Faust, Wolfgang Max, 148–149

fauvism, 123

Feininger, Andreas, 223

Fekner, John, *346*

Feldman, Ronald, 79

Fellini, Federico, 68, 69

feminism, and art, 97, 98, 100

feminism, and film theory, 375–389; approaches, 382

fetishism: and cult of female star, 368; in film structure, 385; and the image, 183; and scopophilia, 368; and woman in film, 369, 373

Fetting, Rainer, 137, 147, 156, 157

fiction film. *See* cinema, narrative

Fiedler, Leslie, 62

figuration: and gesture, in modernist painting, 90, 120; painterly, in German neoexpressionism, 143–144; *see also* representation, traditional modes of

film: and allegorical procedures, 230–231; feminist, 69–70; and modernism, 64–65; role of look in, 372; and sexual difference, 361; structure, 379; textuality and textual analysis, 376, 377n

film, avant-garde: defined, 59–60; history of, 59–73; versus Hollywood films, 60

film, commercial. *See* cinema, classical

film, punk. *See* punk film

Film Culture, 62, 63

Film-makers' Cinematheque, 65

film noir: and castration anxiety, 368

film theory, feminist. *See* feminism, and film theory

film theory: psychoanalytic concepts and, 361–373, 378–389

Firbank, Ronald, 52

Fisher, Morgan, *58*, 64

Fitzgibbon, Colen, *340*

Flaubert, Gustave, 174, 243

Flavin, Dan, *192*, 194

Fleischner, Bob, 60

Fletcher, Angus, 207

Flitterman, Sandy, 97

Flue (Franklin Furnace), *6*

Fluxus, 350

Ford, Gerald, 266

fort-da game. *See* Freud, Sigmund

Foucault, Michel, 22n, 96, 103, 189, 227, 273, 291, 293n, 386

Fox, The, 351

fragment, 179, 181–183, 206–207, 233; *see also* Barthes, Roland, on the film still

fragmentation: as strategy of postmodern art production, 179, 181–183, 206–207

Frampton, Hollis, *58*, 64; *Poetic Justice*, 66

Franco, Generalissimo Francisco, 265

Frank, Robert, 60, 62, 330; *The Americans*, 83

Frankfurt School, 285, 419

freedom: as condition for exercise of power, 428

Freud, Sigmund, 66, 361, 365, 377, 392, 399, 400, 408, 414; "A Child is Being Beaten," 383; on dreams, 406; on fantasy, 382–383; *fort-da* game, 397; on identification, 383; *Instincts and Their Vicissitudes*, 363; on psychological structures of sexuality, 394–396; on the scopic, 407; *Three Essays on Sexuality*, 363, 395, 407

Freundlich, Otto, 124

Fried, Michael, 149, 175–177, 186, 189; "Art and Objecthood," 94–95, 193

Friedlander, Lee, 83, 330

Friedrich, Caspar David, 286

Frontier Films: leftwing films of, 60

Frye, Northrop, 204

Fuchs, Rudi, 129

Furstenberg, Diane von, 56

future, the, 244, 245–246

futurism, 18, 110, 112–113

gallery system, 99, 323, 324, 325–327; *see also* institutions, art world

Gallop, Jane, 394, 400, 401

gaze. *See* look

Gehr, Ernie, 64–65; *Eureka*, *58*, 65

Geldzahler, Henry, 49

General Hospital, 287–289

Genet, Jean, 173

genius. *See* artistic genius

German expressionism. *See* expressionism, German

German neoexpressionism. *See* neoexpressionism, German

gesture: as mark of subjectivity in modernist painting, 89–90; painterly, 120

Gibbons, Joe, 72

Gidal, Peter, 52–53

Gilpin, Reverend William, 23, 24–25, 26
God, 255–257, 269
Godard, Jean-Luc, *58*, 67, 71, 289
Goethe, Johann Wolfgang von, 25
Gohr, Siegfried, 129, 150
Goldbard, Arlene, 341
Goldstein, Jack, 80, *165*, 175, 177–180, *178*;
 A Ballet Shoe, 179; *The Jump*, 179–180;
 Two Fencers, 177–179
Goodman, Paul, 18
Gordon, Bette, 71
Gourmont, Rémy de, 26
Gowin, Emmet, 77
Goya, Francisco José de, 52
Graham, Dan, 80, 177, *364*
Gramsci, Antonio, 107, 156
Green, Christopher, 115, 117
Greenberg, Clement, 65, 90–93, 94, 96, 102,
 127, 155, 189, 320–321; "After Abstract
 Expressionism," 92; "Modernist Painting,"
 92
grid: as avant-garde strategy, 18, 19–21; and
 notion of origins/purity, 19, 21; and
 repetition, 19–21
Grosz, George, 114n
Group Material, *352*, 354
Gründel, Günter, 305
Guattari, Félix, 286, 292
Guerrilla Art Action Group (GAAG), 350
guilt: in cinema, 371

Haacke, Hans, *135*, *234*, 312n, 325n, 350
Haas, Ernst, 330
Habermas, Jürgen, 425n
Hamilton, David, 322n
Hamilton, Richard, 53
Hammett, Dashiell, 241
Hammid, Alexander, 60
Hare, David, 322n
Haring, Keith, *136*
Haskell, Molly, 366
Hatch, Connie, 83, 85; *The De-Sublimation of
 Romance*, 83, *84*
Hauser, Arnold, 334
Hawthorne, Nathaniel, 209
Hearst, Patty, 70
Heartfield, John, *296*, 304
Heath, Stephen, 66, 376, 377n, 393, 400
Hefner, Hugh, 45
Hegel, Georg Wilhelm Friedrich, 423
Heidegger, Martin, 212–213
Heinecken, Robert, 331
Heisterkamp, Peter [pseud. Blinky Palermo],
 128
Herbert, Robert, 26
Heresies, 351
Herzog, Werner, 68
Hesse, Eva, 18
Hiller, Kurt, 301

Himmler, Heinrich, 283n
Hirst, Paul, 90
historical novel, 243
historiography, 242
historicism, 190–191; and art production, 113–
 119; and authenticity, 124, 127, 131
history, 245; as authoritarian construct, 113–
 115
Hitchcock, Alfred, 61, 66, 70; *The Birds*, *370*,
 377, 378–382, *380*; *Marnie*, 369–371,
 385; *North by Northwest*, 377, 379; *Psycho*,
 381–383; *Rear Window*, 369–371, *370*;
 Rebecca, 383, 384–385; *Vertigo*, 369–372
Hitler, Adolf, 184, 185, 205, 229, 243
Hödicke, K. H., 147, 148
Hoffmann, E. T. A., 408
Hofstadter, Douglas, 293n
Hollywood, 61, 70, 362
Hollywood film. *See* cinema, classical
Holzer, Baby Jane, 48
Holzer, Jenny, *188*, *192*, *340*, *433*
Horkheimer, Max, 285
Horney, Karen, 394
Hoving, Thomas P. F., 324
Huillet, Danièle, 67, 289
Hunter, Sam, 88, 90
Husserl, Edmund, 96, 227
Huyssen, Andreas, 61

I Love Lucy, 70
identification: cinematic, 371, 372, 381, 383;
 of spectator, with film image, 365, 376
image: fetishization of, 183; legal status of, 91
Immendorff, Jörg, 123, 127, 146
individual expression: ideology of, 129–130,
 133
institution of art. *See* art, as institution.
institutionalization: forms of, 430
institutions, art world, 99, 323–328; as
 discursive formations, 82; *see also* exhibition;
 gallery system; museum; publications, art
institutions and power, 428–429
intellectuals: role of, 308; and production, 301–
 302
interdisciplinarity, 169
Interview, 46, *51*, 56–57
Irigaray, Luce, 382
Italian neoexpressionism. *See* neoexpressionism,
 Italian
Iverson, Margaret, 404

Jacob, Max, 111
Jacobs, Ken, 60, 62, 64, 65, 70
Jakobson, Roman, 208
James, Henry, 15n, 16, 177
James, William, 10
Jameson, Fredric, 119n, 125, 286n
Jancsó, Miklós, 68
Jaulin, Robert, 257

Jauss, Hans Robert, 391
Jencks, Charles, 117
Jesuits, 256
Johns, Jasper, 18, 48, 76, *198*, 199
Johnson, Lyndon, 266
Johnston, Becky, 69
Johnston, Claire, 367n, 375, 376, 378, 386;
 "Women's Cinema as Counter-Cinema," 67
Jones, Ernest, 394
Jordan, Larry, 62
journalism, 300; *see also* newspaper
Joyce, James, 11, 64
Judd, Donald, 155, 176n, 194
Just Above Midtown (JAM), 353

Kafka, Franz, 207, 209
Kahn, Herman, 294
Kant, Immanuel, 89, 92, 93, 96, 189, 234,
 321, 331, 418, 423
Kearns, Jerry, 344
Kelly, Mary: *Post-Partum Document*, 401–405,
 402
Kennedy, John F., 71, 243, 276, 291
Kennedy, Peter, 344
Kertess, Klaus, 118n
Khrushchev, Nikita, 277
Kiefer, Anselm, 124, 133, 141, 146, 147–148;
 Gilgamesh, 148
King Tut, 319
Kingdom, Elizabeth, 90
Klee, Paul, 200
Kline, Franz, 133
Kluge, Alexander, 68
Kolbowski, Silvia, *390*, 409–413; *The
 Everything Chain*, 412; *Model Pleasure*, 409
Kosinski, Jerzy, 49
Kosuth, Joseph, *86*, 93, 138, 150, 155
Kounellis, Jannis, 128
Kozloff, Max, 122
Kramer, Hilton, 325, 336
Krauss, Rosalind, 191, 194, 223, 225, 226
Kruger, Barbara, *6–7*, 79, 80, 413–415, *415*
Kubrick, Stanley, *236*, 243
Kuchar Brothers, 62, 69
Kuhn, Annette, 398
Kuntzel, Thierry, 93n, 376

Lacan, Jacques, 66, 170, 233–235, 365, 379,
 403–404, 409; on female sexuality, 393,
 395–401, 411–413; and Freud, 394, 395,
 396, 399; and mirror stage, 364, 398–399;
 on the scopic, 407–408
Lacis, Asja, 109
lack: as determinant of phallocentrism, 361;
 representation of, 387–389, 397
Lacy, Suzanne, 343
Landow, George, 64, 67n
landscape, 23–29

Landseer, Sir Edwin, 45
Lang, Fritz, *236*
Lange, Dorothea, *310*, 330
language: and art, 93–94, 193–194; changes
 in conception of, 169, 171; and film, 65–66;
 and subject formation, 397–399; *see also*
 critical language
late modernism. *See* modernism
Lawler, Louise, *6–7*, *16*, *20*, 80, *136*, *188*,
 192, *198*, *310*, *434*
Lawson, Thomas, 138, 145–146, 149, 150,
 165
Leeson, Loraine, *302*, 343
Léger, Fernand, 18
Le Guin, Ursula, 246, 250, 252
Leibniz, Gottfried Wilhelm von, 4
Lemaître, Jules, 211
Lenin, V. I., 125
Leo, Vincent, 82–83, *84*, 85
Leslie, Alfred, 60, 62
Lévi-Strauss, Claude, 228, 229
Levin, Kim, 138
Levine, Sherrie, *6–7*, *20*, 27–29, *28*, 80, 81,
 161, *163*, 175, 185, *187*, 205, 223, 233
Lewis, Joe, *340*
LeWitt, Sol, 18, *20*, 194, 207, 208
Lichtenstein, Roy, *234*
Life, 48
Light Gallery, 331
literary production, 169–174, 297–309; and
 materialist critique, 298–299; political
 function of, 306
Long, Richard, 176
Longo, Robert, 80, 175, 181–183, *192*, 205,
 229, 233; *Sound Distance of a Good Man*
 (film), *182*, 183
look, 369, 379, 381, 382–383, 384–385; and
 control, 393, 407–411; male, as determining
 in film, 367, 376; and scopophilia, 363
Los Angeles Institute of Contemporary Art
 (LAICA), 46
Loud family, 270–271, 274, 275
Lucas, George, 67–68
Lukács, Georg, 107n, 108, 131, 242–243
Lull, Ramón, 4
Lunacharsky, Anatol, 53
Lunch, Lydia, 69
Lüpertz, Markus, 129, 131, 137, 146, 147
Lurie, John, 69
Lyotard, Jean-François, 265

McCall, Anthony, *58*, 67n
McCollum, Allan, *20*, *165*
McLuhan, Marshall, 273, 284, 289
Magritte, René, 199
mainstream film. *See* cinema, classical
Makavejev, Dusan, 68
Malanga, Gerard, 47

Malevich, Kasimir, 18, 110, 114, *116*, 186, 286
Mallarmé, Stéphane, 8, 186, 286
Malraux, André, 145
man: constituted as subject, 392–393; in film, as bearer of the look, 367, 368; as creator and controller of action in film, 367
Mandel, Ernest, 286n
Mander, Jerry, 285
Manet, Edouard, 209, 227; *The Dead Toreador*, 212; *The Execution of Maximilian*, 212; *Olympia*, 408
Mangione, Salvatore [pseud. Salvo], 123
Mangolte, Babette, 67
Manifesto of Fascist Painting, 113n
Manifesto Show, The, 340
Mann, Heinrich, 301
Manzoni, Piero, 123, 144
Marcuse, Herbert, 246, 285
marginalization: as strategy of avant-garde, 88–89
Marin, Louis, 262
Marinetti, Filippo Tommaso, 18
market, art, 54, 57, 134; and authorship, 91; economics of, and effect on art production, 313–319, 328, 337–338; in the 19th century, 319–320; and revival of painting, 329; working within, as radical artist, 163–164, 344–345
Markopoulos, Gregory, 61
Marlborough Gallery, 331
Martin, Agnes, 19
Marx, Karl, 66, 239, 269
Marxist criticism. *See* criticism, Marxist
mass media, 52; conditions of consumption, 253–281
master artist, notion of: relationship to authoritarian domination, 111, 113–115
Matisse, Henri, 133
Maublanc, René, 308
meaning, production of: and representation, 391–415; and patriarchal order, 392–394
Mekas, Jonas, 62, 63, 64
melancholy, 108–109, 205–206
Mendelsohn, John, 181n
Menken, Marie, 61, 62
Merz, Mario, 128
Metropolitan Museum of Art, 324, 338
Metz, Christian, 59n, 66
Meyron, Charles, 212
Milius, John, 68
mimesis. *See* representation, traditional modes of
minimalism, 153, 155, 156, 175, 176, 177, 191, 193, 350; opposition of Greenberg and Fried to, 92, 94
mirror stage, 381–382, 398–399; and film structure, 364, 379
Mirrors and Windows, 74, 75
Mitchell, Eric, 71; *Kidnapped*, 69

Mitchell, Juliet, 396, 398
modernism, 92, 115, 199, 235; and allegory, 212; and capitalism, 108–109, 190n; collapse of, 108–109, 155, 175–176, 185–186; collapse of, and neoexpressionism, 137–138; crises in, 108, 110; defined, 87, 92–93; and notion of artistic freedom, 321; and photography, 75, 92; modes of, 283; postmodernist readings of, 189–191; and purity, 189–190; radicality of, 154–155; and repression of the copy, 26–27; and science fiction, 241; strategies of, 88–89, 137; *see also* avant-garde; avant-garde practice; avant-garde strategies
modernist aesthetic categories: hierarchy in, 193; integrity of, 175–176, 189–190, 191, 193; preserved by museums, 186–187
modernist criticism. *See* criticism, modernist
modernist film. *See* film, and modernism
Mondrian, Piet, 18, 19, 21, 27, 49
Monet, Claude, 26
Monroe, Marilyn, 46, *360*, 367
montage, 306–307
Moravia, Alberto, *Bought and Sold*, 6–7
More, Sir Thomas, 248
Morgan, J. P., 283
Morgan, Stuart, 147
Morris, Robert, *86*, 94, 155, 176, 194, *198*
Moskowitz, Robert: *The Swimmer*, 186–187
Mother Art, 343
Mulheimer Freiheit Group, 148–149
Mullican, Matt, *188*, *446*
multiples: production of, 14–15
Mulvey, Laura, 83, 121–122, 375, 384, 385, 407; "Afterthoughts on 'Visual Pleasure and Narrative Cinema' Inspired by *Duel in the Sun*," 383n; *Crystal Gazing*, 71; *Penthesilea*, 67; "Visual Pleasure and Narrative Cinema," 67, 376; *see also* Wollen, Peter
Murphy, J. J., 64
Musée des Copies, 25
museum: and complicity with art market, 318–319; corporate sponsorship of, 324–325; deconstruction of, 226–227; and institutionalization of neoexpressionism, 127–128; and modernism, 186–187, 191; and postmodernism, 191; and preservation of traditional modes of representation, 121; and simulation, 258–261
Museum of Modern Art (MoMA), 75, 134, 324, 330, 331, 338, 350

Nagy, Peter, *316–317*
Nares, James, 69
narrative: fictional, and the fragment, 181–183, 233; in film, 363, 366; in literary production, 115, 240–252
narrative cinema. *See* cinema, narrative

national-cultural identity: and art production, 124–127, 141–142, 148; economic function, 125; ideological function, 115, 125, 128

National Gallery of Art (Washington, D.C.), 13

nature: as artistic effect, 23–29; in German neoexpressionism, 143

Nauman, Bruce, *2*, 177

Neiman, LeRoy, 45, 46

neoexpressionism: and apoliticism, 132–135; critique of, 153, 156–158; institutionalization of, 127–128; nihilism in, 131; and reinforcement of political conservatism, 132–134; use of stereotypical language in critical support of, 128–129

neoexpressionism, German, 120, 123, 124; and American abstract expressionism, 133–134; characteristics of, 125; critics of, 137–151; as critique of abstraction, 139, 142; and national-cultural identity, 125–127, 141–142, 148; and "natural attitude," 139; and representation, 143; and sexual difference, 121–123

neoexpressionism, Italian *(Arte Cifra)*, 121, 123, 130; and national-cultural identity, 125

Neue Sachlichkeit. See New Objectivity

New American Cinema, 65, 67n, 68, 72, 73; and opposition to Hollywood films, 62

New Cinema (theater), New York, 69

New German Cinema, 68

New German Critique, 216

New German Painting. *See* neoexpressionism, German

New Image Painting, 186–187

New Matter-of-factness. *See* New Objectivity

New Objectivity, 108, 114, 302, 303–305

A New Spirit in Painting, 147

new talkie. *See* poststructural film

New York School. *See* abstract expressionism

New York Times, 48

Newman, Barnett, 225n

Newmarch, Annie, 343

newspaper, as literary form, 299–300

Newsweek, 325

Newton, Helmut, 322n

Nietzsche, Friedrich, 9, 221, 423

nihilism, 130–131

Niven, Larry, 244

Nixon, Richard Milhous, 243, 264, 266, 279

Not-for-Sale Project (PADD), 344

novelty, concept of: and avant-garde practice, 115

Nykino (filmmakers' collective): *Pie in the Sky*, 60, 61

objectification: modes of, 417

Oblowitz, Michael, 71

October, 153, 161

Oedipal scenario, 382, 396–397; as key to *The Birds*, 378–381

Oldenburg, Claes, 52

Only Angels Have Wings (Hawkes), 368

Ophuls, Max: *Caught*, 383–385

originality, 3–11; and avant-garde, 18, 19–21, 93; critique of, in postmodern art, 27–29; cult of, 15–16; and photography, 17, 77, 80, 81; and reproduction, 13–29; *see also* authenticity; authorship

Orwell, George, 249, 279

Owens, Craig, 143, 163, 191, 193–194, 195, 196, 199

pain: as authenticating imprint in body art, 96–97, 98

painting, 92, 99, 197; and figuration, 143; neoexpressionist, 137–151; versus photography, 89, 144–146; processes questioned, 144; relevance to avant-garde, 149; reproduction of, 102–103; revival of, 89, 186, 329; as a subversive practice, 162–164; uses of, 153–164; *see also* figuration; representation, traditional modes of

Pajaczkowska, Claire, *58*, 67n

Palermo, Blinky. *See* Heisterkamp, Peter

Pane, Gina, 97

Paolini, Giulio, 128

Papageorge, Tod, 83

paranoia: and shot/reverse-shot, 385

parody: as avant-garde strategy, 137–138, 150

pastoral power, 421–424

pattern painting, 176n

Paz, Octavio, 154

Penck, A. R., 127, 128, 133, 137, 146, 150

performance, 95, 97, 176–177, 193, 318, 327, 338

Peterson, Sidney, 61, 62

phallocentrism: and patriarchal film order, 361

phantasy. *See* fantasy

phenomenology, 97

Philip Morris, 325–326n

photographic image: re-presentation of, in postmodern art, 82–83

photography, 95, 101–102, 145, 163, 164, 318, 322–323, 338–339; as allegorical, 207; art, 77–80, 81–82; and audience, 311, 331, 333–334; and authorship/originality, 17, 77, 80, 81; institutionalization of, 82; and legal status of image, 91; legitimation of, through modernist discourse, 328–330; and market promotion, 331–332; and modernism, 75, 92; as the "non-natural," 145–146; versus painting, 89, 144–146; and postmodern art, 76–85, 197; use by European artists in 1920s, 303–305

photomontage, 207; political uses of, 304

Photo-Secession, 77

Picabia, Francis, *106*, 110, 114, 132

Picasso, Pablo, 18, 52, 53, 64, 110, 111, 114, 115, 117, 118, 123, 133, 163, 199
pictorial representation. *See* representation, traditional modes of
picture: definition of term, 175
Pictures, 175
picturesque, 23–25
Piercy, Marge, 246
Pitt, Suzan, 233
Pittura Metafisica, 108, 112, 123
Place, Pat, 69
pleasure, 98; destruction of, 363; erotic, in film, 362–363; and film, 361–373; visual, manipulation of, in film, 361; *see also* unpleasure
Poe, Edgar Allan, 8, 209, 217
Poggioli, Renato, 118n, 190
political art, 54, 56–57, 341–358; and audience, 322–323; *see also* activist art; art, affecting social conditions
Political Art Documentation/Distribution (PADD), 344, 351, 354
political struggle: consumption of, as entertainment, 305
Polke, Sigmar, 146, 150
Pollock, Griselda, 91
Pollock, Jackson, 48, 86, 90, 133, *188*, 199, 225n
pop art, 68, 76, 328
POPism: The Warhol Sixties, 46–47
Porter, Eliot, 27, 330
postmodern architecture, 117, 123
postmodern art: and allegorical procedures, 191, 195, 196, 203–234; and alternative spaces, 187, 191; characteristics of, 80, 175; and criticality, 80, 85; and critique of representation, 79–80, 234–235, 357; painting, characteristics of, 123–124; and photography, 76–85, 197; as text, 194
postmodern art, strategies of, 80, 186, 195; the already-made, 76; appropriation, 81, 197, 199, 205, 209, 223; deconstruction, 80, 81, 191, 195, 197, 199, 227–228, 235; expanded field, 191, 195; fragmentation, 179, 181, 183, 206; quotation, 181, 183, 186; representation, 82–83; temporality (psychological), 95, 176–185; theatricality, 175–176, 177, 180, 181, 191; use of language, 93–94, 193–194, 208–209
postmodernism: and aesthetic categories, 186; and collapse of modernism, 108–109, 196–200; defined in relation to modernism, 189–191; and film, 68, 70; and pluralism, 186n; and poststructuralism, 194; theories of, 76, 186, 191–196, 203–234; use of term, 189
poststructural film, 65–66, 72; psychodrama in, 62, 67
poststructuralism: and postmodernism, 194
Potter, Sally, 67n

Pound, Ezra, 18
power, 417–433; circularization of, 273–274n; defined, 418; and difference, 429; economy of, 418–419; exercise of, 424, 426, 429, 430; and freedom, 428; and knowledge, 420, 423; of the male gaze, in narrative film, 371–372; and production of the real, 267–270; relations, analysis of, 428–431; representation as mode of, 392–393, 267–270; resistance to, 419–421; and subject, 418; in theories of repression, 386; theory of, 418; and violence, 427
Prince, Richard, 80, 81, *163*, *234*
Print Collector's Newsletter, 79
productive apparatus: transformation of 303–304, 334
Proudhon, Pierre Joseph, 210
Proust, Marcel, 173, 174, 221, 240, 244
psychoanalysis: and sexuality, 382
psychoanalytic concepts: political use of, 361; use of, in art production, 394, 401–415; use of, in film theory, 361–373, 378–389
psychodrama: in film, 62, 67
publications, art, 100, 323–324
punk film, 68–70, 72
purity: and avant-garde art, 19, 21, 189–190; and postmodernism, 191; as a subversive strategy, 190
Pynchon, Thomas: *Gravity's Rainbow*, 292–293

quotation: as strategy of postmodern art production, 181, 183, 186

Rabinbach, Anson, 216
Racine, Jean Baptiste, 211
Rainer, Yvonne, 68, 176, 194; *Film About a Woman Who . . .*, *58*, 67, 387, *388*
Rameses II, 259
Ramones, The, 156
Raphael, 25
Ratcliff, Carter, 54
rationalism: and power, 418–419
rationalization, degrees of: and power, 430
Rauschenberg, Robert, 27, 48, 53, 75, 76, 123, 144, 199, 204, 209, 223–228, *224*; *Allegory*, 223, *224*, 226
Raynal, Jackie, 67
Raynal, Maurice, 111
reader/text: relations, 169–174, 391–392; 393; collaboration, 173–174, 391
Reagan, Ronald, 56–57, 134, *260*, 342
Reagan Administration, 132, 335–37, 339, 355, 356
The Real Estate Show, 354
realism: in film, 367
Les Réalismes, 157
reception: conditions of, 101, 331–339, 391–392

Red Herring, 351
Red Letter Days, 354
Reed, Lou, 47
Reinhardt, Ad, 18, 19
Rembrandt van Rijn, 322n
Renger-Patzsch, Albert, 304
Renoir, Auguste, 111
re-presentation: as strategy of postmodern art production, 82–83
representation: and artists' books, 101; cinema as system of, 362, 378, 381; critique of, 143; and feminist theory, 80, 97, 382; and meaning production, 391–392; and neoexpressionist painting, 143; and postmodern art, 186, 195; and production of ideology, 108, 244, 391–392; and repression, 110, 112; and sexuality, 391–415; and the simulacrum, 253–81; and structures of signification, 184–186, 195–196
representation, institutional modes of, 71–72; in film, 59, 63
representation, traditional modes of: and authenticity, 107; and authoritarianism, 107–134; contemporary resurgence of, 107, 119–135, 197–198; and production of ideology, 108, 124; return to, in European painting between wars, 107–119; and sexual difference, 121–123
reproduction: and originality, 13–29; and painting, 102–103; *see also* aura
resolution: in classical cinema, 377
Ricard, Rene, 153
Rice, Ron, 60, 62, 69
Richter, Gerhard, 120, 128
Rilke, Rainer Maria, 14, 15, 221
Robinson, Lillian, 120
Robinson, Walter, 165
Rocha, Glauber, 68
Rockefeller, Nelson, 318n, 325n
Rockefeller family, 313, 324
Rodchenko, Alexander, *116*, 118
Rodin, Auguste, 13–17, 22, 26; *The Gates of Hell*, *12*, *16*, 13–17
Rollins, Tim, 343
Romantic aesthetics, 213–214, 311, 319–320, 321, 330
Rose, Barbara, 52, 154, 155–156
Rose, Jacqueline, 378–382, 385, 399; "Paranoia and the Film System," 378–381
Rosenbach, Ulrike, 97–98; *Salto Mortale*, *86*, 97
Rosenberg, Harold, 54, 321
Rosenberg, Léonce, 111
Rosenblum, Robert, 55
Rosenquist, James, *188*
Rosler, Martha, 118n, 119; "The Bowery in Two Inadequate Descriptive Systems," *84*, 85

Rothenberg, Susan, 186
Rothko, Mark, 322n
Rousseau, Jean Jacques, 221, 228
Royal Academy of Arts (London), 147
Ruger, Arnold, 239
rupture: in classical cinema, 377
Rupp, Christy, *346*
Ruscha, Edward, 75, 76, *294*
Russ, Joanna, 246
Russell, Bertrand, 4, 9
Ryman, Robert, 18, 120

sadism: and narrative film, 368
Saint-Simon, Comte de (Claude Henri de Rouvroy), 4
Salle, David, 153, *158*, 159–160, 161
Salomé, 137, 156, 157
Salvo. *See* Mangione, Salvatore
Sanchez, Juan, *352*
Santos, René, 181n
Saussure, Ferdinand de, 214
Savinio, Alberto, 113n
Schad, Christian, 114, *116*
Schapiro, Meyer, 124
Schefer, Jean-Louis, 89
Schjeldahl, Peter, 52, 138
Schmidt, Johann Kaspar [pseud. Max Stirner], 130
Schnabel, Julian, 153, 156, 157, *158*, 160, 161, 164
Schopenhauer, Arthur, 208
Schrader, Paul, 68
Schroeter, Werner, 68
Schwarzkogler, Rudolf, *86*, 95
Schwitters, Kurt, 18, 19
science fiction, 239–252; Soviet, 247–252
scopophilia: and film, 363–364; *see also* voyeurism
Scorsese, Martin, 68
Scott, Sir Walter, 242
Screen, 361
sculpture, 92, 175, 191; and production of multiples, 14–15
Sekula, Allan, 334
Sen, Mrinal, 68
Serota, Nicholas, 128
Serra, Richard, 176
Seurat, Georges, 111
Severini, Gino, *106*, 110, 112, 118, *126*
sexual difference, 97; in film, 361–373; and neoexpressionism, 121–123; patriarchal organization of, 391–415; as problem in cinema, 375–389
sexuality: and power, 417; and representation, 391–415
Shahn, Ben, 322n
Shakespeare, William, 8, 242
Sharits, Paul, 63

Sherman, Cindy, 79, 80, *163*, *180*, 180–181, 233–235, *234*

Sholette, Greg, 344

shot/reverse-shot, in film, 380–381

sign: "pure," of modernist art, 190n, 196; and text, 171

signification, structures of: and postmodern art, 184–186, 195–196

Silva, Umberto, 112

Silver, Kenneth, 132

Simmons, Laurie, 80, *272*

simulation, 253–281; and death of referential, 253–254; and deterrence, 275–281; and end of perspectival system, 273–275; and illusion, 266–267; and implosion, 264–266, 286; as instrument of power, 267–270; orders of, 261–263; and production of difference, 254, 258–259; and production of the real, 266–270; and representation, 256–257; and the scientific object, 257–259; and television, 270–275

Sironi, Mario, 125

Siskind, Aaron, 79

Sisters of Survival (SOS), 343

site-specific work, 206–207

Sitney, P. Adams, 61, 63

Smith, Harry, 61

Smith, Jack: *Flaming Creatures*, 60, 62, 69

Smith, Philip, 175, 181n

Smithson, Robert, 155, 176, 194, 196n, 199, *202*, 203, 217, 220; *Spiral Jetty*, 206

Snow, Michael, 63, 64, 65

Solanas, Valerie, 47

Sollers, Philippe, 170

Sontag, Susan, 62

spectacle, 273, 287, 291–292; and spectacular space, 290–291

spectator, 384–385, 387

Speer, Albert, 184

Spengler, Oswald, 130

Spenser, Edmund, 209

Spero, Nancy, 348n

Spielberg, Steven, 68, *236*

star: role in Hollywood film system, 365, 393

state: and the individual, 422–424; and power, 421–422

Steichen, Edward, 15

Steinberg, Leo, 223, 225, 226

Steinberg, Saul, 48

Steiner, George, 109, 118n

Stella, Frank, 53, 120, 195

Sternberg, Joseph von. *See* von Sternberg, Joseph

Stieglitz, Alfred, 77, 82, 145, 333

Still, Clyfford, 133, 322n

Stirner, Max. *See* Schmidt, Johann Kaspar

Stonehenge, 206

Straub, Jean-Marie, 67, 289

Stretter, Anne-Marie, 389

structural film, 63, 65

Strugatsky, Arkady and Boris, 251–252

Studio 54, 54, 56

style: and authenticity, 17; and myth of autonomy, 117

subject: defined, 420; and desire, in body art, 98; formation, 382, 392, 397–399; objectification of, 417; and power, 392, 417–433

subjectivity: denial of, to woman, 393; elitist notions of, 130; of modernist painting, 89–90; produced by patriarchal order, 392–393

sublime, 120, 121

surrealism, 61, 123, 186

suture, 392

Syberberg, Hans-Jürgen, 68, 148

Szarkowski, John, 75, 82, 325, 329–330, 332n, 338

Taller Boricua, 353

Tarkovsky, Andrei, 252

Tasaday Indians, 257–258, 266

Tatlin, Vladimir, 283

Taylor, Elizabeth, 46

television: and the automobile, 289–290; and collapse of bourgeois similitude, 273–275, 287–289, 293; as part of telecommunications, 283–294; and simulation, 270–275; and spectacular space, 290–291; totalizing theories of, 285;

temporal modes: in art production, 94–95, 176–185; *see also* theatricality

Tesla, Nicola, 283–284

text: film as, 375; as system of representation, 392; work of art as, 101–103

text, literary: compared with work, literary, 169–174

theatricality: as antimodernist strategy, 175–176; in art, signaling collapse of modernism, 175–177, 193; and the pictorial image, 177; in postmodern art production, 180, 181, 191; *see also* temporal modes

Thiers, Adolphe, 25

Third World cinema, 68

Time, 347

To Have and Have Not (Hawkes), 367, 368

Tourneur, Jacques, 375

Trachtenberg, Alan, 332n

transgression: and avant-garde practice, 108

Tretiakov, Sergei, 299

Tuchel, Hans Gerd, 55

Tuve, Rosemond, 215

Twombly, Cy, 209

Tyler, Parker, 61

Tyndall, Andres, *58*, 67n

Tzara, Tristan, 110

Ukeles, Mierle Laderman, 343

underground movie, 62, 386–389; *see also*

New American Cinema

unpleasure, 363, 376; and castration, 368; *see also* pleasure

Upfront, 354

utopian literature, 246–252

Valéry, Paul, 4, 8, 9

VanDerBeek, Stan, 62

Vega, Lope de (Lope Félix de Vega Carpio), 9

Velvet Underground, 47

Venet, Bernar, 93n

Venice Biennale, 147

Vergine, Lea, 96–97, 98; *Il Corpo Come Linguaggio*, 96

Verne, Jules, 239, 241, 243, 246

Vertov, Dziga, 60; *The Man with the Movie Camera*, 65

video, 328, 338; as continuation of avant-garde practice, 72–73

Vietnam War, 278–279, 291

Village Voice, 62

Viola, Bill, 73

Virilio, Paul, 285n, 289n, 290

Vogel, Harold, 69; *Dear Jimmy*, 71

Vogel, Lise, 120

Vogue, 48, 55

von Sternberg, Joseph: *Dishonored*, 369; *Morocco*, 369

voyeurism: and cinematic pleasure, 66; and sadism, 368; *see also* scopophilia

Wagstaff, Samuel, 338

Waitresses, 343

Walsh, Raoul, 375

Warhol, Andy, *44*, 45–57, *50, 51*, 75, 76, 329; as filmmaker, 63, 64, 65, 69, 71; *Exposures*, 47–47, 54, 56, *POPism: The Warhol Sixties*, 46–47; *Ten Portraits of Jews of the Twentieth Century*, 55

Washington Post, 262, 263

Watergate, 71, 262–263, 264, 266

Weimar Germany, 109

Weiner, Lawrence, 176, 208, *434*

Weinstock, Jane, *58*, 67n

Welles, Orson, 61, 377

Welling, James, *78*, 80, *168*

Wells, H. G., 239, 241

Wenders, Wim, 68

Westkunst, 157

Weston, Edward, 27, 77, 78

White, Minor, 324n

Whitehead, Alfred North, 142n

Whitney Museum of American Art, 52, 55, 176n, 186

Winogrand, Garry, 83, 330, 332

Wodiczko, Krzysztof, *416*

Wollen, Peter, 65–66, 67–68, 89; *Crystal Gazing*, 71; "Photography and Aesthetics," 87, "The Two Avant-Gardes," 68; *see also* Mulvey, Laura

woman: as bearer of meaning, 362; and phallocentrism, 361, 394; as erotic object, 367; and essentialist notions of the feminine, 378; exclusion from law and language, 361; as representation/image, 366, 393; as signifier of male desire, 366; as spectator of film, 377; and subjection in patriarchal order, 397–401

woman, in film, 361–373, 375–389; as disruption, 376; as fetish, 373; guilt of, 371; as icon, 367; masochism of/sadism toward, 377; as object of gaze, 366, 367, 368; as protagonist, 367n; as sexual difference, 368; as spectacle, 376

woman, representation of, 83, 99, 391–415; in film, 372, 375–389; and patriarchal order, 361, 392–393; in performance, 97

woman's film, 383–386

Women Artists in Revolution (WAR), 350

work, literary, 169–174; characteristics of, 172

work of art: legal status of, 90; noninstrumentality of, in modernist discourse, 155, 321, 333, 334; *see also* copyright

Workers Film and Photo League, 60

World War III, 348

Wünsche, Hermann, 55

writing: and theory of the text, 174

Wyborny, Klaus, 64n

Wyeth, Andrew, 45

Wyndam, John, 244

Yeats, William Butler, 221, 222

Zapruder, Abraham, 291

Contributors

Kathy Acker has written over a dozen works of fiction, including her most recent work, *Blood and Guts in High School*, published by Grove Press in 1984. She has also published frequently in small magazines such as *Bomb*, *Top Stories*, *dianas monthly*, *wedge*, *Between C and D*, and *ZG*, has written criticism for *Artforum* and *L=A=N=G=U=A=G=E*.

Roland Barthes (1915–1980), the French literary critic whose work constantly expanded the use of that term, was the author of more than twenty books. These include *Mythologies* (1957; trans. 1972), *The Fashion System* (1967; trans. 1983), *The Empire of Signs* (1970; trans. 1983), *Image-Music-Text* (1977), and his final work, *Camera Lucida* (1980; trans. 1982). He was Professor of Literary Semiology at the College de France.

Jean Baudrillard, Professor of Sociology at the Université de Paris, is the author of *The Mirror of Production* (1973; trans. 1975), and *For a Critique of the Political Economy of the Sign* (1972; trans. 1981). His book *Simulations* (orig. 1981) has recently been published by *Semiotext(e)* in New York. He is also contributing editor to *Artforum*.

Walter Benjamin (1892–1940), the noted German critic, had interests and activities which ranged from journalism to cultural theory. Selected essays have been collected in *Illuminations* (1961; trans. 1968), and *Reflections* (1978). He is also the author of *Charles Baudillaire: A Lyric Poet in the Era of High Capitalism* (1969; trans. 1973).

Jorge Luis Borges (born 1899), the Argentinian man of letters, is noted for his fiction, poetry, essays, and translations. Among his books are *Ficciones* (1941; trans. 1963), *Labyrinths* (1964), *Dreamtigers* (1960; trans. 1964),

and *In Praise of Darkness* (1969; trans. 1974). In an interview in 1970 he said: "I have done but little reading in my life and much reading." He has never received the Nobel prize for literature.

Benjamin H. D. Buchloh, Assistant Professor of Art History at the State University of New York at Old Westbury, is the editor of the Nova Scotia Series/Source Materials of the Contemporary Arts. His critical and art historical writings have been collected in *Postmoderne-neoavantgarde*, published this year by Schirmer Verlag.

Jonathan Crary is a critic and art historian. He has taught at Columbia University and the University of California at San Diego. His current research focuses on the problem of the observer in the nineteenth century.

Douglas Crimp is a critic and associate editor of *October* magazine. He is currently writing a book on the function of the museum in the history of modernism.

Hal Foster is a critic and senior editor at *Art in America*. He recently edited *The Anti-Aesthetic: Essays on Postmodern Culture*.

Michel Foucault (1926–1984) occupied a chair in the History of Systems of Thought at the College de France in Paris. His books include *The Order of Things* (1966; trans. 1970), *Discipline and Punish* (1975; trans. 1979), *The Archeology of Knowledge* (1969; trans. 1972), and *The History of Sexuality* (1976; trans. 1978).

J. Hoberman writes film criticism for the *Village Voice* and *Artforum*. He is coauthor, with Jonathan Rosenbaum, of *Midnight Movies*, and is currently writing a book proposing an anti-aesthetic of film.

Robert Hughes is senior art critic at *Time* magazine. He is well known for the series, *The Shock of the New*, which he narrated for public television in 1981. He is also the author of *The Art of Australia* and *Heaven and Hell in Western Art*, and is currently writing a study of the colonization of Australia.

Fredric Jameson is Professor of Literature and the History of Consciousness at the University of California at Santa Cruz. He is the author of *Marxism and Form* (1972), *The Prison-House of Language* (1974), and *The Political Unconscious* (1981). He is an editor of *Social Text* and is currently writing a book on postmodernism.

Mary Kelly is an artist and lecturer in fine art at Goldsmith's College, London University. She is most noted for the *Post-Partum Document*, a six-part, 178-piece art project, recently published in book form by Routledge & Kegan Paul. She is a founding member of the Artists Union and a frequent contributor to the journals *Screen*, *m/f*, *Studio International*, and *Control*.

Rosalind Krauss is Professor of Art History at City University in New York and editor of *October* magazine. Her publications include *Terminal Iron Works: The Sculpture of David Smith* (1971), and *Passages in Modern Sculpture* (1977). A collection of her essays, entitled *The Originality of the Avant-Garde and Other Modernist Myths*, will soon be published by MIT Press.

Donald Kuspit, Professor of Art History at the State University of New York at Stony Brook, is the author of two books of criticism entitled *Clement Greenberg, Art Critic* and *Philosophical Life of the Senses (Sensibility: Existentialism)*. His most recent book, a collection of essays entitled *The Critic is Artist: The Intentionality of Art*, was published by UMI Press (1984).

Thomas Lawson is a painter and art critic. He writes frequently for *Artforum* and is the editor of *Real Life* magazine.

Kate Linker is a critic and former associate editor of *Tracks: A Journal of Artists Writings*. Her articles have appeared in *Artforum*, *Parachute*, *Studio International*, and other publications. She recently curated the exhibition

Difference: On Representation and Sexuality at The New Museum of Contemporary Art.

Lucy R. Lippard has published thirteen books on contemporary art and art criticism, including most recently *Get the Message? A Decade of Art for Social Change*. She is a cofounder of Political Art Documentation/Distribution (PADD), Printed Matter, and *Heresies: A Feminist Publication of Art and Politics*. She is national coordinator of Artists Call Against U.S. Intervention in Central America and currently writes a monthly column for the *Village Voice*.

Laura Mulvey, a critic and filmmaker, is the co-author, with Jon Halliday, of *Douglas Sirk* (1972). As a filmmaker, she has directed, with Peter Wollen, *Penthesilea, Queen of the Amazons* (1974), *The Riddle of the Sphinx* (1977), and *Crystal Gazing* (1982).

Craig Owens is a senior editor at *Art in America* and former associate editor of *October* magazine. As a critic he has contributed frequent essays to *Art in America*, *October*, and numerous exhibition catalogues.

Constance Penley is Associate Professor of English and Criticism and Interpretive Theory at the University of Illinois at Champaign-Urbana. She is the co-editor of *Camera Obscura: A Journal of Feminism and Film Theory*.

Martha Rosler, an artist and writer, teaches photography and media at Rutgers University. Two books of her work have been published: *Service: A Trilogy on Colonization* (1976), and *3 Works* (1981). Her videotapes include *Semiotics of the Kitchen* (1975), *Losing: A Conversation with the Parents* (1977), *Vital Statistics of a Citizen, Simply Obtained* (1977), and *A Simple Case for Torture, or How to Sleep at Night* (1983).

Abigail Solomon-Godeau is a photography critic and historian who has contributed regularly to publications such as *Afterimage*, *October*, and *The Print Collector's Newsletter*. She teaches photographic history and criticism at the International Center of Photography and is currently working on a study of the political uses of photography from the French Commune to the present.

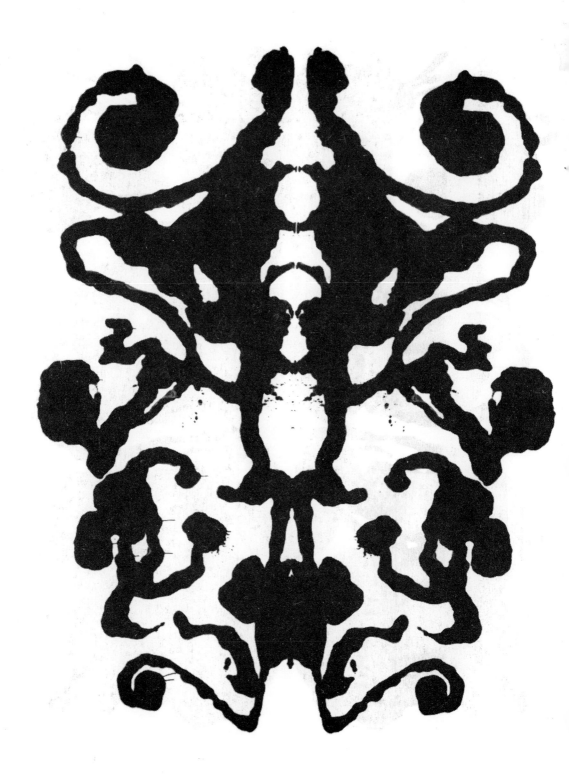